D0350523

Frederic Remington

A BIOGRAPHY

Also by Peggy and Harold Samuels

THE ILLUSTRATED BIOGRAPHICAL ENCYCLOPEDIA
 OF ARTISTS OF THE AMERICAN WEST
THE COLLECTED WRITINGS OF FREDERIC
 REMINGTON

Frederic Remington

A BIOGRAPHY

By Peggy and Harold Samuels

DOUBLEDAY & COMPANY, INC.
GARDEN CITY, NEW YORK
1982

ISBN: 0-385-14738-4
Library of Congress Catalog Card Number 79–6181
Copyright © 1982 by Peggy and Harold Samuels
Printed in the United States of America
First Edition
All Rights Reserved

Photo Credits:
The Kansas State Historical Society, Topeka; Photos 2, 5, 6, 7, 11, 12, 13, 14,
 30, 31, 32, 35, 36, 37, 39, 48, 55, 56, 57, 63
The Library of Congress; Photo 64
William H. Kuebler; Photo 58
The Conservation Center, L.A.C.M.A.; Photo 29
All other photographs are from the authors' collection.

Contents

viii CONTENTS

Introduction

At the end of 1885, when he was twenty-four years old, Frederic Remington came out of the West to claim his place as the primary illustrator of the three competing forces, the Indians and the cowboys and the cavalry. He dressed as a cowboy and used the range lingo to prove that his drawings were authentic because he had "been thar" as ranch owner, prospector, and Indian scout. His statements about himself were replete with episodes where he employed rope and gun as a cowpuncher and where he allied with the cavalry to fight Indians "he saw best down the barrel of a rifle," although he also "lived with the Indians in their tepees to practice their lore."

From the standpoint of prestige as a star in the Golden Age of Illustrators and by the measure of the wealth he earned from his art, he was so overwhelmingly successful that the other practitioners of his artistic patterns such as Charles Schreyvogel and Charles Marion Russell were known during his lifetime only as members of the "School of Remington." At Remington's funeral, the minister's eulogy recited the "Westernness" of the artist's background. When a Remington museum was established by the heirs of his wife, the claims for the artist were the same Western ones that he had clothed himself in when he was alive, the proof that he was a great Western painter and sculptor because he had had great Western experiences. The biographies that were written about Remington drew their information from data he had dictated while he was alive and from the heirs who were retailing a paint pot Buffalo Bill as the image they protected.

In the last ten years, the authors have put together a collection of original Remington materials, his journals and his diaries and 1,400 letters from him or to him or about him, pages from his earliest sketch books to his last, and comments about him from people who knew him that were recorded in hundreds of unexpected sources like oral histories in the Federal Writers' Project during the Depression. The biographical details that emerged were of a wholly different man, an illustrator who had metamorphosed into a dedicated fine artist. In the seven years before his death, Remington had become a leading

practitioner of American Impressionism, running his own routes in painting superb pictures that only he could have done.

The result of the study of these newly collected facts is the first in-depth look at an artist who was not only the progenitor of what became the pictorial stereotype as the Remington-Russell school but who went beyond his image to establish himself as one of America's most powerful fine artists. The limit to what he might have been was curtailed only by his early death at a time when he could have had twenty years of growth ahead of him.

Frederic Remington

A BIOGRAPHY

1.

The Bonfire

The brief winter afternoon was clear following the previous day's blizzard. The place was New Rochelle, a New York City suburb the wealthy residents described as being "north by east of 42nd Street." It was Saturday, January 25, 1908, on a three-acre estate named Endion, which is Algonquin for "the place where I live."

When the estate had been purchased in the spring of 1890, it had seemed an elegant spot, the ultimate home. The first name considered for it was Coseyo, pronounced "Cozy-O" as if it were an Englishman's snug retirement cottage. The front acre was the lawn, shaded by elms, and the grass tennis court. The large house was old in style then, neo-Gothic, with a vine-covered *piazza* as the owners termed it. The rear acres were the garden that made the property the "small farm." Large stables held a gray team, a riding horse, and three wagons. Ten Plymouth Rock hens scratched for their feed.

By 1908, the view of Long Island Sound had palled. Nearby railroad construction promised to become intrusive. New neighbors asked that the chickens be cooped. Endion had been for sale for more than a

year, with no taker in a slow real estate market. It was hard times following the bank failures in the financial panic of 1907.

In the rear corner of the grounds the lean Irish outside man Tim Bergin was gathering newly fallen branches and feeding them to an open bonfire when a middle-aged, three-hundred-pound, five-foot-nine-inch man with a confident waddle emerged from the back door of the forty-foot studio that had been constructed as an additional wing of the residence. Blond turning gray and balding, he had a square face rounded with fat. Slitted wide-spaced eyes, long straight nose, and determined chin complemented a controlled mouth. He had the world-weary air of the commercial impresario.

In his arms he carried large, unframed oil paintings. Favoring his left foot that had been crushed eight years before in the fall of a riding horse, he made his way to the edge of the fire and leaned the paintings against his hip. Frederic Remington was a despondent artist this day. As was his daily practice except for Sundays, he had begun painting in his studio at eight o'clock in the morning, struggling with blocking in a painting he called "Thunder Fire." After three attempts, he had decided he could never satisfy himself on this composition. He had put down his brush, changed from studio togs to his gardening jumper, picked up "Thunder Fire" and four old paintings, and had gone out into the rear yard.

At the fire, he took one painting from his side and held it up to look at it. The scene was of an open green ranch wagon being pulled by horses at full gallop. Behind a jubilant driver there was a subdued smaller Westerner. Four mounted cowpunchers were riding along at the sides of the wagon, firing their revolvers in the air and shouting as they sped through a false-front town.

This was a painting that was quintessential Remington, total action in a nostalgic Western idiom, the horses' legs bunched in the manner Remington had forced the public to accept as accurate. It was a painting familiar to hundreds of thousands of Americans, worth the thousand dollars *Collier's Weekly* had paid Remington for the right to reproduce it as "Bringing Home the New Cook," a full-color full-page feature of its November 2, 1907, issue. It would have been worth, too, the additional thousand or more dollars that was the usual Remington charge to his private customers who purchased similar paintings from him or from his Fifth Avenue dealer at exhibitions.

When he had looked his fill, Remington threw "Bringing Home the New Cook" into the open fire. To him, the subject was only a humorous story-telling episode and not the grand theme he had begun to seek. Canvas and paint and wood flared brightly and were quickly consumed by the fire.

There was a painting, Remington said to Tim Bergin, that would never confront him in the future.

So saying, he held up the second painting, looked at it as he would an old enemy, and threw it into the fire. This painting, "Drifting Before the Storm," was again an incident of the cowboy experience, two punchers bundled against a blizzard on the Western plains, riding slowly alongside the trail herd. It had been reproduced in *Collier's* on July 9, 1904, as a full-color double-page spread.

The third painting Remington lifted to eye level was "The Unknown Explorers," showing a pair of old-time adventurers on horseback negotiating a mountain trail in lengthening shadows. They were "bad men to meet in a ravine, gloomy of face, and ready for a fray." A portion of this painting had been reproduced in full color on the cover of the August 11, 1906, issue of *Collier's*. This too went into the fire.

The fourth old painting in the load, "Snaking Logs to the Skidway," had been reproduced in *Collier's* December 8, 1906, issue as part of "The Tragedy of the Trees" . . . "the epic of the forest . . . the story of man's conquest of the wooded wilderness." *Collier's* concept of logging as conquest was not Remington's idea. He could not look at a Sunday newspaper without thinking of the forests that were being destroyed to make the paper.

The incomplete "Thunder Fire" went into the flames last. After burning the five paintings, Remington returned to the studio and sat at the table. He made a businesslike note of the titles of the four old paintings he had destroyed so he could record the event on the last bound pages of his 1908 diary. Then he picked up another load of paintings including the rest of the "Tragedy of the Trees" series and burned them. At the end of the day, the list in his diary was the sixteen "paintings which I burned up." He called them "old canvases" in his description of the day and regretted only the similar canvases he could not burn because they were already sold.

What the headstrong Remington did not observe was that he was locking a barn door late. While the burned "Tragedy of the Trees" became a rarely seen Remington series because it was never reprinted, "Bringing Home the New Cook" was issued by *Collier's* as a color print in a 1908 portfolio. "Drifting Before the Storm" and "The Unknown Explorers" had been small color prints in 1904. Inexpensive lithographic color prints like these received wide distribution and had lives of their own.

The burning of the sixteen paintings shared space in Remington's diary that date with an entry noting that his chickens were laying six eggs a day and that the price of a stock he had once held had fallen to

below where he had sold, along with comments on a book by Froissart that he was reading on the fourteenth-century church and on chivalry. As casual as this juxtaposition may seem to make the burning, Remington's diary indicated that the destruction of these paintings signaled his sense of arrival on a new plateau of excellence as a creative Impressionist painter of Western subjects. The burnings affirmed the end of his career as a commercial illustrator, a stigma he felt necessary to erase in order to be admitted to the ranks of the American Impressionist painters who were his friends.

When he started in 1886, Remington could have elected either commercial illustration or fine art painting as his path. He had been successful in both areas but actively chose illustration, seduced by the print media. He had relished what he had been offered in publishing, the immediate public acclaim, easy money, and regular Western forays necessary to relieve tension from short bursts of overwork. After fifteen years as an illustrator, however, he had wanted to return to fine art, only to discover that his techniques as a painter had atrophied. His touch for fine color had been blunted. As the result, he had been forced to spend almost another decade trying to recover the capacity for painting in color that he had had in the beginning. Progress had been desperately slow until a breakthrough with the critics in 1907.

That critical approval was the message he had waited for to sever his commercial ties. It made economic security as an illustrator no longer enough to satisfy his professional ambitions, even though his earnings for 1908 were a peak of $36,614.87. He wrote in his diary that "better pictures are being painted in America today than any before," and that he would have to "hustle" to keep up. He was confident that the exercise of his talent would cause him "to land among the painters and high up, too."

A close friend and neighbor, the playwright Gus Thomas, said that Remington was a "mental hermit." Remington thought enough of this comment to record it in his diary, as he did other doings and ideas from 1907 to 1909. All of the nuts and bolts of Remington were written there, all of the artist's determinations from canvas to color to subject to light, all of the man's joys and pains, from cooks to camphorated oil. What was not down in the diary was Remington's own idea of what made him run, what demon led him to eat and drink to obesity, what compulsion forced him to burn sixteen paintings that were among his best to that point, wiping out in a moment an asset he needed.

While there was in the diary little that was specific as to what made Remington tick, there were clues. There was for example mention of

his father, a Civil War colonel. On March 11, 1907, Remington had arranged to have his father's remains transferred to his "new cemetery plot just bought" in Canton, New York, his birthplace. On May 24 he verified for himself that the body and tombstone had been removed to what Remington expected to become his own "lasting place."

May 31, 1908, was Decoration Day. Remington's diary entry was, "I forgot to send flowers to my father's grave—damn it I don't know how I did it." The colonel had died in 1880, more than twenty-eight years earlier, yet his death was still fresh to his son. Remington had begun sending the annual wreath after his success was assured, expressing inarticulate sorrow that the colonel did not live to see what he had fostered, even though he had not believed in Remington's early talent. Remington felt that he had not been a dutiful son to this normally gentle but martially fierce man, and he regretted that.

His young cousin Ella recalled her father saying that "he never saw a picture made by Fred in which there were several faces, but [that] one was of his father Colonel S. P. Remington. I could see it also." The colonel was the original and continuing presence underlying Remington's drive to prove himself at level after level in his work. Forgetting his father's wreath, however, indicated that at last Remington stood on his own feet as a man. He had moved out of the shadow of his father's bravery, patience, and love into an acceptance of his own qualities, different but sufficient now for his personal security.

The bond with his father made the paternal branch of Remington's Anglo-Saxon family tree the more influential. Remington had traced his antecedents to the Reverend Richard Remington, Archdeacon of Lockington, whose son John was born in England in 1601 and emigrated to Rowley, Massachusetts, in 1637. Some of the family presented the genealogy more grandly, substituting for the archdeacon, the Lord Remington and his fifteen children who lived on five thousand acres in the little town of Kerby Underdale in York. John the emigrant was then Lord Thomas' youngest son. Whether descended from clergy or nobility, however, the Remingtons were wholly of English origin.

The American branch of the family moved to Suffield, Connecticut, around 1700. Great-grandfather Thomas Remington settled in Henrietta in Monroe County, New York, soon after the birth of his son Seth Williston Remington on January 1, 1807. Grandfather Seth Williston Remington became a Universalist pastor and married Maria Pickering, who was descended from Mayflower settlers.

The Universalist Society was a small liberal sect founded in the eighteenth century. It was different from the better known and more theologically radical but similar-sounding Unitarians. Belief was in sal-

vation for everyone. Baptism was by choice. Communion was open to
all. In 1780, the first denominational declaration in Philadelphia con-
demned war, opposed slavery and the taking of oaths, and supported
public education. After 1800, the Universalists were further liberalized
by Hosea Ballou and centered in New York State. While early pastors
were highly educated, by Seth Williston Remington's time many of
the pastors were self-taught, as he was, and put their trust in common-
sense interpretation of the Bible. The Reverend's first parish was in
Binghamton, New York. In 1854 he accepted the call from the outgo-
ing minister to become the pastor of The Universalist Society in Can-
ton.

The Village of Canton was one mile square on both sides of the
Grasse River in the North Country of New York State. It had been
founded in 1800 by mill operators from Connecticut. By the time the
Remingtons arrived, the population of the village was about 1,500, and
dairying was an important activity in the countryside. There were ten
factories including a saw mill begun in 1801 to process logs floated
down the river, machine works, a grist mill, a forge, a tannery, and a
wagon maker.

Plank roads had been laid about 1850 and were the principal thor-
oughfares. There was a railroad connection, the Rome, Watertown, &
Ogdensburg Company. Stores had substantial trade volume. There
were fourteen lawyers, six physicians, and six dentists. In comparison
with neighboring Ogdensburg which had twenty-five saloons to its
sixteen schools, Canton granted no liquor license.

The older settlers still remembered the village's origins in the wil-
derness, with the St. Regis Indians frequently in town to trade. Service
in the War of 1812 when the British captured Ogdensburg and the
events of the Patriot War of the 1830s on the Canadian border were
believed to have fostered a fervent love of country. The long winters
and heavy snows made a cameo of the short summers. Woods, lakes,
and streams were close at hand. From Canton the foothills of the
Adirondacks were visible in their rise to the southeast.

In 1855, Canton was suggested as the site for a divinity school to
provide educated ministers for the Universalists of New York State.
When a general committee to solicit subscriptions was formed, the
Reverend Remington relinquished his pastorate early in 1856 to partic-
ipate in the fund raising for what became St. Lawrence University.
Although the Reverend did not thereafter have a fixed income, he was
paid $552 in December for obtaining subscriptions.

That same year, the Remingtons bought a clapboard house at 55
Court Street in Canton. Title to the house was in the name of Grand-
mother Maria Remington. When she died in 1867, the Reverend

moved on to a pastorate at Henderson, Jefferson County, New York, where he died in 1881. His children eulogized him as "the pleasantest companion" they ever had.

There were seven Remington children. Three of the sons were established in Canton. The oldest of the three was Seth Pierre Remington who had been born February 19, 1834, in Chautauqua County in the northwest corner of New York. He was apprenticed at eighteen in the office of the Binghamton *Democrat* newspaper, then worked on the Buffalo *Commercial-Advertiser*. In July 1856, he was in Canton. With William B. Goodrich, a Canton lawyer, he started the St. Lawrence *Plaindealer* as a Republican newspaper. It was intended to function only for the election campaign of 1856, to aid "The Pathfinder" John C. Fremont against the Democrat James Buchanan. Seth Pierre Remington was the junior partner, staking his experience in the trade against Goodrich's capital. At the start the newspaper was printed on what was even then an ancient hand press. Business prospered immediately, justifying the purchase of new equipment for a permanent enterprise.

After a few months, Goodrich sold out to his junior partner, who as S. Pierre Remington continued the management and editorship of the paper which grew to four pages. His hallmark was a vigorous editorial style and a masterly command of language. The equipment consisted of a newspaper press and a job press, with a Eureka steam engine.

The *Plaindealer* adhered closely to Republican Party policy. On April 6, 1861, S. Pierre Remington was appointed postmaster for Canton, a position he retained until he was succeeded by his brother William on December 3, 1863. The office of postmaster was part-time, a political appointment under the new Lincoln administration. Stamps were sold, the flow of mail was handled, and contracts were let for servicing rural areas.

S. Pierre Remington was tall and lean, a fine horseman, a kind and gentlemanly companion, and a good story teller. Like his younger brothers William, the county clerk and postmaster, and Lamartine, a lawyer who became a New York State chief clerk and an Albany newspaper publisher, he was working in what had become the family pattern of local politician, country journalist, or parish minister.

S. Pierre Remington married Clara Bascomb Sackrider early in 1861 on a date that remains elusive. He was twenty-seven, she twenty-five. He brought her across town in Canton to live in the home of his parents. The second of four children, she had been born December 28, 1836, in Norfolk, New York, near Canton. Her parents were Henry Lewis Sackrider from Fort Edward, Washington County, New York,

and the English Mary Hutchins. The Sackriders had moved to Canton in 1850. They were shopkeepers in the hardware trade. A substantial commercial building in Canton was owned as H. L. Sackrider & Sons.

The Sackrider family came from Strasbourg in Alsace-Lorraine. They were French and German, tracing their lineage to Christian Sackrider, an Episcopal clergyman who died in Strasbourg in 1726. His son Christian emigrated to Philadelphia where he married. The next generation settled in New York State.

Clara Remington was plump with wide-spaced eyes, a straight nose, and the same determined chin that became a feature of her son Frederic. Her personality and physique contrasted with her husband's. She was nonverbal, considered to be retiring, and did not seek company outside her near friends and relatives. Her family said she had the courage of her convictions; nothing could change her course. She was painstaking in everything she did. Her recognized talent was adeptness with the needle and artistry in her fancy work. Large afghans were beautifully crocheted. Her older brother Horace, known as Dude, and her younger brother Robert, called Rob, also lived in Canton.

Grandfather Sackrider was not thought by his children to be especially pious but he was nevertheless an elder in the First Presbyterian Church. He was called the Deacon and conducted morning prayers after breakfast every day until his death in 1895. Kindly to children, outspoken about any dislike, he was a strong supporter of Lincoln. His grandson Henry Sackrider considered him to have been a poor business man.

Frederic Sackrider Remington was born October 4, 1861, to S. Pierre and Clara Remington in Grandmother Maria Remington's Canton home. Although he was born very early in his parents' marriage, he was to be an only child.

Eight weeks later, his father enrolled at New York City in Scott's 900, the first United States Volunteer Cavalry for the War for the Suppression of the Rebellion, the Civil War. His initial task was to recruit men. This he did in his home territory of St. Lawrence County, around Canton, Ogdensburg, Colton, and Potsdam. In the beginning of 1862, S. Pierre Remington sold the St. Lawrence *Plaindealer* to J. Van Slyke to wind up his civilian affairs. On March 13, 1862, at Washington, D.C., he was mustered in as captain of what became Company D of Scott's 900, the Eleventh New York Cavalry, to serve three years. His young wife attended the ceremony. She then took the infant Frederic and moved back to her parents' Canton home next to the Fair Grounds on Water Street.

The "faithful and fearless" Captain Remington, as his men charac-

terized him, sported a dangling mustache and the kind of pointed beard called an imperial. Captain Remington was a good deal like General George Custer in appearance and action. His name regularly appeared in the official list of engagements of New Yorkers in the war, on the Roll of Honor, and in citations for gallantry in action. His company wrote poetry to his leadership. In his absence they called "Oh! for a Remington to have been in command that day."

Captain Remington was commissioned a major on March 1, 1864, with the rank dating back to September 27, 1862, when he began serving as a major in the field. He was mustered out and honorably discharged as major March 11, 1865, at Memphis, Tennessee, at the expiration of his term of service. When he was cited after the war for gallantry at Doyal's Plantation, Louisiana, on August 4, 1864, it was as brevet colonel, which means he had the field rank of colonel but the official rank at which he was paid remained major. In his later civilian life, he was properly addressed as Colonel Remington. This did cause some confusion. After his death, his widow Clara Remington engaged an attorney to attempt to establish for veteran's benefits that his official rank had been colonel, but she was unsuccessful.

Seven engagements, skirmishes, and affairs specifically named Major Remington as having been in command. The listing "916. June 27 1863. Engagement at Fairfax Court house, Va. Companies B and C, 11th Cavalry, Major S. P. Remington" fleshes out to the critical episode. Major Remington with four officers and eighty-two enlisted men was returning to Washington from a scout near Centerville, Virginia, when they encountered a line of what they thought to be John Mosby's bushwhackers. Lieutenant Dagwell precipitated a charge that became a chase on a dilapidated corduroy road. The bushwhackers proved to be the advance guard of a Confederate cavalry brigade. The major's little force was then in a pocket with winded horses within six hundred yards of eighteen hundred enemy soldiers and twenty-four pieces of artillery.

Lieutenant Dagwell wanted to run but the "brave, dashy" major gave him confidence: "The gallant old boy had blood in his eye, and was always in for a fight . . . and say d____n the conditions." When the long rebel column on their dark horses advanced, Major Remington gave the order for his eighty-six men to charge the eighteen hundred Confederates. The jammed rebels at the front of the brigade turned off into the woods with the Major's two companies pressing after them through a crossfire. The Major had broken free on the far side of the woods when he called a halt: "Boys, I am not going back to camp with four or five men; load your revolvers and see if we can't help some more through that hedge."

Major Remington returned to Washington with just eighteen of his eighty-six men, stating, "We found the rebs, and here are all that are left of us." His commanding officer's report read, "Whatever valor, coolness, and determination could perform was accomplished. I am agreeably surprised to see even the remnant he brings into camp." A Southern magazine called this "the charge of the Gray Devils," referring to the color of Remington's horses. It was "the most gallant charge and the most desperate resistance we ever met from Federal cavalry."

The rebel brigade the Major had charged was Stuart's Cavalry, the eyes of General Lee. The fight at Fairfax Court House on June 27 caused a halt in Stuart's march to meet Lee. Stuart was delayed a whole day. Lee's consequent collision with the Union army at Gettysburg was accidental, attributed by military historians to the absence of Stuart's Cavalry with the information that Lee needed on the location of the Union troops. One cause of Stuart's delay was the engagement with Remington's detachment, which may thus have influenced the course of the war.

On July 18, 1864, in Louisiana, Major Remington assumed command of the regiment and its four companies stationed at Doyal's Plantation. By August 3 the sick report showed fifty-three men unfit for duty. Daily scouting expeditions had to be abandoned. At daybreak August 5 the camp was completely surrounded by rebel forces who at once sent in a flag of truce with the note, "To avoid a useless effusion of blood I hereby demand an unconditional surrender of the Stockade and the forces under your command. I have a Brigade of Cavalry and a Battery of Artillery at my immediate disposal. Your refusal or compliance with this demand must be made within five (5) minutes after its reception." Major Remington replied that he was not in Louisiana to surrender his command.

Within ten minutes, the enemy's cannon began hitting the stockade. The Major's orders were to form into a column of fours and cut their way out. The rebel horses were small and were bowled over. The Major's column was quickly through their line and on the way to get assistance. The Major's horse was shot and fell but Private Keif gave him his horse and was made a corporal for bravery.

With reinforcements, Major Remington retook the camp by nightfall. His August 26, 1864, report to headquarters read, "In reference to the order requiring me to report the reasons of my being surrounded by the enemy without my knowledge, I have the honor to state: My force does not admit of my keeping patrols constantly on these roads, and the fact of [the rebel] Colonel Scott crossing and getting near my

camp without my knowledge does not seem to me a very remarkable circumstance. He has attempted it twice before, but on each occasion I have taken means to prevent it. This time he crossed during the night and succeeded in getting here."

The Major was very proud of the surrender note that had been written by the rebel colonel in pencil on a page from a pocket diary. He did not send it in with his report, saying, "No, sir; I would not part with that little piece of paper for $100."

The survivors of the command met for a reunion in 1895. One contribution was a poem titled *"Retrospective* (written upon receiving a photograph of the late Major Remington, so beloved by his men) 'Backward, turn backward, oh, time in your flight,/Make me a soldier boy just for tonight./Major, come back from the echoless shore,/And take command again just as of yore./Snatch from my shoulders these fashions so new,/And garb me again in the old army blue./Then sing us a song in your joyous refrain—/Enlist me again, Dag—enlist me again.'"

When the Major was mustered out and his command continued under new leadership, he took the surrender note with him. The paper was stained with blood. The Major had the note carefully folded inside another paper and tucked into a separate compartment of his wallet. After Frederic Remington died the note was found retained in his papers, part of the heritage of courage from his father, a man whose bravery was so extreme as to border on the foolhardy.

After the war, the Major was addressed by the courtesy title of Colonel. When he returned to Canton in 1865, the village looked smaller. The Civil War had bent his bonds with the North Country. His attention was drawn westward to Bloomington, Illinois, a flourishing railroad center in the prairie 126 miles south-southwest of Chicago. Although there were two daily newspapers and five weekly papers including one in German, the Colonel was appointed editor of the newly established Bloomington daily *Republican* in May 1865. He moved his family there in 1866. Remington was four years old so his negative memory of Illinois reflected the experience of his parents, his mother who did not make friends quickly and his father who might not have fit in as an employee. When Remington was fifteen, he told a friend that "I lived in Bloomington, Illinois, once in my life and never want to live there any more." The *Republican* changed management, however, and became a weekly, terminating the Colonel's position.

In 1867, the Colonel repurchased the St. Lawrence *Plaindealer* from Van Slyke and took his family back to comfortable Canton where they spent the next six years. Colonel Remington was a presence in St.

Lawrence County. Through him, Frederic Remington was a boy who was noticed, privileged, the Colonel's son, born in Canton, and ultimately buried in Canton.

Remington was a hyperactive, physically oriented boy, the leader through his imagination and inventiveness as well as his strength. He was given to outrageous behavior at times. He put on and lost excess weight, depending on his activities, and was not a scholar. Although he was pleasure-loving and not at all esthetic, Clara Remington claimed she knew her son was artistic. At the age of two or three, wearing the skirts that were a boy's costume of the day, he would lie on his stomach on the floor drawing on a slate for hours. While this was not an unusual activity for a child in his circumstance, Remington continued to draw, wherever he was, the rest of his life.

The young Remington was described as racing down Canton's main street on a sunny day in 1870 yelling, "Let's go swimming. Let's go swimming." No boy stopped for the bathing suit that was a rare costume then. Big for his age and strong, Remington was among the first to test the Grasse River in the spring. While his hair was still wet from having swum across the river, he would return to town to tease his mother by asking if he could go swimming that day. No, Fred, his mother would reply, the river is so big I hate to have you go. Remington would then solemnly promise not to go out where it was deep or the current dangerous, an example of his formula for dealing with adults: Tell them what they want to hear and do what you want to do.

Remington also fished, hunted, and camped with his friends. The boys played cowboys and Indians on the wooded hillsides. Remington once acted out a scalping by forcibly cutting the hair from a playmate's head.

The little girls and their parents remembered him as having been heartily disliked. The mother of one of these children, Alice Poste, considered him to have been a very disagreeable child as far as his attitude toward other people's property and feelings were concerned. Alice Pettibone called him a dreadful boy; he once spilled water on a brand new doll and ruined it. One day he caught her pet cat and painted it green.

Remington was a poor pupil in the elementary schools. He failed to remain attentive and did not prepare his lessons. His deficiency in mathematics particularly worried the Colonel. It meant no chance at West Point or for training as a civil engineer. When the Colonel awoke early, he would try to teach the multiplication tables to his son, but to no avail. With figures the subject, Remington was obtuse.

The Colonel also involved his son in the Canton fire department. An

informal fire company had been established in 1840 with a small rotary hand engine. After the engine became disabled about 1853, Canton had no organized fire protection. When a fire started on the north side of Main Street on August 14, 1869, half of the village's business property was destroyed including the brick building with the Colonel's printing plant on the second floor. The fire made a clean sweep of the plant except for a small job press, the subscription sheets, and the ledgers.

On September 9, 1869, an official fire department was organized with the Colonel as assistant engineer. A hand-pumper was purchased as fire-fighting equipment to replace the bucket brigade that had failed the month before.

The second "Great Fire" occurred a year later, August 4, 1870. It started where the previous year's had stopped and destroyed the remainder of the business area. The firemen arrived promptly with their pumper, but, according to the report in the Colonel's newspaper, "there was an insufficient length of hose to reach the flames." The *Plaindealer* plant was destroyed again in its new location. The paper continued to be issued, on small sheets until new equipment was purchased.

A frame structure was built for the fire department. Hook and ladder equipment was ordered in January 1871. When the department participated in the Fourth of July parade in 1872, along with them marched Frederic Remington, age ten, dressed in a replica of the fireman's uniform, with cap and gloves. At the Colonel's urging, Remington had been chosen official mascot and was photographed with the members of Engine Company Number One.

Through his connection with the Republican Party, the Colonel was appointed Collector of United States Customs in nearby Ogdensburg in December 1869. He was awaiting Senate confirmation when he began in the office informally in January 1870. The second appointment was December 24, 1873. The official document retained in Frederic Remington's papers was from the President of the United States, Ulysses S. Grant: "I have nominated Seth P. Remington and with the consent of the Senate appoint him Collector of Customs for the district of Oswegatchie in the State of New York during the term of four years from the date hereof." It was countersigned by the Secretary of the Treasury, William A. Richardson.

By August 1, 1873, the Colonel had again sold the St. Lawrence *Plaindealer*, this time to Gilbert Manley. The Remingtons moved to 30 Hamilton Street in Ogdensburg. Walter Van Valkenburg, who had trained and driven standard-bred horses in partnership with the Colonel since 1867 in Canton, went to Ogdensburg, too. The boy who had

been Fred Remington in Canton was now called Puffy. With his new friend Peter McMonagle, spare time was spent at the Remington–Van Valkenburg stables.

Remington was once again the leader of the boys. His lifelong friends John C. Howard, Edward Strong, and George Hall claimed he invented more games than anyone they knew and drew endless little sketches on scraps of paper, mainly of horses. He was still the scourge of the schoolgirls. A matron interviewed in 1944 as to whether she remembered Remington as a boy replied, "I should say I do. I sat right in front of him at the old Free Academy and I can still feel it where he used to pinch me," and she rubbed the back of her hip.

On January 1, 1874, the Colonel purchased a one-third interest in the Ogdensburg *Journal* and *Republican,* which he owned with S. H. Palmer and the founder, Henry R. James. The paper had 4,512 subscribers who soon felt "the traces of his vigorous pen" on the editorial pages. The Colonel also became a member of the Republican State Committee.

After receiving his appointment as Collector in 1869, the Colonel had become financially able to travel and had bought land near Greenfield, Dade County, Missouri. On one trip, he wrote from the Sherman House in Chicago March 9, 1871, addressing his nine-year-old son "My dear little Fred" in an appropriately simplified style and signing as "your Venerable Papa":

I write this letter with a pencil, because I cannot get a pen except in the office, and your mother wants I should write in her room so she can see what I say to her old darling.

We arrived in Chicago last evening at 8 o'clock. It was 9 by my watch, there being an hour's difference between the time here and in Canton. Your uncle William will explain to you how that queer state of things arises. Your mother behaved like a veteran on the train.

Your mother has bought you some soldiers, and they are not little "peanuts" but regular "square-toed" veterans. We leave on the 5:30 train this afternoon for Bloomington. Your mother says, every little while, that she would like to know what her little Freddie is doing, trusting he is well. You must say your lessons regularly & be a nice boy, so that when she gets home there will be nothing to mar the pleasure of your meeting. Your mother is well, & I hope will enjoy the trip—almost as well as seeing you on her return, which will be a regular pleasure.

The Colonel's letter was in line with his relationship with his own father and with the Universalist creed where children were thought of as individuals to be reasoned with, to be taught by the example of adults rather than by fear. In the letter, the approving father made no threat concerning the mischief he knew would occur in his absence.

Rather, he offered his love through the figure of the doting mother and her jumbo toy soldiers. His only child was happy and secure, the recipient of continuous approval, and free from fear of physical punishment. This was the paternal relationship with an unusual boy who became an unusual man.

2.

The Acting Corporal

When Frederic Remington was thirteen, his parents placed him in the third form for the 1875–76 school year in the Vermont Episcopal Institute at Rock Point, two miles from Burlington, Vermont. Remington was eager to go. Secure in his Ogdensburg relationships, he wanted to test himself in what would be his first sustained period away from home.

The reason for the change in schools was that Ogdensburg had no place for him. The city had established a graded educational system in 1857 with primary and secondary schools. In 1871, however, the high school had been abolished in favor of an expanded grammar school. Students like Remington who were intended for college had to do their preparatory work elsewhere.

The Vermont Episcopal Institute was a considered choice, a nationally known church school operated on a military format by a competent and experienced headmaster, the Reverend Theodore Austin Hopkins. While the Colonel had picked a military school partly as an attempt toward discipline for the carefree Remington, it was more the last hope of the soldier father that a taste of cadet life would make the

military appealing as a career. Although the Colonel had been a notable leader of men in the cavalry, he would not command his own son.

The Institute was in a magnificent setting, a wilderness that had been acquired by the Reverend's father in 1840 and cleared by his brothers and himself. The school was a large stone structure built on a bluff along the shore of Lake Champlain facing the majestic Queen Mountain range of the Adirondacks across the lake. The Institute's catalog promised that the view would tend "to refine the feelings and cultivate the taste" of the cadets.

Remington entered the school in late August 1875 as one of fifty boys, half from Vermont. He was the new boy in the third form, happy at being thrust into a group way of life in a stimulating terrain. The course of instruction was college oriented. His first formal art lessons were in the drawing class taught by the Reverend himself. The church portion of the studies was daily catechism with hymns and scripture readings. There were prayers after breakfast and just before bedtime at 9 P.M.

The joy of the transfer was quickly stilled. The Institute was a military school. Discipline was strict. Remington could not avoid the prayers or the catechism that had never been forced on him at home. Half of his classes were in subjects he abhorred—spelling, public speaking, German, and mathematics at the level of algebra. He was expected to attend classes, pay attention, and apply himself, whether he liked what he was to learn or not.

The military functions were more acceptable. As a cadet, he wore a uniform of "genuine West Point gray." The cadets were organized into platoons for drill according to *Upton's Manual of Arms*. The older boys carried Springfield rifles. The younger ones like Remington trained with wooden guns. The snap and the polish of soldierly compliance were difficult for Remington. His pocket money of twenty-five cents a week was limited to periods when he was rated among the "good boys," and that was not often. Infractions of rules resulted in demerits that required him to stand in military posture for fifteen minutes. If he could not stand at attention that long, a real problem for a hyperactive boy, the demerits had to be thrashed out on Saturdays at five blows per demerit. Whatever part of Saturday was left was spent swimming or boating in warm weather, skating or exploring when it was cold.

The enforced discipline at the Institute caused Remington to run away, but the revolt was of short duration. He would not have worried his parents. His own version of the cause of his unhappiness was that the Institute meals left him hungry all the time, despite the

promise in the catalog that "the very best of meats and poultry and other substantial fool is provided." He was barred from obtaining food from his mother because of the Institute proviso that "boxes from home containing eatables are *Needless* and *Mischievous* and are forbidden." He could not supplement his meals through purchases at the Burlington store because he was not a "good" boy and therefore was not allowed pocket money. Although "I don't amount to anything in particular," he said, "I can spoil an immense amount of grub at any time in the day," and the Institute kept him in unresolved hunger.

To his mother, who had raised him with an appreciation of hearty eating, the notion that extra eatables could be mischievous was not acceptable. The Colonel, too, joined in the dissatisfaction with the Institute. His son was being improperly influenced, away from the military. The conclusion was for Remington to return to the Institute, accept his punishment for running away, and submit to the regimen for the balance of the year, on the promise that he could transfer to a different school in 1876.

That made Remington tractable again and he somewhat reluctantly returned for the balance of the semester. He wrote his Ogdensburg chum John Howard on June 13, questioning "why a fellow wants to get away to school, [when] he wants to get home again sooner, but everyone has to find this out." June was the end of the term, and he left the Institute for good, as he had been promised.

For the summer of 1876, Remington's parents were planning a visit to Albany, New York, without him. He would be staying with Grandfather Sackrider in Canton, a milieu he enjoyed. The Deacon's daily Presbyterian prayers did not bother Remington. As cousin Henry Sackrider said, "I can never remember Fred at any of them." The tightest patriarchal restraint on Remington was the admonition, "Fred you will never amount to anything." He played pranks on Grandmother Sackrider, who was frugal but kind and generous toward children. He was kept within bounds only by the Deacon. It was a complete change from military school.

This was the summer of Remington's first painting. He combined Reverend Hopkins' elementary drawing lessons with the Institute history lessons to create "The Chained Gaul." He sketched the composition on paper first, then the next day made a rough four by three foot painting of a barbarian bound to a dungeon pillar, guarded by a Roman soldier in a crested helmet. The Sackriders hung the picture in the hall of their home on Miner Street.

By late summer, the Colonel had returned to Ogdensburg to campaign for Rutherford Hayes for President. The slogan of the Colonel's

Journal was, "Don't leave a Republican at home because of sickness, lameness or any other disability. Fix him up tenderly and take him to vote." Remington joined in the campaign parades and participated in the summer electioneering. Hayes won without a majority of the popular vote nationally but did get 70 percent of the electorate in St. Lawrence County. He reappointed the Colonel as Collector for a third term.

For the 1876–77 school session, Remington transferred to Highland Military Academy in Worcester, Massachusetts. This was a larger private school, farther away but not as remotely situated, whose catalog claimed it to be similar to a high or scientific school. The military department taught infantry and artillery tactics. Church attendance was obligatory. Remington, who was then called Bud, wore a uniform made by the Academy tailor.

He was enrolled as a sophomore in the four-year English course, as opposed to the classical course. In the family tradition, his best subject proved to be English composition. Remington found the Academy acceptable. He remained there for two years, until June 20, 1878. School was programmed to involve long hours of hard work, with strict military discipline administered by cadet officers. A new cadet received his first instruction as a member of the "Awkward Squad," to be taught setting-up drill in calisthenics, marching, and later the manual of arms. Remington was the only new cadet placed in an "Awkward Squad" who was an experienced transfer from another military institute, with a year's practice in the manual of arms.

At the Academy, Remington displayed the contrary traits that characterized him as a young man. His response to military discipline was a half-hearted compliance entered into with a completely good-humored air of achievement. He gave the appearance of a cadet whose blood raced at the prospect of parading with a musket, but his feet lagged. His stoutness and carelessness were overlaid with an easy manner, so that he was a pleasant young man to have around, but a poor soldier.

His physical strength distinguished him. In a friendly wrestling match, cadet Julian Wilder from Augusta, Maine, received a broken shoulder blade, a broken collarbone, and a dislocated arm. As Remington described himself, "I go a good many on muscle. My hair is short and stiff, and I am about five feet eight inches and weigh one hundred and eighty pounds. There is nothing poetical about me."

What made him popular at the Academy was his breeziness, inner happiness, generosity, and his ability to draw caricatures of the officers and teachers. He drew easily and gave away sketches of the cadet corps on parade, the color guard, and the company maneuvers. He

was called upon to decorate pages in the souvenir books that other students maintained.

These early Remington sketches were original in composition and style but very stiff and out of proportion. There was none of the sensitivity or power that would be expected from the early efforts of a great artist. The bold drawings caught the eye because Remington was not afraid to try for figures in motion, but behind the quick lines there was no grace or conventional artistry.

The rough quality of his workmanship in no way diminished the confident Remington's enthusiasm for drawing. At the Academy, classmate Julian Wilder also sketched. Wilder had a hometown correspondent, Scott Turner, who had studied art. When Wilder showed Remington a Turner letter embellished with ink sketches, Remington felt impelled on March 3, 1877, to write to Turner himself, an assured advance by a fifteen-year-old: "Friend Scott—Having seen some of your drawings which you sent Wilder, I am desirous of opening a correspondence with you. I hope you will honor me with your sanction. I am the fortunate possessor of one of your drawings, entitled 'Where is the Cap't?'" He told Turner, "You draw splendidly, and I admire your mode of shading, which I cannot get the 'hang' of. I do not pretend to compare my drawings with yours." The letter's signature "F. S. Remington" was a unique usage of the middle initial.

While he was at the Academy, Remington continued to correspond with Turner. They never met. Turner saved four letters and five of these early sketches. Remington's second letter was autobiographical, an early reading of the man: "I don't swear much, although it is my weak point, and I have to look my letters over carefully to see if there is any cussing in them. I never smoke—only when I can get treated— and I never condescend to the friendly offer of 'Take something, old hoss?'" The letter was straightforward in comparison with the teasing tone of the third one:

Hearing you wanted a picture of me, I send you this "misfortune." I don't see what you want of such a looking thing as this. You probably would not have wanted it if you had known what it was going to look like. You can burn it up, but don't throw it into the back yard or it may scare some wandering hen to death, and if perchance a small boy should find it he would exhibit it for two cents a look as the Grand Duke of Alexis or "A What Is It!" There is nothing about that picture which shows me off to advantage. They all say I am handsome. (I don't think so.) But you wouldn't get that idea from that photo. No! And in fact I never had a picture taken which showed my fine points. Besides, it costs like sin for me to have my "fiz" got inside of a camera, as they have to put a coal sieve in front of the box to keep it from cracking the glass.

His next letter to Turner was liberally "decorated" at the top with silhouette sketches:

I hope you will excuse the blots [the sketches] I got on the upper end of this sheet. They don't mean anything in particular; but I wish you would make some similar ones on your return letter. Draw me a good picture, only one, and I'll be your slave forever. Give us a battle between the Russians and Turks, or Indians and soldiers.

It was soldiers Remington sketched, and soldiers he wanted from Turner: "Your favorite subject is soldiers. So is mine." When Turner drew people in evening dress, Remington wrote, "Don't send me any more women or any more dudes. Send me Indians, cowboys, villains, or toughs. These are what I want."

At sixteen, Remington used drawing as an alternate means of communication to supplement the verbal forms he also handled well. He had caught the trick of making crude cartoonlike line drawings convey motion and expression. He envied sketches with more technical ability in shading or proportion, but his involvement was with the subject matter, the soldiers and Indians and cowboys, rather than with the technique.

In addition to the art-oriented letters to Turner, there was one on lifemanship to his Uncle Horace Sackrider in Canton. This was at once more philosophical and more practical than the pretentious and playful letters to his friends:

I have just finished a complete course in book-keeping both single and double entry. I am of quite to much of a speculative mind to ever make a success at the solem reality of a book-keeper. No sir, I will never burn any mid-night oil in squaring accounts. The Lord made me, and after a turn of mind which would never permit me to run my life from the point of a pen. . . . I never intend to do any great amount of labor. I have but one short life and do not aspire to wealth nor fame in a degree which could only be obtained by an extraordinary effort on my part.

No, I am going to try and get into Cornell College this coming June and if I succeed will be a Journalist. I mean to study for an artist any how, whether I ever make a success at it or not.

Next Wednesday we start on our annual encampment. Well, its hard with the marching etc but its different from barrack life. I am an acting Corporal now and dont have any more sentinel duty to do, which is the bug-bear of a soldier's life.

I guess the Col is going up in the woods with me this year. It will do the old boy good. Lord I fix him. I fill those pants up so full of flesh that cast iron buttons wont hold and I'll put a tan on his "phiz" that would lead you into a dialema as to what part of the South Sea Islands he came from. Darn him, I'm disgusted so is Mama. We have concluded that the old boy dont

know enough to take care of his precious corpse and we are going to do it for him. Ma snatched him out of his office and I'm going to cast him off somewhere.

Remington addressed his forty-four-year-old uncle by just his given name, a demonstration of reciprocal warmth. Writing to a Sackrider so intimately about the ailing Colonel also indicated the supportive relationship between the families that extended through Remington. It was a Canton touch, as was the contemplated "going to the woods" with the Colonel. The forest south of Canton was a regular summer tour for Remington.

Remington at sixteen was beginning to be concerned about his father's health. Following the Colonel's lead, Remington and his mother attributed his father's pronounced loss of weight to working too hard and failing to get out of doors. A summer trip to the woods was the simplistic recipe.

At the Academy, Remington was only an acting corporal in his junior year. That was the bottom rung for a third-year cadet: Not enough pride to remain a private and not enough ability to rate the lowest regular ranking. It was clear to the Colonel then that the military would be no career for his son, despite Remington's sham of applying himself. After taking three years to learn the basics, Remington could blithely volunteer that "I am well instructed in Upton's 'Infantry Tactics.'" It was another characteristic Remington ploy as a young man to make believe that a miserable failure in an unsuited activity was really a satisfactory accomplishment.

That was the end of Remington's adolescence. He was finished with the Academy. For the immediate future he would try for admission to Cornell, which was nearby and had the only journalism school in the country. He intended to follow his father's profession as his father now wanted, but he expected to couple journalism with art. He did not yet know that Cornell had no art school. He was quite realistic about his lack of ambition. No midnight oil for him, a fair forecast of his inability to stick to conventional work.

When he came to pick a college, however, he enrolled not in Cornell but in the Yale School of Fine Arts in New Haven, Connecticut, a school he had heard about from the New Englanders at Highland Military Academy. At Yale, he could have studied both art and writing, as he had originally said he wanted to do, but he elected to pursue the three-year course to become a painter. He had definitely opted for Yale and fine art over journalism.

The ability to induce his parents to approve the momentous change into art was a tribute to their permissiveness. His mother and the other

Sackriders thought life as an artist would be chancy, not the profession of a man of substance. The Remingtons considered art appropriate only for women. There had never been an artist in either family. There was no professional artist of consequence in Canton or Ogdensburg.

To this point, too, there had been little indication of any significant skill as an artist other than the caricatures and the sketches of figures in action that were enjoyed by his friends. Remington had a drive to express himself by drawing figures, but if there had been a demanding art test to enter Yale he could not have passed. Like many other artists who came from small towns, he simply had not yet seen enough good paintings to have developed a standard of what they should look like.

Choosing where to study art had been another question. There were recognized professional painters in Albany who would have taken Remington as an apprentice. The Colonel had started his own career as a newspaper apprentice when he was poor, but apprenticeship was not good enough for his son. The National Academy of Design was the accepted art school in the country, but it was in New York City and the classes were at night. Syracuse University and the Art Students League were only beginning their art programs. The Pennsylvania Academy of Fine Arts was considered a local Philadelphia school. Most serious art students would have gone to France or Germany, but foreign study was not ever a consideration for Remington. That left Yale.

The Art School at Yale had been founded in 1864. The director of the school was the well-known painter and sculptor John Ferguson Weir, a National Academician without European training, whose paintings of industrial scenes were reproduced in popular prints. Some of these prints hung in Canton homes. Weir had been born in New York State, at West Point where his father had taught. The Professor of Drawing at Yale was "the German," John Henry Niemeyer, who had studied with the prestigious Gérôme in Paris. The school had two art galleries, one of Italian old masters, the other of John Trumbull, a fine painter of Colonial America. Trumbull was to some extent a soldier artist.

In 1878 there were thirty Yale art students including Remington. Twenty-three were women, the only women at Yale. The women students had separate classrooms in the well-lighted upper floor. Their presence caused undergraduates to sigh, "Blessed be the Art School" and "Would I were a model." As the Colonel had suspected, Remington was the only male first-year student. His classroom was in the dingy basement where he labored alone unless an undergraduate chose

to join him for an elective class. The specified course of instruction was drawing, perspective, and lectures on the elements of form and the principles of proportion.

Drawing was entirely from casts of classical antique sculpture. These casts were the only decorations in the cellar classroom, apart from a blackboard on which Niemeyer had inscribed "Drawing Is the Probity of Art," a quotation from Jean Auguste Ingres, the early nineteenth-century French painter. One senior undergraduate who shared a class with Remington was Poultney Bigelow, a sophisticated twenty-three-year-old Easterner who had been in Paris from 1860 to 1867 while his father was the United States minister, in Germany from 1870 to 1873 where his playmate was the future Emperor, and who when his health had deteriorated as a Yale freshman went around the world on a sailing vessel and was shipwrecked in Japan. Bigelow said that "no studio was better designed if its object was to damp the ardour of a budding Michael Angelo. The most difficult of all statues for a beginner was given to us: the madly dancing Faun generally credited to Praxiteles. At long intervals the melancholy professor of drawing entered our cheerless room, gazed sadly at our clumsy crayoning, made a few strokes by way of emphasizing our clumsiness, and then disappeared."

As a prospective figure painter, Remington had only distaste for the still-life discipline of Yale's classical European art training. "At that art school," Bigelow declared, "Remington and I would have been tied in any drawing competition, for he detested casts."

Because he was in a professional school like divinity or medicine rather than in the undergraduate college, Remington was not truly one of "the young gentlemen of Yale." The undergraduates considered themselves an elite group. Undergraduate indulgences were clothes stylish to the point of eccentricity, liquor, oyster and game dinners, bonfires, practical jokes, and sports. Culture came from a strange mix of entertainments such as the theater, burlesque, and Professor Niemeyer's lectures on the history of Greek art.

These undergraduates lived together in the traditional South Middle in dormitory quarters furnished with stuffed chairs before fireplaces above which hung sporting pictures, Yale pennants, boxing gloves, fencing gear, and prints of classic heads. The sophisticated Yale man thought of himself as reading leather-bound Greek classics while smoking a clay pipe.

Undergraduate restrictions were few, for the day. The men could not leave New Haven without permission. They had to attend chapel every morning as well as Sunday worship. After the first year, scholastic standards were not demanding.

Remington's participation in the undergraduate life was by invitation of the friends he made. He caught on quickly. On November 2, 1878, the student newspaper *Yale Courant* that was edited by Bigelow printed Remington's first published illustration, a cartoon for the series "College Riff-Raff." The subject was a bandaged football player, an indication of Remington's future athletic participation. The cartoon brought him whatever attention his size and demeanor did not.

The newspaper featured a "Notice to Freshmen. There will next week occur the greatest event of your lives . . . you will return to your native villages as freshmen of Yale College. You will inform the small but admiring audience seated on top of the sugar barrels in the village grocery store, that your conflict with the sophomores was bloody but triumphant . . . but whether high stand or low stand, stand up for Yale and swear by Yale."

When Remington returned to his native village the summer of 1879, he was able to sit proudly on a box in front of the Ellsworth shoe store in Canton and play the part of a Yale man. In the social hierarchy of Canton, the Remingtons were first generation well-to-do and upward striving. A Yale man, though, had to be somebody.

In July, Remington went on a camping trip to Prison Island, one of the Thousand Islands, with an Ogdensburg friend, Charlie Ashley. The Thousand Islands are rock masses in the St. Lawrence River, stretching from Ogdensburg to near the inlet from Lake Ontario. Many of the islands, then still covered with primordial forests, were owned by city folk and in the summer were dotted with tents. This was an area to which Remington would return many times.

Remington was back in Canton for the annual county fair in August. It was then, in the parlor of the Sackrider's next door neighbors, the DeForests, that he met Eva Caten. He had come bounding across the rear lawn, into the kitchen, and then slowly into the formal parlor to find two guests, Eva and her brother William. Both had completed their freshman year at St. Lawrence University. At nineteen, two years older than Remington, Eva was five feet two inches, barely coming up to Remington's bulky shoulder. Handsome with direct contemplative blue eyes and a fine complexion, she was too full in the nose and chin to be beautiful. She was well-proportioned, poised, and fashionably and gracefully dressed. Remington was "smitten with her," his first love interest. She was used to friendly byplay with younger men because her brother William was the same age as Remington so she made him feel at ease when he called on her every day of her visit to Canton. Openly happy in their relationship, they began "keeping company."

Eva Adele Caten was born near Syracuse, New York, in September

1859. Her father, Lawton Caten, was the superintendent of the Fonda, Johnstown and Gloversville railroad. In 1869, he had moved to Gloversville, the site of the general offices of the railroad and of his own coal business. Known as "the Governor" as Remington's father was "the Colonel," Caten was also a Republican. His family attended the First Presbyterian Church. There were five Caten children, Eva, who was called "Missie," William, Clara, Emma, and Fred.

The Catens treated their daughter Eva as a mature person, having taken the unusual step of sending her away to college in Canton with her younger brother William when he was ready for the 1878–79 year. William continued at St. Lawrence University but Eva, a literate and intelligent young woman, dropped out because she was needed at home.

At the end of that summer Remington returned to Yale Art School for the 1879–80 term. Enrollment at the school had increased to thirty-nine. Thirty-one were women, and Remington was again the only male in his year. He now faced courses in technical practice in drawing, studies from living models, perspective, anatomy of forms and motion, painting from casts and still-life, and lectures on color, chiaroscuro, and composition. He was bored, learned little about the principles of fine art, and only made believe that he was working. The faculty did not consider him a serious student.

Given such a dim daily routine, Remington responded enthusiastically when he was invited to try out for the college football team. He was five feet nine inches tall and weighed about 190 pounds.

Intercollegiate football had just begun to attract crowds the previous season when Princeton was the champion. Remington's year of 1879 was the last of the fifteen man teams. There were nine men on the line as rushers, plus a quarterback, two halfbacks, a three-quarterback, and two fullbacks. Remington was a varsity rusher. The quarterback was the Yale immortal Walter Camp.

Yale's first game that year was with Pennsylvania. Yale won easily by three goals and five touchdowns to nothing. The second game was a rough and hard-fought draw with Harvard. After the game, Harvard complained that Yale players had engaged in bending necks, kneeing downed opponents, punching with fists, throttling, and swearing. The Yale newspaper countered with claims about equivalent Harvard ferocity. Remington's "Riff-Raff" cartoon of the bandaged football player had been an accurate forecast. Professor Weir remarked that the often bruised Remington was the most unusual looking art student he ever had.

The games against Rutgers and Columbia were one-sided victories.

Remington invited his father to the final game on November 28. The Colonel arrived with a New York doctor in attendance, leading Remington to believe that the Colonel feared an accident on the field. The game was a scoreless draw. Princeton played entirely defensively and thereby under the rules retained its 1878 championship.

The New York *Times* reported the game under the head, "Kicking the Leather Egg/The Best Football Game of the Season/Six Thousand Persons Witness the Match between Princeton and Yale, Which Results in a Draw. St. George's Cricket Ground in Hoboken contained teams of 15 . . . dressed in tight-fitting white canvas jackets, black trousers and dark-blue skull-caps and stockings. Yale forwards included . . . C. Remington." There was no mention of Remington in the account of the action, but this game was the origin "of that old, old story of how he dipped his jacket in a pool of blood at the slaughter-house to make it look more business like."

The undergraduate newspaper reported that "the howling Yale swells (so they think themselves) attract unusual attention by their incongruous dress—theater capes accompanying light-colored ulsters, intended merely for traveling and evening dress, excite general remarks and ridicule as they are seen worn on the avenue in broad daylight."

Despite the draw and Princeton's championship, Yale was regarded as best football team in the country. For the season, Yale's total score stood 10 goals and 11 touchdowns to nothing. To have been a varsity player on that team was to receive great adulation. Remington's achievement was celebrated all his life. He was the Yale rusher, as his father had been the war hero.

Years later, when football was under attack in 1894 as too violent, Yale coach Walter Camp solicited Remington's opinion and was asked in return, "Who the devil is making you all this trouble? Football, in my opinion, is best at its worst—to be Irish. I do not believe in all this namby-pamby talk, and hope the game will not be emasculated and robbed of its heroic qualities, which is its charm and its distinctive quality. People who don't like football as now played might like whist —advise them to try that."

At the end of the football season in 1879, Remington went home to Ogdensburg for the Christmas vacation and never returned to Yale as a student. His stay at home was one of the most distressing periods in his life. Two years earlier in the letter to his Uncle Horace, Remington had noted that his father was thin and pale. With sixteen-year-old confidence, he had thought he could take care of his father and cure him with food and sun. When his father brought a doctor to the foot-

ball game in November, it did not occur to Remington that the doctor was for the father's sickness rather than for a possible football accident.

For eight weeks Remington watched helplessly as his father weakened from tuberculosis. It was obvious that there was no hope of recovery. The Colonel made it as easy as he could on those around him. Unafraid he serenely and thoughtfully resigned himself to his end. At 2 P.M. Wednesday, February 18, 1880, the Colonel died at his home in Ogdensburg with his wife and son at his bedside. The obituary in the Ogdensburg The *Republican* read that "the men most needed seem to be those first appointed to death, and so ending a calm, brave, honest life, he bravely, quietly died."

The Mayor of Ogdensburg called a meeting to adopt public resolutions as a token of respect. On Saturday, businesses were closed while the citizens of Ogdensburg escorted the body to railroad cars for transport to Canton. At the depot in Canton, the citizens there formed a procession to accompany the body to the Sackriders' home. The funeral services were conducted by the Reverend Almon Gunnison of Brooklyn, the Colonel's friend. During the services, businesses in Canton were closed. Then the procession led the way to the cemetery for interment. The services were in the Universalist faith, the underlying connection for all of the Remingtons. The image that Remington retained was of his mother in a crepe mourning veil that hung to the ground.

The Colonel had died at forty-six when Remington was eighteen. The loss was the greater because it was before Remington had developed a separate life. His mother had no equivalent control over Remington. She was a nagger but not a force. It was Remington's uncles who became the dominant figures. As the Colonel had been, though, they were generally supportive, not restrictive.

When the Colonel knew he was dying, he had a will drafted in Ogdensburg on January 30. The gross estate proved to be $21,791.40, a substantial sum for 1880. Remington and his mother were to share the estate equally, with Remington's uncles Horace D. Sackrider and Lamartine Z. Remington as executors. Remington received $772.69 at once. The balance was deferred until he came of age October 4, 1882, but he could obtain advances necessary for support or education. The mother's portion was about $10,000. Bank interest at 3 percent would enable her to live comfortably without touching the principal, although country banks were risky in the nineteenth century. The new Canton bank was the successor to two previous banking ventures that had failed.

Remington stayed on with his mother because he had given up on fine art and had not the least idea of what he wanted to do. Under

pressure, he agreed to try a business career. He started a job as a sales clerk in an Ogdensburg store but quit after a few days. The job was a Sackrider-type opportunity of local and limited scope, not the big burst he owed to the memory of the heroic Colonel. Whatever his career turned out to be, he expected that it would not be petty or common.

The Remingtons then moved back to Canton to be close to their families in their real hometown. Grandfather Sackrider found space for them in his Miner Street residence. Preparing a future for Remington became the task of Uncle Mart, who was only thirteen years older than his nephew. They were more like brothers, hunting and fishing together in the Adirondacks.

Mart lived with his wife and children near Albany where he was an important Republican politician, Chief Clerk in the Department of Public Instruction. Within three weeks Remington was given the position of executive clerk in the chambers of Governor Alonzo B. Cornell. He was paid seventy dollars a month, a handsome salary for an eighteen-year-old without commercial experience. The income would allow him to settle down, marry, and support a family, but Remington hated the clerical detail in the job.

At first, he stayed in Uncle Mart's home in East Greenbush, ten miles outside of town. Soon, however, he moved to Albany, renting quarters at 136 State Street where his mother came to keep house for him. This was of short duration and she returned to Canton. They were too much alike in their obstinacy to live together. They clashed on the hours and the company he kept, as well as on the standard of morality she would be condoning if she stayed. She was a churchgoer, like all the Sackriders, while Remington was now professing to be a "free-thinking conservative Englishman" whose personal religion was reduced to "never hypocritical sometimes religious and always moral."

What held Remington loosely in harness in Albany was his attachment to Eva Caten. Whenever he could, he made his way the forty miles up the Mohawk River to Gloversville. To Eva Caten he was a tall, blond, good-looking football hero. Eva and he expected to get married. It was assumed that Remington's art was by the wayside, a hobby to amuse himself.

From Albany he wrote to Lawton Caten on August 25, 1880, on the letterhead of the Executive Chamber:

I pen these lines on a most delicate subject and hope they will at least receive your consideration. For a year I have known your daughter Eva, and during that time have contracted a deep affection for her. I have received encouragement in all propriety and with her permission and the fact of your countenancing my association, I feel warranted now in asking whether or not you will consent to an engagement between us. If you

need time to consider or data on which to formulate I will of course be glad to accede to either. Hoping this will not be distasteful, allow me to sign

<div align="right">

Your obd Srvt

FRED'C REMINGTON

</div>

Despite the hours that Remington spent in drafting this ordered plea and despite the loopholes he left for an indirect refusal or postponement, Caten was quickly and definitely negative. Caten's wife was dying. He needed Eva at home to take care of her younger sisters. Besides, he considered Remington at eighteen to be too immature for marriage.

Being turned down without hope for the future was a bitter blow to Remington, but Eva Caten held to her father's judgment. Her role as manager of the Caten household was satisfying enough so that when Remington's proposal was rejected by "the Governor," she did not rebel. Although Remington's letter was retained by her as a treasured memento, their relationship was more like affectionate siblings than the passion of a Romeo and Juliet.

Remington was not accustomed to denial of what he wanted, but his capacity for contradicting authoritative elders he respected was minimal. His manner of responding to a refusal was either to ignore the prohibition while giving the appearance of accepting it or to drop out. With the Catens, he dropped out.

Lawton Caten's verdict on Remington as a suitor removed Remington's work and personal restraints. Many years later Poultney Bigelow speculated on what Remington's habits might have been if Eva Caten had married him in 1880. Perhaps the union then would have produced a thin, temperate political functionary who edited and published a local newspaper, a family man whose idiosyncracy was a box of old sketchbooks in his closet.

Instead, Remington soon quit the job he hated. He had faithfully tried to apply himself to the clerking, but after the rejection by Caten, Remington was footloose. He held a succession of different jobs in Albany. He became a reporter on the Albany *Morning Express*, a newspaper in which Uncle Mart had a one-quarter interest. Uncle Bill was then the foreman.

Despite the network of support from the family, Remington left the newspaper after five months. His third job was with Uncle Mart in the Department of Public Instruction. This was in the spring of 1881 when he wrote a series of letters to Aunt Marcia Sackrider, Horace's wife. It was an unconventional correspondence, coming from a young man able to address a middle-aged female absolutely unselfconsciously.

The first letter had the Shakespearean heading "Come Hal lets have no more of this/Fal," and the ending "Yours Emphatically Frederic

the Great word juggler/To his Websterian Aunt." In answer to continuing complaints about his spelling, he declared, "I am thrown on an ungenerous world when I write to you. I am subjected to the fastidious scruples of Webster and if I am ever an unknown quantity it is when I venture into the domain of that monopolist. I loose all sympathy for anyone who makes it a point to sit down with one of my epistles and a Websters unabridged and seek to verify a well authenticated fact—namely that I disagree with Webster."

The next of these letters was written later in the spring. In it, Remington acknowledged being incompetent as a judge of wine, "but on segars I am par-excellence as I have tested from 'stogies' to $1.00 Delmonico's and then you know I have inherited from both ancestors a love for the 'filthy weed' so when ever anyone wants to know the quality of a box of imported stubs they have but to call me around and ante up one and I can judge to their satisfaction."

Remington added that "the Adjutant General officially stated that we would be retained until the 30th of April. I will be home that time and then we will try & have some fun." The Adjutant General was Remington's fourth Albany employer. Remington was returning to Canton for the summer to stay with Uncle Horace and Aunt Marcia rather than with his mother. His intent was to enjoy himself, and proximity to his mother made for friction. She represented the Puritan ethic, as did his father's brothers.

Remington was demonstrating in all good will that he did not want to settle down to follow the family track. He was casually leaving his fourth Albany job within a year. His letters sounded light-hearted and smacked of a gay time but he had been subjected to two tragedies, his father's death and his rejection by Eva's father. The family reaction to his devil-may-care attitude was to worry about where he was headed and what he would amount to. The Sackrider pattern was to work hard as tradesmen. The Remingtons were writers and politicians.

Yet here was Fred Remington, the family favorite, the dead Colonel's son, going nowhere. Where was the $772.69 first installment on his inheritance, his mother would want to know. Where was the money he had earned? Every indication was, the money was gone, spent on fleeting personal satisfactions like dollar "segars."

His lifestyle was changing. He was becoming one of the wild clerks. He was casually sketching but he was not painting. Although having a male artist in the family was still a distasteful prospect, the coexecutors offered to send Remington back to Yale rather than see him stray. He refused. He had been persuaded by Professors Weir and Niemeyer that he lacked the talent to be an academic artist.

He was going to Canton, to have fun.

3.

A Trial of Life
on a Ranche

Fun for the easy-going Remington during the summer of 1881 consisted of enhancing his reputation as a massive trencherman, taking camping trips either up the St. Lawrence River or into the Adirondacks, and teasing the Sackriders. His goal was to ease the way through the fifteen months until his inheritance would come into his hands, to get out of Canton when he could, and to avoid any discussion about Albany in the fall.

To his family, Remington's tactics were obvious and worrisome. Uncle Mart announced that a new position had been found for him starting in October, an actuarial clerkship in the New York State Insurance Department. The job was said to be creative, demanding, and tailored to meet the shortcomings of the jobs held the previous year. Remington was expected to be satisfied and to get on with his now ordained career as a bureaucrat in the state government.

Remington was not surprised at the commitment arranged for him. In his mind, the new job did not differ in substance from previous assignments. His price for accepting the boredom he anticipated back in Albany was a vacation trip to the Montana Territory, a Western jun-

ket that would not be unusual for members of his Eastern university group. Like Remington, most of the young men had enthusiastically read books on the West by Catlin, Lewis and Clark, Irving, and Parkman since they were schoolboys. The West had been a topic talked about in the dormitories, and Harvard and Yale graduates had purchased cattle and sheep ranches. Eastern politicians and Hudson River artists were touring the Rockies. North Country newspapers reported regularly on the Indian, the buffalo, the cowboy, the plains cavalry, the outlaw, and the progress of the railroads across the continent.

Although Remington's trip was simply a vacation, a sightseeing trip and a chance to explore opportunities in the cattle country, more concrete reasons were later ascribed. One claim was that Remington was in ill health. "'Why not go West,' the doctor suggested." There was, however, no sickness. Or, he was seen as bitter, a suitor rejected in his first love affair. That, though, had ended a year earlier. Remington himself said later that he went West with the intention of "becoming a Millionaire," but this was an exaggeration of his middle age. He did not go West for art, for he took no art material with him.

When he left for Montana August 10, the Canton newspaper report was that he "intends to make a trial of life on a ranche." The route west was via the Northern Pacific railroad from St. Paul after a connection at Chicago. The rail terminus was in western Dakota Territory where Remington took the stage to Fort Keogh and Miles City along the Yellowstone River. There he bought a horse to ride for the rest of the journey, an animal that he inadvertently caused to become lame because of his inexperience with Western distances.

The only direct statement about the trip was made by Remington in 1905 when *Collier's* published its "Remington Number." The artist was asked to write about himself. The episode he picked as the one that had triggered his career was a chance meeting while he was riding on the high plains during the Montana vacation twenty-four years earlier:

I was in the grand silent country following my own inclinations, but there was a heavy feel in the atmosphere. I did not immediately see what it portended, but times had changed.

Evening overtook me in Montana, and I by good luck made the campfire of an old wagon freighter. He was born in Western New York and had gone West at an early age. Thence during his long life he had followed the receding frontiers. "And now," said he, "there is no more West. In a few years the railroad will come along the Yellowstone and a poor man can not make a living at all."

There he was, sleeping in a blanket on the ground (it snowed that night), eating his own villanies out of his frying-pan, and hunting his

horses through the bleak hills before daylight; and all for enough money to mend harness and buy wagon grease. He had his point of view and he made a new one for me.

I knew the railroad was coming—I saw men already swarming into the land. I knew the derby hat, the smoking chimney, the cord-binder, and the thirty-day note were upon us in a resistless surge. I knew the wild riders and the vacant land were about to vanish forever.

Without knowing exactly how to do it, I began to try to record some facts around me, and the more I looked the more the panorama unfolded. I saw the living, breathing end of three American centuries of smoke and dust and sweat.

This statement was not quite what it purported to be, the feelings of an immature nineteen-year-old. Rather, it was a calculated reconstruction composed by a dedicated artist at the height of his power, so different from the unformed youth he was describing that he might have been another person.

To the youth traveling alone on his first exposure to the raw West, the experience did not result in grandiose conclusions but simply an array of fantastic events. The movement, color, and shape of the West were beyond what he had imagined. The most startling thing he must have seen during the trip he never mentioned. That was the slaughter of the 1,000,000 buffalo that was going on in northern Wyoming and east-central Montana in August 1881. In addition to the Indians for whom the buffalo was a major source of food, about 5,000 white hunters were shooting and skinning the animals. Hunter Vic Smith killed 107 buffalo in one hour. There were "buffalo lying dead on the prairie so thick that one could hardly see the ground." The decomposing flesh could have accounted for the "heavy feel in the atmosphere" that Remington remembered. The year after Remington's visit was the end of the buffalo in Montana.

In making his "trial of life on a ranche" Remington was on the scene at the beginning of the ranching industry in the Montana Territory. One of the cowboys at the fall roundup in the Judith Basin was "Kid" Russell, a green city boy on his first job as night herder. The "Kid" was Charles Marion Russell, who also became famous as a Western artist although he never met Remington.

Remington had no thought of working for wages as a hired hand on a ranch. He wanted to get rich quickly, and investing in the cattle business seemed like a real possibility. Earning money as a rancher, working on horseback in a physical occupation conducted in the open, suited his image. What he found, though, was that the capital required to buy a spread with potential was beyond what he had visualized. He heard of two successful Harvard graduates who were making more

than $30,000 profit on cattle in Montana in 1881, but they had invested $158,000.

There were stories in Montana, too, about prospectors who had discovered gold and then sold their lodes for quick rewards. When Remington investigated the gold fields, the answer was the same as in cattle. A large amount of capital was required for substantial returns. Miners were worse off than cowboys. There were a thousand miners unemployed in the Black Hills camps in 1881.

The lack of opportunity for instant riches did not interfere with Remington's sightseeing. Although General Nelson Miles had captured Chief Joseph of the Nez Perces four years earlier, pacifying much of the area, and the Blackfeet, the Crows, and the Sioux were now confined to reservations, Remington saw plenty of Indians. The first soldiers that Remington observed on active duty were in Montana, escorting General Philip Sheridan and his party to Yellowstone National Park. "Bad men" were commonplace.

Custer had been killed only five years before. The battlefield was less than a hundred miles from Miles City. In 1881, crosses for the soldiers' graves and a log pyramid for the horses' bones could be seen, but the detritus of war was gone from the field. Remington claimed he was fortunate to pick up an old Colt .45 there that he gave to his Adirondack guide Has Rasbeck.

Remington began "to try to record some facts" around him. He had no sketchbook with him but from Wyoming he mailed to *Harper's Weekly* "a little sketch on wrapping paper, all scrambled up in a small envelope." Remington "felt he was taking a long chance. He had never done anything for publication." The *Harper's* art director Charles Parsons "had never received anything as informal and was intrigued by the Wyoming postmark." The wrapping paper sketch was assigned to the experienced Western illustrator W. A. Rogers to be redrawn. Rogers did not meet Remington in the flesh till years after when Remington was famous. He told Remington then that he still "remembered with how much pleasure I had made a drawing on wood from that little crumpled sketch."

The two-month trip had exposed Remington to the high plains when he could see migrating herds of buffalo, a landscape of Montana yellow grass and sagebrush, Indians still wild and armed with Winchesters, trappers in an abundant wilderness, the unfenced cattle range, and Indian-fighting cavalrymen to remind him of the Colonel. It was certainly not to him then "the living, breathing end of three American centuries," nor was it yet "the foundation of his art," but he did see the Old West. When he was widely copied in later years, the derivative Western painters could follow him with confidence because

he had "been thar." He was authentic, and 1881 marked the start of his Western experience.

Remington was back in Albany by October 18, sporting an insignificant blond mustache to try to add maturity to his round and good natured face. With the failure of his hopes for quick money in Montana, he was buoyed by the interest of *Harper's* in his drawing. He wrote to Uncle Horace Sackrider on the stationery of the Insurance Department, State of New York, that "I have an appointment to go to New York soon to see George William Curtis of Harpers Weekly in order to see if that co will publish some work of mine. It would be a good scheme if I could get something in there."

The meeting with Curtis concluded the purchase of the "sketch on wrapping paper" that was not published until February 25, 1882. It appeared as a full page titled "Cow-boys of Arizona: Roused by a Scout," and was credited as "Drawn by W. A. Rogers from a Sketch by Frederic Remington." "Cow-boys of Arizona" was an inapt title for a sketch made in Montana or Wyoming, but *Harper's Weekly* was a national newspaper. Drawings were used primarily to supplement articles, in this case one about the Southwest. The title of the sketch was changed to suit the locale of the story.

Selling the one sketch was all that Remington achieved with Curtis. His talent was still so undisciplined that three years passed before another sketch appeared in *Harper's*. For Remington, though, his belief in his ability to capture Western figures in drawings was rekindled. The sale of the cowboy sketch reinforced his confidence in art to the extent that he later identified himself to Charles Parsons as "Your Discovery" and he dated his career from 1881.

With the sale to *Harper's* under his belt, it was galling to be forced to return to clerking in the Insurance Department in Albany. He dropped right back into his old attitude. Tongue in cheek, he told the Sackriders, "I am in the Actuary Department. It is all figure work and a good scheme for me. I have had no trouble so far. The business consists in calculating the worth of policies. I shall expect a permanent appointment soon and perhaps a transfer to some other branch of work, such as engrossing."

Remington was describing himself as a happy clerk, a temporary mathematician hoping only for a permanent appointment. He claimed to want to prove himself at engrossing, which is the copying of a legal document in large ornamental script. Even in personal news designed to keep the family quiet, a liking for engrossing was going too far. His careless handwriting was almost illegible. The happy clerk and the willing engrosser were like the acting corporal, outrageous misrepresentations.

The recollections of his fellow clerks countered Remington's deceptions for home consumption. They said that boxing and horseback riding were really his favorite pursuits. He would ride outside the city where he could "make a great noise and fire off his revolver to scare the horses." On one occasion, Remington and John Holmes "were cutting 'cross country near Hurtst's when Remington whipped out his revolver, discharged it and screeched to such an extent that both horses ran away." In town, he "put on the gloves" with clerk Albert Brolley more than any other man, and "whenever he did there was a battle royal."

Screeching and shooting were signs of despair at his job. He sat at the end of one of the long tables in the actuary's room, "his clerical work neglected" while he spent the day sketching the other employees. At night, the wild clerks had a favorite rendezvous at a nearby room where they played cards. Remington would sometimes sit all evening making sketches of the group.

His revived interest in art surfaced in his December 12 response to Aunt Marcia, listing dreams of escape from Albany as what he wanted for Christmas:

Well I dont think so much of Santa Clause as I used to—but then . . . I want a brown-stone front, a foot man on a closed cab. I want a situation as son in law in first class family—no objections to going a few miles in the country. I want "La Art" for the year. I want De Neuvilles last autotype . . . Oh laws I want everything. I want to ride a horse Christmas—I want to see mother and you all—I want something to eat—I want to get away from here & Albany—all of which I hate and I am happy.

One Christmas present he did get was "photographs of mother . . . the finest things in existance—well taken and a good subject—I just tell you that the old girl is a good looker if she aint anything else. I take a good deal of pride in her."

After celebrating Christmas 1881 in Canton, Remington went back to Albany as if he had a regular job. He wrote to the Sackriders on the letterhead of the Insurance Department in March, although the payroll records credited him with pay for only a half month for the entire year. He also worked temporarily as a draftsman in the office of the State Engineer. Whatever the total of Albany positions was in this rootless period, though, it was apparent that no matter how hard the Remingtons labored to keep the Colonel's son afloat at the taxpayers' expense, the forecast was for failure.

The exciting moment for Remington was when he spotted his cowboy sketch published in *Harper's*. He told the Sackriders, "Spose you saw the Harpers Weekly picture—got three or four more drawings

coming out in Lippincotts Monthly on the St Regis." The *Harper's* sketch gave him credibility, but the Indian drawings for *Lippincott's* never did appear. His next published illustration was a much lesser accomplishment. It was through Eva Caten's brother Will, a member of a fraternity at St. Lawrence University that published an annual called *The Gridiron* containing a page of Remington sketches titled "A Class in Surveying."

That summer Remington was still unemployed when he returned to Canton. He started August 2 on a wilderness trip to his favorite woods spot, Cranberry Lake in the Adirondacks thirty-five miles southeast of Canton. He did not go back to Albany in the fall. On October 4, 1882, Remington was twenty-one. He came into his inheritance, and that was the end of his career as clerk and embryo politician. With the money, he was able to choose his own way of life, and he was determined that it would be in a Western locale. After a short five months, he took the big step enthusiastically.

The choice of the West, however, seemed to become an immediate calamity. On March 15, 1883, Remington was holed up in room 16 of the Duvall's hotel in Peabody, Kansas. He was hiding and would allow no one to see him but Jim Chapin, a young Kansas stockman. Remington's depression was severe, a melancholy beyond anything the townspeople had heard of. They feared he might do away with himself. Even the children in town knew about the recluse. The ten-year-olds said it was because his father had died.

The innkeeper's wife, Mother Duvall, tried to soothe him. She said it was the worst case of the blues she had seen. She worried about him, washed his clothes, and brought him the crackers and milk she knew he liked. Remington thanked her but did not touch the food. Mrs. Duvall took no pay for her services although Remington was a stranger to her.

The morose young man in the Peabody hotel was certainly different from the blithe Remington of Albany the previous year. The carefree clerk had kept in touch with his Yale classmate Robert Camp, a dropout in 1880 because of poor health. When Camp was well enough to try an outdoor occupation, he purchased a small ranch eleven miles south of Peabody and moved there in August 1882. Camp owned nine hundred sheep and after just two months he wrote Remington that sheep raising was "the boss business."

Remington discussed Camp's investment with Uncle Mart. There was no way that Remington could think of spending the rest of his life clerking in Albany. He had to have a try at establishing himself in the rugged West. He had seen Montana and knew about potentials in livestock. Kansas promised to be more exciting. It was even the locale

of Dodge City, the cowboy capital. Camp told him that stock raising was in the midst of a boom and that the winter of 1881–82 had been very promising for ranchers. Midsummer of 1882 saw the full strength of the boom and prospects for the winter of 1882–83 were still very favorable.

Sheep ranching was a challenge that Remington thought was made for him. It was available for an investment within his grasp. In Kansas there was no stigma to raising sheep, compared to states where cattlemen and sheepmen contested the open range. Texans said that any man engaged in walking sheep was "a Mexican," but there was no such competition for Kansas pastures which had established boundaries.

As yet there was not the equivalent push toward sheep raising in Kansas that there had been in other states, even though the bluestem grass in Butler County was great pasturage. It was part of the tallgrass prairie that in 1800 had extended over 400,000 acres to form a sea of grass as high as the horns of the buffalo that lived there with elk, antelope, coyotes, and foxes, before the land was grazed or plowed.

Wool had advanced steadily in price since 1879. Sheep had been a dollar a head in 1875, then five dollars for good graded sheep in 1880. Sheepmen had wild visions of wealth. Any doubter was told that six dollars was cheap for sheep that would soon bring ten dollars. Large stock ranches were being bought at asking prices without quibbling. Ranch houses were expensively remodeled. Young well-to-do men from the East and from Europe swarmed into the ranch country, extravagant in their management practices and insistent on a personal good time. Ninety percent of the new ranchers were these "holiday stockmen" who started out with a rush but soon left the operation of the ranch business to hired hands while they enjoyed themselves.

The boom was so strong that land swindlers were all over. Robert Camp offered to protect Remington and to arrange for the acquisition of a good section at a fair price. By February 1883, Camp had negotiated for Remington's purchase of the 160-acre quarter section that was a quarter-mile square immediately south of his own place. The area had been a large holding bought about 1860 for the breeding of blooded cattle. When that business failed in 1879, the land was subdivided and sold by the sheriff at auction. Part of the parcel was resold to Robert Camp and two other young college men, Cecil Wickersham of Oxford, England, and James Chapin of Illinois.

Remington believed that raising sheep in Kansas was the bonanza he had failed to find in Montana. From Albany he sent Camp a deposit on the purchase price of $3,400 for the property, a price that was close to the average for improved quarter sections advertised in the

Emigrant's Guide to Kansas. By the end of February, Remington had abandoned Albany for Canton, claiming to have resigned the state job he did not have. He was visiting his family and friends, getting ready to start for Kansas.

When he stepped off the Santa Fe passenger train to be greeted by Robert Camp, however, he did not see the West he expected. Peabody was brown Kansas in the deep frozen mud with the only trees growing alongside empty watercourses. The town was devoid of North Country color. Although stockmen rode horses and wore chaps, the cowboys and the outlaws had left with the moving frontier ten years earlier. The cowboy capital, Dodge City, was 150 miles west.

When Remington went to inspect Camp's ranch, the building was a hovel compared to Canton houses. There were none of the finer things Remington relished, the comfortable homesteads managed by the family women and their hired girls. Operating the ranch as Camp did was simply hard work. Camp was in the process of clipping about seven thousand pounds of wool for a profitable sale, but the sheep stank.

Remington was despondent when he went back to the Peabody hotel and the Duvalls. Raising sheep was exactly what Camp had told him it would be, promising a fine return on his investment, but it was ugly. Foregoing the deposit on his ranch would be embarrassing. Returning to the despised Albany job would be out of the question. He could not decide what to do. He had the "deep blues" and there was no uncle to find him a way out. He did not tell the people around that he could not bear to look at them or to smell them. He said his father had died. It was all he could think of. He brooded in the hotel room for two weeks.

The solution took care of itself. April 2 was the scheduled date for the purchase of the quarter section. The day came, title passed, and he owned a ranch. He hired two younger men as hands, Bill Kehr and William Grandom Scrivner, called "Grand," and moved in. He was soon over his deep depression and back to his confident, carefree self. The difference was, he was a stockman only as an alternative to Albany and not as a commitment to a way of life.

Remington's ranch house had three rooms. Downstairs was the combined living and eating room. Above was the sleeping room. Attached on the north side was a shed with a gable roof that was the kitchen. There were two barns each larger than the house, a corral, and a water well. Bill Kehr bunked at the ranch with Remington. Three miles across Henry Creek was Plum Grove, a hamlet of three houses, an old stone schoolhouse that doubled as a church, Hoyt's general store, and a blacksmith shop. Twenty miles south was the county seat El Dorado, later run together as Eldorado.

In the beginning the mustachioed Remington, whose weight had risen to 220 pounds, spent his days at Camp's ranch to learn the business before he began operating his own place. It was the season for lambing, but the weather that spring had remained dangerously cold for animals new-born in the fields. Each morning Camp mounted his mule carrying a coal oil can full of milk. The lambs he found in time to pour milk down their throats were saved. The few that were too weak to survive on their own, he brought back to the cabin, wrapped them in blankets, and placed them behind the stove until they were warm enough to be fed.

One day that was raw with sharp wind-driven rain, the lackadaisical Remington remained by the stove in Camp's cabin, sketchbook close by. Looking out, he saw the drenched Camp returning on the mule, a twin lamb under each arm, the can in one hand and the reins in the other. Belatedly concerned about Camp's health, Remington rushed out with an open umbrella. The unfamiliar object spooked the mule, sending it into a fit of bucking and running that had Camp trying desperately to control the three animals and the can of milk. Camp nearly squeezed the life out of the poor lambs before he could stop the mule and turn back. After the mule had quieted, the lambs were safe, and the bystanders had quit laughing, Remington made a drawing of the scene, not at all abashed at having accidentally endangered Camp.

Through Plum Grove and Peabody, Remington rode a bucking, galloping pony, waving his sombrero at the townspeople with his free hand. The pony was Terra-Cotta, "a nervous little half-breed Texas and thoroughbred, of a beautiful light gold-dust color, with a Naples yellow mane and tail." Remington was thought of as a big fellow, a little reckless, fine looking and easy, a convivial drinker, jovial and popular. He had shed his Eastern clothes. In town he blended with the Kansans. He wore a rough country suit, bought in El Dorado, that did not quite fit. His manners were country, too. He sat on a box in front of the Peabody drug store just as he had at Ellsworths in Canton. When young women passed, he jumped up and swung off his sombrero with ponderous grace. He did not court any of the women, though. He left that to Bob Camp, who went with a schoolteacher in El Dorado until another rancher "beat his time."

In assigning the work on his place, Remington took the job of cook. Much of the food was from tins but the menu also ran to pancakes and beefsteak. They ate game they shot, antelope and geese, but not lamb. It would have been too close to home.

The neighboring women were solicitous of him. They sent over fresh bakings of bread, cookies, and doughnuts. They also offered advice on cooking. When a neighbor's young daughter saw Remington

put dirty potatoes into water to boil, she asked, "Mr. Remington, don't you wash potatoes before you cook them?" He replied, "I've tried them both washed and unwashed, and they taste better unwashed. Have you ever eaten boiled, unwashed potatoes? Try them this way."

The heavy work was left to Kehr. The other job that Remington accepted was the sedentary one of watching the sheep herd. It was a duty he could readily escape. When he was bored or had something else to do, he hired a young boy with a dog as his substitute. He gave the boys the run of his ranch, employed them, fed them, and rewarded them. He told a handicapped boy to share candy by forcing the other boys to catch the pieces in their mouths like dogs. "Make them pay" for teasing you, he said.

Camp was from a banking family and knew the financial ropes. He had arranged credit for Remington to buy the sheep, with part of the cost mortgaged to the Peabody Bank in the form of installment notes. In combination with Camp, Remington purchased horses. They kept broodmares, a typical extravagance that piqued the townspeople. Camp had a separate interest in the fast trotter Joe Young that grazed in his pasture.

Remington's investment up to mid-May was $3,400 for the quarter section of land, plus the money that had originally covered supplies, wages, and down payments for horses and sheep. To pay for his sheep sheds, he wrote to Uncle Horace on Peabody Bank stationery for another $1,000. "I want the money," he said. "Have no delay as I would not have my draft dishonored for the world." That made the total investment about $6,500. In June, he built another shed at the top of the line of bluffs above the pasture.

When he wrote home to Canton, he exaggerated Peabody's desperado flavor. "Man just shot down street—must go," he claimed, even though Peabody was a law abiding town. No shooting had taken place.

Peabody suited Remington. Like the rest of the holiday sheepmen, he knew he could manage the ranch successfully without giving it his full attention. On May 31 he doubled his holdings, acquiring the unimproved quarter section immediately to the west. He paid $1,250, a fair price, making his total investment about $7,750. He was confident that the livestock bonanza would continue.

He relished his holidays. With a friend, he took two trips on horseback that he called prospecting. South of Kansas was Indian Territory, entered from Caldwell, Kansas, by the stage road and the cattle trail that continued all the way to Fort Reno. He did some sketching and was gone most of the summer.

In Peabody, he was always ready for a party. The neighboring bachelors who enjoyed physical competition were frequently at the Remington ranch for boxing, wild steer and bronco riding, racing, and roping. Sunday was the big day for plenty of fun in the company of this Eastern young man who was "full of life and out for a good time." These were tough masculine pastimes. There were huge parties the bachelors attended at the ranch and in a clubhouse they kept in Peabody. During one party, Remington slipped behind an English rancher and fired his revolver, only to have the unruffled Englishman say calmly, "Put up that gun. You might hurt someone, Frederic."

Boxing matches were held evenings and Sundays. Kids came to watch, too. Remington was the catalyst for the boxing. He fought anyone who would put on the gloves with him. Even in Peabody, when he saw the town bully tormenting a smaller man who was a stranger, he separated the men, telling the bully, "Now I will settle this matter with you. Clear your decks for action."

Remington confessed to his friends he had hoped for recognition as a boxer but had been disillusioned by being knocked out in Albany. His image was of a man's man and strong. Friends in Canton sent their son to him in Kansas "to make a man of him" but Remington gave up. "You can't make a man out of mud," he wrote. The young visitor did not cotton to Remington's physical pursuits.

The more sober neighbors felt the same. They resented Remington's entourage wasting time in games, his lack of thrift, his careless management, his ability to buy anything that appealed to him, and his impact on their children. They had to work damned hard to make out. They called him a "hot sister," an overenthusiastic reckless playboy.

Remington quit the ranch any day there was something more enjoyable to do. One morning he joined a troop of stockmen, owners and hands, out to chase rabbits on horseback. The aim was the same as the formal meets of the American Coursing Club in Kansas but the Peabody approach was just to have fun behind the dogs. The hunt ended at the homestead of a rustic rancher who resented the holiday stockmen enough to trick them into a wager. He matched his unlikely looking champion quarterhorse racer against their equine pets, then gloated when he won, "I hain't got the money that you fellers down in the creek has. I've been a layin' fer you fellers ever since I came inter these yar parts." Remington lost his mare Terra-Cotta on the bet.

Despite his inattention to ranching, Remington had not ceased to believe that sheep would make him rich. In September he wired Uncle Horace for another thousand dollars. That made nine thousand dollars invested, the end of his inheritance. From then on, he had to make money or borrow it.

He certainly tried borrowing. He even went back to Albany to see Uncle Bill, to ask for money to buy more land. Bill in contrast to his brothers believed that Remington was born to be an artist. "Not a cent," he told Remington, "until you are ready to settle down seriously to art."

Uncle Mart as coexecutor was worried about the dissipation of the inheritance. Overtired and in poor health, Mart came out to visit for Remington's twenty-second birthday the beginning of October so Remington could show him the ranching operation. While riding back from Peabody, they were caught in a heavy rain. Drying out before an open fire did not help. Mart's "lung trouble" was aggravated so he returned to Albany after two weeks. He never did recover from the overexposure in Peabody and died the next year of tuberculosis, the same disease that took the Colonel.

With his inheritance committed and his uncles unwilling to lend, Remington lost hope of becoming a livestock baron. His attention turned back to drawing and he filled a Kansas sketchbook. The sketches in the book were of pedestrian Peabody, not the trips to Indian territory. There was a portrait of Mother Duvall, a view of her son holding the lead to the nose ring of a blooded bull, and a rendering of the Peabody Library. The drawings were curiously innocent and untutored, despite Yale Art School. They were clean in line but tenuous and poorly proportioned. As Remington continued to draw, the hand that had been cartoony, crude, and bold became looser, more exploratory of outlines he was beginning to learn how to observe.

He also made and gave away impromptu sketches on whatever paper was at hand. One Sunday Remington sat on a bench in the back of the Plum Grove schoolhouse where the church services were held and sketched the tall preacher. That was a drawing that was passed around in the school for a long time. Remington gave a ranch hand a rough pencil sketch on rusty brown paper showing a wolf ready to attack a cow and her calf. Another sketch was of a "bronco buster."

The drawings helped Remington to be accepted in Peabody but his increasing awareness of the limited possibilities for him as a stockman made him bored again. He drank more, worked less, associated with the hands rather than the ranchers, and became involved in escapades that soon turned the town against him. His Halloween prank was an indication. On November 1, the preacher in Peabody found his buggy on top of the church and his cow inside. Remington paid for getting the buggy down, cleaning and painting the church, and gave a present of ten dollars to the preacher.

On Christmas Eve, Remington rode to Plum Grove with four friends to buy liquor at the livery stable. With nothing better to do,

the five of them entered the schoolhouse where the usual holiday entertainment was in process. People had driven for miles to attend the program that featured a little girl "all in a flutter" in a white dress who recited "Hang Up the Baby's Stocking." The building was large with double doors at one end and recessed windows along the sides like portholes. The crowd was jammed in. Children were standing in the windows.

Remington soon tired of the local talent. A few rows in front of him was the bald head of Squire Nathan Duncan against whom Remington nursed a grudge. The five friends threw paper wads at Duncan's head until the Squire had them ousted from the school. They retired to Hoyt's store where they had more drinks.

In the schoolhouse, the children had been waiting for the program to be over so that the lamps could be extinguished and the tapers on the Christmas tree lighted for the coming of Santa Claus. The Squire was Santa. He had donned a buffalo robe that concealed his bald head and also false whiskers that dangled from his chin. He started to distribute the presents.

Suddenly, the double doors were swung open and someone yelled "Fire!" That precipitated panic. Men and women lost their heads and began pushing out the little windows, the only other exits. An old maid became caught in the sash, unable to get out or back in. The people who got out found just a flaming dry goods box in front of the doors. Remington and his gang had disappeared but they were known to have lit the fire. After having been thrown out of the school building, Remington had taken a box of excelsior from Hoyt's store, brought it into the yard in front of the entrance to the school, and set the straw on fire.

The authorities called the prank criminal and demanded justice. The five friends were brought to trial before a jury in the district court in El Dorado. Remington was blamed for everything and was referred to as Billy the Kid. The jurors held out through a long Sunday, enjoying cigars and a bushel of apples while looking through the windows at the slow-moving traffic in the mud of the unpaved street. They could not agree on a verdict, recognizing that "the boys are a little 'wild and wolly' occasionally." Remington, described as a "bright young Englishman, with heavy fur overcoat and a laughing face," paid the court costs and attorney's fees.

The date for retrial was set for February 4. By then, Remington had departed. Months later, one of the jurors met Remington in Kansas City and asked, "Fred, tell me the truth about that Plum Grove Christmas entertainment."

Remington laughed, "You heard the evidence and decided I had

nothing to do with it, didn't you? But, oh say," and he laughed again, "the sight of the old maw who got stuck in the window, and the way she wiggled her legs to get loose, wasn't that a terrible thing for a modest man to see?"

Remington had decided to leave Peabody as early as December 29. Knowing he was no longer accepted in the community, he wrote to an Ogdensburg chum that he was "trying to sell here and go somewhere else further West and there tackle some business. I don't care whether it is stock, Mercantile—either hardware or Whiskey—or anything else. Why not start a hardware ranch out West?" The friend knew Remington too well to bite.

Remington listed his land for sale and separately advertised an auction of his livestock, equipment, and household goods for February 15, 1884. Buyers of the sheep, cattle, and horses assumed the remaining obligation on the notes to the bank. His half section of land was sold February 18 for $5,500, a price that reflected improvements of $850 in addition to the $4,650 Remington paid. The new owner found the walls of the buildings covered with Remington sketches. He painted them out.

Remington had already left Peabody after only ten months as a holiday stockman. He said goodbye with his customary exuberance, vaulting a five-foot gate at the Duvall's. The townspeople did Remington a favor by hastening his departure. That way, he recovered all but $2,000 of his investment. The crash in ranch and stock prices began that July and was a stampede by the summer of 1885. The other holiday stockmen lost out. The serious ranchers like Robert Camp survived the bad times.

When the stockraising boom burst, the livestock notes that Remington had sold became worthless. The bankers felt that Remington had failed to live up to his obligations. They tried to catch him in Kansas to serve a warrant on him. Years later, when Remington was on a train passing through Kansas with General Nelson Miles' hunting party in 1893, an aide who knew about the notes impersonated a sheriff by calling for Remington from the depot platform. Remington hurried to his stateroom, locked himself in, and would not come out as long as the train was in Kansas.

By mid-February 1884, Remington was back in Canton. The *Plaindealer* quoted him as being "an enthusiastic admirer of Kansas, not as a home, but as a place to make money. He has recently sold out his lands there and appears to have done well. He will return, making only a few days visit."

Remington went back to Peabody twice, both times unannounced and speedy. A decade later, the townspeople said that they "never ex-

pected him to become famous." They "couldn't believe it was him at first." Until Remington became a celebrity, the Kansans never realized he had talent. There is little trace of him there today, other than the Frederic Remington Rural High School dedicated in 1962. Even the hamlet of Plum Grove is gone, except for the cemetery.

4.

The Original
Kansas City Hit-Maker

In Canton, Remington held himself out as having made money in Peabody. He had in his hand the fifteen-hundred-dollar proceeds from the livestock sale to prove his success. What he was looking for, he said, was a partner to "start a hardware ranch out West."

The man he got to join him was Charles H. Ashley, his old Ogdensburg camping pal. The two thousand dollars he wanted to make up for the Peabody loss he borrowed from his mother by telling her it was required for extra capital. Hardware was a business she understood and would underwrite, with the approval of the Deacon and Uncle Horace. Hardware was the Sackrider family foundation. The wandering son was coming home in the nature of his occupation if not geographically.

Another reason for returning East was to renew his proposal to Eva Caten. The Sackriders approved of her and had let Remington know that she was unhappy. Lawton Caten had remarried in 1882, choosing a widow from Oswego. The new wife took over as manager of the Caten household so the 1880 objection to marriage with Remington

was overcome. Eva Caten was twenty-four with no role in Gloversville and nowhere to go. Remington wrote to her. He told her that he had not been with another woman since her father rejected his proposal. He was a one-woman man, he declared, and he still wanted her. If she consented, he would marry her after making a commercial success of the Ashley partnership.

In March 1884, Ashley and he settled in Kansas City, Missouri. Although it was east of Peabody, not west as he had promised Ashley, Kansas City was the center of urban attraction for the Kansans Remington had known. When his drinking pals had talked about where they could have a real good time, it was Kansas City, the natural next stop, the livestock center of the United States.

Seven railway lines led to Kansas City, hauling emigrants, buffalo bones, cattle, hogs, and farm supplies for the largest livestock market in the West. The stockyards were there, soap and glue factories, lumber yards, along with banks and saloons. Passing through were cowboys, Indian chiefs, generals, Sheriff Pat Garrett, Jesse James' brother Frank, and Arizona Jack. Gambling was wide open. There were cockfights, bawdy houses, and cattle breaking loose in the streets that could turn into seas of red mud. The more cultured citizenry had the Orion Singing Society, the Philharmonic Society, and their evening drives on Blue Boulevard where the sports in their carriages tested each other in little "brushes."

It was a vital city of 75,000 that saw the quiet launching of the firm of Ashley & Remington, dealers in sheet and bar iron, nails and railroad supplies at 129 West 6th Street. The principals of the firm were listed as living on Grand Avenue south of Eleventh where the richer early settlers had built their mansions. By 1884, the area consisted of rooming houses perched on clay bluffs left by the grading of the streets.

Hardware dealers should certainly have found prosperity in the unparalleled real estate boom. Citified Queen Anne houses were being constructed in the old corn fields. Street railways were following cow paths. After just one month, however, there was no further mention of Charlie Ashley or of the hardware partnership. The firm's listing in *Hoye's Kansas City Directory* lapsed.

It was about this time that Nellie Hough, a young Kansas City matron, learned that Remington claimed to have been swindled. She said that "the hot blood of resentment had fired in him the idea of revenge, and he had taken a revolver and gone out to make the guilty pay; and in fact was virtually in the act of carrying out his intention when Mr. Hough chanced to see him, went up to him, and spoke to him. His

revulsion of feeling was so intense that when he thought of what might have occurred had my husband not come upon the scene at that exact moment, it almost overcame him."

The nature of the swindle was never disclosed, but it was the end of Ashley & Remington and it cost Remington fifteen hundred dollars. His developing sense of histrionics inflated the event into the tragedy that "almost overcame him," although for Remington, being "virtually in the act of" murder was far from his doing the act. He never had fired a gun in anger.

The Houghs became Remington's closest friends in Kansas City. To Nellie Hough, he was "blond, with large blue eyes which shone with the light of youth. He loomed large beside my husband, looking very much like some Greek god in modern clothes. His strength was so evident in the poise of his head that he seemed the embodiment of power and force." He was only one inch above average height, but his bulk made him look taller.

They were seeing a Remington on the loose after the demise of the Ashley partnership. He still had the $5,500 from the Peabody land sale and had not returned the $2,000 borrowed from his mother. A "young blood with sufficient means to scorn work," he was back at the concerted pursuit of the good time. He "wore clothes and affected a demeanor to advertise his hilarity of purpose." The habitués of every saloon and bucket shop and poolroom where the tough men congregated knew Remington, at Gaston's, at the Gilliss, at Billy Christie's, and at the Pacific. He was a young Easterner with plenty of money and a gentleman's competence in boxing, riding, dancing, drinking, playing poker, and swearing. He introduced himself as an Eastern journalist, not a former Kansas sheepman, and he claimed Western experience gained on a Montana ranch. The engagement to Eva Caten was in abeyance while he considered his occupational options.

Mornings at dawn, Remington rode west to Al Hatch's "clubhouse" near the state line. Hatch said that if Remington "hadn't a taste for art, he could have made a good living as a fighter. Not a bit of a bully, mind you, but a nervy, trained-to-the-minute good looking kid, and a bull for size and strength." Toward evening, Remington would ride out over the cobblestones of Independence Avenue with a rope trailing behind. He was seen lassoing sunflowers and he used to "roap" the young boys returning home from the old Woodland school. He was living in rented rooms on Wabash Avenue about two blocks from Independence.

Some of the days he spent at the saloon of George Gaston, a former Bavarian colonel who spoke five languages and was a connoisseur of music, art, and roast beef. Gaston's had been the hangout of

Eugene Field until the poet left for Denver. John Mulvany, the painter of "Custer's Last Stand," went there when he was in Kansas City, as did the writer Alfred Henry Lewis whose books became collectible because fifteen years later Remington illustrated them.

The Kansas City women were attracted to him but he kept them at arm's length. He hung around James T. Tarsney's billiard hall so often that people thought he had been hired as the blackboard marker. The cashier at Tarsney's said that "Fred was a good-looking chap, you know, and could have been the original hit maker" with the women:

He came to me one day and says:
Jack, do you see that woman outside?
I looked up the stairs—the place was in a basement—and saw her.
Sure, I told him.
Well, how am I going to lose her? he asked me. One of the fellows introduced me to her a week ago and she's been chasing me ever since. You know I don't like women. What am I going to do?
Here, I says, take this rag and take your coat off and start polishing the brass where she can see you.
Well, sir, he polished the brass rail all the way up those stairs, and by the time he got to the top she was gone. She never chased him again, either. But he was One Grand Fred.

Remington's friends were the "past-post-graduates of the hail-fellow-well-met class," the saloon keepers and billiard hall cashiers, the bartenders and hangers on, the professional pleasure dealers and those who catered to them. It was the other side of the coin from Peabody where he had been "an ordinary sort of harum-scarum young man, full of devilment," doing only what "might be expected from college boys full of fire and out for a good time." In Kansas City, his friends were the men who sold the liquor, not the good-time drinkers.

He continued sketching. The subject was always figures. In Peabody, "the only difference about Remington was that he considered himself something of an artist and had sent a St. Louis newspaper some pencil sketches that never got printed." Al Hatch in Kansas City said, too, that Remington "'d be standing quiet over in the corner" of the saloon, "kind of watching the crowd out of the corner of his eye. Then, all of a sudden, he'd take a piece of paper out of his pocket and begin sketching. I don't believe he painted [but] he could draw a picture of a bucking pony that was livelier than the original."

The end of May, Remington still had ready money in his hands. He knew how he really wanted to invest the money. He had said so six months earlier in the letter to his Ogdensburg friend when he was naming possible businesses in the West. It was hardware or whiskey and he had struck out on hardware. He had what the Kansans had

called "a lip for liquor." His cronies always spent whatever cash they had to buy whiskey so his experience made a Kansas City saloon seem safer than banks. He took all the money he had left and bought a one-third partnership in Bishop & Christie at 119 West 6th Street. In three Kansas City months, he had moved from an amateur drinker to a professional purveyor.

The investment began in deceit. He had not repaid the two thousand dollars borrowed from his mother. She would never have lent her widow's inheritance to put him in the saloon business. He had to keep the ownership a secret from her and from the North Country people who were living in Kansas City. They would consider Bishop & Christie a low class bucket shop, scandalous as investment. They would surely have passed the gossip back to Canton.

Remington solved this by becoming a silent partner. He used George Reick, a thirty-year-old bartender in the saloon, to represent him. Reick seemed quite secure as the front man. A member of the secret society of the Knights of Pythias, he was regarded as being of high character, honest and truthful, industrious and thorough at a time when some saloonkeepers even held drinkers' valuables for safe-keeping.

The secrecy about the investment worked. Remington spent a good deal of time in the saloon and the poolroom of Bishop & Christie, but even the employees did not know that he was one of the proprietors. He took no role in the active management, preferring to draw sketches of the customers, looking for an opponent to box with, and talking about the cowboys, the prairie, and the rides he took.

The silent partnership paid immediate returns. Mindful of his promise to Eva Caten, he made a down payment toward the purchase of a small house on Park Avenue at the southeast corner of Pendleton in the Pendleton Heights residential section. To cover the source of his income, he announced himself as an iron broker operating the business from his home.

By August, he was able to renew his proposal of marriage to Eva Caten. This time, her father was happy to consent to an engagement. The Catens did not inquire closely into whether there had been changes in Remington. In the photographs he sent to Eva, he looked bigger and blonder than ever and even more self-confident. He wrote enthusiastically about his prospects as a successful iron broker in a boom town and about the house he was furnishing. It was once again a love match, and the wedding date was set. Invitations were engraved for the wedding of "Frederick Remington and Eva Adele Caten/ Wednesday morning October 1, 1884, at half past eleven o'clock/60

Main Street, Gloversville, N. Y./Mr. & Mrs. Lawton Caten." On the accompanying card was "At Home/after November first/Pendleton Heights/Kansas City, Mo."

In the marriage license, Eva Caten gave her age as twenty-five. Remington claimed to be twenty-five, too, although he was not yet twenty-three. He thought it sounded better for appearances in Gloversville.

The wedding took place as scheduled, the Reverend James Gardner D.D. of the First Presbyterian Church officiating. The couple left on the two o'clock train that same afternoon. They went directly to Kansas City, without the honeymoon that was implicit on the card that had accompanied the invitation.

Remington hoped that his wife would accept the Houghs as their close friends. Nellie Hough said that as soon as Remington brought his bride to Kansas City, "Proudly he came with her to our home, displaying her in much the same fashion as a boy does his most cherished possession. Mrs. Remington was a slight dark woman with large wistful eyes." Nellie Hough thought Eva Remington unattractive and not woman enough for Remington. Eva Remington looked at the way Nellie Hough lived and could not believe that Western manners were so much coarser than Gloversville's. The two were not to be friends.

If Eva Remington had thought she was marrying the same seventeen-year-old boy she had met in Canton in 1879, to live in a glamorous growing city, she soon knew she had made a mistake. Remington was associating with the kind of people who made her acutely uncomfortable. There were no invitations for her to attend the Orion Singing Society or the Philharmonic Society.

There was no brokerage business, either, to run from their home. Instead, she found that her husband was the friend of the city's disreputable element. She had married "One Grand Fred." When he left in the morning, the neighbors noted his tenderness toward her. She came out to kiss him goodbye, and sometimes he reached down one hand and lifted her over the four-foot fence to carry her along the street with him. She squealed with pleasure then, but when he came back at night he smelled of liquor and smoke and sweat. She was soon unhappy. All of the Kansas City she saw was crude and rough in comparison with the quiet New York villages she had known.

She did not understand his compulsion to draw, either. She thought he was a serious businessman, a dedicated iron broker, but he mentioned no deal he was making. Rather, he brought back sketches to show her, figure sketches obviously made in saloons and poolrooms.

He even insisted on having her pose as a señorita for a watercolor he was attempting, but she did not like participating in his art. She convinced him that it was a poor likeness he had achieved, that it made her look "like a Mexican woman of the most ordinary desert type." Because she distrusted the time Remington was giving to art as opposed to business, she was so vehement that Remington never asked her to pose again. He said he had "almost lost his Missie because of his painting her as a poor Mexican."

Within weeks, Remington began to have money troubles, too. Bishop & Christie was no longer profitable. The saloon location was not working out. Something would have to be done for income because Remington could not keep up the payments on his house, small as it was. Then, when conditions were already dark, they turned black.

As 1884 was ending, vital statistics were being collected for *Hoye's Kansas City Directory* for 1885. By chance it became known that on page 87 there would be published the listing "Bishop & Christie (J. S. Bishop, W. H. Christie and F. Remington) saloon 119 w 6th." On page 482 would be the clincher, "Remmington, Fred (Bishop & Christie) r Pendleton Heights." The silent partner was identified loud and clear.

When Remington's investment was discovered, the Kansas City residents with the North Country connections did call the saloon a bucket shop. When they sent the news back to Canton, the consequences for the Remingtons were most unpleasant. It was a scandal, not the sort of situation that Eva was equipped to handle. Already agitated by the threatened loss of their home, she could not understand how Remington could have lied to her about his real occupation and how he spent his days. There was no outward friction between them, but she went back to Gloversville early for the holidays, taking her personal things with her. Separating from Remington was a critical step but she had no choice that she saw and she did not return.

Remington let her go. He did not go East with her. He had all of the remainder of his inheritance invested in Bishop & Christie, and that held him. Prospects were sour but there was no other economic hope. Funds were so short he lost his house. He stored his household goods with the Houghs where he moved in as a welcome guest.

He told the Houghs that he was "planning to go West and retrieve his fortune," but he did not leave. Instead, he spent hours sketching and he began to paint both in oil and watercolor. This absorption in art soothed him in the face of his misfortunes. He was calm, not melancholy. His vicissitudes had cleared his mind for painting. He would sit at the Houghs for hours and draw Western subjects from his imag-

ination. He would read, then pause to pick up a pencil and sketch his interpretation of the characters in the margins and end pages.

With the little money he had, he bought art supplies in the W. W. Findlay art store on North Main Street. Findlay had given him the materials to frame a painting as a Christmas present for his mother. In mid-December Remington told Findlay he needed to earn money and would like to have Findlay sell some paintings for him. Findlay took three paintings on consignment, all of them typically Western subjects, an attack on a wagon train, Indians on a hill spying on a wagon in the valley, and three dismounted trappers looking at a skeleton pinned to the ground by an arrow.

As soon as Findlay put the paintings in the window, they drew a crowd. Customers were given the sales pitch that Remington was an Eastern professional artist who usually painted gondoliers and Spanish gentry, and that these paintings were the result of a summer vacation on a Kansas ranch. The first purchaser took all three paintings for $150. Remington's share was $100.

Findlay later claimed that he not only discovered Remington, he shaped the course of his career. When another customer came in and offered Remington $100 to copy the attack on the wagon train, Findlay's counsel was, "You've got a start now. Don't duplicate anything. Keep conceiving new pictures." Remington followed Findlay's advice throughout his life. He never did do copies. Instead he painted a large canvas of plainsmen that Findlay sold for $250, a price appropriate for an established artist. The dash, spirit, and color of the paintings attracted attention, but despite Remington's devotion to the bravado style of the French military school, the paintings were crude. Although he kept painting, no more were sold.

These few sales that were made, however, persuaded Remington that his future was as an artist. The $265 he received was a substantial sum in 1884. He could have recovered the little house and again supported his wife but he knew that she would not return if she learned that their sole income would be from art. She had thought she was marrying a businessman and that was what she wanted him to become.

Remington survived the stalemate with his wife with aplomb. Full of confidence that his career had been launched and that he needed to remain close to his Western subject matter, he again began submitting sketches to *Harper's Weekly*. A second illustration was sold. The title was "Ejecting an 'Oklahoma Boomer,'" a scene Remington had observed during his prospecting tours in 1883. The sketch was again redrawn for publication, this time blandly by the staff artist Thure de Thulstrup. He also sent in the text for the accompanying article, and that was rewritten by the managing editor Montgomery Schuyler.

The Sackriders in Canton saw the turn to painting as just another calamity, on top of Remington's losing his wife, his good name, and his inheritance. Remington's mother had been in touch with his wife. She wanted to bring the couple back together and she was anxious to learn exactly what had happened to her two thousand dollars. Under the guise of escaping from continuous sub-zero weather in Canton, she spent the rest of the winter in Kansas City with North Country friends in their red brick house on Broadway near 14th Street. She met her son at the Houghs where he was still staying. She opened the conversation by telling him he was behaving disgracefully and she "pleaded with him to give up his foolishness and take a 'real man's job.'" Without "one word of encouragement for his art studies," she "made every inducement" for him to seek employment in business in New York City where his wife would join him.

Even if Remington had not been convinced that his future was as a painter, this would have been an impolitic advance. He "turned a deaf ear to all her pleadings." The senior Mrs. Remington did not endear herself to Nellie Hough, either. She suggested that Remington get out of the Hough house, objecting to the dirt, although Nellie Hough stated that "it was not a western custom at the time to wash dishes and keep otherwise clean." Remington's mother went back to Canton. He remained with the Houghs.

His earnings from Findlay and *Harper's Weekly* were enough to maintain a family modestly for six months, but not Remington. He had bills to pay and was careless with money. First he rented desk space in James H. Oglebay's office at 6th and Wyandotte streets, giving Oglebay a logging sketch as a present. He again held himself out as a newspaperman. Next he rented an art studio in the Sheidley building. He had no contact with the professional painters who also rented there, however, and his work was not reviewed in the press as theirs was. He did not attend the drawing club that was the forerunner of The Kansas City Art Institute, either. Despite his Yale studies, he was regarded as a primitive recorder of Western scenes and not on a par with the local fine artists.

"One day I asked him, as he sat sketching," Nellie Hough recalled, "if he would sketch my baby. 'Mrs. Hough,' he replied, 'if I did you would turn me out of your house forever, for it would look like a papoose. I am not a portrait painter. But this I will do, I'll paint old Dick for you.' And he took his easel and materials and went out into the lot and sketched our old family horse, Dick." Remington knew that he could handle the painting of a horse even though he did not yet have the skill to do a portrait of a beloved baby.

It had been obvious since the beginning of 1885 that the West 6th

Street saloon was a failure. The operating partners J. S. Bishop and W. H. Christie told Remington that they would try to help him by continuing the saloon for a limited period but the partnership was without significant assets. Remington could recoup only by putting up additional money for the establishment of the saloon in a new location. These funds he did not have and he could not borrow them so his investment was slated to be lost.

On July 26, the bartender George Reick went out to Brush Creek to catch crawfish and to picnic with a party of friends. The heaviest rain in years fell. While Reick was returning home across the Troost Avenue ford, water entered the buggy and he was swept away and drowned. The newspaper obituary mentioned that he had "represented the interests of Mr. Remington, a silent partner." The funeral procession was one of the longest seen in Kansas City, but the pallbearers did not include Remington.

After Reick's death, Bishop & Christie closed the old saloon. An elegant new establishment was opened on the ground floor of the Turf Exchange at 511 Delaware. It was Bishop, Christie & Frame, with J. A. Frame as the current investor. Remington was out. He took no active step to recover his loss by force or by law. Bishop and Christie were both men of substance.

With nothing left to hold him in Kansas City, Remington made an undistinguished exit early in August 1885:

He was standing on the corner of Ninth and Main streets, which was just then beginning to be the center of the town, when "Shorty" Reeson—church name unknown—a painter (garden variety) by profession, drove along in a spring wagon behind a little flea-bitten mare.

"Wait a minute, Shorty," called Remington. "Do you want to sell that mare?"

"Nope," replied Shorty, being wise in the ways of horse trading.

"Is she good under the saddle?" inquired Remington.

"Try her," said Shorty. So, right in the center of the town, Remington and Shorty together unhitched the mare from the wagon, borrowed a saddle, and Remington tried her.

"What's the price?" he asked, after the test.

"Fifty bucks," said Shorty.

"I'll take her." And the next morning Remington, on the flea-bitten mare, rode companionless into the desert and out of the life of Kansas City.

They warned him of the perils. He smiled. They coaxed him, but he went. He must have found what he wanted out there, for when his friends next heard of him he was Frederic Remington and people paid real money for his pictures.

After a year and a half in Kansas City as iron broker, bon vivant, silent saloonkeeper, and painter, he was off to prove himself as an artist of the West, riding a horse of his favorite gender, a mare.

As Remington later said, "Now that I was poor I could gratify my inclination for an artist's career. In art, to be conventional, one must start out penniless." Subconsciously, for the last four years he had been stripping himself of his patrimony and of the funds he could borrow from family and friends, perhaps in order to descend to this financial depth that was his artistic requisite.

It was equally true, although he did not say it, that his personal nadir accepted emotional deprivation as well. He had let his wife leave when they had been married only two months. His call to be an artist was so strong he was as satisfied with celibacy as he was with poverty. There was no longer a need to make believe that he was working at a job. There was no sharing person he had to account to, and that left him free to draw all day.

He was certainly poor when he rode southwest on the bitten fifty-dollar mare, a painter when there was nothing else for him to be. In the time he had, he could not have ridden any farther west than Arizona, but he made plenty of sketches. His Kansas City hosts, the Houghs, heard nothing from him for four weeks. Then, one morning while they were still asleep, he entered their home without knocking and called up the stairway, "Say, Hough, can you give me something to eat?"

He told the Houghs that his travels had made him so lonesome for his wife Missie after nine months of separation that he was heading East to be near her while he attempted "to make a go of art there." His money had brought him back only to Kansas City on the return journey. He asked to be allowed to stay while he put together funds and a wardrobe for New York.

He had written to his wife from New Mexico, telling her that he needed her. If she would consent to live with him in New York City, he would agree to a limited period for a try at success as an illustrator. He did not contemplate failing, but in the event he did, he would take a job in business to keep them afloat. He also contacted Uncle Bill who owned a clothing store in Canton. He intended to bring along his Western outfits as props for paintings and to abandon the flashy togs he had adopted in Kansas City to "advertise his hilarity of purpose," but the immediate need was for a sincere suit for the city.

The New York suit arrived from Uncle Bill, but no money. Remington borrowed from Hough to make the trip, leaving the last Western residence he would ever have.

5.

The Brooklyn Cowboy

Now that Remington had chosen the career in art that Uncle Bill approved of, the purse strings were untied. Support money was channeled to Eva Remington who could be trusted to handle the family accounts. Bill knew that she was regarded in Gloversville as a failure in her marriage, wedded for two months and alone for nine when a woman's job was to make her husband satisfied. In Canton, though, where Remington was a long-time disappointment, sympathy was with his wife. Uncle Bill arranged for the young couple to be reunited in Brooklyn under the eye of the Universalist community. That was where the Colonel's old friend the Reverend Almon Gunnison had his parish and the other Gunnisons had banking and newspaper interests.

So, when Remington arrived in the city from the West, he met a happy Eva at the apartment they were to share with Benjamin W. Wilson, a tax assessor, at 165 Ross Street in Brooklyn. Furnishings were in place and Eva had already begun to establish her housekeeping routine of daily shopping, cooking, washing, and sewing for Remington's comfort. The Wilsons were a compatible Universalist family.

There was nothing to keep Remington from starting on his rounds of the publishing houses to find his place among the professional illustrators.

He certainly took quick advantage of the opportunity. His next nine months need to be looked at in slow motion and enlarged. Otherwise, the transition beginning September 1885 is incredible. The angle of professional escalation is almost vertical. To lose focus for a moment is to blur the total change from the wastrel whose wife left him to the self-directed innovative illustrator recognized nationally as prototypically American.

Until 1885, Remington's speciality, the West, would have been a strike against him. Illustrations of the Indians on the warpath or of the Western cavalry in combat with Indians were toned down for national magazines and newspapers. The American establishment was bending its efforts to encourage European investment in America, particularly to induce the British and the Germans to participate in the financing of Western development. The climate for imported capital had to be calm. News of marauding Indians and the fighting cavalry went under the rug. The regular army was thought of merely as a refuge for the few remaining heroes of the Civil War, "a little force kept out West to hold the Indians in check."

The choice not to report excessive Western violence had enabled the publishers to get by with second rate illustrations drawn mainly by staff artists. Even in *Harper's Weekly*, little Charley Graham drew Western settlements in the same style he used as a staff artist for the East. Thure de Thulstrup worked from photographs. Caton Woodville captured motion but was short on technique. The best was the Victorian Rufus Fairchild Zogbaum who provided stopped views of high action. Remington thought that he was as talented as Woodville and that his drawings were more alive than those of Graham, Thulstrup, or Zogbaum, if he could only get the chance to show it.

Just as Remington began making his rounds in October 1885, a new wind was rising from the West, bringing his opportunity with it. The whole country was caught up in the savage drama of Geronimo. *Harper's Weekly* ran posed photographs of the Apache leader and his tribe, but these formal documentary images were ludicrous as representative of the lurid text. If Remington had not shown up at just that moment, the *Weekly* would have had to go looking for an illustrator like him who had recent sketches made right in Geronimo country.

Another force in Remington's favor was the growing national realization that the West was the most uniquely American region. It was a late awareness. The major railroads were already transcontinental. The bonanza days of Western individualism had passed. Long cattle drives

had to cross settled land and the cowboy was becoming a domesticated fence rider, as Remington knew first hand. In addition, the focus of Western glamor was on the horse. Throughout American history, the mounted man had been the center of attention, and Remington knew the horse and horse action.

Thus, Remington had more going for him than he was aware of when he dug a few of his Southwestern sketches out of his portfolio and sent them with his card to Harper & Brothers, which published the *Weekly*, periodicals, and books. Characteristically, when he targeted a publisher for his sales campaign, he picked the best. Years ago, he had tried other outlets from Kansas and Missouri, but those local newspapers had ignored him because his style was so different from what they were accustomed to. He hoped that the press at the national level would be more understanding.

The following day, he received a request to call at Franklin Square. An appointment at the art department would have been usual, but his meeting was with Henry Harper, the head of the House of Harper. At once, Remington's presence in New York made the difference. In person, he was larger than life. He exuded Western breeziness. His personality and salesmanship gave him a huge advantage he would not have had selling sketches by mail from Kansas City or Canton.

Henry Harper was the sophisticated, mature director of America's premier publisher, not an impressionable clerk. Yet, he was predisposed toward Remington as a former varsity football player at Yale who had turned Westerner. He described Remington as having "the build of a young Hercules" with the "vigor and enthusiasm of a born artist." Harper said that when Remington

first appeared in our office he looked like a cowboy just off a ranch, which, in fact, was the case. The sketches which he brought with him were very crude but had all the ring of new and live material. In the course of conversation with him he told me that his ranch life had proved an utter failure and that he had recently found himself stranded in a small Western town with but a quarter of a dollar in his pocket. He was anxious to get to New York, but was at a loss to conceive where the funds were to come from. As he entered an unprepossessing little inn in the evening he noticed that there was a game of poker in progress in the open bar-room, and he took in the situation at a glance: two professional gamblers were plucking a man who looked like an Eastern drummer. Remington watched the players for a few minutes and then suggested to the commercial traveler that he had better stop. The savage looks of the two gamblers put Remington on his guard and he whipped out his gun, told the cardsharpers to hold up their hands, and covered his retreat until he and his befriended companion were safe in the man's bedroom. Remington, anticipating further trouble, sat with his gun ready all night; and when he heard

stealthy steps outside their door, several hours later on, he gave the rustlers clear evidence that he was awake and ready for action. Remington's new-found friend was overwhelming in his gratitude and begged to know what he could do to recompense Remington for his timely assistance. Remington said that he desired to go to New York, but lacked the requisite funds. The upshot was that his new acquaintance was also on his way to the same city and invited Remington to accompany him at his expense. On his arrival Remington promptly called at Franklin Square.

This was the classic con, the modish Remington doffing his sincere New York suit in order to put on cowboy garb for the interview with Henry Harper, then narrating the tall tale concocted in advance for the purpose. Harper not only believed the story when he heard it, he repeated it twenty-seven years later as a highlight of his publishing career.

The only thing that was straight in the interview was the quality of Remington's sketches. They were unpolished, as Harper judged them, but they also had the unmistakable "ring of new and live material." The most distinctive aspect of the art was its raw power applied to human figures and horses in action. The power was based on truth of observation. As crude as these early efforts were, a Remington drawing was so different from other art in 1885 that it was a shock to come upon one in a series of illustrations. His drawings signaled the end of the Victorian era in illustration.

Harper bought two of the sketches Remington had submitted. The first was "The Apache War: Indian Scouts on Geronimo's Trail," reproduced as a full-page cover in the January 9, 1886 Harper's Weekly. This was Remington's initial appearance over his own signature as a professional illustrator. The drawing was printed as a wood engraving "after Remington," where the staff "sculptor," as he was called, duplicated Remington's lines by incising them into a wood block that became the printing plate. The necessity of having the sculptor come between Remington and the reader modified the power of the drawing, but the end result was still the real sense of being present at a live incident of the war. The second illustration was more dramatic. A horse was reined in at the end of a gallop, signifying that "The Apaches Are Coming."

What the two illustrations meant to Remington monetarily was seventy-five dollars for each, enough for frugal living for three months. He also took away from Franklin Square the warmth of his accomplishment at manipulating Harper and the assurance that he had made a start as a working illustrator. The best publisher had immediately accepted him as new talent. When he got back home to Brook-

lyn, he boasted to Eva that his earnings from art would be sufficient to keep him from clerking forever.

At the outset Remington tried to sell his drawings to magazines and newspapers rather than devoting his efforts to fine art. Illustrations meant quick payments. He was initiating the sales of drawings that were of events he had visualized, voluntarily accompanied by text he wrote to explain and enliven the illustration for *Harper's* writers. He was not paid for this text but it supplemented and helped to sell his pictures.

After the excitement of the two *Harper's* illustrations, however, there was no other immediate assignment to keep Remington occupied. He was one of five thousand illustrators looking for commissions from eleven thousand publications. His only subject was the West, and as he said, he knew more about the West than he did about drawing.

He tried his hand at a few easel paintings, that is, paintings in color that were done at the easel as fine art, as opposed to drawings done at a table for use as illustrations. There were only two takers. One painting was an oil for Grandfather Sackrider. The outspoken Deacon gave him just a few dollars, the cost of the materials, because the vivid colors bothered him. He insisted that "there never were any horses like those." The Sackriders were strong on familial support, not pecuniary. The second painting was for a doctor in Washington Heights in New York who advanced a hundred dollars when Remington told him "I'm running very close to the wind, and haven't enough money to spare to buy a painting outfit."

In what to him was just a pause in his career, Remington's wife reminded him of the promise that had brought her to Brooklyn. When earnings from art failed, he had agreed to take a job in business. As a concession to her, he called on Uncle Bill's Republican associates in the city and found them willing to help. United States Senator Tom Platt, the party boss, arranged for clerical work at once, for the high salary of sixty-five dollars a month. Getting Remington to remain a clerk, however, was another matter. Going back to the "burdensome study of figures fretted him so much and so quickly," he said, that he asked the superintendent of the counting room, "Do you like this sort of work?" "I do," replied the official. "Well, you are welcome to all you want of it. I don't," answered Remington, and he put on his coat and hat and left the office. In the second job found by Senator Platt as a favor for Uncle Bill, Remington remained thirty minutes and then quit.

After the highhanded behavior at the Platt jobs, Eva Remington

finally comprehended that Remington was no longer to be ordered or cajoled into office work. He had become a man determined to succeed in art. No clerking position would ever again be possible, not even as a place to fool around in while sketching the other clerks. If she precipitated the same crisis she had in Kansas City, so that the choice was between Remington's art and her, it looked as though she might lose. They had no child to bind them.

What enabled Remington to be cavalier in the face of promises made to his wife he had rejoined just four months earlier was the awareness of an impenetrable foundation to his fortunes: The Remingtons would never let him down. Uncle Bill as his father's surviving brother could always be counted on. Bill was a successful politician. When he was county clerk, he had received a private contract to have the county records rewritten, and he "cleaned up pretty well on this."

Uncle Bill welcomed the new firmness in Remington and was again "ready to back him" now he was going "to settle down seriously to art." The result was that Uncle Bill agreed to pay the five dollars per month tuition for Remington to enter the Art Students League of New York for the spring term beginning March 1, 1886.

Although Remington never acknowledged benefits from the League, his talent was honed there. The League was more than a school, it was an assemblage of eager students with the highest order of raw ability who shared learning with each other. They were presided over by a unique set of European-trained American artists who were among the foremost painters of the day. Beyond the schooling, the League was a way of life, a fraternity, a place for free spirits to congregate, to rub off on each other their discoveries in technique and in the marketplace.

Remington's fellow students included Ernest Thompson Seton and Charles Dana Gibson who were Remington's age, as well as the older Allen C. Redwood and Dan Beard. It was Beard who said that at the League "we enjoyed our work and each other's society. We entered vigorously into the fun and politics." The instructors were "Carroll Beckwith, a natty little man who wore a red sash instead of suspenders; the great William Chase, with his flat-rimmed Munich tall hat and white Russian greyhounds; hollow-chested, stoop-shouldered Kenyon Cox—a famous and picturesque group of painters." Chase brought distinguished world figures into the classes, including a tall, long-haired, "uncanny-looking" man he introduced as Oscar Wilde.

Remington's instructor in painting was Julian Alden Weir, the younger brother of the professor at Yale Art School. Alden Weir was admired by the other instructors, as well as respected and loved by the students. He was an Impressionist, able to convey a broad sense of

color, but his style had little effect on Remington. It would be another fifteen years of artistic evolution before Remington would be ready to understand Weir.

Remington was "the class's strong man champion, having won the title from Gibson in a forearm-bending contest. As if that were not sufficient to clinch a reputation, Remington, fresh from the West, could be induced to display a tintype of himself in full cowboy regalia standing beside a real Indian." The students in Remington's class thought him too worldly and too mature to remain sketching prosaic models, but they had much to teach him about technique in art. In contrast with Yale, the League was run cooperatively and managed by the students themselves. Remington learned quickly and easily from his fellows, particularly the pen and ink man Edward Kemble who became a close friend.

Uncle Bill's generosity extended beyond tuition. Because Remington had no convenient place to work in the shared Brooklyn quarters, he was enabled to rent an attic adjoining the studio of Allen Redwood near the League. To reach it, the visitor was forced to climb a dark and winding stair from the entrance on Fourteenth Street. In Redwood's studio, students met before and after League hours to drink black coffee and smoke Durham tobacco in corncob pipes while developing "wonderful schemes for the improvement of the school."

Coffee and corncobs and student schemes were kid stuff for Remington. He did not participate. By the end of the month of March, he was back calling on *Harper's Weekly*. Again, he sold two Western drawings. The second was redrawn by Thulstrup as a double page, with Remington's strength injecting verve into the older man's usual static quality.

The experience at the League also showed Remington how to do black and white washes in India ink. He worked with haste, sometimes thin and scraggly, but drawn with freedom and vigor, without dependence on posed models. What Remington considered to be imitative of the French military painters was regarded by others as innovative.

He was the same brash, confident, bold, breezy, friendly, and cocky man he had been in Albany and Kansas and Missouri, but now he was self-directed and giving 100 percent. It was fortunate that the professional reinforcement he received through the acceptance of his work was prompt and enduring. He would otherwise have been insufferable.

In his own mind, he was a success, and that made him tolerable at home, too. He needed an environment that would keep him housed and fed and clean while he concentrated on illustrations. Eva Remington took care of him. She was not like his mother, who was as pigheaded as he was, intrusive, opinionated, and interfering with his

work. Eva Remington was not concerned with his art. She was supportive as long as she was happy. Beyond this, there was chemistry. They loved each other and were comfortable with each other. He accepted her as the girlish "Missie" she still insisted on being called, as she had been at home. He referred to her privately as "the Kid" to reverse their age difference, and responded to plain "Fred" as he always had.

The school year at the Art Students League ended May 29. As his fellows had predicted, the League was not for Remington. Loose as it was, the League was too parochial for him, too demanding of juvenile loyalty, and too ingrown. Its models were too mundane in comparison with the outlandish figures of the Southwest. There could be no schoolroom lesson for the moving subjects he favored. Despite what the League had taught him about drawing and color, enough so that Remington was entitled now to call himself an artist, the League's direction was toward style and technique rather than what he wanted, realism in action.

The League proved to be the last of Remington's formal art instruction. It was also the best, but the school was for work-a-day tradesmen, not a socialite association to be bragged about like Yale. Besides, studying at the League imprisoned him in the city, a constraint that the restless Remington could not tolerate for more than a matter of months. He never went back to the League, and he seldom mentioned that he had studied there.

6.

An Artist in Serch of Geronimo

On June 8, 1886, Remington was on the Southern Pacific railroad heading west from Deming, New Mexico. The subtitle he entered into the early pages of his "Journal of a Trip Across the Continent through Arizona and Sonora Old Mexico" was "An Artist in Serch of Geronimo." He followed the subtitle with the prudent "?? in fact it is a matter of congratulation to the artist that he never found Geronimo." The truth is, he never even looked.

In May, *Harper's* had decided to send a special artist to Arizona to make a fresh report to the nation on Geronimo's climactic struggles to avoid the army contingents just being assigned to General Nelson Miles. Remington talked himself into the commission. The job was an illustrator's plum, and it would get him back into the Southwest he saw as his springboard to fame.

He was twenty-four years old, a declared artist for less than one year. Only three of his six illustrations in the *Weekly* had been sufficiently competent to be printed above his signature, but the assignment was for a war correspondent familiar enough with horses to keep up with the cavalry and experienced enough in the Southwest to

survive a dangerous campaign. Remington filled the bill. As a result he now had credentials from *Harper's* that established him as a "special," irresistibly attractive to any Southwestern personality who wanted his picture in the paper and the instant equal of the older special artists, Zogbaum and Woodville. He was so eager to get on with the job to "serch" for Geronimo that he was on the train just three days after school closed at the League.

Dates in the journal that he kept were infrequent and sometimes inaccurate. The handwriting was often illegible and the spelling was phonetic and inconsistent. Remington wrote the journal for himself, but the format was addressed to an undefined masculine audience. "Gentlemen" was the way he began a paragraph directed at the readers his journal never had. Most of the entries were classified under headings such as "Remarks," "Pictures," "Army," "Frontier," "Indian," "Mexican," or "Color Notes." These headings were evidence of another transition in his personality toward the organized purposeful correspondent doing a thorough job on his maiden assignment. Indeed, the classifications were the same ones he used to group his paintings the rest of his life.

Half of the journal was descriptive of his experiences. The balance was devoted to keys for paintings to be done later and descriptive information on Indian tribes, buildings and construction, colors, and the cast of characters he encountered. He was one of the earlier artists whose Southwestern travels were made easier by the railroads of the 1880s. Even so, almost half of his time was consumed by getting there and back.

Remington's first "remarks" were penned as if to be the opening of a travelogue: "June 2 midnight. As the sable robes of night began to fall, the brakeman lit the grand chandeliers of the smoking car & the passengers dozed off . . . and the train butcher sees 'hard times' ahead. He yawns despondently and announces with 'sang-froid' that he 'will now proceed to close the store' as he packs up the novels & bananas, slams the cover to his box and turns the key."

Remington spent his hours in the smoking car, not the coach, holding forth as the Western expert from his new vantage as newspaper correspondent. Occasionally, the "remarks" recorded smoking-car humor that Remington unaccountably found memorable, as, "Every thing equilizes its self—the rich have ice in the summer and the poor in winter." Another was, "yours Truly to Kansas gent 'Have a drink?' Kansas Gent 'I wouldn't wish it, thanke.'" His list of expenditures showed $.90 for "grub" and $3.85 for "expenses," which meant treating for drinks.

On the fifth day he reached Albuquerque: "Our train crossed the

Rio Grande on a new bridge just completed in place of the one carried away by the floods. The muddy surges seemed as though they would momentarily carry it by storm. As we reached the shore a subject of the Queen's remarked that 'that was the last time he would cross the Rio Grande.'"

In the evening, Remington noted that "I ate breakfast this morning at 4 oclock and by a series of unfortunate mistakes I am at the hour of 6 p m with my belly drawn like a four mile racer." Food at regular hours was a necessity for Remington but railroad performance was seldom to schedule. The trains stopped at way stations for meals so he eventually "had good supper at San Marcial" on the way to El Paso. "Saw vagabond setting on the platform with De Neuvilles Henry the 6th eyes, very ferocious but not unduly agitated—sunk not dark."

After transferring at El Paso, he "staid in Deming over night—Got a room—gave it up gallantly to a lady when her big fat relative gave a grunt of satisfaction and never even looked pleasantly at your much abused servant. I slep in my clothes on a cot and am badly in need of a bath." Avoiding personal grime and smells was a long-standing preoccupation. The "need of a bath" was also the reflection of his new status as a *Harper's* special artist, a dignified man who had to keep up a front. He had to act the part, look it, and command the respect it called for. When he met some "nice ladies," he said he looked like Captain Kidd. He was "painfully consious that I am somehow not in accordance with the surrounding conditions, still the people will appreciate I guess."

The journal also provided the first expressions of bigotry. The target was people of Spanish descent in New Mexico. He said that "the Greasers are a villinous looking set, prone to moustaches & imperials. Their costumes are akin to the American tramp—the women show the Indian blood more than the men. They are a very degraded set. The children lay around nearly naked in the dirt." On the other hand, the "frontiersmen all exhibit rough bearded and tanned faces with a very marked stamp of physical courage plainly stamped on their physiogony." They were a good American stereotype to him, compared to the native New Mexicans he saw as foreign.

In contrast, where dislike might have been expected further along in the journal, "negro cavalrymen" were called "good style men." Indians he regarded as individuals, as opposed to the traditional Western view favoring dead Indians. "One squaw" crossed "a deep irregation ditch—she gathered her skirts like a Broadway sister." Chief "Asenscion" was "fine looking—with a strong meety bulldog face, slightly inclined to corpulency." Remington felt that "the cow-boys of whome I meet many are quiet, determined and very courteous and

pleasant to talk to. There is none of your Dodge City stock here."
Remington had more of the Dodge City touch than these New Mex-
ican cowboys. He relished gambling games so much, he had wanted to
deal faro to the soldiers until halted by the army brass.

Remington's "serch" for Geronimo was brief and superficial. He
learned the military background for the campaign from army officers
while he was in Deming. Geronimo had fled the San Carlos reservation
in May 1885 with only 124 Chiricahua Apaches including women and
children. Military officers he trusted had been replaced by politically
appointed agents. In March 1886, Geronimo agreed to unconditional
surrender at a meeting with General Crook in Mexico. Crook had just
12 men with him, so Remington said that "Crook caught Geron-
imo as the Blank caught the bear—how was that?—The bear chased
B_____ into camp and as they came in at full speed B_____ yelled
'here we come by god.'"

The night of the surrender to Crook, a white trader gave Geronimo
"tizwin" whiskey, and the Apache chief changed his mind. With fifty
of his tribe, he fled eighty miles before camping. General Nelson
Miles was sent to replace Crook, just weeks before Remington arrived.
The new strategy was for Captain Henry Lawton and a small com-
mand with Leonard Wood as medico to "go out on foot with 30 days
rations and penetrate into the mountains of Old Mexico on Geronimos
trail to his stronghold."

The Deming officers told Remington he would be foolish to join
the chase. The Apache chief had been responsible for the deaths of at
least two hundred, including more than twenty soldiers and scouts.
Geronimo was headed into the uncharted Mexican mountains where
the advantages of terrain would all be his. Even soldiers trained as In-
dian fighters hesitated at a killing mission like that. Remington's reac-
tion was the brave one. His image as the son of the dashy Colonel
called for pluck. His commission from *Harper's* was to cover Geron-
imo, so he obtained an army letter of introduction to Lawton and de-
clared, "I shall start today" to "join Capt Lawton's command."

Remington's second thoughts were more cautious. He feared what
did happen, that catching up with Geronimo would be a long, danger-
ous, and debilitating effort. The chase called for dedicated slogging,
not dash, so it was no place for an artist in a hurry to find a front page
story for *Harper's*. On his own, he made the practical decision to
change the theme of his journey from the Geronimo campaign to
"Soldiering in the Southwest," a subject more suited to creative con-
versation than real action. He rode over to Tucson where he had
visited in 1884 and got a good room at the Palace. He was right about
the campaign. Lawton proved to be ninety days catching up to

Geronimo after 1,396 miles of historic pursuit over ambushed mountain trails. By that time, Remington's report on the Southwestern trip had already been published.

At the Palace, Remington awakened in mid-morning after a full night's rest and visited with a "detachment of the 10th colored cavalry," his first opportunity for close contact with black soldiers. He met the white "Lieut Clark a young slim manly man" who "treated me cordially. A horse was saddled and I sketched while surrounded by an enraptured audiance of Mexicans and nigger soldiers." Remington "took the 1st Serj down to get him a drink (brandy)," an unusual fraternization with a black soldier for a correspondent whose aspirations ran to drinks with generals. The "1st Serj" told him about "a gallant action by Lieut Clark in rescuing Corp Scott who was shot through both legs, under fire—by going to the front and dragging him under cover—bullets passed between his arms & body as he stooped in the heroc act. The Serj was quite an admirer." "Lieut Clark" was Powhatan H. Clarke but Remington was congenitally unable to spell either the given name or the surname of this career West Pointer who became a close friend.

Remington realized that the rescue merited a front page drawing that would compensate for his abandonment of the Geronimo commission. He immediately sent a letter to the *Weekly* to be printed unsigned as anticipatory propaganda. He described the Clarke incident and concluded that "in any nation under the sun but the U.S. [this heroism] would be fitly rewarded." Remington quoted a trooper as saying, "De Injuns jes fairly ploughed up de groun' wid bullets, when he run, an' never tuk no notice what was gwine on no more'n if de man'd jest fell down in a fiel' any whar. He'd 've fairly dusted 'way fum der to save he own hide whole if he wa'n't a _____ fightin' man —fightin' man, I tell you and it jes do 'im good to see a _____ Injun. An' he don't forgit a man in his 'stress."

The same day, Remington also "bought elegant Sombraro $6.00, cheap." He paid an Indian churchwarden to guide him through the old church San Xavier del Bac, a "rude mingling of Moorish & Bazantine," where "it struck me as very funny the images they are what I would call characters. Two angels in the most approved attitude of the modern prize ring. One saint looks as though he were smoking a cigarette. The paintings are simple and good."

The next morning, "I was greatly shocked by hearing that the warden of the church had murdered the wife of another man last night while in liquor. I am badly left in consequence as I can not take the pictures [photographs] which the chief had promised me he would make the opportunity for. The murderer is a villinous looking chap

and it has occurred to me forcebly since that the dollar I gave him yesterday to show me through the church was the bottom of whiskey and murder—still I am in no wise to blame as I could not controll the destiny of the dollar." Metaphysics was part of the jargon of the day.

He could not take the pictures because "an Indian can not act. I wanted the chiefs people to enact a feast & a war party but when the unfortunate murder occurred he said, 'My heart is down and I cannot do what I had said I would—am very sorry.' "

While in Tucson, he "bought 8 poisoned arrows of an old Indian and a drinking bowl." Remington was acquiring artifacts to be used as props for paintings. The pieces also made exotic wall hangings, identified his specialty for visitors to his studio, and were justified to his wife as an investment.

Remington left Tucson on Sunday morning: "My hotel chap made a grevious error and only charged me $5.00 for what ought to have been $10.00. more luck than I generally have." His destination was Fort Huachuca where he wanted to complete the Lieutenant Clarke story by interviewing and sketching the wounded Corporal Scott.

On the train, Remington introduced himself to Captain Thompson as the *Harper's* correspondent and was brought in to meet General Miles, who was also en route to Huachuca. The experienced general recognized the artist as the beginner he was, rather than the pretentious "very dignified person" Remington called himself. Miles was shrewd enough to welcome the artist with what the suddenly vain Remington characterized as "the usual 'great man' reception, one I ask and expect." The effect on Remington was what Miles intended. Remington wrote that "I felt his presence before consious of his identy. His personal looks I shall never forget."

Miles needed Remington. He was new on the job too, and had just written to his wife, "If the papers had not so much to say about" Geronimo, "I would like it better." His management of the Geronimo campaign was already being criticized in the local newspapers, and here he had in hand the impressionable correspondent of the most prestigious national newspaper. He was glad to encourage Remington in the promotion of the story of the rescue of Corporal Scott by Lieutenant Clarke. It would focus attention on the positive aspects of the Apache campaign rather than on the uncertainty that accompanied Lawton in his tracking of Geronimo. The press would have a hero to fill the hiatus.

When they arrived at Huachuca Station, Miles arranged for Remington to ride the eight miles to the fort in a staff wagon drawn by six mules. The hour was too late to visit the hospitalized Scott, so Remington "went up and saw the Chirrachua [Chiricahua] scouts—They

are a wild savage looking outfit—much more so than any other Indians I ever saw. They were cooking 'guts' over a fire and the ordor was something that would drive a skunk from under a barn. They have been singing all the evening—they have considerable music—an apparnt 'air' considerable 'rythum' and the nigger plantation swing."

On June 15, he walked to the Fort Huachuca hospital "where a fine tall negro soldier lay. His face had a palor orspreading it the result of the lost limb. I greeted him pleasantly and told him of my desire to sketch his face—for he was the Corporal of the 10th wounded and so gallantly rescued by Lieut Clark under fire. He narrated the event in simple soldierly language in the most approved negro dielect. I sketched his face, shook his hand heartily and left him."

The afternoon of June 16, Remington called on General George A. Forsyth, known as "Sandy." He found Forsyth "one of those men who you can bet would fight quick and fight long . . . he is a man like all men and a soldier withal and dont need a title, a uniform and army manners to make people respect and admire him. I like him on first meeting more than any man I ever met. Ill immortelize him or at least help to some day." The high point of Forsyth's career had been the Beecher Island fight in 1868 where he led fifty-one men defending against Roman Nose and a thousand charging Sioux and Cheyenne. His record in the Apache campaign was undistinguished, but Remington's infatuation with the general was sincere. He did keep the promise to immortalize Forsyth, albeit with an "e" at the end of the surname in "Forsythe's Fight."

That night, Remington met August Stautz, "an old battered specimen of the frontiersman on a drunk." He made a "splendid sketch" of Stautz, who called the drawing "a new game on me." Stautz added that he "was 'drawed' up at Fort Stanton with two injins but the feller drawed us with a box stuck up on sticks."

The "box on sticks" was a camera, an essential in Remington's four-part traveling kit. He identified painting projects in his journal, named the colors of the subject matter, took quick sketches with pencil and watercolor, and tied it all together with scores of photographs that he developed himself when he reached a town. He was painstaking in each part of the job.

The color notes were distinctively his own, demonstrating a surprising familiarity with the palette that came from association with Alden Weir at the League. The Impressionist Weir and the realist Remington used some of the same colors, but to different ends.

The color notes were mainly in the early days of the trip: "The far horizon of the plains is blue. The middle ground is streaked with yellow greens, deeper greens and yellows all cold while the foreground is

a blue & red mixed sand, mud, green tufts, yellow tufts & light yellows. Any water settled on the plains is yellow ocher & gamboge." He saw that "a trooper can not be painted too rusty."

Again, "at times on certain grounds the glare is beyond the belief of the casual picture observer. Flake white would express it best but it would be a dangerous effect to attempt . . . The shiny glitter of the sun on the white ground (when it is white) makes a reflected light on [the belly of a] horse . . . Shaddows of horses should be a cool carmine & Blue . . . Arizona the earth is of a blue red color in the shaddows and cold too in the sun though with a marked difference."

The color notes were novel interpretations directly from nature. When paintings employing these colors were exhibited later, the Eastern art critics were harsh in their reviews, calling the colors primitive and unnatural. That they were true impressions was irrelevant to critics who had not been West.

The heaviest portion of Remington's art kit was the photographic. He had not owned a camera when he lived in Kansas City. The whole concept of recording the tour on plates came from the editors at *Harper's Weekly*, as did advice on materials to purchase and the elaborate training that was necessary to develop the photographs. The techniques were equivalent to a handicraft, with trial and error the determinants after acquisition of very basic know-how.

The result of having the "Scovill Detective" camera along led to a reliance on photography instead of on his pencil. He had sufficient plates with him so that in the afternoon of June 9, the day he met Clarke, he had taken "a lot of views around towne" in Tucson. When he developed the plates the same day, "the pictures turned out good." To record a trooper, he "photographed him in various attitudes and then made quick water color. Also photographed a herd of government horses coming into Huachuca. Want now to get some photographs of the scouts." He accomplished that the same afternoon when he "photographed the whole batch of San Carlos scouts, in various attitudes." Later, he "photographed Jose Marie the Interpreter for the San Carlos Apaches."

Again, on June 15, he had "photographed govt mule team which was hitched up in the corral for the especial purpose. I was introduced at Post Headquarters to Lieut McMean 8th Infantry who ordered out two men in service trim. I photographed them." Then he recorded the gear in detail in the journal. The photography gave him a sense of power beyond art: "The Indians regard me as a very curious person— a great man—the camera bothers them—its great medicine."

When he heard June 17 that a command was going to move to Calabasas, Arizona, he "got a govt mule and came along." Unfortu-

nately, as he said, "I got lots of ideas but no sketches as my camera was not loaded." His dependence on the camera was so great at this time that he used "sketch" to apply interchangeably to a drawing and to a photograph, although he had no intention of publishing his photographs or even of disclosing in the East that he used a camera.

After ten days, Remington had all he wanted of Arizona. The weather was "awful hot & I am tanned & burned." He made up his mind to go to Old Mexico to sketch soldiers and Yaqui Indians. A Mexican acquaintance in Tucson had said that Hermosillo was a nice place, so on June 19 he was on the Sonora Railroad heading south. There were no sleeping cars. He had to sit up all night on a cane seat, but the omens were good. The air was cold enough so that he missed the coat he had packed away and there was one "very good looking Mexican girl" in the car. It amused him to see her spit: "She had the art down as fine as Del Sawyer."

On arrival at the depot in Hermosillo the next morning, he "was surrounded by a howling mass of black Mexican hackmen all dressed in white and carrying their whips in their hands and no doubt their knives under their tunics but I had on two of the Colt inventions and a Colt assumes collosal proportions on an American down here because most of the Americans down here have graduated with high honors in the Arizona & California school." The pair of Colts made Remington macho because other tough Americans used guns freely.

Like any large man, Remington suffered from the heat. He found that he had been better off in Tucson: "Hermissillo has a climate that approximates hell very closely. They have the yellow fever here in the summer and the small pox keeps 'em from getting 'Ennui' in winter." Proximity to yellow fever scared him. In the hotel, his first move was to order a bath:

The proprietor was willing but would have to study, no one bathed here and they didn't know exactly how to go about it but in a half hour the bath was announced. I was led into what appeared to be the laundry. A pretty Mexican girl was ironing there and the bath tub sat right back of her. The bath tub was as old Stautz said "a new game on me pard." I looked at the Aztec lady and boldly removed me vest. I had no coat. It did not phaze her, I slammed my hat on the floor, no tremor of virgin modesty, off came boots with appropriate noise. Now came the tug of war—was it the custom of the country? if so could I become used to it. I was afraid to proceed and afraid to ask her to get out so at last with one of those blood rushes that a cavalry officer has when he says "charge" I remarked "Pardon Senoritta" and let fall my lamberquins [and] dashed into the tub.

Well its all over, it is the custom of the country—I guess a man could only keep virtuous through force of arms here.

Remington detested Mexican men whom he perceived as licentious. They were "awfully cruel to their horses . . . They are not a virtuous people it is easy to be seen, selfishness and various other low traits predominate in these characters and all such weak people must be cruel." Their motto was mañana: "The people in this country have studied economy until they can live on a melon and a stick of sugar cane and don't have to work more than one day a week. They study economy of living and working, the general effect of which is a natural decay. Poverty and the Cross rule the race, indolence and averice are hand maidens, and ignorance and decay are the results."

He could "not help seeing the villian in the face of every Mexican. They have none of the open countenance of the Anglo Saxon. A glittering eye which roves about, changes its motive at every glance and looks altogether insincere. They use them to much as a coquette might, not having the steady gaze of the American."

The Mexican women, though, were a temptation. He had noticed the "very good looking" one on the train, and he had speculated about the pretty Mexican girl ironing. The women invaded his consciousness. He knew how attracted he was to the exotic and it bothered him: "This far south and no seniorettas as yet—some good looking animals of the lower class but animals in all but a Raphael Virgin Mary look." His inhibitions kept him from making a connection: "Have seen some very good looking Mexican women but Lord when I think that they never wash I loose the edge of my appreciation. A dirty man—is not d____ned but a dirty woman—bah." He saw these women as magnetic, but dirt was a reason to remain continent. Venereal disease was as frightening to Remington as yellow fever.

He was relaxed enough to enjoy Mexican food and customs: "I ate dinner [at noon] overlooking the gardens. The food is all new to me, chille, fruit and meats all unrecognized but good for this hot climate. The heat was so intense that I took my 'siesta' along with the rest of Mexico. I smoke cigaretts—not to appear strange and really one gets very good cigaretts here."

After just one day, Remington had made up his mind that "I shall not stay here long on account of the yellow fever. The night was fairly cool but no sooner had old Sol showed his firery face than all living nature wept at his presence. I am in a lather all the time." He had a few plates left for the camera so he "photographed the calaboose guard—the worst array of villians I ever saw. Even worse than inside [the prison] and the Lord remember Dante never witnessed a worse—bare bodies hung about a grating in a most wierd and awful fashion, filth and misery depicted on every countenance, in

fact a Mexican naturally possesses a dried, bearded and villinous face only needing the retrospect of the prison to make him a fiend."

Another measure of cruel Mexico was how dogs were mistreated:

And dogs—Constantinople be gone—she is no where—there are dogs and dogs and dogs—big little mangy curs half coyote and the other half resembling nothing on earth in particular. No one owns them, no one feeds them. They are continually getting in ones way and snapping at you. The boys stone them for amusement and the Mexican does not hesitate to kick them most brutally when they come near him. A little bitch who in the days of Cortez had a black & tan ancestor has because I patted her once followed me about in a dog like way. I have given her one good meal and God knows where the next will come from—I am almost sorry to leave her but she has her Fate and nothing can intervene.

Remington felt that the bitch was the only thing in Mexico that liked "gringoes." It was "hot hotter hottest" there, "awful, positively firey, the last place in the world to die and no one who was not a fool native could be induced to stay here. I never before appreciated what the love of my native land was until I came here. I have sweat enough to float a canal boat."

He had decided to leave:

I used to think it would be a nice place to live this Mexico—it might for a certain kind of chap but I aint one of that kind of chaps any more. They can take their sun shine, luxuriant plants, horse, cigarette, monte, mescal drinking regions to the devil seniorettas & all for my northern home with its healthy vigorous climate and solid moral ideas. While a Spaniard or an Indian, thin blooded stock can get along here because of a native affinity I imagine a full blooded Saxon would be a beast in short order were he to run this way.

So after only two days in Mexico, Remington took the train north. The Arizona part of the trip had been an unqualified accomplishment, entirely because Remington had been decisive enough to abandon the elusive Geronimo for the vivid Southwestern scenes that were a bird in the hand. He had made two influential friends, Clarke, who became a role model for rash derring-do, and Miles, whose calmer counsel he followed for a dozen years. Miles even compensated for Remington's failure to be in Sonora while Lawton chased Geronimo. He later gave Remington the job of illustrating the Geronimo chase for Miles' popular book *Personal Recollections.*

Remington was back in Brooklyn June 29. Eva Remington had returned from Gloversville where she stayed while he was away, savoring her new role as the wife of a *Harper's* correspondent. Only

months before, she had lived in Gloversville on the largess of her father.

Remington's new series of Southwestern illustrations in *Harper's Weekly* began appearing on July 17, 1886, with the modest "Signalling the Main Command." In the August 7 issue, five sketches taken from photographs of Hermosillo were published as "Mexican Troops in Sonora." Then, August 21, "Soldiering in the Southwest" included the blockbuster as the frontispiece, "The Rescue of Corporal Scott," the high drama that Remington had promoted by sending the unsigned letter from Arizona demanding Lieutenant Clarke's reward.

While the army might have honored Clarke in a modest way over the course of years, Remington made the young lieutenant into a cause, an instant hero, an engaging topic for discussion of the awarding of the Medal of Honor. The result for Remington was a memorable bit of pictorial reporting, the circle of bullets raising spurts in the sand before and behind the figures caught in action. Even the august General Miles was influenced by Remington's illustrations to make special mention of Clarke. The course of Clarke's life was changed, too, as the notoriety made him cocky as well as dashing.

By using his journalistic flair, Remington was able to enhance other illustrations with publicity like the Clarke hoopla. He was competent enough as a writer to create copy that colorfully described his drawings so that staff writers could prepare an accurate text. And, more important, his drawings contained that extra fillip of tension that made the figures active. He took the French military school mannerisms and then exaggerated the bodies to force them to speak by indicating their future motion as well as the present. He was also learning to select provocative titles for his drawings. While it was his rule not to repeat his own illustrations, he did not hesitate to use titles more than once. The 1886 "In from the Night Herd" became "In with the Horse Herd" in 1888, and again "In from the Night Herd" twenty years later.

The bane of an illustrator's accomplishment in 1886 was the step between him and the published picture. The wood engravers were not all able to take extreme action like Remington's and transcribe the figures onto a wood block without unconsciously modifying the action into a more conventional form. A few illustrators like Winslow Homer overcame this by carving their own wood blocks, but Remington did not know how. He understood, though, that as the new boy he would not have the exceptional engravers assigned to him so he astutely made the engraving operation easier by reverting to pen and ink instead of the preferred wash drawings he had learned at the League. The engravers then had line drawings to convert into identi-

cal lines on the wood rather than values and masses to interpret. Remington gained in the result but he hated the effort: "The pen was never natural with me. I worked with it in the early days only to get away from the infernal wood engravers . . . those clumsy blacksmiths, turned woodchoppers, who invariably made my drawings say things I did not intend them to say—those were the fellows who made my youthful spleen rise up and boil. My stuff was utterly strange to most people when I began picturing Western types."

The other problem with Western pictures was that there was just not enough Western work available at *Harper's*. While the earnings were substantial enough for the immediate needs of the young couple, the assignments consumed an insufficient amount of his time. His hand was becoming so sure that some drawings took hours not days. He wanted to illustrate Western subjects in quantity. It was all he wanted to do. He was beyond returning to classes at the Art Students League, although other established illustrators did so regularly. He was not slick enough to be offered a position as staff artist for *Harper's*. As a Southwestern expert, he was assigned the book *Mexico of Today* to illustrate, but there were only two pictures involved. His reaction was to press *Harper's* for more commissions than were available for his area of specialization.

To keep Remington Happy, *Harper's* made an effort to expand his turf. When an earthquake devastated Charleston, South Carolina, on August 31, the *Weekly* sent Remington there as its special correspondent. Earthquakes called for a paramilitary response, suited to Remington.

The lovely old city of fifty thousand had been built on a soft coastal plain that provided no support for structures. The rumblings continued for thirty-six hours with the central district hit the hardest. All dwellings were abandoned. The September 11 issue of the *Weekly* carried Charleston illustrations by *Harper's* regulars, but not by Remington. The next week's issue contained the follow-up material. The illustrations were by staff artists, labeled as redrawn from sketches by Remington and A. J. Gustin who was not a professional artist. Two of the illustrations were clearly taken from Remington but they were not specially credited to him in the by-line. Having sketches redrawn at this point in his career was a failure for him. Being treated as an amateur again rankled. He never did acknowledge making the sketches or even to being in Charleston at the time. He had considered himself exclusively a *Harper's* man, hoping to get work enough from the *Weekly* to keep him fully occupied until he could be accepted in the Harper magazines and books, but now his pride was involved.

He began calling on other New York City publishers and on the

city agents for the out of town publishers. He obtained work in his specialty right away. The appearance of his pictures in *Harper's* had authenticated his talent. *St. Nicholas,* the children's magazine of the Century Company, gave him two Mexican illustrations to do. He sold a series of sketches of the horse show to the *Illustrated Graphic News* in Cincinnati for forty-five dollars.

In October, Remington called on Poultney Bigelow, his Yale classmate who had become the editor of *Outing the magazine.* Bigelow remembered the interview as melodrama in which he discovered this "unspoiled native genius" when "nearly every great magazine in New York had turned him away." Actually, Bigelow read *Harper's Weekly* like everyone else and was aware of Remington's success. Remington knew from his friends at the League that Bigelow was the editor of *Outing.* He wrote Bigelow for an appointment, as he had Harper, reminding Bigelow of the Yale association and mentioning his subsequent Western experience.

Bigelow was in the midst of publishing a series of articles called "After Geronimo" that had been written by his brother, a Miles lieutenant. *Outing* was a marginal publication. The illustrations Bigelow had been able to afford were poor quality, drawn either by amateurs or by artists like Childe Hassam who had never been West. Remington was a blessing to Bigelow, an illustrator who worked for *Harper's,* who had been close to the Geronimo chasers in Arizona, and whose price was as cheap as the amateurs.

In 1907, Remington was asked what *Harper's Weekly* had paid him for drawings in 1886. He replied, "That I really have forgotten. But I did a lot of pen and ink sketches for *Outing* when Poultney Bigelow was running it, and I got ten dollars apiece for those." In October, Remington had taken over the illustrating of "After Geronimo" for its tenth part, December 1886. This gave him plenty of work to do to finish the year, and he did not complain about the low rate of pay.

7.

Muybridge and Beyond

In his first year as a commercial artist, twenty-five of Remington's illustrations appeared in newspapers, periodicals, and books. He earned about $1,200, an astoundingly high income when compared to the average annual pay in 1886 of $500 for a school teacher, $600 for a factory worker, $750 for a minister, and $1,000 for the bureaucrat Remington might have been if he had stayed on the family track. Of the $1,200, about $900 came from *Harper's Weekly*, the primary publisher of his drawings. Earnings from fine art paintings were negligible.

Remington's expenses were well within his means. He was still sharing the Brooklyn apartment at about $8.00 a month. He paid $5.00 a month to his mother as interest on the $2,000 loan, but he was not expected to repay Uncle Bill. For vacations, the Remingtons stayed with the Sackriders in Canton. The only cost was the train fare. Whatever his income was, though, Remington was not a saver. He spent freely on clothes, food, drink, and entertainment. Both Eva and he were stylish dressers, he leaning toward the ostentatious mode he had seen at Yale.

In the euphoria of his first real earnings, his failures as student, stockman, and saloonkeeper were erased from his mind, as was the technical inadequacy that had required half of his early illustrations to be redrawn. In his good-humored confident view, he felt that he could easily handle anything that might turn up. He had found his life's work and he had mastered its entrance requirements. Success would always be his.

And he was right. By the end of 1886, he was an established illustrator, known in the publishing world as a black and white man to do Western and Mexican subjects. *Harper's* even equated him with the ethnologists, making him more than an artist. Despite the plaudits, however, there was the start of controversy about the relationship between his drawings and photography.

A few illustrators began to criticize Remington for relying on photographic references instead of field sketches for his illustrations. They claimed that because he worked from photographs, he drew without insight, as if he were a stranger looking at a foreign scene. The telltale mark of the camera on his drawings, they said, was the foreshortening. Photographs of figures differ from how the eye sees depth. To the camera lens, a closer object is disproportionately larger. Remington's figures occasionally had photographic perspective, just as some of his backgrounds receded the way they would in a photograph.

Remington could not deny that he sometimes worked from photographs. His journal of the trip to Arizona and Sonora had fifteen pages that mentioned the camera. One was that note in Nogales that read, "I got lots of ideas but no sketches as my camera was not loaded." The advantage was that copying details from photographs let him work fast. His answer to his detractors was that the photograph was just the start of his art: "I can beat" any camera, "get more action and better action," because cameras "have no brains." He was not aware that the perspective showed.

There was also another entirely separate part to the controversy about photography, one that helped to explain why Remington's drawings had looked odd to publishers before *Harper's* printed them. The traditional pictorial treatment of the equine gallop had been the hobbyhorse. A painting of the cavalry attacking en masse showed a regiment of realistic men mounted on waves of hobbyhorses. That was the way the salon painters who taught American students in Paris saw the horse in motion, with both forefeet extended forward at the instant that both hind feet extended to the rear.

Remington, though, was painting a radically different galloping horse that profoundly disturbed the academics. His sympathizers declared that he was the first to give character to the horse in art, and

his studies made him the first to draw the folded position of the fore-legs, with all hooves off the ground at the "tuck" stage. Remington asserted that he had found this "different" horse in his own instantaneous photography. He was a serious amateur photographer, as he said, snapping many photographs of horses, and he was a keen student of horses. He also claimed to have studied photographs of the north frieze on the Cella wall of the Parthenon in Athens which does show a correctly galloping horse.

Remington insisted that his interpretation of the horse in motion was proved by the sequence photographs that were taken by Eadweard Muybridge, showing the identical tuck position he employed. According to Remington, Muybridge and he had arrived on the art scene at the same time. He had formulated his own views before he had seen Muybridge's photographs, he declared, and it was true that the list of American artists who bought Muybridge's privately printed edition did not include Remington, nor was the Muybridge book in Remington's library.

Despite his claims, though, the Muybridge controversy is one where Remington put pride before truth.

The ancients did by eye alone discern the correct nature of the slower phase of a horse's gallop. About 1800, however, European artists switched to what Muybridge later called "the zenith of absurdity," the horse's limbs extended fore and aft, the animal gliding through the air like the leap of a cat. The hobbyhorse became the expected and accepted interpretation, universal in art.

The beginnings of instantaneous photography about 1860 made it scientifically possible to verify the nature of movement. It was not until 1877, though, that Muybridge took an instantaneous photograph of a trotting horse in California. The next year, while Remington was at Yale, Muybridge took the first sequence photographs of a trotting horse, spacing cameras along the track. The photographs were copyrighted and sold and Muybridge began a world tour. By 1882, the work on animals in motion was published both in a book and in the popular *The Century Magazine*.

Remington had to know about Muybridge's work. Horses were his specialization. Besides, it was a painter's business to follow related arts like photography, and Muybridge would have been discussed and shown at the League if not at Yale where one art course was the anatomy of motion. In France, even the traditionalist Meissonier was convinced. The sight of the Muybridge photographs kept him up all of one night, he was so upset at the thought of the thousands of hobbyhorses he had painted. The French founders of the Impressionist movement learned from Muybridge. Degas used Muybridge's photo-

graphs in his sculpture. Manet adapted from Muybridge. In the
United States the illustrious Thomas Eakins used Muybridge's photo-
graphs for his figures. Thomas Moran bought Muybridge's book, and
so did Eastman Johnson and Sanford Gifford, among many other
painters.

Through Muybridge, the movement of horses in action was re-
solved. In a gallop, when the horse's hind legs are straight up and
down, the forelegs are raised to extend horizontally. When the hind
legs are extended horizontally to the rear, the forelegs are down.
When the hind legs are brought forward to drop, the forelegs are
tucked into the position to extend, and the four hoofs are off the
ground. As early as August 21, 1886, Remington drew two horses in
this correct gallop.

Remington denied having used Muybridge photographs, but he cer-
tainly knew the concepts existed. They were in the air of the art
world. "It seems almost inevitable that Remington was familiar with,
and influenced by, these striking photographs of the horse," a photog-
raphy expert wrote at a later date. "Some of Remington's side views
show leg and even tail positions identical to Muybridge." The wonder
was not that Remington followed Muybridge, but that he was among
the first. The hobbyhorse rule was so powerful, no other American
artist had yet done so.

Remington claimed that the value of Muybridge's work was to
prove the mechanics of the equine gallop, not to serve as a model for
artists. "I've taken lots of photographs of horses myself, and they
never give you the feeling of motion. The camera paints what it sees
and not what our eyes see. We want what we see," he said. His tech-
nique in conceiving horse action coincided with Muybridge only for
an instant. Then, he went beyond.

As he wrote, "the artist must know more" than the camera. What
Remington did was to take the action a step farther than the photo-
graph. He drew the galloping horse in an extension beyond what any
normal horse could achieve, in order to accentuate the motion. He re-
alized that just as the moving wheels of a train cannot be painted to
conform to the instantaneous photograph, because the wheels would
look stopped, so the horse's legs must show motion, too.

One thing Remington did was to place the forelegs in the extreme
tuck position as if drawn at the start of a leap rather than a gallop.
The drawing was physically unnatural, but it satisfied the eye. As he
said, the horse was then "incorrectly drawn from the photographic
standpoint," and so was no longer a Muybridge horse.

Another device was to credit the reader with eyes moving from left
to right. When the horse was moving in the opposite direction, from

right to left, Remington placed the rear legs in a later stage of the motion than the forelegs in order to make the eye see the movement. A third technique was employed in a drawing of a two-horse race in *Outing*. The horse in the lead was a Remington galloper, the one in the van a hobbyhorse. There is no question in the viewer's eye but that the Remington galloper is faster.

Remington attacked his work energetically. He drew rapidly, with assurance, and he was up at six in the morning. He now had a small backlog of commissioned illustrations, mostly for *Outing*, that kept him at his drawing table until the middle of the afternoon. Then he relaxed, sitting around with a drink or going for a walk. After the evening meal he began drawing again. That was his routine, seven days a week. After a few months, an interruption was an emotional necessity. Just before the Christmas holidays at the end of 1886 his right arm pained him. The doctor called it rheumatism. That gave the Remingtons a reason to leave for Canton, a way for him to break the routine, to let off steam.

They returned to Brooklyn in January 1887, full of confidence in Remington's ability to support them with his illustrating. The first additional expenditure they talked about was to improve the way they were living. Remington had given up his New York studio on 14th Street because it was too far to travel after he quit the League. He had taken over most of the small shared living room as a studio and, as his assignments multiplied and as he acquired Indian artifacts, the quarters had gradually been outgrown. The smell of his paints had spread through the entire place. Recognizing the need to have their own home, they moved to an apartment at 60 Broadway, north of the Navy Yard in Brooklyn, out of the parish of the Universalist congregation that had been both supportive and watchful. They could afford the move. Rents in Brooklyn were so low that the whole third floor of a fine brownstone was fourteen dollars a month. The new apartment was an improvement for Remington, with one of the rooms turned into a separate studio. The apartment was good for Eva, too. They were together most of the day, and continued to be affectionate with each other.

In his illustrations, Remington had progressed from ink drawings to wash drawings done with a brush. As better engravers were assigned to him, he strove for more complex effects. Wash drawings were in black and white because they were illustrations to be printed in black and white. A watercolor was just a pigmented wash drawing but it qualified as fine art and he felt assured of his skill at watercolors, a medium he had been using for some of the field sketches.

He began entering watercolors in professional painting exhibitions

where he could compete for sales, reviews, and prizes with the preeminent artists of the day. Many of the established painters had started out as he had, working as commercial illustrators for many years in order to have a regular income while they developed a market for painting in color. Remington believed he was ready to make the jump into fine art, even though he realized he had comparatively little training or experience. At the 20th Annual Exhibition of the American Water-Color Society in February 1887, his watercolor was hung on the same wall as a painting by J. Alden Weir, his former teacher at the League. That was glory enough, but his watercolor sold at the exhibition, and the eighty-five dollars seemed like a large sum for a little picture like that.

Encouraged, he entered another watercolor in the 62nd Annual Exhibition of the National Academy of Design and priced it at $250. This exhibition was a yearly competition where the best men hung their major efforts. It was a juried show featuring Winslow Homer and Eastman Johnson, with eleven hundred entries of lesser quality rejected. The Remington watercolor was accepted but it won no prize, did not sell at the show, and was not mentioned in any review of the exhibition. Clearly, though, he had made the giant step of having a jury of the art establishment accept his picture for exhibition with theirs.

In April, after he had returned from a short vacation with his wife in Gloversville, the wanderlust struck again. He solicited and got a commission from *Harper's Weekly* for a sketching trip to the Canadian West. As he had in 1881, he traveled West on the Northern Pacific through Bismark, North Dakota, past Medora in the Bad Lands, to Custer north of the Crow Indian Reservation in Wyoming. Remington went by stage to Crow Agency to familiarize himself with the life style of the horse Indians.

From there, he went by rail to Calgary in Alberta, Canada. His destination was the Blackfoot Indian reservation, south of the Bow River. When he approached the Blackfeet with his sketching pad, however, he discovered that he would not be allowed to "take the Indians' image" with his pencil. One Indian model showed a "desire to tomahawk" him. Remington called the hostile act ungracious because he was "endeavoring to immortalize" the Indian. "Immortalize" had thus taken a more sophisticated meaning in the ten months since Forsyth. He now thought that anyone he drew would become famous.

"After a long and tedious course of diplomacy," he said that it was possible "to get one of these people to gaze in a defiant and fearful way down the mouth of a camera." Diplomacy meant gifts, but the

result was worthwhile. The *Weekly* reported that its "special" had got to the roots of "Blackfoot existence" and had made "a characteristic drawing of Blackfoot arms, implements, and bead-work."

The end of May, Remington proceeded home on the Canadian Pacific via Moose Jaw, Regina, and Winnipeg, happy to find that his name was becoming more known to the public. His signed *Harper's Weekly* illustrations had been appearing once a month as features, accompanied by flattering textual references. Each drawing was reproduced as a whole page, generally inspired by events from Remington's Geronimo trip rather than to highlight someone else's article. The *Weekly* had such wide circulation that his name was recognized by passengers on the train.

Like the Geronimo trip to the Southwest, the tour of the Northwest produced elaborate full-page drawings that were published once a month in *Harper's Weekly* for half a year and then continued intermittently into 1888. The subjects were the Blackfeet, the Crows, and the Canadian Mounties.

The Brooklyn press under the Gunnisons' influence now regarded Remington as a newsworthy resident. They reported in June that Remington was in Canton on vacation after returning from the "British North West territory." The "puffing" was welcome. It made people remember him.

In Canton, the Remingtons stayed at Uncle Rob's house the summer of 1887. Early every morning, Remington donned his artist's smock daubed with paint, took his brush and palette in hand, and headed for the barn he used as a studio. He put a halter on the Sackriders' old nag so he could tether it behind the barn to make anatomical studies. He worked in oil paints on artboard, making study after study as he struggled to satisfy himself in colors rather than the black and whites he used for illustrations. Now that his watercolors had been accepted in fine arts exhibitions, he was determined to succeed with oil paintings, too.

He was an object of curiosity to the small boys who saw him as an enormously big man, muscular, blond, and red-faced. George Partridge who lived near the Sackriders on Miner Street was ten. George would sit at the edge of the property, one eye on Remington painting and the other on the Sackriders' plum tree. Remington ate all he wanted of the plums and tossed a few to George. One morning, Remington made George a proposition. "How would you like having all the plums you can eat," he asked. "You can have a hat full of plums every day, if you hold the horse for an hour or so each morning to give me a different pose." From then on while the plums were ripe,

George held a model's pose with the old nag in the sun while Remington stood in the shade of the barn where it was comfortable, continuing with the studies in colored oils.

Charlie Hayden worked for Remington, too. He was twelve. When Remington wanted someone to run errands, he called Charlie. He paid Charlie pretty well the first few times but after that the pay dropped off to what was usual in Canton. He did give Charlie a sketch called "The Captive" that Charlie still had after thirty-five years.

In his determination to master colors, Remington worked at the sketches until the middle of each sunny afternoon. Then he would change to immaculate white ducks, jacket, and pants, to stroll around Canton, obviously glad to be in his hometown and acting as if he had never left. He still looked longingly at the canoes in Rushton's Boat Shop. He gravitated toward the dry goods box in front of Joe Ellsworth's shoe store, spending as much time with his childhood friend Stanley Ellsworth as he did with the Sackriders. His wife was the connection with the family, talking at length to Remington's mother and going for carriage rides with Uncle Horace Sackrider. Some days the Remingtons would visit at the home of William A. Poste, the lawyer and friend, where they played tennis. On warm summer evenings, the Remingtons would sit out on the back lawn at the Sackriders', entertaining their neighbors.

Except for sophisticates like Poste, who lived in New York City and summered in Canton, the locals were not entirely at ease with Remington. They had known him first as a Peck's bad boy while the Colonel was alive, then as a young man who had dissipated both his inheritance and a loan from his mother, squandering in two and a half years most of what his father had accumulated in a productive lifetime. The townspeople expected Remington to be repentant.

Instead, he was the same Fred Remington, the confident country boy he had been, coining money down in the city but still compulsive about coming back to Canton to touch his roots. He had no grievance against Canton because the people questioned him in his new role. He even expected to return to Canton to live.

The townspeople were slow to accept him at face value. He wrote letters in the post office every afternoon before dinner, seated at the desk while Postmaster Johnnie Mills listened skeptically to Remington's tales of hard riding in the West. Remington claimed to be able to ride like a Comanche but Mills was an old cavalry lieutenant and all he had seen was the studies of the Sackriders' nag in vivid colors.

One afternoon, a carload of Western ponies was shipped into Canton for sale. They were put into a corral near the depot while Milt Packard, Joe Ellsworth, Dick Bridge, and Mills looked on. When Ells-

worth asked his cronies whether they thought Remington could ride
one of this lot, Mills sent Charlie Hayden to tell Remington about the
ponies.

Remington had finished painting for the day and was dressed in his
usual white ducks. When he reached the corral, Mills asked him about
the relative merits of the ponies and how a cowboy held his seat. Then
he challenged Remington to demonstrate. Remington took the dare
without hesitation. Though all the animals were in rough shape after
their trip, he picked out the pony that looked to be in the best condi-
tion. The owner of the ponies sensed a sale. He put on a bridle and a
saddle borrowed from Mills, as Remington watched. Then he led the
horse to the front of the old American House where it stood like a
kindly and docile pet while Remington in his white ducks leaped
lightly into the saddle.

Remington raced the pony up and down the street as the gang
watched approvingly. Even Mills said, "Damned if Fred isn't a _____
_____ _____ good rider." Then, when Remington again rode the
pony past the hotel waving one hand, the animal suddenly sensed its
own kind in Patsy Valnia's livery stable up the lane that ran alongside
the building. While everybody was applauding, the pony swerved
without warning and the surprised Remington slid off the near side,
falling flat into the deep pool of stable water that always collected
along the sidewalk after a rain.

Remington had drawn as big a crowd as if there had been a fire or a
dogfight. Edgar A. Barber of the *Commercial Advertiser* with tall silk
hat and Prince Albert coat and Gilbert A. Manley of the *Plaindealer*
were among a score of onlookers. The next issues of both papers
carried the story of Remington the Western rider who fell off a pony
in front of the American House.

The people of Canton soon noticed that Remington remembered
even the minor associations from his childhood. He did not forget to
drop by the Malterners' at the farm where he had gone with his
mother when he was a little boy. He rolled and tumbled with six-year-
old Pierre who had been named for the Colonel, just as he had with
Pierre's father when they were both six. He brought his paints along
and did oil studies of the animals around the farm. Mrs. Malterner had
so many studies and drawings he had given her that they filled a whole
box that later was burned in a fire. She described Remington as "just
full of life and very friendly, not allowing his talent to obscure his
life."

Gradually, the townspeople came to agree with her, accepting him
as being as straightforward and unpretentious as he seemed in Canton.
They were half proud of him because of his achievement in pictures,

half-mocking because of the personal failures they remembered. They took him almost as one of themselves, a little bigger than life perhaps, but country smart and outgoing, good natured, outdoorsy like they were, the antithesis of the effete personage they expected an artist to be. Even so, when he fell off the pony, they enjoyed it and talked about it for years.

Eva Remington tolerated Canton, but what she wanted was to live closer to the social and cultural centers in New York City.

Soon after the Remingtons left Canton in the fall, they moved from Brooklyn to the posh Marlborough House at 360 West 58th Street near Columbus Circle in Manhattan. The rent was fifty dollars a month, half of what Remington's total monthly earnings had been for the first year and an excessive portion of what he was currently making. While the Remingtons had become free spenders on big items like the rent, Eva still haggled on the groceries.

Remington was that rare artist whose power of concentration let him work at home. He liked company while he was drawing, although he paid no attention at all to a visitor the moment he reached a critical point in the picture. In the new apartment he again took over the parlor as his studio, spreading his collection of Indian objects all around the room. Eva Remington didn't mind. She enjoyed seeing the Indian things. "Fred's studio would make you dizzy with its many beauties," she wrote to Uncle Horace. They still entertained in the parlor where the guests could look at the art work either in process or completed alongside the exotic artifacts.

Remington was unsure of himself in the elite new surroundings, calling the building "Marlborough Tenement" and "Marlborough Manor" in "Gothum" to make fun of the social connotations. He did, however, appreciate the location of the apartment building, in the expanding northern section of the city. That put him close to Central Park where riding was in vogue with the well-to-do who kept twelve hundred horses at four riding schools and the Riding Club at the park. He could now take his afternoon relaxation on horseback.

His usual ride was an hour, once around the park or twice around the reservoir, about six miles. For a longer ride, dirt streets led to the Fort Lee Ferry, which crossed the Hudson River to New Jersey, giving him access to the trails on the top of the Palisades. Fall was the fashionable season. In winter, riding was in classes indoors. Remington told a friend that "I went over to the Central Park Riding Ring and joined in a musical ride. I have ridden a great deal in my life—ridden for a living &c and my ideas of how to do it are very pronounced—These New Yorkers have their scheme and I was forced to do likewise as they hang the stirrups just forward of the horses ears. Aint

it hell." To participate without making a stir, he had to use the artificial English riding style called posting. He said he didn't like it, but it was a backhanded brag.

Like Remington, William Poste was in the city for the winter. He was eight years older than Remington and had been First Deputy Attorney General of the state. Remington entertained Poste now that they both lived in Manhattan. "Immediately on receipt of this," he wrote Poste, "start for Remingtons—that is, after dinner—see—come up and spend the evening—would invite you to dinner only don't know your business address and this will be too late."

In return, Poste asked Remington to a formal stag affair, eliciting a response that implied Remington knew he was putting on weight: "That dress coat proposition is one of the most low down tricks which a white man could resort to. Of course it is plain enough that you want to economize well knowing that I have outgrown my dress suit which is now so tight that I cannot take breath, let alone eat in it. But I patiently take my medicine. Order one French chop and an after dinner coffee—that will be all right if I let out the top button." The other guests at the dinner were to be business notables of the city, men Poste thought Remington should know.

When he arrived at the hotel where Poste was giving the full dress affair, Remington wanted to tease Poste about being formal. Victorian society in New York City was in awe of English nobility so he told the attendants to announce him as the Duke of Marlborough. He was taken at his word. The news spread swiftly among the hotel staff that the Duke was there in person, and he received royal attention.

For a man who could make believe he was a duke and carry it off, who sometimes claimed to be descended from an English lord, and who had acted like an Englishman before a Kansas justice of the peace, the contradiction was that when he wrote to Westerners like Lieutenant Powhatan Clarke, he said that "the disease of Anglo fobia is very marked in my case." Clarke had initiated the correspondence, asking Remington's advice on his military career. Remington's reply reflected a new and welcome problem. The demand for his work was commencing to run ahead of his ability to think of salable subjects:

Say old top when you write me write sort of discriptive like—all that you see and do down there. while it is stale matter to you it is of great interest to the undersigned—tell me what you do and what U S soldiers do these days—write any observations you may make or hear relative to Indians or Mexicans—who knows but you might inspire me to make an illustration for which I would get $75.—but alack—I do not reason well, you would not get anything out of that—I hear you say but then to proceed with the argument I have a clincher—you are a soldier and a soldier has

nothing in the world to do in time of peace except to make himself and others happy.

He added, "at present I am hard at work_____ 'getting there' so to speak. Thats a pretty good break for an ex cow-puncher to come to New York with $30 and catch on in 'art.' Jesus it makes some of these old barnacles tired. Well write you dont have anything else to do." Remington would not admit to a Westerner he admired that he had been a sheep herder, not a "cow-puncher."

What Remington meant by "getting there" was that late in the fall of 1887, he had been contacted by The Century Company to do the illustrations for the book *Ranch Life and the Hunting Trail*. The suggestion had come from the author Theodore Roosevelt, who had seen Remington's drawings in *Outing* and talked about Remington with Poultney Bigelow, an old acquaintance. Before publication, the book was to be serialized in *The Century Magazine*.

Roosevelt was part of a wealthy New York City mercantile family with solid social status. He went to the Bad Lands of North Dakota in 1883 and bought a cattle ranch, investing $52,500 which he lost in the harsh winter of 1886–87. Roosevelt had just returned from a summer in the Bad Lands where he had sold the remnants of his stock. Remington had passed through the area, the scene of the book, on his Canadian trip as well as in 1881.

There were many parallels between Roosevelt and Remington, and as many differences. Both Roosevelt and Remington were advocates of the strenuous life. Both were self-confident Easterners, one a city boy, the other small town. Roosevelt, born 1858, went to Harvard, as did others in his social class. Remington went to Yale, which was less than Harvard but more than his family rated socially. Roosevelt's father died in 1878, Remington's in 1880. Both had bought ranches in 1883, Easterners with short Western residencies. Both considered themselves uniquely American products. They came together through Bigelow, who liked Remington and detested Roosevelt after being charged full price for six *Outing* articles that Bigelow had counted on getting as a favor.

The *Century* commission called for sixty-four illustrations for the magazine and an additional nineteen for the book. To get the first drawings in by November, Remington had to begin immediately. This one Roosevelt job for publication in 1888 was equivalent to his total output for 1887 when 80 percent of his work consisted of ten-dollar drawings for *Outing*.

The contacts with Remington during the course of the production of the book were not memorable to Roosevelt. Unknown to Roose-

velt, however, he evoked bitter feelings in Remington, who told Poste, "As to Roosevelt _____ my opinion is that he is a g_____ d_____ and that is all I have got to say about it in public." Remington was so vehement that he began the dashes near the bottom of one sheet of notepaper and continued them for several lines on the next sheet before concluding the sentence. Part of the reason for Remington's enmity was that Roosevelt was a radical young Republican, the enemy of the Old Guard Republican politicians like Senator Platt and Uncle Bill Remington.

To Roosevelt, Remington was only a young illustrator to whom he was giving a break. He treated Remington condescendingly. It is possible, too, that when Roosevelt interrogated Remington, he discovered that Remington had herded sheep. Roosevelt had already given his firm opinion that "no man can associate with sheep and maintain his self-respect."

A year later, though, Remington was getting over his peeve and bragging to friends that in his career to date, "the thing which I like best is a holiday book by Roosevelt." Remington's finished illustrations for the Roosevelt book were of a higher order than anything he had done before. A number of the pieces were oil paintings in black and white, beyond the usual drawings. Remington may have been led into the improved quality, despite the tight schedule, because he was challenged by Roosevelt's charisma.

His earnings from drawings and paintings reached twenty-four hundred dollars for 1887, just double his 1886 receipts, and his star as an illustrator had risen. His earnings put him in the upper 10 percent of his peers. The series of Roosevelt articles was published in *Century* in six installments beginning February 1888. The hardcover book was released later that year to favorable reviews, "cleverly told," "a thorough familiarity with his subject," and "very handsome," which included the illustrations. Roosevelt was the star, but it was a double breakthrough for Remington's drawings. He had now progressed from the *Weekly* newspaper to a slick national magazine as well as to a celebrated book. The illustrations had reached a level of competence that was equal to any but a handful of his fellows, just two short years after Mr. Harper had properly called him crude.

Popular acclaim was soon his, too. There were plenty of people who were willing to be quoted on how Remington's success came about. Some artists, considered to have an advantage because they were European trained but who struggled financially, were jealous. They said that he "was lucky enough to stumble upon a new field, one of great size, that had not been touched, and one that all America cared for. The West, the cowboy, soldier, and miner were virgin soil,

waiting for his touch." Others said that before Remington, "the Indian was of little more than incidental interest," and only he had "camped with the real red men who did not speak English."

It was of course not true that Remington had found an unexplored field. There were hundreds of professional artists who had painted the American West before Remington. Seth Eastman was in Wisconsin in 1829. George Catlin painted in Prairie du Chien in 1830. Alfred Jacob Miller was in Wyoming in 1837. John Mix Stanley was in Minnesota in 1830. Albert Bierstadt sketched in the Rockies in 1859. Thomas Moran was with the Hayden expedition in 1871. Remington was actually the last of the great Western artists to go West.

Rufus Zogbaum was Remington's immediate predecessor as a leading Western illustrator. He was a fine painter, if Victorian, but he never came close to Remington's popularity, although the military mentioned Zogbaum as often as Remington among artists who had dodged "the bullets from a redskin's rifle." Remington himself thought that "it wasn't because I knew how to draw that I met with my first success, for I didn't, but because I knew the West better than any other man." He believed that his territorial expertise gave him the advantage.

What led to Remington's swift triumph over the more artistically timid Zogbaum was the accentuated realism of his portrayals. He drew Western figures objectively, with the approving hand of a proud American. He was also a salesman, not above calling on editors in cowboy garb and telling fanciful stories in order to open the door to work.

His friends pointed out that "when Frederic Remington went West to draw the cowboy and the Indian it did not occur to him to fling the glamour of the studio over his frontier types. He drew them as he saw them, and he saw them with the sharp, accurate, coolly appraising American eye." His objectivity as an artist swallowed any personal bias that might have tainted the man. He distrusted Mexicans, but he drew them as they were and not as he described their personalities in his journal. He recorded the Indian and the black cavalryman without prejudice.

And, simplistic and derivative as Remington's technique was at the end of 1887, it was seen as "fitted" to his Western subjects—"strokes rough and sketchy and lacking in finish." His supporters declared that "his earliest [published] line drawings, though rough-hewn and sometimes violent, are among the most original works of art in black and white ever done in America. They have the same freshness and incomparable native flavor that characterizes Mark Twain's 'Roughing It' . . . Action was at the bottom of everything Remington recorded."

8.

Seven Little Indians

When Remington crossed the cobblestones to enter the National Academy of Design building in Manhattan on March 30, 1888, it was in vindication of the confidence he had always had in his talent as a figure painter. This was "varnishing day" for the 63rd Annual Exhibition of the National Academy, held at what the artists called the Doge's Palace because it made the northwest corner of Fourth Avenue and 23rd Street reminiscent of Venice.

Varnishing day was the day before the opening of the exhibition, traditionally set aside for the hopeful artists to provide a last sprucing up of their pictures. This juried exhibition was called a harbinger of the new liberalism in American art. Established Academicians who had hogged the limelight in previous shows had for the first time made some of the space on the "line" available to the strong young men. The line was the tier of paintings hung at eye level so as to be most visible, as opposed to paintings hung in higher tiers or placed against the wall on the floor.

The interspersing of youthful colors and forms made the whole show attractive enough to rival the usually more picturesque exhibi-

tion of the American Water-Color Society that Remington had entered with conspicuous recognition two months earlier. His watercolor "Arrest of a Blackfoot Murderer" had been honored by being reproduced in the catalog. A detail of the watercolor was shown again in the *Harper's Weekly* review that called it a "spirited bit," and then was reproduced in entirety as an illustration in the *Weekly* the day the National Academy exhibition opened. The text claimed that Remington had "made his acquaintance with horseflesh in a very practical way on a ranch in the far West," echoing what the New York daily newspapers had been writing about "his splendid record as an illustrator" and his "good work in black and white."

The full-color oil painting entered at the Academy was exhibit number 10, "Return of a Blackfoot War Party," and the critics were primed for it. Remington had given the painting the bravado price of one thousand dollars, four times what a new man usually demanded and the same figure he asked twenty years later when he sold through a leading gallery. Because he was still only twenty-six years old, the painting was eligible for the Hallgarten prize awarded annually to American painters under thirty-five.

In its review of the exhibition, the New York *Herald* acknowledged that Remington would "one day be listed among our great American painters," praising his painting as one of the "works which commend themselves for the various prizes." That took the sting out of the critical comment that the painting was "very strong, but has a suspicion of caricature in the red men's faces." The *Times* also called the painting a caricature, and added that "he might have made the braves and their steeds equally meagre without giving them the air of masqueraders."

The reviews were the start of another complaint against Remington, that the faces of his Indians were not just dusky whites, the Victorian stereotypes that fit the then accepted standards of beauty in art. Rather, Remington's Indian faces were what he knew to be the real redmen, the "caricatures." As a target of the critics, Remington was in good company. These hypercritical reviews also complained about the more established painters, asking Winslow Homer for a sky less "heavy," Louis Moeller for "proper flesh," William Merritt Chase for a mouth less "queer," and Alden Weir for more light. The big thing was, Remington had made it into the ranks of the leading fine artists, cited as deserving of a prize and criticized as seriously as Homer or Chase. Some of his fellow illustrators acknowledged that he had outstripped them as a painter. Before the Academy painting had been submitted, the *Harper's* illustrators De Thulstrup, Parsons, and Redwood had gone to the Marlborough House to give Remington their advice.

The "Return of a Blackfoot War Party" was thus Remington's most distinguished painting to that point. He certainly recognized the importance himself, and it is incongruous that the work should have had so torturous and mysterious a history over the succeeding decades. The same year as the Academy show, 1888, the painting was photographically reproduced in George W. Sheldon's book *Recent Ideals of American Art*. As one of 175 treasures in "the galleries of private collectors," Sheldon implied that the painting had been sold immediately after the exhibition. The illustration of the painting showed seven mounted Blackfeet and two trudging captives. The signature was lower right, with no date visible.

In 1911, the painting turned up again in a feature story in the Kansas City *Star*. "We have had it for ever so long," Mrs. T. H. Mastin declared. "My late husband bought it. However, I never liked Indians and haven't paid much attention to it." The family attorney remembered that Mr. Mastin had bought the painting for $250. Remington's original art dealer, W. W. Findlay, added that the attorney's "remembrance of the price was very warm, indeed. The picture was not bought directly from Remington. A man had purchased it from Remington several years before [about 1889] and needing money put it up for quick sale. The picture today is worth not a cent less than $5,000."

With this feature story, the *Star* printed a different photoengraving of "Return of a Blackfoot War Party." The painting was not exactly the same. There had been a multiplicity of alterations in the twenty-three years since the Academy exhibition and the Sheldon photoengraving. The original "seven little Indians" now were only four little Indians. Dress and positional details were different.

In 1973, "Return of a Blackfoot War Party" was still owned by the Mastin family when it was illustrated in the catalog of an exhibition at the Amon Carter Museum of Western Art. The number of mounted Indians had stabilized at four, the same as in the *Star*.

In 1975, "Return of a Blackfoot War Party" was offered for sale at auction by Sotheby Parke Bernet in Los Angeles. The painting was reproduced in full color in the catalog, showing the same four mounted Blackfeet, the signature lower left, and the date '87. The catalog specified in part that

An x-ray examination of the canvas reveals that in spite of apparent differences in composition, it is the same painting as that included in the National Academy exhibition of 1888, and illustrated in George W. Sheldon's *Recent Ideals of American Art:* . . . Between the exhibition of the painting in 1888 and its sale to Mr. T. H. Mastin of Kansas City in the early '90's, Remington painted out or altered the position of several figures in the background; in addition, he moved the signature from the lower

right of the canvas to its present position on the left, but retained the original date of '87.

As the auction house claimed, Remington's seven-little-Indian painting appeared to be still there, hidden below the surface and discovered by X ray. The seven Indians were just not all visible to the naked eye because they had been painted over with the four-Indian version on the same canvas. The later painting was ascribed to Remington, along with the moved signature and the "original" date. No proof was given that it was Remington's hand that had "painted out . . . figures," "moved the signature," or "retained" the date. There was no proof given that the painting was ever again in Remington's possession after he apparently sold it or that he would have had any reason to repaint such a successful work.

The 1887 date is another odd aspect of this painting. Eva Remington wrote a letter to Uncle Horace Sackrider marked February 1, 1888, in which she said that Fred "has just started a *big oil* picture for the April [National Academy] exhibition and it is splendid so far." In March she added a reference to "the painting Fred has just finished for the exhibition in April." That would seem to make it an 1888 painting, not 1887.

All that is clear about this puzzling picture is that the four-little-Indian painting which sold for $155,000 at the Los Angeles auction is not exactly the one Remington exhibited in 1888. Then, he was just assuming his role as one of the most promising of the "strong young painters," and the seven-Indian painting had boosted his image.

Eva Remington was proud of her husband as his fellow illustrators told her that he was on the road to greatness. She relaxed in the assurance that he would continue to win plaudits as an artist of Western subjects and that the income from his illustrations would support them beyond any level they had initially contemplated. The earnings even made it possible for her to grumble about the Marlborough House apartment. "We have no store room here," she complained, "and it is impossible for me to keep any amount of anything. My refrigerator is built right in the wall in the kitchen and is but a foot wide." Dissatisfied with the city, the Remingtons thought briefly about returning to Canton to live but discarded the idea as too far from the creative centers. They next considered the northern suburbs. Eva said that "we have not decided where we will move to as yet but about the middle of this month we are going out to New Rochelle to see what is to be had there in the way of houses." What they found was that the type of New Rochelle home they wanted was still too expensive for them so they began to look at closer less costly communities.

Small as they made their apartment sound, they did have house guests. One who stayed a month without arousing hostility was the mellowing senior Mrs. Remington. Eight years after the death of the Colonel, she was still attractive at fifty-one. She had a beau, Orris S. Levis, who had run a Canton hotel called the Hodskin House and was now a "boniface" in Ogdensburg. Marriage had been talked about but the Remingtons and the Sackriders were united in considering an inn-keeper to be beneath them socially. Eva reported that "she is not en-gaged to Mr. Levis and does not know as he wants her and I am not afraid of her marrying him."

After the month, though, Remington's mother became restless. She claimed to suffer more from the winter air in New York City than she had in the Canton snow belt. Eva nursed her, putting mustard plasters on her back. That helped, but twice it looked like the onset of pneu-monia. Clara Remington seemed miserable. She kept talking about re-turning to Canton, and finally she did, although she was not quite can-did about her motives.

After learning that his mother was seeing Levis again, an agitated Remington sent a letter to Uncle Horace:

I have written the old lady to start tomorrow for my home here—see that she does.
I am awfully shocked at this—I have given her to understand that this thing must cease forthwith and it will cease. I can make her see it and if I cant make her see it I can make him see it for I will politely inform him on the very next occasion that if he dont cease I will kill him and I will.
PS/Show this to Bill.

The conspiratorial postscript turned the threat of violence into his-trionics, like the Kansas City threats that had impressed the Houghs.

Remington and the Sackriders considered the "old lady's" marriage to the Colonel to have been the holy one. When the Colonel died, the widow's role was to live out her years with her family, helping like a glorified servant. She could not marry again in the absence of eco-nomic need. Remarriage would be for sex, a bestial urge to enter an active bed, a prohibited act for a middle-class widow in a Victorian age.

Besides, Remington's new economic and professional standing gave him social pretensions to match. His parents had started poor but the Colonel had achieved superior posts and earnings for a man with local roots. Remington had already outstripped his father financially and socially, achieving national recognition without yet satisfying his am-bitions. How could he admit that his mother would be working with her hands to help the successor husband, making beds and cooking

food for strangers of questionable repute? The prospect was a slander on the Colonel and a blow for the upward strivings of the son.

Clara Remington was independent enough to resent existence as an appendage, being a burden wherever she boarded, without control over her own finances. She struggled for a role where she could again have meaning as a person, while her family considered her of so little consequence that they could conceive of no reason for a man to marry her apart from her inherited money.

The outcome was what could have been expected from a confrontation between a stubborn mother and son. Within a week, Remington was again writing to Uncle Horace, who was on the scene in Canton representing the family:

> I received a letter from mother to day in reply to one wherein I stated the case plainly and temperately I thought and she says she is not engaged or has not thought of that yet but she says Mr. Levis is a gentleman and the remainder of the population are not, myself included. She says I am impudent—so, well be it I am I suppose—if she chooses to look at it that way—I am done writing to her—I have said my say—I have piped my peep and it dont seem to take her off her feet exactly so I will ante and pass. There aint no use advising any one who dont want advice—you cant argue with a man who advances the proposition "that you may go to hell" —Well let her go it—let her marry the old stuff but I confess that I should not take the interest in a Mrs. Levis that I do in Mrs. Remington. How in the deuce did it all come about—that is beyond me.
>
> Ask her what she will board her relatives for if they come to Odg.——
> Oh shit.

On April 25, Remington's mother received the list of her assets that she had requested from the agent who managed her business affairs. The property turned back to her totaled $8,740, just about what she had inherited from the Colonel's estate plus interest, less the loan to Remington for the Kansas City hardware venture. Eva Remington remained in contact with her mother-in-law until the remarriage. She bought the fabric for the wedding dress, though she could not believe "Mother is to marry that damed old goose" who "played his cards slick & will get her money if he can." Mrs. Remington did remarry about May 15. The Sackriders had little contact with her after she left Canton to help Levis run the Windsor Hotel on State Street in Ogdensburg. The Levises were later the proprietors of the Levis House in Carthage, New York. They were out of the Ogdensburg area before Remington began spending summers in the nearby Thousand Islands. Remington never saw his mother again. She had told him to "go to Hell" and they never made up.

Eva Remington's usual correspondent among the Sackriders was the

one she called her "dear old fat uncle" Horace. She titillated him with the latest New York slang, telling him she would write a long letter while "Fred is reading the paper" by saying "I am going to give you a dose." She declared "I'll be bumped" if Horace did not visit them, and she signed off, "Well ta-ta-ta."

She told him she did "not want to pay these awful prices here" for butter, "especially as we have furniture to buy for our house this spring." They had rented an entire house on Mott Avenue in the upper city near 140th Street for fifty dollars a month, the same rent as the apartment in Marlborough House. It was still country in northern Manhattan, with vistas running to the Harlem River. Eva proudly sketched the floor plans, telling Horace "I have given you an idea of the home but not as accurate as it might be as I am not in the business of making plans for houses." The first floor had a porch in front, with the studio over the porch on the second floor. The kitchen was in the basement.

Remington called himself "beautifully situated." He had his own studio in a private house for the first time and his next door neighbor was his good friend Kemble, who specialized in illustrations of blacks.

My friend "Kemble" was shortly ago an honored member of the Manhattan Athletic Club and has numerous 100 yd trophies and some startling tales appertaining therto. He is light and willowey still. Time was when the undersigned had somewhat of a local reputation in "Yale" but alas the reputation has vanished until there scarcely lurks a semblance under the heaving mass of the aforesaid 200 pounds. Some banter ensued between us on our walk yesterday and the proposition was advanced that the road was perfectly level ahead and that talking would never settle it, wherat we fell to running—at the end of about 75 yds Mr Kemble had learned not to trust always to appearances and yours truly felt inspired to "brag" in a manner that none but an utterly crushed audiance would have endured. There is now a cautious exchange of opinions as to who knows the most about the "manly art"—I suppose that will end in a "bout" in one of our back yards which will greatly edify the Irish help and create consternation among our wives. The great questions must all be settled before two people can proceed to perfectly understand each other.

The Remingtons now had live-in help. The choice was between Irish servants and black. Irish help was what their parents had had in upstate New York, so they had Irish help too. So did the neighbors.

Access to the heart of the city was via the New York Central railroad, with the two-year-old station two blocks south at 138th Street. Before 1886, the Mott Avenue area had been without express rail connections, so humorists said it was "a d_____ sight nearer Boston than New York." Now it was only nine minutes to Grand Central Depot,

close enough to make it easy to go in to see publishers or drink with "the boys" in the evening: "I was out late last night," he wrote. "Banquet at Canadian Club but I have gone back to whiskey—no more beer."

The new studio let Remington work without any outside distraction. His success in fine art at the earlier exhibitions had pointed him toward oil painting in color, but it was hard times for the young painters like Remington. Sales at the 1888 National Academy exhibition turned out to be the smallest in years. Only one painting was sold at the Society of American Artists' show that year. The Montross Gallery presentation of American pictures "was a farce" as far as sales were concerned. Particularly discouraging was the knowledge that the New York art dealers were doing well. They were selling academic foreign works while the young American painters could not earn a livelihood unless they taught, made etchings for the trade, or illustrated. Remington did not have the educational background or temperament to teach. He had never learned to make etchings. He had a few paintings for sale in New York City and at Findlay's in Kansas City, but when they did not sell, all that was left to him was to illustrate.

Luckily for him, Theodore Roosevelt had given him the opportunity to become popular as a Western illustrator, at a time when "most people didn't know whether cowboys milked dairy cattle or fought in the Revolution," as Remington put it. Although even friends remarked on the disproportionately "small hands and feet" that he drew, his illustrations were markedly different from other pictures. They were instantly recognized as new and modern. That made Remington a welcome visitor at *The Century Magazine* where the first Roosevelt/Remington article had appeared earlier that year.

Remington saw the *Century* editor Richard Watson Gilder both professionally and socially. When he described to Gilder the Indian tribes that he had visited in the Southwest, he was commissioned as a special correspondent to return to the territory for material to do articles on the "wild tribes" for the magazine. At first he demurred, flippantly requesting a writer for the text because "all he had ever written was his name on the back of a railroad pass." When Gilder insisted that he write his own story, as he had in "Coursing Rabbits on the Plains" for *Outing* the previous year, "he gained confidence from the interview" and began planning the trip.

He saw the key as Lieutenant Powhatan Clarke who owed him a favor. The Indian tribes were secondary in his mind to the "Black Buffaloes" that Clarke commanded, and he so wanted to be the first to do a story on them that he kept the nature of his mission a secret. As

he had told Clarke, with the usual exaggeration, "I should be willing to give ten years off from my life for a trip into Arizona this Spring." By April 11, he had made the deal with *Century* for his third Western commission in three years and could say to Clarke,

"The die is cast," "I'll plunge I'll cross," or in a more prosey diction I will go on and explain that I have beguiled a certain distinguished publisher into sending me on an artistic and litterary tour through the Indian Territory and into Arizona. I am going to do the "Black Buffaloes"—This information you will please keep private as I do not want to be anticipated. I shall then return by the way of Texas and the Territory. I shall get letters from the Secty of the Interior and can get them from the Secty of War. I rely on your good nature largely for the facilities for working up my material.

Now tell me candidly—can I have men to "pose" for me at your post and how can I get *bed and board* there. I have no desire to impose myself on your good nature on this a purely business venture of mine.

Clarke foresaw more publicity for the cavalry and for himself. He promised Remington whatever might be needed, so on May 18 Remington wrote again.

I have yet quires and reams of work to do—I am dead stale and hate to do it but the gods must be propitiated so I will "sweat" a little yet and by the 1st of June I hope to start on my pilgrimage._____

That reminds me that I am to day undergoing the tortures of the d_____, I am doing a penance which would be a theme for Poe. I had "too many blood of the grape" ensconced in my system last evening and well you have probably been there—I take it you have been before now initiated into the ancient and honorable order of drunkards. We elected Gilder of the "Century" President of the Fellowcraft last evening and the thing was hot.—many bottles were broken—we all made a frantic attempt to lead the procession—by two A M the dead were thickly strewn about and as the ancient Arabs said "God only knows how many men were perished in that war."

Of course I realize that we are all d_____ fools, but the creater should have altered his plans of construction when he made *Man* or he should have designed "the straight & narrow way" so that it would have covered more ground. Well I will save the time by working in order that it may be spent with you in the flesh instead of the spirit._____

As Remington's friend the illustrator Walt McDougal wrote, "Most persons imagine that artists and writers were constantly intoxicated. The truth is that they were sober more than half the time."

9.

A Scout with the Buffalo Soldiers

When Remington left Mott Avenue early on May 29, 1888, to head for Arizona to document the "Wild Tribes" for *Century*, his first step was toward the city, not the West. In his mind, status as a *Century* correspondent called for plush accomodations. That meant taking the extra-fare New York Central Limited with its parlor cars that departed from Grand Central Depot, not the routine westbound local-express that stopped at Mott Haven.

Both trains went in the same direction, but Remington left the local-express to his wife who was off for Gloversville the same day. She was escorted to the train by Kemble who carried Toto, the Remingtons' miniature dog, also known as Snip. From his parlor car on the Limited, Remington fretted about whether Kemble's dignity had permitted him to hold Toto, or, if Kemble put Toto down at the Mott Haven station, whether he had seen that "no one laid a trunk on him or stepped on him."

Back in March, *Century* had allotted Remington two months to complete his outstanding *Harper's* assignments and make the arrangements for the trip. Catching up with the work load had been difficult.

Eva Remington said that *Harper's* was "giving Fred orders for double pages and he is solid with them now." She was impressed: "A great boy he is too, I can tell you."

Part of the reason for Remington's good standing at home was that Eva was having her "portrait painted by Mr. Pennington and hope it is going to be all right." Harper Pennington was just back from twelve years of European training in portraiture. No Remington or Caten had ever been pictured in oils by such a trained hand. This made the sitting a step up for Eva Remington's social ambitions, but it was one that her husband privately thought pretentious. As a joke, Remington casually imitated Pennington's academic drawing style and signature in a quick ink sketch of a modishly dressed woman.

His pace as an illustrator had accelerated to an average of a finished piece every two or three days, including Sundays. Some of these illustrations were now oil paintings done in black and white. Painting in black and white called for a technique different from painting in color, and it meant that his color sense that had been strong enough to get paintings mentioned for National Academy prizes was not being fully used. His friends who were illustrators were black and white men too. None of them realized they were blunting their color skills.

While he was painting against the deadline, he also had to take care of the travel preparations. They were manifold, including getting letters of reference from the government. In addition, Remington arranged for a personal stopover in Kansas City. He wanted to visit with Frank Hough, who had called on him in New York City early in 1887, on the way to Canada. He needed guidance from Clarke, too: "Will you enquire among your soldier friends and ask them where the 'Kiowa Commanche Arapahoe & Cheyenne' indian agencies are." Indian Territory was an uncharted area in 1888 and was called "An Unknown Nation" in *Harper's Monthly* magazine.

After the preparations were complete, Remington had shipped a trunk with photographic gear the day before leaving to make the Grand Central Depot connection with the Limited. When he was ready to board, however, he found that he had forgotten the baggage check for the trunk. He had to expend "a little diplomacy and a half dollar" to get straightened out. In the parlor car, he indulged his Anglophilia, wearing his most modish clothes and affecting a Yale accent. "One fellow insisted on mistaking me for an English Lord but I convinced him that I was the plainest sort of an American."

Chicago was new to him. Remington was unusually reserved there, "regarded as wintry of a look by nearly all I meet." The train his wife took would have put him in Chicago in time for his westbound connection, but the later departing Limited arrived earlier, giving him both a

plush ride and a working day in Chicago. He had brought a few paintings along to foster sales and went to the Grand Pacific Hotel to clean up before calling on the art galleries. The first dealer was Stevens, whom Remington named "a magnificent ass" because he limited his stock of paintings to the European academics who were in vogue. The other was O'Brien, who "is the absolute stuff" because he agreed to take paintings on consignment.

The next morning, Remington was in Kansas City where Frank Hough, "the best fellow in the world," picked him up at the station with his "magnificent span" of horses that reflected economic prosperity. Hough took Remington to visit with the more genteel of the people he had known. The change in attitude toward him was what Remington had come to expect: "They are all mightly impressed with my importance." One family said they were going to invite Eva Remington to visit the next summer. Remington's advice to his wife was that "if they do you can make some excuse for not coming. As a summer resort K C will never be great." Remington also stopped in to see W. W. Findlay, his first art dealer, who had a few paintings on consignment at an asking price of $275, a satisfactory level in 1888.

After a day in Kansas City, Remington and Hough took the Denver Express together. They paused in Topeka to have Remington's excursion ticket adjusted. Painters doing Western subjects were eligible for the cheaper excursion rates. He had mistakenly bought a ticket that had to "be carried to Los angelos to be signed there for return passage —smart aint I." On June 3, he was at the Depot Hotel in La Junta, Colorado, where Hough left. He had business in Colorado Springs. Remington spelled the name of the transfer point as the phonetic La Hunta in a letter to his wife. He already missed being home so his salutation was the affectionate "Love & kisses little girl," followed by the manly "keep a stiff upper lip."

Two days later, he was only as far as Deming, New Mexico: "Missed our eastern connections yesterday by one hour and have to lay over here 23 hours. It's a d_____ shame." That night he arrived at Willcox, Arizona. From Willcox on, Remington spoke with three voices. The first was uxorious, his letters to his wife that were censored versions of relationships with men he met. The second was personal, the diary he kept in a House Book he had started to use at home for domestic accounts and took along to save buying a new one. The diary was a casual record of events, the sparse keys of the professional artist. The third was public, the detailed articles he wrote for *Century* after he returned. The articles were the highlights of the trip.

The next morning, Remington found that Clarke had sent a six-mule "ambulance," an army passenger wagon, to bring him to Fort

Grant. Clarke was waiting for him, posed "on horse surrounded by greyhounds. The hospitalities extended were almost magnificent and beyond all expectation." At the fort, he was assigned the quarters of an absent officer and was able to sit behind irrigated green vines with a drink and a hand-rolled cigarette while looking out at the dusty, scorched parade ground. Clarke escorted him for the day, explaining the "many peculiarties of the soldier type" and "the little inventions of necessity—as it were." As an example, the black cavalrymen stored chewing tobacco in the flare at the top of their boots, a pocket not envisioned by the quartermasters in Washington. Remington said that "I like the negro soldiers character as a soldier in almost every particular." The wagon they were using for an evening tour of the area broke down so that night they slept in the open on the ground.

Remington and Clarke developed an affection for each other without needing to understand the other's motivations. Remington looked on Clarke as a glamorous, "manly man," but the intimate details of Clarke's life, and what Clarke thought about himself, were not proper currency between them. Remington would not have revealed his own core emotions, and did not welcome them from Clarke. It was enough to be aware that each could depend on the other.

Remington did know that Powhatan Henry Clarke, born in Louisiana, was a year younger than he. Clarke was the son of a professor, with two years of study in France that had helped him get an appointment to West Point. He graduated a respectable 37th in his class, but was characterized as "incorrigible, a wild, mischievious irrepressible boy." He was "the wild cadet" whose "buoyant nature" would not let him "submit to those humdrum rules so necessary for the rest of us." Where Remington's tendency was to accommodate, Clarke was a rebel.

When Remington first met Clarke at Fort Grant in June 1886, Clarke was just back on duty after confinement to quarters for treatment of gonorrhea. The disability had not prevented Clarke from rescuing Corporal Scott with proper nonchalance. As he had said, "I was scared to death, but the man called to me and you know, I couldn't leave him to be shot to death." When Clarke initiated the Remington correspondence in 1887, he was on sick leave for "stricture of urethra," which was gonorrhea-connected. The disability required an operation in New York, but he did not contact Remington then. Clarke's medical problem for 1888 was "a pain in the articulation between the third metatarsal and the external cuniform left foot." Classified as incurred in the "line of duty," it was a "sprain received while dancing." He had returned to his troop only two weeks before Remington arrived.

Clarke's convalescence made him happy to be freed from duty to
serve as Remington's escort. His commanding officer thought of
Clarke as a malingerer, and not the hard rider that Remington saw. He
assigned Clarke to a two-week scout in the mountains and told Clarke
to invite Remington to go along, as much to punish Clarke as to see
that Remington the man from New York was "ridden down" on the
patrol. It would not do, the officers agreed, to have a correspondent
"trifle with the dragoons" and "get away with the impression that the
cavalry don't ride."

Remington had no choice about joining in—his host was going—but
his trepidations were obvious. For a year his exercise had been limited
to evening walks with Kemble. He could not pretend to be in the su-
perb physical condition he attributed to Clarke and was very much
afraid he was going to be laughed at. He wrote matter-of-factly to his
wife, but he signed, "Am well. Take good care of yourself. Yours
Respt. Frederic Remington. excuse the Yours respt. It was a slip.—love
—dont loose Snip." He was a disturbed man.

Before the scout started, Remington spent a night in an infantry
camp. He took his camera. In the morning, he "ran along on foot and
shot 12 plates at the dough boys." He was using glass plates as opposed
to the new paper negative that was light in weight and offering up to
one hundred shots on a roll but that was risky. His camera box had to
be big enough for the plates, a correcting lens, and a shutter. He
carried holders that readied two plates for the camera and the Pho-
tometre, new in 1888, which gave the number of seconds for an expo-
sure. To photograph the doughboys marching, Remington took the
eye level sighting that became a frequent painting device.

In the afternoon, Remington's apprehensions about the scouting pa-
trol grew when he observed Clarke's skill as a horseman. He "took a
ride up the canon with Clark.— saw Clark do some military trick
rideing. Very fine." They watched "a view of sun-set on the mesa
which was simply one of those phenomena of coler beyond the prov-
ince of art to portray." These were leanings toward landscape painting
that Remington suppressed for the next fifteen years. That night, he
sat up to talk with Lieutenant Carter Johnson of the Tenth, gathering
material about experiences with the Cheyennes that he used in an arti-
cle nine years later.

On June 11, "our scouting outfit got together," including Clarke
and Remington and six of the black Buffalo Soldiers he had come so
far to record. The black cavalrymen had been named "Buffalo" by the
Indians because their curly hair was thought to be similar to the fur of
the buffalo. The route was up "the heavy rise of the mountains"
where "we all dismounted and led our horses—up—up as steep as a

pair of stairs.–very tiresome–more particularly as the air became rarer. I was almost dead with fatigue." It was so hot and debilitating that Clarke's greyhounds quit and were left to find their own way back. "Then we came down. One place we hesitated but went down & Clark's horse slid on its rear elevation all the way. We finally reached camp in the afternoon about 5 o'clock. Clark was tired he said and I was also–my feet were sore. I photographed the camp."

The second night they slept at Fort Thomas, then went on to camp near the San Carlos Apaches. Remington tried using a sketchbook held behind Clarke's back to do figure studies but the drawing was "straightway torn up, for Apaches more than any other Indians dislike to have portraits made." The fourth day they rode "at right smart gait" to the San Carlos army post. Remington was surprised to find he "stood the march very well–My seat is not chaffed at all." The next day at the post was ration day, where cattle that had been driven to the reservation were slaughtered on the spot by Apache butchers and the meat was thrown to the Indian families. Remington "photographed to my hearts content and the Indians never seemed to notice the camera," as opposed to the sketchbook.

Remington had not only matched what Clarke could do, he had thrived on the scout. The officers at San Carlos determined privately that Remington by enjoying himself had made light of the 10th Cavalry and deserved no mercy. When the outfit pulled out of Carlos the next morning, June 16, they were accompanied by Lieutenant Jim Watson, the most tireless rider among the all-white commissioned officers of the 10th Cavalry. Watson was to be their punisher.

At first, Remington thought Watson was funny. He was a "character" and a "spectacle" but he soon displayed an "aggravating" trait, "an insane desire to march." The outfit ducked away from Remington while he was "taking up a 'cincha'" at an "impassable" place, giving him a "hell of a time making down rocky precipice" alone. Watson then arranged for him to sleep "on rock, big rock–hard bed–no good." The next night, "a rattlesnake got into my bedding which I had on the ground," an event Remington did not associate with soldier hazing, "and I betook myself to the rock again in consequence of the extreme hardness of which I did not sleep much." They made a "quick march" with "some bad drops," then "got lost, made right up over the Mescal range–crossed on the second highest point–from the lurching of my horse I got very stiff and sore & the constant pinch of going down the mountain nearly paralyzed me."

The eleventh morning they rode the thirty-five miles to Fort Thomas: "The heat was awful and the dust rose in clouds–men get sulky, go into a comatose state–the fine alkali dust penetrates every-

thing but the canteens. The color of the command was completely lost.—as I bathed at Thomas my hair and beard was simply a mass of mud." The evening of the twelfth day, they returned over the mesa road to Grant: "I was elected an honorary member of the cavalry—the skin is coming off my face.—I am thiner."

The cavalry had tested Remington in relays. Clarke had gone up the Sulphur Spring valley and through Taylor Cañon pass over the 10,720-foot Sierra Bonitas, taking two arduous days to do thirty miles as the crow flies. When Remington survived five days of the convalescent Clarke, the command had switched to Watson who led west, parallel to the Globe stage road and up the Pinal Mountains to the Continental Divide, a height that now overlooks the Coolidge Dam. Remington was not fazed by Clarke or Watson, so the command returned to Grant by the level road through the valley to Thomas and then the easy mesa road.

At Grant, mail awaited him from his wife who enclosed family photographs from Gloversville. Remington answered the same evening, reporting that "I have lost 20 pounds at least—feel well. If it had not been for my helmet I could not have stood it." Remington's subsequent illustrations for *Century* included his own figure when he depicted the command in a file. The beard he shampooed at Fort Thomas was missing, but he was wearing an English safari helmet rather than cavalry issue. He felt that it was "a very successful trip and will help me professionally very greatly," and added, "Well good bye little girl when I come home we will have some fun."

Remington never did realize that the cavalry had subjected him to an extraordinarily rigorous scout, but he had paid his dues with his sweat and could afford to remain good natured when he later wrote Clarke that "I'm going to give old Jim Watson hell in this article for marching me so." The article was "A Scout with the Buffalo-Soldiers," published in *Century* in April 1889. What the experience did for Remington was to make him more sophisticated about the cavalry where "soldiers, like other men, find more hard work than glory in their calling."

After two days of recuperation with Clarke at Grant, Remington took the train again, backtracking to El Paso so that he could begin to do the report on the "Wild Tribes" that *Century* had commissioned. From Fort Grant he had "shipped a large box of Apache & Soldier bric a brac by freight—consigned to Lawton Caten" because "they could not give me a rate to 561 Mott.—" He "lay over for a day" at Willcox to make up for lack of sleep and "bought a nice lott $20 worth of Mexican & Indian pottery here and 1 Mex zerape—which I have consigned to you—collect.— It will make us some unique deco-

ration. Much rarer than any thing we could buy in New York no matter how nice."

From the Grand Central hotel in El Paso—the "Only First-Class Hotel in the City"—he confessed to his wife that "I am getting tired, want to go home—It is hotter than the devil here— you can form no idea—The sweat drains from me as I write.— I have $380 out of 600 when I left the house—I'll get through." He ended, "Love Missie—I'm *dying* to see you—Yours lovingly, Fred." After Fort Grant, however, Remington had lost interest in the rest of the *Century* commission. The excitement had been left with Clarke. Doing the "Wild Tribes" would be just a series of way stations on the route back home, as he wrote July 1 from Henrietta, Texas:

My dear Girl:—
The mosquitoes like to have eaten me up—there is not a square inch on my body that is not bitten—and oh oh oh how hot it is here—I have sweat & sweat my clothes full—I can fairly smell myself—I am dirty and look like the devil and feel worse and there is no help for me. Well you can bet I am going to make the dust fly and get through as soon as I can—
This is a miserable little frontier town with a little hen coop of a hotel—I am nearly starved to death—this Texas grub is something frightful.
And my room—I wish you could see it.—you would smile—Well all this is very discouraging but its an artist life. I have no idea how long this thing will take for these Indians are scattered all over the earth but I "touch and go" and you can bet I wont spend the evening with them—still I came to do the wild tribes and I do it. Love missie—Your old boy, Fred.

From Henrietta on, his impatience showed. He went straight north, entering choppy and spasmodic notes in his journal. Dirty, tired, hot, and disinterested, he endured the proscribed trials of the trip stoically but in a rush to get it over with.

Remington was a correspondent, a man in the business of making pictures in the West, but his interest in Indians was philosophical as well as physical. "The one thing about our aborigines which interests me most," he wrote, "is their peculiar method of thought. With all due deference to much scientific investigation which has been lavished upon them, I believe that no white man can ever penetrate the mystery of their mind or explain the reason of their acts."

He represented the army point of view, advocating continuance of the existing reservation system, under army control. When his article "On the Indian Reservations" was printed in *Century*, the editors put in the same issue a response from the educator Hamilton Wright Mabie favoring assimilation of the Indian.

At Henrietta, Remington could not wait for the stage to Fort Sill. He hired a Texan to drive him through Indian Territory in a covered

spring-wagon big enough to haul the trunk with the photographic gear. The wagon was drawn by a pair of plodding little brown mules that would quiet down to a walk whenever they could. It was a slow pace for a man who expected to tour three agencies and then head home.

After a tedious drive across a rolling grassy plain, they arrived at Fort Sill, the Comanche agency, on July 3. Remington appreciated the Comanches because they were "rich in ponies and excellent judges of horse flesh." The next day was the Fourth of July. Remington "went up to Indian Traders.— indians in all their finery came in to race.— saw races—made photoes.— I can describe this scene." The guide assigned to Remington by the commanding officer at Fort Sill was Horace P. Jones, an interpreter who had been with the Comanches since five years before Remington was born. Jones did not appreciate being wet-nurse to a correspondent so he ignored the responsibility. Rather than explore on his own, Remington pushed on.

On the way to Anadarko, they "camped in a beautiful post oak & black jack grove . . . along came a Witchita indian—[with a] little boy on horse—nicely dressed—I wanted to trade for boy's clothes— we agreed on 10 dollars—I proffed 10 bill—he said 'no wayno me ketch em white money—heap no good maybe so'—no trade."

At Anadarko, Remington "bought beautiful pair of Apache mugs of fierce young buck for 4 dollars—white moneys.— he got sick of trade, wanted to trade back—I said no—as I walked off he ran to me seized my hand & tried to put dollars in them but I turned my hand and the money dropped. If he had gotten money in my hands I would have had to give back the mugs.—"

He was restless after one day. "All Kiowas gone to Reno—so I pulled for Reno also—hot—flies—no grub. Hell & repeat." The night of July 7 he arrived at Fort Reno which proved to be the most productive agency for him. "Saw Post lights over across the pararie. Rapped devil out of hotel doors—could not get in—finally did—got good enough rooms—" The scout Ben Clark "detailed to do the business" for him was friendly. Remington stayed at Reno for four days to observe the Cheyenne.

Remington had a unique opportunity at Reno to unearth material for articles by searching out the survivors of the military depredations against the Cheyenne in 1864, 1868, and 1876. The old story of mistreatment of the Cheyennes was available to Remington there but he did not sense it. His sympathy then was not with the Indians but with the army in following its instructions to subdue the "Wild Tribes," and he thought of himself as a picture man, not primarily as a writer.

Led by Ben Clark, he did pay a courtesy call on Chief Whirlwind

of the Cheyenne. He sketched the Chief but did not find common ground although the old man was something of an artist himself. Whirlwind had recorded battle scenes and Indian life in pencil and crayon drawings that have since found their way into museum collections.

Clark and Remington "drove around the camp and I got one of the old buck saddles.— Saw Medicine man at work—young bucks preparing for a clan dance—picking bugs out of hair—children playing with dogs—women beading moccasins—bucks at monte, or smoking &c.— a wild enough scene but strangely coupled with wagons & modern inventions.—" Remington sketched the figures while Clark engaged the Cheyenne in disarming conversation. He later made the sketch into the black and white illustration "A Cheyenne Camp" for the *Century* article, a faithful rendering of Whirlwind's encampment as he had described it in words. Remington wrote about and painted what he saw, without censorship.

From Fort Reno, he took the stage eastward on July 11 to connect with the Atchison, Topeka & Santa Fe (AT&SF) railroad to Kansas City. He arrived there late that night, met Hough at the station, sent a telegram to his wife in Gloversville, and boarded the Chicago Rock Island & Pacific. In Chicago, he transferred to the New York Central, to be in Gloversville the night of July 13. When he got there, he found that he was supposed to have died on July 12 at 5:40 P.M. in Trinidad, Colorado.

10.

Has the Artist Killed Himself?

The New York *Tribune* dispatch from Trinidad, Colorado, on the July 12, 1888, suicide was headed "Has the Artist Killed Himself." The subhead was, "Frederick Remington of 'Harper's Weekly' Said to Have Committed Suicide." The article was clear: " 'Fred' Remington, a young man representing himself as an artist on 'Harper's Weekly' arrived in this city some days ago and employed himself sketching mountain scenery. To-day he took morphine with suicidal intent and died at 5:40 this evening. Soon after his arrival here he made the acquaintance of Miss White, a milliner, and it is thought she jilted him, causing him to commit the act. Remington left a will bequeathing to Miss White $4,000 and to the Journalists' Home $2,000. His father is supposed to be in New York."

A fuller version was in the New York *Herald*, headed "An Artist's Suicide. Frederick Remington, A Painter of Talent, Takes Morphine in Colorado." The article was from a special correspondent in Trinidad on July 12:

Several weeks ago a good looking young man calling himself Fred Remington, and stating that he was an artist on *Harper's Weekly*, came to this city and spent some time sketching mountain scenery in this vicinity. He mingled with those of the citizens who had been recently residents of New York, and there is no reason for doubting that he gave his genuine name and true relation to the journal he claimed to represent.

He took morphine today with suicidal intent. Several physicians by means of artificial resperation and hypodermic injections of alcohol prolonged the young man's life until six o'clock this evening, when he died. He left a will bequeathing to Miss White, a handsome young milliner in this city, whose acquaintance he made a few days after his arrival here, some $4,000, and setting apart some $500 for the expenses of his funeral; $2,000 he left to the Journalists' Home and $1,000 to the hired help on his father's farm. He also wrote a letter to his father, a banker, asking him to grant Miss White a position in his bank, as she was capable and worthy.

Just what transpired, if anything, between Mr. Remington and the young lady is not at this time known. Rumor has it that he fell madly in love with her, and that [because] she refused to listen to his protestations he committed suicide. Another rumor is that he has been ill for a couple of days and took the drug as medicine and with no suicidal intent.

The young lady was properly modest July 13 in a special bulletin headed "What Miss White Says" in the Denver *Rocky Mountain News*:

Your correspondent called on Miss White, the lady for whom Remington committed suicide, at the United States hotel to-day. She replied as follows to a question of what she knew of Remington: "Last Friday I met Frederick Remington while on a visit to Mountain City and he was going on business to take some sketches. He forced his acquaintance upon me and invited me to go riding with him while he sketched. I, being out of employment, thoughtlessly went with him two or three times for pastime. He always behaved as a gentleman. Tuesday forenoon, while near Morley, he spoke to me of his regard. I refused to listen to him and got quite indignant. As we neared the city he complained of feeling badly, and spoke of being troubled with heart disease and took a capsule from his pocket and swallowed it. I then and there decided that I would go with him no more. I feel badly over the matter and am sorry that my name has been brought so prominently before the public."

After reading the article in this morning's [Trinidad] *Advertiser*, in reply to the question, "What do you think of it?" she said, "Well, what is stated there is true."

"What do you think of Remington's action and his object? There must be something at the bottom of it."

"I only saw him once after the buggy ride, when he proposed. On Wednesday, at his request, I, accompanied by my sister, called at his room.

After that he sent me numerous requests, but I only answered the first one and that with a blank refusal. He only mentioned that he had a claim in Kansas. I know nothing of his folks or his wealth."

Miss White is only about seventeen years old and has been here but a short time. She was seeking employment here as a copyist. She has a sister here who is employed at the court house.

The article that Celia White referred to in Trinidad's *The Daily Advertiser* was "His Last Sketch/Frederick Remington Sketches His Last Will and Testament/Then Takes a Journey Over the Morphine Route —He Was Crazy." The article was long, recapping and expanding while clinging to the Remington identification as the attention-getting aspect:

On the 3d inst. a young man about 21 years of age came to our city from the northern part of the state, claiming to be an artist for Harper's Weekly, and giving his name as Frederic Remington. It was plainly seen that he was of foreign berth—either German or Swede. Apparently, he appeared to be a perfect gentleman, but of very queer actions.

It is currently reported that a young lady of our city by the name of Celia White attracted his affections. She says he always treated her like a gentleman and was very jolly. This is as far as their courtship went, but his letter to his father shows conclusively that he was in love with the young lady. He told many different stories of his past life and little reliance can be depended on what he repeated. It is a plain case of suicide and that he was not of his right mind. The following letter addressed to Frank Remington, president of the Michigan State bank, Detroit, Michigan, was found on his bed yesterday:/The Letter . . . Dear Papa:—I was taken ill quite suddenly last night, (heart trouble.) and the doctor says it is quite dangerous. Please don't tell mamma, so she won't worry, for if I should get worse I will wire you and ma to come. Please draw on my account in First National bank $200 and send draft for that amount. Best regards, Frederic R.

The Advertiser took the responsibility to telegraph to this man Remington but soon learned that no such bank as the Michigan State Bank existed and that Frank Remington could not be found.

Investigations so far show nothing to substantiate his writings, and it is very doubtful whether he owned any of the property named in his will (found with the letter), and that the case is a clear one in favor of insanity and suicide. L. H. Turner have charge of the body and will await a short time for developments.

The "last and final will" was then reproduced in full. The real property bequeathed included a cottage in Winfield, Kansas, and acreage in Finney County, Kansas. The attorney named was R. O. Codding of Winfield.

By July 14, the New York *Tribune* began to have doubts: "The

dispatches from Trinidad, Col. announcing the death by suicide of Frederick Remington, the artist, of 'Harper's Weekly' were not regarded as entirely reliable at the publishing house of Harpers and Brothers yesterday."

The New York *Times* was more definite:

It is not at all likely that the Fred Remington whose suicidal death at Trinidad, Col., was reported yesterday by telegraph is the artist Frederic Remington whose pictures in the National Academy of Design, in the Century magazine, and in Harper's Weekly have been so generally admired. Charles Parsons, superintendent of Harper & Brothers' art department, said Saturday: "That may have been the name of the suicide but I have strong reasons for believing that the man was not our free lance. The latter left New York two months ago for a trip into Mexico, but just where he is at present I do not know." He [Parsons] received a telegram from the United States Hotel at Trinidad asking for a description of Mr. Remington and sent an accurate one. He [Remington] is a portly, ruddy-faced fellow, with a sunny disposition.

"We were the first to recognize Mr. Remington's talent and encourage him by accepting his drawings. His work has attracted much attention, especially his pictures of frontier-life and scenes. My theory about the Trinidad case is that some young artist out there has been representing himself as Frederic Remington for the purpose of imposing upon somebody. To back up his trick he mailed us a package of drawings and descriptive matter which reached me to-day. The drawings are not our Remington's; neither is the handwriting his. The former have the initials 'F.R.' on the corners and the letters are apparently bold imitations of the original. Our artist is happily married and has a family. I am confident the bogus character of the suicide will be established within a few days."

As the author of *Century* articles Remington had illustrated, Theodore Roosevelt was asked for his opinion of the Trinidad mystery. Roosevelt said that he was surprised. Remington did not seem to him to be the kind who would take his own life.

In St. Louis, a special correspondent from Kansas City declared that "Franklin B. Hough, an intimate friend of Fred K. Remington, the artist, reported to have suicided in Colorado a day or two ago, says he met Remington last Wednesday night [July 11], that he [Remington] was on his way east, and that he had not been in Trinidad."

Trinidad's *The Daily Advertiser* reported on July 14 that "the Frederic Remington, who created such a sensation in our city, was buried in the potters' field yesterday in the presence of three or four of our citizens. The telegrams sent out in search of his parents or friends failed to receive any definite answers. In his 'grip' was found papers to the effect that his name previous to his visit to Trinidad was Raymond, and that several letters from the fair sex indicated that he

had played his little suicidal game as here on other occasions but not with the same result, however. There is not a shadow of a doubt but what he was crazy and was traveling under an assumed name."

The *Rocky Mountain News* added that "it has been concluded that the suicide was one of the most genteel of dead beats and had assumed the name of Remington. Papers in the dead man's satchel indicate that his former name was George F. Raymond. He was a confirmed co-caine eater and so planned his death as to create a sensation. After writing a letter to his father referring to much wealth and after disposing of much wealth in his pretended will, it was found that his total of funds amounted to 15 cents. The remains were buried at a cost to the county of $5.85 [$6.00 less the confiscated 15 cents]. He was evidently an artist of merit."

The New York *World* quoted a telegram: "Groverville [Glovers-ville], N.Y./Fred left Kansas City Wednesday night. Will probably reach here tonight. Was well then. L[awten]. Cater [Caten]." The *World* concluded, "If the artist really left Kansas City for the east Wednesday night it is difficult to conceive how he got into Trinidad, Col., by 3 o'clock the next day. The story about Miss White also fails to fit, for Harpers artist is a married man, lives at No. 561 Mott avenue, this city. The house was closed up yesterday, as Mrs. Remington is spending the summer by the seaside. The general impression is that the suicide was an insane artist who imagined himself to be Mr. Rem-ington."

Trinidad's *The Daily Advertiser* quoted the *World,* adding that it "indicates very plainly that the suicide was not the man he purported to be, and that he was laboring under the hallucination that he was Harper's artist. Who the unfortunate was is now only a matter of guesswork."

The *Advertiser* then answered itself July 20:

The True Sketch/The Artist Remington's Identity Established at Last. Another chapter in the sensational suicide of Frederic Remington, alias Raymond, has been made public and it seems the end is not yet reached. Yesterday Mayor Collier received the following letter:

Winfield, Kas., July 17, '88. Hon. Mayor, City of Trinidad, Colo. Papers at hand containing an account of a suicide by a young man who claimed to be Remington, of Harper Bros., at your city on the 13th inst. Late ac-counts state that papers found in his valise give his name as Geo. Raymond, a blond, 5½ feet tall, but weighed 170 pounds, also a pledge given to Miss Flora Bell Lamper that he would abstain from the use of morphine and other drugs of like nature.

This description tallies with the young man we know here as Geo. F. Raymond, all but his weight, which was 135 or 140.

I send you by this mail a photo of him. Will you please take the trouble to have some one who knew him, before he was buried identify him as the one in the photo. I have known the man whose photo I send you since last November. He left here unknown to anyone about the middle of April. When last heard from he was in Colorado sketching. We believe, beyond a doubt, that the man who committed suicide was the identical man, but wish positive proof before we write his parents.

They live in Katschen, Germany [*Katscher* in Prussian Silesia], and are well to do and of a noble family, his father being a colonel in the German army. The true name is Rohowski, the young man's name is Raymond, Baron Von Rohowski.

Please write me the full particulars if this photo corresponds with the dead man. Please return photo. Yours, D. Chapman, Gen. Sec'y Y. M. C. A.

The photograph sent is a perfect likeness of Remington, or Raymond, which appears to be his name, and easily recognized by any one who has ever seen the original, and there can be no doubt as to his identity if the facts set forth in the letter are true.

It is certainly a variation of the usual circumstances where imposters claim to be noblemen, as in this case Raymond made no claim to a title but it now appears, actually possessed one.

Raymond had, apparently, indulged in the use of narcotics until his mind had become so impaired as to be easily impressionable and it was probably one of the vagaries brought about by the constant use of opiates that caused him to take his own life.

He was naturally brilliant, possessed of a fine education, attractive manners and a kind, generous heart, although much of his better nature was obscured and hidden by the unfortunate habits, which have brought to a sad termination what might have been a brilliant life.

It is a sad ending of the life of one cradled in luxury that he should through his own indiscretions occupy a pauper grave in a strange land.

When the *Advertiser* thought that Raymond was a morphine-eating pauper, the editor clung to the Remington image as the more newsworthy, with Raymond as the alias. The suicide was called crazy. When Raymond was found to have been a baron, he became attractive and unfortunate. The paper did pick up the twist of the nobleman pretending to be Remington, but it was not aware of the irony concerning Remington, who sometimes pretended to be a nobleman.

The missing element was Remington's story. The announcement of his demise took place while he was on the train, out of contact with newspapers en route from Chicago. He thereafter was the living disproof of the Trinidad sensation, but there is no record of an interview with him. Although the dead Baron Von Rohowski had crossed Remington's tracks in Kansas, there was no effort to ascertain whether Remington had known the baron. The bequeathed cottage in

Winfield, Kansas, was in Cowley County, immediately south of Butler County, on the way from Eldorado to Oklahoma. Finney County was west of Dodge City and Cimarron. Remington had traversed both areas as a "holiday sheepman."

There is no indication, either, of an interview with Eva Remington. She was waiting for her husband in Gloversville when she was exposed early on July 13 to the press report from Trinidad about the suicide. She knew he had been safe in Kansas City two nights earlier but she was not certain of his fate until he arrived in Gloversville that night, still unaware of what had taken place in Trinidad.

There was no further reference to the suicide report. There was nothing in letters from Remington to his friends, nothing in letters from Eva Remington to the family, nothing mentioned. The subject of the suicide became nonexistent, as if hidden. If the story had not been a real live two-day sensation, one could doubt it ever happened. The report was not published even in Canton where anything about Remington made the papers. The secrecy was odd for the outgoing, story-loving Remington who enjoyed "one on him."

He returned to the Mott Avenue house July 16 and settled back into the work pattern that was to be his for the next ten years. He was described as tall and heavy, round faced and smooth shaven. The Arizona beard was gone. He was twenty-six years old, in good physical condition after six strenuous weeks in the Southwest but about to add back on the excess weight he had lost during the scout. His putting on weight he blamed on lack of physical activity: "I think on the whole I will buy me a horse soon—I must have exercise." He still deplored the English style of "posting" and declared that "it gives me a pain to see these 'bobbing chappies' who go about these streets making a frame of their ass and the saddle for a landscape which happens to be beyond."

To his Eastern friends, he embodied the cowboy philosophy. They excused his dissipation in food and drink as appropriate for the free-booting Westerner he seemed to them. They considered that he had learned uncivilized habits in the course of gleaning pictorial material from his cavalry and Indian sources, as a sacrifice to his profession. Because he was a Westerner by vocation as well as an Easterner by birth, he could sometimes be bluff and indifferent to the rites of society, while at other times he would dress and compose himself in the highest style. "He worked unhampered by rule, example, or opinion, at high pressure, by a series of explosions. [He] kept near the ground in all his thinking, [with] a passion for the roots. His speech was laconic. His vocabulary was small, vital, and picturesque, strongly colored with military [and Western] terms and phrases. He was a good listener, and a good laugher."

It was midsummer by the time he reached Mott Haven and he

wanted to spend August in Canton. He wrote to his uncle Robert Sackrider in late July 1888 saying that "it is my intention to start with Eva for Canton on Wednesday morning." This would be his first visit since his mother's remarriage. He expected to be faced with the local gossip and declared that "I dont care a d_____ for anyone. I want Mrs. Levis to know she is nothing to me. She has got to find out and she might as well take her medicine. I am perfectly calm—I dont propose to skulk before the good people of Canton."

He relished the urgency of his assignments, alternating between *Harper's* and *Century*, so four weeks in Canton meant a change of place, not a halt in work. The more he had to do the better he responded. He set up the old temporary studio in the Sackrider barn, and now that he was accepted as an author, he composed in longhand on the porch. This summer, he was in the midst of rewriting an article that was to establish him as an expert on the American bronco and its origins in the Barbary horse of northern Africa. *Century* had turned down his first draft as just a showcase for the ten strong illustrations of North American horses but the rewrite done in Canton was published in January 1889 as "Horses of the Plains," ahead of the other *Century* articles on the Southwestern trip with their thirty-two illustrations of buffalo soldiers and reservation Indians.

After he returned to New York City in September, he exulted, "I am rushed to death, got two MS—25 Century illustrations—4 chromos—a Harper page & an oil painting to make before the end of next month and that wont give me much time [to] monkey." The *Harper's* pictures were still for the *Weekly*, not the *Monthly* magazine. Half were assignments in military and sports subjects. The others were from his Western trips, including five illustrations of Lieutenant Carter Johnson of the Tenth Cavalry.

He also told a former classmate that "I have had a very encouraging success both as an illustrator and a painter. My time is so well taken by the publishers that I have had little time to paint in colors but I manage to exhibit two or three paintings in the National Academy of Design." He said he had "put a small study of a 10th Trooper in the N A this Fall. Also a Cheyenne." Both paintings were sold at the exhibition.

Prospects were bright, as Eva Remington wrote to Uncle Horace December 3: "Fred has just left for Boston as he wants to get there in the morning. He goes to see Houghton, Mifflin & Co. about illustrating 'Hiawatha.' Ever since he had done any illustrating he has dreamed about doing that & now he hopes he can. Fred is still as busy as a bee and very happy—also enjoying perfect health." A few days later, she added that "Fred has as firm a grip on Harpers & The Century as any artist in this country. He has all he can do. Harpers if you

notice is having something every week in the Weekly—Harper takes all he can make & asks no questions & gives him from $75 to $125.00 per page. Fred is told by artists that he is talked about more than any artist in this country & every one looks upon him as the strongest man."

In contrast, he was selling only a few easel paintings, and those for insignificant amounts. He thanked the Gunnisons at the Brooklyn *Daily Eagle* for publicity about his paintings by saying that "this is the kind of talk I want. A young chap who goes in on the line I do has got to have the moral support of someone because the Breton peasant idea has a 'dead mental cinch' on the people over here." The demand in the galleries was still for classical European subjects.

Any sympathy for Remington because the American art buyers preferred classical Breton peasants to Indians would, however, have been misplaced. His earnings of about $8,000 for 1888, in only his third year as an illustrator, were more than fifteen times the average annual pay of a wage earner. At twenty-seven, his income exceeded the entire estate that would be left at the 1910 death of Winslow Homer, the most important American painter of the age.

There were 139 illustrations in periodicals during 1888, half of them for magazines at rates up to $125 per page. There was only one article by Remington printed by *Harper's Weekly* during the year, "A Peccary Hunt in Northern Mexico." The $25 he was paid as author was for his ego not his pocketbook. The article did let him claim in print that "I had learned to throw a rope in an indifferent fashion during my life on the cattle ranges of the North," another step in the cementing of the mythology of his Western experience. There were seven books published in 1888 that contained his illustrations. The one conveying the most lasting prestige was *Picturesque California* edited by the legendary naturalist John Muir. The four plates were also printed for sale separate from the book, putting them among the earliest Remington prints.

Illustrating had made him a rich man by the end of 1888. And, as he wrote to Powhatan Clarke December 24, he expected 1889 to be even better: "Xmas is merry with you I know—I go north [to Canton] with the Madam for a few days and hope it will be merry with me. Have got big job for this year—take half the year—illustrate Hiawatha." *Hiawatha* would require the largest number of illustrations Remington ever did for one book, but he had so much work ahead that he could not start until summer.

For an artist who was supposed to have killed himself in July, he was very much alive.

11.

The Place
Where I Am At

"I am at work on a big oil," Remington wrote Clarke in his year-end letter. "Spring Academy or 'Paris Ex'—don't know yet—'Lull in the Fight'—sand hill—hot as devil—big plain—mesquit. indians around in far distance. 4 old time Tex cow punchers.— one dead—two wounded —damdibly interested—tough looking chaps.— four dead horses—saddles canteens old guns buckskin &c—one man bandanging a damaged leg.—critics will give it hell—brutal—&c." Then, faithful to what was in the painting, he decorated the letter with a drawing of the heads of two of the characters, adding, "Very rough—give you an idea."

His practice during his whole career was to solicit criticism of important paintings in process, both from Westerners like Clarke and from fellow artists. One advisor was Charles Parsons, Harper's art director since 1861, whose suggestion erased the mesquite. As Remington acknowledged, Parsons "gave me some new points and a new stimulus and 'I went at her again' and have made various improvements. It is a great deal better now than before. I cut out the mesquit, redid the sky—warmed the horses and articulated the ground."

The painting was submitted to the American jury for the 1889 Paris

International Exposition at the suggestion of publisher Henry Harper, a regular visitor to Europe. William Poste helped with the title, suggesting "The Last Lull in the Fight." Poste observed that Remington had "several smaller works under way, all of them having to do with the far West, and none of them intended to be hung in a sick chamber. Fred is the same as ever—very ambitious and confident. He is bound to kick and fight his way to the front, and will do it without going to Paris or Rome [to study]."

Instead of Paris, Remington went to Mexico, as his fourth paid assignment in the West in four years. Henry Harper commissioned Remington to illustrate Thomas A. Janvier's *The Aztec Treasure-House* from studies to be made in the field. Eva Remington wrote that "about Feb. 1st Fred starts for a trip through Mexico. I shall go to Gloversville. Mr. Harper took him to Delmonico's to lunch yesterday & told him he was the greatest artist in America for him or the House of Harper." That was hyperbole. *Harper's* also published Remington's equals as illustrators, Howard Pyle and Edwin Abbey.

The Mexican trip took six weeks, compared to the quick visit he had made to Hermosillo in 1886. Again, almost half of the trip was consumed by rail travel, but the time spent in Mexico was utilized productively. Sketches made there provided the material for seventeen installments of the Janvier story, even though the illustrations were of poor quality. He was making pictures of an ancient culture for an author with whom he was not comfortable, and his work showed it.

Remington considered competing with Janvier by writing his own article on the Mexican army. He asked Clarke to tell him "all the facts concerning the operation of Mex regular troops in Sonora—their methods—their marching & fighting—I may use it." He did not have the opportunity to write the article, however, despite orders from the Mexican Minister of War that had made one soldier from each of the regiments available to him for a complete documentation of the Mexican military. The illustrations of the Mexican soldiers were so striking that they were used for a second Janvier piece, this time in *Harper's Monthly*. The appearance was Remington's first in the glossy magazine that was the top of the *Harper's* periodicals.

Writing the four *Century* articles had tilted Remington toward authorship. His wife noted that "Fred is still hard at work. The Century people tell him he is quite a literary man." He was not so sure. He sent an apologetic letter to Clarke about the "Buffalo Soldiers" article, asking to be absolved from the need for accuracy in details because he was now a professional writer concerned with story-telling, not truth: "There is a great deal in that article which *reads well* and has nothing else to recommend it. A friend of mine charged a reporter

once with writing what was not so, but the reporter meekly querried 'dont it read well'—'oh yes—but its a d_____ lie' replied my friend. 'Then its all right' perorated the reporter."

The reason that Remington needed to write was to get a sufficient number of his pictures printed. All of the *Century* illustrations in 1889, for example, were for articles he had written. His rate as an author was roughly $12.50 a printed page, or about $150 for two full articles. The meager pay scale for the text did not deter him. What he could not stand was getting short-changed. He told Editor Gilder of *Century* that "I was paid $100 on account for the two articles as you had not had time then, in the office, to look the matter up thoroughly. If there is any more coming to me I should like to know it and if not the determination of that fact will have a soothing effect on my mind."

He quit writing for *Century* because of the $50 he was shorted, in spite of the fact that the articles he wrote for slim pay made possible the illustrations for which he had earned $965. He was a goal-oriented man working at a trade considered to be for dreamers. He received the publishers' commissions that were his forte—soldiers, Indians, cowboys, and trappers in action—without pretense of being a pictorial historian of world-shaking events. He went where the publishers sent him, but he insisted on being treated with deference.

The *Hiawatha* illustrations that he had undertaken to do he looked upon as decorations for the reissue of a favorite book, not as researched ethnographic material. The poem was hugely popular because of its emotion and style, not its historical accuracy. His assignment was 401 illustrations. Twenty-two were black and white paintings to be used as full-page plates, one for each canto of the poem. The remaining 379 were pen and ink sketches for the margins.

He arranged to start the drawings during the summer vacation in Canton. His conception of the job as ornamentation did not require research. Right after July Fourth, he was with a Canton party of eight at Cranberry Lake. Two guides had erected a temporary camp at Witch Bay to accommodate two weeks of fishing and hunting. While most of the party was out with the guides, Remington sat in the stern of a skiff, resting his drawing board on the sides and sketching for *Hiawatha*. His wife and Grace Lynde, a teenager, were seated in the bow, drifting with him. Other days he would place his easel near a big stump on the cleared point. His habits were those of the artist alone in his studio. Grace Lynde said that "he'd sit there cross-legged painting, diddling his free foot up and down, up and down, and whistling, whistling, whistling until we all thought we would go mad."

Because he intended the *Hiawatha* illustrations to be decorative, he

insisted on a printed disclaimer in the book that they were "designed to serve directly as accompaniments to the poem," like music, and that "he had followed the poet in using a certain freedom of treatment." Nevertheless, the full-page illustrations were criticized later because "he dressed the ancient forest-dwelling Ojibwa of the Great Lake region" who were the subjects of the poem "in clothing of the late nineteenth-century Indians he had known on the Western grasslands." The drawings used as margin decorations were mainly of nineteenth-century Indian objects, the artifacts Remington had been buying on his Western trips. Thus, the drawings were not Ojibwa either, and were not intended to be.

In mid-July, while the Remingtons were still in Canton, they learned that "The Last Lull in the Fight" had won the great honor of a second-class medal at the Paris Exposition. With the exception of Edwin Abbey, the other Harper illustrators received lesser awards. The awarding of the medal to Remington had meaning for the whole art community. Some of the American critics no longer "gave hell" to Western subjects painted realistically. The American committee that chose Remington had rejected Albert Bierstadt's classic "The Last of the Buffalo" as not in keeping with current American painting styles, a move away from earlier Germanic influences that were reflected in the old "Hudson River School." The acceptance of Remington was recognition of native realism.

The second major Remington painting for 1889 was the full-color "A Dash for the Timber," a commission from the industrialist Edmund Cogswell Converse. Converse had invented a tube coupling and was celebrating his appointment as general manager of his father's company. "I have a big order for a cow-boy picture," Remington told Clarke, "and I want a lot of 'chapperras'—and if you will buy them of some of the cow-boys there and ship them to me I will be your slave." That was the same empty promise that had brought drawings from Turner as a teenager.

The dimensions of the "big order" were four feet by seven feet, as large as a mural. Remington said it was " 'bout size of Tel el Kabir," a reference to the big 1882 battle where British soldiers put down an Egyptian revolt and, incidentally, wore their red coats for the last time. He arranged with Converse to be allowed to show the painting at the fall National Academy exhibition because he had had a "heap of flattering things said" and the painting had been photoengraved for big prints in black and white and in sepia.

Remington was elated with the response to his painting at the exhibition. He reported to Clarke that " 'Dash for the Timber' in the Academy got a grand puff in the papers." The *Herald* said it "marks

an advance of one of the strongest of our young artists." The *Times* observed that "the picture before which stands the largest number of people is Frederick Remington's," and added that "the white men are of the same types we find in corner grogshops or among the bummers or in the prisons. One is prone to suspect that any defenseless Indian of either sex who came across their path would be destroyed by them at once, as a rattlesnake might."

Despite this recognition from the critics at the exhibition, Remington still had to think of himself first as a Harper illustrator in order to maintain his earnings: "Harper heard in Paris that I was 'the coming strongman of America' & he is very gracious these days." According to Eva Remington, "Mr. Harper said they wanted all of Fred's work they could use." The result, though, was that Remington felt obsessed: "I am driven to death with work and hardly have time to breathe." He declared that his address should have been "Bloomingdale Asylum," a reference to the upper Manhattan home for the insane that symbolized his feelings about the pace of his life. Eva said that "Fred is working as hard as he would if he had 40 children hanging to his coat tails crying for bread." He had become a workaholic as an artist.

Eva Remington was proud of his accomplishment but dissatisfied that his relaxation was increasingly aided by alcohol and by food. "He weighs 230 lbs," she observed, "and thinks he will have to have something that will give him violent exercise." In an attempt to break out of the pattern of obesity, Remington bought a horse "which I ride every day or I would die." Riding for pleasure did not help his weight.

He had been brought up by his mother to associate hearty eating with good health. She was of the school that thought that putting fat on the Colonel was a cure for tuberculosis. Like his mother, Remington was of heavy build, solid and thick-necked. He was very muscular with big shoulders and huge calves.

After he had the money and the status to eat and drink as much as he wanted, he did not restrain himself despite his wife's displeasure. He became a massive eater and a steady drinker who could control his weight only when his physical activity was sufficient to burn off the calories he ingested. Recreational horseback riding would not compensate for overindulgence. He was on the way to becoming a classic example of obesity, not for mysterious reasons but as the result of an eating habit learned as a child.

To avoid his wife's complaints, Remington did his drinking away from home. He maintained friendships every place he had been, in Canton and Ogdensburg and Kansas City and Brooklyn. He "used to

run up often" to Albany where he had a customer, George P. Hilton, and a drinking pal, George Hughes, who was a professional portrait painter. One evening when Hughes and he "were both feeling a bit gay," he posed for a portrait. It "was not to his liking," so Remington "smeared it with his hand before it was dry."

By December 1889, Remington was known in New York art and literary circles as an enthusiastic celebrant at stag affairs. Dan Beard, the illustrator and later the head of the Boy Scouts, recalled a dinner in Beard's honor at the Aldine Club. Remington was there and drinking. As a jibe at phrenology, Remington offered to read the bumps on Beard's head. "He was full of high spirits," said Beard, "and when Remington felt that way there was no stopping him." Remington and Beard came close to a confrontation when Beard interpreted the reading as calling him a coward. Remington could be a truculent drinker.

As a consequence of Remington's convivial wanderings, his wife was abandoned at home on Mott Avenue, her scope diminished to domestic comments about the maid who "is an improvement on my last one & I hope to keep her" and "I am going very soon to get hangings for my house and some furniture." Her resentment grew to the point where in a chatty letter to Uncle Horace Sackrider, she referred to her husband as "the 'Fatty.'" It was the same thing she had been saying to Remington's face. In return, she was no longer "the Kid" to him. He referred to her as "Madam" and "the old lady" in letters to his friends. "The old lady" was the same slur he had called his mother when she remarried. It was an abrupt change from a loving young couple to sarcastic cohabitors. She was bitter at her failure to influence Remington to control his weight, at her inability to have children, at her lack of a function outside of homemaking, and at the absence of communication with her husband. She was alone too much.

One break that helped the routine was a short visit from Powhatan Clarke in response to Remington's invitation, "You have got to eat my porridge this time or bust a flue." Remington wrote Clarke later that "Missie says 'that Clark is a funny fellow—I did not feel I knew him until he went away, and then I could see how funny he was—he was always thinking of his old war business when he ought to be thinking of something else.'"

Remington's favorite watering spot was The Players in its new clubhouse facing Gramercy Park in Manhattan. Founded by the old Shakespearean Edwin Booth, the club that had been Booth's home was primarily for actors but also accepted compatible writers and artists. In mid-December, Remington was part of a typical Saturday night at The Players, where the club filled up rapidly with members who were "not total abstainers by any means." He drank with the journalist

Julian Ralph, complaining of the same "over work and inebriety." All he had to look forward to was Christmas in Canton with his wife and his relatives. He could eat all he wanted in Canton but drink would be limited. He needed a physical break, a chance to use his muscles, to generate violent exercise that would help take off weight in the great outdoors. Ralph was a fat man, too.

On the spur of the moment, the liquored pair decided to hunt moose in the great north woods. They found Harper, obtained a commission for Ralph to write and Remington to illustrate an article on moose hunting, and still dressed in their New York clothes, took the next train to Montreal.

As Remington described the trip to Clarke,

Another man who was also insane and I started to make a dash for the North Pole—we got as far as Mat[t]awa Canada [500 miles north] and then concluded to hunt the "festive moose" as you would say. We got three degenerate Algonquins who had been doing the "flowing-bowl act" for some days & then started—we had wet weather—hard tramping—we had grub which was tough enough for an Arizona prospector. We slept in a log camp with half the roof off and as the Western man said "d_____ us we liked it too"—we killed t[w]o moose & we have "done the thing."

The result was another appearance in *Harper's Monthly,* thirteen illustrations for Ralph's article "Antoine's Moose-Yard" published the following fall.

Remington's "dash for the Pole" that left his wife alone for Christmas and New Year's Eve alienated her further. She was reduced to adding a flirtatious postscript to Remington's letter to Clarke, telling the lieutenant who was a familiar figure after his visit that he "had better come up here & comfort me in my sorrow as of course I get no sympathy from men in such a state." Remington did not even notice his wife's archness. He ended his short letter by promising Clarke a fuller story later: "I am a mental rag and like the little boy who made an error in the seat of his pants—'Ill do different next time.' "

Earnings of about eleven thousand dollars for 1889 reflected his strenuous efforts at illustrating. He was among the 10 percent of Americans with the highest individual incomes, at a time when the gap between the rich and the poor was tremendous. The number of his illustrations in periodicals had actually decreased 15 percent from 1888, but the outlets he eliminated were the ones that paid least, *Outing* and the children's magazines, *Harper's Round Table* and *The Youth Companion.*

Private sales of Remington's easel paintings had begun to grow over four years to the extent that exhibitions were listing the names of indi-

viduals who were lending to the shows. Remington said he had "three orders for oil paintings" in April and three more in December. The major difference in earnings, though, was the income from the illustrations for *The Song of Hiawatha*. He was paid about twenty-seven hundred dollars in advance, half of the commission. The proceeds from this one job provided more extra funds than the Remingtons ever thought would be theirs. Free spenders like them found it unsettling. Remington declared that he "had no capital and was trying to accumulate some but since we only go through this life but once I propose to go easy." He was still repeating what he had said as a teenager.

For Eva Remington, the way to use the extra money was clear. When they had been penniless in Brooklyn, sharing living quarters, and scrimping, she had got them by, doling out Uncle Bill's allowance until the earnings from the Geronimo trip put them on their feet. Their poverty had been a bond during working and leisure hours. Now that Remington subordinated her to his preoccupation with work, she wanted a house that would be a showplace to occupy her thoughts and her hours while she was alone.

Remington joined in the dream. A year earlier, he had said that he was buying land in New Rochelle in order to build in the summer of 1890. He went so far as to ask Uncle Horace to "write & tell me just what my indebtedness to Mrs. Levis is. I am going to buy a lot in Iselin Park and assume some little debt and I am afraid Mrs. L. will want her money meanwhile and it might cramp me like the devil. I have always paid her interest but wont now unless she demands it. It is lovely weather here. I am doing well." The indebtedness was the same two thousand dollars he had borrowed from his mother for the hardware ranch in Kansas City.

Gratuitously opening old sores was an ill-chosen accompaniment to acquiring a happy house, but by December 1, 1889, the Remingtons had arranged for their seventh home in six years of marriage. He told Clarke:

I have signed the contract for the purchase of an estate—estate is the proper term—three acres—brick house—large stable—trees—granite gates —everything all hunk [short for hunky dory]—lawn tennis in the front yard—garden—hen house—am going to try and pay $13,000. cold bones for it—located on the "quality hill" of New Rochelle—30 minutes from 42nd Street—with two horses—both good ones—on the place—duck shooting on the bay in the Fall—good society—sailing & the finest country 'bout you ever saw—what more does one want. I wouldn't trade it for a chance at a Mohamedan paradise.

I wish you could see my house—[followed by a freehand survey of the plot]

But I wish you could only see my house—my head is getting large on account of it.— The proportion is as this—[sketch of head in profile, the size of a dime] to this [sketch of head enlarged to the size of a quarter].

Eva Remington added a postscript indicating that even before they moved in, the new home made them "the happiest people you ever saw & [we] just live in anticipation of the good times we are to have there." Remington had "a studio 13 by 22 feet and a smaller room out of that where he simply keeps his saddles, costumes &c. We also have the walls of his studio full of his things. We have a delightful room up stairs about 13 by 22 that we are going to make a little art-gallery of. The ceilings are very high and is just the kind of a room for his pictures."

Remington was no longer "the Fatty" to her: " 'Darlin' is dieting & is loosing some, not so much however but what you would know him." Where "Fatty" had been hostile, "Darlin' " was tolerant. He was trying to control his weight for her, and he had produced an elegant house.

By April 9, 1890, Remington could write Clarke, "We are up here. Missie will tell you all about it." She did, in her May 24 letter headed "Coseyo:" "We just returned from a trip in the Adirondacks yesterday where we have been for ten days." Five weeks after they moved to New Rochelle, they had taken a vacation to recover from their labors.

As she had hoped, the new "small farm" brought them together. "We both dig in the garden & take all the pleasure we can out of this place and I can assure you it is a great deal. We are just as happy as we can be and perfectly satisfied with our home." She asked Clarke, "What do you think of the name we have given this place?"

Clarke did not think much of "Coseyo" (*Cozy-O*). He suggested the Apache word for "large grassy lawn." Remington scoffed at Clarke's idea and brought up " 'Endion'—whats the matter with that—sounds like Greek dont it—well its Ojibwa for '*the* place where I live.' " The Ojibwa language was appropriate. It was the Ojibwas in *Hiawatha* who had provided the down payment for Endion.

Remington had uncovered the name Endion while "floating up the Nepigon in Canada in a birch canoe" with Julian Ralph the previous month. A Chippewa Indian was paddling them when:

"A Squaw hailed the Indian from the shore.
"What is her name?" the Indian was asked.
He repeated some outlandish word.

"What does that mean?"

"That mean," said the Indian, "one black raven with wing heap red when sun go down."

"We'll see if he is on to Longfellow's Indian vocabulary," Remington said. "What do you call God?"

"Manitou-Gitebe Manitou."

"I'll get a name for my house," said Remington. "What do you call your home?"

"Tepee."

"No, the place where you put your tepee—the village—the place you always go to when you are idle?"

"Oh," said the Indian, "you mean the place where I am at? Me call him Endion—that mean where I am at."

So Remington's place was named.

12.

A War Dance in Advance

The mythology of Frederic Remington as a rough and tumble Westerner was fostered by a massive promotional campaign launched by the House of Harper in 1890. The publisher's goal was to make Remington one with his pictures, to equate the man with the violent characters he drew.

Having decided that, the publisher's next problem was how to bind the artist to the *Harper's* publications. Henry Harper's approach to controlling Remington was not to offer to hire him as a staff man—Remington was too important for that—or to put him under contract. That would have been too expensive. Instead, Harper elected to rely on Remington's sense of gratitude for his discovery by Harper four years earlier and on the warm personal feelings between them. The goal was to insure that Remington would always think of himself as a *Harper's* man first. That way, *Harper's* would get an informal option on Remington's services, without paying for it, and in return would be expected to take the bulk of his output, without guaranteeing it.

Remington wholeheartedly approved of this "gentlemen's understanding." He liked the Harpers as people and gave the firm first call

without being asked. He created the data required for his own promotion, and eventually grew to believe the story himself.

The form that the publicity took was a string of laudatory references by Julian Ralph and by the staff writers. What came from Remington's brush when he painted, they wrote, was "bits of his past" that flashed onto the canvas as if from "a camera with a memory." He was a scholar who "perfects the history which his pictures illustrate." Accuracy was his keynote: "It is not the especial beauty of Frederic Remington's drawings and paintings that they are absolutely accurate in every detail, but it is one of their beauties, and gives them especial value apart from their artistic excellence. He draws what he knows, and he knows what he draws." He "is in the highest degree realistic."

A favorite device was to make the text accompanying a Remington picture in the *Weekly* praise the artist more than the painting. Remington's realism was said to result from his unique individual experiences in the old Wild West: "To the public the strength of Mr. Remington's pictures has been a secret. That secret is that he has experienced the Western life in all its phases, in the fulness of one whose lot seemed at one time permanently cast in that country." No matter how dangerous or unusual the scene in the painting, it was an incident Remington was "too used to" to "be able to tell how many times" it had happened to him.

What he had done was "to cast aside the conventional, and to follow out his own individuality. The subjects accommodate themselves to his virile and masculine style." Using the Western army as an example, "he has lived with troops, has marched with them, and has been with them in action." He "knows his subject" so well, he was able to make suggestions for improvements in army uniforms that were "revolutionary, original, striking, and decidedly interesting."

In *Harper's* articles and later in books, Julian Ralph was the main source of Remington's publicity. He enjoyed telling stories about Remington. One anecdote featured Remington's sensitivity to Indians. When the pair were on the hunting trip in Canada with Algonquin Indian guides, Ralph grabbed a whiskey bottle from one of the guides and threw it away. " 'You madman,' said Remington, who was a hundred times more used to Indians than I; 'he will brood over that until at last he will kill you, or try to. You must never do an angry thing to a savage unless you are prepared for worse from him.' " Ralph concluded that "Remington shows by his stories and pictures that he knows" Indians "as we all ought to know our Bible."

Ralph also said that Remington could be happy eating an Indian diet that would repel an ordinary white man. On the same Canadian trip, Remington was content to share rations with the Algonquins, al-

though "mornings, noons, and nights we soiled the very forest with the eternal frying of pork. 'Fried bacon,' as Mr. Remington expressed it, 'will be found sticking to our ribs when the last trump is blown.'" The pork diet eventually turned the cast-iron stomachs of the guides without affecting Remington.

Super strength was another Remington characteristic. In the East, it served to distinguish him from ordinary Easterners.

One night after the theater, on the train home from New York, Remington was by the car window, Kemble next to the aisle. An obstreperous commuter was disturbing the passengers. On his third blatant parade through the car, and as he passed Kemble's side, Remington's two hundred and fifty pounds of bone and muscle reached out into the aisle, and lifted him from his feet like a naughty boy and laid him face downward over Kemble's interposing lap. As Remington held the ruffian, Kemble spanked him. Being done, Remington stood the offender on his feet. The man began a threatening tirade. Before half a sentence was uttered Remington had him again exposed to Kemble's rhythmic tattoo. This was enough; and when again released the fellow rapidly left the car for the relative seclusion of the smoker.

The opulence of Endion was the setting for his prosperous image:

One might hardly fancy a man of Remington's artistic proclivities caring especially for home luxuries; his pictures are vivid with the breeziness and dash of outdoor life, and on the great plains at that, with savage and half-civilized actors as the chief figures. It is therefore something of a surprise to find him ensconced in a Tudoresque villa surrounded by grounds kept as exquisitely as any of the park-like estates owned by the bankers and brokers who live near him.

As in any promotional campaign, some of the incidents related were half-truths or less. Remington's "revolutionary" drawings for a new army uniform were reproduced in the *Weekly* with text by a staff writer, but the ideas had come primarily from Powhatan Clarke in response to Remington's 1888 plea, "I enclose you some ideas for a new U S A uniform.— think em over and dont get out of patience with a d_____ citizen—ha-ha—if I didn't know anymore than you do about war I'de keep a grocery store." His acceptance of pork in the Indian diet was because he adored pork and would have been content to eat it for breakfast, lunch, and dinner at home. And, he had marched with the troops, as stated, but he had not yet seen the action that was claimed for him. He was an observer and a listener, not an actor.

The publicity did make Remington into a celebrity, the equal of those other stars of American illustration, Abbey, Pyle, and Charles Dana Gibson. While it was only within the year that "with a burst of

speed" Remington had "come very much to the front," he did not consider any of them superior to him: "Met Edw. A. Abbey to day—first time—rather nice little fellow— stuck on England— can talk American though—most people manage to forget it in two or three years." The expatriate Abbey was the *Harper's* illustrator who did the literary subjects.

Remington relished the obligations of fame. He still rose early, worked steadily until mid-afternoon, then left for a relaxing ride on horseback before dinner. Two or three nights a week, he was out on the town with the art and literary crowd. Now the excuse for the drinking was business, engaged in with his competitors and customers. His wife could scarcely object to that.

The centerpiece of his indulgences remained the all-male Saturday nights at The Players. Remington customarily got there in the evening but it was not until after eleven that the larger groups of celebrated actors, authors, and artists arrived to discuss the topics of the day on the highest levels of artistic authority. Midnight was the peak of the assemblage, when the groups became more animated. Champagne corks popped in the thick haze developed from the cigar smoke. The dining room was full. After one o'clock, the club began to thin out, although many sat "till they surprise the hush of the Sabbath morning on the streets." Remington was such a sitter.

During the week, there were frequent stag dinners, all attended by the same clique of the famous. There was a banquet given by *Harper's* for Abbey at the Union League Club. There was a testimonial for Charles Parsons. Richard Mansfield, a leading Thespian, invited Remington "to come to dinner at Delmonico's." All of these were nights free from the restraining home influences, open to any desired excess in the finest fare and rarest liquor.

Ed Kemble was available as a companion on most of these outings. He had moved to New Rochelle from Mott Haven when Remington did and continued their friendship. Kemble was Remington's age and would have seemed more suited to illustration of Western subjects than Remington because his father had been an Inspector of Indian Affairs. Instead, Kemble specialized in pen and ink drawings of blacks, a widely published star but of the second magnitude.

Their relationship was very close. In Remington's mind, Kemble had never grown up, and Kemble felt the same about Remington. They practiced each other's art as a game. Much of their leisure they passed together. In the winter, they skated and took long walks. In the summer, they swam in the Sound and played tennis. Their understanding proceeded from the similarity of their lives. They were two entrepreneurs descending from Remington's estate on Lathers Hill,

walking the Westchester byways while seriously discussing mortgage financing and the cost of domestic help, far from the exotic habitats of their artistic specialties.

One of their constant topics was the expanding use of the new photoengraving process in the reproduction of their artwork for periodicals. Kemble's line drawings were not as greatly affected because lines were more easily and truly duplicated in the old wood engravings sculpted by hand, but Remington was deeply involved. He was fascinated with the idea of using photography in a mechanical process that would reproduce his illustrations on a metal plate, fine enough to print on magazine stock and yet eliminate the sculptor of the wood block. He came to believe in later years that part of the reason for the success of commercial photoengraving was his sponsorship in 1890. He was even willing to assume the risky posture of attempting to teach his bosses. He wrote to Fred Schell, his editor at *Harper's Weekly*, that "the [photoengraved] double page this week is immense in the matter of reproduction. It comes nearly as well as in the proof. It has all the qualities of the original. It is one of those things that make an illustrator's life worth living. The point of this letter is to let you know that I am happy—& there is no charge for all this information."

An advantage that Remington made for himself over other illustrators was that he chose to immerse himself in the technical end of the reproduction process. When there was a question raised by Schell about the use of photoengraving rather than wood engraving for a particular picture, Remington called at Kurtz's process house himself so he could report back that the plate was "an entire success," just as he had declared it would be. He also took the liberty of carrying on his own experiments in conjunction with the process, and telling *Harper's Weekly* only after the result was successful: "With this drawing a little color is used. Mr. Kurtz suggested it—it is an experiment with his process." Remington had discussed the black and white drawing with the photoengraver and had agreed to add a color accent before showing the drawing to his editor. The reproduction proved to be so fine that the *Weekly* printed it as a special supplement in sepia rather than the usual black and white.

The result was that the *Weekly* deferred to him on the selection of the work it commissioned. He undertook part of the editor's function: "I would like to do a supplement" on a Henry Inman manuscript submitted to him for illustration, "but think the text to short and not of great enough litterry merit—I can do Mr. Jones adventure as a page but think on the whole that the sentiment of the MS dictates that I do a series of pen sketches." Sometimes the *Weekly* would mail Remington a group of manuscripts so the artist could suggest which would be

more suitable for illustration and what emphasis to place. His recommendations were influenced by loyalties as well as "litterry" merit: "I have a MS [by Julian Ralph] with a limit of four pages. That is a prime article. There is more good pictures in that MS for me than any I have had in a good bit. Why not let me do more. The other two MS [by strangers] are not as great in an illustrative point of view but this is."

His dealings with editors and friends were assured and sophisticated. The self-confidence he had displayed early in life had settled into poise. He still considered himself to be a nervous man but it was the kind of unrest that pushed him into extremes. He worked at his painting as excessively as he ate and drank. He could not sit still without using his hands. When he used his hands, his feet jiggled.

He managed his business deftly. The press was excitedly playing up the prospect of an imminent Indian uprising, particularly by the Sioux, but Remington knew from his army friends that in the absence of a triggering event the Sioux would not fight. They were too few and too weak. Instead of dashing to the Dakotas, Remington remained in New Rochelle to deal profitably with more routine subjects. He accepted as much work as he could get, pushed for a little more, and delivered what he agreed to do. His reliability as an illustrator was absolute. Only once did he make an excuse: "Have had a bad tooth ache and cant get at the militia business as yet but will now do it."

Some illustrations Remington painted without any advance commission, certain that *Harper's* would pay him when he sent the pictures in. He created "A Bull Moose Fight" from "seeing a place in the forest where there had been a fight," not from seeing the fight itself. He enjoyed horse shows as a spectacle and told *Harper's*, "I should very much like to do a picture of the Horse show if I was at all sure I could get a subject which I like in advance." He continued to illustrate horse shows for years.

The House of Harper respected his talent. The work he volunteered was purchased without complaint, even when there was no immediate use for it. The editors did not generally presume to correct his illustrations. When they did, he was not cooperative: "You suggest my improving the original as far as possible—that I do not understand —I have touched it up a little but its 'past all surgery' if indeed it needs any.— I return it by express." And back it went.

The Harpers also let him talk them into a series of pay scales that became administratively impossible. Remington's fear of being cheated added to the confusion: "The page drawing should come under the $100 a page contract—it is now paid for at $60. Please let me know your impression as to this. I do not understand why that material

should be $60 a page when you pay me $75 for other material which is not of the same value, to say nothing of an exception contract. Possibly I am wrong and if so I wish you would have the goodness to tell me how." He received the regular pay scale for the top *Harper's Monthly* illustrators, $60 a page. In addition, he had negotiated for $75 a page for some special assignments and $100 a page for Western excursions. This particular problem arose because a drawing made in the West was used a year after the event, rather than with the basic material from the trip, and Remington caught the underpayment.

He fought the editors to have his illustrations handled like jewelry instead of like a transitory galley of type. Editors historically considered original illustrations to be of no value apart from the reproduction. They wrote instructions and numbers all over the portions of the artwork that would not show when reproduced. Remington's deal with the Harpers was to have the illustrations for the *Weekly* returned to him after the reproduction rights had been exercised. He wanted the original pictures kept in pristine condition so he could resell them to private buyers as drawings. He told the editors, "Please do not make pencil marks on the front side of the water colors and return them to me." He knew that in the artwork, he had a second commodity to sell and he wanted that commodity guarded from the scribblings of careless editors.

As he protected what he saw as his turf, his reactions could be testy. He entered two paintings, "The Indian Trapper" and "The Mexican Major," in the Brooklyn Art Club exhibition, only to discover from press reviews that somehow the Club had inadvertently switched the titles on the paintings. He sent two quick cartoons to the official who had arranged the hanging, one clearly of the uniformed major and the other of the blanket Indian following a pack horse against a backdrop of the Canadian Rockies, adding the snide hope, "My little sketches are inexcusably bad but I rely on your trained mind to appreciate that they are not alike." His tune changes quickly when the Club sold "The Indian Trapper" for him.

The results of the Paris International Exposition in 1889 had presaged a resurgence of interest in American paintings and Remington was a strong man among the realist figure painters. His oil paintings in color began to be in moderate demand as he pushed for enhanced recognition in the world of fine art. His first one-man show was presented at the American Art Galleries in New York beginning April 7, 1890. Six of the twenty-one paintings were exhibited by permission of private owners. The show was enthusiastically received, even by fellow illustrators like Frank Millet who wrote proposing the toast, "May you never die till my dog bites you and he ain't born yet

and the pigs have ate his mother." Sales, though, were slim at the show.

In the same month, Remington also participated in the 65th Annual Exhibition of the National Academy where Millet was influential. The painting was "Dismounted: The 4th Troopers Moving the Led Horses," a cavalry tactic where one trooper frees three cavalrymen to dismount and fire by taking the bridles of their horses. The tactic was a favorite of Remington's until Powhatan Clarke told him that the device came from the European cavalry riding trained horses rather than unruly American broncos that could not be hand held alongside each other. The reviews of the exhibition did not mention Remington.

Successful as the fine arts exhibitions were, they still could not pay the bills for an estate like Endion. Remington was required to plug away at his illustrating in 1890 as he had in the past. As a prudent man, he planned his assignments year by year, to maintain the flow of work. For 1888, it had been the Roosevelt articles. For 1889, it had been his own *Century* articles and the first portion of *Hiawatha*. For 1890, it was the end of the Janvier pieces and *Hiawatha*.

Looking ahead, Remington concentrated on getting *Harper's* articles from Julian Ralph, who was a free-lance writer. Eight years older than Remington, Ralph was the son of a New York doctor. As noted earlier, he mentioned Remington frequently in his writings, never in a manner less than admiring. In the Remington social circle, however, Ralph was cavalierly treated, much as Kemble was taken for granted. When Ralph was invited to dinner at Endion, Remington told him to get off the train "at New R[ochelle] station" and "take Webster Ave Trolley." When Remington invited Ralph to dinner and asked him to bring along the popular playwright "Chimmie" Townsend who wrote in the dialect of the Bowery, it was different. Remington met the train with his trap.

In January 1890, an opportunity for a series of articles had arrived in the form of an invitation from General Miles for Remington to tour California as a guest of the army. The price was a gift of army paintings that Miles wanted:

Gen Miles sent me a nice little note [Remington told Clarke]—wanted all my work—I gasped—he would [too] if I had made him pay for it—but the Kings request is a demand so I upset N Y, got the plunder to gether, sent it to him, nice note, all about how happy I was & he replied by a very graceful letter missive which is now pasted in my scrap-book—but seriously it was good of the Gen to like my stuff and I was duly honored — &c. He asked me to come out next summer—would like to you can bet —I recon you & I could get a pack train if we wanted it. But no—

Selkirks—better mountain scenery, more game—good hotel for the old lady at Banffe.—

This was Miles using his position as Commander of the Army's Division of the Pacific to demand Remington paintings in return for access to army facilities. Remington acquiesced immediately. He knew when it was prudent to pay tribute. He shipped the pictures because he saw that as the only way to attain a privileged position with Miles, but he threw away the letter he said he had "pasted" in his scrapbook.

Remington accepted the invitation to California, substituting Ralph as his companion when Clarke could not get away from his Apache-pacifying duties. Taking Ralph was good business. It made possible a commission from *Harper's* for a series of illustrated articles on Western Canada as well as California.

As Remington implied in the Clarke letter he also took his wife along. She had announced the previous Christmas that the next time Remington and Ralph entered Canada, she would be there too, and she was when they went in July. Bringing his wife on a working trip into the West, however, would have been regarded as weakening Remington's masculine image. It would have made him an object of humor, as a squaw artist. The way he got around the problem was simple. It was just not disclosed that Eva Remington made the trip. Ralph never mentioned it in his articles. For the record it did not happen, except that Remington told Clarke about it in a private letter after he had returned August 7: "Missie and Julian Ralph & myself went to Montreal and thence to Victoria, British Colum—we had a nice trip and got some good stuff. I had the old lady packed over the mountains on a 'cayuse' and she stood the racket like a little man." A little woman acting as staunchly as a little man was a compliment from Remington.

For Ralph, however, there was no compliment: "Ralph is a large fat man & he had a little runt of a pinto—it was his first experience in the saddle and with a funny hat with a piece of cheese cloth on it, pants worked up to his knees, he did an act which made one think of Mark Twains Doctor in the Holy Land." Because he was an accomplished horseman, Remington did not see himself as larger and fatter.

Remington ended his letter to Clarke, "We saw a 'pony war dance' at the Blackfoot reserve and it was tremendous. They are a fine outfit those Blackfeet." Ralph, who had trouble distinguishing the pony war dance from other rituals, confessed in his diary to a second secret:

When we reached the Indian grounds we found that we were five weeks early. Enterprise rose up in us, and we hired the chief and his head men to order the whole tribe to do their great religious dance for us in advance of the regular season. It cost a chest of tea, plenty of sugar, still more money,

a large quantity of tobacco, but the whole tribe performed for us with mad enthusiasm. We had let loose all the savagery there in that great reach of wild nature.

Remington had his camera along as usual but photographs were limited to backgrounds and to dancers: "On no account," Ralph recorded, "would the old chief permit us to take his photograph once he discovered that the camera employed the sun to do its work."

Money could not buy portrait photography, but the chief was willing to order his young men to perform the "sun dance," for five dollars each. Ralph was revolted at the prospect of money buying human suffering so he refused the "shocking sight" of warriors undergoing self-torture. Remington, however, returned with a handful of five dollar bills while Ralph was not looking. He brought back the sketch for an illustration called "The Ordeal of the Sun-Dance among the Blackfeet Indians," posed by the braves for money, not ritual. It was just one more secret that Ralph kept in the name of friendship concerning this Canadian trip that was productive for both of them. *Harper's Monthly* ran six Ralph articles featuring fifty-two Remington illustrations.

Unfortunately, the presence of Remington's wife put strains on what would have been a carefree trip for the convivial writer and artist. The two men who were drinking companions back home fell into bad habits in Canada, too, despite their responsibility for Eva. The Remingtons broke off the joint excursion the end of July, before getting to California, and went back to New Rochelle. There was no need to fulfill the original offer from Miles because he had moved to another post.

Ralph remained on the West Coast to follow the rest of the journalistic assignments. When Ralph returned to New York a month later, he asked for an invitation to visit Endion to settle the business end of their venture. The answer he got was orchestrated by Eva Remington, who was still angry. Remington's scribbled reply read, "Your short note at hand and it will not be convenient for us to entertain guests at present. On Tuesday at 11 A M I have an engagement at Harpers and will meet you there and talk. You must be glad to be back from your long trip. Mrs. Remington sends her regards. Yours, Frederic Remington."

With his wife reading over his shoulder and adding no intimate postscript, Remington told Ralph there was no welcome for him at Endion. Eva Remington may have been the staunch "little man" coming over the mountains, but at home she held grudges.

13.

"Tally-hoeing" After the Indian Fox

Through junior officers like Powhatan Clarke, Remington had access to the details of army life in the Southwest and was increasingly able to hold himself out as a soldier artist. He had become a specialist in drawing the American fighting man as well as the Indian, the cowboy, and the Mexican. To the army, that made him the country's most valuable artist.

From their first meeting two years earlier in Arizona, General Nelson Miles had known that Remington would be useful to him and he had carefully monitored Remington's progress. Miles was the coming "king" in the military, an egotist who was a generation older than Remington. It was no secret that his ultimate ambition was to be the President of the United States. For that he needed writers and illustrators to pump out his publicity and Remington was at the head of the list. In return, Miles put the facilities of the army at Remington's disposal, offering the trip to California, tips on what was coming up for the army in the West, and easy access to the soldiers. For Remington, Miles was thus the key to the army brass. That was where Rem-

ington wanted to be, with the generals, whom he saw as his own social class.

For a tough Indian fighter, Miles held some liberal views. He had participated in avenging Custer in 1876–77 by routing Sitting Bull at the Yellowstone, deploying 394 infantrymen against a thousand warriors. He then wrote his commander, General Sherman, that "I will soon end this Sioux war, and I would be very glad to govern them afterwards for the more I see of them the more respect I have for them and believe their affairs can be governed to their entire satisfaction as well as for the interests of the government." The concept of governing for the satisfaction of the Sioux was so unusual that Miles did not get the administrative job. Instead, he was occupied with subduing Chief Joseph in 1877 and then Geronimo.

When Miles' superior General Crook died March 21, 1890, it left a vacancy as major general, the highest rank in the Army. The aggressive Miles set out to gain the promotion, inducing the West Coast leaders Leland Stanford and George Hearst to support him. He also lobbied through his wife's uncle Senator John Sherman. After two weeks of intense politicking, Miles met with President Harrison April 6, 1890, in Washington, securing the new rank and a transfer to the Missouri Department of the Army.

Miles' strategic position in the negotiations was aided by the fact that he had been on the spot in the East when Crook died, as documented in a March 25 "Personal & Private" letter from Remington to Clarke. "My dear boy___ Gen Miles had been here for a week. He invited me down the Bay [to Governor's Island]—could not go. I had him up to ride and dine with me—he feels very kindly disposed toward me." It was Remington who had been Miles' host at the opportune moment. In addition, a Remington article in the *Weekly* that praised Miles had fortuitously appeared while the General was in New Rochelle. Miles liked the article, Remington said. He should have: "General Miles has succeeded in making it possible for a white man to live in [Arizona], for until he took command an Apache Indian never had much discrimination between a white man and an antelope when he was abroad with a gun." Even the President of the United States read and was influenced by the *Weekly*, so Remington had done Miles a valuable favor.

One way that Miles reciprocated was mentioned in Eva Remington's October 23 note to Clarke: "Your letter to my 'Darlin' arrived & I opened it, as I do all of his mail when he is away. Pardon me won't you. I enjoyed it *immensely*. Gen. Miles invited my *small* boy to go with the Commission and he accepted and I am sure he will have a charming time and see lots of Indians &c that he so much enjoys. It is

a trifle lonesome for the 'Missie.' He will be gone about three weeks I think & hope not longer."

Eva Remington's "small boy" was truly in his favorite environment. He was with the official Miles' Cheyenne Indian Commission en route from St. Paul to Lame Deer, Montana, to investigate whether the Northern Cheyenne should again be moved to another reservation. In the course of Remington's task of producing an illustrated article laudatory of Miles, a small literary masterpiece emerged. A leading critic, Royal Cortissoz, praised the article "for its directness and close-packed simplicity" as "an absolutely clear descriptive statement," a rare talent in 1890. He quoted from Remington's opening paragraph: "The car had been side-tracked at Fort Keogh, and on the following morning the porter shook me, and announced that it was five o'clock. An hour later I stepped out on the rear platform and observed that the sun would rise shortly, but that meanwhile the air was chill, and that the bald, square-topped hills of the 'bad lands' cut rather hard against the gray of the morning. Presently a trooper galloped up with three led horses which he tied to a stake."

Remington's writings, precursors of the American realists of the 1920s, were as sharp a break with Victorian authors as his paintings were with the academic artists. The story line of the article matched its title, "Chasing a Major-General," in providing an impression of feelings of admiration for Miles that were aroused by the chase. When the Major-General paused to convene the meeting between his Commission and the Cheyenne that was the reason for the chase through Montana, the central event was worth just six lines to Remington. The article was not the simple boost that Miles had wanted but it has endured in reprint, fresh when Miles is forgotten.

Also present in Montana at this time was another writer and an amateur artist, Lieutenant Alvin H. Sydenham, a topographic officer. Remington and Sydenham became friends, leading Sydenham to record his memories of Remington in a reminiscence he elected not to have published:

My first personal introduction to him took place on the dusty, alkaline banks of the Tongue river, among the Montana foothills of the Big Horn mountains, to which place Mr. Remington had penetrated in company with General Miles and an Indian Commission.

We first became aware of his existence in camp by the unusual spectacle of a fat citizen dismounting from a tall troop horse at the head of a column of cavalry. The horse was glad to get rid of him, for he could not have trained down to two hundred pounds in less than a month of cross-country riding on a hot trail. Smoothed down over his closely shaven head was a little soft hat rolled up a trifle at the edges so as not to convey quite

the barren impression which you get from inspecting the head of a Japanese priest. Tending still more to impress the observer with the idea of rotundity and specific gravity was a brown canvas hunting coat whose generous proportions and many swelling pockets extended laterally, with a gentle downward slope to the front and rear, like the protecting expanse of a brown cotton umbrella. And below, in strange contrast, he wore a closely-fitting black riding breeches of Bedford cord, reenforced with dressed kid, and shapely riding boots of the Prussian pattern, set off by a pair of long-shanked English spurs.

Sydenham's description omitted one other idiosyncracy. Remington brought with him and used an English saddle, adjusted so his legs were "tucked up" under his chin to let him "loose" his seat at every alternate footfall as he had in the stylish riding academies in Central Park. Remington said that Miles "was duly amused by my teetering, and suggested to the smiling escort officers that 'he has lived so long abroad, you know.'" This was Remington playing his old Duke of Marlborough game. His costume and demeanor were a form of self-salesmanship to cavalrymen and scouts who would certainly remember him, as Sydenham did:

As he ambled toward camp, his gait was an easy graceful waddle that conveyed a general idea of comfortable indifference to appearances and abundant leisure. But his face, although hidden for the time behind the smoking remainder of an ample cigar, was his most reassuring and fetching feature. Fair complexion, blue eyes, light hair, smooth face—would probably have been his facial description if he were badly wanted any place by telegraph. A big, good-natured, overgrown boy—a fellow you could not fail to like the first time you saw him—that was the way he appeared to us.

My first lieutenant essayed the formality of an introduction, but his effort was not destined to meet with the usual success. Mr. Remington shook my hand vigorously.

"Sorry to meet you, Mr. Sydenham. I don't like second lieutenants—never did. Captains are my style of people—they lend me horses. Eh? Yes. Where do you live? Well, don't care if I do." And thus we met. Notwithstanding his acknowledged predilection for captains, commissioners, and generals, we occupied the dust at the rear of the column in company several times after that.

In the evening we wandered among the tents of the commissioners and the aids, trying to get acquainted, and partaking of the government ration, and of the strong water which does not bubble out of the rocks at the foot of the pines. Casey came in with his scouts after the moon rose. The little Indian ponies could not keep up with the big horses of the cavalry, and in the sixty-five mile march of that day they were left far to the rear. Which caused Mr. Remington to observe, as he looked at the moon:

"They say an infantryman can't keep up with a cavalryman, but General

Miles is an infantryman and he came into camp to-night half an hour ahead of that cavalry troop."

Remington praised the Cheyenne scouts as "d-andy." He was an original supporter of Lieutenant Edward Casey in the use of Indians as irregular cavalry, writing that "they fill the eye of a military man until nothing is lacking."

As an amateur painter, Sydenham did not see how Remington could function without making sketches or taking photographs:

I watched this fat artist very closely to see "how he did it." My stock of artistic information was as great when he went away as it was before he arrived. There was no technique, no "shop," about anything that he did. No pencils, no notebooks, no "kodak"—nothing, indeed, but his big blue eyes rolling around at everything and into all sorts of queer places. Now and then an orderly would ride by, or a scout dash up in front of the commanding officer's tent. Then I would see him look intently for a moment with his eyes half closed—only a moment, and it gave me the impression that perhaps he was a trifle nearsighted.

The reason Remington had no "kodak" but only his "big blue eyes" to take notes was that he had sent his regular camera to Clarke. He had bought a new camera before leaving for the Tongue River but he did not bring it along because he had not had an opportunity to test it. He did not make sketches at Lame Deer because he had previously drawn what he needed of Miles and Casey and could rely on his memory for local color.

He managed with little sleep, as Sydenham noted:

One morning, just as the grey of dawn was about to brighten the east, there was a prolonged scratching upon the fly of our Sibley tent. It awoke the ever-watchful captain; the captain kicked the first lieutenant; and the first lieutenant took it out of the deeply slumbering subaltern.

"Who's there?" growled the captain.

"It's me." The voice was Remington's.

"What do you want?"

"Breakfast," was the laconic response.

"It's too early for breakfast; you had better go back to bed," and the captain rolled over to his slumbers.

"Well, can't you give a fellow a cavalryman's breakfast, anyhow," pleaded Remington.

"What's that, old man?" I ventured.

"A drink of whiskey and a cigarette."

"Ah-h-h! certainly!" After which he went away happy.

Once Remington had arisen, he could not remain in the general's tent. He could not wake the general. As the general's guest, though, he

could try his luck with the captain, especially when the captain was his old Arizona friend Viele.

The "cavalryman's breakfast" of whiskey and tobacco was a Remington invention, a new one on the cavalry. In Remington's article, he acknowledged the cigarette for his breakfast but not the whiskey. Remington's drinking was a problem. Miles had to delay the whole Commission for one day because Remington was missing in the evening after enjoying the "strong waters" with the junior officers.

The Commission finished its business with the Cheyenne by issuing arbitrary recommendations that were never followed. The accomplishment of the Commission proved to be nil. On the way East, Miles' party "went over Custers Battle ground." Remington gave it as his opinion, borrowed from Miles, that Custer "would have licked Sitting Bull if Reno hadn't been a d_____ coward."

Remington was back in New Rochelle by November 12. After repaying Miles for the invitation to accompany the Commission by writing and illustrating "Chasing a Major-General" for the December 6 *Harper's Weekly*, he began to promote the Army's position favoring military status for Indians. In the article "Indians as Irregular Cavalry" for the December 27 *Weekly*, his thesis was that the government was "oppressing a conquered people. The Indians Bureau's management of Indian affairs is liable at any time to send wild Indians on the warpath. Every man knows that this is so, and yet the thing goes on. The army people would like to take the Indians, and the thing farthest from their minds would be to precipitate hostilities, since the War Department does not regard Indian campaigning as war." Remington concluded, "Let us preserve the native American race, which is following the buffalo into painted pictures and printed books." Indian policy became a national debate. President Harrison, General Miles, and Red Cloud favored Remington's position, while *Harper's Weekly* editorially supported continued civilian control, the position that won out.

The period of "Chasing a Major-General" and "Indians as Irregular Cavalry" was the prelude to the 1890 Indian War. As Remington prophesied, it was a war provoked by a government that treated the Indian service as party spoils, replacing experienced Indian agents with political appointees. While Casey was forming the Cheyenne scouts, 11 million acres of the Sioux reservation had been taken away for white settlement. The *Weekly* reported that "an Indian Messiah has appeared, who promises final vengeance of the Indians upon the whites and the restoration of Indian supremacy." The Messiah vision inflamed the Sioux who were led by Sitting Bull, and caused the Indian Bureau to regard Sitting Bull as dangerous. The "single spark"

that precipitated the Indian War was the shooting of Sitting Bull December 15 by the Indian police. The very next day, Remington located Miles in St. Paul, received permission to join his staff, and then negotiated a special contract with the Harpers for Indian War drawings at a hundred dollars a page. By the 17th, Remington was on his way "to meet Gen Miles at St. Paul & go on with him."

On the 18th, Remington was in Chicago, writing to J. Henry Harper, "I leave here to-night for Rapid City—near Deadwood [to join Miles]. There is going to be a row—that's settled—it was good judgement to come I think—excuse postal. Frederic R." To communicate the feeling of haste, a postcard was better than a letter, but a week later Remington was still with Miles in Rapid City in southwestern South Dakota. Nothing had happened, so when Lieutenant Casey and his scouts were unloaded from a freight train, Remington elected to join Casey and the colorful Cheyennes on another freight car heading south on the branch line. He was more hopeful of seeing hostilities in the field with Casey than with Miles, who had so far kept the peace by negotiating with each separate Indian band. Miles was satisfying conditions imposed by Washington but his officers disapproved. They wanted to meet the Indian threat head on.

On Christmas night, Casey's troop was unloaded ten miles south at Hermosa. The ponies were herded into corrals and the men including Remington went into Sibley tents. For the holiday festivities, "the Sibley stove sighs like a furnace while the cruel wind seeks out the holes and crevices. The toasts go around, brewed" as "a little mess of hot stuff in a soldier's tin cup." Casey's orders were to follow the Sioux to keep Miles informed and to continue to avoid hostilities. The troop rode to the Cheyenne River. Remington slept on the ground, taking the saddle blanket from his horse. His saddle was the pillow.

By December 30, Remington was growing concerned about what might be going on in Pine Ridge while he was isolated with Casey. Although *Harper's* said later that the "warfare drew him, as with ropes of steel, to the front of the fighting just as it began," he was no closer to a war story with Casey than he had been with Miles. He knew that there was a large press corps with Miles, filing stories that would be the usual mixture of rumors and facts. He wanted to be on the scene when the Indian War broke out, so he joined a wagon party with interpreter H. C. Thompson, scouts Red Bear and Hairy Arm, and a Swedish teamster, who were being sent the twenty-five miles to the Pine Ridge Agency for provisions and messages.

Remington and the scouts were on horseback, calm after reassurances from friendly Brule Sioux that the way was clear. At an Indian camp that was halfway to Pine Ridge, however, they became aware

that something had gone wrong. Painted Indian warriors were riding alongside the trail, circling the wagon and the riders. Red Bear was warned by an Indian he knew to turn back at once because the Sioux "hearts were bad." A band of six Brule Sioux in war paint then stopped the wagon. One asked Thompson for tobacco. Thompson gave him the sack to fill his pipe but the Sioux kept the whole bag, a deliberate insult. As Thompson said, "Tobacco was mighty scarce just then and none of us could get as much as we needed but I didn't say a word; if tobacco was all he wanted he was welcome."

Although Thompson remembered that Remington remained on his horse alongside the wagon, Remington said he had dismounted. He claimed that Thompson warned him that a buck was slipping up behind him. Thinking quickly, Remington turned and shook hands with the Sioux to ease the threat. When Remington told the story in later years, the buck had a knife in his hand.

The wagon and the riders wheeled around and started back for Casey's camp with the Sioux still circling. The scouts quickly got their rifles out of the wagon. Remington took Thompson's pistol. It looked like a fight was imminent as the number of warriors increased. Just then the wagon party met five mounted settlers who were on the way to Pine Ridge. The settlers turned back, too, and together the soldiers and the settlers made a large enough show of force to let them all get away. Remington thanked Thompson for the warning at the wagon but he was convinced that it was Red Bear who had saved his life. He never specified how.

For all of Remington's publicized participation in Indian hostilities, this was his closest brush with action and no shot was fired by the wagon party he was part of. When Remington told the story to his readers, however, he was brave, on a par with the soldiers. When Thompson told the same story to the other soldiers, he said Remington had had a "bad scare," but that any civilian "might well be excused for getting a little scared at such a time." He questioned whether Remington would have been able to use a rifle if he had to. Thompson put Remington's courage on a par not with the soldiers but with those other civilians, Remington's readers. After a few months of thinking about the episode, Remington began to agree with Thompson. He confessed that his "natural prudence had been considerably strengthened" by that "half-hour's interview" the wagon party had had "with six painted Brule Sioux who seemed to be in command of the situation." The process of turning the wagon around had taken only a few minutes but it was harrowing enough to Remington to have seemed like thirty.

He spent December 30 and New Year's Eve back with Casey's

troop. The holiday was celebrated "in a proper manner." Very early on New Year's Day, Captain Baldwin, who had been dispatched by General Miles to bring Remington back to Pine Ridge, found the fuddled artist deep in sleep. Baldwin managed to get Remington onto a horse and on the way to the Agency so that Miles could tell Remington that the Indian War was over. The twenty-five-mile ride to Pine Ridge was uneventful this time. Remington had missed the war, but he had had a good time with Casey.

To many Easterners, the Indian War was ludicrous, the cavalry in the guise of gentlemen hunters "tally-hoeing" in pursuit of the exhausted Indian-fox. To the Army and to Remington, however, it had been a serious matter. Following instructions, Miles had negotiated for the surrender of 4,000 Sioux who had come into the Agency. In an area beyond Miles' personal control, one small band under Big Foot that contained the remains of Sitting Bull's followers was in camp on Wounded Knee Creek. The band was surrounded by the Seventh Cavalry with 470 men and four Hotchkiss guns, ready to avenge Custer's debacle a generation earlier. Big Foot, who was in the act of going to the Agency to surrender, refused to give up his weapons. Fighting broke out when the Army began to search the braves for hidden arms. Nearly 300 of the Sioux were then massacred by the Seventh Cavalry the morning of December 29. That was the whole war. The Sioux from the other bands who had previously come to the Agency in peace fled in fear. They were the disturbed warriors who had menaced Remington and the wagon party.

On January 3, Remington rode over to the camp of the Seventh Cavalry. He collected the stories about the massacre from the wounded officers and men and composed it into the article "The Sioux Outbreak in South Dakota" that transformed the regiment's actions into a glorious battle. This apologia later caused considerable discomfort for Miles, who had called for a Board of Inquiry against the colonel of the regiment on the grounds of carelessness in killing Sioux women and children and in firing on Miles' own Indian scouts. The colonel was exonerated as the hero Remington had made him out to be in the article, which was called a "superb report."

Miles' long-range plans for Remington were important enough to let him forgive aberrations like independent action infrequently taken, but Miles' staff resented the burden that Remington was on them. Captain Baldwin was particularly antagonistic. He had been ordered to forsake his own holiday celebration, no small thing on a Western outpost, in order to fetch the artist, and then he had to ride back another twenty-five miles while Remington groused that he was hungry.

At Pine Ridge, Baldwin warned Remington against riding out alone

because of continuing danger from Indians around the Agency, but Remington persisted in making sketching trips by himself. Miles' staff resolved to stop him and settled on what they called a practical joke to keep him inside the Agency. On January 5, Baldwin collected six of the Cheyenne scouts Remington did not know and dressed them and painted them like Brule Sioux. The scouts surprised Remington when he was riding by himself in a lonely spot. Impersonating the hostile Sioux, they held him up at gunpoint and took his tobacco, with Remington making no move toward the pistol he carried. Baldwin never told Remington that the hostiles were masquerading army scouts. Instead, Miles' staff said later that the joke "settled the Indian question so far as Remington was concerned, and within a few hours he was at the railroad, waiting for the first train east bound." The story about the incident was circulated in the Army, and "some of the officers looked upon Remington as a man with a pronounced yellow streak." They said that the prank was without peril because the cowardly Remington would never draw his pistol. They did not credit Remington's courage in having made sketching trips by himself before the hold up, nor did they appreciate that Remington's work was finished at Pine Ridge. The war was over, and he had his job still to do.

The Washington *Star* reported the joke as "How Remington Was Discouraged." The story was not picked up in New York where Remington would have seen it. He never did know the truth about the masquerade. He told the New York *Times* what he had experienced, the hold up by the hostiles near the Agency, being taken captive at gunpoint, the loss of his tobacco paralleling Thompson's loss, his being allowed to keep his sketches that did not interest the Sioux, and the charm that his English riding outfit continued to cast over redskins who let him go. It was the Duke of Marlborough triumphant once again. He had cast himself in the role of an eccentric hero.

Eva Remington poked fun at his pretensions of English nobility by granting him a title in telling Clarke that "My Lord has come to the conclusion that Winter Campaigning is not all together the pleasantest thing in the world. He came home with a *horrible* cold." She, too, credited the way Remington dressed as the charm that had saved his life, unaware that Clarke knew the real story through the army grapevine: "He just escaped being captured by those *horrible* hostiles; had he been dressed like a Western man instead of his riding habit, guess he would not have escaped but he was a queer looking man & bad medicine.

"Too bad about Lieut. Casey," she continued to Clarke. " 'My Lord' became very fond of him." Casey was eleven years older than Remington. Unlike the rebellious Clarke, Casey's family and his demeanor

were all regular army. He had been cited for bravery, breveted in the field, and all of the categories on his efficiency report were rated excellent. There was a clear pattern of success ahead.

After Remington had left South Dakota January 5, Casey was attached to the Ninth Cavalry to keep watch on a big Oglala and Brule Sioux camp under Red Cloud while Miles sent in messengers to negotiate their surrender. Casey knew the Sioux and was encouraged by them to hope he could personally end the impasse. On January 7, he approached the Sioux camp as a volunteer to request a meeting with Red Cloud. While waiting, Casey talked to Plenty Horses who had been educated at Carlisle Indian School. When the meeting was denied, Red Cloud's emissary warned Casey to leave the area. As Casey turned to go, Plenty Horses shot him in the back of the head with a Winchester.

Plenty Horses said that the motive for the killing was to overcome the alienation from his people that had been caused by his white education. He was tried for murder and acquitted. The verdict was that he had acted in a time of war, against a scout who could have been called a spy. After the assassination, Casey's Northern Cheyenne scouts carried on as regular soldiers of the Eighth Cavalry. The troop was gradually reduced in numbers and was disbanded in May 1895.

Remington learned about Casey's death on the train going home: "I had eaten my breakfast in the dining-car, and had settled down to a cigar and a Chicago morning paper. The big leads at the top of the column said, 'Lieutenant E. W. Casey Shot.'" Remington blamed the government for having directed the army to avoid bloodshed and the integrationists for having protected the "poor savages" concluding that "where one like Casey goes down there are many places where Sorrow will spread his dusky pinions and the light grow dim."

The army still had its job to do. Miles was apprehensive that Casey's murder might slow the return of the skittish Sioux to the Agency. It did not. As Remington's Eastern friends saw it, the Indian war that was also called the Sioux Outbreak was thus limited to the one episode of a revengeful regiment "tally-hoeing" after the last unfortunate hostile "foxes," the 106 warriors led by Big Foot. Following Wounded Knee, the Easterners said that the played-out Indians would no longer be able to mount anything resembling even such a minuscule war as the Sioux Outbreak. The army and its soldier artist Remington took a different, more complex view. The war had been no fox hunt to them.

14.

An Associate of the National Academy

During 1891, the House of Harper continued its publicity campaign to enhance Remington's reputation. Remington loved it. He was familiar with how publicity worked. As he told his friend Clarke, "Take my word as a fellow who knows a little something about the advertising business."

After the Indian War of 1890, the emphasis in the publicity continued to be the characterization of Remington as the soldier artist. The way that Remington's personality was viewed by real soldiers, good natured and eccentric according to Sydenham, inebriate and cowardly according to Baldwin, never surfaced. Instead, Julian Ralph issued an official version of the Remington soldier psyche:

> The ardor that the artist has exhibited in rushing into the fighting on the plains is not to be wondered at, since his ancestors have responded to every call to arms upon this soil.
> Frederic Remington dwarfs the average man in height and width and weight, with a warm, blond, English complexion and light hair. The only contradiction between his character and his appearance lies in the fact that

he looks restful and content, whereas he is quick, nervous, incessantly industrious, and ambitious far beyond his present realization.

The building up of the West formed an era that is past; but the scenes have left him upon the stage, with an enthusiastic memory filled like a storehouse with accurate notes. Remington has had adventures in such numbers as to have made his career almost romantic, but as he never refers to them except in rough outline to his most intimate friends, delicacy forbids the exploiting of them here [whereupon Ralph exploited an Indian anecdote taken from a Remington article].

A man's books often tell more of him than his works, and so it is with Remington's library. The temptation to betray what they reveal is very strong, but it is enough to say that, though the present demand upon his pencil is mainly for Western scenes, he has other subjects at heart. His quiver is as full as ever warrior wore. His arrows are of many kinds.

It was Remington's martial genes, Ralph declared, that compelled him to become a soldier artist rather than just the portrayer of the usual Western figures. The implication in the article was that Remington believed that public interest in the West was a fad and fading, only five years after he had helped to get the boom started. He had the backup subjects for his future art researched and ready, according to Ralph. They were as plain as the titles of the books in his library, but Ralph did not say what the titles were. He did not identify the alternate arrows in the quiver.

What Remington would not do when the West faded was clear. He would not invade Abbey's turf with Shakespeare, Pyle's with pirates, or Gibson's with girls. He would do action scenes as he always had, drawn from life without requiring elaborate studies. Riders of the world, the Cossacks and the Arabs, were subjects he would enjoy doing. Travel, too—into Mexico, Canada, and the Caribbean. Hunting and fishing were additional arrows in the quiver, along with canoeing and with sports that involved horses. Mostly, though, he would stick with soldiers as alternate subjects because his friends were soldiers and the military milieu was where he was comfortable. If he could wangle a commission he would extend the scope to the armies of the world. He thought of doing historical battles, but the research for each picture would be overwhelming and he did not have the patience. He expected foreign wars soon.

When Remington made his one field trip in 1891, he combined soldiers and travel as an exercise in the development of these alternate subjects. General Miles had invited both of the Remingtons to accompany his family on a junket to Mexico that started in March. The party assembled in Chicago and then went south in style in Miles' own special railway car. The purpose of Miles asking Remington along was

to have him do the article "Gen. Miles's Review of the Mexican Army" with a full-page illustration of Miles. By the time Remington wrote the article, however, Miles was ignored in the text in favor of a boost for the Mexican Army.

Eva Remington was on her second trip in two years. She attended the review in Mexico City and declared that "there certainly is something attractive about a uniform & so much more when worn by a bright man mounted on a beautiful horse." The Remingtons met President Diaz and his wife and attended a dance at the American Ministry, seeing "every one & every thing of any account in Mexico." Eva said that "Frederic did not enjoy any too much the social part of it, but I went wild over their music, especially 'La Poloma.'"

In order to see different sights on the return, the Remingtons left Miles' party in Mexico City and headed east on the railroad, precipitously descending the mountains to the port of Vera Cruz. They then embarked on a steamer for Havana and New York. Eva called Havana "vile. Very nasty, not in the least picturesque & loads of dead cats, chickens &c lying in the streets. Excuse me from living in such a country."

Remington was back in New Rochelle the end of April, submitting drawings to *Harper's Weekly* for a double page to be entitled "The Cinco do Mayo in the City of Mexico." The *Weekly's* editor was Richard Harding Davis. He cut the space to a single page but he did not ask how Remington could draw a picture of a May 5 celebration when the artist had left Mexico before the celebration occurred. The *Weekly* also reduced to one page "Chinese coolies coaling a Ward Line Steamer in Havana," despite Remington's promotional comment that "they were the hardest looking outfit of humanity I ever saw and they are coming up here by the hundreds and are all lepers." Whites are "the people," he said, and why quibble.

Apart from soldiers as a subject, Remington never did get much of an opportunity to find out where his diversified library would have taken him. He had underestimated the continuing pull of the frontier, and the other subjects were not needed. Popular interest in the West became even stronger, and Remington was the primary practitioner of the art. The ultimate Western accolade was his:

In his pictures of life on the plains, and of Indian fighting, he has almost created a new field in illustration so fresh and novel are his characterizations, realized as they have never been before. It is a fact that admits of no question that Eastern people have formed their conceptions of what the Far-Western life is like, more from what they have seen in Mr. Remington's pictures than from any other source, and if they went to the West or to Mexico they would expect to see men and places looking exactly as

Mr. Remington has drawn them. Those who *have* been there are authority for saying that they would not be disappointed.

To the Eastern public, the West was what Remington made it. He was the one who set the pattern. When a quality Western illustration was called for, at the top price, Remington was first for the job, and an increasing number of assignments were for contemporary Western genre pictures in 1891 rather than violent historical episodes. Not surprisingly, Easterners visiting the West really did see some of the scenes that Remington was painting.

Although Remington suspected the permanence of the national involvement in the West and had planned for successor specialties, he remained in the limelight as the captive of the subject. Part of the price was that youths like the California painter Maynard Dixon at sixteen were asking his help in entering the Western field. Remington never was a teacher but his response to Dixon was considerate: "The only advice I could give you is never to take anyone's advice, which is my rule. Most every artist needs 'schooling.' Be always true to yourself—if you imitate any other man ever so little you are 'gone.' Study good pictures and above all draw—draw—draw—and always from nature."

Remington's ties to the House of Harper were still based on the close personal relationship with the family. According to Eva Remington, "Mr. Harry Harper & Mr. Will Harper came out here from town & I drove with Mr. Will while Frederic & Mr. Harry rode horseback. We arrived home at 5 P M & at 6.30 I served as good a dinner as I know how. After dinner the men discussed art, politics, war & many other interesting things & at 10 P M I made some chinese tea in the real chinese style & we sat & talked until 11 when they had to depart."

The day-to-day relationships with the *Harper's* periodicals were carried on with the editors, however, and not the owners. As soon as Remington presumed on friendship to step beyond the freedom he had had, he was brought up short. He told his editor, Fred Schell, in one ingenuous letter that he wanted to do artwork for a whole supplement on the New York State Militia, for a double-page picture of an unspecified subject, for a page of sketches on a summer visit he had made to the St. Lawrence River resort at Concuna in Canada, and for a dozen pages on "Mexican stuff." The Latin material he said "is all good stuff and I thought I would send you a list of titles but you would not know any more about it than you do now. So I will not send the list. I suppose you will not lay down a rule of thumb in this matter but take what is good that I may do, just so it is not over abundant."

Remington's inflated view of his role with *Harper's* came from believing his own publicity. Schell quickly put him on notice that an arrangement to buy every illustration that Remington elected to draw would not be satisfactory, and that the non-Western material was not wanted at all. Remington accepted the rebuff gracefully, replying that "I am sorry that Canada ain't in it. I unload that on the English," although his English outlet *London Graphic* did not buy the page either. From then on, Schell did not hesitate to return drawings for correction and to exercise his editorial judgment on the space to be provided for an individual drawing.

Remington's 1891 easel paintings in color were mainly of the Western army. When he selected his own subjects for exhibition, he knew to avoid the Eastern militia and the foreign travels that he tried to sell *Harper's*. He did a black cavalryman from the Tenth for the American Water-Color Society and an army courier for the spring exhibition of the National Academy. For the fall Academy exhibition, he asked Clarke's advice: "I am doing a big painting and I aint sure of my tactics. They are coming like hell & I want to get the title 'Right front into line, come on!' The 'Come on' is all in the expression of the officer & the bugler is blowing the Charge.— The men are large on the right & trotting while as they go away they begin to go faster & faster until on the far left they are turning double back handsprings.— Now is this right." For his fine art that was to be exhibited, he was the soldier artist, with the tactics verified, but to *Harper's* he was offering the alternate and less desirable arrows from his illustration quiver.

The effort that Remington had put into exhibiting his easel paintings did pay off. In June 1891 he was elected an Associate of the National Academy of Design, the prerequisite step to the highest honor his fellow painters could bestow, that of Academician. He was twenty-nine, an exhibitor at the National Academy for only five years, and an illustrator for six. It was a notable distinction.

Remington was now entitled to put ANA after his signature on paintings, as substantially all Associates did, but he did not. He recognized the honor that was his, and knew better than his friends who stated that he should have been declared an Academician right off rather than an Associate. He was aware that the selection processes of the National Academy were fixed. One had to become an Associate before he could receive the ultimate honor of being elected an Academician. Remington did not sign ANA after his name simply because he considered ANA just a transitory stage. He expected to be named an Academician in the next few years, so he chose not to involve himself with the short-lived lesser honor.

As a stepping stone, however, the qualifications for Associate had to

be complied with. One requirement was for Remington to have his portrait painted for exhibition at the induction ceremonies. Remington did not want to get involved with Pennington again. Pennington took forever, so he found Benoni Irwin, an established portrait painter who regularly did sitters for donations to museums, and he made a deal with Irwin. He traded his painting of Indian horses at a stream for the portrait. He must not have included a frame for the Indian painting because Irwin wrote the Academy, "I am making a portrait of Mr. Frederic Remington for presentation to the N A D for his ANA qualification and will have it ready for exhibition at the coming ex[hibition] if there is a frame available for it. If I mistake not the size is 17 X 21 inches; could not a frame which has been used before for the same purpose be used again for this." He did not conceive that Remington would be any more enduring a sitter than those older Associates whose frames he was seeking to subvert.

When Remington did not find the required portrait at the Academy as the fall exhibition grew near, he too wrote to the Academy: "May I ask you if you have received a portrait of myself painted by Mr. Benoni Irwin which same consumates my membership of the National Academy as an Associate. I ask this formally to know if I have complied with your laws." Irwin eventually found a second-hand frame and sent the portrait in on time. Many years later, Remington's Indian painting was sold at auction for the benefit of a school. It was estimated at $35,000 to $50,000 and brought $62,000, at least $50,000 more than the portrait would be worth.

In addition to the exhibitions at the National Academy, Remington conceived the radical idea of having a one-man show under his own sponsorship at a private gallery, to be followed by an auction of the paintings and drawings. An auction would rid him of the accumulation of published illustrations he could not dispose of privately. For the show, he was devoting himself "almost exclusively to American and Mex military subjects." He was even including a portrait he had made of Clarke in uniform. As he told Clarke, "I am going to sell you— d____ it you are more or less public property—Ill call you 'A cav officer' and the result of the sale may determine your popularity." The press of illustrative assignments was so great, however, that he could not manage the planning of the sale. His wife said that "Frederic got completely tired out. He has given up his exhibition for now & I am so glad for he was overtaxing himself."

After two months of hard work, Remington took his summer vacation in Canton and Cranberry Lake, as he did most years in the decade. He often stayed at Bishop's log hotel at the foot of the lake. At the dining table, two of the heaviest plank-bottom chairs would be set

before his place, close together. "Remington's big bottom would fill them both," the waitress remembered, "and how that man would eat. My, how he would eat!" His country cry was for "salt pork and milk gravy! Salt pork and milk gravy!" He liked pork and plenty of it, as Ralph had discovered, and would settle for spare ribs, pigs knuckles, or slabs of ham or roast pork when "salt pork and milk gravy" was not available.

He relaxed fishing. He caught a speckled trout that weighed more than five pounds, brought the trout into the bar, and drew its outline on the back wall. Then he painted in the fish and added a glass of whiskey in the trout's mouth that he lettered "BAIT." The guide at the hotel was Has Rasbeck, and he said that "Fred always liked 'bait' and plenty of it."

His sketching was done on the porch of the hotel. He drew on a pad, ripping the pages out and throwing them on the floor. A rifle and a quart of whiskey were within reach. If he spotted a loon over the lake, "he put aside his drawing, picked up his gun and would blaze away at the loon. He said he had shot a ton of lead into the lake and had never killed a loon." Eva Remington came along on the summer trips but generally remained in Canton.

In the fall, when Remington "got completely tired out & needed a change," he arranged for an all-male hunting trip to Cranberry Lake with Uncle Rob Sackrider and other Canton friends. A week to ten days was sufficient. The group would hire Has Rasbeck and his brother Bill as guides. The first days they would be active, hunting and fishing. Bill Rasbeck's 1891 diary indicated that they "killed 3 deer. Fred killed 2 & Mr. Sackrider one." After that they became inactive and drank. Bill's diary read, "We all stayed at the house & shot & had fun. I dug a few potatoes."

Even on a trip intended for a rest, Remington sketched. One drawing, "A Good Day's Hunting in the Adirondacks," showed a dead bear being brought into the camp. The drawing was published in the *Weekly*, along with an article "The Butchery of Adirondack Deer" by Caspar Whitney who was the expert on the outdoors. Whitney said that "we may be assured that the group of lucky chaps have not secured their venison by illegitimate means, though they should throw that steel trap into the lake instantly." This was sarcasm. Remington and the guides were hunters for meat, not sportsmen, and Whitney knew it.

Eva Remington wrote in 1891 that "our 7th Anniversary is the 1st of Oct," but Remington was still in Cranberry Lake where he stayed at the house with the guides and "had fun." She said to Clarke that "we are getting old, I can tell you. Frederic's 30th birthday will be the

4th of Oct & such is life." On the eve of his birthday, Remington was back in New Rochelle, worn out so that his wife said that "Frederic has just retired (7.45 P M). Late hours do not agree with him." She was "going to the 8.35 P M train from town to meet Papa & Mother who are to make us a little visit" to celebrate the two anniversaries. As Remington's father-in-law complained to his second wife, Fred was certainly more solicitous before he became famous.

In the blooming of Eva Remington at thirty-two, she recognized that she could not control Remington's appetite for food and drink: "Frederic took dinner at the Fellowcraft last night and does not feel any *too well* this A M. He has just gone out for a horse back ride in the country as the morning air is always bracing you know." While she was becoming more reconciled to Remington's drinking with "the boys" he was beginning to feel remorse.

I went off the other night [he said] and met about 11 million folks all "to once" and got a "jag on'" which will not become eradicated except by time and lots of it. I am not a strickly temperate man and am going to walk in the "big road" as the cow-boys say.

There is a class of d_____ fools in the world who dont know enough to drink whiskey and I'm one of them—I had always cherished a fond delusion that I was one of the men who could but I aint and henceforth "no thank you, a little Appollinaris [bottled water] please." This is no drunkards afterclap but a square deal if I have to join the "Bicloride of Gold Club" [a remedy].

Leaving his wife alone when he attended stag affairs did not concern him. What did bother him was that the effects of intoxication lingered and hampered his work.

Eva Remington knew that her husband had given her more in an economic sense and in status than she had ever dreamed of, and that she risked driving him away if she harped on his indulgences. When her father resented Remington's failure to meet him at the station, he would not say anything to her. In her new perspective, her father the "Governor" was a little man from a little town, compared to her husband.

Her attitude was mature and confident, her language clear and slangy. She prided herself on her housekeeping role as she developed roots in New Rochelle. A year earlier, her recurrent ovaritis had made relations with her husband difficult. She had had a crush on Powhatan Clarke, posting an envelope with the two-cent Washington stamp affixed upside down as a symbol of silent affection and flirtatiously telling him that "if you were near I would bore you to death by having you spend an hour or so every day teaching me French."

Now, her attitude toward Clarke was matronly, as she was superficially descriptive of the events of her day: "I am expecting an old lady some 70 years old to visit me. Horrors how I dread it for she is not interesting in the least. I am going to White Plains tomorrow to the County Fair to see the races. Mrs. Heminway a neighbor of 65 years & *extremely* interesting & pleasant has invited me to go with her party—Champagne & many other good things we carry along for our luncheon."

She told Clarke that "in the whirl and excitement of dinners, luncheons, receptions, teas & the Opera you may infer that I am all of a sudden a social leader, but not so at all. This last Thursday I presided over a tea table at a large reception. Had a charming time but it would have been brighter had there been more men present. All women & no men makes it very tame. I would rather have all women though than men if one has to meet a lot of *Its*. I hate that kind of man," the egotists and know-it-alls.

Because she was the wife of a famous artist, her friends expected her to be assertive about the latest examples of culture. She was "reading a very charming book 'Col. Enderby's Wife' by Lucas Malet. It is quite original in part & very charmingly written." With Remington and without, she attended the theater: "I heard Barrett in Romeo & Juliet last Saturday. I am not particularly fond of Barrett as he is too fond of himself & too, not as large a man as I care for." The Shakespearean favorite Lawrence Barrett was an "It."

She became more motherly toward her husband, and ceased the derogatory appellations. She saw her job as keeping him happy: "I never allow 'Darlin' to be blue in the slightest way for there is a bright side to *every* thing & a way to overcome everything. So much for the first lecture." Remington loved the popular theater but going to *Romeo and Juliet* made him blue and going to the opera made him disappear. An invitation to share a box at the opera *Otello* gave him the chance to don a tall silk hat and a dark blue coat over a jacket with tails. The accessories were tan kid gloves, patent leather shoes, and a stick with a stag horn handle, but the music was a bore. For the duration of two acts he met Lieutenant Sydenham by prearrangement at the bar in the Grand Hotel. To Sydenham, "nothing could hide his broad good-natured face and laughing blue eyes. He was different only in the surface covering from the weighty party who had descended from the horse at the head of the troop that day on the Tongue river." They talked about saddles and stirrups and curb bits, and Remington wondered if Sydenham "had heard why the Indians didn't hit him the day he rode into their advance guard in the bad lands." The chance to gossip with Sydenham was a pleasant relief from the opera.

The talk took place in January 1892 when the "Sioux Outbreak" was fresh in Remington's mind. *Harper's Weekly* was just getting around to publishing his account of a wartime visit to Brevet Major General Eugene A. Carr near the Cheyenne River in December 1890. Remington had described Carr as a "bacon and forage" colonel, the "autocrat of the cavalry camp" because the Colonel had called for a count of the regiment's bacon supply "in the quiet hours of the night." Carr had told Remington that "the stomachs of the men and horses" were "most important."

Carr viewed Remington's characterization of him as an outrage. Just as the article appeared, Carr was trying to gain promotion to fill a vacancy as brigadier general while already breveted to the higher rank of major general. The timing of the article was an unexpected blow. Remington had complicated Carr's effort by not addressing him as general, an intentional slight. Besides, the events had taken place during the Indian War when food and forage were critical, but the article was made to read like a recent happening. Worst of all, the *Weekly* article ran concurrently in the *Army and Navy Journal*. The republication in the *Journal* was intended by *Harper's* as an innocent promotional tie-in, but it reached all of Carr's peers.

Three weeks later, Carr struck back. The *Journal* published a response from his Second Lieutenant, Alonzo Gray, that "Mr. Remington's pictures of Army life are not true, and have always given Army officers and soldiers the appearance of being cowboys, greasers, or desperadoes. Mr. Remington's article deserves the contempt of all well-wishers of the Army." Unfortunately for Carr, that response evoked a professional squelch from Richard Harding Davis in behalf of *Harper's:* Remington "has done more for the Army than any artist in this country, he has taught the people of the East that there is an Army, and instead of grudging him, they should rather welcome him and do him honor. If there is one individual on the Army list who should best write [a letter of apology to Remington] it is Brevet-Major-General Eugene A. Carr."

Remington considered the altercation a big joke, a turning of the tables on a hidebound senior officer. He called these retirement-age military conservatives the "coffee coolers," the "curse of the army." Sharing the humor with Clarke, he wrote that "a d_____ sub-lootenant of dragoons roasted me in the Army & Navy Journal—its a long story and its a great scheme—I'll tell you when I meet [you]." Carr never forgot the "bacon and forage" label, although his peers, the other coffee coolers, did give him the promotion to brigadier general so he could retire with the extra pension in 1893. Six years later, Carr was still writing a letter of complaint to Henry Harper, eliciting the

flip Remington answer that "I dont see why he lugs in that old subject. He took offence where I intended none—I apologized & explained in Army & Navy Journal at the time and supposed the incident was closed. I have met him since and he was pleasant to me. But I cant bother about that now." There had been no apology from Remington in the *Journal* or anywhere else. Remington had his own concern about the Carr article when it was published January 16, 1892. He was demanding that *Harper's* pay him for the article at the extra wartime rate he had negotiated, because he got the material during the war.

Richard Harding Davis had written his squelch from San Antonio, Texas, where he was completing the research for articles and a book on *The West from a Car Window*. Remington was commissioned to do the illustrations. Like other *Harper's* writers, Davis was obliged to mention "the many compliments I have heard paid by officers and privates and ranch-owners and cowboys to" his illustrator. Davis supplied Remington, who did not make the trip, with an excellent set of photographs for reference.

Now that he was a leading *Harper's* illustrator, Remington no longer cared what critics thought about his use of photos. He even wrote on his drawings, "from a photograph" or "adapted from photographs," in instances where he was not present at the event. For his own field trips, he declared that "my drawing is done almost entirely from memory. I never use a camera now. I haven't for a year past. The interesting never occurs in nature as a whole, but in pieces. It's more what I leave out than what I add."

In addition to the Davis book, which remained in print for years as Davis' reputation grew, the other major job of illustration for Remington in 1892 was for a new gilt-top edition of *The Oregon Trail* that has since become a rare piece of Remingtoniana. This book described the 1846 journey of Francis Parkman from St. Louis to California, a classic in Western Americana. Parkman, who was sixty-eight when Remington wrote to him for detailed data, replied that "I am very glad that you are to illustrate the Oregon Trail, for I have long admired your rendering of Western life, as superior to that of any other artist." Parkman also asked, "Do you know the admirable drawings of Charles Bodmer, the artist who accompanied Prince Maximilian of Wied to the Upper Missouri in 1833 '34? He painted Indians exactly as I saw them, before any touch of civilization had changed them in costume or otherwise."

Remington's response was typical of him: "I immediately went to the Astor Library—Before that I had never heard of the book and I

was delighted. Bodner drew much better than Catlin and for refference and scientific purposes he is much better [but] I desire to symbolize the period." Remington told Parkman, very diplomatically, that Parkman would be getting Remington and not "Bodner" illustrations, with symbolic representations rather than simulations of the period.

When the book appeared, the illustrations included ten that were tinted full-page reproductions of watercolors, printed on specially coated paper. Parkman had accepted Remington's personalized approach and added a new preface noting that the "pictures are as full of truth as of spirit." To Parkman, some Bodmer "truth" was discernible in Remington's spirit, although Remington was again, as he had been in *Hiawatha*, vulnerable to the critics who dated the costumes. Parkman's praise encouraged Remington to write to "enclose a photo of myself which I hope you will accept. I am a sort of regenerated Puritan having lost the facial type but not the characteristics."

Remington's idea of himself as a proper Puritan clashed with his social practices. Some evenings he attended consecutive stag affairs. He "went to a dinner given by Poultney Bigelow Friday night & met the bright men of our times & later in the evening went to a dinner at the Union League given by Mr. Harper." That night he ate for two and drank for two, despite earlier resolutions to reform. He responded to an invitation from George Wharton Edwards, the illustrator and editor, "Your kind invitation to the Aldine [Club] to hear a superb collection of liars tell about how old the trail was when they struck it, is here. I may go, as I know you to be no better liar than I am." He went to the engagement party for the illustrator W. T. Smedley and saw the same crowd. The place cards were by the illustrators Charles Dana Gibson and C. S. Reinhardt. Among the guests were Stanford White the architect, Augustus St. Gaudens the sculptor, Carroll Beckwith the painter and teacher, John Harper, De Thulstrup, and Zogbaum.

With his wife he attended the first invitational dance at David's Island, an artillery post in Long Island Sound near New Rochelle. She went because of the social contacts, he because it was army. By the middle of the evening he was sitting alone at the side of the hall, watching the dancers. Captain Jack Summerhayes' wife Martha came over to introduce herself to him and sat down with him. An "enthusiastic woman," she told him how much his paintings meant to the army folks and to her, and she added the other laudatory comments that she believed he had come to expect in his role as a great painter. Because she thought she might be rebuffed, she was surprised when he acted

pleased and at ease and thanked her modestly and informally. She was the rare woman of his own class who shared his mood, as a man might.

Meeting Remington was an event that she recorded in the book she wrote on army life. She said that he fell into a comfortable silence, watching the soldiers who were acting as waiters as they passed by a huge flag stretched across the end of the hall to hide the kitchen. Mrs. Summerhayes asked him what he was looking at, and he replied, "I was just thinking I wished I was behind that flag with the soldiers— those are the men I like to study, you know. I don't like all this fuss and feathers of society."

Then, when he realized he had been uncomplimentary, she said that a blush came over what she thought of as "his round boyish face," and he corrected himself: "It's all right, of course, pretty women and all that, and I suppose you think I'm dreadful and—do you want me to dance with you—that's the proper thing here—isn't it?" To the surprise of his wife and the others who knew him, he "seized" her "in his great arms and whirled me around at a pace I never dreamed of." After one circuit of the hall, he had done his duty so he stopped and said, "That's enough of this thing, isn't it. Let's sit down. I believe I'm going to like you, though I'm not much for women." As an army wife, and accustomed to the gauche, she replied, "You must come over here often." He, in his best cavalier style, concluded the meeting with "You've got a lot of jolly good fellows over here and I will do it."

In Mrs. Summerhayes' recollections, Remington was made to seem backward with women, and pompous. There was no cause to think her inaccurate. He read her book when it was published and wrote her a flattering note about its tenor.

The reason he was stiff was that he carried with him village values where no gentleman was expected to be at ease with a decent woman of the same social level unless she was his wife or mother or child. After dinner in Canton, the men separated from the women and talked about business. Those were "the boys" that Remington loved. The women were left to talk about homes. If a man and a woman were marooned on the same settee, the silence could be lengthy. Remington was a throwback among his sophisticated New York friends when he was cast into the company of respectable women who were forward and talented men who were gallant, but he was representative of the average man in Canton, and maybe even a shade advanced. The same social restraints were also part of the "aw shucks" cowboy stereotype that he not only affected but had helped to create.

15.

The Emperor's Spies

Most artists who had been honored by election as Associates of the National Academy would have been quite concerned about what to exhibit in the Academy the succeeding year, to put the best foot forward. Not Remington. He believed that there was no doubt about his forthcoming election as an Academician. Consequently, he was casual in the extreme about what he showed. Goals came easy, and he acted like they did.

The picture that he entered in the 1892 spring exhibition of the National Academy was a minor pastel. The soft edged and soft colored sketch was called "The Army Packer." Priced at a full $250, the pastel did not sell, partly because the Hanging Committee thought so little of the picture they hung it where it could not be easily seen. This annoyed Remington. It was shabby treatment for an Academician-to-be.

In contrast, his major painting in color for the year was entered in the exhibition of the Society of American Artists, a group who had been the young progressives when they broke away from the Academy fifteen years earlier. They were the French and German-trained painters who even on their membership list included after their own

names the names of their European masters. The painting that Remington chose to show with these elitists who were involved in the Impressionist movement was the hard-edged "A Cavalryman's Breakfast on the Plains."

Unfortunately, he had his audiences reversed. The big realistic oil would have continued his hold on the National Academy and the soft pastel would have pleased the European-oriented Society. The result was that the Society denied that he had a role in the new art movement, and properly so. He was a Western realist, not an innovator. The Academy failed to elect him an Academician, where he thought he belonged, because they wanted a longer demonstration of his personal stability which they were beginning to doubt.

From his observations of the paintings at the Society, however, he did understand that there were things going on in European art that he should see. He had told Parkman that he would probably spend a year in Europe. Even apart from work, "going abroad" was the upper-class American's dream of happiness in 1892. Eva Remington had exclaimed that she was "wild to go to Europe & shall never be satisfied until I go around the world." She had "an idea that London social life might please," and she hoped to get to observe the German Emperor "& see what I think of his looks. He seems like a man with plenty of force & nerve."

Lieutenant Powhatan Clarke was in Germany to observe cavalry training there. That was another reason for travel, but Remington as a professional artist wanted the trip on commission from the Harpers rather than out of his own pocket. Armies of the world was a subject for paintings that he was anxious to do, but it was one that the Harpers would not underwrite.

Clarke thought he could help Remington to find a sponsor. The Lieutenant had become a celebrity in Germany, an acquaintance of the Emperor and a familiar of Americans living abroad. When Remington wrote Clarke that "we must do a trip together.– Lets go down into the Balkan states or Hungary–or Algiers.– Lets do a 'Scout with the Buffalo soldiers in Algiers.' –would nt that be a world beater," Clarke replied that he couldn't make it but Poultney Bigelow needed an illustrator for a Russian trip. Remington's response was that "Bigelow and I are all right only I don't recon we would pull double very well." Nevertheless, Remington was so anxious to go that he added, "Get me Poultney Bigelows address and I'll see if he'll pull me in out of the wet."

Remington was aware that Bigelow had developed a reputation both as a correspondent with publishable ideas on foreign subjects and as a

mettlesome partner. Just the previous year, Bigelow and Frank Millet, who was now vice-president of the National Academy, had made a canoe trip down the Danube River from the Black Forest in Germany to the Black Sea between Russia and Rumania. Like Remington who had grown up admiring the Rushton canoe in Canton, Bigelow was a canoe enthusiast. He favored Rob Roys with folding centerboards and drop rudders, two masts for sails, and watertight compartments to hold the gear for shelter and cooking.

Sponsored by *Harper's Monthly*, Bigelow and Millet had sailed the canoes eighteen hundred miles in three months. After illustrating Bigelow's article, Millet wrote and illustrated his own story of the trip, for another periodical. The competition enraged Bigelow who had thought that Millet as a painter was necessarily illiterate. The altercation was common gossip, as was the bragging of Bigelow about his sexual performances along the Danube in "every form of recreation known to the combined wits of woman and man." He claimed to have been "made honorary member of a bed" where "we did every sort of something else." In a deflowering venture "between the two virgins of Serbia," he sighed that "there was little of me left."

For 1892, Bigelow wanted to make a similar canoe trip down the Volga River in Russia but he had irrevocably quarrelled with Millet and had no other illustrator available who was a canoeist. When Clarke suggested Remington, Bigelow was overjoyed. Remington would be the best possible man for the job as an artist and as a more malleable companion, but Bigelow had assumed that the Harpers would restrict Remington to Western subjects and that Remington's own lifestyle was strictly provincial American. He recognized the plea in the message from Clarke, however, and wrote to Remington immediately to involve him in the project by promising that if the Harpers would not foot the bill, he would get the commission from *Pall Mall Magazine* in London. He also expressed the opinion that there would be a war between Russia and Germany in 1892. Remington the soldier artist would be on the spot in Europe for an intensive study of major armies of the world in conflict.

The prospect of seeing war intrigued Remington. He alerted Clarke: "I go to Europe and while my plans are not yet matured I hope to be able soon to tell you at what particular point in Europe you can go to and gaze once more upon my classic form. To a man up a tree it looks as though there would be a war in Europe this spring. How is that? Bigelow thinks *yes*." Eva Remington was less trusting. She comprehended that Bigelow was leading them on about impending hostilities and asked Clarke, "Are there any prospects of

war there this Spring. I hope not. Should think we might hear something of it, if there was to be." She distrusted the whole concept of the Russian trip. "I discourage it," she said, "as I think it very unsafe. I have no desire for them to suddenly take him to Siberia & a man who is handy with his pencil & likes soldiers is liable to be looked after more carefully than he may desire. There are many more interesting places & countries to go to beside Russia. India is not so bad."

Remington, though, was hooked. "Well I hope to come over," he told Bigelow, "and would be glad to work for the Pall Mall Magazine. Would they give us six articles and give me 5 or 6 pages at $125 a page? Hope to hear from you soon and if everything is straight 'I'm wid ye.'" To play up to Bigelow's superior position as a foreign correspondent, Remington added a few timeless words on politics: "Things are badly out of joint in the U.S. The West and South and East are fighting each other in Congress. This sectional difference is inevitable and will increase. It bears danger in it to the Republic. The Republican and Democratic parties are disintegrating."

He did not object when Bigelow altered their itinerary from the Volga River to the Amber Coast of the Baltic along the Gulf of Finland, particularly since the Harpers appeared to have changed their minds about sponsorship. The Harpers understood that Bigelow and Remington were going in any event. Remington acknowledged to Bigelow that "the plot thickens—Well, if Harper puts it up that way I'll go to Russia or hell or any undeveloped country with you. —I'll jump Harper a little and report."

Early in February 1892, Bigelow came over from Germany to New York to resolve the commission from the Harpers. He drafted a formal proposition on the stationery of the Century Club on 43rd Street, providing for a "canoe cruise from St. Petersburg to Berlin along the Gulf of Finland. This is the country likely to be fought over in the next war & is the part in Russia where are the most troops. Six articles shall come of this trip, written by P. B. and illustrated by F. R. The country is thick with troops under canvas." The suggested articles included the Russian cavalry, a profile of a Russian colonel in the Imperial Guard, the German Emperor at manoeuvers, a German military horse farm, and "other subjects [that] will offer themselves no doubt." Bigelow concluded, "I do not wish expenses but am satisfied to have same rate of payment as Danube trip. I expect to have ample official and social protection in Russia." His experience with Millet in mind, Bigelow had Remington sign an informal agreement certifying that the artist would stick to his art, leaving Bigelow as the only writer on the trip. Bigelow's rate was about $750 an article. Remington was to receive $125 a page, or about the same amount per article, but in his

mind only an innocent like Bigelow would have refused an advance to cover expenses.

Remington was assigned to do a promotional piece on his partner for *Harper's Weekly*. For publication, he called Bigelow an outstanding citizen of the world and a true cosmopolitan. The puffs were lavish: Bigelow "knows half the distinguished soldiers and diplomats of Europe, and goes to the reviews and manoeuvers on horseback behind emperors or on foot with the peasants, always singing or digging for facts." Privately, as Remington told Clarke, he regarded Bigelow as "a natural chump." His complaint was that Bigelow still treated him as the junior partner, without being competent as negotiator or leader.

In contrast, Bigelow wanted to be recognized as Remington's discoverer, to reinforce his position as senior partner. He thought of himself as a misunderstood man. He was disappointed and disgruntled because others like Remington and Roosevelt, whom he considered less able than he, were forging ahead.

Bigelow said publicly that he was happy to make the journey just for the joy of Remington's company, although he was willing to be paid "handsomely in coin" as well. In essence, though, he was patronizing. His private opinion before the trip was that Remington "knew no language but Rio Grande slang," unconnected by grammar. Remington "was honest, blunt, witty—usually wrong, but ever entertaining. The wrong sprang from his provincial braggadocio." Bigelow's tactic was to boost Remington as an unschooled illustrator but not as a fine artist. "He agreed to go to Europe, but only for the horses—not for the art galleries. In colour and composition he was lamentably crude. Rubens, Titian, Raphael, Van Dyck, Durer—all these names meant no more to him than Mozart and Beethoven to an African." That was Bigelow's viewpoint. Remington's fellow illustrators had the opposite opinion. They were afraid that exposing Remington to European art might weaken his uniquely American talent.

On March 2, Remington wrote Clarke about their planned meeting: "I am to be in Berlin by the first of June SURE." He continued, "I am afraid I wont like Europe. I was born in the woods and the higher they get the buildings the worse I like them—I'm afraid those Europeans are too well set up in their minds for me—but you can't tell." He had joined the New York Canoe Club and was prepared to fly the club's burgee on his craft, but Remington and Clarke did not get together because Clarke was transferred back to the states.

With all in readiness, Bigelow sent a postcard to Henry Harper at Franklin Square: "Sail with Mrs. B. on May 19 with Remington." The voyage was on the luxury steamer of the North German Lloyd line to

Bremen, Germany. Mark Twain took the same trip just a month later and said that "this is the delightfulest ship I was ever in. One can write in her as comfortably as he can at home."

Eva Remington did not go along. She had become a strong-willed woman, not accustomed to denials from Remington, but the wives were not included in the men's friendship. Mrs. Bigelow had her own life as a novelist. Eva would have had to be alone for a month or more in London or Berlin where her continuing ovaritis could have been troublesome. She did not show pique at being left behind but where she had saved Remington's letters from most business trips, she did not for this one.

In Berlin, Bigelow took Remington to lunch with the Emperor who had seen Remington's illustrations and had liked them. Remington pretended he had had an "interesting time," but he was out of his element. He had a natural antipathy to Germans. He did not speak the language, had trouble fielding questions in accented English, and felt awkward. The Emperor invited Remington to return for dinner and was amused when the artist did not accept what would have been a command to members of the court.

Remington was necessary to Bigelow and the Germans. He was a natural cover for them. The Germans were busy acquainting Bigelow with their system of acquiring espionage information. The itinerary for the canoe trip had been switched from the Volga River to the Gulf of Finland at the request of the German Army, which was looking for data on Russian military activities around the Baltic. In addition, Bigelow was closeted with a large landowner from Poland "who prayed for the day when Germany should invade Russia, put a stop to the Russification of Poland, and make Warsaw once more the capital of a great nation under Hohenzollern suzerainty." Bigelow was set up as a conduit for military data that the Pole might unearth.

Another cover Bigelow had was a commission from the United States government to "make a report on the best means of protecting our [American] sea-coast against the ravages of wind and waves, particularly [in line with] what had been done along the sandy shores of the Baltic." This was ostensibly to apply Russian knowhow to the Long Island and New Jersey beaches, an inquiry that was not the most believable basis for the Baltic expedition.

Remington had no inkling of Bigelow's mission. He avoided the Emperor's formality in Berlin, suffered the train ride to St. Petersburg so they could obtain the routine approval of the Russian government for the canoe trip, and was pleased to find that the Russians would treat them well: "Champagne and everything else! Got out a whole regiment of infantry to drill for us." He was uneasy, however,

remembering his wife's misgivings. He complained that "you felt all the time that there was a pack of spies at your heels and that the first thing you knew you'd be digging salt in the mines of Siberia." His feelings were colored by a popular American novel he had been reading called *My Official Wife* by Richard Henry Savage that described the revolutionary Russian underworld.

The two correspondents were ensconced in a luxury hotel while they awaited the permit. Suddenly, without warning, Bigelow disappeared, and Remington's apprehensions were magnified. He spoke only English, "and even the lettering over the shops was foreign. He felt a loneliness never before experienced." His confidence as an important figure in American art had been diminishing during the few days in Russia. Now all confidence had evaporated and he was reduced to the depression he had experienced in Kansas.

The Russians were aware that Bigelow had slipped away, and they concentrated on Remington, the only lead they had. He was "mysteriously hounded by men who asked questions in tongues that he did not understand—who opened his door softly and peeped in, and said something strange and then softly stole away. Remington saw Siberia, whether asleep or awake." He "lashed himself into a fever of imaginative misery which was not alleviated by frequent recourse" to brandy.

When Bigelow reappeared after three long days, Remington "was pacing the floor in mental agitation. His face was flushed." Bigelow's explanation for his absence was that he had had to make a private contact that required "elaborate tactics" to fulfill one of the promises to the Harpers about research for an article. Remington accepted this. What Bigelow did not say was that he had clandestinely met the Polish landowner from Berlin and had picked up secret military data to be conveyed to the Prussian General Staff, including the plans of a Russian fort.

The Russian political police kept up the pressure. When the pair went out of the hotel, their room was searched openly to let them know that everything had been handled, the writings and the drawings particularly. The storage compartments on their canoes were broken open. Even Remington began to suspect that the canoe trip would never take place, and that the reason was Bigelow's connection with the Kaiser. Bigelow quoted Remington as saying in lachrymose tones, "I don't mind being shot, Big, but don't let them lock me up in a damp cell! Get me out of this damned country."

Despite Remington's unease, Bigelow continued with the pretense of getting the permit to complete the canoe trip. He hurried from bureau to bureau, professing to be as virginal as the Serbians along the Danube, and giving the fullest guarantees regarding "the purely inno-

cent nature" of the cruise. "What can be more innocent," he protested, "than the question of tree-planting along the sea-shores?" In spite of his claims, the political police were now wary of the pair and refused the permit, advising them to leave Russia. The American Embassy would not substantiate the seashore story and recommended prompt compliance with the advice of the political police. According to the "charge d'affaires, we would be reported missing. The police would inform our Embassy that we had been killed by brigands." In short, the correspondents were informally deported.

The transport chosen to get back to what Bigelow called "a civilized country" was a river steamer. The pair became more cheerful as they approached the frontier. Remington began to make little pencil sketches as they moved along, but they were still under surveillance and the political police stopped him. "We were politely escorted out on to Prussian soil near Tilsit—but our escort was armed." They spent several days in the first East Prussian frontier fort. Remington was so relieved to be out of the Russia he saw as a prison that he overlooked the fact that Bigelow had caused his predicament.

Bigelow began to prepare the articles and Remington immediately commenced the illustrations, working from "his remarkable powers of memory and vision. This I emphasize," Bigelow declared, "because many a jealous rival has taxed him with employing the camera to excess. The truth is that Remington could see more than his peers, and could retain longer the impression made on his mind."

From Tilsit on June 11, a more confident Remington wrote to Ralph, "Here I am on German soil—thank God. Bigelow and I have been fired bodily out of Russia. We dodged the police telegrams and got off with our notes and sketches—you talk about Ingins—they aint in it. I have been as lonesome as a toad in a well—cant talk the d_____ language. Well adios, old man—you know that God loves a cheerful son of a gun and he hates me."

Four days were spent at Trakenan, the Emperor's horse farm. They then went to Berlin where Remington caught his breath before heading on to Paris alone. Bigelow was busy in Berlin. He had risked their lives because of his strong feeling about "the offensive attitude of Russia against the Germans of the Baltic provinces," and now his job as courier was complete. "The information I had brought from Poland was imparted to William III in conversation at a Court ball," Bigelow said later, "and he was keenly alive to its value, if confirmed. The General Staff sent an admirable officer in disguise to inspect these works." Russian "military movements on the frontiers of British India were on such a scale as to draw the German General Staff into friendly relations with the Intelligence Department of the British army," so Bigelow dropped a "hint" to the British government as

well. He did not appear to have reported to the American government, even about the seashore he did not see, because General Miles wrote a letter marked CONFIDENTIAL not to him but to Remington, expressing interest in the illustrations of the Prussian Army.

Remington contacted Bigelow from Paris on June 25, complaining that "every son of a b_____ in France is trying to get my money. I have to cough up at every step. Why even in the water closet there is a man who wants you to render unto Caesar. They are a miserable set of petty thieves." Remington boasted that he forced the watercloset attendant to earn his money by making him "hold my head while I abort." He did seek out the art galleries, coming away "with a general feeling of dissapointment although I have learned much." He saw the Impressionist paintings of Monet, who was later to have a major influence on him. He "did not stop long in France—I dont like France—and they were doing me up in good shape to the tune of $20 a day (this for the mere right to live and breathe & have my being) and as I had a contempt for them and was not very well amused I took my sneak."

Two days later Remington was in England, which he liked: "Got to London with out having my cargo list in the channel although it was a narrow squeak. Have been to Buffalo Bills—on the Thames, and to day to a Guard Review—I have 'slummed it' in Whitechapel. I got some London clothes and am a very nice young man but have great difficulty with the cab drivers whose pronunciation of English is so different from mine. You should hear me tell a cabbie to go to the Bath Hotel—you would think I had two sweetbreads in my throat." He could not make his Duke of Marlborough act play in England, where the Harpers' English agents were his guides.

Without expenses advanced by the publisher, he was becoming concerned about money and thinking ahead to his work. "Will you write Harper," he asked Bigelow, "and tell them when and what you are to write so that I can get the illustrating." To that point, their deportation had not "been written up much," he said, but all at once the contretemps went public: "Harper is burning the ocean cable for the material of 'how we were fired.' I know so little about what happened in your official relations in Russia that I can say nothing. You can speak for both of us."

The New York *World* called "the expulsion of Mr. Poultney Bigelow and Mr. Frederic Remington from Russia 'an international episode.'" From a safe distance, Remington was able to speak with restored confidence: "Had a very polite invitation to get out of Russia and accepted with out hesitation. '*Chased* by the Czar'—hows that. We left them alone with their cholora & fleas—oh—how I hate them."

Armed "with a bag full of sketches," Remington announced that he

would "sail on the 2nd of July for God's country." Bigelow called him "good as gold" because he "never once upbraided me whom he might have charged with most of the calamities that fell upon us." He claimed that "Remington treated me as his trusted 'bunkie.' Drunk or sober he was white through and through." This was a change from Bigelow's earlier attitude, but it was faint praise, couched only in terms of Remington's loyalty to Bigelow and not Remington's general qualities as a person or an artist.

Remington arrived in New York Saturday morning, July 9, having by then concluded that he had had a "fairish time in Europe." His wife took over the supervision of his activities. By July 22, she had "decided to leave for Canton. Frederic is tired out and must have a rest & change. I am very happy now." They were back in their regular routine. Remington bought a sixteen-foot Rushton canoe in Canton and had his cruise after all, five days to descend eleven hundred feet in fifty-one miles on the Oswegatchie River with Has Rasbeck. The result was the sensitive Remington article "Black Water and Shallows":

The long still water is the mental side of canoeing, as the rapid is the life and movement. The dark woods tower on either side, and the clear banks, full to their fat sides, fringed with trailing vines and drooping ferns, have not the impoverished look of civilized rivers. The dark water wells along, and the branches droop to kiss it. In front the gray sky is answered back by the water reflection, and the trees lie out as though hung in the air, forming a gateway, always receding.

The ramifications of the Russian trip continued for years. In August, Bigelow announced that the Russians had finally "through some strange freak" granted the canoe permit for the Baltic cruise. The offer looked like entrapment, and he did not go. Despite the danger of being compared to the "tricky behavior of Millet," Remington thought about a book—"'A Mimic War' or something like that"—but he did not do it. He tried unsuccessfully to involve Clarke in a book on the German army: "It is not yet settled that you wont write a German book for me—Army of course—Bigelow is no good—turning in rot." To repay a fine that the Russians had levied against the canoes, Bigelow reported that "the Russian Government offers us the sum of 174 marks and 70 pennyfigs, representing 86 roubles and 46 kopeks of Russian shin-plaster." He pressed Remington to complain to President Cleveland, evoking the measured response that "to overdo the thing will serve to make us notorious without any particular compensation."

For all that Remington had debunked Bigelow to Clarke, saying that he was a chump and that he wrote rot, he could not overcome the subservient feeling he had had at Yale when Bigelow was a sophis-

ticated older man and he was a country kid without apparent talent. He played up to Bigelow's narrow opinions by saying that "you should hear me talk up William III and a bas Bismark—you captured me" and "D_____ those stinking Russians. Hows that—does it echo?" Bigelow reported that the Emperor "said he had looked over all your pictures and thought they were splendid and proposed getting up a little present for you." The letter was followed by the gift of "His Majesty's photographic picture, framed and bearing the Imperial autograph, which His Majesty has been graciously pleased to bestow upon you." Remington told Bigelow that he "acknowledged the courtesy to the Minister in a letter so formal and cold that you could freeze beef on it," but he held on to the pronouncements from the German government that announced the presentation.

Contact with Bigelow brought out the worst in Remington— drunkenness, depression, panic, intolerance. It also produced violent bigotry. Bigelow's writings were a catalog of the hates that consumed him. He was a complete anti-Semite, justifying his libels by quoting anonymous sources like "a Russian who is not a Jew-hater by any means" and "some friends in Georgia and Alabama who were in no sense Jew-haters." He had side ventures into anti-black and anti-feminist sentiments, and he evoked similar threats of violence from Remington:

> Just gotten your Russian Jews [article]. Very interesting and dead right —make all the Moxies crazy and red in the face—but they can't get hunk with a white man 'cept quit lending him money—and we dont want money—hey old man. Never will be able to sell a picture to a Jew again— did sell one once. You cant glorify a Jew—coin "loving puds"— nasty humans—I've got some Winchesters and when the massacreing begins which you speak of, I can get my share of 'em and whats more I will. Jews —inguns—chinamen—Italians—Huns, the rubish of the earth I hate—Our race is full of sentiment and we invite the "rinsins—the scourins and the devils lavins" to come to us and be men—something they haven't been, most of them—these hundreds of years.
>
> These Russians would have none of that—they have abated the Jew and defy the world—I rather admire them.

The same week, Remington wrote to Powhatan Clarke that he was "jamming away on Cossacks—got to tackle the stinking Russian Jew next and ought then to do dogs—'The Rise and Fall of the Russian Pup'—how would that do—little worse than Jews. How in hell is a man to create an interest on such loathsome coin loving puds as these."

The letters to Bigelow were not all preserved in the original. Some survived as strained through the strange sieve of Bigelow's transcription and selection. As Remington wrote later about the inter-

preter Sundown Leflare, whom Ralph and he had met with the Black-feet in 1890, you could not always tell how much was the source and how much the medium. Bigelow sometimes edited as he transcribed. If the comment was about him and favorable, he might add exclamation marks. If the comment was about the Germans and it was blasphemous, Bigelow deleted it.

The Remington letter about Jews as "coin loving puds," however, has survived as written. It was vintage Remington, modeled after Bigelow. The violent language reflected the inner antagonisms of many of their class in the 1890s, the fear of the descendents of the first American settlers that they were being overrun and outnumbered by the poor of Europe. Each month, ten thousand Russian Jews were entering the United States, according to *Harper's Weekly*, and their most frequent occupation was tailor. It was understandable that some of the old Saxon families felt threatened.

Part of Remington's personal problem with the "rinsins and the scourins" was morbidity, an unhealthy dread of disease he expressed both verbally and in his need to keep clean. Bigelow attempted to excuse the artist's "diatribes against nations and races" on the ground that "he knew of them only the poorest." The lowest class of Chinese laborers was seen as lepers, and the most economically disadvantaged Europeans were thought to spread cholera. In Remington, these poorest of the immigrants evoked the fear of the diseases they could have carried.

"Inguns" was a surprise entrant among the "rubish of the earth." They were not immigrants to be classed with the Italians and Jews, and Remington's public posture was supportive of Indian rights. The inclusion of "Huns" was odd as addressed to Bigelow, a Hun lover. The letter was an impromptu communication, written while drinking, but it was true to Remington's feelings and to the feelings of most of the leading figures in his life. In addition to Bigelow, Julian Ralph wrote of Jewtown. The author Owen Wister rode with a driver to avoid sitting with a "Hebrew drummer," and Theodore Roosevelt shared Remington's fear of Orientals and popularized the "yellow peril."

The pogroms that Bigelow praised were real, though, and Ralph, Wister, and Roosevelt did not offer to join in with a rifle, as Remington did. If they had made the offer to shoot, they might have done the deed. Remington talked about violence, but never acted violently. True to his trade, however, he did not draw Jews as "puds" or Chinese as lepers. They came from his brush as humans, different but attractive. He did not use his art as a weapon to paint a picture that would mock or detract.

Where Remington did intend to use his art as leverage was against the National Academy. The treatment he had had at the hands of the Hanging Committee of the National Academy for the spring exhibition still rankled. The rebellion he decided upon was as radical as a shooting, but it was an act he could take with a paintbrush. In November 1892, he began to put together a collection of one hundred of his own pictures that he could exhibit in a one-man show and sell at auction in January, in lieu of participation in the 1893 exhibition of the National Academy. Some of the paintings were left over from the aborted sale the previous year, some were illustrations, and some were done expressly for this exhibition. He had won a reputation as a hard working painter. His "amazing industry" was the talk of his fellow professionals. Now, he even avoided writing letters because of the inroads on his time and he got the paintings ready. Publicity for the sale was nationwide.

The January 13 auction was reported in the press as a news event. Ninety-six pieces were sold for $7,300. With one exception, the watercolors brought $25 to $65, "prices that were regarded as not large." The paintings sold for $100 to $410, not quite the estimated prices, while the drawings were knocked down at $85 to $100 and "the buyers tumbled over each other in their eagerness" to get them.

Remington called it "a rather good sale. I have since many orders." His wife also took a cheery view, saying "he feels well paid for his work." It was apparent, though, that the average price was about $75, and that the oils and watercolors sold below market. Worse, the auction as an act of rebellion against the National Academy was self-defeating. The Academicians were annoyed rather than impressed that Remington's sales were about the same as the total of all sales at the Academy show. He was labeled unreliable and he lost momentum for selection as an Academician.

Preparing for the auction sale had been such a strain that Remington admitted that "I am getting crazy to be out in the woods, plains or somewhere, where the air and clouds are and where the pestiferous human is not." Two weeks after the auction both of the Remingtons were ready to head West, along with Will Harper, on a commission to write and illustrate articles on ranching in northern Mexico. Eva Remington expected to "have my hands full" with the men. "Will simply tie a string to each one of them & allow them only a little way out, never out of sight."

Remington saw the trip on a grander scale, as he wrote Bigelow January 29, 1893: "To-morrow—to morrow I start for 'my people'— d_____ Europe—the Czar—the Arts—the Conventionalities—the cooks and the dudes and the women—I go to the simple men—men

with the bark on—the big mountains—the great deserts & the scraw-
ney ponies—I'm happy." He had been at work for four uninterrupted
months and that was the end of his attention span.

The first stop was in Detroit where the men left Eva Remington "to
be very gay" with a friend, "a great social woman who has a beautiful
home & spends her time & money in making people happy. Shall go
from there to Dayton, Ohio & visit my brother & then a *short* stop at
Chicago & also in Kansas City & then rush South to meet those men."

The men saw Miles in Chicago, photographed a drill held just for
them, and were next heard from "on schedule time" in Chihuahua,
Mexico, February 7. Remington told Henry Harper that Will "is now
reposing on the breast" of the Western people, and that "no one out
here has encouraged us to leave." Their destination was the remote
ranch called Bavicora, 225 difficult miles northwest of Chihuahua.
After a week of rail travel, it involved days on a stage and then on
horseback. Remington called Bavicora "An Outpost of Civilization"
but he meant that it was one of the few remaining outposts that civili-
zation had not reached. It was in the Sierra Madre, near the former
"summer place of 'a nice toof old geezer' named Geronimo."

The host at Bavicora was Jack Follansbee, the kind of "simple" en-
trepreneurial Texan Remington described as one of "his people." He
romanticized Follansbee's story, the American cowboy who rode in
and said "I will take this" in 1882, then chased off the Apaches and
built the estate. Follansbee's reality was that when he was a Harvard
freshman and William Randolph Hearst's best friend, his California
family lost its money in the stock market. Hearst's father bought
Bavicora and made a gift of an adjacent hundred thousand acres to
Follansbee just so the two young men could be neighbors. Hearst
remained Follansbee's patron, enabling him to "gallop around so fast
one only sees you through the openings." He was able to flit all over
the world on Hearst's money.

After four weeks of cowboying, Remington had accumulated mate-
rial for three articles for *Harper's Monthly* and one for the *Weekly*,
as well as reestablishing himself as the Mexican "sharp" to handle fu-
ture articles for related news events that would occur. He wrote to
Clarke from Albuquerque, New Mexico, on the letterhead of the San
Felipe Hotel: "The old lady arrived last night from the East and I
caught her just as she fell of the car platforms. We are paying $5 a
day," and he drew a line connecting $5 to the statement on the letter-
head, "Rates $2 to $3 per day," "—this is a bluff on the part of the
Hotel.—" The next stop was Zuni. Remington wired ahead to alert
the colonel in command at the fort and he carried letters from Miles,
but his wife and he were turned away at 2 A.M. The angered Reming-

ton, insulted in front of his wife, looked to Clarke for revenge: "What *do you* think of that? Is that the kind of sporting blood you have in the army? I want Col H hair—that is I want to know how to take it off if he ever gets in a 'tight.' "

From Zuni, the Remingtons took the train to California. Eva Remington said that "I think Southern California sort of a dream land & at Coronado Beach it is simply perfect for one who wants to rest & do nothing. Frederic never did sleep & eat so much." He was making up for Bavicora where he spent "17 days on venison—coffee & flour—put a 3 gallon coating on my stomach." He had told the stylish Clarke that "I want to tell you how thin I have gotten—I could wear your pants."

Outside of San Diego, he sketched at the Putnam family ranch. Arthur Putnam was the youth assigned to getting the horses to "cut up" for him. When young Putnam applied for admission to the Art Students League years later, the sketches he submitted were rejected as copies of Remington. He was admitted only after it was explained how he had been influenced by Remington in the flesh, and he went on to become a Western sculptor.

From San Francisco, the Remingtons turned toward home, although he had promised Clarke that they would stop off in Fort Custer for a visit. The reason he gave Clarke was, "I didn't tell you why I had to hurry home from San F but I got a chance to make $40 000 and I 'rolled my tail.' Thats all—Am no end of sorry." There was no $40,000 to be made. What had happened was that Eva Remington became ill again, and the malady lingered after they were back in New Rochelle: "We were all torn up here with decorators for five weeks & in the midst of that my eyes gave out & I have belledonna in them for ten days. No sooner were those better than I took a severe cold bringing on *ovaritus* & I was in my bed nearly ten weeks & have only been out one week so you see I have had my hands full." Ovaritis, her chronic complaint, was an inflammation of the ovary, and sterility was a possible result. Although ovaritis may have been the cause of their not having children, neither of the Remingtons evidenced regrets at being childless.

Despite his fear of disease in strangers, Remington was loving with his wife in her moments of illness: "At times Eva had very severe pains and was terribly ill for a number of hours. I have seen Fred take her in his arms and carry her across the house and up to her room, putting her to bed—tenderly as a child—often he would hold her in his lap." In contrast, he would not consider spending the summer with the Bigelows in the Austrian Tyrol because there was cholera in France.

16.

My Friend Clark

Remington had a rare capacity for retaining friendships, despite a celebrity's usual imbalance of receiving more than he gave. He had pals in the North Country and Albany and Kansas City, as well as in the military and among his neighbors, the artists, the actors, and the writers, the bankers and the brokers. It was an amazing multiplicity of males, thirty-five or forty friends who could be called close. Most of them believed in him as a unique talent and a highly individual personality, and their warmth toward him when they were apart was maintained by the frequency that they saw his art in print. They felt that seeing his illustrations was like being touched by him.

His home in New Rochelle provided him with an opportunity to meet the sophisticates of the day. He rode in to New York City with Eddie Foy or Francis Wilson of the stage or George Chester, the author of the best-selling book *Get Rick Quick Wallingford*. The playwright Gus Thomas had built a house in New Rochelle in 1892. He established a liberal literary and art circle that included Remington and Kemble. Men Remington would not otherwise have met like the atheist Robert Ingersoll were often Thomas' guests. Such associations

provided the newly urbane Remington with many of the jokes of the literati in 1893: "Do you see all the row the Catholics are having—papers are full of it. The Presbyterians have developed some strong doubts about the exhistence of hell lately—as Bob Ingersoll says 'If they keep on, they will let me into the fold.'"

Examples set by other cronies led him into some conspicuous extravagances, particularly concerning horses. While he was in Mexico, Follansbee introduced him to thoroughbreds for recreational riding: "Follansbee rides a California thoroughbred—$5000 hoss on his Chihuahua range—does well. They are the stuff, if you ever get bone in 'em." Bitten by the idea, Remington "bought a son of Bend Or. The biggest thoroughbred I ever saw. A cat aint in it with him—puts his foot down like a bull fighter." After six days, Remington confessed that he "got thrown off. I find that I cant get my old 225 lbs of tallow to keep up with him." Through another friend, he imported an "Irish hunter 'be God'—am the best mounted man in Westchester County, N. Y." With the hunter, Remington also imported an Irish groom, Tim Bergin, who remained in his service for sixteen years.

As the so-called pictorial field marshal, he maintained the closest relations with civilian heads of the army and with progressive members of the military. After Cleveland was elected president, Remington told Powhatan Clarke, "Do not say a word but I heard that Danl S Lamont was to be Secty of War. It is simply out of sight. I know him as well as I do you. We are in it. Its too good to be true." Lamont had matured in Republican politics in New York State with Remington's father and uncles. Ten years older than Remington, he had been Remington's predecessor as engrossing clerk in Albany and briefly Remington's boss. Soon after the letter to Clarke, Lamont initiated an informal correspondence with Remington, soliciting suggestions concerning the army. The responses were long and unconventional, in favor of old soldiers and against old colonels. One "old soldier" that Remington supported was General Miles. When the ambitious Miles found that he had poor relations with the new Secretary, he was forced to call on Remington to intercede. Miles' career was in jeopardy because he was not a West Pointer.

The friendship that was the deepest was between Remington and Powhatan Clarke. It was a bond that was launched in self-interest on both sides and that grew to fraternal love although they saw each other on only three occasions. Clarke and his family saved seventy-nine letters from the Remingtons, providing enough background to indicate what manner of man Remington was in friendship. On the other hand, Remington retained only six of the hundred or so letters that came from Clarke in the seven years they corresponded.

The relationship proceeded like a country dance, that advanced and retreated and stepped in place, first one leading, and then the other. It was founded on physical testing during the scout trip with the Black Buffaloes. During the scout, Remington regarded Clarke as superior, young and slim and manly, an officer who would "grace the uniform of a Kings body guard" while the artist would be remembered only "as a kind of quasi tramp." Remington was flattering and exploratory, bragging and self-deprecatory by turns.

He saw in Clarke the image of his father as a young man, the dashing Colonel who was nonchalant under fire in disregard of his own life. It was a level of valor that was incomprehensible to the civilian mind, this appearance of foolhardiness that required an attack when all seemed lost.

By civilian standards, Remington had proved himself to be a resolute and tenacious man. He was able to endure physical punishment to the same extent as the army officers, relishing the gruelling tour with the scouts, just as he had played football while he was injured and he had returned to boxing after he had been knocked out. What Remington did not know was how he would react when his life was on the line. The question was whether he could walk into likely death from rifle fire like Clarke could, his father's surrogate. In the Sioux Outbreak it had been the army men themselves who had turned the wagon around in the retreat to Casey's camp, although Remington suspected that Clarke or the Colonel would simply have ridden through the Sioux lines despite Miles' order to avoid confrontation. And, when he had been ambushed by Baldwin's Indian band, he had had no opportunity to resist the sudden superior force.

Using bravery as the standard of masculinity, he saw himself as less than Clarke because he suspected that prudence would be his continuing reaction to danger. He told Clarke that his "business in life, as a painter and illustrator is to give other fellows the credit that is due for gallantry—I desire no honors of this kind myself. In the public judgement of to day I am accorded the benefit of a doubt as to the heroism of my moral nature and I never want to get up very close to an evily disposed person with a gun for fear that the doubt might be dissapated." That, he feared, was truth in jest.

Remington grew to love Clarke like the brother he never had. He took advantage of the friendship with Clarke to facilitate the visit to the Buffalo Soldiers. When the trip was over, Remington saw himself as a survivor, Clarke's equal. Clarke sent him a posed photograph, partly to serve as a model for any likeness required for illustration or easel painting. Teasing Clarke, Remington said the photo showed "a

remarkably good looking sort of a chap." After Clarke asked for advice on writing, Remington became avuncular and superior, telling Clarke to stick to "Garrison Life in the Southwest" rather than the arty or unusual. Clarke came East for the third meeting in the fall of 1889. They never met again, although there were many schemes to get together in Germany or at Remington's house or in Canada or at Fort Custer.

Despite his "broncho" nature that required intermittent revolt and the taking of dares, Clarke's interests were those of a professional officer determined to force the American army to modernize. His letters were tirades against the old fogey officers who were no longer brave and adventuresome, but who rather had become regressive, protective of their senior status, and oppressive to their ambitious juniors like Clarke. Supremely patriotic, he was anxious to use every device to make the army better known to the public. He opened Remington's eyes to the truth about the colonels and generals who had been romanticized in early illustrations and articles.

Their mail discussions had become a serious exploration of how the army should be improved. Clarke pushed Remington into subscribing to the *Cavalry Journal* and had him elected to the Cavalry Association, overcoming Remington's reluctance as an artist who said he was concerned about the past while the officers were wrangling about present pursuits. In turn, Remington's goal was to "make the best American youth enlist" in the army, in order to produce a more democratic structure under Miles' command. He talked to Miles about Clarke's military prowess and to Harper about Clarke as a writer whose text "had balls and fringe on it," a "word painter from the *old house*."

He saw Clarke as he saw all of the literate officers—as sources for illustrative work. Remington felt that the jaunty Clarke had an ease with words and a modern cadence, if only he could be cajoled into writing professionally, whereas he considered his own writing to be labored and uninspired. He praised Clarke because "you have the faculty of not taking people or life seriously and that's it the heart throb of modern litterary men. Thats what makes me such a d_____ fool—I'm too serious. When the doctors get the trepanning down a little finer Im going to have the top of my skull lifted off and two or three bumps sawed off—then I think I can be quite a feller. Well—take care of yourself—MAKE NOTES—MAKE NOTES. MAKE NOTES get the color of his eyes.—" And Remington added a sketch of the elegant Clarke with his pad at eye level taking note of the eye color of an Indian who had his nose resting on top of the pad.

In response, Clarke described the local festivities:

You ought to have been with us today—went to the "Vineteria"—clear cool morning, everything as bright as gold—a springy pony—the packs—my old Serjeant and our Roper who you may recall; Eleven miles in a hour over the hills and draws to wild picturesque spot hidden in the hills a few miles from the [Mexican] line—then the little patient burros were rolling in with their immense loads of mescal plants to the great white piles—a few feet off four Yaquis are swinging their bright axes cutting and beating the cooked plant into a pulp—its sticky stuff to eat, rather sweet but nicely flavored—then rows of rawhide vats where the fermentation goes on, then a primitive still out of which the clear white liquid is pouring into kegs, then from the keg into a little brown jug and then WOW! damn the Fellowcraft Club and Veuve Cliquot—we loaded our canteens and wine bottles. Then taking a start for our horses we loaded ourselves *just a little* and struck for home while able.

Remington's answer was, "I bet I wish I was along. We can get up a great article on that affair." Reflection indicated, however, that the visit to the Vineteria was not publishable without causing certain investigation by the adjutant general.

To accompany the requested manuscripts, Remington tried to get Clarke to learn to use a camera. His instruction was, "photograph the whole outfit 'till they lay down and kick with one foot." He sent his own camera to Clarke at Fort Bowie, but Clarke "took train to Dragoon with two Indians—they were tickled to death over the ride in the 'Soon Wagon'—Got Indians and saddles off, train started, said to Brakeman 'put my camera and lantern off in Tucson.' 'All right' said he 'I'll put her off at Benson,' next station. The camera has been traced to Oakland Cal and traces lost—life is too short to be taken seriously but wait till I *sic* my nigger on that brakeman." Remington urged Clarke to "get hunk with that bloody brakeman," even "if we have to tackle old Stanford or Huntington." Clarke promised direct action but Remington's route was through the executives of the railroad.

Clarke's correspondence provided Remington with the touch of the day-to-day West his own experiences had not covered:

My 28th Anniversary came on the 9th [of October 1890]. I made a mescal toddy for the foreman in a one *quart* cup. I am sorry you could not have been with us though I was glad I was the highest military power at the time in the place. We were just beginning to see the tin under the toddy when in came the maestro of the "vineteria" a pleasant faced Smuggler who lives in Mexico because they are *short* on him in Tombstone (Sheriff—sabe) or as he said himself he was very near a man who got shot once. It is useless to relate that he brought some of the produce of his loom. We had an awfully jolly day.

Well I like these people—cow punchers, liars, thieves, murderers & smugglers—they are hell but they are not fools.

The general officers suspected Clarke's peregrinations and sought to impose controls:

Oh my pride! or conceit! Our new general "Gutsy" [McCook] was here with his aide de camp, a son in law of his—McCook says who is this young man Clarke—he seems to be pretty independent and guess we will have to saw his horses or words to that effect. Then he tells one of these 25 Cavalry 1st lieutenants that he was going to put him in charge. McCook is now at Apache and I have wired "Carter" [Johnson] to get the old gentleman to leave me alone.

Remington's advice was good, as usual: "Keep out of a row with old McCook—those old devils are the curse of the army. Old story— youngsters full of enthusiasm—old chaps full of whiskey.—cant get along—but Death is around and hes got his eye on the fellows of that kind. You just keep easy you young broncho and I tell you your day will come.—"

In 1891, Clarke had been distracted from his discontent by wangling a year's assignment to the cavalry school in Germany, although his captain had declared that Clarke wanted to go abroad to avoid arduous service in Arizona rather than to study. Remington was busy and turned the correspondence over to his wife, saying that "I write for a living and detest nothing so much as writing letters—come see me and I'll tell you all about it." When Clarke began to think again about the American army, he asked Eva to "tell Fritz dear that we need an awful lot of change in our service but I bet it will come if we can get the People who rule (big P) to look into it. We will get nothing out of our superiors, but the 'papers' 'the press' must be got to leap on them every Sunday. Those of us who tackle the 'machine' must be 'harmonical' among ourselves. I believe we need a *little* Army but an awfully *good* little Army, then some good militia laws with the assistance from our Uncle Sam without giving him too much pull." Clarke had become a populist in an autocratic society, ready to take on the army establishment as Remington had the art establishment. The difference was, the army controlled Clarke's fate.

Clarke's letter was the manifesto of the revolutionary crusade for the new army that involved Clarke and Remington. For Clarke, it was the start of a rush into print, with *Harper's Weekly* through Remington and the *Cavalry Journal* on his own. Remington had all the periodicals and the press open to him, and he had the ear of Miles and the President's Cabinet. Clarke's report on the German cavalry was accepted by the *Weekly* as an article, with Remington's sponsorship, but

the manuscript for "A Hot Trail," an Arizona adventure story, was not. The German article was credited to "Lieutenant Pohattan H. Clark," with Remington erring on both names. The space allotment was three pages. Remington's illustrations covered more than two pages, resulting in the wholesale cropping of the text.

That was one aspect of the friendship, the business side, where Clarke's role was often compressed, but when Remington went duck hunting in Maryland he found time to visit with Clarke's family, to drink convivially with the father, and to call the sister a beauty. He knew how Clarke felt about him and he reciprocated. He told Bigelow that "I have painted a bunch of German soldiers and everyone says they are out of sight but everyone dont know so I will have to wait until someone besides Clark says they are 'proper to a degree.' He is my friend and like a fellow in love with a girl cannot see the freckels on her nose.—" He saw friendship as blind as love.

Clarke was indeed in love. He became engaged to a cousin of Mark Twain, and the result was a lag in his letters. With a heavy touch that he thought humorous, Remington complained:

> I suppose as a matter of fact that as the hour approaches it would be unchivalric if I even suggest to one who must be expected to have had his thoughts diverted that even crisis does not absolve a man from certain obligations called friendship.
>
> I had thought that through the years of trust I had merited the good feeling in my friend Clark but I see that the young woman is getting the whole bloomin benefit of your correspondence and when the fit is on you, you are a regular case of diahorreha in written words.
>
> Knowing that you will not write to me anymore I suppose we are no longer friends.

The letter made Clarke "a sad dog." Remington apologized that "you took what I had intended as a lot of nonsense seriously and I am sad too. Missie sends love and says I ought to be more careful what I write—& I agree."

Clarke married his young woman. They had a baby in April 1893 while they were stationed at Fort Custer. Remington was intrigued with the advent of the child. "Hows 'Jim'—I mean Jim Clark—or 'Pow Junior'—what will boys call him."

The birth of a son did not, however, modify Clarke's hard lines on the army. His regular reports critical of the army were suppressed. No official publication was now open to him. Because he believed that the military could survive only by rejuvenating the general staff, he wrote a lengthy article to that effect that was published May 7, 1893, in the New York *Herald*.

The article was excerpted in the *Army & Navy Journal*, with intent

to impugn him. The heading was "Our Army all Wrong" and the legend was that Clarke tells "the world how badly our Army is drilled." The next week, a Clarke article in *Harper's Weekly* ended by describing "our little army" as "overridden by bureaucracy, devoid of a competent modern staff organization, without cannon or modern small arms, with depleted ranks, [and] deplorable lack of instruction."

Remington warned Clarke that he had seen the *Herald* article and "of course you will get cashiered. Just think [of] young J H P C," but he promptly came to Clarke's defense with an article in the Sunday *Sun*, attacking "that band of sleepy old tubs in Washington who are General This and Colonel That of the staffs, forsooth," who "sit about with whiskey and water before a fireplace putting up jobs on young men who are active, intelligent, and progressive."

The army bureaucracy could not touch Remington but it made a new entry in Clarke's personal file to supplement the commendation for gallantry in the action on May 3, 1886, that had resulted in an 1891 award of the Medal of Honor, as well as the citation for distinguished services March 7, 1890, in the capture of hostile Apache Indians, and the brevet July 23, 1890, when Clarke was a symbol of security for the settlers in Arizona.

This time, after consultation with the general commanding Clarke's military territory, the Major General commanding the army effectively terminated Clarke's professional prospects by determining on June 8, 1893, that he "is deserving of severe censure" and that "future publications of a character like that will form a basis of trial by court martial." A copy was circulated among the generals commanding all of the military departments and given to Clarke. The generals had decided upon this rebuke from General Schofield rather than court martial because "a trial might be used by the newspapers to make a hero of him, and as an opportunity to further malign the Army." Clarke was made into a marked man, a pariah in the service.

Six weeks after the censure, there was another entry for Clarke's file. In his training functions at Fort Custer, Clarke had discovered that cavalry horses did not swim well. Some could not swim at all, although in Sioux country there could at any time be an emergency that required crossing a deep stream. Military statistics also showed that more army officers died by drowning in sudden Western floods than navy officers did in the ocean. The enlisted men had the same deficiency.

Clarke's teaching horses and men to swim became an outlet for his discontent. Every afternoon, he took horses to the Little Big Horn, half a mile from the fort. Some days he took entire detachments of men with their horses for practice in an area of the river where the

water was ten to twelve feet deep. It was not a popular pastime for the men, but it was similar to other horse exercises that Clarke had previously described for Remington—horses jumping over obstacles and horses standing fire. Clarke expected to write this story himself as a noncontroversial example of proper training.

The afternoon of July 21, 1893, was hot. When Clarke hitched his horses after the exercises were over, he remarked to one of his men that "I believe I will take a swim myself now," and he dove head first from a bank about five feet above the water level. Although the area he chose was just above the exercise pool, it happened to be only two and a half feet deep in a spot where the current had washed the mud from jagged rocks. He hit his head on a rock, was knocked unconscious, and was carried down into the deep pool. He sank twice before any one noticed his weak struggles. Even then, the men were "stampeded" in all directions at the danger to their dishonored leader. They did not dive into the deep hole to save him, claiming later that they were "too tired and worn out" or were not able to swim. For whatever reason, there was no move to search for Clarke in the "deep hole" until one enlisted man plunged in by himself. He reached Clarke but then became scared of the current and let go. A lieutenant also dove in and grabbed a body he thought was Clarke but it was the enlisted man, while Clarke sank for the third and last time. A mounted man was sent to the post for assistance. Another lieutenant hurried over to the river and in five minutes located Clarke and brought him up to the surface. Clarke had been in the water for twenty-five minutes and he was dead. The entry into the file was, "died at this post this date at three P. M. Cause of death, accidental drowning. In line of duty."

Remington wrote immediately to Clarke's mother, "Missie and I were shocked to hear of Pohattan—We cannot believe it—or have it so—It really seems so improbable and we cannot get used to it. We feel for you in your berevement and mourn the loss of our old friend Clark more than I dare say. We cannot imagine how it came to pass."

Three months later, he wrote to Clarke's father:

I have hardly had the heart to write of your poor dead Powie before now, yet my wife and I are not yet at all reconciled to the loss we feel.

I am doing what I can to help erect a memorial of some kind to him—I find petty jealousy in the way but also much encouragement. I have tried to get Harper to publish his "letters to myself" but hard times & & &c—it is useless.

Clark was a fellow who appealed to my imagination—he entered into my life to that extent that I can hardly make it seem that I have got to get along without him.

What a wonderful reputation he acquired in so short a time. If he could

only have lived he would have been a Great Man. He had awful good judgement (to me the leading attribute) of course perfect courage.

The loss to you is irreparable—seriously I would give a leg if he could be restored.

I cannot and never will be used to the idea that my friend Clark is dead—

Remington continued to think of his dead friend Clarke but there was nothing he could do to keep the memory green. The military establishment did not show the slightest interest in authorizing a historical marker for a dishonored lieutenant who had died while seeking personal pleasure in swimming, making another medical entry that sprang from self-gratification like the earlier gonorrhea and the sprained foot. The Harpers continued to refuse to publish Clarke's letters, but in 1894 Remington was able to tell Clarke's widow that "I have sold Pohattan's article—the MS of which was in my possession—'A Hot Trail'—to the Cosmopolitan Magazine—for $75—or thereabouts—$15 a thousand words. I will send you the check as soon as it comes to me. —I hope you are well and we often think of you. Poor Clark—I will never get used to it and often feel as though I did not want any more friends—its so hard to get along without them."

Mrs. Clarke did not pursue association with the Remingtons. She had resented the blow to Clarke when, after all the anticipation and arrangements, the Remingtons failed to visit them at Custer. She felt that Remington had cautioned Clarke with mild words from afar when he could have commanded sensibility face to face in Custer. Remington had had reason to believe that he would see Clarke cashiered and he had not stopped the inevitable progress toward calamity. Her life with Clarke had thrown her right from the beginning into a career approaching disaster and had steadily swept her from new bride to new mother to new widow with a child. In a letter, Eva Remington asked for a picture of the baby. Mrs. Clarke wrote at the top, "to be ans_____/when check arrives/send photo of baby." She received the check for "A Hot Trail" in 1895, and she did not send the photograph until then.

17.

Mister Wister

Within days after Remington lost Clarke, he found Owen Wister. He had unwittingly cast the pattern of Clarke's tragic life by promoting rewards for heroism that had culminated in the Medal of Honor. Now, he began the molding of Wister into the happier role of popularizer of the fictional cowboy stereotype. In both instances, Remington's original goal was only to generate illustrative opportunities for himself.

Remington met Wister by chance in the Yellowstone late in the summer of 1893, just after Wister had surfaced as a writer of Western fiction for the Harpers. A year older than Remington, Wister came from Philadelphia. He was an only child, too, but in a family where the father was treated condescendingly as a country doctor. The mother was the star. She was the daughter of Fanny Kemble who had been a celebrated Shakespearean actress and beauty, the scion of a signer of the Declaration of Independence.

Wister's mother was an aristocrat dedicated to the arts. She wrote magazine articles, played the piano, spoke French and Italian, and numbered the elitist author Henry James among her close friends. She

was the kind of social leader who believed that if an outstanding event in the arts happened in Philadelphia and it did not happen in her salon, it did not happen in Philadelphia.

Wister's early education had been controlled by his mother. At nine, he was sent to a boarding school in Switzerland. From there he wrote the first of the hundreds of letters to his mother that he continued for forty years. His mother held on to every letter. Added to Wister's later journals and papers, these holographic materials constituted a huge reservoir of information on the times. Included was a mass of Remington data comprised of Wister references to Remington and 103 letters from Remington and his wife to Wister.

The same year that Remington was attending military school, Wister returned from Switzerland to go to a most select preparatory school, St. Paul's in New Hampshire. In 1878, Wister entered Harvard to study music when Remington enrolled in the Yale Art School. At Harvard, Wister was a writer, musician, actor, and editor. One of his associates in an undergraduate social club was Theodore Roosevelt. Wister knew the literary William Dean Howells and Oliver Wendell Holmes, Jr., and a series of his stories in the Harvard *Lampoon* was reprinted as a book. Although he needed opiates as medication for migraine and insomnia, he was elected to Phi Beta Kappa and graduated in 1882, near the top of his class in intelligence, talent, and social background. After a walking tour of Europe, he studied music in Paris for a year until his father asserted masculine control over the family by bringing Wister back to the United States to go to work at a "man's job," computing interest in a bank in Boston.

The skinny and sad Wister underwent a severe depression after the clash of temperament between his parents. His face became swollen. He had intense headaches, vertigo, and hallucinations. A neurologist recommended a stay in the West. With two maiden ladies delegated to take care of him, Wister went to Wyoming the summer of 1885. His hysterical symptoms abated. He entered Harvard Law School in the fall of 1885, graduated in 1888, and took a desk in an office on Walnut Street to practice law in Philadelphia. He went on additional Western vacations in 1887, 1888, and 1889. In 1891, he made his fifth trip, but this time he was looking for material for stories he could write as an alternative to law:

And so one Autumn evening of 1891, fresh from Wyoming and its wild glories, I sat in the club [in Philadelphia] dining with a man as enamoured of the West as I was. From oysters to coffee we compared experiences. Why wasn't some Kipling saving the sage-brush for American literature, before the sage-brush and all that it signified went the way of the California forty-niner? . . . Roosevelt had seen the sage-brush true, had felt its

poetry; and also Remington, who illustrated his articles so well. But what was fiction doing, fiction, the only thing that has always outlived fact? Must it be perpetual tea-cups. . . . To hell with tea-cups! we two said, as we sat dining at the club. The claret had been excellent.

"I'm going to try it myself!" I exclaimed. "I'm going to start this minute."

I went up to the library; and by midnight or so, a good slice of *Hank's Woman* was down in the rough. I followed it soon with *How Lin McLean Went East*. A check came for those first two stories from Alden, the first editor who saw them, and I wondered if I should ever know the joy of being illustrated by Frederic Remington.

That was January 1892 when he received $175 from *Harper's* for the two stories. The rate was $12 per thousand words, roughly the same rate the established Remington received.

In early June 1893, Wister was sent $300 for the second pair of stories, "Balaam and Pedro" and "Em'ly," to be published later in the year. This was $20 per thousand words, and, as Wister noted, "good enough pay at present" even though a year and a half had elapsed. He so distrusted success for what he felt was little effort that he prayed,

> O Muse of mine, if such a Muse there be,
> Lean from thine airy hill and bid me speed.
> Give me God-speed, my Muse, and hearten me
> For noble ventures; all thy help I need.

Wealthy enough not to need the money from *Harper's*, he was sufficiently poised to make his independence politely clear. This led Alden, the editor, to be more amenable to Wister than he was to Remington who was still being paid at an author's starting rate.

Soon after getting the $300 check, Wister received a June 27, 1893, telegram from Alden calling for a meeting. The following day, Wister took the train to New York:

Alden wants me to do the whole adventure of the West in sketches [articles] or fiction, as I find most suitable in each case—taking Indian fighting—train robbing—what I please. He suggests articles of 7,500 words on an average, and to pay me $250 apiece—or on a basis of $30–$35 a thousand. He also is willing to send Frederic Remington along with me if I desire it! he said that Remington was a very companionable fellow—but that I should do as I liked. Events in my literary life have crowded so thick of late that I am a little bewildered—But one thing I plainly see—that one of my dreams—to have Remington as an illustrator is likely to be realized in a most substantial manner.

Making a prompt start for the West, Wister took the Columbian Express for Chicago the next day. He was accompanied by his mother so that they could see the World's Fair. After recovering from an attack

of gout and a cold in Chicago, he departed for Rawlins in south-central Wyoming with a male companion on July 14, leaving his mother in Chicago. From Rawlins they took the stage north on the seventeenth, then switched to a pack outfit they had reserved. Despite a bout with erysipelas, Wister made it to Dubois and went on to camp along the Continental Divide. The two men turned east toward the Yellowstone the end of August, traveling by stagecoach, and left Canon early on September 8, 1893:

Lunch at the Norris basin, where who should I meet but Frederick Remington! When I told him my name he said he had many things to say —he had just illustrated "Balaam and Pedro." I had many things to say to him, and we dined together at the Mammoth Springs. Remington is an excellent American—that means, he thinks as I do about the disgrace of our politics, and the present asphyxiation of all real love of country. He used almost the same words that have of late been in my head—that this continent does not hold a nation any longer, but is merely a strip of land on which a crowd is struggling for riches. Now I am a thin and despondent man and everyday compel myself to see the bright side of things because I know the dark side impresses me unduly: but Remington weighs about 240 pounds, and is a huge rollicking animal. So to hear him more caustic in his disgust and contempt at the way we Americans are managing ourselves than I have ever been was most unexpected.

It was a momentous encounter for Wister. Remington accompanied him on the railway east: "During the journey to St. Paul, which was hot and odious, Remington and I discussed our collaboration and many other things. He made a good criticism on the first two pages of 'The Promised Land,' which I accepted and profited by. In fact Remington's artistic insight is quick and clear and forcible. At St. Paul our company parted—He went on in an earlier train." Part of Wister's fixation on Remington as an illustrator was Remington's earlier connection with Wister's friend Roosevelt.

The writer and the painter were an eye-catching pair. Wister was a thin man of average height, somber visage, and dark clothes, reserved and poised in manner. Remington was fat and tall, a jocular good fellow, dressed ostentatiously to advertise his latent Anglophilia. Even their speech was contrasting. Wister's accent was Philadelphia Main Line overlaid with International and Harvard, while Remington was pseudo-cowboy edged with his idea of Eton.

Wister named September 15 as the day he was back in Philadelphia. That should have been a firm mark for counting backwards one week to the lunch at the Norris basin, but his dating is suspect. His exhortative entry for October 4 was, "Awake my journal and regain some punctuality if possible: I am some 3 months behind, and return to the

first missing link." He began the reconstruction of his journal with the entry for July 13. By the time he reached September 8 and Remington, his entires could have been misdated.

From Remington's side, Wister's dating was late by almost a month. A letter from Remington to Bigelow was placed in New Rochelle and dated "Aug. 19–1893" in a clear hand: "Just back from pararie chicken shooting in North Dakotah and from the Yellowstone Park. Made the d_____est ride with a detachment of 6th Cav over the mountains. One would not believe where a horse will go. Have seen the World Fair. Its the biggest thing that was ever put up on this rolling sphere." Remington did not say that in the Liberal Arts Building at the Fair, fifteen of his illustrations were being exhibited.

In the Bigelow letter, Remington mentioned the "pararie chicken shooting" that was the basis of his article "Stubble and Slough in Dakota." He said he had already returned from the Yellowstone, although he did not comment on meeting Wister. Wister was a rare bird. Looking at Wister and listening to him did not persuade Remington that he was in the presence of the new Bret Harte.

Remington's talk with Wister once again raised the question of how he was being compensated by *Harper's*. His rate of pay for writing was only one-third of what Wister had told him he was getting. While the editors were romancing the new boy Wister, they were tightening the screws on him by condensing the art work. His friendship with Henry Harper was his recourse:

My dear Mr. Harper:—
I do not at all understand what the basis of my pay is for work for your house and in order to remind you of our conversation of this afternoon ask you to investigate.
"Stubble & Slough in Dakota" was one article—gotten on a trip which I had talked with you about and said that three articles might be gotten out of—to which you consented—they to pass muster at your discretion. I only got two—that being one. For some 4000 words I get $50 and numerous drawings are made only two pages and not paid for at $125 a page. This I do not understand and did not expect.

Writing was hard going for Remington, compared to drawing. The four thousand words took him two to three difficult days. The pay was about twenty dollars a day, a poor return by his standards. Writing had become a sensible occupation for Remington only if it generated multiple illustrative opportunities. For "Stubble and Slough," though, he had made eight separate drawings that *Harper's* reduced in size until they were all together the equivalent of only two full pages. That was the editor's discretion, exercised because these were sporting pictures, not the preferred Westerns.

Also [Remington continued] I got $75 for [the seven drawings that made a full page of] the British Soldier in Madison Square. Is this all you propose to pay me for Weekly material per page. Do I have these drawings returned after use?

What am I to understand I am to be paid for the Owen Wister magazine stuff and do I have the drawings returned.

For the *Weekly* newspaper, the arrangement was to continue Remington's regular rate at $75 per page with the drawings returned to him. For the *Monthly* magazine, Henry Harper's pencil notations on the sides of the letter indicated that for "Stubble and Slough" Remington was entitled to $125 a page, with *Harper's* retaining the originals. Even with the compressed paging, however, Harper was not happy. He did not want to own original Remington drawings at any price.

For the Wister stories, Harper finally agreed with Remington on a rate of $100 a page with the originals returned to the artist, and then both parties had what they wanted. Remington was relinquishing a total of $50 in money for two pages but he got back a group of originals he could sell for $300 to $400. Thus, for a frothy little report on the World's Fair that ran in the *Weekly*, the pay for the text was negligible but the drawing went on the cover of the newspaper, making it highly publicized for his resale.

The Harpers had to be frugal. The second half of 1893 was a period of economic depression that had begun after President Cleveland took office. It was a time of bank failures and a stock market panic. Despite the economy, Remington was pressing the Harpers to send him to Spanish Morocco as a war correspondent. As he told Bigelow, "There is some d_____ good fighting going on down in Morroco but Harper wont let me go. I can never learn that tough old lingo. I can wing a waiter with my Spanish and talk English to beat hell—I guess I belong on this Continent." Instead of Morocco, *Harper's* sent Remington to New Haven in Connecticut where the fare was $1.50. He covered Yale football with Richard Harding Davis and felt his thirty-two years: "The boys all smoke pipes and look, *oh so young*. It seemed like pictures I have seen where the old white haired sailor spins his yarns to little ox eyed kids."

In six weeks, Remington was restless again. He took so many trips in 1893 that the quantity of work accomplished in his studio was surprising. He said he hadn't "had much fun this year—had to hustle for a living," but he was in Mexico, New Mexico, and California, in Canton, in Dakota, Wyoming, and Chicago, and then in New Mexico again. The bait in October was an invitation from Miles to go on a grizzly bear hunt.

The party assembled in Chicago. It included General Hugh Scott, Colonel Michler, Leonard Wood, and Miles' young son Sherman, as well as Miles and Remington. Transportation was via Miles' private railway car with dining area and sleeping quarters. After dinner, the table was cleared so that these men whose work was war could talk comfortably. The subject was uniforms, and there Remington was more of an authority than the generals. He produced some large sheets of paper that he filled with detailed illustrations of soldiers of the European armies he had seen, drawing as he commented on the features of their outfits. The demonstration was a Remington tour de force on a subject he loved, and the pages documented the best aspects of the various services in a manner that would have been meaningful to the designers in the Quartermaster Corps. When it was time to retire, Remington left the drawings on the table and they all went to bed. As soon as it was quiet, General Scott returned to the table to pocket these drawings, but they were gone. He said nothing because he suspected Miles had been there first, but later he found that the drawings had been placed with the garbage by the conscientious porters.

The car was shunted to a siding at Fort Wingate where Remington fulfilled his promise to get even with the colonel who had turned his wife and him away at two in the morning the previous spring. He told Miles about the incident, and the escort of cavalry that accompanied the party to the hunt was led by Lieutenant Hoppin, not the unnamed colonel.

The host for the hunt was a one-armed English rancher, Montague Stevens, who had pioneered hunting grizzlies with a pack of bloodhounds, fox terriers, staghounds, boarhounds, and Russian wolfhounds. The bloodhounds were the trailers, and the pack would bring to bay any grizzly it could catch. Miles called bear hunting the most dangerous sport partly because the hunters were required to ride at breakneck speed up and down the sides of precipitous mountains.

The way Stevens hunted, the key was preparation. He considered that he had committed himself to finding a bear for Miles, so a few days before the scheduled arrival he rode around his spread until he located a cow that had been killed by a grizzly. The cow he found meant fresh tracks, and, as he said, he had then kept his promise to Miles and "it was up to him and his party to do the killing provided they could contact the bear."

The hunting party started out at daybreak, mounted on strong and sure-footed horses and accompanied by the pack of trained dogs. Stevens took them to the dead cow he had discovered. The grizzly had eaten at the carcass during that very night. The scent was powerful and the hounds took the trail in full cry. Stevens was sure that

Miles would catch up with his grizzly before the bear got to the protective timber at the mountain top. Unfortunately, the carcass was in a rough canyon. The hunters picked their way after the pack as rapidly as they could but the hounds were soon out of earshot. The party spent the whole day riding around and listening for the hounds but never heard them.

Discouraged, they returned to the base camp in the evening, tired and hungry. To their amazement, the hide of the grizzly was pegged out on the ground near the campfire. Stevens' cowboys had been rounding up cattle when the grizzly came into their sight, crossing the valley. They quit the cattle and took after the bear even though they had no gun. One cowboy roped the grizzly by the head, another by a hind foot, and the third by a fore foot. They stretched the bear out with the ropes while the fourth cowboy cut the four-hundred-pound silvertip's throat with a pocket knife. When that did not work quickly, he smashed the bear's head with rocks.

Stevens was delighted that he had fulfilled his promise. "The general had now gotten his grizzly," he declared, "though not exactly in the way he wished." On the second day of the hunt, the party managed to kill a three-hundred-pound black bear and Remington said he "shot an antelope through the heart at 200 yards." He also told his grandfather that the silvertip had weighed seven hundred pounds.

A rare event like the hunt called for an article that Remington could illustrate. The problem was that Stevens, who had become Remington's friend, considered himself a writer and wanted to do the article. Remington needed the illustrative work and did not trust Stevens' writing abilities. He fabricated an elaborate scheme to hoodwink Stevens into believing that Wister would be the author so that the rancher would defer to the famous professional. Stevens acquiesced, telling Remington that "you are of course the best judge & if you would prefer Wister to write it I will cordially do my level best to aid him. Of course it will be a handicap for him to accurately describe a hunt in which he did not participate."

Then Remington informed Wister about Stevens, building him up as a character: "Stevens had a hell of a time killing off & running out thieves—Had 5000 in bank—to go to the man who killed the man who killed him.—they used to bushwhack." Remington also told Wister that Stevens wanted to meet him and he asked Wister to be ready to come to New York at a moment's notice. When Stevens did pass through the city "heading for *Hengland*," as Remington put it, Remington kept Stevens and Wister apart. The explanation he gave Wister was, "Stevens thought (he musunderstood me) that you were to do the *bear hunt*—which I have written and which I can do much better than

you because it was a lot of little things which happened and very little *bear* and you were not there anyway—but this Stevens is a character and *sand*—say O W—more *sand* than you could get in a freight car."

Miles did not know about the convolutions among the three authors. He told Remington that "your descriptive powers are certainly very good. I think you will in time develop as much skill with the pen as you have genius with the brush. There is a bright future for you if you will adhere to my council. I wish you would come over some day as I want to talk with you about your illustrating one or two old-time Indian scenes." Miles was another author, and he wanted to "council" Remington for the brush, not the pen.

Wister had no complaint about Remington. A few days before Christmas 1893, he was on the Keystone Express east of Harrisburg, returning home from San Francisco and entreating, "Ah Muse, don't give out, nor become vain!"

At Harrisburg I bought the January Harper, which has Balaam and Pedro in it—I am curious to have a verdict on this story. I know that I have never done anything so good, but the event related is cruel—This is not the kind of thing the general reader likes.

Later. My 1st verdict on Balaam and Pedro was given me with miraculous promptness. A youth with whom I have been playing whist came about an hour ago and sat down here by me. "Did you say you had Scribner for January?" said he. I told him to get it from my valise at his side. He got out Harper—"It's all the same," said he, and began looking at the illustrations. When he came to Remington's of the horse deal, he stopped and looked at it three times as long as at the others. Then he read a few sentences in the text opposite, and turning more leaves finished all the illustrations the number contains. Then he returned and looked at Remington again. After that he found the beginning of the story and began to read it—he continued the story till it was about half finished—Then took to skipping, and at length read the end. My author's pride was chastened by his not reading every word I had written, of course. But he read nothing else in the number; looked at the pictures in the advertisements, and then put the volume back in my valise. "You can take Scribner," said I. "It's in there." "No, much obliged—It's all the same—Scribner and Harper both generally have one good story, and that's all I wanted." This youth is a matter of fact youth, not showing in talk at least —any literary interests. If such as this will read me, I am secure. But I think I owe it to Remington's picture; otherwise he might not have been arrested.

That was Mister Wister, a humble, thankful man, before he became famous.

18.

Amongst the Skoptsi of Bessarabia

While Wister was eastbound on the Keystone Express, Remington was passing through Philadelphia on the way south. He said his "ideas" were all used up. He had to "go somewhere and see something new" so he had talked Ralph into a two-week trip to hunt deer in West Virginia on commission from the Harpers. Once again he was leaving his wife at Christmas, but she had become more forbearing. She had arranged to visit her family in Gloversville for the holidays.

Remington's route with Ralph was by train through Washington and south to Richmond, Virginia, an interim stop to prepare an illustrated article on the city for *Harper's Weekly*. The visit pleased Remington because of the memories of his father and the Union Army. "Think of my being in Richmond," he told Ralph. "My father tried for four years to get into Richmond, along with the rest of the army. I'm glad I'm here." Ralph said that talking about the Civil War made Remington's manner brighten and his eyes snap.

From Virginia, they transferred to the Chesapeake & Ohio railroad, going west for the hunting. They had a Pullman car to themselves, sitting cosily in the smoking room and looking out at the rugged moun-

tain landscape. Suddenly, Ralph declared, "like an apparition there appeared between us a raving, frothing maniac, wild-eyed, excited, and stalwart." The man demanded to know whether Remington thought he was crazy and was soothed to hear that Remington "had never seen a man more evidently sane."

"Of course," the lunatic replied, "I'm sane as can be, but I'll kill my wife before they get me back in the asylum again. That's all I want. I'm going for her now, and I intend to cut her into mince-meat, because it was she who put me away. I've just escaped from the asylum this morning, you see."

The two friends agreed with the lunatic's opinions and approved of his murderous projects until the train reached the next station. It was their destination so they got off and left the lunatic alone on the train with the porter who had not shown up to help them with their gear. "All that day," Ralph declared, "we shook the West Virginia woods with laughter as we thought of the porter alone in that coach with the madman, frightened out of his five senses, and perhaps locked up in his little linen closet." Neither of them regarded their failure to report the escape as improper, although both the porter and the wife were endangered. Apart from the humane considerations, they did not even investigate the outcome of the escape. They were not reporters.

After the hunting trip Remington and Ralph were still busy promoting each other for the Harpers. Remington wrote a routine puff on Ralph for the *Weekly*, obtaining the information from Ralph, revising it at Ralph's direction, and then telling Ralph to "go to Harpers and read my article on you—have re written it." Ralph was assigned to compose an unsigned explanation of a Remington illustration, eliciting the comment from the artist that "lots of moongazers think I write all the letter press that goes with my pictures. I suppose likewise lots of people think you are a drawer."

The most elaborate interview of Remington was reported in the Sunday *Herald* in New York. It was the first time that the biographical details Remington had been creating for himself appeared as a complete portrait. The word had come from the artist himself, and it was taken as gospel.

The view of the man that was given was close enough. He was thirty-two and had been an illustrator for eight years. Big, thick, and smooth faced, "he may be dressed in old clothes after three o'clock when he rides for an hour or two. Then he indulged in a first rate cigar and a drink of fine old Scotch wiskey that he said he could not afford. His language savors very decidedly of the West, though at the same time it has a curious mixture of English, peculiar to Mr. Remington himself. In manner he is the polished gentleman."

On top of that candor, however, came pretense. According to the

interviewer, some people have erroneously declared that "his personality had been deified." In proving that Remington had not been made into a "god," it was stated that he was mortal, "a man among men, a deuce of a good fellow, he never drew but two women in his life, and they were failures, while his greatest hope is a war in Europe. He knows the life which he depicts."

The personal experience that was credited to him was more than pretense. It was bogus. Remington said that at Yale he had helped Walter Camp invent modern football and that he took part in other sports. It was the beginning of the story that he had been an intercollegiate boxing champion. After Yale, he declared, work as the confidential clerk of Governor Cornell in Albany was too slow. He went West, punched cows in Montana, and lived four years in the saddle as a "bona fide cowboy." That "intimate knowledge" of the West was "the secret of his wonderful success." From there, he made a good thing out of a mule ranch in Kansas, and then he wandered south as an Indian scout until he "dropped his wad." To recoup, "he made some drawings and took them in to the Harpers" and he was instantly an artist.

For these promotional purposes, Remington did not hesitate to call himself a cowboy and an Indian scout when at most he might have punched a casual cow and met a scout. He made a conscious effort to avoid linkage with sheep. The description of his work habits as an artist, though, was quite true. He could not just sit, without painting. As soon as he would "kind of get my idea of what I am going to do, then the rest of it is nothing. I've made the best things I ever did in two hours. It is all in feeling it. If I don't feel it I work something else till I do feel it." His painting was an emotional expression, restrained until he was sure of his composition, then consummated in a burst.

He drew from field sketches, he said, and never used a camera now. A reviewer of Bigelow's book on the Russo-German 1892 trip deprecated Remington's illustrations because of the old claim that the animals in motion were copies of Muybridge's studies. *Harper's* commentator E. J. Martin came to Remington's support, saying "no doubt they are, and doubtless Mr. Remington is prepared to maintain that they could not have a more legitimate foundation." Martin never understood why he had earned Remington's eternal enmity.

Upstairs in one gable at Endion was his studio and on a little platform was the wooden horse he used for posing models when he needed help with the drapery of clothing. According to the interview, food and drink were kept in the studio to fortify him during the hours from early morning, but three o'clock was his deadline. His internal whistle blew. He could no longer stand it indoors, "I must get out. I have to get out in the country. I never could live in town in the

world. It would kill me." Then he was off, generally to ride. He knew
that with his biological clock, after three his work would diminish in
quality and that if he continued to work, the malaise would carry over
to the next day.

Except for the aborted Russian trip, he had in the past gone toward
the frontier whenever he had been able to get away. Now, he was
convinced once again that "the West is all played out." He still
believed that it was necessary for his career to branch out from the
American figures of his first Western subjects. "What I want to do is
[foreign] soldier men," he said. "I hope to travel in various parts
of Europe, looking up the armies, and to go to Africa. One had got to
see something new all the time, you know, to keep in stock for mate-
rial." He thought of soldiers as "his pets," and stated that he knew
"their every habit." His original ambition, he declared, had been to be
a Detaille, a follower of the French soldier artist, before he was side-
tracked by the flamboyant West.

Within a few weeks, the opportunity that Remington was seeking
came to him. Poultney Bigelow was commissioned by the Harpers to
do articles on the French soldiers in the military posts in their North
African colonies and Remington was to go along. It all happened fast.
The date for sailing was scheduled for the twenty-first of February.
Bigelow said Remington "snorted with contempt" and agreed to go
only "in the prospect of once more blinking over a blistering desert,"
but the snort was for joy. Remington had been anticipating the oppor-
tunity.

Remington knew that American whiskey would be scarce in Africa.
In his baggage he protected himself with a store of Bourbon, and
when he found a bar on the trip that sold only French wines and li-
quors, he "withered it with a Mexican curse." He supplemented the
whiskey with a pair of Arctic overshoes, a huge army revolver, and a
"few collars and the like."

They arrived in Oran in Algeria without incident and arranged to
travel by train to the railhead at the edge of the Sahara Desert. After
boarding the only first-class compartment, they sat alone while wait-
ing for the train to depart. Remington was puffing happily on a big and
strong cigar, his pockets full of replacement stogies, with his valise at
his feet. He expected Africa to look like Arizona, with the plus that
he would be seeing native Arabian horses and a new kind of soldier.
Suddenly he observed a very sophisticated French lady and her hus-
band on the platform, walking toward their car. Bigelow held his
ground but Remington got up from underneath a cloud of smoke and
moved himself into the nearest second-class compartment where he
could continue to enjoy his cigar. He crowded his perspiring bulk into
the exotic odors "amid marvelling Kabyles, Jews and Moors."

The cosmopolitan Bigelow found out that the gracious French couple were also going to the railhead. Their daughter was married to the governor of the district. Bigelow told the couple about Remington, the famous American artist, and the woman asked, *"Et votre camarade —ou est-il?"* Bigelow replied that Remington feared his smoking would bother her. *"Mais, monsieur, c'est tout au contraire,"* and the couple stepped out onto the platform to locate Remington in the second-class compartment. They sprayed him with compliments and entreated him to move forward while the horn of departure was sounding and the *chef de gare* was politely inviting *"messieurs les voyageurs* to *'En voiture'* at their earliest." And so, amidst "much puffing, Remington was finally pried out from between a Jew pedlar and a Moorish cattle dealer" and returned to the first-class section.

The railhead was a French military post. From there, the Governor took Bigelow and Remington "far into the desert. Fiery horsemen rode at us as though to trample us but just in the nick of time their horses fell back upon their haunches, and long carbines were waved in the air to signify welcome." Bigelow declared that Remington "was in a chuckle of delight" at these horses that came freely to their masters so they could "whisper lovingly to one another."

After Bigelow and Remington returned to the railhead, the desert sand was in their pores and they looked for a Moorish bath. They discovered the *hammam* nearby but there was no turbaned porter at the entrance. He had walked off to watch a dog fight. They pushed in, through the anteroom and into the steamy fog, grabbing at figures to find the gate guardian. The figures were nude females who began screaming while the startled journalists searched for the exit in the steam. Once outside in the blazing sun, they were met by a mob of furious Moslems ready to attack the unbelievers who had invaded the sacred women's section of the *hammam*. Bigelow was able to shout back at the mob in French, denouncing the unfaithful porter, and diverting the mob's attention so they could escape.

Back at the hotel, Bigelow described the reaction as giving them an appetite. They also drank two quarts apiece that afternoon and sang Yale songs:

> Oh, if I had a barrel of rum
> And sugar a hundred pounds;
> The College bell to hold it and
> The clapper to stir it round;
> I'd drink to the health of dear old Yale
> And friends both far and near; for
> I'm a rambling rake of poverty and
> A son of a Gamboleer.

Bigelow said that men have done stranger things than sing after a supreme escape.

Despite what Bigelow called Remington's bravery "in facing murderous men," he claimed that Remington was "an ignoble quitter when called upon to face a lady. Yet, in justice to my muscular and manly companion, I must add that he was no Joseph nor would he have been eligible amongst the Skoptsi of Bessarabia." Bigelow had been in Bessarabia with Millet on his canoe trip down the Danube, where Rumania bordered on the Black Sea, and there he discovered the Skoptsi, a sect that regarded emasculation as so pleasing in the sight of God that they indulged in self-mutilation of their genitals. The men were eunuchs. Bigelow was observing, obliquely, that on their trips together, Remington was neither chaste like Joseph nor castrated. He had no place among the Skoptsi of Bessarabia. He was sexually active, not with a "pure and high-bred woman of the world" who "would throw him into a panic," but with "the other kind." Bigelow the womanizer doubted that Remington "ever held a lady's hand until his marriage day," but with a different sort of woman he was a hit-maker.

Remington was back in New Rochelle by April 1, happy with the experiences in Africa and sure that his Arabian illustrations were moving him into a new subject that would enhance his popularity. After excessive imbibing on the trip, he said that "the latest news is that I haven't had a drink in three weeks and aint going to have any more till I am about to die. I feel better." To recover from the heavy eating, he went "up north for two weeks—Did 15 miles a day on foot and am down to 210 lbs. I have been sick for two years and didn't know it. Too much rum."

Unfortunately, the diet and the physical conditioning that he imposed on himself did not last. Also, he said that the African illustrations proved to be "unpopular." There was no call for other foreign subjects, and Africa was his last transoceanic venture. He even tried to do pictures of the New York City poor, showing the ragged immigrants with sympathetic realism, but apart from the West he was just another superb "drawer." There were a hundred competent illustrators who knew the city slums better than he. He did the Eastern militia with dash but without a following. He had grown to regard the annual Horse Show as his personal turf, but in 1894 the *Weekly* turned to other cheaper illustrators who recognized the Show as a social affair rather than just for the horses. He could not evade either his incipient obesity or his tie to the West.

In addition, Remington was having what was for him a skimpy year in fine art, despite his elevated status as an Associate. He had returned

to exhibiting at the National Academy, with his feelings about the 1892 hanging position having been soothed by time. The painting was "A Mexican Cavalry Column," priced at a mild four hundred dollars, but again he was not elected an Academician. To get broader exposure, he participated in local exhibitions of paintings and in a show of drawings at the Union League Club in New York.

Whether the West was his choice or not, he was continually thrown back on it for bread and butter. His role had changed from chronicler of current events to historian, with the fence-mending cowboy and the reservation Indian minimized in favor of Indian fighters taken from his memory and his memorabilia. That was why the Harpers saw Remington as the obvious illustrator for the cowboy stories of their new Bret Harte, the Philadelphia socialite Owen Wister. By teaming Remington and Wister, Remington's stature and vigor would be extended to boost and enliven the introspective Wister, and it would force Remington to think cowboy, the right subject for him. As the result, when the bound volumes of *Harper's Monthly* for 1894 are fitted with markers for Remington appearances, the two books look like a forest of protruding slips. The largest single source of this work was Wister.

Remington was casual about the relationship in the beginning. He was the veteran and had seen lots of new boys with the pen. After the first three stories, however, he realized that Wister was a genuine talent and he became enthusiastic about the windfall in illustrative opportunities. He was unsparing with gently given advice, encouragement, and the benefit of his extensive Western experience. Wister was immediately professional in transcribing into written words the oral history that he picked up in assiduous Western searches. He had a talent for listening to anyone who uttered decipherable speech, down to the idioms of a drudge in a Wyoming way station.

Sometimes, though, Wister missed a usage, a nuance, or a name, and Remington was quickly at hand with a carefully tendered face-saving correction. "I would change 'Young man afraid of his moustache' to some other Sioux name," he urged. "That has been made game of. You will find some good Sioux names in the M S of the council." Wister altered the name to "Young-man-afraid-of-his-horses." In the same story, Remington very tentatively offered a second recommendation: "Dear Nerve-Cell—I notice in Big Horn you make conversation easy between Sioux & Crow—they would employ a squaw interpreter or the sign language.— This is awful—but its true—and I suppose it is artistically insurmountable—I only '*throw it out causually*.' No one but some old chump would ever get on this and I want to put you in mind of it so that you are surely justified in your own mind." Wister made

the change, as Remington noted: "I interpolated the sentence you gave me about the squaw—Its good—it does the trick."

The *Harper's Monthly* procedure was for Wister to complete the manuscript about five months before publication and submit it to the editor, H. M. Alden, who made his corrections and sent the manuscript to Remington to illustrate what was supposed to be the final text. In spite of all the hands that had gone over the manuscript, Remington, the practical man, still made very basic suggestions. "In Specimen Jones—," he asked, "why dont the white fellows run away —they are on hossback and the Inguns on foot? P S. That's what I did under much more complicated circumstances on an occasion. P S. —Change, so that they are surrounded." Wister did not ask for details on Remington's personal experience. He merely added to the manuscript, "The enemy was behind them also. There was no retreat." When Wister gained more confidence in his own abilities, he ceased relying on Remington for factual analysis, and his stories were equally well accepted. The critics did not take Wister seriously as an ethnologist the way they did Remington.

Remington was a laborious writer. Wister was facile, able to spin his way to a story's end without interruption. When Remington finished writing, he began the illustrations. When Wister completed a story, he started to look for people to read it to, for criticism. Any negative comment was taken as profound, causing Wister to begin rewriting as if what he had completed had been a draft. His mother was particularly harsh. Some stories lingered a long time in the writing and rewriting. Wister had it as his goal to write well enough about the West so that his mother would approve of him as an author the way she did Henry James.

Throughout their relationship, Remington felt that Wister should write faster and be printed more. When Wister asked how he should establish his position as an author without becoming common through overexposure, Remington expostulated, "That about being too much before the public is d_____ rot—(pardon me) but I must tell the truth. The public is always in a frame of mind to forget you if you will let them." Remington did not distinguish literature from journalism. What counted was the illustrating that paid the bills. An article was a license to make the pictures. The writing was only supposed to be straightforward and to educate the public to an understanding of the subject as he saw it. Remington had as much to learn from Wister about the art of authorship as Wister had to learn from him about the West.

Wister had seven stories published in *Harper's Weekly* in 1894, but

Remington could not see how a writer could take more than a month to turn out a mere 7,500 words. Even at Wister's magnificent pay scale, it was only $250 a story. How could Wister live on that? Just to illustrate a Wister story, Remington would get two pages of easy drawings that paid him $200. The originals were returned to him, after being publicized for free, and they could be sold again for about the same amount, all for a couple of days' work. That was business.

Remington ceded to Wister the subject of cowboys, retaining for himself his favorites the soldiers. He tried hard to make Wister see and accept his own evolved concept of the West. He was warm, affectionate, and forgiving with Wister, but he was never able to relax with Wister on quite the same basis that he did with his older friend Bigelow. Wister and Bigelow were roughly of the same social level, along with Roosevelt, but travel had made Bigelow more the cosmopolitan that Remington had called him and more accepting of self-made men with talent. Wister was a Main Line Philadelphian wherever he happened to be. His intimates were restricted to men born to the upper class and to literary figures. Remington was just an associate. The line was drawn in subtle ways that Remington perceived only subliminally, but it was one he could never cross. Wister saw people as divided between those he would bring home to his mother and those he would not, and he was not likely to bring home anyone she did not already know. Wister's letter to his mother that mentioned his momentous first meeting with Remington described the artist as "a good sort" and that was all.

Nevertheless, Remington continually offered Wister the hand of friendship. He wanted Wister to succeed and even invited Wister to participate in the choice of story elements to be illustrated. He urged Wister to look for the broad themes: "Your text holds me down too close. Write me something where I can turn myself loose. Tell the story of the cow puncher, his rise and decline." Remington could never understand that Wister wrote to create verbal images, not to satisfy the artist's needs, but he helped the writer all he could and answered all sorts of questions:

As per your request. —99 men out of 100 when hit with a bullet say "*My God—I'm shot.*" dust—blood—sweat—dead horses stink. men awfully desperate—when they make a hit—say "I got that s_____ of a b_____ for sure." old soldier says to recruit "save your cartridges—this thing will last all day."

Shot in foot—cut boot off—do foot up in blouse—also take off clothes do wounds up in drawers & undershirt. dont have wounds to serious as men are out of it when hard hit.

horse turn on his back in a hot day unless men stab him to let wind out. You know the dull sound of a ball striking a dead horse or live one— makes him grunt.

Indians burn grass toward troops. This is all I know.— Mrs. R. wishes to be remembered.

It was a productive professional relationship until Remington went to Africa with Bigelow. Before leaving, he wrote Wister on February 21 that he supposed "there will be 11 or 12 M S by the time I return." That was a joke. The one story that Wister was working on was "The General's Bluff," and that's all that Remington expected.

On his return, he wrote Wister from New Rochelle April 1, 1894, that "I am back from the Arabs and the fleas and the French language which I do not understand—How's the 'Bluff' getting on." When there was no answer, he tried again: "Are you well—I hope so and please get a move on—I am starving—I want M S to illustrate. Fire a half dozen in at Alden and I'll live to bless your memory. Put every person on horseback and let the blood be half a foot deep.— Be very profane and have plenty of shooting. No episodes must occur in the dark." Remington was making another joke, but it was an odd situation. Where was the manuscript for "The General's Bluff?"

Wister was about to leave for the Southwest and was in the course of confessing to his journal that "so far as the public goes, I have fallen into favor with an ease." He interrupted his self-congratulation to give Remington the bad news he had been withholding. The Harpers were economizing and had replaced Remington with a lower priced illustrator for Wister's stories. That brought a quick response: "Sorry to hear your health is bad but if Arizona wont cure you, you'll soon die. The duplicity of Harpers is very confusing—but I hope the 'other artist' will have luck."

After less than a year, Wister was so high on his own achievements that he no longer dreamed of Remington's illustrations. He told his journal that the Harpers had approved another story, and that if the Harpers did not, there were other publishers approaching him who would. He did not intercede on Remington's behalf.

Remington had no reproach. He went on the attack at the Harpers on his own and, as he told Wister, he won. "They sent me the M S with a quaint letter that indicated that 'I am too new.' I'll wroop her up." He added that "things are done by the great house of Harper that jolt the intellect of common mortals. They play on the credulity of a pencil pusher like a state legislator does on his followers. They explain it in such a careful way, afterwards, that no one knows anything about it and we [artists] cannot change this—we are too few."

Despite his years with the Harpers, his conclusion was that "I have got to lay myself out on 'The Generals' Bluff' to knock out the inspiration of the 'other artist.'" He did, by dropping the approach of illustrating the characters in the passive manner he felt appropriate to Wister and instead reverting to his patented style of high action. He gave the Harpers "The Charge," the Indian-fighting cavalry from a quarter of a century earlier, and an escape, an Indian chief and a squaw on one horse, racing away from the cavalry seen in the background.

Just one month after Remington had drawn these historic Western horsemen who were his trademark, however, Miles snapped him back into the contemporary cavalry. The United States was still in the midst of the depression, the worst it had ever experienced. The depression had led to the Pullman strike that began in Chicago in May 1894, when the Pullman Palace Car Company responded to operating losses by reducing employees' wages without reducing rents in company housing. The strike resulted in a boycott that shut down national rail transportation, causing President Cleveland to bring in federal troops under Miles to give the strikers a "first lesson by the bayonet and the bullet." Miles called for Remington to write his publicity, to try once again to ignite the spark that would make Miles the President of the United States.

It was not until ten days after the strike was broken, though, that the *Weekly* published "Chicago under the Mob," written and illustrated by Remington. He described the city as in "a state of anarchy" from the "malodorous crowd of foreign trash" talking "Hungarian or Polack, or whatever the stuff is," but he forgot about Miles. The next week, Remington's "Chicago under the Law" resurrected his purpose: "The trouble is all with General Miles [that the strike was broken]. We have got to get him out of the army before we can have any wars. He spoiled the Sioux war, and he will spoil this too—so all the soldiers think. He is too anxious to fight." Remington approved of using force to put down the strikers, as did the national press and the administration. His wife declared that "Frederic was in Chicago during the riots & enjoyed every minute of it. He is always happy if with the troops."

The summons from Miles had been welcome. Miles meant articles he could write, and the articles provided him with the extra illustrative opportunities he needed to be fully occupied. No matter how large a proportion of the available Western commissions he received, he always had to have more to keep up the pace he set for himself. In 1894, he was writing a third of the pieces that contained his pictures. That ratio brought him into another abrasive contact with E. S. Mar-

tin, the satirist in the *Weekly*, who wrote a commentary with Remington in mind:

There is a growing propensity of the contemporary illustrator to do two men's work. Time was when illustrators looked on authors with respect. Whereas literature had been the staple of the periodicals, and pictures merely a supplementary attraction, it began to happen that the pictures were the indispensable thing, and the reading matter the thread that they were strung on. Writers and illustrators still continued on terms of amicable interdependence, but, alas! through continued association with writers, the illustrators learned to spell. Mr. Remington does not scruple to garnish his horseflesh with narratives of adventure.

Remington did not appreciate Martin's sly humor. Remington jollied writers and fed them ideas and nursed their confidence to milk as many manuscripts as he could from them on Western subjects. When the output of the writers fell short, he stepped in as his own author so that he did not have to seek illustrative commissions from publications other than the Harpers'. To him, columnist Martin was making jokes that were in bad taste.

The next Martin commentary was on Wister and it infuriated Remington. "No one since Bret Harte has made the wild West contribute so much to the entertainment of readers as Mr. Owen Wister," Martin declared. "He gets into his stories the indispensable human interest as a figure-painter, not a landscape artist. Mr. Wister has humor, too. A man who can see men in the West can see them everywhere. Mr. Wister may swap skies, but if he continues to use the same mind he took with him to cowboyland he may be expected to deal with the concerns of polite life as successfully as with the beefy West."

That really stung Remington, the idea of Martin soliciting Wister to drop the West for the "polite life." Remington had a letter off to Wister two days before the publication date of Martin's column: "In the last Harper's Weekly—a piece of office furniture fell on you—the upholstery of a library chair sprang all over you. The first concern of polite society is not to be a d_____ snob. If one finds that he is one he ought to try like the devil to conceal it—Just write Mr. Martin or Harpers to that effect, old man. Jump on 'em heavily."

Remington was ringing the wrong bell. Wister had returned from a long Western trip that had him soppy with unexpected adulation. He confided to his journal that "there was flattery, the real, delicious sort! I had quite as much incense [appreciation] as was wholesome. But incense is unluckily necessary for me." Wister wrote Western fiction because he was aware, if Martin was not, that Western subjects paid better than "polite society" and offered quicker rewards. He had no

reason to "swap skies," but Martin's column was flattering and Wister loved it.

Remington remained disaffected with Martin. Even when he asked Wister about writing an article on "The National Guard of Pennsylvania," a subject too mundane for Wister to have chosen to do, he brought in the columnist: "Had allotted on meeting you at Penna State Camp. I want to see how you can wrestle the military proposition. Sorry you dont go. Better reconsider it—go down—tell how much better red-blooded soldiers are than little stinking library upholstery such as Martin of Harpers is."

Wister relented on the Guard article and met Remington at Gettysburg in August 1894. There was the usual convivial time with the officers, occasioning an emergency that Remington discovered only after he had returned to New Rochelle. "I left a pair of crocodile shoes in Col. McClenllan's tepee," he wrote to Wister. "Got letter from him 'Phila Club'—awful signature—couldnt be sure of it—said he had 'spoke' to you about them—I wrote him—do not hear—want to go West—can't go without my *crocodiles*—can you help a fellow."

Then the crisis was resolved: "Have gotten the 'Crocodiles'—dont bother—I am off for Chicago—Leavenworth—Riley—Wingate—New Mexico." Remington had been waiting for word from Miles who had invited him West again. He heard from Miles, and left in September, and he took his crocodiles along. Once he had retrieved his precious shoes, he was at peace with the world and his feelings toward Wister were warm.

19.

The Origin
of the Evolution
of the Bronco Buster

In 1894, the best-known popularizers of the West were still Theodore Roosevelt in nonfiction and Frederic Remington in art. During the second half of the year, Remington induced that other Easterner, Owen Wister, to join him in documenting the origins of the American cowboy. First presented as a Wister essay, the cowboy study was based mainly on data supplied by Remington. This essay set the stereotype for the whole genre of romantic Western literature that followed, and was the origin of the evolution of Wister's cowpuncher, the "Virginian." It also elevated Wister to the status in fiction that Roosevelt and Remington had in their fields.

Roosevelt did not participate in this creative partnership, but he did attest to Wister's new eminence. He declared in his *Autobiography* that Dakota Territory on his first trip "was still the Wild West in those days, the West of Owen Wister's stories and Frederic Remington's drawings, the West of the Indian and the buffalo-hunter, the soldier and the cow-puncher." He added their names to his as laureates of the cow country.

Remington's reason for encouraging Wister to write the essay was a

continuing one, the need to generate stories for *Harper's* that he could illustrate. When he had announced the trip West with Miles, he asked Wister to keep him "informed when you discharge M S at Alden." He did not want to chance the loss of a commission by being out of the city at the moment Alden was ready to call in an artist.

Wister's answer arrived after Remington had left. Eva Remington had remained in New Rochelle with her sister Emma as company and she undertook a gushing acknowledgement: "We shall hope for a visit from you. You are one of the few men who he loves & he cannot see too much of you. When I see you I'll tell you how much *many* women are interested in all *you* write." She then went on to ask what Wister as an author thought of the book *Trilby* that had been serialized in *Harper's Monthly* beginning January.

Remington had marveled at Svengali and Trilby, too. Like him, the Englishman George DuMaurier was an artist turned author-illustrator. Remington had actually written a fan letter to DuMaurier to be delivered through Bigelow in Europe: "Every once in a while some chump or some *very great man* writes me and tells me *I will do*—I never did a thing like that before [myself], but Trilby is so great by G_____ every man living ought to thank a genius like the creator.—" DuMaurier, who died in 1896, did not respond to Remington on *Trilby*, any more than Wister did to Eva Remington.

When Remington returned to Endion from the West, he invited Wister to visit in October: "Well—old man—whats the matter of your coming out here for next Sunday. Why, also, cant you come so that we can have a ride Saturday afternoon. Better bring your boots and breeches—it may be nasty. I have the 'Second Mo Com' and its bothering me to know just how to illustrate. We will 'raise our voices' in the matter." This time, *Harper's* had forwarded the latest manuscript without argument.

Illustrating a routine story like "The Second Missouri Compromise" between the federal government and Idaho legislators would not have been difficult for Remington. He needed to see Wister for another purpose he did not disclose in advance. He was full of enthusiasm about the New Mexican cowboy he had just observed, and what he really wanted was to launch a joint effort to fulfill what he saw as the "Great & rising demand for—a cow-boy article. 'The Evolution & the Survival of the Cow-boy' by O. Wister with 25 illustrations by the eminent artist Frede*rico Remingto*nio.— just out." That was Remington's title for the proposed essay.

Wister went to Endion, and surprisingly, he agreed to do the writing even though the evolution of the cowboy was not his choice of subject and he was far less experienced in cowboy lore than Reming-

ton. In lieu of doing his own research, Wister asked Remington to provide the details. The first response was on the cowboy and his horse:

I wrote an article in "The Century"—The horse of the Plains '87—I cant find the article.

Cortez had horses but they must have been all killed—subsequent importations [by Spaniards into Mexico]—the Sioux have a legend of the first horses—they were stolen from Mexico.

"Cayuse"—a north Western indian tribe who raised good horses—the term grew and is localized in the north west.—

"mustang"—a California word for a steed.—much used by '49 but never established (out of story books) East of Mountains.—

"broncho"—"wild" [in] Spanish—means anything [at all] north of where the people don't understand Spanish.— Cheyenne saddle—made in city of Cheyenne from California models—now so called all over—All made in St. Louis I believe.

Don't know how he [the cowboy] was affected by Mex war.— he did not exist as an American type [then]—he was later a combination of the Kentucky or Tennessee man with the Spanish.

In civil war he sold cattle to Confederate Armies—was a soldier in Confed army.

but he grew up to take the cattle through the Indian country from Texas to meet the R R—at Abilene—or before that even drove to Westport Landing—These were his palmy days—when he litterly fought his right of way—he then drove to the north and stocked the ranges—then the thing colopsed and he turned "rustler"—and is now extinct except in the far away places of the Rocky mountains.— Armor killed him.— Dont mistake the nice young men who amble around wire fences for the "wild rider of the Plains".—

Remington's notes were bare bones. "Armor" for example was Philip Armour, the Chicago meat packer. Wister not only deciphered and utilized these random concepts, he called for more, and Remington was eager to comply:

Go ahead make me an article on the evolution of the puncher—"the passing" as it were—I want to make some pictures of the ponies going over the hell roaring mal-pai after a steer on the jump.

[Sub] Title "The Mountain Cow-boy—a new type"—

The early days '65 to 1878 he was a poor Texan &c—cattle boom he was rich—got $75 a month—wore fine clothes—adventurous young men from all parts went into it—Cheyenne saddles—fine chaps—$15 hats—fringed gloves—$25 boots &c. With the crash of the boom—Yankee enginuty killed the cattle business as much as any thing.— the Chicago packers—the terrible storms, the drough[t] &c—then the survival of the Stevens cowboys [in the mountains]—run down a hill . . . as fast as a deer—over mal-

pai—through juniper.— they are all Texans—do not drink now—get 30 a month—work the year round. Stevens had 14 men killed over a maverick. —they dress poorly [now], wear very wide chaps.— are in saddle all the time. "ramuda" [means] horse herd—horses bred in mountains—great lung power—& hoofs like iron.

the cattle are wild—do not wait for punchers but pull out as kwick as deer—are killed by bear & wolves—mavericks in bunches—some 8 & 9 & 10 year old.

Jokes—"I understand you went up a tree with the bear just behind you" —"The bear was not ahead of me"

Well go ahead—will you do it.— get a lot of ponies "just a smokin" in it.

One way that Remington tried to secure prompt reactions from Wister was to supply the "incense": "Mr. Nerve Cell—You have an air tight cinch on the West—others may monkey but you arrive with a horrible crash every pop. 'What size hat are you now wearing.'" When there was no response he tried again: "Dear Broncho Quill— When does the *puncher* come, O—thing of Truth—veil-raiser of the Past—story teller of the desert—let on." By the third time, Remington asked in a prosier manner, "How is the cow-boy article coming on?"

There had been no response on the article by January 1895, so Remington and his wife decided to go to Florida for a vacation. He invited Wister to join them: "I have grip—and there is a riot in Brooklyn and I am tired out—and two servants are sick—and the old lady has to work and is out of temper and I am going to Florida the very minute I can get the Doc to say I can. Come—go 'long. —aligators—tarpon—Well—come on." He said that Punta Gorda was "where the festive tarpon monkeys and the quail and jack snipe range."

At the Hotel Punta Gorda, he was enthusiastic: "Come down—deer —bear—tarpon—red snapper—ducks—birds of paradise—curious cow-boys who shoot up the rail road trains." When Wister did not join him, Remington exclaimed that "I am like a sixteen year old school girl now. There is a man down on this neck of land who owns 90 000 head of cattle—but that s another story.—" What he had found was the material for an article "Cracker Cowboys of Florida," that he wrote and illustrated for *Harper's*. Punta Gorda was on the Gulf coast, the trading point for a cattle industry that Remington said followed Buckle's law of the physical aspects of nature. Poor land made for stunted cattle, emaciated ponies, and bedraggled cowboys.

The prototype "Cracker Cowboy" was Morgan Bonapart (Bone) Mizell, an illiterate ranch foreman with a speech defect: "Frequently in trouble because of his drinking, he was asked by a judge how long

it had been since his last drink. 'A momph,' lisped Mizell. When the judge asked him what a 'momph' was, Mizell shot back, 'Hang hit, jedge I fought ever'body knowed what a momph is—hit's firty days.' After he was found dead in the Fort Ogden railway depot, a physician listed the cause of death as 'Moonshine—went to sleep and did not wake up.'"

Remington was a connoisseur of the whole cowboy species, always excited at the prospect of adding a new variety to his collection. In contrast, Wister did not want to dilute his image of the Western cowboy with the poor Southern variety like Bone Mizell. Besides, Wister did not consider the Remingtons to be stimulating holiday companions. He had cautioned his mother who was also in Florida that "I don't suppose you have run across Remington. He writes me from Punta Gorda; but as I told you, he is not the sort of person you would find available to talk with."

After the Remingtons had returned from the South the beginning of February 1895, Wister finally sent the opening portion of the essay. Remington replied, "The 'Cow-boys' are all right. Tell of the settlement and decline of the cattle business and of the *survival*—such as one finds in the mountains." In a few weeks, Remington tried again: "When will you have in the rest of your cow-boy article? Dont forget to tell about the *survival of the* fittest 'way down in the back reaches of New Mexico and Arizona." Two months later, Remington had seen enough of the essay to say, "I am simply lost in the immensity of space with the 'Evolution.'"

From then on, however, Remington forgot the "incense" and began revising his opinions downward: "Strikes me there is a good deal of English in the thing—I never saw an English cow-boy—have seen owners. You want to credit the Mexican with the inventing the whole business—he was the majority of the 'boys' who first ran the steers to Abilene Kansas—" That was Remington's thesis on the national origin of the cowboy. Not only did the cowboy's horse come from Spain but the cowboy himself was a mixed breed that had started in Spain, the Mexican type blended with the Kentucky or Tennessee mountaineer in Texas. The "bummers" in the painting "A Dash for the Timber" were the real cowboys.

In May, Wister was still holding on to the essay after eight months. Remington would not say anything more flattering about what he had seen than that the piece was satisfactory: "No particular hurry about sending it in only would like it as soon as you can without throwing a spavin. The article is all right—I would make *more scenes* and less essay—if you can see your way to do it. Make more of the 14 men and

the maverick &c." He realized by then that Wister was not his Trilby in writing the essay but operating in his own style, at his own pace.

Then, Wister misplaced the manuscript, occasioning an expression of utter disgust from Remington: "Well you are a Derby winner— you ought to get a small cheap man with just ordinary good sense to act as your guardian—some fellow to kind of look out and see that you dont starve to death in a resterant or go to bed with your hat on —little precautions which are usual for persons to take. I hope you find the M S but had better watch out or you'l have a jury of lunicy on your spine. Some fellow will paint a Liver Pill sign on your back if you are not more alert."

When Wister found the essay, he was at last satisfied with the writing. The completed essay was sent to the Harpers, letting Remington resolve the illustrative commission: "I 'charged' on The 'Evolution' & the enemy broke before every forward movement. They did not wait for the 'shock action' but pulled immediately when they heard my bugles—I captured 5 pages—& Wister if we can't lug you into the immortal band with 5 pages you had better turn lawyer & done with it."

After Remington told Wister about the article "Cracker Cowboys in Florida," Wister professed to feel endangered by its forthcoming publication. He considered the article to be needlessly competitive with "The Evolution," until Remington declared that the "Cracker Cowboys" would be printed in the *Harper's Weekly* newspaper rather than the *Monthly* magazine. When Wister questioned him again, Remington repeated that "my Florida article is in the Weekly." He did not, however, say which article. It was another article, "Winter Shooting on the Gulf Coast of Florida," that appeared in the *Weekly* on May 11, 1895. "Cracker Cowboys" went into the *Monthly* in August, the month before "The Evolution," just as Wister had feared. He need not have worried. He had written a classic, and Remington's was just a clever piece.

"The Evolution of the Cowpuncher" was published in *Harper's Monthly* in September 1895, one year after Remington had suggested the concept. The article was the first statement on the mythical cowboy in popular American literature, the prototype of the cowboy character for the 20th century novel, the stage, the motion picture, and the comic book. From "The Evolution" and from his stories derived from "The Evolution," Wister achieved the heights in fiction that paralleled the accomplishments of Remington and Roosevelt. In the creation of this prototype, Remington had been responsible for the conception of the idea, the factual content of the essay, the constant pressure to get the job done, and the title. He had been so involved in

creating "The Evolution" that he could have saved time by writing the piece himself. If he had, it would at least have been thematically correct.

Instead of sticking to Remington's definition of the origin of the cowboy, Wister had compressed Remington's statements into just the meat of the essay, copied straight from Remington's letters, and he sandwiched the meat between two heavy slices of his own bread. The top slice immediately changed Remington's Mex-Tex cowboy into a Saxon lord. Although Remington had said he never saw "an English cowboy," Wister's thesis was that it was actually a nobleman from England who had been transplanted to Texas to become the cowboy prototype. The Englishman prospered by relying on his Saxon heritage. The clean cattle country was for Saxons like him, Wister wrote, not for Poles or Huns or Russian Jews, Swedes or Frenchmen or Italians, Spaniards or Portuguese. In history, the knight and the cowboy were the same noble Saxon, and the horse was his ally. True, the Saxon free-booters had looted, but not for money like the Hebrews. In comparison with the Saxon, Remington's Mexican cowboy was merely a small, deceitful alien. That was Wister's view.

The bottom slice of the sandwich was more of the same Saxon, the glorification of Wister's make-believe cow-puncher, the American descendant of English ancestors. The article was a fantastic tour de force for Wister, taking Remington's truths and distorting them for a novel conclusion.

After the essay was published, Wister soon observed that Remington had lost interest in their business association. He ascribed the change to the personal problems that had arisen during "The Evolution." What had happened, however, was that Remington was still affectionate with Wister as a friend but his eagerness as an illustrator was turning into diffidence. This new attitude had started sometime after October 20, 1894, a year earlier, when the two of them had conferred at Endion on "The Evolution" and on "The Second Missouri Compromise." A few days later, Augustus Thomas the playwright had been visiting in Remington's upstairs studio under the big gable. There was a blank 25 by 35 inch canvas on the easel. Remington was seated in front of the canvas, beginning to block in the composition with vigorous strokes of charcoal.

As Remington visualized the scene from "The Second Missouri Compromise," frontier politicians were massed around a card table in an otherwise bare room in the Idaho State House. One man had drawn his pistol. Remington sketched the gunman as a large figure at the left, menacing the players before him. Then Remington sensed that the central detail was obscured. Working "chic," without a model, the

sure-handed artist quickly wiped off the charcoal lines and reversed the characters, putting the gunman in the background and the players toward the front, setting the stage for Corporal Specimen Jones to enter the room from the left. Thomas was impressed, "Frederic," he declared, "You're not an illustrator so much as you're a sculptor. You don't mentally see your figures on [just] one side of them. Your mind goes all around them, and you could have put him anywhere you wanted him. They call that the sculptor's degree of vision."

Thomas' compliment concerning the sculptor's eye was the spark that turned Remington's attention to modeling. He had been aware of sculpture as a separate art, practiced by men who trained in their medium as he did in his. He had opinions about sculpture, saying that the Poles and the Russians "lead the world in their horse modelling in bronze." Although appreciation of sculpture was a long way from sculpting, Thomas' comments had motivated him. The possibility that he might be qualified to work in bronze was exciting. After ten years of ink and paint, his involvement in illustrating was more commercial than emotionally rewarding and his achievement in fine art was not progressing. The opportunity to feel forms and masses with his bare hands would be something new.

The chance to try sculpting arose within a week of his conversation with Thomas, when the classical sculptor Frederick Ruckstuhl who had been Thomas' childhood friend visited New Rochelle. One Sunday morning, Ruckstuhl was with Remington in the Endion studio when the subject that had been occupying Remington's dreaming burst out. "Ruck," Remington asked suddenly, "Do you think I could model? Thomas suggested that I could." "Certainly," Ruckstuhl answered. "You see in your mind anything that you want to draw. You will be able to draw as clearly with wax as you do on paper."

"But how about the technique of it?" Remington asked. "Forget technique and it will take care of itself," Ruckstuhl replied. "Then you will have an individual technique, personal to you, and that will be an added quality. All you need to think of is a popular subject, a fine composition, correct movement and expressive form. Begin right away. I'll get a modelling stand, and tools and modelling wax for you, and show you how to make a wire skeleton for supporting the wax, and all that." "I can try," Remington said.

Ruckstuhl ordered the sculpting paraphernalia when he returned to New York City. As soon as Remington knew that Ruckstuhl had received the tools, he took the early train into the city so he could watch Ruckstuhl model. They discussed how to construct a twelve-inch armature, and Remington got his hands into the wax that he called clay or mud. He brought the equipment and materials back to

Endion with him and told his wife for the first time what he was planning. "Kid," he said, "I think I have found something," and he described all that had been happening with Thomas and Ruckstuhl.

Remington and Ruckstuhl had discussed a Bronco Buster as the first subject, although it would be a hard one. They did not pin the idea down to a particular drawing. Ruckstuhl meant a relatively horizontal composition like a sun fisher or a running bucker where the body of the horse was basically parallel to the ground although the hooves were off the ground. The composition would have had to be modeled in the Grecian style with a supporting post connecting the horse to the base. Remington, however, took Ruckstuhl to mean the vertical arrangement of "A Pitching Bronco" he had done for the Richard Harding Davis book *The West from a Car Window*, where the horse was erect on its rear legs. A vertical Bronco Buster with its inherent structural problems seemed an impossible task for an untrained hand, a composition likely to put an early end to the sculpting ambitions of the cocky Remington. No one before Remington had ever modeled a three-dimensional cowboy on a bucking Western horse, and Remington had not yet modeled anything.

By January 15, 1895, Remington was actually sculpting. He told Howard Pyle, the *Harper's* illustrator, that "I am modelling in wax—great fun." That was the truth. He was handling the clay and enjoying himself, but he was not succeeding in sculpting the Bronco Buster. He wrote to Wister a few days later when he was no further along but his enthusiasm was high:

I have got a receipt [recipe] for being *Great*—everyone might not be able to use the receipt but I can. D_____ your "glide along" songs—they die in the ear—your Virginian will be eatin' up by time—all paper is pulp now. My oils will all get old mastery—that is, they will look like *pale molases* in time—my water colors will fade—but I am to endure in bronze —even rust does not touch.— I am modeling—I find I do well—I am doing a cow boy on a bucking broncho and I am going to rattle down through all the ages, unless some Anarchist invades the old mansion and knocks it off the shelf.

I have simply been fooling my time away—I can't tell a red blanket from a grey overcoat for color but when you get right down to facts—and thats what you have got to sure establish when you monkey with the plastic clay, I am *there*—there in double leaded type.

With the letter was a sketch of "The Broncho Buster," followed by the frivolous question, "How does that strike your fancy Charles—." In the sketch, the rider was almost in the position that was ultimately adopted, except that his right hand was fanning his hat instead of brandishing a quirt as in the finished work. The sign of the months of

work and anxiety that remained, however, was the position of the bronco. The construction was in the form of a right angle, off balance, with the horse reaching out with its forelegs instead of up and the rider's weight bearing down on the unsupported body of the horse. The statuette would not hold up its own weight in bronze under foundry practices of the time, and Remington's standards were too high to permit the use of the conventional Grecian post.

In March he was still ebullient. He told Wister that "you ought to see the 'great model' I am making—it's a 'lollo.'" Great meant wonderful and lollo was lollopalooza, also great. In response Wister jokingly deprecated the sculpture in favor of his own poetry, causing Remington to respond, "Go ahead with your d_____ epic poem—my *model* is said by competent judges to be immortal. —your sneers will live to haunt you.—" Remington was bragging to everyone. He stated to Bigelow that he was "modeling a bronze which is to be one of the world's treasures," and he asked, "Did I tell you that I was about to become a great sculptor.— if not—well d_____ my modesty—it is so."

The reality of his effort, though, was quite different. The model could not be balanced without a supporting column and all of the professional sculptors he consulted recommended compromises with what Remington was determined to do. By then, he had been working on the model for five months. He seriously contemplated quitting.

That was the point, the start of the warm weather in May, when Ruckstuhl came to New Rochelle to stay for a while. Ruckstuhl was ready to begin constructing the working model in clay for an equestrian bronze of General Hartranft that had been commissioned for Harrisburg, Pennsylvania. The statue was too big for Ruckstuhl's city studio so he arranged to put up a shed in Thomas' back yard. Every afternoon, after Remington had finished his painting for the day, he went over to Ruckstuhl's shed instead of riding. He watched the progress of the model right from the beginning. The artists were both horsemen and they argued at length over the relative merits of Hartranft's mount in comparison with Remington's mustang.

With Ruckstuhl's sculpting taking shape before him, Remington was able to solve his own mechanical problems. He shifted to a larger twenty-four-inch armature that followed the more vertical posture of the final statuette and made progress that was unbelievable to observers who thought he was just beginning. His success confounded his artistic confreres. One of his neighbors was Rufus Fairchild Zogbaum, who had switched from the West to the navy as his illustrative specialty to avoid competition with Remington. Zogbaum's eleven-year-old son Rufus Junior, who considered himself to be Remington's

friend, had been crossing Endion's lawn when the artist called him. Remington was standing in a French window that led to the conservatory on the south side of the house. There was a pedestal with a platform on it, and on the platform was a two-foot-high mass of mud in the rough shape of a horse and rider. Tools were scattered about.

After being invited in, the boy watched all morning without a sound. He was fascinated as bits of clay were added, bits scooped away, and the horse and rider grew more lifelike before his eyes. He left for home when it was time for lunch and told his parents what he had seen. Zogbaum threw his napkin onto the table. Remington had said nothing to him about the bronco buster. He turned to his wife and asked, "Is there anything that man can't do!" He invited the Remingtons over for a visit that night to talk about the sculpture and he allowed his son to bring the whiskey and the glasses out under the stars so the boy could listen.

That was when Remington had the bronco buster all resolved in his mind. He was attacking the wax, working boldly with his usual intensity, although he still had the "buster" fanning the air with a hat rather than holding a quirt. By mid-August, his modeling was done. He told Wister that "I want you to see my model—I am afraid it will be cut up [for sand casting] this week [before you can get here]. You talk about fellows who have arrived—all they have got to do is keep my name in steno type in printers cases—they will have to use it right along because if my model wont do I am going to be the most eminent market gardener in the Suburbs of New York."

Wister was the right one to tell about the model. His story had accidentally triggered Remington's leap into sculpture. The bronze was part of the evolution of the cowpuncher, like the essay had been, but Remington's bronze "The Bronco Buster" was taken from the real old Texas rider, not some fantasied Saxon knight.

20.

Art That the Moth Dont Steal

Remington had already selected the Henri-Bonnard foundry in New York City to cast "The Bronco Buster." The foundry had started as a molder of small industrial bronzes before the Civil War, and expanded when the Vanderbilts provided the capital for the larger ornamental bronzes needed for their new residence. Despite high prices, the firm was the established source for complex sculpture like "The Bronco Buster."

Henri-Bonnard used the French sand-casting process, the most accurate available in 1895. The firm's owners were French but French sand casting was an Italian process using French sand because of its high clay content. French sand held shapes better.

Remington's model had been worked up in Plasticene, a commercial wax. The next step was to cast a duplicate in plaster. That was a technician's job, painting the Plasticene model with coats of glue to form a thin flexible mold into which the plaster was poured. Because of shrinkage, the plaster casting was a little smaller than the Plasticene had been, and some detail was lost. The sculptor was

expected to clean, repair, and sharpen the plaster casting exactly to the final degree of finish he wanted in the bronze.

It was this solid plaster casting that Remington brought to Henri-Bonnard. The foundry was a large open building with great rafters high above a dirt floor. Plasters of extreme intricacy like "The Bronco Buster" had to be cut into sections to make up for the limitations of the process. Remington conferred with the foundrymen on where the cuts were to be. He was then finished. There was no continuing artistic relationship with the foundry on that piece.

The foundrymen took each cut plaster section and pressed it into the damp sand held in a metal frame. Rough cores were built into the mold to form the inside wall that would make the bronze hollow. After the mold was oven dried, the foundrymen poured molten bronze into the mold through a gate. In the course of removing the cooled bronze sections from the sand, the mold was destroyed.

The cast sections comprised a kind of three-dimensional jigsaw puzzle. The artisans filed the edges clean so they could fit the pieces together with bronze pins to assemble the hollow bronze statuette and give it the patina Remington had chosen. The small appurtenances, the bridle and the lariat, were added separately. A quirt had replaced the hat that was too heavy in sand casting to be at the end of a thin extended arm.

When the first "Bronco Buster" was finished, it was again smaller. Half an inch had gone to shrinkages and the height was now 23½ inches. Remington's copyright for the statuette was granted October 1, 1895, his eleventh wedding anniversary and three days before his thirty-fourth birthday. The description was "The Bronco Buster: Equestrian statue of cowboy mounted upon and breaking in wild horse standing on hind feet. Cowboy holding onto horse's mane with left hand while right hand is extended upwards." Remington wrote "broncho," but the patent lawyer corrected his spelling.

The marketing of a bronze was a new experience for Remington. A painting was a singleton, offered first to a publisher for the sale of the reproduction rights and then returned to the artist for sale of the painting itself to one purchaser. A bronze was a multiple, castable in any desired quantity, like a book or a print. Remington could do other work while signed bronzes were manufactured one at a time in the elaborate process. Best of all, bronzes were sold in a store, like eggs, but the price, unlike eggs, was $250 each, in Tiffany's window on Union Square. Tiffany's was the usual outlet for the leading modelers of statuettes, including Ruckstuhl.

In Remington's home publication, *Harper's Weekly*, he managed to secure a full page on the bronze in the October 19 issue. Below a huge

attention-arresting photograph of "The Bronco Buster" was a thousand-word article by the critic and painter Arthur Hoeber. The essence was that "Mr. Remington has handled his clay in a masterly way, with great freedom and certainty of touch, and in a manner to call forth the surprise and admiration not only of his fellow-craftsmen, but of sculptors as well. In short, well as he has succeeded in other directions, it is quite evident that Mr. Remington has [now] struck his gait."

Hoeber was damning Remington with strong praise, implying that he was only a "craftsman" with no pretense to sculpting, and thus classifying the statuette as the equivalent of a handmade ornament, not a work of art. The critic Preston Remington, who was not a relative, added that "this highly literal accuracy has little to be said for it to those of the public who have pedestaled the element of imagination in art." Loredo Taft, the sculptor and teacher, spoke for the art establishment in making the judgment that Remington "has been tempted to carry certain of his illustrations over into another medium, and, while they remain illustrations, this clever artist seems as much at home in one form of expression as the other. Mr. Remington is not ever likely to conceive a theme sculpturally." To the sculptors, the "Buster" was just an illustration given a third dimension.

The volume of popular applause was so loud, though, that Remington did not hear the carping of the establishment. No less than the doyen of American letters William Dean Howells, whom Remington knew through *Harper's*, told him that "you are such a wonder in every way that it would be no wonder if sculpture turned out to be one of your best holds." When the New York *World* correspondent Frank Carpenter requested an interview, Remington replied that "you dont want to write me up—there is nothing new about me except that I am growing older every day. See my 'Broncho Buster'—new and worth writing about. How does this strike you—with a pen sketch to go with it."

Even *The Century*, for which Remington no longer wrote, requested a drawing to illustrate an article on the "Buster." Remington replied that "I have no pen and ink of the statuette. The World had the best pen drawing of the thing and you would probably have no trouble in getting a plate of them." In lieu of the drawing, *The Century* published four photographs of the bronze, one from each side, along with a quote from Remington: "I have always had a feeling for 'mud,' and I did that—a long work attended with great difficulties on my part. I propose to do some more, to put the wild life of our West into something that burglar won't have, moth eat, or time blacken."

The New York *Times* noted that " 'The Bronco Buster' presents

Mr. Remington in a new and unexpected light, opening up great possibilities in a field wherein he will be quite alone, for as yet the artist working in plastic form has ventured but little in this direction." Whatever the sculptors might say in deprecation, very few of them had ever achieved what Remington did, a home run in his first time at bat, in a new kind of ballgame.

Buoyed by the enthusiastic reviews in the press, Remington wrote Bigelow, "When you Europeans get your two eyes on my bronze— you will say '*Ah there*—America has *got a* winner.' It's the biggest business I ever did, and if some of these rich sinners over here will cough up and buy a couple of dozen I will go into the mud business." He was a proud and excited man.

To search out individual "sinners," the newly Anglicized Henry-Bonnard Bronze Company mailed an advertising piece to a list of prospects furnished by Remington. The addressees included Remington's cronies, business associates, and the art and literary gentry. One friend who responded with a dig at the establishment was A. S. Brolley, the former sparring partner from Albany: "So St. Gaudens [a leading sculptor] says it is 'very good,' does he? I know he cant touch it. You wait."

Another respondent was Owen Wister, who penned an October letter that Remington thought memorable enough to keep: "Why in he____ Oh Bear Don't you write to me—Where are you. How are you. Who are you. The notice of the Bronze Bully Buster by Bear came this a m and precipitated this—Kindest regards to the Madam." All of the bragging Remington had been doing about his "immortal model" had come true. Wister realized that Remington might even elect to discontinue illustrating, an impending blow of sufficient magnitude to elicit the closing bow "to the Madam."

Remington's response to Wister was ecstatic but impersonal: "I have only one idea now—I only have an idea every seven years & never more than one at a time but its *mud*—all other forms of art are trivialities—*mud*—or its sequence "bronze" is a thing to think of when you are doing it—and after wards—too. It dont decay—the moth dont break through & steal—the rust and the idiot can not harm it— for it is there to stay by God—I am d____ near eternal if people want to know about the past." Accumulated emotions were making him so incoherent that he saw moths rather than burglars stealing the bronze. He was swept away, his usual high spirits inflamed by the new triumph.

Wister remained conciliatory, despite the threat that bronze had turned illustration into a triviality: "Dear Mud: You are right. Only once in a while you'll still wash your hands to take hold of mine I

hope. It would be an awful blow to one of this team if bronze was to be all, hereafter—I am going to own this Broncho Buster. The name is as splendid as the rest. My best regards to Mrs. Remington & the Gods prosper you."

Wister never did buy the bronze. It was too realistic a concept for a poet. Some other "sinners" were buying, however. The outlook was promising enough in the beginning for Eva Remington to add a postscript to a December 30 letter from Remington to Wister, boasting that "Santa Claus put a Steinway piano in my stocking this year. How is that?" The piano was a used rosewood upright that Remington bought just two days before Christmas.

Despite the deprecation by the establishment, the bronze was the art event of the year, celebrating the first cowboy sculpture. A new career modeling statuettes had opened to Remington. The key to the overwhelming acceptance was the portrayal of the bronco. That was where Remington excelled. Julian Ralph was the first to report that Remington "loves the horse, but what not everyone knows is that he had said he would be proud to have carved on his tombstone the simple sentence, 'He knew the horse.'" An equine epitaph was unique, but it was sincere, and it followed Remington the rest of his days.

Soon after the first of the year, though, the early flurry in bronze sales tapered off. The concept of the bronze was new and radical for the time. Some buyers were disconcerted by the excess of publicity and some by the price of $250. Others were appalled by the realism of "a horse in a perfect agony of fear" as "the savage bit is tearing the delicate mouth, while the long sharp spur on the rider is ripping his hide." To Remington, his statuette showed a historic happening in the West that he had actually seen. He was memorializing a real Westerner at work, not moralizing.

Only about forty-five of the sand castings of the "Buster" were to be sold during the next three years. Earnings would be $6,000 as the net to Remington for the whole period. Despite the relatively modest proceeds that had followed the big applause, however, the ebullient Remington was quick to assure Bigelow, "You once told me that my friends would have to pass the hat for me some day—Well—I guess 'no.'—"

Besides the bronze, another reason for his feeling of economic security was that he had "invented a military appliance which will make me 'rich.'" The invention was an improvement in military ammunition carriers. While he explored licensing the device to the War Department, Remington sold a half interest in the patent to his Albany crony Joel Burdick, the General Passenger Agent of The Delaware and Hudson (railroad) Company. Remington was still corresponding

with the Secretary of War on military policy, telling him that the new army cap was a mistake that would cause "respectable freight train conductors" to be "all mixed up with U S Army officers. The man who did it must be a son of a tailor." Secretary Lamont saved Remington's letters for his children's autograph collection but he did not buy the patented ammunition carrier for the government.

Remington had so many ventures in the air at the given moment, displaying so many facets of talent, that he was a writer, a painter, a sculptor, an illustrator, a correspondent, an engineer, a military expert, and a promoter, with unusual aptitude for each capacity. He explained to Wister that "Pony Tracks [a book]—that sale [of paintings coming up]—the bronze—magazine pictures—a patent I am trying to engineer—story (good one)—and several other things make life perfectly *Chineese Coolie* to me."

The press of his projects made him unable to get away for long enough trips in 1895. Staying home left him edgy, although he worked off some of his fidgets by cycling. He told Bigelow that he was "riding 'bike'—its great fun—Every one in America is riding 'bike.' It makes the grease come out of a fellow and is the greatest thing to produce a thirst for beer—besides any one can desecrate the Sabbath on a bike. In that respect it is like going to hell—everyone is [going there] whom I like." Unfortunately, cycling was the wrong image for a man who "knew the horse."

One-day junkets were another compensation. He met Wister in Philadelphia, for example, when he attended a dinner of the Nameless (art) Club, where he expected to be "under a Doctor's care" for inebriety. This was one of the times when, as he said, he was "having a little dissipation," as opposed to other times when he had "concluded to quit drinking—I reasoned that I had had all that kind of fun one man could expect to have and do anything else so I cut square off and feel better—but I am not a d_____ bit sorry about any drink I ever had." Remington drank when it would not interfere with his work and at other times gave lip service to abstention.

He also saw Wister at "A Western Camp Fire" held at the Aldine Club in New York. General Miles and Remington "sat around and told stories, while the lights glistened on the Navajo blankets and the Mexican trappings on the walls."

After two years, Remington had settled into what he considered to be an intimate personal relationship with Wister, although the demands of his sculpture had made inroads on time available for illustrating. In the course of preparing for another day trip with Wister, though, Remington suddenly discovered that he was not even close enough to Wister to know the nickname that all of Wister's real

friends called him. Remington wrote, "Dear Dan—I am going to Washington Friday morning to dine with Theo Roosevelt—he said Dan Wister was coming—are you Dan—if so you have been trifling with me."

Remington carried off as a joke his crushing discovery that Wister had never accepted him as an intimate, but his new awareness of the nickname flawed the friendship. Thereafter, there was a noticeable seesawing to the relationship, with Remington tending to demonstrate a natural warmth toward Wister and then restraining himself so he would not be hurt again. These emotional shifts made contact between the men difficult to sustain, although Wister became more accepting as Remington retreated.

Once in a while, Remington still remembered to flatter Wister, as in "I am by nature a sceptic—I would not recognize the Second Coming if I saw it—I have long held *you* in *mental reserve*—In the market place I have said 'Behold you d_____ ignorant gold besodden rum bloated mugs'—'Wister—not Kipling'—Wister is *doing* it." Generally, however, Remington now told Wister the truth, that "I am d_____ near crazy between illustrating talky-talky stories where everything is too d_____ easy to see in your minds eye and too d_____ intangible to get on a canvas (that's you)." Ambivalence was the characteristic condition.

Roosevelt was then a federal Civil Service Commissioner living in Washington. He had arranged a dinner to have Wister meet the world famous writer Rudyard Kipling and had invited Remington as the lure to get Kipling to come. After learning about Wister's nickname, however, Remington did not attend the dinner, pleading illness and causing Kipling to complain that he "had counted a good deal on your being there."

Remington and Kipling had been drinking companions at The Players and had become friends in the course of Remington's illustrating a Kipling story for *Cosmopolitan*. They enjoyed debating the merits of England versus America. The two were called "well matched in audacity, frankness, and power of picturesque speech." At a lunch at The Players, Kipling riposted Remington with, "The real difference between us is climatic. We live in a climate so damp that one needs a half a dozen stimulants during the day to keep his spirits up; and you live in a climate so exhilarating that a man can run across a rug in his stocking feet and light the gas with the end of his finger."

The few long trips Remington did make in 1895 he devoted to painting. He had notified Bigelow in the spring that "I go to Canada to morrow for 10 days fishing—Lake St. John 200 miles W of Quebec.—I do not fish but I sketch. The other fellows fish." When he

returned, he exhibited at the National Academy's 70th annual spring show, but it was just a reuse of an illustration, not an easel painting done in color specifically for the exhibition. Nevertheless, Royal Cortissoz singled out the illustration "Mexican Cowboys Coming to the Rodeo" as a spirited example by one of the realistic painters, as opposed to the American Impressionists who were, he said, only emulating Monet.

In connection with his awareness of the new trends in art, Remington told a revealing story about Joe Jefferson, a leading character actor who also painted as an Impressionist. Remington said that when they were together in Florida, Jefferson once exclaimed, "What a beautiful bit of landscape!" Remington suggested that Jefferson paint the scene but the actor replied, "No, no, no! Not now. I will paint it sometime in the future—when I have forgotten it." That was a tip about concepts that the literal Remington was not ready for, although he attended the New York City art exhibitions and saw what the Impressionists were doing. He could not paint with their Monet palettes, but he admired the color.

He had lost belief in his own capacity to do easel paintings in color. Although he told Bigelow that he had "just learned how to *paint*," it was an empty boast. He confided the true doubts to Wister: "I have to find out once and for all if I can paint. The thing to which I am going to devote two months is 'color'—I have studied form so much that I never had a chance to 'let go' and find if I can see [color] with *the wide open eyes of a* child. What I know has been pounded into me—I *had* to know it—now I am going to see—I am sufficiently idolic to [think I do] have a *color sense* and I am going to go loco for 2 mo.—" Loss of color sense was a tragic incapacity for a painter, but it was common among illustrators who worked in black and white. When they did illustrate in color, which was rare, the color was for commercial ends, part of telling the story, and not as pure art, for beauty.

Going "loco" did not help him to see Impressionistically, with a child's eyes. He did not manage the mastery of color in 1895, although he was said by *Harper's* to be the busiest artist in America, with his name known all over the world. Military figures in action were his preferred subjects for illustrations. His current goal was to be a war correspondent. Ralph supported him, writing that Remington "is a war artist in peace as well as on the instant that any troops are called upon for serious service, and find him [already] on the ground." Remington's instinct told him that the country was getting close to a military conflict. He said to Wister that "I think I smell *war* in the air,"

and he told Bigelow that "I have only one ambition and that is to see a war."

Until there was shooting someplace, however, the West remained his specialty. He declared to Bigelow that "you never tell me what you think of my French soldiers—No one else does—So I guess they are not much good—No one ever says anything about what I do outside of America so I guess I [will] work the 'main lead'—it goes into the ton—and not try to burrow for pockets. 'Cow-boys are cash' with me." Ralph supported him there, too, adding that Remington alone is "anxious to leave a pictured record of the conquest of the country west of the Alleghanies."

Most of Remington's illustrative assignments, even the Westerns, had become routine. The way he had begun ten years earlier, doing paintings and drawings of scenes he had visited and enjoyed, had given way to commercial art. He was picking lines in texts written by others now and interpreting words with pictures instead of having the writers describe his pictures. The work was not sufficiently creative for him, and serving as just an interpreter bothered him. He told Howard Pyle that he had "done nothing but potboil of late," and that months might pass before he painted in color. He said the same thing to Bigelow, that "we are pot boiling along—making a living and waiting for 'hard times' to let up so we can sell some pictures."

The illustrations that Remington had drawn for Wister's "The Evolution of a Cowboy" were the best that appeared in 1895. Critics noticed them and some declared that the pictures overpowered the text, saying that the art "goes away up into the azure heights of genius, so to speak." Wister himself had mixed emotions. "The Last Cavalier, though it brought tears very nearly to my eyes, is not quite so good as you intended. I'm not sure the idea can be adequately stated short of a big canvas. To me personally, The Last Cavalier comes home hardest and I love it & look at it. It's so very sad and so very near my private heart."

Remington got the message. He replied, "As for the Last of the cavaliers—it is yours but you must pay for the frame. Will that be cheap enough—" Then he realized that Wister as a reader was judging the picture by looking at just the little black and white reproduction in *Harper's*, without any idea whether the original work was a wash drawing, a watercolor, a black and white oil, or an oil in color, and without knowing the size. With Wister's poetic luck, "The Last Cavalier" was a fairly big canvas, in full color, that made a substantial present. If it did not adequately state the idea for Wister, the fault was not in the size of the canvas.

The personal relationship between Wister and Remington was

tested again by the competition between books by each that came out in 1895. Both books were anthologies of previously printed stories, both were published by Harpers', and both were illustrated by Remington. Remington was particularly proud of his title, *Pony Tracks*. A third anthology, this one by Poultney Bigelow, was also illustrated by Remington and published by the Harpers, under a title Remington derided: "I got the *Borderland* [of Czar and Kaiser]—a stinking title —and a cover—ye god—it would scare a cav[alry] horse—A Florida negress would wear calico underclothing as bad as that." His elation at equalling Bigelow's status as a writer of books led him to retaliate for past put-downs by adding, "By God sir I have read 'Borderland of Csar & Kaiser' and I am going to have a d_____ sight better book published myself—called 'Pony Tracks.' As for your title—guess again. no good—too book shelfy. Put some mystery—some fog into it. Something imaginative—like the title of my new book—'*Pony Tracks*' —thats the stuff me boy."

Wister was trying to keep the business relationship with Remington alive. He threatened, coyly, that "if you don't send me Pony Tracks with my name written inside, I'll buy it myself and send *you* my book Red Men & White with your name written inside—Then you'll feel 'shamed—." Remington responded with the camaraderie of a fellow author, "My dear 'Dan'—As that seems to be the only way I can identify you with your friends—*Well* Dan—I want *Redman & White* with you in it, with no d_____ commonplace sentiment like *yours truly* top of your name—as for 'Pony Tracks' the next time I am in Franklin Square I will inscribe my theory of nerve-cells & ship to you."

Pony Tracks was dedicated to "the fellows who rode the ponies that made the tracks." The book was reviewed as "a better idea of army life on the Western border than all the official records." Another critic declared that "it is the verve which the author possesses which he imparts, and so you catch on to his devil-may-care ways. This rapid pen work is none the less able because there is no premeditation about it."

Pony Tracks was a Remington high spot that remained in print for years and has been reissued three times. It was the foundation for his acceptance as a "literary man." Like "The Bronco Buster," *Pony Tracks* was patently the real thing, the Indian-fighting army reported on by an eye witness. That was the difference between Remington and Wister. The Wister book was more studied, by an observer after the fact. When *The Bookman* later drew "a literary map of the United States," however, separating the country into regions to as-

cribe to specific writers as specialties, the Southwest was divided between Remington and Wister.

In order to make the present of "The Last Cavalier" to Wister, Remington had to remove it from the catalog of the fall exhibition and auction that he had scheduled as a repeat of the 1893 sale. He told Wister that " 'I open' as the theatrical folks say on Nov. 14. American Art Association—and sell every thing but 'the old lady' on the night of Nov. 19—I am going to send you a bunch of my cards and ask you to mail them to Phila folks where they may do some good." This was to be an auction where "the whole 'bilin' is sold to the most enthusiastic bidder and thats the end of it because 'I run a square game' and what in hell kind of game do you think a fellow can play and have 'the gang wid him.' "

There were 114 pictures included in the two-year accumulation but only ten were classed as "paintings," that is, oils in color, and even they had been published as illustrations. The remainder were "drawings," the black and white oils and the wash drawings that had previously been printed. At the sale, Owen Wister bought "What an Unbranded Cow Has Cost" for $255 to hang with a Thomas Sully painting of his grandmother Fanny Kemble and "The Last Cavalier." The press report was that "anxiety to secure black-and-white sketches by this popular man made the bidding lively, and $5,800 was realized." The sale was not as productive as the 1893 auction had been.

The day after the sale, Roosevelt wrote Remington that "I never so wished to be a millionaire or indeed any person other than a literary man with a large family of small children and taste for practical politics and bear hunting, as when you have pictures to sell. It seems to me that you in your line, and Wister in his, are doing the best work in America to-day." Roosevelt never did buy paintings by Remington. He waited for gifts, although good drawings sold for $50 and he was a rich man.

The songwriter George L. Spaulding was another rich man. While Spaulding was being driven to the New Rochelle station in his rig one morning and Remington's driver was returning home, a collision occurred. Remington sued for the damages to his demolished carriage but "the witnesses did not agree very well." The local newspaper called it "an inglorious end to the famous trial" when Remington, who had claimed $45, won a verdict for only $15.50. Remington bragged to his friends about the victory, multiplying the verdict by ten. He wrote Bigelow that he "won the law suit—we smothered the defence —a d_____ song writer does 'Two Little Girls in Blue'—gets rich—

buys a d_____ plug—thinks he owns the roads—runs into the wrong man—gets it in the neck for $150.— No moral—."

The lawsuit was another of those situations where Remington could not rest until he achieved some sort of redress satisfying to his ego, however futile the exercise might be.

21.

Good Bye Little One

Remington made up his mind to stop exhibiting at the National Academy late in 1895. Friends who were Academicians had hinted that he was never going to be elected to membership because he was not personally acceptable to the Academy establishment. Consequently, exhibiting a picture there would be kowtowing to his detractors, and there was no reason he saw why he should.

This was the period in his career that he later called fallow in fine art painting, the years when he said he offered the public the same superb pictures that became so successful a decade later, only to have the pictures rejected because the public was not ready for them. The truth was that he did not exhibit because he was not content with his own capacity to handle color, in the face of the beauty that he was starting to see captured by the Impressionists. The realistic colors he had painted for ten years looked archaic to him now, despite his inability yet to see Impressionistic hues "with the wide open eyes of a child." He was caught, betwixt and between the old and the new. If he had submitted a painting to the Academy show in 1896, it would

have been a warmed over illustration like the one he showed the previous year, rather than the prize winner that his ambition demanded.

Even though neither his illustrations nor his paintings in color satisfied him as art, the simple fact was that his illustrations by themselves were clearly professional enough to merit Academy membership. His work was demonstrably superior to the paintings by some of the artists who exhibited at the Academy and were elected as Academicians. The annals of the Academy were full of examples of Academicians who were inexplicably chosen and later were deservedly forgotten.

The objection of the Academy establishment to Remington was not to his art but to his image. He was considered too popular with the public to be sincere, too rich to be pure, too cocky to be without conceit, and too ostentatious in the level of his living. No other artist in the country would have thought of and managed to carry out commercial auctions of his own work, and then have made money at it. Auctions were for artists' estates, done only for the deceased, and Remington was far from dead. Everything he did was in the public eye. He was interviewed regularly. His published illustrations were a constant reminder of his presence. Besides, he could write competently and his unexpected talent in sculpting had produced the art event of the year.

Even his trappings irritated the Academicians. Whatever Remington did, he did in keeping with his size. When he decided that the studio under the gables at Endion could no longer encompass his talent, he brought in the local architect O. William Degan to plan a whole additional wing, forty feet long with a skylight in the high ceiling, to be the new studio. At the far end was to be a double door that could be opened to admit a team of horses for models, although no horse ever made it inside.

Remington had told Wister that he had "concluded to build a studio (Czar size)—a great thing for American art. The fireplace is going to be like this [and Remington sketched himself in an easy chair in front of a ten-foot-wide fireplace under a mantel surmounted by a huge moose head]—Big—big—."

Remington mentioned to Wister that his wife and he would be in town for a month while the studio was being built. Eva Remington regaled everyone with the tale about the night during that month when she had gone to bed in a New York City hotel while Remington went to The Players club. At two in the morning she was awakened by the repeated slamming of room doors, starting at the end of the hall and moving toward her. When her own door opened, Remington

stood there, accompanied by a protesting porter. "It's all right," he said. "This one's my wife."

Incidents such as these made the art establishment distrust Remington, particularly when he masked his disappointment and showed no apparent reaction to the professional blackball. He just continued with his bread and butter illustrative work where he was more sure-handed than he had ever been. He even hit on an innovative device that saved time while adding a note of authenticity. During his last Western trip the previous year, he had painted field studies of the rugged landscape in oil on big canvases as well as on the usual small boards. When he needed to illustrate in color in his studio, he could pull out the canvas with the appropriate background and just insert the figures.

Unluckily, his major illustrative job for publication in 1896 was Caspar Whitney's series of articles on the Barren Grounds in the Canadian North. For the North, he had no study. Not only did Remington have to do the landscape from photographs but as he said, "I'm d_____ if you can imagine how little I know about musk-ox when you get down to brass tacks." Nevertheless, Whitney was first "very much pleased" with the result, and then he got carried away: "It is fine, I am awfully pleased with it, I think it is awfully fine. You need not get stuck on yourself though and come down here swelled out like a porpoise when you come into my little office; you might blow out the sides."

In the beginning of 1896, Remington had secured a pass from General Miles addressed to Southwestern army commanders, to "introduce Mr. Frederic Remington who has been a very good friend to the army." During this period when his feelings about Wister were especially warm, Remington put on an exaggerated act to press the Philadelphian to join him in using the pass to tour the Southwest. "Do you go to the South West to 'dream' with men," he asked. "Do you dont you if you don't I will be in the slough of despond—Say Yes for Gods Sake say Yes." When that plaintive call was not productive, he tried once more: "Do say you are going West with me 'to dream dreams.' Come! come! Come! COME!" Wister replied that he could not go. He was ill again.

In place of Wister, Remington turned to Captain Jack Summerhayes, his friend from David's Island, and the two men left for Texas in January 1896. They were compatible in spite of the fact that the relaxed Summerhayes was a generation older. He had been a private in the Civil War, breveted to major, reduced to second lieutenant to remain in the postwar army, and after thirty-one years was only a captain. Remington had missed his shooting the previous fall so for

this trip he declared, "Ave course I'll take me shoot-gun," and they hunted peccary in Texas and blue quail in Mexico.

Remington managed to find material for six articles in the Southwest. The best one was "How the Law Got into the Chaparral," based on meetings with famous old Texas Rangers. Remington used the subject to peck at Wister again in late February 1896: "Just back from Texas and Mexico—got an article—good illustrations but I tumble down on the text. May have to ask you to bisect, cross-cut—spay, alter, eliminate, quarter & have dreams over it and sign it with the immortal sig of he who wrote 'Where Fancy was bred'—had a good time—painted—shot—loafed—and got some ideas." He did not know that Wister was on his way to Europe for his health, but it did not matter. Remington was already writing the article.

In May, Remington organized a two-week canoe tour of Lake Champlain for the small group of outdoor friends he called the Abwees. He bullied Edward Wales, the industrialist who was crony, patron, and amateur artist, into going along, describing Wales as a "front-room-on-the-ground-floor-dude" with "light blue fluid" in his veins instead of "lots of good red corpsiclues."

Although Remington was still "pot boiling along" with his illustrations, he was suddenly full of joys and expectations about pastels as a medium for his art. "It is fortunate for you that you happen to know the greatest living handler of pastels—that is the undersigned," he told Wales. Pastel lent itself to color and looseness. "I tried my first shot at my old mare to day and in an hours time I had a portrait which I could not do in three-hour sitting with oil—a thing which could never be done in water color—and Columbus when he discovered America or the boy when he discovers the moon were not half so tickled as I am."

With his oversized enthusiasm, he declared that "I have cornered the New York market in pastel boards and am going up to St. Lawrence Co. for the summer and I am going to paint every d_____ thing in it." He counseled Wales to "go down to [New] York village Eddie and blow all your wealth on pastels—pas[tel] paper—fixitif—go to work and hail me as benefactor." It was as if he had never tried pastels before. He had, of course. He had even exhibited a pastel at the Academy, but now, when he could not satisfy himself with color in oils, pastels came easier. That summer, he drew North Country landscapes in pastel from the "Herkimer Co. line to the St. Law. River."

While he was drawing his soft summer pastels that verged on Impressionism, his second bronze statuette was released. "The Bronco Buster" had been in Tiffany's only since October 1895, but by February 1896 he was already telling Wister, "Got big ideas—heap talk—

new mud—'How the bronco buster got busted'—its going to beat the 'Buster' or be a companionpiece." In June the modeling was completed and it was another radically new concept: "I had my 'Wounded Bunkie'—wax model—done up in plaster last week," he remarked to Wales, "and am going to knock an eye out of the art world this coming winter."

The July 9, 1896, copyright description for "The Wounded Bunkie" was "two horses in full gallop, side by side. Each horse carries a cavalry man, one of whom has been wounded and is supported in his saddle and kept from falling by arm of the other trooper." The technique was virtuoso. The entire group was balanced on just the "nigh hind leg of one horse and the nigh fore leg of the other," with this massive chunk of bronze held to the base by only those two slender contacts.

The European-trained sculptors had called "The Bronco Buster" just a three-dimensional realistic illustration, but they had missed the point. The bronze was realism, true, but the essence of the West was captured in it, for the cowboys themselves as well as for the buying public in the East. Remington now considered "The Wounded Bunkie" to be more artistically advanced than "The Bronco Buster" because the fraternal qualities of the cavalry under fire were symbolized in the modeling. To show the scoffers that he could "conceive a theme sculpturally," Remington had emphasized the spiritual values of his favorite subject, the romance of the cavalry in battle.

The attempted compromise with the art establishment did not succeed. To the sculptors, the statuette was still an illustration, no matter what Remington felt. To the public, the five-hundred-dollar price of "The Wounded Bunkie" was too hefty a sum, and the episode was considered to be too tragic. The "Buster" kept on selling, while the "Bunkie" was offered in an edition limited to twenty castings. Fourteen were sold, a number that would have been satisfactory to any other sculptor. On Remington's own list of his bronzes made late in his life, "The Broncho Buster," as he preferred to spell the title, was number one in his mind, while "The wounded bunkie," written without capitals, was number sixteen, although it was the second bronze cast.

In September, he announced that he was "going [to] Montana for two months—to sweat & stink and thirst & starve & paint—particularly paint." He was the guest of his old friend Carter Johnson, 1st Lieutenant of the 10th Cavalry, a Virginian who had been promoted through the ranks. That was the kind of trip that Remington relished, a chance to stay with the cavalry, live with the officers, observe the maneuvers, and then get paid to write and illustrate a travelogue on the

visit for *Cosmopolitan*. A second article that came from the trip was "A Sergeant of the Orphan Troop" for *Harper's Monthly*, a skillful recounting of Carter Johnson's compassion in the fighting with Dull Knife's Northern Cheyenne near Fort Robinson, Nebraska, seventeen years earlier.

One incident that Remington recorded in his sketchbook, "The attack on the Camp—Johnson charging the infantry up hill," took him back to the shades of his father the Colonel and his dead friend Clarke who had also been a lieutenant in the 10th. The sketch was stick figures of the cavalry charging in a "line of white horses, coming down over the slooping land" to cut off the infantry lying in rifle pits. It was only a sketch interpreting motion in a practice battle, but to Remington "it was magnificent," a high point in his romantic conviction that the American cavalry was an invincible force in war.

When Remington planned his first picture book for late 1896, he was still so imbued with the wartime cavalry that he reproduced a photograph of "The Wounded Bunkie" on the title page. The book was simplistically titled *Drawings*. The Harpers did not publish art books, so Remington entered into a contract with the smaller New York publisher Robert Howard Russell, agreeing to furnish forty new pictures plus a cover design.

Even before he signed with Russell, he had started urging Wister to write a preface for *Drawings*, despite his own continuing recalcitrance in illustrating Wister's stories. "Got my work done on book—its 'away from the Kodac,'" he declared, "and when I get fixed want to load you up with ball cartridge and fire you off." There were only four letters from Remington to Wister in this whole period and they all concerned *Drawings*. "You must not run off without writing my *preface*—It don't want to be long," he said. "Write me about preface," he directed, "such as will *stun* the public by its brevity & by its Homeric style. Get off the Earth—see visions—go back—launch into the future."

Wister's preface was fulsome, brief as requested, and Homeric by reference if not in style: "I have stood before many paintings of the West but when Remington came with only a pencil, I forgot the rest: It is Homer or the Old Testament again. If Remington did nothing further, already has he achieved: He has made a page of American history his own." The magazine reviews of *Drawings* were strong: "One instinctively hides behind the cover of the book in the hope of escaping bullet and scalping iron."

Total royalties for *Drawings* proved to be $2,609.10, not a lot when Remington in an excess of industry had included sixty-two original drawings rather than just the forty-one contracted for. Many of the

pictures were reissued as prints and otherwise reused, with royalties to Remington that compensated for the middling returns from the book. One picture, "Her Calf" showing Indians killing a buffalo cow that was shielding its young, was also reproduced on a china serving platter made by the Buffalo Pottery Company, a potter located in Buffalo, New York, not named after the animal.

Remington sent Roosevelt a complimentary copy of *Drawings*, evoking the truthful criticism that "the badger's legs" in one picture "are too long and thin." Just as Remington remained deferential toward Miles who might become President, he sought continued contact with Roosevelt who had become a celebrity as writer and politician. When New Mexican Montague Stevens visited the city in November 1896, Remington brought him to Mulberry Street to meet Roosevelt who was then the Police Commissioner. They talked about grizzly hunting.

It took the Werner Company, however, to show Remington an easier way to make money than the sixty-two original pictures he did for *Drawings*. The Chicago publisher of General Miles' memoirs that Remington illustrated found a loophole in the artist's contract for the book. As a second step, Werner enlarged the page margins to make the plates seem bigger, and without authorization or further royalties simply reprinted the fifteen Miles illustrations as the new picture book *Remington's Frontier Sketches*. The cover of the Werner book even bore a simulated Remington signature, with a preface intended to make up for the loss of royalties by promoting "the vivid pictures of that heaven-born artist, Frederick Remington."

Then, to compound the injury from this outlaw picture book that was competing with *Drawings*, Werner had the gall to use the illustrations a third time, blowing them up and issuing them as a set of separate prints. Remington complained to publisher Russell that "this is a bad business—The Werner Co are using my illustrations for Miles book. I am going to jump them some how—I think I shall sue for drawings not returned," but he did not have grounds to sue. From all of this, Remington earned no profit but he learned a lesson—how to compile a picture book from already published pictures and issue prints as well, before selling the originals to earn four payments for a single work. When he could from then on, he sold the illustration, the book, the print, and the original, too.

The cajolery with Wister had worked itself into an elaborate tease that was personal, contrasted with a professional disinterest in Wister's stories that had become absolute. When Wister mailed Remington the manuscript for "Destiny at Drybone," instead of sending it to the Harpers first, the response was that the story "is good," but there was

no offer to do an illustration. "Destiny" was published with just a stilted drawing of the protagonist, after *Harper's* insisted on a Remington picture. The next manuscript evoked only the comment "good" in a Remington postscript, and the publication was without any illustration, as were the next two, despite what Remington had called the "immortal sig" of Wister.

Remington had become tired of searching for a focus in Wister's "talky talky" writing. He saw the illustrations that resulted as so limited artistically that they were destructive to his image as an action painter. He was politely refusing to illustrate Wister's work while going through the confusing routine of showering professional compliments and demanding personal companionship, all at the same time. Remington was increasingly turning to doing his own writing in *Harper's Monthly*, with two pieces written in 1895 and three in 1896. He had illustrated four stories for Wister in 1895 but he did none in 1896.

Remington was not aware that Wister considered his illness to be a serious recurrence of his debilitating adolescent attacks or that the physical weakness made Wister more vulnerable to teasing. Wister was a tentative personality anyhow, tremulous at first, overbearing when preferred by *Harper's*, now tremulous again in the face of Remington's defection. Having his stories run without illustration was intolerable. He finally turned to the fine illustrator A. B. Frost for pictures to go with a story about country bumpkins, but Frost was as colorless as he was color blind. The relationship was purely business, without the pushing pulling cajoling flattering insulting chameleon acts of Remington.

Besides, Wister was not getting a Western authority in Frost. Remington was Frost's own expert on cowboys. When Frost called on Remington for advice, the response was, "Am shipping you a little study—taken on Custer Battle field—about noonday. This will fill your bill. The grey in foreground is the tone of the greasewood. The big thing in Western landscape is that there is no atmosphere and the light is dazzling. In one picture you do—you had cow boy on right side of horse—it would be improbable." And then he applied the perfect put-down: "Hope it helps you out. Old man Hooper is hell to work for. He ought to do his pictures himself. I told him." The *Century* job that Frost had and needed help for, Remington had turned down.

Remington was becoming more and more convinced that a war with Spain was approaching over Cuba. It was going to be his personal war, the testing of himself as the intrepid war correspondent he believed that he was. In February 1896, he had told Wister "I think

we are going to have that war." Two months later he wrote Ralph that "we rather hope for a war with Spain." The same month, when Wister was starting for Europe, he added that "I expect you will see a big war with Spain over here and will want to come back—and see some more friends die. *Cuba libre.* It does seem tough that so many Americans have had to be and have still got to be killed to free a lot of d_____ niggers who are better off under the yoke. This time how- ever we will kill a few Spaniards instead of Anglo Saxons which will be proper and nice." "Lets form a partnership on the *scrap*," he offered, "only if it promised hot enough I will start in as a capt of in- fantry."

Remington's militaristic aspirations were in advance of national sen- timents. The country sympathized with the Cuban rebels against Spain, but the feeling was expressed in emotion, not action. In Cuba, Spanish forces held the cities and the rail lines, while the Cuban guerillas under General Gomez controlled parts of the countryside. American reporters risked their lives behind the insurgent lines to write inflammatory articles on guerilla privations and Spanish atroci- ties. That was where Remington wanted to be, with Gomez, and William Randolph Hearst offered him the opportunity.

The job was to illustrate the reports of Richard Harding Davis, now one of the better known correspondents, for the New York *Journal.* Hearst's newspaper was a leader of the "yellow press." The *Journal* competed with the New York *World* in sensational journalism and in bidding for the rights to the "yellow kid," a boy in a bright yellow shirt who was featured in Outcault's comic strip "Hogan's Alley."

Remington and Davis were a poorly matched pair. Davis was three years younger than Remington's thirty-five, a supreme egotist, hand- some enough to have been the prototype for Charles Dana Gibson drawings. Davis was what Eva Remington had called an "It." Like Wister, he had a dominating mother who was a writer. He sent her a letter almost every day.

Because there were supposed to be spies for the Spanish government in New York City, Remington and Davis were asked to meet late at night in the *Journal* office to wait for the closed hack that would start them on their secret way to General Gomez. This was Davis' first im- portant campaign and he acted like all that a campaigner should be, dressed in a pseudo-military uniform with white hunter trimmings, complete with a new saddle, bridle, horse blanket, and two leather trunks designed to be made into a field bed. Remington wore his Duke of Marlborough field outfit, including the canvas jacket that did not disguise his obesity. The Hearst staff saw Davis as "dignified and

remote, the silent military man of iron." Remington, they sneered, "had never been on a battlefield, and he was distinctly nervous," while he frequently "sprang up and rushed out to stimulate his courage" until "he didn't know whether they were going to Cuba or Coney Island." The staff did not recognize that Remington was already bored with the comic opera security measures.

The first stop on the "secret trip" was Key West, Florida, where they waited amidst public fanfare while Hearst had his yacht the *Vamoose* readied for them. The *Vamoose* was "a mackerel-shaped speed boat of sheet-iron and shallow draft," not the usual broad-beamed pleasure vessel. That design made the steam yacht the fastest on the seas, risky in rough weather but otherwise able to evade Spanish ships while carrying Davis and Remington to Santa Clara province where Gomez's troops were to meet them. The plan was for the *Vamoose* to return once a week for copy and sketches and then bring the correspondents back after a month with the insurgents. Davis expected to earn four thousand dollars for the month and Remington the same.

During the time they waited for the *Vamoose* to be fitted for the dash to Cuba, the correspondents fraternized with Navy personnel in Key West. Remington practiced with the five-inch rapid gun on the U.S.S. *Raleigh* and was able to cut the flagstaff from the target with a single shot. Christmas day he wrote to his wife, "Vamoose is now being painted grey—it is blowing hard and we may not go before tomorrow night. See Chicago banks are unsafe—watch out and if you think New York gets weak check out most of our money." In the midst of crisis, he cocked an eye toward his cash deposits.

The following afternoon he wrote again: "Dear Kid—It is now 4 o c—we leave at six—the boat lies at the dock steaming up. The town is wild with excitement—we have only the Custom House to fear. Two Cuban officers go with us—I am well—and feel that I am to undertake quite the most eventful enterprise of my life—think there will be war with Spain—I leave my effects at the Duval House here—Good bye little one—from Your loving old boy Frederic." This sentimental equivalent of his last will and testament was quite in order, in view of the manifold dangers. The "Custom House" threat was only a preliminary. The *Vamoose* and its men were subject to arrest for suspicion of transporting supportive goods to the Cuban revolutionaries, if the port authorities wished to make the charge. Remington had talked to the Collector of the Port the previous day and had used his naval contacts. The second hazard was the trip itself. The *Vamoose* was built for speed, not safety, and the crossing could be risky. That danger they could not mitigate but they could the third, attack from the in-

surgents if the party landed unrecognized. The two rebel officers were along for identification. The fourth hazard was the greatest, the risk of falling into the hands of the Spanish who might execute them as spies. Just five months before, Charles Goven of the Key West *Equator-Democrat* had been hacked to death by machete after the Spanish forces caught him with the insurgents.

The crew of the *Vamoose* were afraid of the Spaniards. Just as the yacht was ready to depart, the crew went on strike and then quit. While the captain hunted replacements, Davis wrote to his mother who had premonitions of disaster in Cuba: "Of course, dear, dear Mother thought she was cross with me. She could not be cross with me, and her letter told me how much she cared, that was all, and made me be extra careful. Remington and I already are firm friends."

The crew that quit were the smart ones. With a replacement crew the captain tried three times to make Cuba but the winter storms turned them back each time. On the third attempt, all hands lost hope of regaining Key West. Davis and Remington were lying flat on the deck clinging to the rail to avoid being washed overboard while the Chinese cook was constructing a raft out of a door and some boxes. Davis suggested doing the same but Remington commanded him to lie still: "You and I don't know how to do that. Let him make his raft. If we capsize, I'll throttle him and take it from him." When Davis later told the story to Gus Thomas, Remington's explanation was that "I don't have to talk of myself" but "Davis alone was worth a dozen seacooks."

In Key West, Davis as the writer became the leader. He knew that Hearst's advance publicity about their going in the back door to Cuba had committed the afternoon newspaper to the trip at any cost so he first "rocked them for $1000 in advance payment because of the delay." He told his mother on New Year's Day that "we tried to cross fairly in the dam tub and it was her captain who put back. I lay out on the deck and cried when he refused to go ahead."

If the *Vamoose* was not able to make the crossing in bad weather, however, there were "filibuster boats" that could have been hired, local craft with local crews who were accustomed to conveying contraband to the insurgents. Davis got "carte blanche from *The Journal* to buy or lease any boat on the coast," and then he settled back to decide what to do. He "could not have faced anyone" had he not gone to Cuba, but his mother's "letters had become so violently opposed to the venture that he was goaded" into placating her.

While he waited, he told his family that what he needed was "patience, not courage." Remington was on edge, desperate to get to see Gomez. Someone would come along and tell Davis that Remington

was looking for him. "I get up and look for Remington," he said on January 2. "There is only a triangle of streets where one can find him. In the meanwhile Remington is looking for me a hundred yards in the rear." To resolve the pressure from both Remington and his mother, Davis decided to book passage to Havana on a regular commercial passenger vessel, the *Olivette*. He told Remington that they would make their way through the Spanish lines to Gomez by trying, as Remington put it, to "go around and knock at the front door since we could not get in the coal-window."

In Havana, they were controlled by Spanish jurisdiction. The Spanish "butcher" General Weyler granted them an interview. Remington noted that "the marble stairway of the palace recalled Gerome's painting 'L'Eminence Grise.' Davis squinted at the scene for future reference, and I made the only profile of Weyler on this side of the Atlantic on my cuff."

There was no fighting to be seen. Davis refused to contact Gomez from the Spanish side, claiming he was under surveillance because he had been made notorious by Hearst's "yellow journalism" report that he was already with Gomez. Instead, he decided to tour the sectors under Spanish control, as a Cuban variation on *The West from a Car Window* that he had done for *Harper's* in 1892. He started traveling by train, carrying a pass signed by the Spaniards, and spending Hearst's expense money lavishly. His entourage included an interpreter named Otto and a valet. Davis relished his role on the train. "What would the new school of yellow kid journalists say if they knew that I am seeing it [Cuba] from car window with a *valet*."

Remington's dream of being a war correspondent in Cuba, "the most eventful enterprise" of his life, was over. He had expected to be able to join Gomez and the insurgents to use his pencil to push the United States closer to declaring war. He had not hired a filibuster boat on his own, however, and he did not attempt to filter through the lines on his own, although the next year Scovel of the *World* was able to get "into Havana, get out of it again, and to find an insurgent force all in just twelve hours." Remington did not blame Davis for what seemed like a failure of courage, but boarded the train with him. He became excitable, according to Davis who said he was "a perfect kid and had to be humored and petted all the time." Davis told his mother that Remington "always wanted to talk it over and that had to be done in the nearest cafe, and it always took him fifteen minutes before he got his cocktails to suit him."

In the absence of fighting, Remington wanted to go home. There was no hope of convincing Davis to head for Gomez. Remington had been paid for a month in Cuba, and the month was up. He had plenty

of notes and sketches he could work up in the comfort of his own studio. He sent Hearst a cable that has been quoted as, "Everything is quiet. There is no trouble here. There will be no war. I wish to return."

The *Journal*'s advance publicity to the effect that Davis and Remington had reached Gomez required Hearst to ask Remington to stay in Cuba to preserve the fiction. Consequently, Hearst replied by cable, "Please remain. You furnish the pictures and I'll furnish the war." A decade later, Hearst denied having sent the cable. He called the whole tale "clotted nonsense."

Remington decided to leave Cuba despite Hearst. He had been no farther than Matanzas where "they asked Remington if he was the man who manufactured the rifles," an ancient joke even for Matanzas. Davis told his mother on January 15 that he was "so relieved at getting old Remington to go as though I had won $5000." When Remington returned to New York City, Hearst was able to convince him that he had seen more than the "everything is quiet" that was in the cable. Remington's first illustrated article was January 24. "The acts of the terrible 'guerrillas' employed by the Spanish pass all understanding by civilized man. The blood curdles in my veins as I think of the atrocity, of the cruelty, practiced on helpless victims."

Remington knew that he had given in to the militant Hearst's efforts to "furnish the war." He told Ralph that "I am a yellow Kid Journalist as you may see. I have been in Cuba for them. I have fallen —I now compete for preferment with Anna Held and other ladies. Oh God Julian why did this cup come to us. This delerium of new journalism cant last." With Bigelow he was more prosaic: "Just Home from Cuba—saw more hell there than I ever read about.—small pox—typhus—yellowjack [fever]—dishonesty—suffering beyond measure—Davis will tell & I will draw but cant do much in a Yellow Kid Journal—printing too bad." Eva Remington added, "I had no picnic while my massive husband was with those civilized fiends in Cuba who care no more for a man's life than they do for so many rats."

When Davis left Havana on the *Olivette* three weeks after Remington, he seated himself next to a young Cuban woman at dinner to make his charm and his square jaw accessible. The señorita was Clemencia Arango. Two other young women and she were being exiled for acting as couriers for Gomez, and she had an exciting story to tell. Leaving the señorita to continue her voyage north, Davis disembarked at Tampa February 10 and filed the front page *Journal* dispatch, "Refined Young Women Stripped and Searched by Brutal Spaniards While Under Our Flag on the *Olivette*. This is what the Spaniards did to these girls: they sent detectives to their houses and

had them undressed and searched. They then searched them at the custom house. When the young ladies stood at last on an American vessel, the Spanish officers demanded that the girls be undressed and searched for the third time."

That was the kind of dispatch for which Hearst overpaid Davis. Hearst then had the other half of the team, Remington, make a drawing of the body search, the nude girl standing with her curvy back to the viewer while the bearded Spanish officers gathered in front of her. The girl with her "bare backside" was "nuder than Remington's usual Indians," the artist evidencing a surprising "knowledge of just how to do it so it could be published without censure." The drawing ran five columns wide on the second page. That edition of the *Journal* sold close to a million copies, the largest newspaper run in history till then. There was an immediate call in Congress for an investigation of the incident. Harvard professor Joseph H. Beale, Jr., was pressed for his opinion and replied that the Spaniards had been within their legal rights in the search.

To gain an exclusive interview with Señorita Arango, the *World* shipped reporters on a tug to intercept the *Olivette* as it entered New York harbor. Señorita Arango was horrified to see the Remington drawing in the *Journal*. The Spanish official who had searched her had been female, not male as Davis had implied. The *World* then confronted Davis with the misrepresentation.

Davis was remarkably quick witted. He immediately accused Hearst and Remington of twisting his dispatch for their own purposes: "My account distinctly says [which it did not] that the Spanish officers walked the deck while the search was going on. Mr. Frederic Remington, who was not present, and who drew an imaginary picture of the scene, is responsible for the idea that the search was conducted by men." Davis even included the contretemps in his books on the war, but Remington ignored Davis' charge.

Davis quit Hearst at once. The Congressional investigation was quashed. Hearst went on to bigger and bolder ways to involve America in the coming war with Spain. Remington was fatalistic. He did not say that while he was not present during the search of the señorita, neither was Davis. He had done only what an illustrator is called on to do, take the text and interpret it at the direction of the editor. Remington was committed to his role in helping to precipitate the coming war, just as Hearst was.

22.

The Anticipation of War

Davis was applauded for quitting Hearst, while Remington stayed on with the *Journal* to complete his Cuban impressions. In his drawings and articles, he went right to the counterpart of his own love, the U. S. Cavalry. "The appearence of the Spanish cavalry in the field," he declared, "is really pathetic." The Spanish soldiers in Cuba he characterized as "poor fellows! Plundered and robbed by their officers—shot at and harassed by Cubans." The Spanish rural forts he called "chicken-coops." To support Hearst's jingoism, he gave the picture of a Spanish army that would be easily defeated by any opponent with modern armaments. Gomez could do it, given the guns, or the United States could do it as a frolic.

Although war with Spain seemed inevitable to the jingos, the Spanish government was still officially classified as a friendly foreign power. Matériel for the troops occupying Cuba was purchased in the United States, much as the Japanese obtained scrap steel from American railroads before World War II. The Spanish cavalry bought its mounts cheaply in Texas. The Texas broncs bucked when they first landed at the docks but were soon reduced to "pitiable objects." These

were the descendants of the Barb that the Spanish conquistadors had introduced into Mexico, and that had then migrated to Texas, so the circle was complete.

The Yellow Press used Remington and other correspondents to describe the underlying cause of the Cuban revolt as Spanish cruelty. The Easter supplement of the *Journal* on April 11, 1897, was a good example, carrying four pages of Remington drawings demonstrating Spanish inhumanity under the ironic heading, "Peace on Earth Good Will Toward Men As It Is in Cuba." On the other hand, the same day's issue of the New York *World*, that other metropolitan specimen of the Yellow Press, had a page one announcement, "Frederic Remington. Best American Artist. Hereafter He is to be a Regular Contributor to the World, and the World only." Because it was losing circulation, the *World* had outbid the *Journal* for Remington, making him a prize in the newsstand competition just like the "yellow kid" comic strip.

One week after Davis left the *Journal*, Remington had quietly met with his old *Harper's Weekly* associate Arthur Brisbane, who had become the editor of the Sunday *World*. On February 19 they had entered into a secret agreement, with Remington represented by his attorney George M. Wright. The *World* agreed to pay Remington $150 a week for a year in return for the exclusive rights to his pictures and articles in newspapers, to take effect as soon as he completed his contract with Hearst. These were to be artistic Western and military subjects printed as features, not news reports or Cuban propaganda.

One hundred and fifty dollars a week was a very large sum of money for newspaper rights to pictures that could also be resold by Remington for magazine rights, prints, picture books, and miscellaneous licenses like calendars and decals for giftware, in addition to the sale of the original drawings themselves. From the beginning Remington acted in a surprisingly high-handed way toward the *World*, despite the high price he had negotiated. Because he did not feel quite right in the association with the *World*, whose publisher Joseph Pulitzer was a Jew, he did not give the *World* new paintings for its money. The first picture that was reproduced was the fourth appearance of the ever-present "Her Calf" from *Drawings*. Other pictures that ran in succeeding weeks also came from *Drawings*, with slight title changes. The association between Remington and the *World* was not destined to be happy.

One problem with Remington was that he was waiting for the inevitable spark that would set off the war with Spain over Cuba. The battles between the two sophisticated armies were to be the true highlights of his life, but nothing new was happening in Cuba. Although

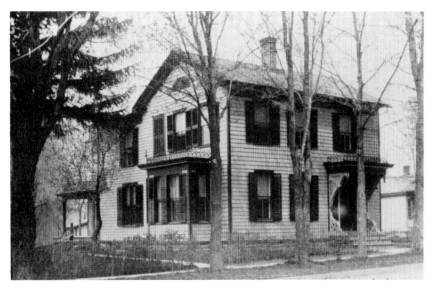

1. Grandmother Remington's clapboard house on Court Street, Canton, N.Y., where Remington was born October 4, 1861.

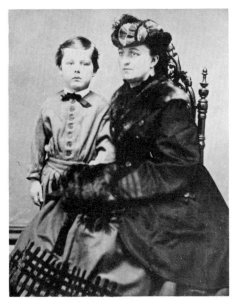

2. Remington at four with his mother Clara Bascomb Sackrider, who was shy but "nothing could change her course."

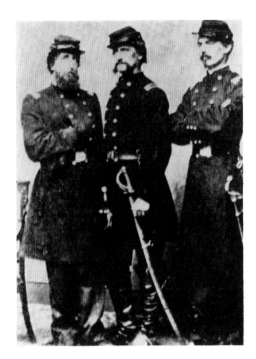

3. According to Gus Thomas, Remington "adored the memory of his father [center] in uniform."

4. At seven, Remington was "a stout looking boy in white summer clothes" leaning on a studio prop.

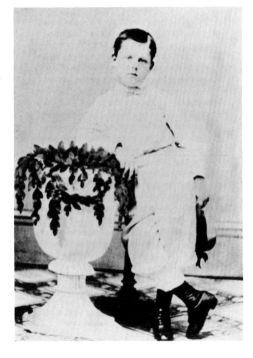

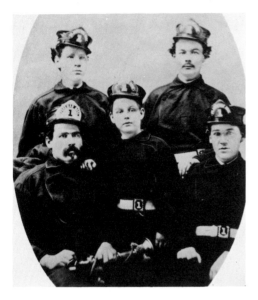

5. Engine Number One and its ten-year-old mascot.

6. In Ogdensburg, "the boy who had been Fred Remington in Canton was now called Puffy."

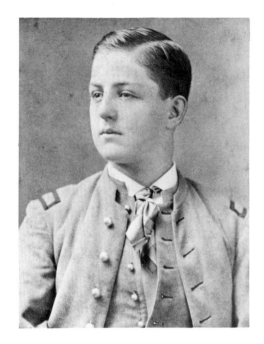

7. "My hair is short, and there is nothing poetical about me."

8. – 10. Remington's drawings at Highland Military Academy — no women or dudes.

8.

10.

11. A Yale man at sixteen, "the only male first year student" in the art school.

12. "The best football team in the country" with Remington shown lower right on the Yale "15."

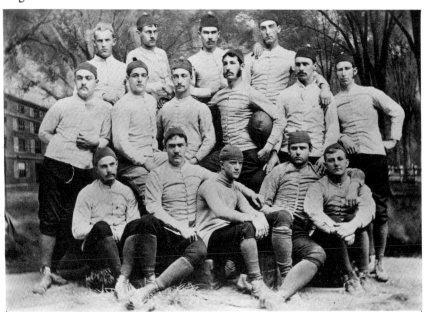

13. Remington as "The Holiday Sheepman" in Peabody in 1883, having a "try at establishing himself in the rugged West."

14. "It was clearly a love match" when Remington married Eva Caten on October 1, 1884, in Gloversville, New York.

City ofGloversville..........

Office of City Clerk

Certificate of Marriage Registration

Record No.155.... *of Year* ..1884....

This Is To Certify

thatFrederic Remington........ *residing at*Kansas City, Missouri......
 (City & State)

who was Age25........ *Born at*Canton, New York......
 (Date) (City & State)

andEva B. Caten........ *residing at*Gloversville, New York......
 (City & State)

who was Age25........ *Born at*Syracuse, New York......
 (Date) (City & State)

were married onOctober 3, 1884...... *at*Gloversville, New York......
 (Date)

as shown by the duly registered license and certificate of marriage of said persons filed in this office.

Dated at ..Gloversville.. *N. Y.*

..........February 24, 1978..........

Barbara S. Frederick
Dep. CITY CLERK

[Seal]

Any Alteration Invalidates This Certificate
Issued Pursuant to Section 14-a, Domestic Relations Law

VS-12 C (4-66)

15. Remington "claimed to be 25 although he was not yet 23," and the clerk got the wedding date wrong, too.

16. "He looked like a cowboy just off a ranch" but the Remingtons were living in Brooklyn in 1885.

HARPER'S WEEKLY.
JOURNAL OF CIVILIZATION.

NEW YORK, SATURDAY, MARCH 28, 1885.

17.

17.— 18. Remington's early *Harper's Weekly* illustrations had to be "redrawn by the staff artists."

18.

19. "The Apache War: Indian Scouts on Geronimo's Trail" in *Harper's Weekly* January 9, 1886, was Remington's first professional appearance.

20. Remington deliberately made "The Rescue of Corporal Scott" controversial in 1886, after Powhatan Clarke risked his life for a black soldier.

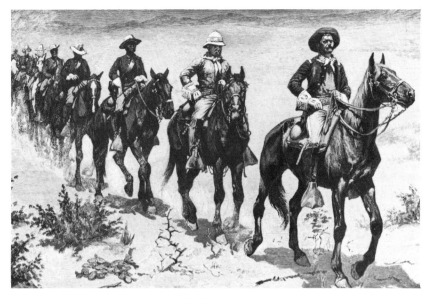

21. Remington personalized early illustrations, as by drawing himself behind Clarke with the Black Buffaloes.

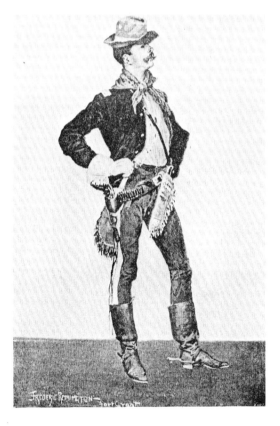

22. The vainglorious Powhatan Clarke, whom Remington called "a young slim manly man."

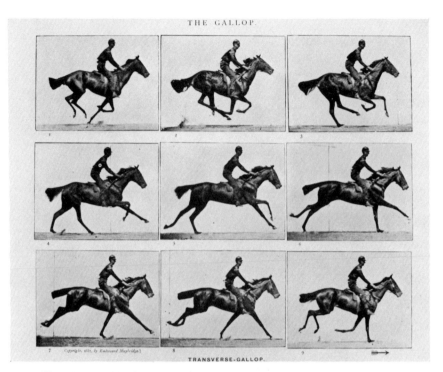

THE GALLOP.

TRANSVERSE-GALLOP.

23. "Remington felt that his view of the galloping horse was proved by the [Muybridge] sequence photographs."

24. Remington's drawing for Roosevelt's *Ranch Life and the Hunting Trail* features the old hobbyhorse gallop.

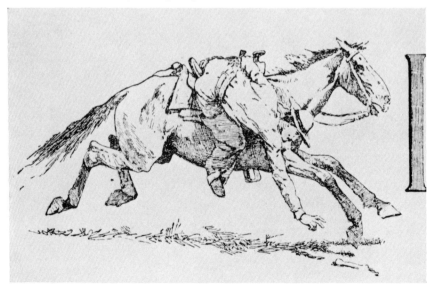

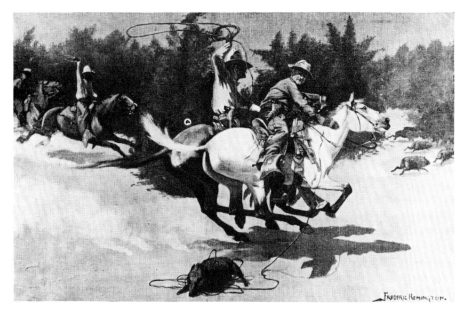

25. The self-portrait in Mexico is the gallop a la Muybridge, with the hobbyhorse in the rear.

26. Remington "came to do the wild tribes" in 1888.

27. A photoengraving of the original painting "Return of a Blackfoot War Party" as reproduced in 1888.

28. A drawing of "Return of a Blackfoot War Party" with simplified composition and no signature as reproduced in the Kansas City *Star* in 1911.

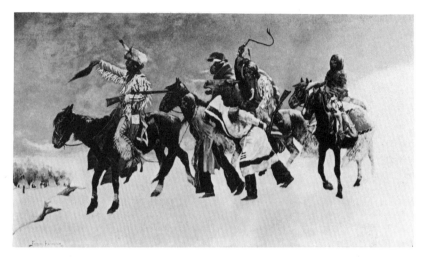

29. A recent photograph of "Return of a Blackfoot War Party" with signature on left.

30. A recent x-ray photograph of "Return of a Blackfoot War Party" said to. reveal "it is the same painting" as the original.

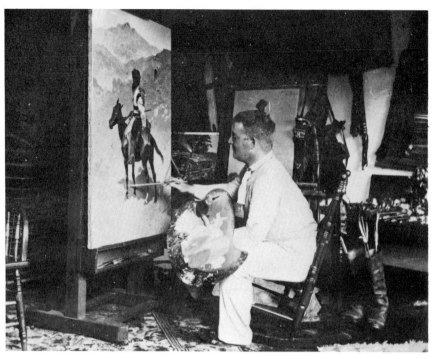

31. Remington on his squatty rocker painting "An Indian Trapper" in his Mott Street studio in 1885.

32. Remington and Julian Ralph hunting "the festive moose" Christmas 1889.

correspondents were still protesting "Spain's brutal rule," with 200,000 Cubans said to be starving and nuns imprisoned, the American reaction was sympathetic, not militant. As Remington watched for the Cuban news, the details of his career slipped by him. That made 1897 once again a potboiling time for Remington, and the monotony was complicated by his having "just squeaked through a case of pneumonia which the Doctors said would have been a dead gamble in my case." It was his first serious illness, and it too limited the time he was able to give the *World* for new drawings. The pneumonia was "all fixed" by May but the episode was scary for a man who thought of himself as athletic, muscular, and impervious to disease.

While Remington was bedridden, he had time to dream about the coming war and to plan what his course of action would be when war came. It seemed to him that he needed a writer as partner. He had "thought of this thing," combining talents, "with various other geniuses—Richard Harding [Davis] for instance or Poultney [Bigelow] without instance," but Davis would not have him and he would not have Bigelow. Of the tens of other writers he knew, he picked Wister, and from his sickbed he dictated a "scheme" to his wife who sat at his desk and wrote Wister that "There is going to be a war (in Frederic's mind) and it is possible for a pair of old nerve-cells such as you and I to make an alliance. We are getting old and one cannot get old without having seen a war. I want to talk to you about this and I want you to think of it and I do not want you to think it is not great." To the offer Eva Remington added a deprecating postscript: "Frederic's anticipation of war soon does not frighten me in the least as he has anticipated it for 11 years and now it is all very funny to me."

To show Wister his good faith, Remington agreed to draw an illustration for Wister's short story, "Lin McLean." "I will do L McL———— justice or bust," he told Wister. "It is not always possible to live up to the strange ideals of such a fanciful cuss 'as you be.'" Wister mailed a photograph of "what I think McL looks like" but he rejected the first drawing. Finally, Remington told Wister that he had "just shipped two more Lin McLeans—they [*Harper's*] can have their choice."

Despite Remington's enthusiastic offer of a partnership with Wister, there was no chance that Wister could accept. His health would not stand a field campaign. Besides, two years earlier Wister had said that "I am dining an engaged man in the evening." His fiancée was his cousin with whom he had been playing four-handed piano duets for years. Now, they were planning their wedding for the coming year, which ended any immediate possibility of serving as a war correspondent.

As soon as Remington recovered from the pneumonia, he tried to put together a group of friends for a bike and sketching trip for a week in early May but could not find a taker. He delayed the trip to the end of May, changed the locale to Chateaugay Lake in northern New York, and brought his wife so there was "no more ground-mole business—we stop in hotel." Catching pneumonia had scared him about camping out. He told Wales, "I sleep 9 hours a night & 1½ hours a day.—eat 4 times—nerves, why d_____ it you couldn't find a nerve in my body with a knife.—" The Cuban situation was calm, too. America was still far from war with Spain. The Congress was just officially recognizing the state of belligerency in Cuba and authorizing $50,000 in aid for the Cuban people.

While Remington was on vacation, the association with the *World* became an issue. After only six weeks had passed, it was obvious that Brisbane had made a bad deal for the publisher in not insisting on new pictures especially drawn for the newsprint medium. Remington's rehashed illustrations did not change the downward circulation trend, Pulitzer cut Brisbane's $300-a-week salary because of the reduced circulation, and Brisbane quit. He went to work for Hearst, getting $150 a week plus a percentage of sales that eventually made his earnings more than Hearst's net profit as owner.

Before he left the *World*, Brisbane was told to break the agreement with Remington. He wrote Remington June 1, 1897, to the effect that he had exceeded his authority in granting a yearly contract, implying that he would be personally liable unless Remington released the *World* from the obligation. Remington acquiesced, although his lawyer told him he did not have to. He would not have been comfortable enforcing the personal service contract at Brisbane's expense. What he did was to choose as one of his closing pictures "My Heart is Bad," a full-length view of a blanket Indian staring morosely ahead while thinking, "I want to eat White Man's Heart," and on that note he accepted his discharge.

Six weeks later, the Remingtons left New Rochelle for their second trip together that year, a month's vacation at Cranberry Lake as the guests of the Keelers from Canton. The portents were bad. They arrived at Benson Mines Station on the railroad in a heavy thunderstorm. A woman standing next to the hotel was struck by lightning, right near the livery where the Remingtons took the horse-drawn stage for the lake.

Keeler's lodge at Witch Bay Camp was a rustic one-story cabin. At night the place was overrun with mice. The cabin was set on a knoll that provided a fine view of the lake and of Merrill's Point a hundred yards up the shore. Thunderstorms and rain continued, to the point

that Remington thought it would never stop. His routine had changed drastically after the pneumonia and during his personal prewar doldrums. He arose about one in the afternoon, had lunch followed by a couple of drinks and a couple of cigars, and started painting about three instead of quitting at three as his internal clock used to dictate. In a succession of rainy days at Witch Bay, he painted until the light failed, then drew or wrote until midnight when he would "get thoroughly liquored up." He threw his empty whiskey bottles back of the camp but he did not hide them. Drinking was a manly failing, as was obesity, a Victorian phenomenon affecting policemen, judges, kings, and other professionals who were overfed and underexercised.

At the neighboring camp, Tramps Retreat, the liquor was hidden to keep it from Remington. One evening when he came over with his wife he found the liquor. Drinking at the lake made him merry. There were Roman candles along with a mouse's nest in the firework box and when the rain let up for an hour he began setting off the fireworks, making believe that he was chasing his wife around the grounds with Roman candles erupting as they both laughed.

After two weeks he sent for medicine because he feared a recurrence of his pneumonia. On August 8 he went to dinner at Tramps Retreat, leaving his wife at Keeler's camp because she was not feeling well. In the evening they sang songs and set off fireworks and Remington seemed content, but the next morning it looked like rain again and the Remingtons left for home. From Endion, he told Bigelow that he had "been canoeing on a lake with 125 miles of shore—Catching trout & killing deer—feel bully—absolutely on the water wagon but it dont agree with me—I am at 240 lbs & nothing can stop me but an incurable disease." The "water wagon" ride was frequent but short, while the weight was a constant rise.

"Killing deer" was accomplished with maximum efficiency. Remington was with local residents who depended on game for their meat and so were not Caspar Whitney's kind of gentlemanly sportsmen. "We had a raised platform," one of them declared, "above the deer lick back of Tramps Retreat. We used to go up to the lick and, after looking out to see that the game warden was not around, wait on the platform in the dark for deer, then open the jack [lantern] to light up the animal for a shot."

Wister had been hunting in the Wyoming mountains and Remington told him that he was "lucky to get sheep this day and age." Remington considered himself an expert in all forms of sport shooting. One noon when the conversation turned to hunting while he was seated at the general table at The Players, he was stimulated by the presence of a little English army officer to talk about tiger hunting.

"Just imagine the experience," he said. "You go out into the edge of the jungle, mounted on elephants, then you get down while the beaters are scaring up the game. It must be terribly exciting. First thing you know—before you can pull a trigger—a black-and-yellow streak goes past your head. After what seems an eternity, *crash* through the bushes comes the tiger again and streaks past your head." Just then he caught the eye of the little English officer and asked, "Captain, have you ever been tiger hunting?" "Oh, yes, oh, yes." "Have you ever shot any tigers?" "Oh, yes, oh, yes, about five-and-twenty." Remington went on earnestly, "Well, Captain, isn't tiger shooting as I've described it? Don't they come leaping at you?" Oh, yes," said the little captain. "They do bound about a bit."

In the Cuban conflict, President McKinley was writing to the Spanish government, requesting political reforms for the island and the end of concentration camps. The situation eased off in August when a new Spanish government was formed that was more liberal and promised to accede to McKinley's requests. At the same time, the *Journal* was concentrating on finding female victims of Spanish cruelty to inflame American public opinion. In mid-August, Hearst discovered the cause of Evangelina Cisneros, seventeen and pretty, who had been sentenced to twenty years in a Cuban prison for alleged participation in the uprising. The *Journal* induced thousands of Americans to petition for the release of this "pale flower of a woman fading away in a dank dungeon" and then sent a correspondent to engineer her escape by sawing through the bars of her cell from the outside. Brought to the United States, she was received by McKinley and then taken to a *Journal* rally in New York City where a hundred thousand people cheered, including Remington, who then illustrated her book.

In this interlude before the war, Remington could not concentrate on sculpting. "The Wounded Bunkie" was on exhibition at the Royal Academy in London, through the sponsorship of Julian Ralph, but there was no enthusiastic market in England or in the United States. While a bronze had advantages over a painting in its multiplicity, the modeling consumed months. When a bronze did not sell up to Remington's expectations, not only was the bronze an economic failure but the huge investment in time had also been lost.

He was not doing many easel paintings in color, either. He showed forty works at his first comprehensive exhibition in Boston in the fall of 1897, but most of the pictures were again from *Drawings*. The reviewer for the Boston *Evening Transcript* declared that the cumulative "horror reminds one of Colonel Hay's 'Mystery of Gilgal,' where 'They piled the stiffs outside the door: I recon there was a cord or more.' Remington's indifference to beauty of form, his unfeeling real-

ism, and his poverty of color are formidable handicaps." Remington never was accepted as a fine artist in Boston where the accent was on the classical and the European, but the comparison to a cord of stiffs was a little strong.

Despite such crushing criticism, Remington had a steady core of support, both in and out of art circles. Theodore Roosevelt considered Remington to be America's greatest painter. He was in awe of the talent and respectful of the man, just as Remington was careful yet effusive with Roosevelt. Fellow illustrator Howard Pyle grouped Remington with Winslow Homer to prove America's artistic accomplishments, and the two illustrators exchanged paintings.

The Post Office Department also honored Remington, using his paintings of Western life as part of a series of stamps commemorative of the 1898 Omaha Exposition. Two from *Drawings* were selected. "Protecting a Wagon Train" retitled "Troops Guarding Train" became the eight-cent stamp, with 2,927,200 printed in dark lilac. The fifty-cent stamp was "The Gold Bug" redundantly retitled "Western Mining Prospector," with 540,000 printed in sage green. That amounted to almost 3,500,000 little Remingtons, a considerable quantity to be circulating among everyday people.

He refused an invitation to visit Germany, telling Bigelow, "No honey—I shall not try Europe again. I am not built right—I hate parks —collars—cuffs—foreign languages—cut & dried stuff—No Bigelow —Europe is all right for most every body but me—I am going to do America—its new—its to my taste." He advised Bigelow that he was again "going to Montana—kill elk—get short stories & paint" the beginning of September 1897. As Buffalo Bill Cody's guest at the Wyoming T E Ranch, Remington hunted and painted with Cody's protege R. Farrington Elwell. He had become friendly with Cody when they were both in London, and Cody thought enough of Remington's *Harper's Weekly* review of the Wild West Show to reprint it in the yearly programs. The trip was his only Western excursion in a year when his sights were on the Caribbean.

In the slowing down of his efforts as sculptor and as painter, Remington was becoming more serious as an author. He had written his first fiction for *Harper's Magazine* a year earlier, "The Great Medicine-Horse," which became the beginning of the series about the half-breed Sundown Leflare. He told Bigelow that he had "a 'hummer' in next Harp mag September 1897—dialect by God—and that will give Alden [the editor] a hemorage unless its a top roper." He expected his storytelling to be competitive with Wister's and truer to the West. His friends supported his expectations. His experience in the West and his perceptions were unique.

He had learned from Wister that fiction can be made to spring from reality. The character Sundown Leflare was drawn from the interpreter on the 1890 trip Remington had taken with Julian Ralph. Leflare was "ol Laraeux," recorded in an 1891 letter to Powhatan Clarke: "'dose Angun' as old Laraeux-Blackfoot interpreter used to say 'are the way up stuff—nothing like em on the Earth—they could take a Cossack and milk his d_____ mare on the run.'" Remington was a phonetic speller. Ralph had the name correctly as L'Hereux and quoted him more artistically, "Nevaire ask one of dose Engine anyt'ing, but do dose t'ing which are right."

Another of Remington's sources was the old Sioux chief Rain-in-the-Face who traded tales for a quart of whiskey. It was against the law to give whiskey to an Indian, but the law was not enforced against an artist and author in search of material. Remington in his fiction admitted to sharing social drinks with Leflare, too, to get a story.

After transcribing the simplified pidgin Blackfoot tongue to quote Leflare, Remington was encouraged to try his hand at an "alleged journal in the diction of 1650" titled "The Spirit of Mahongui." It was his most pretentious effort, full of "ye fearfome warre cry of ye Iriquoit," where s's written as f's in addition to f's written as f's made for hard going and "cry" sneaked in instead of "cri." He was proudest of the third stab at dialect, "Joshua Goodenough's Old Letter" purporting to relate experiences of the Rogers Rangers in the 1750s, in the speech of the time. This was the piece most reprinted during Remington's life, at his direction, but the date of the story was a century too early to be widely appreciated by his fans.

Roosevelt kept a close watch on Remington, as he did on other major artists and authors. He told Remington, "You know you are one of the men who tend to keep alive my hope in America." After he read "Massai's Crooked Trail" in *Harper's Monthly* in January 1898, he asked, "Are you aware that aside from what you do with the pencil, you come closer to the real thing with the pen than any other man in the western business? And I include Wister. Literally innumerable short stories have been written. Even if very good they will die like mushrooms, but the very best will live and will make the cantos in the last Epic of the Western Wilderness, before it ceased being a wilderness. Now, I think you are writing this very best." At different times, Roosevelt told Remington and Wister that they were both the best.

Remington had learned about Massai's exploits in Arizona from a scout of the Tenth Cavalry while visiting Carter Johnson in Montana in September 1896. A Warm Springs Apache, Massai had been a

United States Army Scout exiled to Florida along with Geronimo. He escaped from the train near St. Louis and no one reported seeing him again until he was back in Arizona. These Western stories were edited oral history, in the same way that Wister functioned. Remington did not have the stomach for elaborate research but he was becoming a good listener. He told Roosevelt that he "did not want to read history but only original documents for more sure inspiration to do 'my little things,'" but, he added, "You do the thing in a very big way—which will only set me straight."

Roosevelt was an exception to Remington's purported dislike of politicians. Roosevelt had moved back to Washington to become Assistant Secretary of the Navy and now wanted to demonstrate his new loyalty by converting Remington to a marine artist. "I shall be able to take three days in some government tug to visit the fleet of battle ships off Hampton Roads," he wrote. "Would you like it? I am having a bully time as Assistant Secretary." Remington consented to go only if he could also have the opportunity to visit his cavalry friends near Washington. He hated any boat larger than a canoe, just as Roosevelt was secretly uncomfortable in anything but a rowboat, and he never again mentioned the visit to the fleet. Roosevelt called him "O sea-going plainsman," but told the truth when he said that "I wish I were with you out among the sage brush, the great brittle cotton-woods, and the sharply-channeled barren buttes." As an adoptive Westerner, he could not really convince himself of the superiority and "the majesty of our ships, and the heroic quality which lurks somewhere in all those who man and handle them."

The Remingtons lived comfortably in New Rochelle where their social relationships were structured. Remington's close friend was Gus Thomas who was at a low point in his career as a playwright, stale and confused about subjects. Remington was able to direct Thomas toward Arizona for a fresh perspective. He got Thomas a letter from General Miles and organized his traveling kit. The result was Thomas' hit play *Arizona* produced the following year.

The well-to-do in New Rochelle entertained frequently and participated in local charities. Help to run their homes was inexpensive. The Remingtons had Tim Bergin living in as coachman, plus Nora McCormick and Nora Sullivan as domestics. The heavy work was done by help brought in by the day.

Eva Remington had found a charitable cause in a nursery for the children of poor working mothers. She was Secretary of the organization that supported the New Rochelle Day Nursery, the oldest in New York State. After she had Endion redecorated by the local house

painter, F. W. Parsons, and the grounds had been groomed meticu-
lously, she gave a garden party that drew two hundred visitors as a
benefit for the nursery. Remington's Indian artifacts, paintings, and
statuettes were hung as exhibits on the gray wall surrounding the
lawn. The studio was open for viewing, and books, fancy needlework,
and refreshments of ice cream, cake, and lemonade were for sale.
With admission at twenty-five cents and a place for visitors who came
on bicycles to have their wheels checked, Eva Remington's party was
a success.

At the end of 1897, the magazine *The Art Interchange* published an
article that featured a new photograph of a mature thirty-six-year-old
Remington smiling confidently into the camera. His light hair was
parted in the center and he sported a carefully tended flat mustache.
The suit was a custom-tailored single-breasted model with lapels on
both jacket and vest. The shirt had a high stiff collar with wings and a
wide ascot tie, and the cuffs were "shot" half an inch beyond the
jacket sleeve. He held a glove in his right hand.

The text was psychological rather than biographical: "The absence
of the melancholy and the morbid have led some to suppose there was
a want of poetry in Remington, but below the surface of this artist"
there is "a nature as warm and as appreciative of the beauty of life as
was ever met with. Among a whole army of out-of-door artists, one
may not find a single anarchist."

The picture was of a Remington who was comfortable while posing
as a fashion plate, without needing to rely on the image of the cow-
boy he never was. Settled as he looked, however, this was a Reming-
ton who would be ready in a moment to trade the modish vested suit
for the plain garb of a war correspondent.

The movement of the nation from sympathy with Cuban rebels to
an overseas war with Spain was not planned but it was inevitable, al-
though this adventurous flexing of young America's muscles was un-
dertaken with no thought of a need to defend the United States or of
national gain in money or territory. The Republican Party welcomed
Cuba as a diversion from the 1897 tariff that fostered business monop-
oly, but the party did not intend war. The yellow journalists Hearst
and Pulitzer were inflaming public opinion as a circulation device and
Hearst was said to have offered to bet fifty thousand dollars he would
cause the war to happen, but by the end of 1897 it had appeared that
Spain's compromises would avoid confrontation. Weyler the
"butcher" had been recalled to Spain. The Cuban insurgents were
offered autonomy.

By the middle of January 1898, the Cuban situation was so calm it
had dropped out of the news. At the end of January, the Cuban rebels

refused autonomy, causing concern among the Spaniards in Havana, and the battleship *Maine* was sent to Havana harbor February 5 to protect American citizens. Cuba was relatively quiet until 9:45 P.M., February 15.

23.

The Greatest Thing Men Do

It was early February 16, 1898, when James Waterbury who was the Western Union telegrapher in New Rochelle telephoned Gus Thomas with startling news. The battleship *Maine* had been blown up and sunk in Havana harbor with the loss of 266 sailors. Thomas knew the urgency the report would have for Remington so he immediately rang up his neighbor on the party line and repeated the information. According to Thomas, Remington's only response was to shout "ring off!" While Thomas was breaking the connection with his finger so he could repeat the news to another friend, he could hear Remington calling the Harpers' private number in New York. It was clear to Remington that the Spaniards had struck the *Maine* as an act of war. The potboiling and the anticipation were over. His campaign as a war correspondent was under way.

Getting a call from Remington before the sun was up was not a boon to the Harpers, particularly on a subject that they had been discussing late into the night after hearing about the *Maine* from their man in Havana. Here was Remington agitatedly asking to be sent off on an immediate mission to chastise the Spaniards, when the moderate

Harpers did not believe that the Spaniards had been involved in the explosion. They put him off as gently as they could.

Miles the opportunist was more sympathetic. Remington and his wife were invited to Washington February 17, the day after Thomas' call. Miles wanted Remington to illustrate the coastal forts, showing "Major-General Nelson A. Miles, U. S. A., Inspecting the Defences of New York." Seaboard Americans were afraid of Old Spain because of the world power it had been. A Spanish naval attack on American ports was anticipated, according to the Secretary of War. "In Boston and some of the other cities, towns, and fashionable watering-places on the New England coast, treasures and valuables were moved into the interior for safe-keeping." Through Remington's illustrations, Miles was reassuring the public that he would protect them against Spanish naval might.

Remington had been planning for so long what he would do when war came that the procedure was clear to him. The first step was to connect with publishers. For him that meant the Harpers for the *Weekly* and the *Monthly*. His arrangement with the Harpers was for exclusivity in magazines and weeklies, preventing him from also reporting on the war for *Collier's Weekly* where he had begun illustrating in a small way. For daily newspapers, he went back on contract with the *Journal* and he added the Chicago *Tribune*. Hearst promoted Remington first among artists, the one warmonger pushing the other. The Harpers published a list of their war correspondents, subordinating the soldier painter Remington to the marine specialist Zogbaum. Zogbaum was given preference because he was not involved with Hearst.

In thinking ahead, Remington knew he could find a publisher like Russell for prints and for picture books of the war, but for descriptive books he could illustrate, he continued to seek a writer as a partner. It simply did not pay Remington to write if he could get a compatible journalist to handle the words and leave him free for the more lucrative art work. Wister, Davis, and Bigelow had been eliminated in 1887. The respected Caspar Whitney, who was the sporting authority, would be in Cuba as a *Harper's* staff man, but Whitney's writings would belong to *Harper's* so he was precluded from making a private deal with Remington. The partner Remington chose was Stephen Bonsal, four years younger than he and part of the American aristocracy who had attended St. Paul's School like Wister. Bonsal was a most experienced correspondent, having reported on Cuba a year earlier when he also testified before a Congressional committee. Bonsal's first assignment had been the Bulgarian-Serbian War in 1885 when Remington was a silent saloonkeeper in Kansas City, and he

had spent five years in the diplomatic service. In turn, Bonsal felt that "Remington was indeed a good friend of mine. I had often listened to his wars, and he had listened patiently to mine, and we had frequently decided what a very perfect and fortunate war that one would be which should go into history depicted by his pencil and described by my pen." Sharing with Bonsal looked like Remington's answer when the pen was so economically unproductive. He did not get much more for his writing in 1898 than he had when he started in 1887.

In his planning and in the practice of his trade, Remington was a disciplined man. He knew where he was going in art and in literature and he understood what he had to do to get there. Where he was out of control was in regulating his intake of food and drink. Although he did not recognize himself as obese or appreciate the difference that ten years had made since he rode with Clarke and Watson in Arizona, he was a fat man, abusing his body despite the handicap that excess weight would be in a field campaign. At thirty-six, he believed that he could quickly exercise himself into condition, as he had when he was younger. He had recently been to the Laurentians in Quebec. In a cold milieu, supported by guides and companions, he had done well enough to convince himself he could manage whatever demands might be made in Cuba. He took his body for granted in planning his role in the war and he concentrated on the business end, lining up his accounts, the newspapers and magazines and publishers, and protecting his news sources, Roosevelt for the sea and Miles for the land.

Hearst and Pulitzer were in the course of persuading the public that the explosion of the *Maine* had been caused by a Spanish underwater mine intentionally detonated. The moderate *Harper's Weekly* countered that there was no evidence that the disaster was from a mine, Spanish or Cuban, and that there was no reason for the war other than as the result of "jingo talk" in the Yellow Press. The explosion could have been an accident of internal origin.

The *Journal* treatment of Cuban events was to write as if war had already been declared. Remington agreed with Hearst. His sister-in-law Emma Caten had been alerted to come to New Rochelle for the duration. "I am waiting further communication relative to the movements of F. Remington," she said. As the little sister with no job or family of her own, she had taken on the role of Eva's companion when Remington was away.

Opposition of the moderates to the war was being eroded. President McKinley was accused of timidity. When the naval court of inquiry reported on March 28 that the *Maine* had been blown up by a submarine mine, the prospects for peace were exploded, too. The statesman

John Hay declared that it would be a "splendid little war," as if it were an extension of the Indian fighting. The Cuban war was expected to be popular, light-hearted, emotional, without economic motive, nearly unanimous, and to involve both Democrat and Republican, the North and the South, for liberty and democracy, against the Old World. The wartime theme song was "There'll Be a Hot Time in the Old Town Tonight."

After it was too late to cool American emotions, Spain ceased hostilities in Cuba and pointed out that while Spain had no reason to have attacked the *Maine*, the Cuban rebels did. Congress issued an ultimatum on April 20, making it appear to Spain that the United States was aggressively seeking Cuba as a colony. Spanish national pride became involved, and diplomatic relations with the United States were cut April 21.

Remington and his neighbor Zogbaum had left New Rochelle for Florida on April 14, part of a large contingent of correspondents centering in Key West to look for berths on American battleships that were ready to begin a blockade of the Cuban coast. Roosevelt had granted Remington permission to be the only correspondent with "Fighting Bob" Evans on the *Iowa*. Zogbaum was assigned to the flagship *New York*, along with Davis, Bonsal, and Stephen Crane. Davis told his mother that "I wrote you such a cross gloomy letter that I must drop you another to make up for it. Roosevelt telegraphed me the longest and strongest letter a man could write instructing the Admiral to take me on as I was writing history." Davis had migrated to a respectable newspaper, the New York *Herald*.

The blockade was in effect April 22, war was formally declared April 25, and the *Journal* began publishing Remington's illustrations drawn the week before, showing the advance elements of the army arriving in Tampa, Florida. The circulation of the Yellow Press exceeded the publishers' expectations. The *World* had reached 1,300,000 daily.

Remington was acutely unhappy on the *Iowa*. He had nothing to do that interested him and he ate too much and he drank too much. His wine "chits" were substantial. Even "Fighting Bob" noticed that "the 'dough boy' fever was really too strong" for him and that he "couldn't stand the quiet ways of the 'web foot.'" Remington said he missed the army and he "wanted to hear a 'shave-tail' [lieutenant] bawl; I wanted to get some dust in my throat; I want to kiss the dewy grass, to see a sentry pace in the moonlight, and to talk the language of my tribe."

Because Remington was alone as a correspondent on the *Iowa*, he

had to write his own articles. The first dispatch that he sent was to the Chicago *Tribune* explaining the strange nautical behavior that had puzzled the admirals of the American and Spanish fleets:

The black cat fell overboard one morning, or the fox terrier who inhabits up forward chased him overboard—we do not know which. An alarm was promptly given—it would never do to have a black cat lose her life in such a way, for black cats in particular are portentous things even when alive, but dead ones are something awful. Who knows what might happen after that?

So a boat was lowered and the big battleship *Iowa* temporarily abandoned the blockade of Havana and steamed in a circle, hunting one lost black cat. The cat came alongside, pawing the water frantically, and was rescued by a jackie [a sailor], who went down the sea ladder and grabbed her just in time.

The closest Remington came to action was a quick view of two Spanish gunboats that ran out to the mouth of the harbor to peek at the *Iowa*. On April 29 he "sneaked on board" a courier boat to transfer to the *New York* and said that he "nearly had the breakfast shaken out." On the flagship he found that the guns had shelled Matanzas the previous day in the first action. He was jealous that Zogbaum and Davis had reported the firing of the impressive naval guns but the Spanish at Matanzas said later that the only injury was to one mule.

All the other correspondents were stuck in Key West or were dashing about in small dispatch boats chartered by their publishers. A charge of favoritism was made about the five on the *New York*, and on May 2 Remington and the rest were put ashore. That began what Davis christened the "rocking chair" period of the war. It took place on the porch of the Tampa Bay Hotel.

In contrast to the efficient navy, the army had been unprepared for hostilities. The staff in Washington was as inept as it had been in 1893 when Remington and Clarke had tried to enlist public opinion to oust the superannuated coffee coolers. Regular army forces numbered only 28,183, and 10 percent of them were staff. Spain had sent 214,000 soldiers to Cuba to put down the insurrection and 80,000 remained in 1898, supplemented by 25,000 volunteers in Havana and 2,000 black guerillas.

In the structure of the American government, all military power under the President was in Secretary of War Russell Alger. Miles as commanding general was merely an adviser. A la Gilbert and Sullivan, Alger declared that "the life of the Secretary of War was not a happy one. The office of the Secretary was daily visited by not less than one hundred persons whose business or position entitled them to a personal

hearing. Therefore it became necessary to devote the greater part of the night and Sundays to the consideration of department work." Alger was in charge of the army in wartime, and as he said, he performed military duties only at night and on Sunday. He delegated little, and little got done.

Provision was made for adding 200,000 volunteers to the American army. All of the men and the matériel were directed to Florida, slowly inundating Tampa, but there were no modern rifles for the volunteers and no lightweight khaki cloth for uniforms. There was poor camp sanitation for personnel.

The correspondents were bunched in Tampa, too, with only the news they could create. It was said as a joke that there were more journalists in Tampa to describe the army than there were medics to take care of it. Davis wrote home that "it is a merry war, if there were only some girls here the place would be perfect—here am I—and Stenie [Bonsal] and Frederick Remington and all the boy officers of the army and not one solitary, ugly, plain, pretty, or beautiful girl." That was for home consumption. There were plenty of young Tampa women. The dance band played nightly in the hotel ballroom.

Davis had reason to be happy: "I expect to make myself rich on this campaign. I get ten cents a word from *Scribner's* for everything I send them [ten times Remington's rate], and I get four hundred a week salary from *The* [London] *Times*, and all my expenses." That was in addition to his basic pay from the New York *Herald*. Remington's earnings from pictures were to be about the same.

With uncharacteristic modesty, Davis reported that "the two men of greatest interest to the army of the rocking chairs were Frederic Remington and Great Britain's representative, Captain Arthur H. Lee. These two held impromptu receptions at every hour of the day, and every man in the army either knew them or wanted to know them. Remington was, of course, an old story." Davis always wrote Frederic with a k. The editors corrected his copy. Although he did not say so, Davis was an equal attraction. He wrote home for two-dozen photographs of himself to give to officers who had requested them.

An appointment reported by Davis was "Lieutenant-Colonel Theodore Roosevelt, with energy and brains and enthusiasm to inspire a whole regiment." Roosevelt had resigned as Assistant Secretary of the Navy to join Colonel Leonard Wood in forming the First United States Volunteer Cavalry. Wood was valuable to Roosevelt because he was an insider. He was physician to President McKinley's wife and to Alger. The regiment they enlisted was a blend of New York socialites and twelve hundred "rough riding cowboys" from the Southwest. Wood located modern Krag-Jörgensen carbines with smokeless am-

munition that were supposed to be issued to the regular regiments and he rejected the Army's heavy blue uniform in favor of its lightweight brown work clothes. In an article, Remington agreed with Wood that soldiers being sent to the tropics could not stand woollen uniforms.

In the midst of all of the Tampa bustle, Remington was in his element. To his experienced eyes, though, it looked like the old coffee coolers on the Washington staff were cooking up a tragedy. His story "The War Dreams" that was published in *Harper's Weekly* without an illustration May 7, 1889, depicted the artillery running out of shot and firing people as ammunition. He described the cavalry as being ordered to ride into a picket fence, and reported a marine seeing women's tears as a wet spot on the breast of a blue uniform. Roosevelt shared Remington's view of the chaos and wrote in his diary that "the delays and stupidity of the Ordnance Department surpass belief. There is no head, no management whatever in the War Department. Against a good nation we should be helpless." Davis told his family that "it is a terrible and pathetic spectacle, and the readiness of the volunteers to be sacrificed is all the more pathetic. I have written nothing [on this] for the paper, because it would do no good, and it would open up a hell of an outcry from all the families of the boys who have volunteered." General Miles opposed any invasion until the volunteers were trained and equipped and the summer had passed.

Bigelow went public with the same complaint. He wrote in *Harper's Weekly* that the American Army was absolutely unprepared for the invasion of Cuba, that it was losing vitality in Florida, and that the men had neither adequate food nor proper clothing. In their articles, Davis promptly denounced Bigelow as a traitor, Whitney called Bigelow seditious and unpardonably ignorant, and Remington was silent. He did not defend Bigelow, and that was the end of Bigelow as a credible correspondent.

After venting his fears in "The War Dreams," Remington had no public posture on the army other than supportive. He was busy sketching soldiers for the *Journal* and *Harper's Weekly*. One of his routine drawings, of a mounted cavalryman at a halt during maneuvers, became accepted as the representation of the cavalry spirit and was reproduced on the front cover of *The Cavalry Journal* for forty years. When an expedition was decided upon to ship arms to the insurgents on an old side-wheeling river boat called the *Gussie*, Remington did not go along. He did not have confidence in the troop commander on board so he stayed on shore, sketching the departure.

Davis did not go either. He had been offered a captaincy on the staff of Brigadier-General William R. Shafter, the commander of the Fifth

Army Corps, which was to be the invasion force. Shafter who was more obese than Remington had been selected over Miles not because of his own qualities but because Miles was a politically ambitious Democrat preaching caution, out of step with the national demand that the invasion be launched at once, ready or not.

Davis was serious about the captaincy. He said that the "love of soldiering was in his blood" but that "there was the loyalty to his contracts to be considered." He sought Remington's advice on whether to accept the commission, and then turned the offer down. His peers snickered at what they called his lack of courage and he had another bout of the petulance that led him to attack those closest when difficulties arose. He decided he had made the wrong decision and he blamed Remington. "On reflection I am greatly troubled that I declined the captaincy," he told his family. "I was unfortunate in having Lee and Remington to advise me. We talked for two hours in Fred's bedroom and they were both dead against it. Now, I feel sure I did wrong." Months earlier, Remington too had dreamed of being a captain in this war, but, as he told Davis, that role was for the professional soldiers and there were a lot of them while Davis and he were unique in the world in what they did. Miles supported Remington's advice, taking time from coping with the logistics of invasion to send Davis a friendly message.

After six weeks in Florida, Remington returned to Endion for a brief vacation. He told Wister in late May that "if I dont become a bucket of water before that time, I hope to see the landing in Cuba but if any yellow fever microbes come my way—I am going to duck. They are not in my contract. Say old man there is bound to be a lovely scrap around Havana—a big murdering—sure." He was writing as the militant who wanted to watch civilized men make war, in fulfillment of "a life of longing to see men do the greatest thing which men are called upon to do."

Two major powers were to clash, one declining and the other emerging. Both were white and Christian, one defending its colonial empire and the other sure of its strength but not its goals. Remington saw the war as a conflict between the professional military services of the two countries. His loyalties were pinned to the regular army field generals, Henry Ware Lawton, Adna Romanza Chaffee, and Samuel Baldwin Marks Young. All three had enlisted in the Civil War as privates. They were officers committed to the army as competent team players. Although Young was an old friend of Roosevelt and had promised "to put him in the action," Remington was counting on Young as his particular protector, at the behest of General Miles.

Remington believed in these experienced field generals rather than the dilettante volunteers like Roosevelt who did not even have the military background of the coffee coolers on the staff.

Davis had disliked Roosevelt when they first met. They had come close to fighting in a chance encounter outside Delmonico's in New York City in 1894. Roosevelt had detested Davis. He had considered Davis an Anglophile, a poseur, and a fop of doubtful courage. He thought Davis' mannerisms were outrageous. In Florida Davis wore a quasimilitary uniform of his own concoction and was capable of the gesture of buying up the entire supply of rum in Key West to secure it for himself and his friends. In turn, Roosevelt scandalized Davis' sense of military propriety. He ate with his noncommissioned officers. Davis did, however, comprehend that the Rough Riders were the romance of the day. He subordinated personal feelings to do his job, just as Roosevelt recognized Davis as the most potent of the journalists and put himself out to be accommodating. Davis became Roosevelt's personal publicist, as Remington served Miles, but Davis chose the more newsworthy master. Davis ended up having a brilliant war that was the foundation for a brilliant career. Remington had a terrible war.

At this early point in the hostilities, the Spanish admiral Cervera was locked with his fleet in the harbor of Santiago in Cuba. The American Navy was outside the harbor, unable to enter because of mines and unable to sweep the mines because the Spanish Army controlled the gun emplacements in the city and on the shores. The American Navy had requested the Army to flush the Spanish Army from Santiago.

Remington's sponsor Miles was in Washington delivering invasion plans that had been requested by an unsympathetic Secretary Alger. Miles' plans were never accepted in full, but one feature was an invasion at Daiquirí, twenty miles east of Santiago, where there was an old metal pier like the one described by Davis in his novel *Soldiers of Fortune*. Security was not tight. The *Journal* made up a story describing as fact the invasion not yet charted, and giving Daiquirí as the landing place. The *World* copied the *Journal*'s lies. In retaliation, the *Journal* invented the artillerist Colonel Reflipe W. Thenuz. When the *World* copied and embellished the Thenuz story, the *Journal* gloated that the Colonel's name read backwards from the middle initial was "We pilfer" and the last name read forward was "the news." There was an absurd newspaper war going on in the middle of the real war.

On May 31, Secretary Alger ordered Shafter to have his army board the transports and set sail. It was easy to say, impossible to do. The next day Miles arrived in Tampa on his special train with his wife, daughter, son, staff, and Remington returning from New Rochelle to his rocking chair. Miles consulted with Shafter. One decision

that resulted was to unhorse the cavalry for duty in Cuba because of a shortage of transport. Joseph Wheeler was the general in charge of the cavalry, having been appointed as a political and sectional gesture because he was the senior Democratic congressman and a former Confederate general. Wheeler asked Remington to intercede with Miles on behalf of the cavalry. "I edged around toward him," Remington said, and asked, "General, I wonder who is responsible for this order dismounting the cavalry." Miles replied, "Why? Don't they want to go?" and he had Remington "flat on the ground. A soldier who did not want to go to Cuba would be like a fire which would not burn—useless entirely." Remington knew that some soldiers would be left behind, and malcontents might lead the list.

Miles was unable to get the invasion started. Washington had forwarded three hundred sealed freight cars to Tampa, loaded with all the necessities of the army, but there were no bills of lading to tell what was in any given car. All the cars had to be opened and every sealed box taken out and inventoried. On June 7, President McKinley ordered Shafter to sail at once, with or without the support matériel. Shafter then told his commanders that they would have to be on board the expeditionary fleet with their men the next morning or be left behind. The troops were in Tampa, nine miles from the port. There was only a single-track railroad connecting Tampa with the port and there was no one managing the movement of the trains.

The Rough Riders had not arrived in Tampa until June 3. They had no assigned way to reach the port, so Roosevelt commandeered a train of coal cars heading away from the port and made the engineer back up all the way to the docks. Shafter could not tell Roosevelt which ship was theirs. Wood searched out the port commander and found that their ship was one that had been assigned to three regiments where only one would fit. Wood located a launch to take him to the ship in the harbor and he ordered the ship to the pier. Roosevelt double-timed the men to the pier. They boarded the ship, and then repelled the other two regiments when they arrived.

Remington had no such excitement. He was on Shafter's headquarters ship the *Seguranca*, in a cabin befitting his status. Davis and Whitney were along, as were the Englishman Lee and Bonsal because he was both Remington's partner and Davis' intimate friend. As with "Dan" Wister, Remington did not know that Bonsal was "Stenie" to Davis. The remaining eighty-four correspondents were packed into the *Olivette*. Other journalists were stowaways on the troop ships.

The invasion fleet was ready to sail at 2 P.M. June 8. Cheers rang out and bands played at the docks. The transports were towed out, then towed back. Suspicious ships that might have been Spanish had

been seen along the coast so the fleet returned to port. Davis told his family that "I would have thought I would have gone mad or gone home long ago. Bonsal and Remington threaten to go every minute. Nothing you read in the papers is correct. God bless you, this is a 'merry war.'"

Two days later, amid more cheers the fleet once again attempted to leave, only to drop anchor farther out. Finally, on June 14, the coast was clear. Without cheers or bands this time the fleet of thirty-two transports, rented from private owners with private masters and crews, raised anchors. The cargo was sixteen thousand soldiers bound for Cuba. Protected by fourteen warships, the convoy was off on a voyage south on the Gulf of Mexico and eastward around the Florida keys. The pace was set by the speed of the slowest vessel. The weather was perfect, the sea like glass. At night all the lights were lit and regimental bands played. The fleet was strung out for miles. No Spanish ship made any hostile move.

On June 19 the expedition cleared the Windward Passage at the easternmost tip of Cuba and turned for the southern shore. The next day it was off Santiago where the *Seguranca* picked up Admiral Sampson en route to a conference with the Cuban general Garcia. The Cuban could not come on board because he suffered from sea sickness. Shafter, Sampson, and their entourages went ashore in Spanish territory, with Shafter riding a mule to the top of a cliff he could not climb. Remington and the others walked. The decision was reached to land the army at Daiquirí, exactly as published in the *Journal*.

On June 21 the Navy bombarded the Spanish positions on Daiquirí beach. The beach was shelled again early the next morning and the invasion began at 10:15 A.M. The transports remained as far off shore as they could. The private masters were protecting their owners' vessels from possible Spanish artillery fire. Soldiers were loaded into ships' boats and towed toward shore by Navy launches. The choice of Daiquirí as the beachhead was obvious to the Spaniards because of the pier and the selection had not been a secret. The American forces had not scouted the beach or the cliffs even though there were fires on the cliffs indicating Spanish presence and there was a blockhouse to command the whole beach. It was the moment of truth for the invasion.

While Shafter was apprehensively watching the progress from the *Seguranca*'s promenade deck, Davis came up to complain that he had not been sent with the first landing party. He was, he said, not a reporter but a historian, and he demanded preference. The worried Shafter replied, "I do not care a damn what you are. I'll treat all of you alike." Davis retreated to his cabin, humiliated, and he ridiculed Shafter in every future reference.

With American luck, the melancholy Spaniards had withdrawn their forces from Daiquirí. The cliffside fires were matériels destroyed by the retreating Spaniards to keep them from the invaders' hands. The landing was unopposed, and by dusk, six thousand soldiers had reached the beach with only two men accidentally drowned. Spain had lost the war at Daiquirí, if not earlier by failing to attack the expeditionary fleet.

The correspondents on the *Seguranca* were notified to get ready. The standard kit was "three days of crackers, coffee, and pork in haversacks, canteens, rubber ponchos, and six-shooter—or practically what a soldier has." Remington had a camera, too. He also had a length of mosquito netting. Remington and Bonsal had each bought netting in the same Tampa shop, from the same roll, but one length was now missing. The argument over ownership was bitter enough to require resolution through Remington's strength, causing the aristocratic Bonsal to utter the remark that terminated their friendship. He would never again, he resolved, "allow a self-made man to anger me with his parvenu arrogance." Whatever his worldly success, to Bonsal and Wister and even Davis, Remington was in the end just a self-made man.

24.

All the Broken Spirits

When the infantrymen of the Second Division hit the beach at Daiquirí just before noon on June 22, 1898, Remington was watching from the deck of the *Seguranca*. It seemed to him that the soldiers turned on their own and started moving, but the command was General Lawton's as he organized his men for the march toward Santiago. Soon after, the correspondents were loaded into a boat by themselves with the gear that had been issued to them and were ferried to the iron pier.

Instead of catching up to the infantry on the march, Remington found his old friends of the "Galloping Sixth," part of the First Brigade of the unhorsed cavalry division under General Wheeler that had followed Lawton ashore. The invasion was a lark as Remington "sat on a hill and in the road below saw the long lines of [Lawton's] troops pressing up the valley toward Siboney." It was like being in Montana, getting the "great man" treatment, with the discussion centering around exciting prospects of attacking the Spaniards in Santiago, Cuba's second largest city. He bedded down with the Sixth, in the

open on his poncho in the cool night, uncomfortable because of a brief shower. He told his wife that he "slept all night wet."

Lawton had taken his troops three unopposed miles in the direction of the next Spanish stronghold, Siboney, and had then spent the night bivouacked along the road. In the morning, Lawton's troops secured undefended Siboney while the Sixth Cavalry was still waiting for orders. Remington was too anxious to be able to remain behind with the Sixth, so he started on foot on the road toward Siboney, finding the terrain "all so strange, this lonely tropic forest, and so hot." He fell in with a group of orderlies, got a lift for his pack on top of General Young's luggage that was tied to a primitive mule cart, and stopped off for a leisurely roadside lunch as the guest of General Young himself. The General was in command of the Second Brigade of Wheeler's Cavalry. His orderly had discovered a fenced-off glade under a tree beside a stream. It was like a Players' picnic as the orderly put bottles of ginger ale into the mud at the edge of the cooling stream and built a fire to boil water to cook dried cauliflower. Salmon was spooned out of a can for the main course. A table was unfolded, places set, and a bottle of lime juice was opened to flavor the fish.

Remington was supervising the preparation of the lunch when Stephen Bonsal came up the trail. Someone had stolen his pack. "Forlorn and without food," Bonsal's "fortunes were at the lowest ebb." Bonsal did not know General Young, Remington's main man in the absence of Miles, so he leaned over the fence to attract Remington's attention. When the table had been spread, and Bonsal "was simply choking with the fumes of the many savory dishes," Remington paid Bonsal back for the parvenu derogation that concluded their fight over the mosquito netting. "Well, you had better run along, old man," he told Bonsal, "or you'll be late for your supper." Bonsal never forgot his dismissal. He dipped his pen in poison whenever he wrote about Remington.

After lunch, Remington went on to Siboney with Young. He found Lawton's headquarters and was told that General Shafter's instructions forwarded from the *Seguranca* were to establish Siboney as the army's base. Siboney would become the debarkation point for the rest of the troops and the matériel, rather than Daiquirí. There would be no advance until the unloading was completed and until the Spaniards who were falling back on Santiago were out of the way. That meant at least two days before there would be any action. Remington went off to find friends among Lawton's infantry regiments.

General Wheeler was the ranking officer on land but Shafter sent his orders to Lawton the regular rather than to Wheeler the volunteer.

Young reported to Wheeler. Neither Wheeler nor Young respected the cautious and indecisive Shafter. They were looking for combat. After they talked it over, Wheeler had Young with the First and Tenth Cavalry regiments, and Wood and Roosevelt with the Rough Riders, camp to the west of Siboney the night of June 23, on the road to Santiago. Wheeler gathered with him the correspondents he trusted, Davis and Whitney. He did not seek out Remington who was the ally of the regulars, even though his subordinate General Young had close ties with the artist.

Remington cooked his own supper from the last of the provisions in his haversack, sitting at one of Lawton's regimental fires. The officers talked about war until it was night, and then Remington found a place for himself where he could spread his poncho under a mango tree and use his haversack for a pillow. He could "hear the shuffling of the marching troops, and see the white blanket rolls glint past." Sleep was difficult for anyone close to the beach. The landing of soldiers went on through the night. The ships' lights illuminated the area. The men stripped and went dashing into the surf, making the Cuban night into Coney Island on a sunny summer Sunday.

In the early morning of June 24, Remington awoke to see "the field covered with the cook fires of the infantry." He then discovered that the troops he had heard marching during the night had been Wheeler's division heading toward Santiago. They had run into trouble at the crossroad called Las Guasimas, requiring Wheeler to ask Lawton for military assistance in the fight. The first Rough Rider casualties were being brought back to the doctors at Lawton's headquarters.

Wheeler's thousand cavalrymen had been divided into two groups. Young and Whitney with two regiments went along the wagon road. Wood, Roosevelt, and Davis with the Rough Riders followed a jungle trail to the left. The Rough Riders had Cuban scouts out front, then five experienced Westerners as the point, and then an advance guard, but still they overran two thousand Spanish soldiers retreating inland to Santiago and were ambushed by the Spanish rear guard. The fight lasted two hours until the Spaniards were threatened by Young and the Tenth Cavalry, the "Black Buffaloes." As the Spaniards pulled back to continue their retreat, noncombatant Davis took a carbine to join the fight and the Rough Riders led by Roosevelt carried the field with a charge. In the excitement, Wheeler, who had ridden up to join Young, grew confused and encouraged his men in the Cuban jungle with the shout, "We've got the damn Yankees on the run."

The newsworthy note at Las Guasimas was the bravery of Roosevelt. He had been tested under fire and the press made him into a hero.

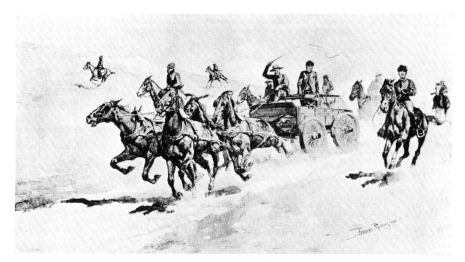

33. Remington's pictorial recollection of the brush with the Brule Sioux in the 1890 Indian War in "A Run to the Scout Camp."

34. Lt. Edward Casey in center and Remington to his left, "Watching the Dust of the Hostiles from the Bluffs of the Stronghold."

35. Remington in 1891, "different only in the surface covering from the weighty party" who had dismounted at Tongue River.

36. Remington holding Toto, also known as Snip, with Eva on the piazza at Endion.

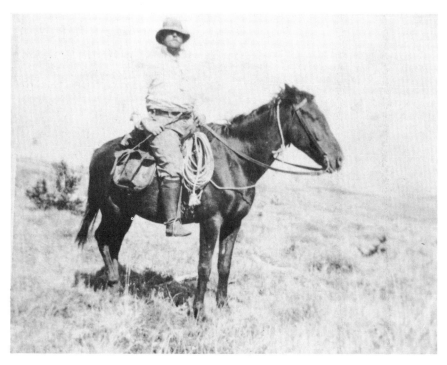

37. A stout Remington about 1893, the time of his Mexican trip, with felt hat replacing the pith helmet.

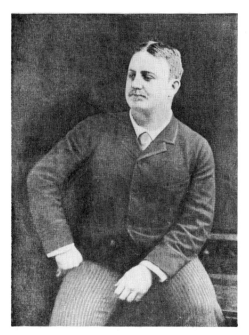

38. "A warm, blond English complexion and light hair."

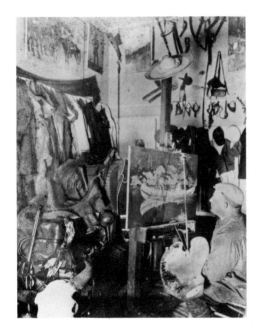

39. Remington at his easel, surrounded by his precious props, just before he built the new studio at Endion.

40. A cyanotype of the studio of M. J. Burns about 1896, with Burns at left, Winslow Homer full face, and Remington at right.

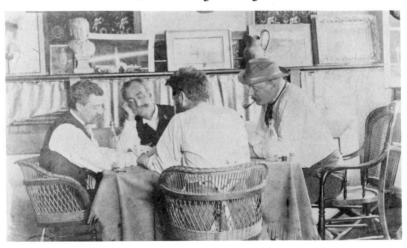

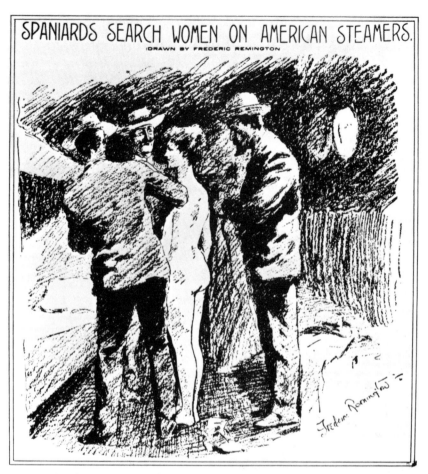

SPANIARDS SEARCH WOMEN ON AMERICAN STEAMERS.
(DRAWN BY FREDERIC REMINGTON)

41. This drawing printed five columns wide on the second page of Hearst's *Journal* helped the issue sell almost a million copies.

42. Correspondents on the *Seguranca:* Davis, Bonsal, Whitney, and Remington.

43. En route to the conference at Aserraderos with Shafter on the mule and Remington afoot with the other correspondents.

44. Lt. Col. Theodore Roosevelt and Col. Leonard Wood of the First U.S. Volunteer Cavalry, the "Rough Riders."

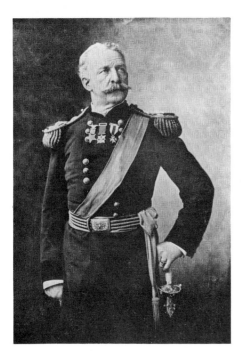

45. Gen. Nelson A. Miles, who never achieved his life's goal, the presidency.

46. Remington in front of his Ingleneuk studio: "After work came relaxation."

47. "Remington and his canoe are inseparable. 'Best exercise on earth; feel my arm,' he says."

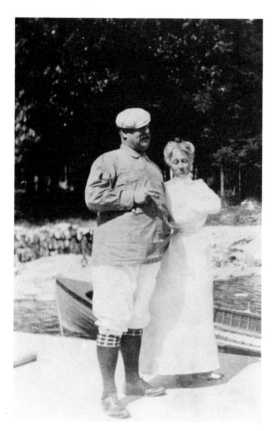

48. "Buying Ingleneuk brought Remington closer to his wife. They worked together to make the island suit them."

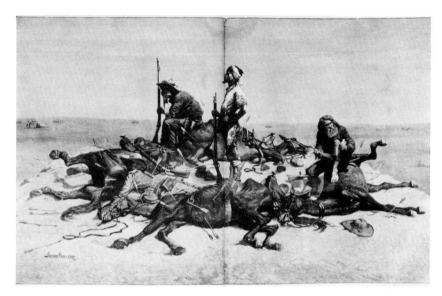

49.

49.–50. Two views of a similar surround, the one in 1889 and the other in 1901. Remington begins to simplify his style.

50.

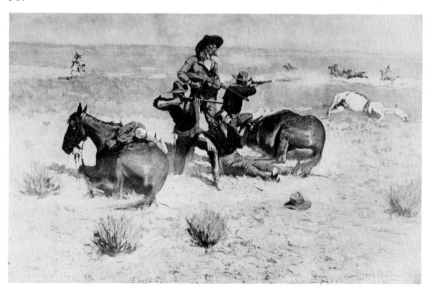

51.

51.– 52. Excerpts from the "Remington Number" of *Collier's* that "was a compendium of Remington's art plus an insider's peek at the artist, his work and his life story."

52.

AMATEUR ROCKY MOUNTAIN STAGE DRIVING

53. The centerfold "Evening on a Canadian Lake" was the masterpiece in color.

54. "Coming Through the Rye" in heroic size at Portland, Oregon.

55. How Remington saw himself — as the dandy in an endorsement for the "Kodak Development Machine."

56. "Mrs R is a good and fine woman and I rely absolutely on her graces to pull me through."

57. Remington sculpting "The Buffalo Horse" at the end of 1907 — realist in bronze, impressionist in paint.

58. "That cowboy had to be on the bluff he was intended for."

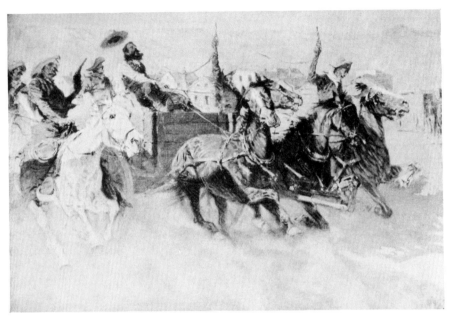

59. On January 25, 1908, Remington, in a fit of artistic frustration, destroyed some of the best of his recent paintings. Among those fed to the flames was "Bringing Home the New Cook," a painting that was quintessential Remington.

60. "Drifting Before the Storm" was another "old enemy" that Remington burned that January 25, 1908.

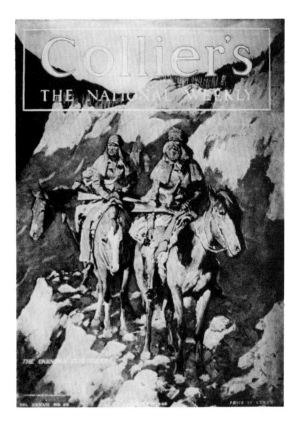

61. "The Unknown Explorers," from his 1906 *Collier's* series, also went into the fire. These were "bad men, ready for a fray" until Remington burned them.

62. "Snaking Logs to the Skidway" was from another 1906 *Collier's* series, "The Tragedy of the Trees." Like the "Explorers" series, this failed to excite the interest of Remington's admirers and it too went up in flames.

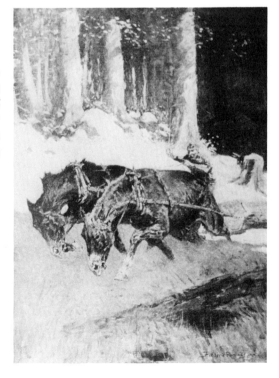

63. "My new shack in Ridgefield—not the biggest building in America, but it is altogether the finest."

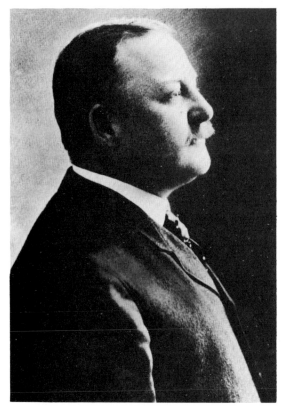

64. He had the world-weary air of the commercial impresario, as knowing as the Prussian banker he might have seemed to be.

In his own official report, Roosevelt cited Davis' courage in combat and he asked the press to mention what Davis had done, in that way binding Davis to him. Shafter considered rebuking Wheeler for advancing without orders, but Wheeler's powerful position in American politics and the emergence of Roosevelt as a new popular hero precluded any reprisal. Besides, Wheeler had no respect for Shafter and would not have accepted a reprimand, public or private.

Davis had won acceptance by the Rough Riders. He told his family that he "was never more happy and content and never so well. It is hot but at night it is quite cool and there has been no rain only a few showers. No one is ill and there have been no cases of fever." He added that "for Whitney, Remington and myself nothing is too good. Generals fight to have us on their staffs and all that sort of thing."

On June 25, the war started to go sour for Remington. General Young came down with fever and was invalided to the States. Remington had carefully cultivated Young as his protector and had up to that point considered the general to be the "strongest" in the army. It was "a regular solar plexus blow" to Remington when Young got sick and went home. "It's mighty hard to organize," Remington said, "right in the midst of the campaign." With Young gone, he had lost the conduit that he had prepared, and no other general was accessible. A continuing connection to Lawton and Chaffee would not help him. Lawton had allowed himself to be circumvented by Wheeler so Remington no longer trusted him as a reliable source for the army's plans. Remington had no respect for Wheeler. To him, as well as to the regulars, Wheeler had let himself be ambushed while acting contrary to orders, and then had to call for aid when the fight did not go his way. He could not trust Wood or Roosevelt either because they had excluded him from Las Guasimas.

When Remington met the novelist John Fox who was a correspondent too, they discussed everything that had happened. The conclusion was that "we had not seen this fight of the cavalry brigade because we were not at the front. We would not let it happen again. We slung our packs and plodded until we got to within hailing distance of the picket posts and said, 'We will stay here.' And stay we did." They had moved to the edge of the no man's land between the two armies so that any advance would have to pass by them. As a consequence, Remington had relinquished the convenient billet he had had near headquarters. In the evening, they went back to headquarters. With no food of their own, they " 'bummed' crackers and coffee from some good-natured officer," and then they "repaired to our neck of the woods" to share two rubber ponchos for sleeping in the open. It was all still fun, with hot days and cool nights and no rain. Shafter was

consolidating his position and building up supply lines. There was no further contact with the Spaniards.

As a result of his choice to sleep outdoors rather than in a staff tent, Remington's health soon began to fail. The steamy heat of the day and the cool night aggravated the cold he developed and he feared the recurrence of pneumonia. He had the beginnings of a fever. His canvas suit and two shirts were getting filthy. He did not wash them or himself. There was no orderly to take care of him as there would have been if he had remained near headquarters. The lull in the military action was growing ominous in his mind, and there was no news to be reported.

By June 26, Remington's physical condition was worsening. To be sure of staying on top of his job, he was continuing to bunk in the open, beyond the soldiers' camps. His cold had become "awful." Food and tobacco were on short rations. The three-day supply issued to some on debarkation had been a small amount of crackers, pork, and coffee, lost by many of the soldiers and correspondents and long since consumed by the rest. Some men began smoking a mixture of dried horse manure, grass, roots, and tea. Heavy smokers could not sleep soundly because they were nervous. Since the day after landing, food had been available to correspondents only by invitation from officers' messes that could be joined by payment of a percentage of the cost. Remington was a fat man. He joined a mess and then ate more than his quota at a time when food was scarce, making him unpopular. In a wartime society of men living with shortages, plaudits went to the "rustlers," the men who could find or steal additional food for their messmates, and Remington was no rustler. He drank too much, too, and liquor was even scarcer than food. Many of the army officers were as dependent on alcohol as he was and they objected to his taking more than his share.

In another twenty-four hours, his physical condition and social relations had deteriorated noticeably. His confreres judged him to have "fallen upon evil days." They said that he had a "jovial way of going up and joining messes," after which he ate his messmates "out of house and home." He had a mammoth tin cup, "enamelled on the inside like a bathtub," that he held up on occasions where drink was limited, saying "Place a votre banquet, Messieurs. I too am about to die for the fatherland." Shortages were serious at the messes. Humor got Remington nowhere when he consumed more than his portion, and his presence was resented.

On June 28, Remington bought a horse from a sick colonel for $150. He said that getting the horse had "seemed great fortune, but it had its drawback. I was ostracized by my fellow-correspondents."

The problem was not the horse. Many of the correspondents had acquired mounts. The *Journal* and the *World* kept a stable for their writers. Davis had a horse, and so did Bonsal. Fox had access to a horse. Remington knew that he was unpopular and he ascribed the dislike to the easy reason. He also told his wife that "John Fox and I *bum* on Genl Chaffees mess—crackers coffee & bacon—by God I havent had enough to eat since I left Tampa—I am dirty—oh so dirty. But I am seeing all the actualities of campaigning." His friends among the correspondents were Fox and the novelist Frank Norris who had found Davis arrogant but Remington "approachable and glad to chat about art and horses." His real problem was neither the horse nor food and drink. He simply did not fit in, a man whose physical condition demanded that some one take care of him, in a milieu where no one gave a damn.

June 28 was also the day that the rains came. Davis wrote home that "it rains at three o'clock for an hour and it is three inches high. Then we all go out naked and dig trenches to get it out of the way. It is very rough living. I have a cot raised off the ground in the Colonel's [Roosevelt's] tent and am very well off." He was wanted where he was, he was catered to, and he had a bed under the head man's shelter, much as Remington had when he camped with Miles.

Remington was determined to stay "up front." He had no tent to keep out the rain. At night, he said, Fox and he "repaired to our neck of the woods, and stood gazing at our mushy beds. It was good, soft, soggy mud, and on it or rather in it, we laid one poncho, and over that we spread the other." He told his wife that Fox and he "sleep in the same blanket." Remington's cold worsened. He was sick, dirty, grumpy, hungry, sober, and tobacco starved. The war that was to have been the greatest thing men do was not going his way.

On June 29, Shafter's consolidation of troops and supplies was concluded for the advance on Santiago. The plan of attack was no secret. Davis wrote his family on the twenty-ninth that "we expect to move up on Santiago the day after tomorrow, and it's about time, for the trail will not be passable much longer." One of the few Americans in Cuba who did not know what was going on was Frederic Remington. Fox had left their soggy camp to find a more sheltered niche with Roosevelt, and Remington was alone and isolated. He could see that the supply lines were becoming hard pressed. The only road from Las Guasimas to Santiago was one lane wide in some places and the hollows were a slough of mud. He thought that "the mules would go to pieces under the strain." The advance had to be right then or not until after the rainy season and every one was impatient, knowing that the roads would just get worse with every day of torrential rain.

The next day, Wheeler reported sick. He was temporarily replaced by General Sumner. Wood was breveted general to lead the cavalry brigade, replacing Sumner, and Roosevelt was breveted colonel to head the Rough Riders. Roosevelt claimed that at this time he was acting as host for most of the primary correspondents. He did house and feed Davis, Whitney, and Fox, but there was no relationship with Remington who was incorrigibly disapproving of Roosevelt as a warrior. He saw Roosevelt as anteing his life as the stake for fame. War was supposed to be a team effort, a business, not individual aggrandizement.

The divisions received their marching orders the afternoon of June 30. Shafter had established his headquarters two miles above Las Guasimas. Four miles west of Shafter, one mile beyond San Juan Hill, was Santiago, the American goal. Three miles north of Shafter was fortified El Caney threatening the American flank. In between San Juan Hill, El Caney, and Shafter was the jungle. Davis saw the terrain as a pitchfork with Shafter the handle, El Caney and San Juan Hill as tines of equal length.

Lawton's orders were to neutralize El Caney while the rest of Shafter's command was held in reserve awaiting a quick Lawton victory. Lawton's infantry division started marching right away. He bivouacked on the road and opened the offensive early on the morning of July 1 by having Captain Capron train his obsolete artillery on the fortifications.

Remington had awakened at 3:30 "in the pale light" before dawn, knowing only that "it was rumored that the forward movement would come." He mounted his horse and trailed a staff officer to find out what was going on. Riding behind the officer, he joined a gathering of staff and correspondents on El Poso Hill, the high point between Shafter and San Juan Hill. Soon Grimes' battery drove up El Poso Hill on the double. "It was a picture worthy of the brush of a great artist," recorded photographer Burr McIntosh. "It will undoubtedly be justly represented some day, as Frederic Remington stood on the brow of the hill upon its arrival."

At 8 A.M., Captain Grimes fired the first shot from El Poso to soften the defense of San Juan Hill and black smoke obscured the emplacement, making a distinctive target for the Spaniards. The first return shots landed right on top of the hill, killing several Rough Riders massed nearby and scattering the staff and the correspondents. Remington said he was "dividing a small hollow with a distinguished colonel." Grimes' battery picked itself up and drove down the hill.

At 9 A.M., Shafter ordered Wheeler's cavalry division under the command of General Sumner into the jungle below San Juan Hill.

Kent's First Division of infantry followed. Above the cavalry was an observation balloon the soldiers towed with ropes. The observer in the gondola could not communicate effectively with the ground and the Spaniards fired their cannons and rifles at the balloon, inflicting serious damage on the troops beneath. Most of the casualties the division suffered were during this first hour while they waited on the trail in the valley, under the balloon.

Remington had come to see the battle, not to hear the experts talk on El Poso. Descending from the hill, he rode slowly in the awful heat, up the jungle trail toward Santiago, winding his way through the troops, saying "Gangway, please." He wanted to experience the roar of a battle but around him he heard only the sound of rifle bullets, a clipping noise "you can make if you strike quickly with a small walking-stick at a very few green leaves." Out in front was "what sounded like a Fourth of July morning." He tied his horse with others near the field hospital. "A man came, stooping over, with his arms drawn up, and hands flapping downward at the wrists. That is the way with all people when they are shot through the body. The bullets came like the rain. There was no place of safety. One beautiful boy was brought in by two tough, stringy, hairy old soldiers. The doctor laid his arms across his breast, and shaking his head, turned to a man who held a wounded foot up to him, dumbly imploring aid, as a dog might. It made my nerves jump, looking at that grewsome hospital."

He went down the creek and out into the scrub, hunting for the American battle line, but he could not find the front. The thought came to him, "What if I am hit out here in the bush while all alone? I shall never be found." After that he stuck to the road. When a bullet sounded right next to his ear, he slid off his horse and crawled to cover, losing his sketchbook in the process.

At 2 P.M., Sumner's dismounted cavalry could no longer stand the casualties they were suffering in the valley. No further communication had come from Shafter who was bedridden with fever. The soldiers in front could not retreat because the only trail behind was jammed. All the men could do was to advance, up San Juan heights and into the fire from the Spanish blockhouses. Remington's view of the action was from a thousand yards in the rear. He had a glimpse of San Juan Hill from behind a low bank under a big tree while the bullets were whistling about. The next time he looked, he "could distinguish our blue soldiers on the hill-top and the Mauser bullets rained no more." General Hawkins and the regulars in their blue woollen shirts had advanced to the top of San Juan Hill while Roosevelt and the Rough Riders had charged up Kettle Hill on the right side of the heights.

After the soldiers on San Juan Hill raised the American flag, Remington followed on up. Frank Norris arrived later and "Remington with his shirt tail out came running to warn him of the danger of enemy fire; they met the situation by taking liberal draughts from a bottle of whiskey Remington carried as his most valued equipment."

At 4 P.M., El Caney finally fell. Lawton's division started for San Juan Hill three hours later, to support Sumner's cavalry that was without water or food in the midst of a Spanish counterattack. One count had 1,475 men killed or wounded, one man of every six. The walking wounded reached the hospital on their own. Some of the seriously wounded were loaded into wagons and were thrown like logs when the wagons bounced in the ruts. At the field hospital they were placed on the ground to wait. After dark, the surgeons continued to operate through the night by the light of candles held by orderlies.

The correspondents including Davis ate dinner as a group but Remington was by himself again. "I found I was too weak to walk far," he said. "I had been ill during the whole campaign, and had latterly had fever, which, taken together with the heat, sleeping in the mud, marching, and insufficient food, had done for me." He was approaching the end of what he could take. "The sight of that road as I wound my way down it was something I cannot describe. The rear of a battle. All the broken spirits, bloody bodies, hopeless, helpless suffering which drags its weary length to the rear, as so much more appalling than anything else in the world. Men half naked, men sitting down on the road-side utterly spent, men hopping on one foot with a rifle for a crutch, men out of their minds from sunstroke, men dead, and men dying."

The Cuban campaign did not turn out to be what he had anticipated, and the course of events had made him into less than the hero he had hoped to be. He had started out enamored of the *Chronicles* of Froissart, the knights and their castles "bright with banners, the gleam of armour, and the liveries of the men at arms." He had expected to see mounted cavalry in tactical forays against the Spanish infantry, much as Carter Johnson had led the line of white horses in "The Attack on the Camp" in Montana. What he found in Cuba was a modern war against an adversary who was seldom seen, with no finesse involved at all in a conflict where men on foot accepted the ultimate brutalization to mount a primitive charge up a fortified hill. In Johnson's Tenth Cavalry that Remington had loved, half of the officers were casualties at Kettle Hill and so were a fifth of the enlisted men.

About 10 P.M. July 1, Remington "got some food and lay down." He found his nerves very unsettled. "During the day," he recalled, "I

had discovered no particular nervousness in myself, quite contrary to my expectations, since I am a nervous man, but there in the comparative quiet of the woods the reaction came. I could not get the white bodies which lay in the moonlight, with the dark spots on them, out of my mind. Most of the dead on modern battlefields are half naked, because of the 'first aid bandage.' They take their shirts off, or their pantaloons, put on the dressing, and die that way." It was nearly three before he went to sleep.

The other correspondents had been in the midst of the battle, or said they had, and they later wrote about the glories of the front line, stringing together the incidents of bravery that their readers expected. Davis was an authentic hero, like Roosevelt, the man that Remington's father the Colonel would have been, fearless under fire and a leader sacrificing his troops. Remington became the chronicler of the battle's rear, with his illustrations and his text devoted to the wounded rather than to paragons, reproducing the muck and not the glory. He was no longer identifying himself with the few who were the heroes but rather with the many who saw the realities of contemporary war as a glimpse of hell.

When Remington awakened July 2 in the rear of headquarters, he was much weaker. He started back to San Juan Hill on foot but reached only El Poso. An onset of fever made him lie down under the creek bank. The heat was intense and he got up just to drink the dirty water. Sick and dispirited, he started to make his way back to headquarters, his haversack "light as a feather and floating out behind him and his canteen as dry as a bone," when he was encouraged to see Bonsal resting before a "squaw" fire in front of a well-stocked camp. He did not realize in his debilitated state that Bonsal, comfortable in a hammock and waited on by the Cuban Pepito, still smarted about the mosquito netting and the canned salmon lunch he had missed nine days earlier. When Remington came toward him, Bonsal sprang from his hammock and shouted, "Stop, old man. You are within ten feet of the dead-line. Pepito will shoot!"

After Bonsal issued an invitation into the camp, Remington came forward in his old free and easy way. According to Bonsal, his voice was still strong but with distinct traces of hunger and hollowness. Out of malice, Bonsal made Remington "recite his sad tale, while he wipes the great beads of perspiration from his face with a towel—the same old towel he started out with from the ship." When Bonsal finally turned Remington away, he said that he watched Remington "as he staggered up the hill, toward a place where there was neither shade nor water, and where the dead mules were lying around in unwelcome numbers."

Remington walked slowly back to his camp, and lay there until nightfall, making up his mind and unmaking it as to his physical condition and his future action, until he concluded that he had "finished." He got a lift back to Siboney with some friends from Arizona who were running the pack train and he secured passage to New York on the old *Olivette* that was functioning as a hospital ship. His fever was not typhoid or yellow jack, but he was through with war.

He missed little in Cuba. It was as if he were prescient. San Juan Hill was the final battle. Everything after was anticlimax.

Like the other correspondents, Bonsal wrote a book about the war, but unlike the others, he castigated Remington so thoroughly that his publishers made Remington into "Mr. Smith" to avoid libel. Remington asked Bonsal's friend Davis what should be done about the book and Davis replied that it was "rot he aimed at you. You certainly were a bit selfish down in Cuba and looked after number one but then we all did that. Writing as he did was the act of a spiteful petty spirit. So, do nothing about it." Secretly, though, Davis agreed with Bonsal's conclusion that through sweat, Remington had "left upon Cuban soil as much of his flesh and blood as many a man who had lost a leg. For a pony-war in a temperate zone, for a campaign through a wine country dotted with hotels, he was the best equipped war artist of them all," but in Cuba the only wonder was that he carried himself as far as he did.

25.

Not Happy in Your Heart

Remington was back in Endion by July 10, 1898. He was immediately a superstar again, with a wife and servants to take care of him. The fever that had toppled him was gone, and so were his physical fatigue and the heavy cold. The only sign of Santiago that remained was his emotional upset, the depressed spirits that hung on from the last five debilitating days in Cuba. As Howard Pyle said, there was "an under current of something else than jocularity" in Remington "that caused me a feeling of real discomfort—a feeling that somehow you were not happy in your heart."

The Santiago campaign was supposed to have been Remington's war. In its aftermath, he was trying to figure out what had happened to him in Cuba and how he had come to lose his aspirations both as a warrior and as an admirer of war. Some things were clear. He was no Roosevelt, no civilian soldier, no "captain of infantry" in the role he had earlier conjured up for himself. He could never lead men to the front of a battle and gamble with his own life and theirs. He was not even a correspondent in the mold of Davis or the others on the list of the courageous in Cuba that Davis published in 1899. Remington was

not the writer who planted the American flag on the enemy block-house at Daiquirí or led the charge at Las Guasimas or stood on the lip of the trench at San Juan Hill to thumb his nose at enemy bullets. Instead of displaying such nonchalance in the face of danger, he was the one who had dropped down into the hollow when snipers shot.

As he came to rationalize his role, his daydreams of himself as Clarke or his father were all over. He saw them now as foolhardy, poor risks for themselves or their followers but good copy for a writer. As he said, his art required him "to go where the human beings are." He was the hero as an ordinary man, a prudent man, the one who never found the front line but who stuck to his job in the middle of the battlefield where most of "the human beings" were. To be a correspondent required him to relate the story, not fight the fight.

For the first few days that he was back, he was "growling over it all." He told Gus Thomas that from then on he intended "to paint fruits and flowers" so that if his publishers ordered him into a future battle to be waged in his new specialty, it would be among peaceable still-life objects. The older illustrator W. A. Rogers said that Remington returned from Cuba with a "hatred of wounds and suffering" that had replaced his old "imaginary love" for war. His unrest was clear to his friends like Pyle, Thomas, and Rogers.

There were other manifestations, too, of his compensations for the loss of the heroic dream. Within six months, he reached his ultimate obesity, 295 pounds. Although he declared that he had not "had a drink of any thing stronger than claret or beer," he was drinking heavily. Hamlin Garland said that Remington was again "a little confused by drink" at The Players, cantankerous, truculent, and hesitant. Another indication was that he was soon back to his old working schedule but turning out more work than he had before the war. He was illustrating, painting, writing fiction, and sculpting, all at once, in a rush. And finally, when he did arrive at a form of self-understanding, when he had rationalized a new role for himself, he cut off sharply his portrayals of the Cuban campaign, refusing to do pictures or books about the war he had seen. He did not have to prove anything more.

By the end of July, Remington had come to grips with himself. Both Roosevelt and Miles were in immediate need of his help in their separate conflicts with Secretary Alger. Roosevelt called first, to gain public support for the demand on Alger that the depleted Rough Riders be sent home. The hostilities in Cuba were over and the bloom was off the war for Roosevelt. Although it was the Rough Riders who had in effect "ostracized" Remington in Cuba, Remington leaped to Roosevelt's side in two articles in *Harper's Weekly* in August and the

Rough Riders were returned home in September. Also, Miles and Alger were trading charges about culpability for the poor preparation for the invasion. Remington came down hard for Miles in October, but not successfully. Miles' tide was ebbing.

Even before then, *Harper's Monthly* had been pressing Remington to record his personal views of the Santiago campaign. With Bonsal out of the picture, Remington had to write the article and illustrate it hurriedly. In spite of his other artistic obligations, the task was completed by the end of August, producing an Impressionist's recital of the modest protagonist caught in the middle of a desperate struggle and telling about it conversationally. The tone was not accusatory of the generals who did not plan or the soldiers who did not fight but rather a dispassionate description of the kind of men he now understood, the men who did their prudent best, waiting out enemy salvoes behind a river bank and advancing by crawling on their knees. Although Remington had willingly responded to Roosevelt's plea for help after the war, in his own story about the war there was a noticeable omission of any mention of Roosevelt in the text and there was no illustration of Roosevelt.

The article was "With the Fifth Corps" published in November. It was a catharsis for Remington, an end to the unrest he had brought back from Cuba. Despite its unheroic approach, the article was even accepted by the "old boys" because Remington was one of them. He was acclaimed for his "naked candor." It was recommended that "every prospective journalist read the account if he wants to know the reverse side of the picture [of war] which allures so many men." Even the editor of *Century* where he was at odds said about the *Harper's* article that "here you are making the best pictures of the Santiago Campaign, and on top of that outdoing everybody with a description of the scenes and the emotions."

When the Harpers received the article, they knew it to be superlative and they asked him to create a book of drawings of the war. He refused. He had lost his sketchbook, he said. While there were hundreds of photographs of what he had seen, he would not use them because he no longer wanted to recapture the memory of the war in Cuba.

When another periodical made an unauthorized copy of one of his Cuban drawings for *Harper's*, Remington declared that he could prove the forgery because the copier had adopted a factual error caused by the absence of the sketchbook. Then Remington recanted, saying that "in thinking over that infringement of my drawing I should not like to testify on the stand to the fact that the 'blockhouse' which I drew 'was not right.' The fact that *I faked* the block-house—

having lost my sketch book & having no photograph—might give the public the idea that such a thing is habitual with me—sabe?" As an illustrator he had to be absolutely accurate, or at least not get caught. On the other hand, he was perfectly willing to draw illustrations from photographs of the war in the Philippines where he had not been.

The ones who could have disclosed the fakery of the blockhouse honored him instead, accepting him as an artist if not as a soldier. When the Rough Riders were shipped back to the United States, they were billeted at isolated Camp Wikoff in Montauk, Long Island, because the public feared the spread of malarial fever. The Rough Riders were mustered out of the service at Wikoff on September 15, in a dramatic ceremony that was reported around the world. The enlisted men had taken up a collection for a present for Colonel Roosevelt, and Trooper McGinty from Oklahoma asked, "Have you seen the iron horse they're going to give the colonel? He ain't no bigger than a prairie dog, but he's all there, saddle, cinch, and all, and the man is riding him all right, with a rope bridle and one stirrup."

Trooper Murphy made the presentation, carrying the object in a folded horse blanket. The blanket was plucked away, and the gift was "The Bronco Buster." The published photographs showed Roosevelt with the "Buster" on a table at his side.

For Remington, the Rough Riders' choice of his statuette as their symbol was vindication. His emotions moved him to incoherence when he wrote Roosevelt,

What can give the blood a stronger action than when the whole tribe says "Ha"?
you know—you have felt it.—
And what is next—is the sensation, when the tribe says "Aye"—I have felt this.—
The greatest compliment I ever had or ever can have was when the Rough Riders put their brand on my bronze
After this everything will be mere fuss.

Roosevelt, who never did buy Remington's art, responded that "I have long looked hungrily at that bronze, but to have it come to me in this precise way seemed almost too good. There could have been no more appropriate gift from such a regiment."

Remington was more comfortable with his acceptance by the Rough Riders than he was with membership in the newly formed National Institute of Arts and Letters that named him one of the hundred most prominent Americans in literature and the arts. He professed to find that honor meaningless, telling fellow member Owen Wister that "I never go to their chin-chins because I should either have a fit or go to sleep. Who cares how a lot of old fellows moan." The "old fellows"

represented academia in art, the group that Remington catered to on occasion without ever satisfying them.

Soon after his return from Cuba he began to sculpt again and completed "The Wicked Pony," which had been on his modeling stand for two years. Copyrighted December 3, the statuette sold for $250 at Tiffany's, the same price as the "Buster," but this pony was triumphantly lashing out at a thrown cowboy, not being broken. An admirer observed that the horse was fighting not for its freedom but to kill and he asked how the rider could possibly have escaped. "He didn't," Remington replied. "He was killed—I was there and saw it!" Perhaps because the pony won and not the rider, only ten castings were sold.

While Remington was completing "The Wicked Pony," he was also modeling his fourth sculpture, "The Triumph," which was originally called "The Scalp." The figure was "an Indian reining in his horse and rising in his seat as he holds aloft a scalp." Copyrighted one week after "The Wicked Pony," this was Remington's attempt to transform his original storytelling realism into a smooth-surfaced symbolism to mollify the "old fellows." The critics accepted this "more agreeable and technically superior" bronze and the public bought thirty castings, but the professional sculptors still debunked his achievement, saying that "the articulations are flat and nerveless. The fetlocks and pasterns do not suggest tension." They pointed out that they had studied with the French "animaliers," performing vivisection on horse carcasses, while Remington's knowledge had been acquired the easy way, by observation. The truth was that there was no basis on which Remington would be accepted by the academics as a sculptor.

In addition to reporting on the war and illustrating and sculpting, Remington was selling a run of short fiction to *Harper's Monthly*. Despite the slim pay, the stories were his finger exercises toward becoming a novelist. The motif was mortality, the old man in front of the fire, musing about long-gone Indians and soldiers who had been the victims of encroaching civilization. Remington wrote about "the calm white forest [that] is almost deadening in its beauty. The winter forest means death" and "the dry leaves [that] had lasted longer" than the lives of an Indian hunter's wife and child.

A second anthology of Remington's short pieces for *Harper's* had been published in 1898 as *Crooked Trails*, a modest example of the past brought forward into one volume. In December the House of Harper put together *Sundown Leflare*, another anthology, this time a collection of short fiction in dialect that Remington considered to be an advance in his writing skills. He thought of the half-breed Sundown as "one of us," but the book did not sell in the shops. Like any

author, he blamed the failure on the marketing and told J. Henry Harper that "I may overestimate my own book etc. though I should like to understand why my book is not available for the popular exposure in order that I may not in the future try to do something in a line which does not seem successful." Like any publisher, Harper did not respond and *Sundown* was quickly out of print.

Remington's friends in New Rochelle were the same ones he had been close to before the war. He entertained in the evening in his studio, burning great logs in the fireplace. The Summerhayes were frequent guests: "Frederic and Jack stretched in their big leather chairs puffing away at their pipes, Eva with her needlework, and myself [Martha Summerhayes] a rapt listener. Frederic liked to solve all questions for himself and did not accept readily other men's theories. He thought much on religious subjects and the future life, and liked to compare the Christian religion with the religions of Eastern countries."

Cousin Ella Remington was another guest. She said that Remington's invitation to her was "come up if you are down," meaning that if she went down from Canton to New York City she should come up to New Rochelle to see him. She was a guest at the dinner party the Remingtons gave on New Year's Eve in 1898, along with Edward Simmons the muralist, Kemble, Thomas, and their wives. Kemble drew a cartoon of each guest as a place card for the dinner. At midnight, they went down the five steps into the studio, put on Indian robes furnished by Mrs. Remington, sat on the floor in front of the fire, and had what cousin Ella called "a luncheon" using wooden spoons to eat out of wooden bowls decorated by the Remingtons. The guests drummed in the New Year with Indian instruments.

Remington kept in touch with other friends in Canton, too. In the spring of 1899, he told his uncle Rob Sackrider that "I want you & Em to go up to Cranberry with us. —get ready—We used to have fun at Cranberry—I guess we aint to old now. We want to board with you for a month—will you take us. Eva is not very well and needs a change—grey—almost white—very skinny careworn—but not yet in need of a maid—though I have to hook up her dresses and am in favor of the maid." He added that "I am getting old and Frenchy and am going to send my own Claret up—for dinner." At the bottom of the letter was "this is the way we look," with the obese artist posing at attention in a single-breasted suit and a boater. To his left was a pitiable Eva with palms together, her puffed-sleeve dress and spiked hat separated by a lined and despairing face. Her recurrent ovaritis made her ill frequently.

Unknown to Remington, the House of Harper was in financial

difficulty and so was both reducing its payment levels to established artists like him and exploring cheaper illustrators like Fernand Lungren, who drew a more decorative West, and Max Klepper, who pictured more stylish horses. Also, Harper's *Pictorial History of the War with Spain* reproduced the most popular Remington illustrations including "Captain Grimes's Battery Going Up El Poso Hill," but the advertisements for the book listed Remington seventeenth among the artists whose work was included instead of giving him the top billing he deserved. In addition, *Harper's Weekly* planned a long series of illustrated articles for 1899 on "The Reconstruction of Cuba," with no role for the Cuban expert, Remington. After fifteen years, Remington was about to be dropped.

To fill the *Harper's* gap, Remington found *Collier's Weekly*, an expanding *Harper's* competitor that promptly commissioned him to be its special correspondent for a series of illustrated articles on the United States Army in Cuba. *Collier's* even placed a large advertisement in the April 8 issue of *Harper's Weekly* itself, to announce Remington's change in publishers.

The Cuban series provided Remington's fourth view of Havana. This time, he lived at the American Club and sat with the Governor General eating rare roast beef. Occupying Cuba was a heady sensation for American imperialists, but Remington knew that control over Cuba would be for a limited duration. The "conqueror" Gomez "wants us to 'get out,' 'all the same' as [he did] the Spaniards," he said, "and I cannot see how we can help doing it." As Remington wrote, he "was no longer a Cuban sympathizer—that was clear."

As another bit of the residue of the Santiago campaign, Roosevelt asked Remington to accept a commission from *Scribner's* to do the "Charge of the Rough Riders at San Juan Hill," as an exception to Remington's unwillingness to depict the Cuban war. The painting was in color, to illustrate Roosevelt's article on "The Cavalry at Santiago," published in April 1899. It showed an unidentifiable officer on horseback leading a thin line of troops, under severe enemy pressure, at the base of a slight elevation. Roosevelt called it a "good picture" even though "the individual faces" including his were not detailed, but he did not acknowledge that the painting helped him to become the Governor of New York State. He did not mention, either, the continuing controversy that was initiated by his political enemies. There were witnesses to swear that Roosevelt had been on foot during the charge, not mounted, and that the Rough Riders had charged Kettle Hill on San Juan heights, not San Juan Hill itself. Remington who had missed seeing the actual charge was caught in the middle. He was still defending his subject matter against the New York *Sun* a decade later, and

when he ultimately listed the 162 paintings in color that he considered to be worth calling fine art, he did not include the "Charge of the Rough Riders at San Juan Hill."

A second painting done in color was the classic "Missing," the old soldier being marched among mounted Indian captors, that Remington exhibited at the National Academy after an absence of four years. "Missing" attracted no attention from the critics or from the Academicians who would not accept one offering as retribution for years of what they saw as misbehavior. Remington had not intended "Missing" as an apology to the Academy and never exhibited there again.

Although both the "Charge of the Rough Riders" and "Missing" were painted in color, when they were reproduced as prints by Robert Howard Russell it was in black and white as platinum prints, an indication that the publisher considered Remington's color sense to be deficient. Other illustrators were aware of the same deficiency in themselves. Ernest Blumenschein went to the Academie Julien in Paris to lick the color problem. "The dreadful thing about it," Blumenschein complained, "is that I have been working in black and white so long I can't paint in color. I can't see color, and everything I start to paint gets dirtier and blacker until I am hellbent for a black and white painting."

That was exactly what Remington faced, except that as usual he was attempting the conversion to color on his own. The key came from seeing the work of another painter, just as he had broken through in sculpture by watching Ruckstuhl model when words had not helped him. An exhibition of California nocturnes by Charles Rollo Peters led Remington to try mastering "the nuances of the moon's witchery in all her moods," and that was the start of his emphasis on night scenes.

While he was in Montana and Wyoming in July and August 1899, he sketched the nights in oils with more optimism. He visited Buffalo Bill again and made a drawing of himself dancing with Cody's wife Irma "at the Cody Ball Aug. 14 '99." The sketch was titled "The Big Things," intended to reflect large spiritual and not physical values.

From Endion in September he wrote to Wister that he had been "trying to paint at the impossible—had a good time—as Miss Columbia said to Uncle Sam 'That was my war'—that old cleaning up of the West—that is the war I am going to put the rest of my time at."

26.

Bits That Had Never Met

By 1900, the United States had arrived on the world scene as a major power and the American people were looking ahead with great confidence in the benefits that expansion would bring to their lives. Remington shared the feeling of well-being, for the nation and for himself. He told Ralph that he "didn't get over Santiago for a year," but he was so far recovered by 1900 that he could afford a momentary relapse. He wrote to Ralph who was reporting the Boer War that "I often wish I was down there." However, when Ralph replied in a parody of Remington's old militant braggadocio that the war in South Africa was "delicious," he fooled Remington into a serious antiwar response.

Remington's life was again on an even tenor. Ralph envied him, saying "God bless you, how damned lucky you are, forever doing your best and having nothing happen except riches." As Ralph observed, "riches" had really come to Remington. At a time when five hundred dollars paid for an average family's yearly expenses, Remington had earned about six thousand dollars just for his drawings and writings on the Spanish-American War. He was beginning to accumulate capital,

in savings and in investments recommended by his neighbors who were brokers and bankers.

No other artist in the country had the equivalent name recognition. When he wrote a congratulatory note to Senator Albert Beveridge, the Republican intellectual and keynoter, his was just one of five thousand letters and hundreds of telegrams supporting the Senator's characterization of "the American people as His chosen Nation" for "the divine mission of America." Remington received a lengthy response because the Senator had "long been a keen admirer" of the artist's work.

Three reports in different newspapers demonstrated how widely Remington's name was known. Hearst's *Journal* spoofed him in a long article with a three-column cartoon on "The Be-Ludless Tr-Ragedy of F. Remington's Bur-Rglar." Gus Thomas' caretaker had phoned Remington at midnight because the burglar alarm sounded. Remington responded, carrying his rifle, after telephoning a request for police assistance that also brought out the City Councilmen and the Sewer Commissioner. There was no burglar. The Thomas alarm had rung because of an electric short. Remington went home and that was the end of the episode. The *Journal* wrote the story as an elaborate theatrical burlesque, however, concluding with the line that "Frederick Remington takes three calls. Curtain." The facetious comment was that "this piece was first performed with great success at New Rochelle. Mr. Remington made such a hit as the hero that offers of engagements have been made to him by the managers of dramatic companies playing weekly repertoire stands at 10, 20 and 30 cents admission, with a silver water pitcher to the lucky holder of the right seat coupon on Saturday night." Satire or not, the nonevent was made into a feature because Remington was a celebrity.

Even the staid New York *Times* did its part. The heading of its article was, "Glad to Meet Remington." A fat, red-faced man from Chicago who was visiting New York City was reported as having said, "I don't know a citizen of your town that I would rather meet than Remington." When he was introduced, he remarked that "Remington is a household word with us. It is a fact, and when I tell my wife that I have met Frederic Remington, she will want to know all about you. She was my stenographer before we were married and she used only your typewriter. I wouldn't have any other machine." As Remington abruptly walked away, the Chicago man declared, "Artist, did you say? Now isn't that enough to freeze your feet?" The mistake was an old one for Remington, but the *Times* took for granted that its readers would identify the artist by name and know the difference be-

tween him and the scions of the distant typewriter and rifle branches of the family.

The Chicago *Times* printed a publicity release about Gus Thomas' play *Arizona*. The play was in rehearsal at the Herald Square theater in New York. "Gus," Remington whispered, "tell that big fellow to undo that bandana and put it on right." Remington explained that "a 'puncher' down in the Southwestern alkali country always folds his neckerchief crosswise and knots the ends loosely at the back of his neck, so the loose 'flap' falls down over his chest in front." Correcting the placement of the bandana made for an eight-paragraph article that depended for its credibility on the awareness of Remington as a Western authority. Neither Thomas nor Remington, however, had noticed that the cowboy actor was wearing a clean white shirt.

These articles were uniform in assuming Remington's status as a celebrity but they were snide. One recognition that was pleasing to him in all of its aspects was the receipt of an honorary degree from Yale at the 1900 Commencement as the "most distinguished pupil" of the Art School. The degree was worded as if he had graduated. The grateful Remington responded with the gift of a painting and a bronze that became the foundation of the Remington collection at Yale.

Despite his reputation, however, *Collier's Weekly* was not giving him regular assignments. *Harper's Monthly* had just about severed its once close relationship with him, although his friend the humorist John Kendrick Bangs as the new editor of *Harper's Weekly* was able to commission a few things. One was to redraw a Boer War sketch by Julian Ralph's son Lester, "A Close Call for Rimington's Scouts," that is always given on lists of Remington illustrations as "Remington's Scouts." Bangs said that he appreciated Remington as a man because the artist had been human enough to enjoy selling a joke to *Harper's Monthly*'s humor column for two dollars, and to follow it with "a humorous drawing, just to make the roster complete." Remington framed the two-dollar check.

He was still surprisingly bitter about having been dropped by *Harper's Monthly*. Wister complained that the *Monthly* had no assignments for him either, and Remington replied, "As to Harpers—they are hard up and employ cheap men. Also Harpers wants new men. New and cheap lets you out along with all the other old men. They dropped me out of the window but I find a way to get printed.—"

Remington did not understand that Wister and he had been released as a matter of economics necessary for the publisher's survival. The Harpers had been operating on borrowed funds. When they could not

meet their obligations, they were foreclosed by the banker J. P. Morgan. The individual Harpers were forced out of management and Colonel George M. Harvey was placed in control. Harvey took over the Harper offices, hung Morgan's picture on his wall, and established a new Harper policy of featuring Mark Twain and Howard Pyle. The rest of the cast was the "cheap men." The choice of Pyle was defensible to anyone but Remington because Pyle handled a variety of artistic subjects and his work conformed to the art nouveau vogue that was coming in.

When Ralph wrote that "the next organized rifle practice will be in China," however, Remington inexplicably wrote to Colonel Harvey at *Harper's* as frankly as he would have to J. Henry Harper, saying that "if this Chineese thing keeps up I should like to go out there in your interest." Colonel Harvey never answered him. Remington was too costly a correspondent for a "hard up" publisher.

Remington eked out a few illustrative assignments from *Outing* and from *Collier's*. He went to Yellowstone Park in February 1900 and told Jack Summerhayes, "Say if you could get a few puffs of this cold air out here you would think you were full of champagne water. I feel like a d_____ kid— I thought I should never be young again— but here I am only 14 years old—my whiskers are falling out."

The work that produced the most income in 1900 was another anthology of his short pieces previously published in *Harper's* from May 1898 to April 1900. Remington had suggested the book to J. Henry Harper in September 1899, recommending that "it might be called 'Men with the Bark On'. What is your opinion?" This was while Harper was losing control over his company so three months passed before Remington was requested to provide more details: "In re— to the book 'Men with the Bark On'—I would add [together] all the stories I have done up to date. The stories have no connection and will be in harmony. I have no more stuff at present."

Harper asked where the title had come from, but Remington had forgotten. He said that he "got the idea that the title was 'The Men with the Bark' because it was so written in the proofs which you are sending me to look over. Do you want to send me a contract." The title was actually a phrase that Remington had used for years, if infrequently. His classic 1893 letter to Bigelow contained the phrase, "Tomorrow—to morrow I start for 'my people'— I go to the simple men —men with the bark on—the big mountains—the great deserts & the scrawney ponies." The meaning to Remington was expressed in the dedication for the book: "Men with the bark on die/like the wild animals, un—/naturally—unmourned and even/unthought of mostly." In

the trappers' lexicon, "bark" was hair, and men with bark on were the unscalped, the valiant ones.

Men with the Bark On sold for $1.25. Its message reflected the post-war Remington where "helplessness and tragedy replace glory and heroism," despite an overall breeziness of style. *Harper's* advertisements coupled the book with Wister's anthology *The Jimmyjohn Boss* but Wister's book was soon out of print while *Men with the Bark On* ran through two editions in two months. The comparative success helped Remington to feel that he had equaled Wister in narrative skill and had overtaken him in the use of grander themes. He believed that his stories were as active as his paintings, not namby pamby subjective images like Wister's.

In the summer, he undertook a step to put him far in advance of anything Wister had attempted. He wrote a novel, *The Way of an Indian,* announcing to the press that the book "will be the longest literary production he has brought forth, and will be of much greater length than his 'Sundown LeFlare' that at present is his longest story." He also did sixteen paintings as illustrations for the novel, selling the package to his friend R. H. Russell the publisher. Russell expected to use the novel as a serial in a magazine that W. R. Hearst was about to launch. Unfortunately for Remington's aspirations to become a novelist before Wister, however, Hearst and Russell could not work out their joint plans. *The Way of an Indian* with its large decorative canvases gathered dust in Hearst's warehouse while Russell made a connection for himself with *Collier's* rather than Hearst.

It was obvious to Remington that he fared better in sculpture and in easel paintings where the ultimate control was his, rather than waiting for assignments to illustrate or for publishers to print what he had written. Even in sculpture, though, there were unexpected problems that arose from unusual conditions. The Henry-Bonnard Company had had a disastrous fire the end of 1898, wiping out the sandcasting facilities and destroying the plaster originals. Remington did not decide on a replacement foundry until March 1900 when he picked Riccardo Bertelli and his Roman Bronze Company.

Bertelli was from Genoa in northern Italy. Medium complected, tall and hefty, he was intense with an air of "superiority over his fellows," calling himself a "cavalier," a minor noble. He had started the foundry on Forsythe Street in Manhattan's Lower East Side, using the lost-wax method of bronze casting that was new in New York, then had expanded to Green Street in Greenpoint, Brooklyn, across from a cigar factory. When he was short of operating capital, Bertelli borrowed from Uncle Ben's pawnshop and from a rich Mr. Peaver who "made

silk from mulberry leaves" in Paterson, New Jersey. The key people in the foundry were a small Jew named Huber who kept the books and two Italians, Contini who did the plaster casting and the foreman Eugene Gargani. Bertelli later married Ida Conquest who had been a famous leading lady for John Drew and Richard Mansfield.

Remington was intrigued with the lost-wax process because it let him participate in producing a finer bronze than sand casting did. In March, he was completing the model for "The Norther," described as a "cowboy on horseback in snow storm. Severe wind [the 'norther'] blowing from rear. Both man and horse almost frozen." In April he wrote Bertelli, "Can't you run out here some day soon and look over my model—I want to ask you how far I should carry it in plasticene." He was not yet familiar enough with the process to be sure of his role. Plans were to make only three bronze castings of "The Norther," and Remington was able to sell all three in his studio before the Continis picked up the Plasticene to do the plaster.

The difference between sand casting and lost wax was that the sand casting left off with the sculptor handing over the completely detailed plaster casting that would be cut up to form the final sand molds for each bronze. In lost wax, that same plaster casting was used to make hard negative molds to produce not the final bronze but the intermediate stage of thin wax castings to be joined together into a hollow wax replica of the Plasticene. Then came the part that Remington liked. When the three waxes for "The Norther" were completed, he went to the foundry to examine them. At that point, he could still make any change that pleased him, handling the wax as creatively in detailing as he had the Plasticene. The possibilities were great. He could add molten wax with a brush, remove wax with a scalpel, or vary the position of a foot or a tail.

Working with the wax was new to him. "Great fun, isn't it, eh?" he asked. "Just see what can be done with it—isn't it wonderful! You could work on this for days, changing and rechanging as you like— the only limit is your time and patience. Great fun, eh?" Every wax casting became an individual sculpture, and every lost-wax bronze was different to some degree from every other bronze.

When Remington was finished with each wax model, an artisan prepared it for bronze casting. The inside of the hollow wax model was filled with a plaster composition called the "investment," a mixture of fine dental plaster, silica, and asbestos, then gates and runners were attached to the outside, and around them was poured the same plaster composition. The entire mold was placed in an oven so that the wax could be "lost" by melting and running out before the molten bronze was poured in. After the bronze was cast in one piece and

cooled, there for Remington to see was "The Norther," wrapped in a forest of bronze gates and runners that had to be cut away before the patina and the appurtenances were added.

There was no public sale of "The Norther," there was no published price, and its completion was not announced in the press. Remington was impressed enough with Roman Bronze, however, to ask Bertelli to help him replace the models of earlier bronzes that had been lost in the Henry-Bonnard fire. With Bertelli it was easy. He had Italian sculptors clever enough to take the sand-cast examples and produce new models in Plasticene so that Remington needed only to make the corrections and add details. The one thing that worried Remington was that Roman Bronze made castings for other sculptors, too, and once his models were at Roman Bronze, Remington regularly cautioned Bertelli to keep the models out of sight and to allow no photograph.

The business relationship grew into an informal partnership between the affable perfectionist Remington and the intense businesslike Bertelli. On a day that was scheduled for retouching wax castings, Remington would arrive at Roman Bronze with a dozen eggs from Endion and a gallon of Green River whiskey. By the time he went home at five o'clock, the eggs remained with the foreman but the whiskey was gone. Remington had the artistic responsibility for the waxes and the finished bronzes, while Bertelli cast the bronzes and handled the commercial end. Tiffany's orders for the earlier bronzes were sent directly to Bertelli, not through Remington, and Bertelli fixed the inventory levels, maintained stock at his own expense, and participated in setting retail prices. Remington could request an increased inventory level for a statuette but he could not issue a command because he did not pay for the inventory.

While Remington had more control over his sculpture in the lost-wax process than he had in sand casting, the only artistic medium where he had absolute mastery of his own product was easel paintings. There, he was beginning to feel comfortable with nocturnal colors. He said to Summerhayes that he was "doing some good work," but he was still at odds with the Academy establishment. He would not exhibit at the Academy unless he was elected an Academician, and the Academicians personified by Chase would not consider him for membership unless he exhibited. When old Professor Weir at Yale had told him that he was going to be honored with a degree at the 1900 Commencement, Remington said to Ralph that he would rather have Yale with him like that than have Chase with him, but it was not really so.

The art establishment was able to operate the Academy like a private club that as a matter of taste frowned on genre pictures that told a story, particularly Western stories. Chase could never understand

why men like Roosevelt and Beveridge who were of national stature thought that Remington was the country's greatest artist, when Chase and his crowd believed that Remington was only a commercial artist who would never amount to anything as an easel painter. For his part, Remington was vocal about the personal and professional deficiencies of the Chase group who were to him only portraitists, imposing foreignisms on American art. He made a point of saying what he thought loud enough to get the word back to the establishment. There was no basis for compromise.

As there had been other Western illustrators available to *Harper's,* there were other Western painters who gained acceptance with the establishment. One, Charles Schreyvogel, was a poor man's Remington. The same age as Remington but of German descent born on New York's Lower East Side, Schreyvogel worked as a lithographic artist. Unsuccessful as a Western easel painter despite three years of art study in Germany and five months' sketching in Colorado and Arizona in 1893, he was generally short of money.

In 1899 Schreyvogel had worked for months on a 25-by-34-inch oil painting he called "My Bunkie," an incident of the Indian fighting army that he had never seen in action. The title was in imitation of Remington's sculpture "The Wounded Bunkie," and the composition was an adaptation of the bronze. The central horse was drawn with its legs in a position that Remington would have said he invented. The forelegs were rising from a tuck while the rear legs were extended, a Muybridge variation that Remington had developed thirteen years earlier. Intended similarities in title, subject, and gallop were not new to Remington. A leader had to expect out and out imitation, coming from artists in a subworld he did not even know. Many of the imitators did their Western research in the Astor library looking at reproductions of Remington paintings. He was the West for them. The copies were always lesser works than his and so were flattering, not a threat.

Schreyvogel's "My Bunkie" was originally sold as lithographic art for a mass-produced calendar, a low-paying job that Remington would not have undertaken. The lithographer rejected "My Bunkie" because it was the wrong shape. Schreyvogel had an arrangement with Lüchow's, a German restaurant in Manhattan, to let him hang pictures for sale on the walls. He said that "I wanted them to hang 'My Bunkie' as they had done with some of my other pictures. I was hard up." Lüchow's owners did not care for the picture, so they relegated it to a dark corner. "I was put out by that," Schreyvogel declared, and he took the picture down. Next, a Rochester, New York, collector promised to buy the picture in November. "November came,"

Schreyvogel recalled, "but he didn't," so he had the picture on his hands as one he could not get rid of and he entered it in the 1900 spring exhibition of the National Academy of Design, on the last hours of the last possible day, without completing the address card.

The Academy awards were announced, and "My Bunkie" won the Clarke prize as the "best American Figure Composition painted in the United States." None of the Academy officials knew who Schreyvogel was, they said. *Harper's Weekly* reported the awarding of the prize and added, "Exactly why, it is a little hard to conjecture." The New York *Herald*, however, deprecated Remington as merely an illustrator compared to Schreyvogel the trained painter. The *American Art Annual*, the yearbook of the Academy, listed Schreyvogel as a painter educated in Munich and featured a full-page reproduction of "My Bunkie." The *Annual* did not list Remington as a painter at all.

Remington considered the Schreyvogel award to have been a deliberate affront by Chase. To his eye, "My Bunkie" was false and fake, with "bits of arms, uniforms, and harness that had never met outside of a museum assembled in the picture." He turned away from the picture in disgust. Later, the official report of the Paris Exposition Universalle 1900 mentioned "picturesque scenes of the West, by painters of whom Mr. Remington may be taken as representative." That was pleasing, but Schreyvogel's painting won the Paris medal, too. By then, Remington had learned that Schreyvogel retained heavy German mannerisms, and Remington hated "Huns." "My Bunkie" and its creator were thorns in Remington's side and they continued to fester.

He made a joke out of the situation when he wrote to Ralph. "I am founding a school here and am afraid to leave for more than a week at a time," he said, "for fear some of my pupils will get my patients away from me." He did not mind, though, letting the "School of Remington" fend for itself during the summer. Taking summers off was part of his life-long pattern.

In the spring of 1900, Remington had heard that George B. Shepard of Middletown near Ogdensburg died. The estate attorney suggested that Remington consider the purchase of Ingleneuk island in Chippewa Bay for six thousand dollars on favorable terms. Ingleneuk was one of the Thousand Islands, not too far upstream from Ogdensburg in the St. Lawrence River. A summer retreat like that would offer two benefits—a private place for serious painting and writing and also the connection to his North Country roots that he had been looking for since 1890. The deal was closed and Eva Remington left New Rochelle May 25 with their architect to plan a boathouse.

By June 1, Remington had finished retouching the waxes Bertelli needed and he left then. The route to Ingleneuk started in the evening

with the New York Central train from the 42nd Street depot. The destination was Clayton, New York, past Ingleneuk but on the river. When Remington arrived at six o'clock the next morning, the train was met by the horse-drawn "bus" from the Hubbard House where Remington had a quick breakfast.

The "Island Belle," a small paddle wheel steamer that plied the river between Clayton and Ogdensburg, was to depart at 7 A.M. Remington boarded and the vessel was soon in midstream, threading its way between the forested islands dotted with the tents of campers. At Remington's destination, Cedar Island, the "Belle" steamed up to the little wharf and the lines were wrapped around the spiles while passengers got off and on. Cedar Island was the site of the general store that sold everything from pins to onions, "and all at a reasonable price." From there Remington hailed Ingleneuk, and he was picked up in a skiff.

Ingleneuk was not large but Remington said that the island was his "own country" and that he loved it with a "Boer like affection." He planned to "stay four months—away from publishers telephones—Trolleys—fuss that makes life down in the big clearing—which I hate, All." The residence was what Remington called "modest size," but there were eight bedrooms, a front parlor and a back parlor, a dining room, and a kitchen in a separate building to keep the heat and the odors of cooking out of the dining area. Eva Remington had the house painted "many colors" on the exterior, and each of the upstairs bedrooms was a different pastel tint of lavender, green, pink, and blue.

On three sides of the house was a veranda that the Remingtons called the piazza as they did in New Rochelle. In 1900 Remington worked on the veranda and he pitched a tent nearby when he wanted an especially quiet spot. Soon after he arrived, he painted a night scene of locals jack fishing for pickerel with a large torch and spears. That was the picture that hung in the dining room.

The new boathouse and dock held a naphtha launch that seldom worked, a couple of Rushton canoes, a pair of river skiffs, and a flat-bottomed punt named "B-Flat." Remington's daily recreation was swimming in the cold river. On nights when the moon was full, he would spend the evenings in a skiff, floating and sketching.

In mid-summer, the Remingtons invited Charles Shepard Chapman and a local girlfriend to visit for the weekend. Chapman was a Chase student who wanted to be an illustrator so the invitation was a kindness, to let the nephew of the former owner of the island see the great illustrator at work.

Chapman, who became a National Academician a quarter century later, watched Remington painting a *Collier's* picture in black and white oils. The scene was a bicyclist passing a stagecoach in the West,

with the horses rearing away from the unfamiliar vehicle. Chapman noticed that both pedals were down on the bicycle, instead of one up and one down, and after hesitating out of modesty finally told Remington about the error. Remington laughed and said, "Hell yes, but we can fix this in a hurry," and he scumbled some dust over that part of the picture to show Chapman how the nonchalant artist could obscure the pedals. By the time the painting appeared in *Collier's* as a double-page spread titled "The Right of the Road," however, Remington had repainted the pedals properly.

No one ever called him indifferent to the requirements of his art.

27.

Derby Hats and Blue Overhauls

In October 1900, Remington was thirty-nine. His work was relatively slack at the moment and he became restless. He had no sponsoring publisher then so he arranged for a different kind of Western trip to suit the different conditions. He got in touch with Major Shadrach K. Hooper, general passenger agent of the Denver & Rio Grande Rail Road Company, and asked for fare and accommodations gratis for a sketching trip through the Colorado mountains, where he had never been. He was enthusiastically accepted. Arrangements like that for professional artists were common. The Sante Fe railroad, which had the Grand Canyon as its primary tourist attraction, assembled a collection of more than 650 Southwestern paintings by acquisition from needy painters. None was by Remington, though.

On October 17 he mailed a postcard to his wife from The Auditorium hotel in Chicago where the management let him have a room for a bath even though the place was full. He had dinner with General James Wade who had been military governor of Cuba when Remington was there for *Collier's* after the war, a year and a half earlier.

In the morning he took the train for Denver. Reservations had been

made for him at Brown's Palace but he was at the hotel before his trunks got there. Instead of socializing, he indulged his hobby and bought a cliff dweller's fragile skull and a basket that he had packed and shipped home. Major Hooper had alerted the business community to Remington's arrival and the response was generous, so much so that Remington said he would "fear large head." Henry Wolcott of Colorado Mining gave a dinner for him that night at the Denver Club.

Remington was looking for customers for easel paintings. In an interview he gave to a feature reporter from the Denver *Republican,* he pretended to be an "arty" painter and a blithe spirit. He told the reporter that "Utes, Navajoes and Apaches are Indians with whom I am not at all familiar. I am going to study them," although he was quite knowledgeable about Apaches and Navajos. He grew progressively vaguer in the interview, adding "carelessly" that "I don't really know how long I'll be gone. You see, I'm nothing but an artist, and I guess I've got all the peculiarities usually attributed to an artist. I may be gone several weeks; maybe all winter, and then again, I may not be gone very long—but I guess that I'll be gone a good while. I have no plans for disposing of my work and I am, therefore, not hampered by orders." If Remington was implying that local orders would be welcome, he did not get any.

The next day his trunks arrived. He was given a luncheon at the Overland Park club and he jokingly told his wife that "these people have treated me better than they did Roosevelt." The Republican National Convention had renominated McKinley for President and had named Roosevelt for the Vice-Presidency. Roosevelt was stumping the country in a Rough Rider hat, evoking wild applause while McKinley remained at home. Denver had been a particularly rousing stop for Roosevelt. He was surrounded by mounted Rough Riders in full uniform and the whole city had been in an uproar that was very different from the polite acceptance of Remington.

For a few days Remington sketched at nearby ranches. Then on October 22, Hooper had Remington routed out of Denver on a fantastic three-hundred-mile journey on the Denver & Rio Grande west over the Rockies and south along the Uncompahgre Plateau on a spur to Ouray in the Uncompahgre Mountains in sight of a 14,286-foot peak with the same name. Remington had a long delay in switching trains at Grand Junction because there was a "freight train in the ditch somewhere in Colorado" so that he did not arrive at The Beaumont hotel in Ouray until late at night. He woke up refreshed in the "Switzerland of America" and wrote his wife that "we are very high here—took walk this morning and it made me puff. Met our Congressman—Underhill of New Rochelle—we had good chat."

Hooper had arranged for a wagon to pick Remington up at noon on the twenty-fourth for a four-day camping trip into magnificent terrain more suited to a landscape painter like Thomas Moran. It was snow country, too cold for painting outdoors even if Remington had been willing to do mountains. A day earlier than scheduled, the wagon took Remington nine miles east to connect with a different branch of the railroad. After another hundred miles south through the Rockies the train finally put him where he wanted to be, Ignacio and the Ute Reservation. He had told the Denver reporter that "I'm going among the Indians as one of them. Major Hooper has given me a cart load of letters to chiefs and prominent Indians. I shall go well prepared to get in with them."

At Ignacio, Remington followed his practices, not his words, by moving in with Ray Hall, the trader, and taking Hall's bed. He was a good customer for Hall, buying a hide dresser, lance, beaded belt, baby basket, and some cliff dweller pottery, and telling his wife that he "could get a great deal of money for my collection. I hope for some stories—I have only one so far but I have some good illustrations." He started the portrait of a Ute chief on the twenty-eighth and finished the following day when the sky was black with snow clouds. By November 4, he had ten color studies done on his usual F. W. Devoe sketching pads and "Academy" painting boards. Two of the studies were later enlarged into illustrations, "A Monte Game at the Southern Ute Agency" in Colorado for *Collier's* and "An Ore-Train Going into the Silver Mines, Colorado" that was the last Remington purchase by *Harper's Weekly*. Ideas for two or three stories had also been noted, although he considered the Utes "to far on the road to civilization to be distinctive." His joy was that he was "dead on to this color, and trip will pay on that account alone."

The next stop was Espanola, New Mexico, where he expected to spend a week sketching at Santa Clara pueblo en route to Santa Fe. He left Ignacio at noon on the fourth but could not find lodging in Espanola. He had to backtrack again "to get a nights sleep and at 6 00 o'c go back." He told his wife that she "came near having your second husband and the 10 000 [insurance]. On a mountain grade our passenger car became detached and Me and the brakeman stopped her. otherwise/Frederic the Past."

In Espanola, he "got ready to do a Puebla village. It was cold and cloudy and I did not like pueblas—blue gin[g]ham breeches did for me—I dont want to do pueblas—too tame." He got on the train for Santa Fe, registered at The Clair Hotel, and had his first bath in the ten days since Ouray. On the seventh, he talked to Territorial Gover-

nor Bradford Prince, a New York Republican who had known Remington's father. Remington told Prince about his misgivings, that he might "never come West again—It is all brick buildings—derby hats and blue overhauls—it spoils my early illusions—and they are *my* capital." He said about the Indians that "I am either going to do Pueblas or not and dont yet know. Think I wont. They dont appeal to me—too decorative—and too easily in reach of every tenderfoot."

He had had what he called a "hard trip—eating all hours—all foods —dirty and not much killing [success in finding extraordinary subjects]," so he took it easy while he listened to Prince's recommendation of an ancient pueblo called Taos that was remote and primitive. On election night, he sat up with Prince to get the telegraphed reports on McKinley and Roosevelt. The next morning, he got back on the Denver & Rio Grande to travel north to Tres Piedras, the closest station to the "red willow," the Taos pueblo. Remington hired a driver and his wagon and they trotted all day along the eight-thousand-foot-high mesa toward the Sangre de Cristo mountain range. They arrived in Taos in the evening to see the blue smoke of the same two villages, Indian and Mexican, that Coronado's foragers had found in 1540.

In the morning, he looked for the French-trained painters Prince had told him about, Bert Phillips and Ernest Blumenschein, who had discovered Taos after a wagon broke down in 1898. Blumenschein was away but Phillips told Remington about difficulties his isolation caused in finding markets for his work. Remington's opinion was that Phillips' paintings were like his pueblo subject matter, too placid. He told Phillips about his own method of imparting dash to a picture. He hummed fast music and then painted in strokes in time with the beat, so that the bravura of tum tiddy tum tum TUM accompanied the stroke stroke STROKE of the paint.

Phillips was younger than Remington but he had studied with Laurens and Constant at the Academie Julien in Paris and he would not vary his style. Remington was quoted as saying that "none of the Indian painters are doing better work" than Phillips, and it was reported that Remington "bought one of Mr. Phillips' Indian pictures for his private collection." Actually, Remington took a Phillips Indian painting on consignment to sell for him but after it hung in the New Rochelle studio for a month, he wrote that "I have heard no one say they wanted to buy—Later I may sell something for you and dont want any commission if I do." Remington returned the painting and in its place gave Phillips the name of his Chicago dealer. That did not

work out either. Phillips later found that he was being paid only a small fraction of the $250 price that the dealer was collecting.

Remington had originally intended to "go back to Denver and if have time go out on Plains to a ranch of a friend." The side trip to Taos, however, finished him off. He was back in New Rochelle by November 17. He had found the Southwest too civilized for his taste but he had managed to strike the right color notes in his painting studies and he had picked up a wealth of material he used in future illustrations and in writings. One negative note was that he wrote the 5,500-word article "Taos" as a tribute to the remote village that had become the site of an important school of American painting, and the article was not accepted for publication. Remington half-heartedly told Alden at *Harper's*, "Well—here is the article on 'Taos' which McClure didnt take. I hope you will once it over."

Instead, *Harper's Monthly* published "Natchez's Pass" in February 1901. In this piece left over from when Remington had been a *Harper's* favorite, he described an Apache Indian agent as "a well-looking man." Edward Simmons, the Impressionist painter who was a fellow member of the Gus Thomas circle, told him that "if with your mastery of clear cut 'American' language you ever say 'well-looking' again—I'll make you less 'good looking' with a club! How many wells in a river of pedantry?"

As an author, Remington felt that his strength was in the direct description of action. His weakness was Owen Wister's strength, mood and poetry, and he told Wister that "I may write a short character story much like Sun-Down Leflare. I dont intend to 'do the West' and I couldnt if I would. I am only a character man. What we do along such lines can have no comparison. I'm a snare-drum and you are an organ." Later on, he said without conviction that he was "never going to write any more—I have spread myself too thin—I am going to begin to do the armadillo act [of curling into a ball]—Kind of get [myself] together."

Part of his ambivalence toward Wister this time was that he needed Wister again. He was planning another picture book in a matter of months that called for poems to go along with the pictures. If poems had to be written, he could not do them. He was truly a snare drum to the complete instrument that Wister was, and he knew it.

In addition, he was now in a frenzy of illustrative work, handling commissions for ten magazines. For *Cosmopolitan*, he illustrated a story that had been written earlier by Bucky O'Neill, a Rough Rider who was killed in Cuba. Another article by the future president, Woodrow Wilson, was his last appearance in *Harper's Monthly*. A

third by Emerson Hough was in color for *Century* as part of a series on frontier transportation by water. One of Hough's references was to "the broad-horned flatboat," a remote enough craft so that Remington could indulge a favorite ploy, asking a famous man a technical question just to keep in touch. He wrote Roosevelt about the flatboat, and received both a useful answer from the popular Vice-President and the conclusion that "it is always a pleasure to hear from you. I only wish I could see more of you."

Remington was busy enough to turn down some offerings. Mrs. Stephen Crane asked him to complete a manuscript about Indians that her husband had left unfinished when he died. Remington refused, saying that "it is utterly impossible that I should undertake what you suggest—for the reason I could not imitate Crane's style and that I have a very pronounced one of my own." He made his usual considered and courteous response although he understood that Crane had married her before the war when she was the madam of a Jacksonville sporting house named the Hotel de Dream. Remington also refused commissions from Robert Howard Russell's *New Magazine*. Russell had paid him for *The Way of an Indian* the previous summer but the story was still unpublished and Remington could not get his subsidiary rights sold or get the original paintings back for resale.

In addition, he exercised the prerogative of an artist by destroying work completed for a client who had ordered Civil War illustrations and then complained about the accuracy of the drawings. "I have your very agreeable note looking for the war drawings," Remington replied, "but I am not going to send them. All the objections against my drawings were quite true no doubt, only I should have been furnished with the knowledge, photos etc. before and not after the work. It is quite my fault and so we will give it all up." In a rare moment like this, he could write a letter of complete urbanity when he was seething.

Most of Remington's illustrations at this time were going to *Collier's* where the policy was to produce a weekly national magazine, not a newspaper. It was the right direction. *Collier's* circulation jumped from 88,000 in January 1898 to 178,000 in January 1899 to 185,000 in January 1900 and 250,000 in January 1901.

Collier's art editor George Wharton Edwards praised Remington as the Harpers once had. Edwards handled his job with a sense of humor and an appreciation of talent. To encourage Remington, he sent frequent notes, sometimes in rhyme. On one occasion, he recounted for Remington the "things in thy possessing [that] are better than a bishop's blessing" and concluded,

> He that hath these may pass his life,
> Drink with the Doctor, and bless his wife;
> On Sunday rest, and eat his fill;
> And fast on Friday's—if he will;
> Toast friends or foes, argue on the news,
> Or fight with the Deacon over Pews;
> And after all these then are done
> God Bless you Freddy Remington.

When Remington needed encouragement because an illustration had been returned to have a simple box added, Edwards wrote, "*This* is *no* parody, but tis good advice!/Be bold good Remington, and never fear/the carping critics or their pens severe!/Your art is young, the best is yet to be,/What is to come not even they foresee." And then Edwards got to the point, "How comes on the D____n box— Hast filled it yet? Say! ?"

Remington was seeking customers for easel paintings, too, but not so hard that he would do what other artists did, enter paintings in the exhibitions. His whole painting technique had altered. He used to say that some of his best things were done in an hour. Now, painting was painstaking and it could take a week to complete one picture. He no longer worked "chic," but rather used a model like the high-priced Tahamont, an Abnaki Indian who was regarded as "almost a perfect specimen of manly beauty."

He had one customer for an easel painting who lived in San Diego. He sold the picture by first sending a sketch, saying "if you like it, return the sketch and I will attempt it. Canvas about 50″ long. If you dont like it I will submit another idea." The sketch was an ink drawing and it was so good that the customer who bought the painting asked for the sketch back, too.

A few galleries were beginning to request his paintings. The William Macbeth gallery in New York City was advised that "I have only two watercolors framed—now at Thos. A Wilmurts [the framer] and you can have them if you choose. I will give you an order." Remington was an organized seller, the practical man he denied he was. He set his own prices without asking the advice of the gallery. He did not quibble about who would bear ancillary costs like framing and shipping. When one picture did not sell in two months, he volunteered that "if you will box & ship my picture here I will pay the bill." He knew that some galleries would take advantage of a diffident artist by not paying for paintings that had been sold or not hanging paintings at all, and he did not intend that to happen to him.

Remington had settled into a comfortable way of life that contin-

ued until April 14, 1901, when he was "confined to his home suffering from injuries received by the horse on which he rode falling Monday afternoon," according to the New Rochelle press. He was riding his thirteen-hundred-pound mustang along North Street and was turning into Weyman Avenue when an automobile came chugging along. The horse was startled, shied violently, slipped, and fell on the brick pavement with Remington's left foot underneath, tangled in the stirrup. The men in the automobile and the passersby commandeered a carriage and drove him home where he was confined to bed for two weeks. The medical report was that his ankle was sprained and ligaments were broken so he could not walk.

In four days he was taking care of business. He signed a letter to Wister as "Old Pulpy Foot," after saying that "it may be some time before I can play tennis. Think I'll do my sporting in a trolley car after this. They are about my size. Am busy and it knocks out my calculations." That was the part that concerned Wister. In return for agreeing to compose the poems for Remington's picture book, Wister wanted illustrations for his stories, and he wanted them on schedule.

In a few weeks, Remington added that he had "the splints off my tootsie but the thing is pulpy yet. I hobble around on crutches and I never could find any inanimate object in my best days—now judge of the amount of my contributions to a 'swear box' which the old lady has organized on me. I say d_____ the cavoliers—d_____ all saddles and horse painters and— Well D_____ that's my sad fade-away now. Hope to go to my island on 1st June but am woobly and my work is behind. Have a painting to do besides my illustrations." One easel painting on order was certainly close to the minimum but to Remington it was a hopeful sign.

By the first of June, he could no longer resist the pull of Ingleneuk, pulpy foot or not. Tim Bergin was left behind to care for the horses and grounds, and the cook and the maid were sent ahead to join forces with Pete Smith, the island boatman, to open the summer house. Remington was anxious to get going on the erection of his studio. He had planned with the architect to place it on a small hill just west of the house, primarily because the view would be of the movement on the river, but now he became practical and located the studio on the north tip of the island. Windows all across the studio wall provided north light.

Pete Smith posed for Remington at Ingleneuk, just as Tim Bergin did at Endion. He would sit on a sawhorse, arranged so that Remington saw him as an Indian or a scout on a pony. Smith's nine-year-old nephew also posed. He was paid fifty cents a day for sitting on a stool

holding a paddle. Baskets of the working sketches were handed to Pete Smith to burn, and later Smith visualized himself as having burned bushels of dollars.

The way the local people saw Remington, he was a big man who rowed himself over to the village at Chippewa Bay for telegrams. When he came close to the dock, he would stand up in the skiff, yell boisterous greetings to anyone in sight, take his boat hook in his hand, and then slam the steel point of the pike into the wood of the wharf to pull the boat in. His arrival was always accompanied by a great deal of commotion, the same way that he landed in most other places.

28.

40 Years and
a Down Hill Pull

Remington's substantial financial position was still improving in the middle of 1901. One asset was that *Collier's* paid better than *Harper's* had. From August through November, *Collier's* reproduced about two paintings a month in black and white. These were large oils, generally the 27 by 40 inches that was his usual size, and painted as fine art with subjects conceived by the artist rather than to illustrate a text. The first of this series was "Trout Fishing in Canada," a result of the old Remington comment that "the other fellows fish" in Canada, "I sketch."

Collier's art editor George Wharton Edwards was becoming more and more a Remington fan. He cheered Remington on: "Your trout fishing picture is 'bully'! Keep on sending 'em—You're doing better work all the time! I want more—more! The pictures which Fred Remington hath wrought/Are with sauve and finished beauty fraught,/That proves he's mastered, tho the Stipplers Scoff,/The art, so little known of leaving off./A picture is not finished till it shows/No trace of industry to mar repose—/ (eh-what?)"

Remington was caught up in Edwards' warm feelings. After years

of arguing with *Harper's* for commissions and then being dropped, he had an editor who was demanding more and more pictures. On the reverse of "Smugglers Attacked by Mexican Customs Guards," Remington went out of his way to suggest the text for the picture. He was a rejuvenated man at *Collier's* and was acting as cooperatively as he had at *Harper's Weekly* when he was a beginner looking for work.

From *Collier's* standpoint, Edwards was receiving paintings of a higher quality than he could have anticipated. His reaction was to show his appreciation by using the pictures as double-page spreads and as covers. That meant extra pay to Remington. For one picture, Edwards went to the extreme of wiring Owen Wister, "Can you mail us tomorrow quatrain to go with spirited drawing by Remington, mounted cowboy about to throw lariat, wire answer." This was an arresting painting of a confident cowpuncher with his hat down over his eyes, riding right at the reader whose eye level was the mustang's shoulders.

The quality of Wister's poem reflected the overnight service: "No more he rides, yon waif of night;/His was the song the eagle sings;/Strong as the eagle's his delight,/For like his rope, his heart had wings." The first line was emotionally wrong. Wister's poetic mood was pity, not cocky like Remington's cowboy, and when Wister got the chance the following year, he revised the line to "He rides the earth with hoofs of might." Remington liked high-sounding rhymes he could never have managed to write on his own and he loved this one. "That little verse on my Collier's puncher was a corkarina," he applauded. "The thing you did was a great help to the picture. Sort of puts the d_____ public under the skin."

Other paintings in the *Collier's* series like "Killing a Cattle Thief" and "Post Office in the 'Cow Country'" became Western stereotypes, the bear at bay and the mailbox on the high plains. They were reproduced as prints and in picture books so that they became as familiar as friends. Some of the prints were in color, and "Calling the Moose" was like inlays of old leather in nouveau tints. The colors from the dark side of his palette were ripening to a winey richness and even the lighter hues were an advance that resembled the quality of the pastels he had praised to Wales. The Christmas issue featured the classic "Caught in the Circle" that was reproduced in color as a double-page spread. It was also issued as a color print 12 by 18 inches mounted on a 22-by-28-inch board for $1.50, then reissued with the center action enlarged and the edges cropped away to enhance the excitement. "Caught in the Circle" was so visually evocative at the time that the novelist Frank Norris was inspired by it to write the story of what he saw as "A Memorandum of Sudden Death."

The spark between Remington and Edwards reached out to the readers. Tens of thousands of males of all ages across the country waited for their issues of *Collier's* to see what Remington had painted for them that week and many sent in dollars to buy the Remington art prints to hang in their rooms. Compared to these eye-catching 1901 paintings, those determinedly realistic portrayals done during Remington's early days at *Harper's Weekly* were just youthful stabs at hard-edged reporting. The typical contrast was between "The (Last) Lull in the Fight" from 1889 and 1901's "Caught in the Circle." The "Last Lull" was an overstated tragedy of the doomed and dead plainsmen encircled by confident Indian warriors plotting the final attack, the whole focus of the picture on grotesquely twisted horse carcasses and the litter of arrows, bandages, and blood. "Caught in the Circle" was a spare and imaginative treatment of the same type of "surround" showing Remington's use of "the art of leaving off." In a calm manner that heightened the drama, the resolute plainsmen were still in command of their own defense and the horses were in more ordinary postures.

It was the Santiago experience that had helped to mature him. Just as Roosevelt became a national politician because of the Santiago campaign, Remington developed as an easel painter by coming to terms with himself after Santiago. He had learned that he would never be a hero, the humility gave him insight, and three years of dedicated drills in applying color gave him the start toward mastery.

Wister and Remington were corresponding regularly again. They needed each other once more. Wister depended on Remington for illustrations because he had finally come to believe that Remington was most suited to interpreting his words. He had secured Remington's attention by agreeing to write for him, and in exchange Wister wanted pictures for short stories as well as illustrative help on the novel he was planning.

For his part, Remington considered Wister to be the most competent verbal recorder of the Western spirit. There were tens of other authors, but he preferred Wister to them all. Wister was outrageously lavish in praise and Remington wallowed in encomiums. There was, however, an implicit limit to what he would do to reciprocate. When he illustrated a Wister story in *The Saturday Evening Post* that featured the Virginian, he advised Wister to get the reproduction rights "so you can use it" in the contemplated book. That was a warning to Wister that additional drawings might be hard to come by, but it was not understood.

Wister even made the rare social overture of inviting Remington to visit in Philadelphia. He was refused. Remington had not been entirely comfortable with Wister ever since the "Dan" episode and he knew of

Wister's mother by her forbidding reputation. "Simply cant come over," he replied. " 'How be ye these days any how?' I dont expect to meet you again in this incarnation but I sort of remember how you looked back in the spring of '50."

After Wister's wife had borne twins, Remington wrote, "Congratulations on babies—you are quite a daddy by now. Am simply going to do a pastel of old time buckskin with no background [a silhouetted frontiersman] for Wilderness Hunter." To please Wister on this short story for *Outing*, Remington had chosen to illustrate the passive sentence, "In the Supreme Court of his heart he had filed a protest against civilization." He had passed over action lines he would normally have leaped at, like "the free trapper, weatherbeaten and tough with hardships, galloping into camp with his fine horse and his splendid trappings, hungry for a boisterous holiday."

That was Remington in the spirit of compromise when he needed the "Introductory Note" from Wister for the picture portfolio *A Bunch of Buckskins*. The eight drawings for the portfolio were pastels done at different times in different original sizes. They look to the modern eye like simple Impressionist studies, but in 1901 they were a sunburst of unexpectedly savage color. Remington said that "when the shoppies put them in their windows, passing fire engines will stop & hook into the adjoining hydrant." He thought that the drawings were almost incendiary.

In the introduction to the portfolio, Wister acknowledged that "Mr. Remington not only makes a generalization" in his drawings "but creates a personality." Wister's first draft, however, had inaccuracies in identifying the personalities. The publisher R. H. Russell complained to Wister that "you have described the Mexican borderer, known as 'Old Ramon,' as the 'half-breed.' The Half Breed is the man with a gay blanket." Remington added that "Old Ramon was a Mexican—was an indian trader from Taos before the northern indian wars and then scouted for Miles & was quite celebrated. He was an old typical Rocky Mountain man." The power of Remington's characterization of "Old Ramon" had involved Wister in an instant dislike of the subject as a person. Wister corrected his copy to the extent of admitting that "Old Ramon may have scouted for the military," but he stuck with a steady attack on Ramon's parentage that he said had spawned double evil, worthlessness, a haymaker hat, contemptible saddle blanket, splintered rifle stock, and stolen horse.

Remington told Wister, "October 4 & I am 40 years old to day. Its a down hill pull from here." In his letters, the imagery was sometimes mixed, the moth that stole and the pull required to go downhill. He was so pleased with Wister's introduction that he said he blushed: "As

for the article—it is immense but when I read it Extract of Vermillion would make a blue mark on my face. I have to put on my smoked glasses." The publisher liked it too. "I think they are the best reproductions that have been made in this country and ought to prove very popular," Russell told Wister. "Your introduction is just what I want for them. I enclose herewith check for twenty-five (25) dollars, as agreed." Wister's pay was picayune.

Remington sent Roosevelt a presentation copy of *A Bunch of Buckskins*. The acknowledgement was, "I appreciate the pictures themselves as I always do everything of yours," but it came from the President of the United States. McKinley had been murdered in Buffalo by the assassin Leon Czolgosz as part of the anarchic wave that engulfed the King of Italy, the Empress of Austria, and the President of France. Roosevelt had become the twenty-sixth American president, a quick progression from New York State Assemblyman, and he "inspired confidence," as *Collier's* observed.

The reply from Roosevelt was addressed to Remington care of *Century*, an odd place to send the note except that Remington had just sold *Century* an illustrated story after having written nothing for the magazine since 1889. Associate Editor R. U. Johnson found the contemporary Remington a little more nonchalant in his dealings. Johnson asked, "Can you not give us a better title for your story, 'Ochoa Waters.' We want to get the *Southwest* in it somehow." Remington returned Johnson's letter with his response scribbled at the bottom: "I like 'Ochoa Waters' but you might better call it 'A Desert Romance' —'The Romance of Ochoa Waters' or 'The wooing of'—giving her name which I can't remember. 'A Rough Wooing' 'A old Tale of the South West' 'A wooing on horse-back'—Oh call it anything which suits your fancy." Handwritten at the top was Johnson's choice. "Miss Bliss/Make it a *Desert Romance*/A Tale of the Southwest." The new title was an improvement over "The Wooing of Whatsername."

Remington had returned to sculpture the past spring to begin modeling his sixth bronze in seven years, a prodigious quantity for a multitalented man. When it was almost done, he had offered to show Wister this "mud of a indian & a pony which is burning the air— I think & hope he wont fall off as I did—he has a very teetery seat and I am nervous about even mud riders." He asked Bertelli to "send best man you have to do the plaster cast" in New Rochelle rather than shipping the Plasticene to Brooklyn "because I don't want to have a fall down on my indian." The plaster was delivered to Bertelli in May 1901, and Remington added, "Glad the thing got over all right but look—You had better not put it in wax now. This Fall I will be able to get about and then I will come over and finish the thing."

The statuette was "The Cheyenne," copyrighted November 21, 1901, as "Indian on pony galloping with all four feet off the ground." That description was wishful thinking. The horse was joined to the base by a classical post camouflaged as a stump, a device that permitted the horse's four hooves to be in the tuck position that Muybridge had photographed. Remington's joking ambition was to devise a composition where the galloping horse was truly in the air, as it would be in life. Bertelli said later that "Remington always wanted to have his horses with all four feet off the ground. I sometimes had quite a time with him. Once he sent me a Christmas card. It showed himself beside the clay model of a bucking horse precariously balanced on the tip of one toe, like a ballerina. Underneath the sketch he asked, Can you cast him? And below was my imagined reply, Do you think I am one of the Wright Brothers?"

The price of "The Cheyenne" at Tiffany's was $250, the same as "The Bronco Buster." About a hundred bronzes were cast, and Remington placed it second to the "Buster" on his own list. Different castings of "The Cheyenne" showed a marked variation in height. Cast number 8 was 20¼ inches, number 17 was 22½ inches, number 32 was 19 inches, number 51 was 24⅞ inches, and number 80 was 21½ inches. Each of these casts has been authenticated by one authority or another.

Sculpture was like an annuity. Remington's paintings for *Collier's* in the second half of 1901 had made him twenty-five hundred dollars but he was always under pressure to paint to earn current income. In contrast, the "Buster" sold an average of twenty-five castings a year. Remington theoretically retouched each one but he did not always have to, and his yearly earnings from the "Buster" were about three thousand dollars. The four succeeding bronzes had added only five hundred dollars a year in total, but now "The Cheyenne" sold well and produced a thousand dollars a year. The aggregate income from sculpture was a lot of money.

He also had a commission from a customer in Chicago for a singleton bronze, an edition of one. It was for a Christmas present and he told Wister that "I am on a bronze rush order and cant stop long enough to hitch up my breeches." This statuette was "The Buffalo Signal," copyrighted December 17, 1901, as an "equestrian statue of Indian on pony with [its] head held high and right front foot raised. Indian holds aloft a buffalo robe on a pole." The gift was for a fifteen-year-old youth who wrote that "the bronze is fine. It was the best present I got not counting an army saddle and a bridle. Papa told me what it was meant to represent. Guess I will have to feed now. Hope you will have a happy year."

The year 1901 closed with what Remington considered to be his

first exhibition as a serious fine artist, from December 9 to December 30 at Clausen's Gallery on Fifth Avenue. He called the show of fifteen paintings and ten pastels "a step ahead as far as paint goes," although most of the paintings like "Missing" and "When His Heart Is Bad" had been done earlier and eight of the pastels were from "A Bunch of Buckskins." Another of the exhibited paintings was "The Buffalo Signal" dated 1900, the inspiration for the unique bronze. Remington generally used action or verb titles for paintings and descriptive or noun titles for sculpture so "The Buffalo Signal" had been more apt for the bronze than it was for the oil.

In an interview, the illustrator F. S. Church had drawn a gloomy prospect for painters. The new American art patrons were still "rainbow chasers," he said, seeing only European paintings to buy rather than "the beautiful things that are at their feet" in this country. Despite Church's forebodings, Remington's paintings sold well and the newspaper review of the show was more favorable than might have been expected after Remington's years of absence from major exhibitions: "We are not claiming that Mr. Remington yet displays any genuine mastery of or subtle feeling for color and we doubt from what we have seen if this may ever be expected; but the experience of years have brought the man considerable more ease of expression, with a clearer sense of composition and there is no picture here lacking interest. Depicting night the artist is more successful. But we would not for the world have Mr. Remington change his style since he [is] quite in a class by himself."

The popular President Roosevelt read art reviews like those of the Clausen show and kept in close touch with the painters, particularly Remington. He continued to believe that Remington was the most talented artist in America and came to respect Remington as a friend and advisor, even allowing him the freedom of the office of the Presidency to intercede in behalf of military personnel. As an example, a January 15, 1902, memorandum from the Secretary of War to the President's private secretary stated, "Referring to your letter of Jan. 11th, inclosing one from Frederic Remington in behalf of the application of Sergeant Edward L. Baker for appointment as second lieutenant, Mr. Baker's appointment has been ordered." That was clout.

Another example occurred when Admiral Schley appealed to the President from a decision of the Naval Board. Roosevelt turned Schley down, but only after reviewing the decision with Remington. While he was still in Washington February 16, Remington provided some good advice. "You have travelled beyond the necessities of the case in saying that neither Sampson nor Schley did anything to deserve a vice-admiralship," Remington counseled. "This is going to

wound all of Sampson's friends. You believe what you have said, but is it necessary to say it? I hope that you will strike out that sentence." Sampson had been Schley's superior in the Spanish-American War, and Roosevelt was adroit enough to agree that a gratuitous rebuke to Sampson would not have been appropriate.

The Rough Riders did not usually need a special channel to reach Roosevelt's ear. Even Mrs. Roosevelt said she felt like the mother of "a thousand very large and bad children." To Roosevelt, "a Rough Rider was always better qualified for some appointment than the other aspirants." Sometimes, however, every one of them seemed "to be either under indictment, convicted, or in a position that renders it imperatively necessary that he should be indicted." By being in the second of the alternatives while Roosevelt was in the course of seeking Congressional approval to appoint him United States Marshal of Arizona, ex-Sergeant Benjamin Franklin Daniels alienated Roosevelt to such a degree that Remington's conciliation services were called for. Remington wrote to Roosevelt in Daniels' behalf but the President was adamant, stating that Daniels did not tell him he was a prisoner in the state penitentiary at the time of the appointment and so he had put Roosevelt "in an attitude of unwittingly deceiving the Senators to whom I gave my personal guarantee that Daniels was all right." Roosevelt's exasperation was short-lived. He appointed another Rough Rider, Lieutenant Colonel Alexander Brodie, to be governor of the Territory of Arizona, and in turn Brodie made Daniels the warden of the penitentiary where Daniels had been imprisoned, a state job that did not require Senate approval.

The Rough Riders were fortunate to have the President as their patron. In 1902, the naval conquerors of the Spaniards, Dewey, Schley, Sampson, and Hobson, all took falls in public esteem, along with the Commanding General of the Army, Miles. It was a year of antiheroes for the nation, a pedestrian time. Indian Commissioner Jones ruled that Indians must have haircuts, relinquish body paint, and forget tribal dances. Geronimo was released from custody. The cost of living was continuing a mild upward movement. The pay of an artist's model in New York City had risen to fifty cents an hour or three dollars a day. Women models were scarce, but that did not concern Remington.

In the beginning of the year, Remington's accomplishments were negligible. No new sculpture was released. He wrote none of the short fiction at which he had begun to excel. Illustrations were few, and easel paintings for customers were limited in number, too. The termination of the relationship with *Harper's* that had been sour turned acrimonious. Remington was like a bulldog on the subject, incessantly declaiming that the new publisher was "broke" and "cheap." Because

Wister was a quiet professional who would return to *Harper's* if paid enough, *Harper's* still advertised Wister and praised him editorially as the leading Western writer, but a policy was adopted to downgrade the abusive Remington. *Harper's Weekly* published a feature article on "The West's Painter-Laureate, Charles Schreyvogel" who was called "first the artist—and the artist of the Western frontier." The distinction was between Schreyvogel as a real artist and Remington as a commercial illustrator. After seeing the article, Remington was incensed at Schreyvogel all over again even though Schreyvogel was a modest man.

Remington believed that *Harper's Weekly* had been able to get away with calling him a commercial illustrator because he had not been sufficiently selective in the commissions he accepted. For one thing, he had discovered the field of advertising art. Easel paintings could be sold to manufacturing companies like the Smith and Wesson Arms Company and to railroads like the Union Pacific to promote products and services, and he had welcomed the sales despite the conflict with his intended image as a serious artist superior to Schreyvogel. These advertising outlets paid more for paintings than the magazines did but from this point on he expected to be more protective of the image he wanted to project.

Also, while some of the pictures he had painted for *Collier's* in 1901 had been what anyone would call "real art," his pictures published in *Collier's* in 1902 actually were commercial art, the illustrations drawn for the Richard Harding Davis serial "Ranson's Folly." He then became reluctant to work for *Collier's* at all, even though Edwards tried the same exhortative approach that had been effective in 1901:

My dear Fred:
I want som DRAWINGS now—wine nell cant I have some of Ewers? Hive assked U fer em time and time again Avent I? But!!! I dont get them —DO I? NOW when do I get em???
SAY FRED—When DO I Get EM!!!!!
Now Fred this is serious— This is——serious—when do I get em?
Necnon euisdem Escudebat—That is to say, I want em bad Fred. Worse than the ink. Thine

The personal appeal did not work this time. Edwards knew that for the future he was going to have to sit down with his publisher to discuss how to resolve the flood of inquiries from *Collier's* subscribers asking what had happened to Remington.

Another reason that Remington was not available to *Collier's* was that he had been commissioned by *Scribner's* to do a group of four paintings in color. Called "Western Types," these paintings were published in the magazine in October 1902 and then issued as boxed

prints. Remington also wrote the text, calling the cowboy "no longer strange, and becoming conventional."

John Howard, the boyhood friend from Ogdensburg, had watched "The Cowboy" being painted for "Western Types" and he took a fancy to the picture. He asked Remington what the price was and was startled to hear "Twenty-five hundred dollars," two and a half times the usual price to strangers through a gallery. When Howard hesitated, Remington pressed him to buy "The Cowboy" until Howard finally wrote out the check, feeling that he had been taken advantage of. Months passed and the check did not clear Howard's bank. Each time Howard saw Remington, he complained about the failure to deposit the check and how he had to carry the amount forward at the end of each month in order to balance his account. Remington always promised to take care of the deposit. One evening when they were sitting in the studio after dinner, Remington took a small piece of paper out of his desk, rolled it into a spill, lit one end, used it to light their cigars, and then held the paper until it burned out. "There you are, John," he said. "Now I've deposited your d_____ check."

Although the market for Remington prints seemed to be saturated with *Western Types* and *A Bunch of Buckskins*, as well as with individual prints offered by *Collier's* and by advertisers, another Remington venture for 1902 was the third book of his drawings. Again, R. H. Russell was to be the publisher. For this picture book, Remington had asked Wister to compose poetry, in addition to the introduction. "I am as you know working on a big picture book of the West," he had told Wister in September 1901, "and I want you to write a preface. I want a lala too—no d_____ newspaper puff saying how much I weigh &c &c but telling the d_____ public that this is the real old thing—step up and buy a copy—last chance—aint going to be any more West &c. How's that hit you? Will you?" A bit later Remington reminded him, "hope you are going to do the little poems."

Wister was willing. He was at last negotiating the contract with the publisher Macmillan for his own proposed novel *The Virginian* and planned to retire to South Carolina to do the fitting and polishing that would assemble the tale from his short stories. In return for the poems and preface, he expected Remington to illustrate this major effort that would be the critical juncture in his career.

Russell confirmed the arrangement with Wister but did not send Wister the proofs of Remington's pictures until May 16, 1902, when he added, "What we particularly want is a good title." By then Wister had returned from the South. He was unfamiliar with the history of the paintings, the book dummy looked weak, and the title seemed to be the least of the problems. He could not locate Russell so he com-

plained to Remington who acknowledged that "what you say is true—
[but] Russell has gone to Europe—the thing is in 'the formes' and
Colliers Weekly is behind it. I cannot change now. The play will have
to go as it lays and d_____ the odds. Do what you can and dismiss
the things which don't appeal to you. Just pass it up."

Although it was Remington's book, not his, and Remington was un-
concerned, Wister insisted on meeting with Remington to force revi-
sions. Wister had to be in New York City anyhow to look at proofs
of his new novel so he wrote Remington, asking that a date be set for
them to get together. Wister said that he told Remington to contact
him at The Players in New York.

Remington received the note and jaunty as usual answered, "Say
Thursday Players at noon—how's that." He confused meeting at The
Players with sending word to The Players and addressed the response
to Philadelphia, after Wister had left for New York. When Reming-
ton did not get a confirmation from Wister, he sent a wire, also to
Philadelphia. He was in his annual rush to leave for Ingleneuk. He had
not heard from Wister by May 30 so off he went, for the summer.

Wister considered Remington's leaving without getting in touch
with him at The Players to have been insulting. He tried to locate
Remington through Russell's office, then returned to Philadelphia and
found Remington's responses that had not been forwarded to him.
The explanation did not calm him. The chatty and casual letter that
came from Remington in Ingleneuk incensed Wister more:

Telegraphed you at Philadelphia but got no reply—left NY Friday night
a week gone and have been settling. On the batch.

As for the poetry—I cant say anything more than that I would like you
to do it but I wouldn't stop important work to do pen edgings for you and
dont expect you will for me. Tell Collier you will or you wont and pass it
up— ——no harm done pardner.

The letter left the burden on Wister. He could write the poetry or
not. Remington did not seem to care which.

The next affront to Wister was a June 6 follow-up from Russell's
associate F. T. Singleton, who said, "I am anxiously awaiting a line
from you regarding the manuscript for Mr. Remington's new book. I
think that every day's delay after the 15th of this month will mean a
considerable loss to Mr. Remington and myself." At last Wister had a
way to work off his anger. He replied to Singleton the next day that
"last September Mr. Russell asked me to do this work. It now comes,
eight months afterwards, but with a request now that I hurry. I am
sorry to say that I am not free. I shall be busy for five or six weeks
more. Then I shall be more than glad to do this portfolio; but I can
not consider that the delay is any responsibility of mine."

After that, Wister felt better. He wrote a gentler complaint to Remington who answered, "Oh gee—Oh gee—here is a how do do— now I dont know anything about it one way or the other—so fire away.— dont hit me?" Wister completed the manuscript on schedule, earning Singleton's praise that "the introduction will add greatly to the general effect of the book." Wister suggested the title, too, one that was worth having waited for. Remington exulted that " 'Done in the Open' is good—my what a killing you have made—."

The Wister introduction started with a sound observation: "Our heritage in portraiture includes the leaders of men; it does not include the men themselves. No artist until Remington has undertaken to draw so clearly the history of the people." Then came the hyperbole. "Remington is not merely an artist; he is a national treasure. And if it should occur that Remington should be crowned I should like to hear him receive his degree in these words: 'Frederic Remington, Draughtsman, Historian, Poet.' " "Poet" was a new thought, but it came out of Wister's technique, not his conviction. He had written to his mother on August 2, "I am doing some doggerel for an album of Remington's pictures. He is the most uneven artist I know, which you find out very much when you come to extract verse from each drawing. Some are full of meaning and some empty as old cartridges."

Remington was aware of Wister's printed words, not the secret feelings. His thanks were, "Copy of my book just at hand and I have read Intro & poems—the poems are great and I feel like this—sort of unusually puffed up [sketch]. There were passages in that Intro which sent my natural color up several octaves. Did you see in N Y Herald that we have all got to join the union. Amalgamated Ass[ociation] of Quillers and Daubers No. 2 affiliated with the Pants Makers and Liberty Dawners. Say wouldn't that warm your ears?"

For *Done in the Open*, Wister did no homework after he missed meeting Remington. Although some of the pictures had been previously published with Remington titles, he retitled them all in accordance with his personal interpretations and he committed geographical, racial, and sporting sins with abandon. It was all to the good. *Done in the Open* contained more than sixty new paintings and drawings and ran through at least five editions. Remington called his lot a down hill pull at forty, but it was profitable all the way.

29.

Long Story Is
My Problem

In the last quarter of 1902, Remington finished two major creative projects. One was the "long story" that was his main bid for honors as an author and the other was a most complex bronze group that has endured since then as a symbol of cowboy fun.

He had been modeling the "mud" of the cowboy group since the beginning of the year, worried because the composition was the most elaborate he had tried and hoping that if the model could be cast commercially, the finished bronze would rival the "Buster" in popularity. Because he was not completely confident about the outcome, he did not at first let his friends know what he was doing. That was an unusual reserve for Remington.

On March 24, 1902, Bertelli had received a note from Remington concerning the Plasticene model, saying that he would "have the 'bunch' done this week and so get ready to put it in plaster right away. Should think the man might board up here somewhere and save time and travel. I want to go away 1st of June so will have to hustle." The note was headed "My dear Bartelli," a consistent misspelling that had started with the first communication to Bertelli and could never

afterward be corrected. "My friend Clark" had been a similar permanent misspelling.

Bertelli did hustle, as requested. Remington wrote him April 7 that he had "shipped 4 boxes of [plaster] models and hope to God they arrive whole and not in small chunks." The shipment was via Adams Express, a common carrier in an age where special attention to cartons marked "fragile" was the rule and delicate plasters could be buried in bales of hay to give adequate protection.

The next seven weeks were absolute drudgery for Remington. He told Wister in May that "I go to the Roman Bronze Works—275 Green St Greenpoint—Brooklyn—leaving here every morning at 8.20 a m to work out a new horse bronze and I reach this above oasis at 6 P M—eat n' smoke—go to bed and day after day I am to do this until I die or complete the bronze—and its even up." His task was first to repair the few shipping breakages in the plasters, and then to assist in tackling the mechanical problem of adjusting the model to fit the requirements of the casting process. The bronze was gravity cast, not cast under pressure, and in the first trial castings, air was trapped in remote mold sections that could not be anticipated. The answer each time was for Bertelli to add more vents and runners where he could, and thereafter look to Remington for design changes to get the mold to fill properly.

Another sculptor might have regarded his role as ended with the modeling but Remington was deeply involved in the casting process as well. After six weeks of failures, the urgency mounted because he was anxious to leave for Ingleneuk on schedule. The continual delays, the getting ahead but not quite there, were increasing frustrations. At one point when he had spent hours in the foundry, adjusting the wax model so they could try casting bronze one more time, Bertelli pointed out that the changes would not work. Remington picked up a crow bar that had been standing against the wall and raised the bar over his head to smash it down on the model. Bertelli stopped him before he could do more than minor damage but Remington had obviously carried the project as far as he emotionally could. He went on vacation June 1 as scheduled.

Bertelli remained at the foundry to complete the gating and venting. Within a week, he was able to tell Remington that progress had been made. Remington replied June 10, "When do you cast? Let me know before you finish—I may run down and look after bits, bridles &c spurs and bring you back." He was friendly enough with Bertelli to invite the foundry man to visit Ingleneuk but he did not have to go to Brooklyn to help with the bronze. Bertelli handled the casting on his own.

It was only at this promising point that Remington started talking to others about the bronze group. He told his father's old friend Almon Gunnison that the new bronze was a winner and that he would "spring it on the unsuspecting public this winter—God help em. If they like it I'll swell up—if they dont I'll tighten my belt."

He was back in Brooklyn about September 15 to manicure the statuette into its final form. The copyright application was filed early in October as "Coming through the Rye: Bronze group of four cowboys on running horses. Men shooting pistols and shouting. Men represented as being on a carousal." The bronze was so active that only five of the sixteen hooves touched the base and some viewers said that they could almost hear the shooting and the shouting. The statuette was exhibited by Tiffany, whose *Blue Book* listing of the price was the very steep two thousand dollars. Four cowboys in a bronze were a lot more complicated than just four times one cowboy; the first casting had taken five months to resolve, after the plaster model had been completed.

Because of the expense to Bertelli, the marketing arrangement called for making only the one finished casting that was on exhibition. That casting sold immediately to a private buyer, however, and a month was lost before another casting could be assembled for exhibition in its place. Thereafter, the inventory level was established at two sets of components cast but not assembled. Delivery of the first of these could be made in ten days. Beyond these two sets, the lead time for additional statuettes was still a long four months.

The group was received without fanfare in 1902 and sales were few, but over the years these four hard-riding punchers have increasingly captured public imagination. As early as 1904, "Coming Through the Rye" was chosen to be remodeled into "heroic" size and placed in the eastern entrance of The Pike, the amusement area of the Louisiana Purchase Exposition in St. Louis. This enlargement was in plaster, done by New Jersey technicians under the establishment sculptor Karl Bitter who had chosen the piece for the Exposition. Remington did not travel to St. Louis to see the sculpture in place, but it was included among the "Notable Statuary" of the fair.

The next year, the Lewis and Clark Exposition in Portland, Oregon borrowed the huge plaster from St. Louis for exhibition at its Exposition entrance. The lease arrangement provided for Portland to pay for crating and freight both ways. The plaster statue was dismantled soon after the Portland exposition closed October 15, 1905, and was shipped back to St. Louis. All trace of it was lost from there on.

Remington's choice of the title for this remarkable statuette was

puzzling. Although he was a voracious reader, he connected "the Rye" with whiskey. The obvious source of the phrase was Robert Burns' "Gin a body meet a body/Comin' thro' the rye,/Gin a body kiss a body,/Need a body cry?" In Scotland, "gin" meant "if," but despite the combination of rye, Scotch, and gin this was a kissing song, not a cowboy carousal. "Coming Through the Rye" was just not the right title for a bronze of a drunken Western escapade, and it did not sit well with the contemporary buyers and critics.

When Tiffany's listed the bronze, "Through" was immediately changed to Burns' "Thro," and shortly after, "Coming" was shortened to "Comin'." The Corcoran Gallery in Washington added the bronze to its collection in 1905 but rejected the original title in favor of "Off the Range." That was also the title that *Collier's* used in reviewing Remington's sculpture. The Louisiana Purchase Exposition had called its full-sized plaster both "Off the Trail" and "Cowboys Shooting Up a Western Town." Neither of those names had satisfied Portland, which titled the borrowed plaster "Shooting Up the Town" and "Hitting the Trail." Remington persevered with his misnomer, however, and today the title that is generally used is again "Coming Through the Rye."

The bronze group became the second best known of Remington's statuettes. Sales of "Coming Through the Rye" settled down to about two a year, and only fifteen were made. The two-thousand-dollar price was a limiting factor, although museums and well-to-do collectors spent that much and more for paintings. By 1978, the level of appreciation of the bronze had risen sharply. Casting number 2 was in a dealer's hands, but thirteen castings were in museums and the fifteenth was in the White House.

In 1902, however, the slow-blooming "Coming Through the Rye" was less important to Remington than the "long story" that he had mentioned to Wister. The story was *John Ermine*, a novel that held the public eye for a year and then was adapted as a play. In its message, in locale, and in how it came to be written, *John Ermine* was related to two other novels published earlier the same year.

One was an Indian novel, *The Captain of the Gray-Horse Troop*, by Hamlin Garland. The message of that novel was the enlightened program of leading Indians to happiness in an agricultural utopia, as opposed to the credo of the old Westerners that "Indians are nothing but a greasy lot of vermin—worthless from every point of view." Roosevelt and Wister could be taken as representative of the Westerners, and Garland himself as the enlightened Easterner.

The second novel was *The Virginian* by Wister, who had secluded himself in Charleston, South Carolina, late in 1901 to rework seven

years of *Harper's Monthly* and *The Saturday Evening Post* short sto-
ries into a cowboy novel. From Charleston, Wister told his mother
that writing the book was "like going up a mountain" with another
"last rise" always ahead. He was a painstaking craftsman, working
with the assurance from Remington that he would "remember the
virginian" when the time came for the illustrations.

Wister had finished *The Virginian* in the middle of March 1902. He
delivered the manuscript to George Brett at Macmillan in New York
City, only to find that Remington had reneged on the illustrations.
Remington had warned Wister to get the rights to the original pic-
tures for the short stories, but Wister had not done that. Since the
warning, Remington had devoted himself to sculpture, working on
"The Cheyenne" until November 1901, "The Buffalo Signal" until
Christmas, and immediately after that he was in a bind on "Coming
Through the Rye," struggling to complete the model. Remington
could make no promise as to when he would be free, so Wister was
compelled to turn to a lesser illustrator, Arthur I. Keller. *The Vir-
ginian* was published with Keller's Victorian illustrations the end of
May, just before Remington left for Ingleneuk.

Remington had been immersed in his bronze group since the begin-
ning of 1902, but not so completely that he did not dream and talk
about *John Ermine*. He was intrigued with the life of the protagonist
as a boy, and first explored the idea of the boy as an Indian before
concluding that more dramatic effect would be generated by having a
white boy raised as a Crow Indian. He discussed the characterization
with close friends like the Summerhayes, when they were sitting in his
studio in the evening, and Martha Summerhayes said that "now he was
going to try his hand at a novel, a real romance. We talked a good
deal about the little Indian boy, and I got to love White Weasel long
before he appeared in print as John Ermine."

Remington described the boy to professional writers at The Players,
too, and Louis Shipman was encouraging. Shipman was younger than
Remington, Harvard educated, and had been a staff writer for maga-
zines before turning novelist in 1896 and playwright in 1898. He met
Eva Remington at a neighbor's house and sent the message that impor-
tant concerns in a Western novel would be the description of the
landscape and the use of dialect. He did not mention motivation or
plot but Remington replied jokingly that he would "fail right there"
on the landscape and the dialect "and you are just enough of an old
grey rat to see it." He had to go ahead with the novel anyhow, Rem-
ington said, because "it is useless to struggle against one's loves," and
he issued the disclaimer "to all whom it may concern—Be it known
that the rocks lay and if I hit them—which I will—simply say 'he

couldn't help it, poor man'; and begone." To all of this elaborate word play Remington added a sketch of Shipman guiding Remington's writing hand while pronouncing dolefully that "I like you personally but its Bum." Remington trusted Shipman's judgment and he expected Shipman to come to the rescue if the novel hit a snag.

When Remington went to Ingleneuk in June to get away from his problems with "Coming Through the Rye," he was entering a time box that he had set aside to write the novel. He believed that he had enough of the plot thought through so that there would be no problem and he gave himself until September 15 to finish the book and do the illustrations for it. After that, he had to be back on the statuette to meet his commitment to Bertelli.

With that kind of schedule, he had no opportunity to draw for Wister. When Wister sold another short story to *Collier's* and waited to see the Remington pictures, what he got was a series of responses from an artist too busy to be tied down. Remington knew that Wister was becoming angered because of the string of omissions and evasions. Perversely, he undertook to send Wister a series of misleading signals that could only intensify the hostility. From Ingleneuk he told Wister that "now that the relaxation has come I despise labor," which implied that he was on vacation and not about to do any work at all, even for Wister. Then he gave the same excuse he had given in earlier years, that he had "just been through your short story and it nearly killed me before my time—say Bill you are all right. I sent it back because it dont need illustration—its all there—I wouldn't care to interfere."

Because Wister had complied with all of Remington's requests, he felt that he was entitled to count on Remington for illustrations. He pressed Remington to change his mind, saying that the story was written for illustration, featuring action sequences instead of talk. The reply was "I simply couldn't stop to do your story now and so told Edwards—and I dont suppose they want to hold it to suit my convenience. I have done no painting since late last winter and have three pictures which must be finished since I want to get away later so I have had to suspend all illustration for awhile." He added, "if you can get them to hold the thing I would like to do it," but again he would not be pinned down to a date. In view of the success of *Done in the Open*, Wister also wanted to do a joint picture book for Macmillan, but Remington fobbed that off, too, on the basis that "I can't see how I am to go about it—it is such an interminable job."

What the situation came down to was Remington saying, "Cawnt do it yu no—I am busy as a cat havin a fit. Long story is my trouble —but I mean to see you later—I have got an idea which I think will interest you—it concerns a statement which must be made which will

stop dead the fools who are trying to confuse the public, by their ignorance into thinking that they too understand. I have collected material but haven't the right kind of mind to discharge it. It must be, I think an essay—that's however."

And "however" is what it was for Wister, answers from Remington that were consistently friendly but inconsequential, incoherent, and invariably inconclusive.

Next, Remington invited Wister to "come to 'Cedar Island—Chipewa Bay St. Lawrence Co. NY'—why dont you come and see the only place in N America which is as still as Death except for Us." Wister would not have visited Ingleneuk when they were friends. Now that he was hostile, he certainly would not come, and Remington would not really have wanted him. Remington was writing the long story and did not need another author underfoot. It was the old push-pull on Wister, an unconscious expression of the ambivalence that he felt.

Inviting Wister to Ingleneuk, an ingenuous seeming act of friendship, was a finesse, too, for a slight that had come from Wister. For the first time, Wister had not sent Remington an autographed copy of a new book. Remington wrote Wister that "the Kid says 'Virginian' out—will order a copy." That was sarcasm, but Wister did not respond.

Wister's ability made his novel more galling to Remington than Garland's because the plot was more persuasive. A rough jewel of a make-believe cowboy got the Eastern girl. In one month, *The Virginian* was a runaway bestseller. By August, fifty thousand copies were in print and fifty thousand more were being run. Publishers were offering Wister ten cents a word for new material just after he had written poetry for *Done in the Open* for a pittance. His name connected with Remington's book had added sales, as Remington had given credibility to Wister in the beginning of their association. *Harper's* reissued Wister's earlier books to cash in on Macmillan's bonanza. The novel eventually sold almost two million copies and set the stereotype for the popular Western novels by other authors that followed. *The Virginian* was the start of a style.

To Remington, though, the plot of *The Virginian* was slop, a contrivance of a cowboy without cows, all formula and no truth. He resolved that he would beat Wister and Garland and he would do it with realism, just as the veracity of his paintings would in the long run confound Schreyvogel. He picked an auspicious era for his novel, one he knew well, the years surrounding the Custer massacre, and his characters were drawn from the Indian-fighting army and from the Crow Indians who had sought to live cooperatively with whites. The

story would be told from a bridge between the races and would put the artificers to shame. The protagonist was White Weasel to the Crows who raised him and Ermine to the whites he served. The background sounded good to everyone he tried it on, and once he was settled at Ingleneuk he got to work. He had even remembered to bring pens, implements that he hated and cursed. "D_____ this Pen it wont write" was his frequent complaint.

His regimen as a writer was a little looser than when he was painting. He was up at six and turned on his phonograph at full blast to play the popular tunes like "In the Good Old Summertime" and "The Floradora Song," regardless of the way sound carried over water. An enervating swim in the frigid river got him ready for breakfast at seven. The fare was four to six lamb chops, cut thick, or liberal helpings of pigs knuckles, with the customary side dishes, fried potatoes, toast, and three cups of coffee. It was a stultifying start for a writer's day but he was in the studio by eight, the brush and the palette hung on the wall while he labored with the pen and the ink. He did not permit any interference while he was writing. Guests were not welcome as they were when he painted. On most mornings, the muse had departed by ten and he took a second swim to clear the air. Lunch was at noon, with a third swim before it, and he was back in the little studio by one.

At three, the working day was ended and it was time for another swim to prepare "to get up a sweat," for he said that "every man should sweat once a day." A court had been built and sodded in the spring so he could spend a couple of hours at tennis when he had a partner, or he could take a cruise in his canoe. "Best exercise on earth," he told his visitors. "Feel my arm." Canoeing was a ruminative pleasure. Tennis he played to win. He had no use for a sailboat and said that he would "just as soon ride on a street car."

The hours after dinner were for "common hospitality," which meant a cigar, a nip of whiskey, and "heap talk" if he had male companionship. Serious drinking was off Ingleneuk. He told guests that they would be met on Cedar Island, if it was in the evening, by "a perfectly preserved old gentleman with a bottle of Scotch in his left and his right all open or Madam will paddle you home to a place where 'she says no drunks are allowed'—you can have it either way." Those were the days when Carrie Nation was wrecking saloons and smashing liquor supplies in the name of the women's temperance movement. The spirit of the movement gave Eva Remington the confidence to tell that "perfectly preserved old gentleman" that he was disgracing himself with liquor and that when he wanted to get drunk he could take himself off her island. He acknowledged his guilt,

accepted her limitations, and drank on Cedar Island, despite the risk in getting home across the water while intoxicated. At this stage of his life, his three hundred pounds required an enormous intake of alcohol to disable him, and the quantity he drank was exhilarating without impairing his balance.

By midsummer he was more than halfway through writing the novel. He showed the garrulous first chapter on White Weasel in the mining camp to his neighbor Edwin Wildman and was told that the "world has lost a great humorist in the finding of a great artist. The humor is hilarious, yet rich, and interlaced with fine blue veins of pathos." Remington was aiming for human interest, not slapstick, and he gave up on Wildman as a reader. He did not show Wildman the next part of the book, exploring the life of a child in a Crow camp, his play, his jobs, and his religion in communion with the Great Spirit. Because White Weasel was of the white race, he was also taught civilized ways by a white hermit and as a man was renamed John Ermine. Led to enlist as a scout in the United States Army, he tried to play a white man's part in camp and in the hostilities against the Sioux. The officers treated him only as a special kind of wild man, however, and grouped him with the Indian scouts.

The first half of *Ermine* was easy going for Remington, the description of two societies he knew well, the Indian and the soldier. Then, however, he introduced the romance and the motivation muddied. He needed to talk to someone about where the plot was heading and there was no one near by. Wildman was too shallow and Eva Remington was just not involved. He sent a plaintive note to Shipman who had promised to rescue him, chiding that "you got me into this writing habit and then abandoned me—I have 90,000 words which need looking after—you got me into this game—I have lost my color sense and can only hum in my weakness." The tune he hummed was "Louis Shipman was a teacher/Of the cult of Writing/He got a sucker named F R/Left him on a nail a biting/From the old saying Oh d_____ you." He was aware, though, that Shipman's first play was opening in New York. Written in four months, the play had taken three years to get produced. Shipman was fully occupied and no more able to help Remington than Remington was Wister.

Next he tried Ralph. "My story is like castrating a 12 yr old stallion —d_____ hard," he complained, and he told Ralph, "If you want to come just wire me and if I am here I will wire back, sabe! Hope to see you." Eva Remington was moved enough by her husband's impasse to add the postscript, "Do try to get up here for a few days," to let Ralph know that she would welcome him, but Ralph did not make the visit.

Every passing day was closer to the end of the summer when Remington had to be back in Brooklyn at Roman Bronze so he pressed on with the novel. The girl in the story was the daughter of a Colonel, pretty but just a flirt. Remington described her as "a cruel little puss." She gave Ermine a glove as a talisman and she let him kiss her but when he fell in love with her and proposed marriage, she was horrified at serious advances by this wild man and in tears she told her parents and her fiancé about the proposal. When he was challenged by the fiancé who pulled a gun, Ermine wounded the young officer in self-defense and was forced to flee, while the Colonel ordered the guard to shoot to kill. The pressure of the unexpected reactions of the girl and the soldiers turned Ermine back into an Indian. He resolved to murder the fiancé because "he was going to put his foot on me" and "she made a fool of me." He smuggled himself into the army camp with his rifle at night, and was assassinated.

The novel was finished about September 1. By September 10, the illustrations were done. The same afternoon, Remington paddled over to Wildman's island, shoved the nose of the canoe up against the dock, and called, "Come down here; I want to speak to you. I've coined two words to-day—the sweetest ones in the English language." Wildman leaned over, and Remington said, "Bend low. I want to whisper them to you." He grasped Wildman's arm, pulled him down, and yelled in his ear as loud as he could, "T-h-e E-n-d!" The book was finished, and as Wildman said, they "went on a holiday."

On September 15 Remington dropped off the manuscript and the illustrations at Macmillan's and continued on to Brooklyn to commence the fine tuning of "Coming Through the Rye." A month later, the bronze group had been delivered to Tiffany's and Remington penned another of his push-pull notes to Wister, "My little old story comes out soon but that wont interest you," he wrote. "However if you read it tell me what's what and spare not. I havent seen you since you were a young man—I'm bald headed and one legged and the curves are more easily followed than ever."

Right after he wrote to Wister, Remington was called back to Roman Bronze to retouch the wax for the second casting of "Coming Through the Rye" and then to help nurse that wax into bronze. He also worked in his studio on the three easel paintings that had been commissioned. Just as those tasks ended, *John Ermine of the Yellowstone* was published November 12, 1902. All of his obligations were under control. Three weeks later, Brett of Macmillan wrote that "we are going to press with a second edition," adding that "the first edition will be quite sold out before we shall be able to get the second edition ready." The publisher's slack planning was on the same level as his

poor printing. Remington had been too preoccupied to check the novel in process, as he normally would have. The illustrations were reproduced looking dark and inconsequential. They were not innovative and had been painted too fast, reminiscent of the Remington who had drawn for the children's magazines. Macmillan did not improve them. In addition, it was supposed to be "an open secret that Charles Dana Gibson is known to have drawn the female figures." Gossip like that promoted sales but the sophisticated line drawings of the "cruel puss" were done by Remington himself. His saying that he "can't draw a woman—never tried but one" was untrue, the expression of a macho image to fool the public.

John Ermine was a modest best seller, netting Remington about four thousand dollars in royalties. The critics were divided. Some called it a "remarkably good story" told with "fidelity to Western life," and others said that "in working out his culmination, Mr. Remington's method or his patience fails him. It almost looks as if he had become tired of his job and hastened his conclusion." The novel began in mining camp humor like Bret Harte, changed to tales of Indian genre like Lummis, and concluded in tragedy like Ibsen. There were three stories in one, and that was two too many.

Remington had copies of the book sent to his friends and associates. The lawyer George M. Wright responded with a letter addressed to "John Ermine Esq. You are all right and got yourself properly killed. I was afraid something would turn up to make you appear as a gentlemanly cowboy—but thank Heaven you died with your boots on." The only negative comment was from the Louis Shipman who had been missing when he was needed. He said that there were "some technical defects but [the novel was] too short." Commander Jerrold Kelley who wrote for *Harper's* on naval subjects said, "Dont you worry, honey, about that book. Your friend Wister is, compared to what you have done, telling things at second hand in The Virginian."

Despite the compliments, *John Ermine* suffered in relation to *The Virginian*'s popularity and influence. The theme was not as simplistic. There was no one quotable line. No character came through as believable. The hero was not 100 percent true blue but a confused man whatever his race. The girl was neither heroine nor villainess. There was no happy ending, a difference that linked the plot with the modern Western novel as well as with Remington's own dedication to the trappers who died like wild animals in *Men with the Bark On*.

The conclusion would have to be that Remington's talent as a writer was not equal to his extraordinary abilities as painter and sculptor. It was amazing, though, that an artist of Remington's stature could have been as good a writer as he was. Few artists have ever been

able to both paint and sculpt on the highest level, and here was a man who also had an unrelated talent, writing, that proceeded from a different area of the brain, an ambidextrous creativity that was unique. Despite the restrained applause, however, Remington realized that *John Ermine* was his best shot. If *Ermine* was not good enough to beat Wister or Garland, then he was better off spending his dreaming time on bronzes like "Coming Through the Rye" or on the series of paintings he had in mind as the ultimate statement of Western history.

Howard Pyle had told the Society of American Artists that "the world to-day wants illustration, and I, as an illustrator, believe that by nobly satisfying their wants there can be created another and vital art." Remington too had served many authors. In less than two decades of commercial work, he had drawn about twenty-seven hundred original illustrations for Generals Miles and Howard, Colonels Dodge and Inman, the Custers (the General and Mrs.), Bret Harte and Thomas Janvier, Richard Harding Davis and Emerson Hough, Alfred Henry Lewis and Frank Norris, Theodore Roosevelt and Woodrow Wilson, Rudyard Kipling and Owen Wister, Buffalo Bill Cody and his sister, Henry Wadsworth Longfellow and John Greenleaf Whittier, John Muir and Francis Parkman, Eugene Field and Joaquin Miller, Henry M. Stanley and John G. Bourke, Hamlin Garland and Edward Ellis, Cyrus Brady and Irving Bacheller, Arthur Brisbane and Caspar Whitney, Agnes Laut and Maurice Kingsley, Stephen Crane and Poultney Bigelow, Generals W. H. Carter and Charles King, and Julian Ralph who had died January 20, 1903 from injuries during the Boer War. More than half of these writers were friends, but he was through with illustrating. What Pyle had said was now hogwash to him. He no longer had the desire or the time to make pictures for some one else's text.

He did not show in the Second Annual Exhibition of the Society of Illustrators and gave his reason to Dan Beard as, "You are almost irresistable and if you agree not to quote me—Now hold up your right hand & Swear—I will tell you. The Society of Ills—is a nigger baby and it aint worth saving—at least that is my opinion and its all the opinion I have to go by. I dont want to discourage you but since you put it up to me—there is no good in shuffling."

He had been an easel painter who continued to illustrate because that was the way he had started. Illustration and writing had been his money makers. By the end of 1902, they were no longer needed. He was the leader of the sculptors modeling statuettes of popular Western subjects and his paintings equaled any by his peers.

30.

A Perfect Jack

After reading *John Ermine*, George Wharton Edwards declared that Westerners would accept the novel as "Good Medicine," but he predicted that the "meat is too strong for Broadway." That amateur opinion did not influence Remington's theatrical expert Louis Shipman. Adapting popular novels as Broadway plays was the vogue of the early 1900s. Shipman thought that he could straighten out the plot defects in *Ermine* and expand the conclusion and that then the book would be just right to make into a hit drama. He said so to Remington immediately after *Ermine* was published in November 1902 when he took an informal option on the play, a handshake between friends. Adaptations for the stage had twice been successful for Shipman and as an ambitious playwright he was looking for an exotic concept to transform into his third winner.

Within two weeks, Shipman had good news. He had discussed *Ermine* with James K. Hackett and reported that Hackett "wants another week to think over dramatization. Will send contract if he decides to go ahead." Another member of The Players, Hackett had been the youngest leading man in New York stage history seven years

earlier. By 1902, he had become one of the few thriving actor-managers in the American theater. He selected his own plays, arranged for the financing, and retained a troupe of supporting actors. Despite his success as one of the most popular leading men New York had known, he was controversial among critics because "he is good to see, good to hear, but the next morning one remembers that Mr. Hackett laughed too much, swallowed many of his lines, and declaimed nasally." *Ermine* appealed to Hackett for the romance associated with handsome Indians, the opportunities in manly costuming, the fight with the girl's fiancé, and the death scene he could project as a Creek Macbeth.

The prospect of dramatization coming right on the heels of the friendly reception of his novel was an enormous boost for Remington. He was a regular at the popular theater, numbering stars like Francis Wilson, Richard Mansfield, and Otis Skinner among his friends, and was so taken with the glamor of the "boards" that he used the terminology of the stage in his own speech. "I open," he had told Wister in announcing the dates for his 1895 auction.

When Hackett did decide to proceed with *Ermine*, Remington was prompt in sending his power of attorney to Shipman to conclude the contract and added, "you and Hackett fight it out." The earnest money on the agreement was only a couple of hundred dollars to Remington but he wanted it as a binder on the pleasure he anticipated. "If your deal goes through," he said to Shipman, "send check for me to Lincoln National Bank and wire me at Santa Barbara" where the Remingtons were going for a vacation.

The play that Hackett was currently starring in was *The Crisis*, a dramatization by Shipman of a novel by the American writer Winston Churchill. To check on the qualifications of both Shipman and Hackett, Remington told Shipman that "we go see the bad play Wednesday but I understand she is knocking the chuck out of the dear old public. Your pants will be so heavy [with royalties] you'll have to wear two pair of suspenders before spring." By "bad" play, Remington meant melodramatic, and he later confessed that "we have been to the Crisis and I quit at the third act—I am such an old fool. I am always doing [painting] the 'blood pictures' but I don't like them in real life or on the stage. An[d] Hackett is all right—his is a dashing part." Remington marveled that most people saw his make-believe paintings as real, but at an engrossing play he himself was simple enough to be swept into the action. When a form of doom threatened an actor on the stage, Remington quickly went out for a drink before the axe could fall, leaving his wife to report on the outcome. It was a

part of his overactive imagination that led friends to continue to describe this famous forty-one-year-old artist as boyish.

After seeing *The Crisis*, the stagestruck Remington developed a crush on Hackett's female lead. He told Shipman, "SAY BILL I'M NOT YOUNG BUT IF SHE ISN'T THE ONLY WOMAN LIVING I will take my hooks out and walk. If I hadn't been in love so often that it hurts I would get a divorce, hire a hack and steal that young woman." The "woman" was the beautiful Charlotte Walker, who was tall and slim with her hair in braids as she gently restrained the emoting Hackett in violent scenes.

Remington was aware that he owed Shipman for the chance to socialize with stars off the set as well as for the ease of transition from novel to play. Nevertheless, when Shipman asked for one of the original illustrations from *Ermine* as a present, Remington who was free with paintings to most associates acted shabbily. He wrote that "I have a pastel made over a print of John [Ermine]—you can have it with my compliments if you wave all claim to the other [one that was asked for]—if you don't you still have claims but not pastel—Savy." Shipman was not a risk taker. He accepted the hand-colored print.

Remington visited Shipman at his home to read the script in progress and was introduced to the Plainfield-Cornish-Windsor art colony along the Connecticut River on the border of Vermont and New Hampshire. Maxfield Parrish the painter said that Remington stayed with the Herbert Cralys, and Churchill said he went with Remington "for a day, over the hills." Remington liked the reception he received, saying after he had returned to New Rochelle that "I haven't yet recovered my senses after what you did to me up there. I don't really need an unknown mountain in my business but by God there is no use of my having money—when I do some guy always sells me something I don't want. Anything from a jigging horse to a naphtha launch will do—I used to be content with such things, but now its mountains. If a man is organized to be a d_____ fool he is bound to be Cornished sooner or later."

Remington expected to buy land in Cornish. He told Shipman that he would "run up" with his attorney "and get deed for Lizard Hill." Mason Wade who was Francis Parkman's biographer mentioned "a local legend" that Remington "acquired a lot of land" in the area, but Remington did not buy the Cornish mountain, not even in its diminished height as Lizard Hill.

While Shipman was writing the script, Remington was "working like hell," painting, touching up the wax for the third "Coming Through the Rye," and hanging over Shipman's shoulder. He did not

miss having given up on illustrating, but the illustrations never gave up on him. In 1903, for example, a large ad ran each week for months on the publication of a new set of Richard Harding Davis' works. In the upper left corner of each ad was the bucking bronco drawing that Remington had made eleven years earlier, the one that had inspired his first bronze. Smith and Wesson continued to advertise Remington prints. R. H. Russell brought out an Alfred Henry Lewis anthology with pictures from *Done in the Open*. These old illustrations edged forward in time until it seemed that they had just been drawn.

Western painting buffs like the humorist Irvin S. Cobb never realized that Remington had quit realism in his art, saying that "Remington wasn't any impressionist either," although in 1903 Remington had moved into exactly the painterly milieu that Cobb decried. He was a long way from his old professional associations with Kemble and Gibson, although they remained close personal friends. His more frequent companions now included six of The Ten, the prestigious American Impressionists who had in 1898 brought the Cincinnati influence to New York City and The Players.

He had pushed on to a higher level in painting, and he was not out of his element there. The home of J. Alden Weir who had been his teacher at the Art Students League was a focal point for many of the American Impressionists. Weir lived in Branchville near Ridgefield, Connecticut. Some of the leading painters came up from the city for a day of sketching or sport followed by good food, drink, and conversation about art. Childe Hassam was a regular visitor. So was John Twachtman until he died in 1902 and was replaced in The Ten by William Merritt Chase. Edmund Tarbell joined Remington and Weir on their "tramps," and they even entertained the expatriate master John Singer Sargent. "Metty" Metcalf was there, and so was "Bobbie" Reid, and sometimes Edward Simmons.

Remington's particular preoccupation at this time was still trying to catch night effects on canvas. His "A Reconnaissance by Moonlight" was selected for the exhibition of *Paintings by Contemporary Americans* at the Union League Club in January 1903. Three months later there was a *Special Exhibition of Recent Paintings by Frederic Remington* at the Noé Art Galleries on Fifth Avenue. The New York *Times* review was typical, holding that "these pictures are more notable for drawing than for color." The major art critic Royal Cortissoz was more discerning. He declared that "I have seen paintings of his which were hard as nails. But then came a change, beginning with his exhibition of night scenes, where a painter took the place of the illustrator's brittle pen drawings and blaring reds and yellows." Remington was finding his way to his own statement of Western light, see-

ing the night in clear bluey tones rather than the pastel tints of The Ten that were now accepted interpretations. The establishment's *American Art Annual* added the classification "painter" to his labels of illustrator and sculptor. It was a heady time for Remington.

As his emphasis was increasingly on new techniques in art, he had lost contact with the routine operations of the army. He no longer went West to visit cavalry units. Schreyvogel continued to make frequent Western tours, and the art establishment cited his growing experiences in designating him the "Painter of the Western Frontier." Solon Borglum was now said by some of the academics to be the leading Western sculptor, and the first to have modeled Western subjects. Remington was jealous of Borglum, too, pointing out that Borglum had been a student at the Cincinnati Art School when Remington modeled "The Bronco Buster" in 1895. He asked Bertelli to put his work in process under cover at Roman Bronze, without saying why, but the reason was to keep the models out of Borglum's sight. He suspected that Borglum like Schreyvogel borrowed ideas.

Remington was civil to Borglum personally. His real hate among artists was Schreyvogel, the professional "white hope" being promoted to unseat the self-made self-taught king of Western painters. Some of the critics, particularly those on the New York *Herald* that Remington came to abhor, on *Leslie's* where Remington had never offered to work, and on *Harper's Weekly* where the grudge existed, wrote that Remington's mantle had fallen on Schreyvogel's shoulders. It sounded as though Remington had died.

The Literary Section of the *Herald* for Sunday, April 19, infuriated Remington. The lead article was, " 'Custer's Demand,' Schreyvogel's Latest Army Picture. Artist Made Famous by 'My Bunkie' Produces a Picture of a Historical Event in Indian Warfare. His latest work represents the meeting between the famous Indian fighting general and other American officers, including Colonel J. Schuyler Crosby, with Satanta and other Indian chiefs." The article continued at length under a four-column photograph of the picture. A smaller shot showed Schreyvogel in a derby painting a posed soldier on his Hoboken roof, with the Palisades of the Hudson as the backdrop simulating the West.

The New York *Times* had called Schreyvogel a "beginner" in comparison with Remington but that did not soothe Remington's resentment in his belief that the establishment was lashing at him through Schreyvogel. He read and reread the *Herald* review. It had even attacked him in the area of his special pride by writing, "Noticeable as in all this artist's work are the horses. They stand out as if in high relief." Remington was the one who "knew the horse," not this dull

German pawn of his enemies. He stewed in his rage and after a week he boiled over, playing right into the hands of a newspaper where controversy meant circulation.

He wrote a letter to the editors of the *Herald* that was printed under the heading, "Finds Flaws in 'Custer's Demand'/'Half Baked Stuff' and 'Unhistorical' Are Frederic Remington's Comments/Officers' Arms and Accoutrements Taken as the Basis for the Artist's Attack." The *Herald* termed this "very sharp criticism and it now seems a question as to who knows the West best."

I saw in the Sunday Herald [Remington wrote] a print of Mr. Schreyvogel's painting called Custer's Demand—a so-called historical picture. I have studied and have ridden in the waste[land] and made many notes from older men's observations for twenty-three years and I would set down the following comments on that painting. While I do not want to interfere with Mr. Schreyvogel's hallucinations, I do object to his half baked stuff being considered seriously as history.

Remington then listed twelve specific objections to gear and adornments in the painting because the items shown were "not in general use until many years after," because of the wrong color or shape, because the horses were not "in the long hair" despite the snow on the ground, or because "Custer never rode a 13½ hand horse." He concluded that "the picture as a whole is very good for a man who knows only what Schreyvogel does know about such matters, but as for history—my comments will speak for themselves."

Remington's letter created a controversy in the surprised art world and in the army. "Custer's Demand" was a pleasant painting, stiff like all of Schreyvogel's compositions, a collection of individual equestrian portraits spotted on a static canvas. The picture was viewed tolerantly at Knoedler's in New York City, a quality gallery that had not yet accepted Remington's work. The *Herald* review had been read by some and dismissed by most, until Remington's unanticipated attack on the research-oriented Schreyvogel.

Two days passed while Schreyvogel would only say that Remington "is the greatest of us all." Then, he released to the *Herald* a letter from the General's widow, Mrs. Elizabeth Custer, that was dated four days before Remington's complaint. The *Herald*'s heading was, "Schreyvogel Right, Mrs. Custer Says/Widow of the General Impressed with the Fidelity in 'Custer's Demand.'" The purport of her letter, though, was to respond in detail to three of Remington's specific objections that had not yet been made when she wrote. She ended by referring to her personal relationship with the Schreyvogels, who had named their daughter after her.

The dead General Custer was a venerated idol at the turn of the century. Mrs. Custer was devoting her life to promoting her husband's glory. She maintained a wardrobe of Custer's old clothes and she circulated them like library books among painters and sculptors who were embellishing the Custer image. To her, Remington's letter was a challenge to the reason for her existence. She was prepared to retaliate with all the power of her impregnable position, and predating a letter was not beyond her.

Remington had never painted a serious picture of Custer and had no idea that the disingenuous widow was hoodwinking him by praising Schreyvogel for painting what she lent artists for the purpose. The *Herald* reporters showed Remington her letter before it was printed so that his apology could be carried in the same issue. He would have been better off if he had apologized, but he reacted without thinking. His response was a subhead to Mrs. Custer's endorsement of Schreyvogel, in the same *Herald* issue: "Mr. Remington's $100 Offer/Invokes Colonel Crosby's Aid as Expert on Trousers as Shown in the Painting." Remington stated that since Schreyvogel was "going to fly to the protecting folds of Mrs. General Custer's skirts," Schreyvogel was out of reach, but he was making the offer of a gift to charity if the still-living Colonel Crosby would confirm that the color of his pants in the picture was the color of the pants he wore.

Remington was sure that he was right on the details and he was counting on Crosby to rescue him. Crosby was regular Army, a New York Stater who came from Albany where he had known the Remington family in Republican politics. Remington had not talked to Crosby, however, and so was not aware that Crosby too was celebrated for his old connection with Custer and that he regarded the reference to "Mrs. General Custer's skirts" as an insult to her and to the Seventh Regiment. Besides, the painstaking Schreyvogel had also visited Crosby at the suggestion of the widow, to research the exact clothing worn, and had borrowed from Crosby the actual leggings but not the pantaloons that were shown in the painting.

Crosby's response to Remington's offer was the most polished paddling the artist ever received. "As Mr. Remington seems to suffer from his gratuitous criticism," Crosby declared, "perhaps it would be as well to put him out of his pain. I was present at the moment Mr. Schreyvogel depicts on canvas, and Mr. Remington was riding a hobby horse, which he seems to do yet." Crosby went on to agree with Remington on some details and with Schreyvogel on others. "On the color of my trousers," he added, "Mr. Remington is absolutely correct. They were not the shade of blue depicted in the picture; they were blue, but not that shade." He closed with the crusher, "Of

course it must be very annoying to a conscientious artist that we were not dressed as we should have been, but in those days our uniforms in the field were not changed as regularly as Master Frederic Remington's probably were at that date." Crosby's letter was printed in the *Herald* May 2 and it ended the two-week tempest.

Remington knew he had been hornswoggled on his corrections to "Custer's Demand," but his hands were now tied. The closest he came to an apology was a note to Crosby that said, "I dont mind your 'wooling' me [roughing me up]. I venerate the memory of Genl Custer and wouldn't offend Mrs C on my life. That is why I pulled in my horse because I dispise Schreyvogel." Crosby sent the note to Mrs. Custer as "Further Schreyvogel information—Please keep confidential." She read this as "For Mr. Schreyvogel's information" and sent it to him.

The end of the episode for Schreyvogel came in November. He was invited to the White House to meet President Roosevelt while "Custer's Demand" was on exhibition at the Corcoran Gallery. As he wrote to his wife, "My dear Schnuck:— The President said, 'What a fool my friend Remington made of himself, in his newspaper attack, he made a perfect jack of himself, to try to bring such small things out, and he was wrong any way.' The President seemed to be posted very well, he must have followed up all the newspaper articles. [signed] Schnuck. P. S. Don't tell any one about Remington, I mean what the President said."

The question that remained was not what the President had told the one Schnuck but why the *Herald* puff of "Custer's Demand" had led to such Remington impetuosity. Schreyvogel was demonstrated to have been an intensive researcher, which Remington certainly was not, but compared to Remington, Schreyvogel proved to be a painter for one season, a season that Remington had passed. Yet, because Remington's jealousy overcame his common sense, he made a futile and foolish stab at a popular rival with powerful connections, not in an unpremeditated manner but after the passage of a week. He had nothing to gain from the attack, and he had the economic opportunity of his artistic lifetime to lose in the form of a contract being negotiated with *Collier's*.

George Wharton Edwards had not been able to buy a Remington picture for publication by *Collier's* since September 1902. Remington feared that if he sold pictures to a magazine for conventional reproduction, he might still be classified as an illustrator. It was up to Edwards and his publisher Robert Collier to arrive at a solution. While Edwards and Collier were trying to figure out how to publish art that would not be an illustration although it would be appearing in a com-

mercial magazine, Remington was acting "the jack" with Schreyvogel, and Collier might well have concluded that so rash a man might be too argumentative to manage as his feature artist. Edwards prevailed, however, and a letter agreement was prepared as of May 1, 1903, handwritten by Collier on his personal stationery the day before Colonel Crosby's riposte. The stipulation was that Remington would choose his own Western subjects to be printed in full color, without connection to any text and without dictation from *Collier's*. The magazine would select at least one painting a month at five hundred dollars a painting for a minimum of six thousand a year, later increased to a thousand dollars a painting and twelve thousand dollars a year. The minimum annual payment was less at first than in the *World* agreement, but for fewer pictures. It was the commitment to color, the key to easel painting in Remington's mind, that was the clincher.

The contract was to be for four years, with originals to be returned to Remington, prints to be issued by *Collier's*, and an option to *Collier's* on any future Remington writing. One additional provision was granted as a sop to Remington. In the event of a war, it was agreed that Remington might serve as a foreign correspondent for *Collier's*. *Harper's Weekly* was running articles on the inevitability of war between Russia and Japan over Manchuria and so were the newspapers. Remington wrote Bigelow, "I hear a good deal of Jew comment in the Herald about Russia going to War with Japan or England or someone—I dont think they will but do you? Answer me that." After this eruption of old bigotry, he boasted to Shipman that "for me, oh nothing but Japan and Manchuria—that is their idea of where I belong. There is no use of having a comfortable home in these days. The Lurking Powers pull you out of bed & say 'go get full of bullets & typhoid.' "

Remington knew, as did Bigelow and Shipman and Collier, that he would have neither the will nor the body to make the Manchurian trip. Besides, he had grandiose plans for series of paintings that would appear in the magazine to astound the public with their color and content. He told Shipman that "no one sells paintings anymore" at exhibitions, "we do them to keep our hands in, so we can draw for Collier's."

He left for Ingleneuk earlier than usual in the spring of 1903 because he was afraid that the summer would be interrupted by the *Ermine* play. Robert Collier, who summered sometimes in the West and sometimes in the Adirondacks, agreed to meet Remington in Ogdensburg to consummate the magazine contract. Remington's friend John Howard took charge of the arrangements. Howard had heard that Collier had doubt about Remington as a reliable man to deal with so

he lectured his pal on the need to act conservatively and to stay sober. Howard was an officer of the Century Club in Ogdensburg, a social club that proudly displayed the "Charge of the Rough Riders at San Juan Hill" as a loan from Remington. Howard ordered lunch for the group at the Club and had Remington come in from Ingleneuk the night before to sleep at the Club so he would be under control. Waiters and room service were cautioned about keeping liquor away from Remington.

At the lunch, everyone but Remington ordered his usual drink while Remington with Howard's approval called loudly for plain seltzer water. When the drinks were repeated, Remington stuck to his water glass full of plain seltzer. The discussion of the contract's terms changed to talk about the West. That meant more drinks and more plain seltzer water, and it was not until months later that Howard discovered that Remington had made his own arrangements on the plain seltzer water. His drinks had really been half seltzer and half gin.

When Remington found that the Ingleneuk dock had heaved during the winter, he hired local boys to work in the water to repair the supports. Soon, the boys were out of the water, sitting in the sun, claiming that the "water's mighty cold." Remington called them sissies. In his white flannels, he walked to the end of the dock and jumped in, then climbed out of the frigid river as fast as he could. He took the boys back to the house with him and fed them while they warmed up. There was no indication that Remington missed having children, but he was always considerate and unpretentious with young boys.

Another job he found for the local boys was to rid Ingleneuk of its toads. He paid the boys five cents apiece to catch the toads and release them on the mainland. The boys held the captured toads in a box for a few days and then brought them back to the island so they could pretend to catch them again. Selling the same toads to Remington five or six times gave the boys great pleasure, and it was a cheap price for Remington to pay to get a good story to tell at the Century Club in Ogdensburg.

He said he was "working like hell here on stuff which I cannot neglect," paintings to be shown to *Collier's*. His regimen was as it had been, and so was his relaxation. John Howard was a favorite tennis opponent. That was the year that Remington invented a suction stick to pick up the tennis balls. He could not bend comfortably. He was too fat.

In June, Remington had asked Shipman, "Whats the prospect of your wanting me in New York. If I come down I want to kill two birds (some bronze work I have)." He was in Brooklyn July 6 to retouch the first wax for "The Mountain Man" that was to be

copyrighted as "man on horse coming down mountain side. Man fitted out with traps, knife, gun, cup, powder horn." Remington's ninth sculpture in nine years, "The Mountain Man" was offered in Tiffany's for three hundred dollars, along with "The Bronco Buster" and "The Cheyenne" at two hundred fifty and "Coming thro' the Rye" at two thousand. "The Wounded Bunkie," "The Wicked Pony," and "The Triumph" were no longer listed, sad failures in view of time invested, but eighty castings were sold of "The Mountain Man."

Remington said that "the Mountain Man I intend as one of those old Iriquois trappers who followed the Fur Companies in the Rocky Mountains in the '30 & 40'ties." The model for the sculpture had been an unusual choice, even for Remington. He had invited General Wood to bring his horse to New Rochelle to demonstrate equine leg motions descending a slope. The visit took place as Roosevelt was giving Miles a cold farewell into retirement and nominating his friend Wood for the vacancy ahead of senior officers. Roosevelt distressed the regular army staff on both counts.

While he was in Brooklyn for "The Mountain Man," Remington also went to The Players to review the completed script for *John Ermine of the Yellowstone* with Shipman and Hackett. The play seemed fine to him. He provided ideas for costuming and went back to Ingleneuk when rehearsals began. During the rest of July he wrote detailed notes on robes for the Indians, shirts, Stetsons, and boots for the soldiers, and how the races wore their hair, before concluding, "whats the use—you stage people dont care what was worn by the people of a period. You will have your cavalrymen wear boots up to their asses." He could see the joke in the whole rigamarole. "Get grey shirts on those soldiers and grey hats me boy," he told Shipman, "or you'll have Schreyvogel knocking."

When he was needed for consultation, he tried to get to Shipman in Windsor, but "the rail road management seem never to have thought that a man would want to go from Ogdensburgh to Windsor & vica versa" without "days of sorrow and nights of anguish." He asked Shipman to come to Ingleneuk with his wife to "go over the play under the beautiful environment which I have here." "Brace up," he said, "& bring your tennis racket and I will show you that painting is greater than the Drama by Gee," but it was no easier for "Gee" (Shipman's nickname) to go from Windsor to Ogdensburg.

Painting at Ingleneuk in the summer of 1903 was as "great" as the relaxed Remington claimed. More and more, he was trying out techniques of Impressionism in landscapes. He was also formulating theories to go with the paintings. "Big art is the process of elimination," he said. "Cut down and out—do your hardest work outside the

picture, and let your audience take away something to think about—
to imagine." The trick was to stop the action in an event before its
conclusion. "Then your audience discovers the thing you held back,
and that's skill."

Just before dark, he would paddle out on the river. "Seems as if I
must paint" sunsets, he said, "but people won't stand for it. Got me
pigeon-holed in their minds, you see." The trick, he felt, is that "you
want to get away from everything civilized. White man spoils nature
by trying to improve on it. The march of the derby hat around the
world is answerable for more crimes against art than a hundred wars."
Just after sunrise the morning before he left for Endion, he paddled
out behind the island and painted a sketch of his boathouse and the
white rocks and green pines, "to take some of the light and water
home with me to look at this winter."

In New York, *Collier's* agreed to the pictures to be reproduced in
color. The series started September 26, 1903, with "His First Lesson"
that had been exhibited at Noé, a peaceful genre scene of the
workaday cowboy and his horse, painted with Remington's version of
an Impressionist palette based on earth colors. The second picture was
the "Fight for the Water Hole," another surround that rekindled the
enthusiasm in all of the Remington fans, the "boys between twelve
and seventy." The Chief of Police in Abilene, Texas, asked Remington
which one of the defenders in the picture had described the scene to
him because the Chief said he remembered the actual site in the make-
believe fight.

In adapting *Ermine* for Broadway, the problem became one of
achieving the same kind of reality in make-believe that Remington
found in "Fight for the Water Hole." After seeing a rehearsal, Rem-
ington's message to Shipman was, "Do persuade Hackett to be a real
John E and cut out the old world curves." This was the start of an
awareness that the stagey Hackett would never be a believable Indian
or plainsman. The catch was that the writers had the obligation to
provide a vehicle that fit the actor. He owned the play.

The first tryout of *Ermine* was the week of September 14 in Boston
at the Globe Theater which belonged to the vaudeville team of
Weber & Fields. The opening was a social event. The Governor of
Massachusetts attended. Remington did not, but he reserved seats for
the Summerhayes who were living on the island of Nantucket. They
set sail at noon, snatched supper at a hotel, and were late for the cur-
tain. There before them on the stage sat Hackett, not with Ermine's
long yellow hair but looking well-groomed like a parlor Indian. They
thought the play "was too mystical, too sad, better suited to the 'New
[experimental] Theatre' patrons."

Remington was in New Rochelle complaining to Shipman, "Why don't you tell me what is happening—I should like to see the Boston notices &c—you are such a lobster Louis—it's out of sight out of mind with your frivolus nature." The reason Remington had not heard was that Hackett and Shipman were wholly occupied in trying to decide what to do. The play was not working. Hackett was not right for the serious tone that Remington had pushed on Shipman so the tone had to be altered. That having been decided, Shipman called Remington to Boston. The theater stopped being fun.

After a week in Boston, Remington was home again and wrote Shipman, "You d_____ people nearly killed me—the Doctors are working but I fear the '*worst*.' I know that you people do not understand a bed." He told Martha Summerhayes that "the long rehearsals nearly killed me—I was completely done up and now I am in the hands of a doctor. Imagine me, a week without sleep." She had questioned the appearance of the counterfeit Indian, and Remington responded, "I fought for that long hair but the management said the audience has got to have some Hackett—why I could not see—but he is a matinee idol and that long with the box office." To avoid the onus of the experimental theater, he confessed that "we may have to save Ermine. The public is a funny old cat and won't stand for the mustard." Remington's original symbolism in the novel had been the classic confrontation of the alien who was Ermine and the snake who was the girl, the savage West and the corrupt East. He compromised the symbolism, giving in to the superior theatrical authorities the moment that Hackett and Shipman decided that the original plot was elitist.

Three weeks after Boston, *Ermine* was in Chicago for the second tryout. The reviewer for the *Evening Post* wrote that "in Boston Ermine died. Now he lives, and it requires no far stretch of the imagination to hear wedding bells in the distance. That is where the debate comes in. The public insistence upon a cheerful, rather than a logical close has made the playwright alter his story. But it is inartistic, absurd." The reviewer also talked of "waits and rough spots." They were up to Shipman to repair. Remington wrote Shipman that "my money is on you. If you fail me Gee, Hackett and I will come up there in the dark of the moon and we will sink your dead body in the deepest darkest eddy in the Connecticut river. We want the last bit of running there's in your hams out of you. Get 'ap—vamoose—get to hell—go it you son—and action action—not a ladies dress which has been stepped on but ACTION." The "blood" painter wanted a "blood" play.

John Ermine opened in November at the Manhattan Theatre in New York City. The plot had come full circle: "Ermine is accused of

murder, but his innocence is finally established, and he wins the girl for his wife." Shipman had pasted a smile on the end of the innately tragic confrontation, while the beginning was still set to cry. Remington did not object: "Old Lady and I & the Kembles saw John Hackett in matinee today and the whole thing ran as smooth as a marriage dream. D_____ the Stage—its now an Art—its Business—Oh well." In his mind, John Ermine and James Hackett had merged as "John" Hackett. He told Bertelli at Roman Bronze, "Have just emerged from the horrors of the stage—'John Ermine' has hit the boards and now we must [get back into] bronze or we wont have anything for the winter."

In a short four weeks, though, *Harper's Weekly* carried *Ermine*'s obituary. "James K. Hackett as John Ermine of the Yellowstone failed to draw in New York." The trend had reversed and "the dramatized novel was blamed for many of the disasters of the season," including this one. Emerson Hough, a Remington antagonist, accused Remington's "bad verities," not understanding that the changes he disliked came from Hackett. Remington said a year afterwards that the fault was with the public which "don't want to know anything about the Indian or the half-breed, or what he *thinks* or *believes*. What they want is a back yard and a cabbage patch and a cook stove and babies' clothes drying beside it." That was in reference to the 1904 hit *Mrs. Wiggs of the Cabbage Patch*.

The failure of *Ermine* rankled. Remington had lent himself unstintingly to the production and had placed himself in the hands of proved craftsmen. He had thought the play a hit when the "bad verities" the theater called for made *Ermine* mediocre. There were a few later road tours, but Remington's gross earnings from the play were only a few dollars more than the advance. In three years, when Remington listed his artistic accomplishments he did not include either the novel or the play.

31.

Why Why Why Can't I Get It

Remington was not one to blame a friend. He was as close to Shipman after the *Ermine* fiasco in the Manhattan Theatre as he had been before. They saw each other frequently and often exchanged letters. Shipman shared his interest in the stock market so Remington could ask him, "What do you think of us poor painters and 'steel' at 11¼." He claimed to be poor when steel shares were a good buy.

His personal stockbroker was his neighbor Jennings Cox of "Shingaloo." In 1899 he had handed Cox $500 to invest for him, taking his "loss when that was made—'Standing and in silence.'" Five years later, Cox sent him a check for $787.63 as "the money *made back* in just the same way it was *lost*—namely, by the buying of certain stocks and then selling them out at a profit." Remington could buy steel at 11¼ without funds, when he had New Rochelle friends like Jen Cox who were protective of him.

These friends were not the hangers on who surround any celebrity. Some of them like Gus Thomas were stars, too, and yet they were concerned about Remington as a person. When Remington visited a new osteopath for treatment of back discomfort on a Sunday morn-

ing, Thomas went along. He walked into the examination room to see
the mammoth artist strip and get himself onto the table. Remington
lying on his stomach was an impossible size for the slight doctor to
manipulate. The smaller man put a chair alongside the table, climbed
up, and eventually sat astride Remington in order to obtain the angle
of pressure needed for the treatment. "I hope I'm not hurting you," he
said to Remington, and Thomas heard the muffled reply as, "It's all
right, Doctor—so long as—you don't—use your spurs."

Thomas and Cox had been Remington's cronies for a dozen years.
In that time, his fame as artist and author had skyrocketed, while his
physical powers had diminished as he became obese. By 1904, much
was being made of Remington's talent and his wit, but his vaunted
strength had dissipated to the point that his buddies were concerned
about his health.

As Remington's oldest friend, John Howard was as protective as
Thomas or Cox. Howard was president of the coal company in Og-
densburg and an investor in banks, the railroad, and manufacturing
companies in the course of accumulating "a generous portion of this
world's goods," but his scope was local. When he looked through
Harper's Weekly and saw a drawing of a social function at the White
House, he knew that Remington had either been there in his role as
Roosevelt's representative of the arts or Remington had turned down
the invitation because he preferred to stay home. Remington was rou-
tinely invited to the launching of battleships and the opening of plays.

What Howard wanted was to have shine on him a little of the light
that reflected from Remington and he was willing to put himself out
to accomplish it. As the year 1903 was ending, Remington told How-
ard that he had been in the studio as long as he could stand it without
a break. He needed to blow off steam and he asked Howard to go
with him on a Western trip. The proposal was to take six weeks in
Mexico to rest and to paint, and, implicitly, to drink in quantities that
were not permitted at home.

They left on New Year's Eve and arrived in Mexico City January 5,
1904, registering at the Hotel de Palacio which was "much better than
the old place Jardine" because "they have a new sewer system here
and bath rooms thank God." Howard's friends in Mexico City had
them in a "perpetual row—not a moment to ourselves" and saw to it
that Remington's "awful fears of terrific bills flatted out" and would
be "very decent." Howard had "a bad cold & I a little dioraheia but
nothing remarkable."

Before they could get settled into Mexico City, another Howard ac-
quaintance who was superintendent of the Mexician National Rail-
ways hustled them into his private car that was hooked to a special

train used to pay section hands. Right after a Sunday bullfight, they were off on a nightmare railway ride, seeing the mountains from the car windows, stopping at every crossroad to pay the section men, eating where and when they could, and sleeping in the car on sidings in nameless towns. They were moving so fast that there was no chance to sketch. Remington said he was "resting up if we can call this constant jaunting around resting. It is mental rest but not physical."

After ten days of drinking local liquors on the train, Remington was lethargic. The alcohol had let him unwind, but Howard was getting worried about Remington's condition. He said he was "in a hurry" and "must maneuver to get home," so they skipped the planned tour of Guadalajara and the Pacific to head for Chihuahua to meet Jack Follansbee. Remington declared that "one cant paint and jaw around as we have been doing." One thing Remington needed Follansbee for was to find a laundress for his dirty clothes: "The Mexican women take it down to the river and beat it on a rock—making holes of various sizes in it."

At Chihuahua, both of them had "bad throats and I suddenly was taken with a violent dihorreha so went to bed." Follansbee was there, promising to provide "punchers to paint" for a week. To Follansbee, this was a disappointingly different Remington, very fat, covered with the native soil, and not writing or illustrating. Follansbee's ranch was too far for the travelers to reach easily so he showed them around the Chihuahua area, replenishing Howard's "plunder" that had been stolen on the train and finding opals for Eva Remington at less than tourist prices.

Howard was "getting 'homeward bound' pretty fast" and so was Remington whose telltale was his signature on the letters to his wife. The closing line ebbed and then flowed in warmth relative to the length of time he had been away. He started as "Love Frederic R" and faded to "Yours Frederic" and "Yours Frederic Remington," before going back up the uxorial scale to "Lovingly Frederic," "Yours lovingly Fred," and finishing with the slurred "Y_____ Fredrc." As he was lionized he became pompous even to his wife, but when he was going home at last, he was "Yrs Frs." He was back in Endion by February 1, ten days sooner than expected, but at the end of Howard's tolerance and without sketches to work up into pictures.

In 1903, Remington had produced paintings on schedule for *Collier's*, despite Robert Collier's fears, and public reaction had been overwhelming. The plan for 1904 was to reproduce the twelve major pictures that had been contracted for, one a month except that January would be omitted in favor of two issues in December. Although the Old West had already been superceded by the Ford automobile,

the flight of the Wright Brothers, and the Russo-Japanese war, Remington's concept was to roll back time to paint Western history. The first series was to be on the settlement of the Louisiana Purchase territory, to tie in with the Louisiana Purchase Exposition in St. Louis where "Off the Trail" was featured. The story line was necessarily tenuous, but the result was a major historical essay in paint. The opening scene was of the pioneers in riverboats on their way to homesteads in the new land while peaceful Indians watched. As the white population increased, settlers were supplied with goods by traders. The trappers with their boisterous gatherings were forced out. When the Indians resisted the pressure of the emigrants, the military was introduced. Ranches were established, with packtrains serving remoter outposts. Cattle were driven to the railway termini and stagecoaches were used for points between rail lines. The series concluded with "The End of the Day," symbolizing the end of the era.

The subjects of Remington's Louisiana Purchase paintings were so basic that today they would do for a child's primer on the opening of the West, but the composite pictorial theme was immense in 1904. The paintings, eagerly awaited when they were new, have been so copied over the years that they have become graphic stereotypes, like stills from cowboy movies. As Wister's *The Virginian* set the style for the Western novel, so Remington set the art.

In technique, he retained his central figures as semirealized, with only the important faces detailed. The backgrounds had become loose patterns, with the landscape sometimes identifiable, generally not. The daylight colors were muted, no longer garish, and edging toward the palette of The Ten. The gems were the nocturnes. Remington was dipping his toe deeper in Impressionist waters. Because he was a successful innovator with the greatest exposure among the painters of Western art, he was again popularly and critically recognized as the leader. Both The New York *Times* and the editor Charles De Kay called Schreyvogel his follower, along with Charles Marion Russell.

Charlie Russell was a painting phenomenon. He went West as a working hand in 1879, before Remington, and was entirely self-taught as a painter. As an experienced participant in Western life, he was more natural and less sophisticated than Remington. In 1904, he was in New York, hanging out in the illustrator Will Crawford's studio, meeting a lot of Remington's friends among the writers and actors but never Remington himself.

Russell had the reputation of not criticizing the work of others, but on a hunt with a pal he was in a cabin where a Remington print hung on the wall. The scene was an old-timey trader riding at the head of a packtrain down a mountain trail, holding his rifle in both hands across

his horse's withers. The title was "In the Enemy's Country," and Russell pointed out the flaw in Remington's logic: If the packtrain was "In the Enemy's Country," "then why the hell did he leave that God damn bell on the lead horse's neck?" What Russell did not realize was that the publisher of the print he saw had changed the title from tranquil to warlike. When the painting was originally reproduced in *Collier's* on August 13, 1904, Remington had called the picture the peaceful "The Bell Mare" to reflect the dreamy nocturnal composition.

Although Remington had put his best foot forward in *Collier's*, he was unconcerned about his 1904 exhibition at Noé Art Galleries. He handled the show as if it were a retrospective or an auction to clear out his unsold stock. The ten old paintings covered fifteen years, starting with "The Last Lull in the Fight." Consequently, the reviews emphasized the "strong colors" he had stopped using rather than the new pastel tints and did not advance his reputation artistically. He had not learned to cull out the pieces that were no longer representative of his current direction.

Eva Remington never became part of his art, nor did she develop a chain of friendships the way her husband did, but in 1904 she began to go off on her own, even when he was home. Her aggressiveness piqued him. In May she was on Nantucket Island visiting the Summerhayes. Remington wrote her a brave letter: "Foot troubled last night but is better this morning although I lay in bed until postman had gone. Saw Doctor and he says I'm good for a week before I get a shoe on—everything lovely—planting potatoes. Have a good time and no news is good news." The signature was Y——— Fredec R." His foot trouble was gout and he knew that she attributed his condition to excesses on his Mexican trip. He had earned little sympathy.

He told Shipman what the condition was really like. "I am just down stairs: Have been in bed with inflamtory hell in my right foot for a week. Its the most trouble I ever had. When the horse busted my other leg that didn't hurt if I kept it still but this son of ——— would fire anyhow. They told me what my course of life would lead to but they plum forgot rheumatic gout—its water wagon & mutton broth for me hence on. I tell you Louis its as near hell as a man can get without jumpin' off."

What upset Eva Remington was that despite his vulnerability to alcohol, the water wagon did not hold him. He confessed his weakness to Dan Beard:

I did most d——— faithfully burn the candle at both ends in the days of my youth and I got the high sign to slow down some little time since. Therefore I have cut out the "boys"—God bless 'em for I find them just as

irresistable as ever despite all I know. I always loose my bridle and when I get going I never know when to stop. If there is any thing in the world I love it is to sit around the mahogany with a bunch of good fellows and talk through my hat—I like it a lot better than it likes me.

Yet your appeal goes to my heart (my head bids me harden it) but I must say I will try to line up for present or accounted for. Just figger Ill be there.

Mark me down, on your dinner list. Here's how you bully old Dan.

Ancient habits died hard, and they toughened Eva Remington's heart. When she was in Gloversville, he told her, "Dear Kid/Everything all right here (except this ink). D_____ lonesome here. I was 102½ [degrees of temperature]. Yur—Fred. Buy a bottle of ink Friday." The fever got him as little sympathy as the foot.

Gout and fever did not prevent Remington from painting but they restricted his field studies. From Endion, he told Shipman, "Ho! for the Yellowstone—the drama has gone to hell—lend me a cigarette. Have been painting Jersey cows all day—getting ready to do Texas Longhorns because they have the same color." The gout also kept him from going to Brooklyn to complete two new bronzes in process and to retouch waxes for existing bronzes. By the time he could get around, he had "to finish 5 models" of "The Mountain Man."

His illness abated by June 1. Eva Remington had returned to Endion and they went up to Ingleneuk where he expected to paint the twelve pictures for *Collier's* in 1905. He hired a high school boy, as the other cottagers did, to row to the boat landing on Cedar Island to get the mail and buy the staple groceries, to sweep the veranda, and to do the casual labor. For Remington, the boy also had to serve as a model.

His regimen was as it had been, up about six, put on his bathing suit and plunge into the river before breakfast, eat heavy servings of meat and potatoes for his first meal, and then retire to his small studio that was on the Canadian side of the island five hundred feet from the house. The entire morning was spent painting. Then came the corned beef hash that he had started eating every day for lunch. After three, he quit painting and took a swim. For guests, he would throw a cork onto the river and while it was bobbing around shoot it to pieces with a .45 revolver. In the late afternoon, he went out in his canoe even if the waves were high, or played tennis. The gout was gone and he played tennis as an expert, active on his feet considering his obesity. In the evening, his wife's definition of "on the wagon" allowed him a quart of liquor, a quantity that had no "pronounced influence" on him.

Two new bronzes were copyrighted while Remington was at

Ingleneuk. The first was "Polo," a "group of three horses and riders in game. One horse had fallen and rider is caught under him." The wax had been finished in May but casting this sinuous statuette had taken Bertelli two months. On July 15, the week before the copyright issued, Remington told Bertelli he was "crazy to see *Polo*." The next day, however, the Remingtons "suddenly concluded to leave on a trip to New Foundland for two weeks." They went to Ogdensburg to connect with the Canada Steamship Line that ran big three-deck excursion liners down the St. Lawrence River to its gulf. Remington "saw nothing worth while. I guess I am getting to be an old swat—I can't see anything that didn't happen twenty years ago." As soon as he returned, he asked for a photograph of "Polo." He became impassioned, bragging to Shipman that the group had the Cornish sculptor St. Gaudens "whipped to a creamy foam." Boasting was not enough, however, for the public that expected Western or soldier subjects. Only six castings were sold, at a thousand dollars each.

The second bronze engendered no such fervor from Remington. The misspelled description was, "Bust of Rough Rider Sargeant, height 10 inches." Bertelli had suggested such a small simple casting as an "easy ford" for buyers not ready for a major piece, just as Remington had said that his father's religion Universalism was an "easy ford" for converts to cross to Christianity. About four hundred "Sargeants" were sold at fifty dollars each, producing more than three times "Polo's" revenues, but Remington did not think enough of the bronze to make a present of one to President Roosevelt, the original Rough Rider.

When the Remingtons went home to Endion in the fall, he continued painting at his more contemplative pace, determined to learn new ways to color the American West. He also took up the modeling that he had abandoned for the summer, hoping for a commission for a monument to prove himself as a sculptor.

The holidays were difficult for him. Right after Thanksgiving in 1904, he took off again on a most unusual junket. At the invitation of Fred Gunnison, the Canton boy who had become a Brooklyn banker, he joined a bankers and brokers convention on The New York and Cuba Mail Steamship Company's *S. S. Morro Castle* bound for Havana. He was the darling of these monied men, a famous artist as rich as they were who knew the same people they did and who even looked like the most fastidious of them. His careful tailoring was designed to disguise his fatness and to cast him in the banker and broker image, a sedentary type overindulging in de luxe surroundings while favoring a gouty foot.

Remington said that "the boys play *Bridge* from morning until

night, Jen Cox among them. They have a scheme to get some Cuban bonds and I am to have some—it seems a simple form of business hold-up." The plan was to end the tour in Santiago where Remington expected to sketch "and then *Home for me.* Am having a grand time with very big financial people—which gives me a new idea or two. Cant write with these g_____ d_____ Spanish pens which have either one or three nibs." The ideas were how capital makes earnings, not about art. Cox stayed on in Santiago with The Spanish American Iron Co. and Remington wrote to him after he returned to Endion: "Had Fred Gunnison in the other day. I was intent on buying some thing [stock] but they told me to go back to the nail press, that John Rockefeller was not needing any suckers money just now. Its a great thing to have friends among the Frenzied.—"

Remington's excess funds were coming from his expanding earnings from art. On January 16, 1905, Knoedler & Co. exhibited nine of his bronzes, giving him a sculptor's showcase for the same statuettes that the critics had called handicrafts when they were in Tiffany's window. The only bronzes that were missing from the show were the two limited editions and "The Wounded Bunkie." "The Wicked Pony" was restored to the sales list and the new bronze for the show was "The Rattlesnake" that was copyrighted two days after it went on exhibition. The description was "cowboy on bronco. Rattlesnake on ground ready to attack horse. Horse shying and in a position denoting fright."

"The Rattlesnake" was Remington's favorite. Bertelli said that "Fred was really pleased with it. He felt that it fulfilled his desire for faithful realism and fine artistic rendering." The price of the statuette was $325 and 125 were sold. Remington told Cox that "I hit em for a few this season. Had a good bronze show. The Corcoran bought two groups, thus giving me a brevet before death." These were "Coming Through the Rye" and "The Mountain Man," the first of his statuettes to be acquired by a museum.

In March, a "Special Exhibition of Recent Paintings by Frederick Remington" opened at Noé. The pictures were mainly from the 1904 *Collier's* series on the settlement of the West and the leading critic of the day, Royal Cortissoz, wrote Remington a personal letter to say "as a friend what I shall presently be saying as a critic. So full of life they are, and oh! so rippingly painted! I wanted to find you, to slap you all over that mighty back of yours, to ask you if it isn't great sport to be alive and doing work like that, making something beautiful that no one else could make. More power to your elbow." *The Artists Year Book* for 1905 even dropped the reference to Remington as an illustrator and deleted his membership in the Society of Illustrators in

favor of the U. S. Cavalry Association, a memorial to Powhatan Clarke.

A few knocks came with the brevets. Samuel Isham was a graduate of the Yale Art School who had later studied in France and was in line to be named a National Academician. He wrote from the Academicians' viewpoint, maintaining that Remington was still "an illustrator rather than a painter. The subject is more to him than the purely artistic qualities." That was the old objection to all genre painting, coming from a Yale painter who had to have been miffed when old Professor Weir called Remington Yale's greatest art graduate. The Isham criticism was substantially true, though, and Remington took it to heart, despite the otherwise overwhelming applause. The time had come to examine just where he stood in painting and sculpture, and what his goals were.

The March 18, 1905, issue of *Collier's* was the "Remington Number," the greatest triumph of all that year, and his desire for self-appraisal was made easy. The entire magazine was given over to a compendium of Remington's art plus an insider's peek at the artist, his work, and his life story. The cover was a pastel of a most engaging mounted Indian in full color waving his right hand with its abbreviated ring finger. The frontispiece was "An Apache Scout" in black and white. Full-page 14 was "Amateur Rocky Mountain Stage Driving" in black and white, followed by "The Map in the Sand." The feature of the issue was the centerfold, "Evening on a Canadian Lake" in full color. *Collier's* advertised a press proof of the centerfold for two dollars with a print of the cover one dollar, as "splendid" reproductions for the den or the library. Another full page was "Frederic Remington—Sculptor" with photographs of four bronzes.

The whole issue was one big sales catalog for the artist. The five paintings that were shown were all copyrighted in 1905 and available for purchase through Noé. The statuettes were on display at both Tiffany's and Knoedler's. And, to clinch the sale of the art, the top of page 13 was "Remington—An Appreciation" by Owen Wister, reprinted from *Done in the Open.* A photograph of Remington showed the 1905 man, absolutely poised as he stood with hands in pants pockets of his four-button single-breasted custom-tailored suit, a barbered and shod Easterner with the only discordant notes the Indian artifacts on the studio mantel behind him. Below the photograph was a half page of puff by Charles Belmont Davis, the brother of Richard Harding Davis. This was verbal garnish more exaggerated than Wister's, the tale of the "man at whose birth the good fairies gathered," who "watched this throbbing, full-blooded life of the prairie fade away into history," and who arranged it so that "his greatest

admirer must search in vain through all the artist's pictures and bronzes for a petticoat."

Surprisingly, there were two new notes in Charles Davis' passionate text. "Remington once took a course in the French language," he declared, "and when it was all over he admitted that he had learned to pronounce correctly only three words—'Oui' and 'Boussoud-Valadon,'" the name of a worldwide art dealership that was far too grand a resource for an artist of the American West.

The other news was that the Remingtons would "once more take up the trail" and move. "The town of New Rochelle is gradually encroaching on the view from his studio windows, and a millionaire has erected a palace on the very next island" in Chippewa Bay. "He is going to a big place of his own, where the commuters will not crowd him by winter or the millionaires by summer." That "big place" was once more to be Cornish.

The trouble with New Rochelle was part civilization and part the lack of companionship of artists whose work he admired. Illustrators lived in and around New Rochelle. Painters were in Cornish. Remington asked Shipman to see "if you can find a good place for me within four miles of Windsor," closer to the train than Cornish. What he wanted was "an old farm house that I could fix over," but it soon occurred to him that Windsor/Cornish was the center of the academic artists, some of the ones who were keeping him out of the National Academy, and for that reason he again decided not to be "Cornished."

Collier's "Remington Number" had bits of commerce, too. Remington Typewriter ran a full-page advertisement that was clever merchandising, the manufacturer attaching itself to the artist's coat tails. Also, the Acme School of Drawing in Kalamazoo, Michigan, held out Remington and his "$50,000 a year" earnings as an example of what students could accomplish if they enrolled in the Acme correspondence course. The sum was inflated, but only by doubling.

By mid-spring, Remington could not wait for the Ingleneuk ice to break up. He arrived there in late May. By August, however, he was bored, as he had been the previous year. "In September," he said, "I go back to Dakotah to paint," and by September 17 he was in Omaha, Nebraska, posing for a photograph. His traveling companion was Henry Smith, a New York lawyer who joined in Remington's nostalgic journey to touch the old Indian War bases. They began by having dinner at Fort Robinson with Carter Johnson, who was in charge of the army post. They then backtracked to Chadron where they outfitted a wagon party, hired drivers, and drove north to Hermosa, South Dakota, in the Bad Lands. This was Remington's return to the Cheyenne River where he had celebrated Christmas with Lieutenant

Casey fifteen years earlier. He rode the wagon, camped out without complaint, and never mentioned the Casey connection.

He was back in New Rochelle in time to see the advance sheets of his novel *The Way of an Indian* serialized in *Cosmopolitan* starting November 1905. Hearst had finally purchased *Cosmopolitan* as his magazine, allowing him to publish the story he had acquired through R. H. Russell in 1900. *The Way of an Indian* was of the same historical period as *John Ermine,* in the same place, but told from the Indian side rather than from a bridge between the races. It was Remington's most effective and developed fiction, but not commercially successful. When the illustrations were delivered from Hearst's warehouse to the *Cosmopolitan* office, though, the editor said that they were "stuck up around our desks and leaned against our walls" as a "triumph of American illustrative art." It was another slippage for Remington, to have paintings done five years earlier regarded as current illustrations.

The Way of an Indian in hardcover was called the "best novel by a white man about Indian life" and "a sympathetic and deeply probing novelized study of the life of a chief unable to cope with the inroads of the white man." The book was included among the *High Spots of American Literature,* as "perhaps the only successful attempt to give the psychology of the western Indian in his war and love-life." The novel did not sell in the shops, however, and there was no indication it would have done better if released when it was written, before the excitement generated by *The Virginian.* The plot was a tragedy, sympathetic to the Indian.

In contrast to the more conventional illustrations in *The Way of an Indian,* the paintings that were being reproduced in *Collier's* in 1905 favored the darker palette in continuing the historical theme of the period that Remington knew. "An Argument with the Town Marshall" and "Coming to the Call" were new variations on the old fantasies of Western adventure.

Unfortunately, George Wharton Edwards resigned the art editorship of *Collier's* at this point. On his own, Remington could no more stay forever with a proved formula than he could remain in his studio when he was restless. Change, moving to something new, leaving the conventional—all of these were part of him. He searched for a different theme, one that would de-emphasize the subject in favor of "the purely artistic qualities," as Isham had put it. He thought he had the answer when he initiated "The Great Explorers" series that began in the October 14 issue of *Collier's* and ran for ten months.

Early exploration of the American West was not Remington's specialty. He did some casual research, but only superficially. His concern was with the pictorial aspects of the work, the beauty, rather

than the accuracy of the message or the detail. The result was Long-fellow revisited, ten poorly conceived decorations that were published in full color for a disinterested and protesting public. After the first few of the series, there was an air of déjà vu. "The Great Explorers" was the turning point in Remington's relationship with *Collier's*, after just two years. Only one of the ten paintings was worth republishing as a print, and selling prints was part of where *Collier's* profit should have come.

Another disappointment was the bronze "Dragoons—1850," described as "two dragoons and two Indians on horses in running fight." The casting was the most complex Remington had modeled. Tiffany's called the statuette "The Old Dragoons" and priced it at $2,500, but only seven were sold. The fault was with the composition that was too busy and too expensive. While "Dragoons" was selling poorly, however, Remington was complaining to Bertelli that "we have no bronzes to sell. What have your people been doing. Tiffany is going to be out of bronzes especially Broncho Busters. We ought to have made 20 Broncho B_____ this summer. I told you so." That was a high-volume bronze business that Remington was describing, and like any entrepreneur he was trying to make the most out of his Christmas sales.

Remington had taken a fancy to young Charles Shepard Chapman, who had opened his own studio as an illustrator, and he invited Chapman for a weekend at Endion just before Christmas 1905. Chapman arrived on the trolley from the railroad station in the late afternoon on Saturday. After dinner, the two men took Remington's three dogs for a walk through the little woods in back of the grounds. It was the evening of the first snow of the season, starting off gently, yet wet enough to stick to the branches of the trees in the fading light. Remington was ecstatic about the painterly qualities of what they were seeing. "Just look at the beauty everywhere," he exclaimed to Chapman. "Why can't we get it, come some where near it. It's maddening." Talking to another artist let Remington verbalize his problems with recording night light on the snow.

When the dogs had had their walk, Remington led the way into the big studio. The men took off their outer clothes and hung them to dry. Remington lit a fire in the huge fireplace and was limber enough to sit cross-legged on the floor facing the fire. Chapman followed suit and they talked about techniques of Chapmen's illustrating while the dogs nuzzled at them to get attention. Remington was still thinking about his frustration at painting snow at night and he extended that lack into his inability to satisfy himself in any of his landscapes. The popular acclaim he was receiving on his Westerns meant less to him at that moment than the landscapes he wanted to be great.

To prove his point, Remington reached back under the table behind him where there were fifty or sixty studies on academy board stacked in piles and took a handful. One by one, he showed them to Chapman, expressing his doubts about each. Chapman thought they were all beautiful and would have treasured any of them but after Remington found fault with a study, he threw it into the fire. Chapman was horror-struck as Remington threw ten or twelve of these jewel-like studies on the fire, one after the other, while bemoaning his inability to put down in paint what he saw in his eye. Soon, the flame was smothered by the little paintings and smoke began pouring into the studio.

Remington did not notice the smoke but his wife came running in from the house, through the large arch at the end of the studio, and down the five steps. "Frederic," she yelled, "what are you doing? You'll ruin everything in the house! Do something! Put it out!" Remington replied, like a naughty child, "Well gee Kid, I don't know what we can do to stop it. What can we do, Chapman?" The younger man suggested opening a window and throwing the studies into the snow. Remington did that, picking out what he could with his fingertips and dropping them out of the window. The rest burned through and that stopped the smoke.

Eva Remington went back in the house and the two men resumed their talk. Remington asked Chapman whether there wasn't one kind of thing he liked to paint best. Chapman replied that he most enjoyed being in the deep woods in Canada. "Then," suggested Remington, "why not get a job as a lumberman there." Within three weeks, Chapman was an assistant culler in what he called the real timber. He worked in the woods for a year and after that he painted in the woods for a couple of weeks at a time whenever he could.

Chapman also said that as an illustrator he didn't have the opportunity to paint in color, and that set off the story of Remington's main sorrow in art. "You know how popular I've been," Remington declared. "Every place I go I'm the great Fred Remington, but all my life I've planned what I would paint when I had money enough and for ten years I've been trying to get color in my things and I still don't get it. Why why why can't I get it. The only reason I can find is that I've worked too long in black and white. I know fine color when I see it but I just don't get it and it's maddening. I'm going to if I only live long enough."

Chapman thought that Remington helped him on the one evening more than any teacher he had had. Sunday night after dinner, the Remingtons went to the front door with him and said goodbye. Through the glass, he watched them go into the living room and he put his bag down on the walk, sprinted through the snow to the spot

outside the window in the studio, grabbed three of the studies Remington had thrown out, tucked them under his coat, picked up his bag, and hurried to the trolley. Only one of the little paintings was whole, but Chapman kept all three.

Chapman never spoke to Remington again and did not know that Eva Remington had seen him. She told her sister, and years later when Chapman became an Associate of the National Academy, Emma Caten said, "Why yes, he's the one who ran off with the studies."

32.

The Folks
from Philadelphia

The Fairmount Park Art Association was a citizens' group established in 1872 by the Commonwealth of Pennsylvania to buy statuary for outdoor display in the city of Philadelphia. The Association was continuing a program begun in 1809, so by 1905 Philadelphia was the most experienced city in the United States in dealing with sculptors. As the direct result of almost a century of purchasing public art, the folks from Philadelphia were also the most cautious sculpture buyers in the country.

The Association had installed Cyrus Dallin's 8-foot bronze "The Medicine Man" atop an 8½-foot granite base in 1903. This motionless Indian on a posed horse at the Dauphin Street entrance to the Park was immediately popular with the public and the Association was led to consider a cowboy figure as the natural complement. The Secretary of the Association was the patient and prudent Leslie Miller, who had been the principal of the Philadelphia School of Industrial Art since 1880. He called himself an artist, kept in touch with art news nationally, and saw the Knoedler show of Remington bronzes in New York City in January 1905. For him, that exhibition provided Remington

with the credentials of a major cowboy sculptor. He wrote on behalf of the Association to find out whether Remington would be interested in doing a cowboy statue for Philadelphia, as a commission without the competition that some public agencies insisted on, if the Association decided to proceed.

By return mail, Remington replied that "I am delighted to find I am to do the 'puncher' for Fairmont Park and I shall go ahead about it as soon as authorized. You may rest assured I will make a complete success of it and I cannot thank you enough." Miller had this time hit on a sculptor with no "if" in his enthusiastic lexicon. Neither the Association nor its Philadelphia lawyers were prepared for dealings with Remington. They could never believe the extent that his anxiety to do the job made him putty in their busy hands.

After twenty-five years as administrator of commercial artists, the urbane Miller was not disconcerted by Remington. He quickly told Remington that the Association had not yet made any determination on the cowboy statue and that Remington had no authority to take any action at all until he received further word from Miller.

The trustees of the Association had their monthly meeting in March 1905 just as the "Remington Number" of *Collier's* came into their hands with its full page on Remington as a sculptor. The superlative Cortissoz review of the Noé painting show also made Remington seem to be the most desirable man for the Association's cowboy job. Miller reported that Remington was available to do the statue and he was asked to have Remington submit a proposal. The Knoedler exhibition had produced the inquiry, the Noé show had backed up Miller's judgment, and *Collier's* "Remington Number" had clinched the commission.

When Miller wrote Remington on March 16, the request answered a yearning that Remington had had for ten years. He was supremely confident that he would produce the greatest statue America had seen. He had watched Ruckstuhl make a working model a decade earlier, he knew how "Coming Through the Rye" had been enlarged, and he had a lot of ideas. Besides, the offer was from strangers, drawn to him solely by his talent, and the trained monument makers like Solon Borglum had been by-passed. Remington told Miller the next day that "I should be delighted to make a horsed cow-boy for the Park. It would be necessary to see the place where it is to go and to consult with you generally before I can say more." The second response was as openly accepting as the first had been.

Miller asked what day would be appropriate and Remington volunteered to be available anytime during the week of April 3, to take a "drive through the Park &c." Miller did not reply by the third so the

impatient Remington sent a reminder and was enabled to confirm "Very well—I will be in Philadelphia on April 11th at noon. I shall bring Mr. Bartelli—my bronze man with me." Not only did he bring Bertelli but the careful Remington also alerted Charlie Trego from Honey Brook, Pennsylvania, to stand by. Trego had been a hand on the Cody ranch and a manager of the Buffalo Bill Wild West Show so he was just the fellow to take his horse to the Park to try out the sites. Miller was impressed. He reported to the Association that Remington had picked a rocky ledge on the East River Drive "for such a statue as he had in mind. It is Mr. Remington's own choice, and was not selected until after he got a horseman to pose for him in that exact place." The experience had been unique for Miller, watching the artist and his friend the old cowboy hallooing at each other as they explored bluffs and niches along the Drive.

Remington and Bertelli shared a couple of drinks on the train back to New York while they carefully estimated the costs that would be involved. Remington was so intent on doing the statue that he remained in the city overnight to be able to write Miller April 12 from The Waldorf-Astoria, saying that "I shall be glad to undertake the work and set up the figure in the Park for the sum of $20,000.— My opinion is that the mounted figure should be 10 feet hight—the details of which are not thought out yet. If it were not for the considerable added cost of nearly 50 per cent I think the addition of a pack horse would be desirable. You can address me at New Rochelle N Y."

That was a high price, mainly because Bertelli was an expensive resource. In 1907 Solon Borglum did the Bucky O'Neill equestrian statue in Prescott, Arizona, for ten thousand dollars. Dallin's "The Medicine Man" had been an enlargement of an existing statuette and he charged six thousand dollars.

Remington wanted to produce a composition designed expressly for the heroic size and the site, the way a trained sculptor would do the job. While Dallin as a sculptor of large figures had originally conceived his bronze as a statue and then scaled it down to a statuette for merchandising, Remington had been modeling statuettes as the end product, designed specifically as indoor decorations with built-in action to provide the illusion of greater size. For example, "The Bronco Buster" told a savage story to draw the viewer's attention to a relatively small object and might be overwhelming if enlarged into the heroic size it was not designed for. Remington was a forward-looking man, not self-satisfied or seeking the easy way, and he wanted to do something both appropriate and new.

At its next meeting on May 5, the Association resolved that Miller "be authorized to address Mr. Remington in an informal manner to

secure the sketch model of the cow-boy at an expense of $500." A sketch model of a statue was the size of a statuette, the same size as the bronzes that Remington had been selling commercially, and the model had to be finished completely because it would be the determinant of whether or not Remington got the job. Five hundred dollars was as low a sum as it was gentlemanly possible to offer. For a popular statuette like "The Rattlesnake," Remington might net twenty thousand dollars, but Remington wanted desperately to sculpt a statue, and the cowboy was the only offer he had. He would cheerfully have done the sketch model for nothing.

Before contacting Remington, Miller made a draft of the infomal offer on the sketch model. When the Philadelphians put anything in writing, it was a worked-over statement, and he wanted to circulate the draft among his associates before sending it. What he wrote was, "We are willing to give you $500 for making a study, big enough to give a fair idea of how the thing would look. If our Board wishes to have you carry it out (at least 10 feet high), they will sign a contract with you"—and then he added—"with the understanding that the $500. which they will already have paid you for making the model shall be regarded as a payment on account of the contract. Does this strike you as a fair proposition?"

Miller's associate Charles J. Cohen liked the draft because the offer was "entirely without contract-responsibility." The Association's lawyer was James M. Beck, a man who made three-million-dollar deals for his commercial clients but who was a nit-picker for the charities. He asked Miller to add the words "without any liability on the part of the Association beyond the $500 before referred to." Surprisingly, Beck then volunteered that "I think we want more statues in our Park such as that suggested by Mr. Remington."

Miller's draft as approved by Cohen and amended by Beck was mailed May 13, 1905. Remington took one day to accept. "That will give me all summer to think about it," he declared, "and I will do the sketch this winter." He did not mind the five hundred dollars being transformed from a payment into an advance and added that "if I cannot satisfy your committee, that will be quite reason enough for not going on with the thing." Miller told Cohen that Remington regarded their position as "perfectly fair" and he sent Remington site photographs along with the five hundred dollars. The job was under way.

There was no word from Remington for six months, over the summer and into the fall. He had been dreaming about the statue, making sketches and small rough Plasticene models. He was nervous, he broke away for the unusual summer trip to Newfoundland that he could not enjoy, and his paintings suffered. Pictures he did for *Collier's*, among

them "The Great Explorers," did not have his customary attention. He did have in mind, though, a composition for the cowboy statue, and he started in on a model in the fall, first a "minature model" and then one "statuette size," as Remington called them.

He had taken what was for him a long time to decide on the design because the theory he had about compositions for statues was un-proved. The statuettes he had modeled told stories in three dimensions, as slices of action with the players in extreme positions. Statues, he thought, must be independent of a story, and yet so evocative that the viewer's imagination was grasped and stimulated. Like the illustration he had drawn of Buffalo Bill on a performing horse acknowledging applause in "Under the Lime Light," the sketch model he was doing of the cowboy for the Association was equally stagey. This was a relaxed cowboy sharply reining in his mount at the edge of a cliff, the horse's left foreleg raised and stiff as it extended over the edge. The inherent movement of the model came from the tension in the muscularity of the horse in that strained position, the foreleg pointing forward and the hind legs the brake. Remington had never before at-tempted as high an order of sculptural artistry, to suggest action op-posed to dramatic inaction, and he was not positive that he could achieve what he intended.

Even when fall came, Miller did not notice that he had not heard from Remington. Sculptors were all like that, full of ardor when they got a job, and then nothing. He was surprised to receive Remington's November 24 note that the statuette was "nearly done—in ten days I hope it will be presentable and I then hope to invite your committee to run over here and see it." Miller agreed to have the committee go to New Rochelle and Remington replied November 29 that "the model will be ready. I will be glad to entertain you here at my house at luncheon if you will indicate how many to expect."

Offering lunch was a mistake. The folks from Philadelphia were afraid that accepting lunch at this stage of the negotiations might be considered a bribe and they called off the trip. Instead, Miller asked Remington to ship a plaster cast to Philadelphia. On a matter of sculp-tural procedure like the handling of the clay model, Remington was firm. He repeated what he had said before, that "I want to save my plasteline and it is so much more satisfactory than a [plaster] caste, be-sides if found necessary I can make changes in it."

In the impasse, Cohen took over the correspondence and wrote, "Our committee has arranged to visit your studio December 19. We shall leave Philadelphia by the 9.50 train, taking luncheon en route and making the 1.04 from the Grand Central Station, reaching New Rochelle at 1.42." Cohen was a different kind of Jew for Remington.

Cohen had been born in Philadelphia of parents who had emigrated from England. That did not make him an Anglo-Saxon but he was an established manufacturer of paper products, president of Jewish organizations, and later president of the Chamber of Commerce and the Fairmount Association. His sister Katherine was an artist and sculptor whose work was on view in Fairmount Park. Remington was on his best behavior with Cohen.

Remington's December 14 reply was first to the point and then reminiscent of the "Be-Ludless Tr-ragedy": "If you will let me know how many people will come as your committee I will have carriages at station to take them to my studio which is about one mile. I will also be at station to meet the committee. I know Prof Miller personally but otherwise I shall have to trust to my instincts to tell the committee from the other arrivals. My dectective instincts are highly developed however." The committee of six did arrive on the nineteenth, to shake hands with Remington, proceed to the studio, look at the clay statuette, make polite comments of individual approval, shake hands with Remington again, and leave. Remington told Bertelli that "from what I could judge they like my model very much," but he was going by their actions, not their words.

Miller reported on December 20 to Cohen, who had not accompanied the committee, enclosing "minutes of a meeting of the Committee on Works of Art which was held on the elevated railroad train in New York." The committee did not tell Remington but the sketch model was unanimously approved with recommendation to the trustees that a contract be prepared "to cover the preparation and completion in bronze of a statue of a Mounted Cow-boy for the sum of $20,000, payments to be made in sums no greater than $4000. in any one calendar year." The trustees approved the committee's recommendation of this installment contract on January 12, 1906.

Remington knew that the committee had been friendly but he was apprehensive. To escape the trauma of the negotiations, Eva Remington had gone to visit her sister in Syracuse where Remington wrote her January 13. "I don't hear from Philadelphia," he told her, "but it is early. I am going to start a new small model anyway," in case the committee disapproved of what he had done. He had just returned from Albany where a customer gave a dinner for him, but it rained in Albany and he was jumpy and, as he told his wife, "its d_____ lonesome around here." To keep up his spirits he had gone to see *Man and Superman* and thought the Shaw play "the greatest thing."

By January 15, four weeks after the committee inspection, his emotional state was deteriorating. He told his wife that "if I dont hear from Philadelphia I don't know what I will do." Still alone in his

empty house, he pleaded, "Well—come home when you can—its d_____ lonesome here. I dont know how much more of it I can stand," but he was busier than it seemed. He had been to the city to see the osteopath for a back treatment, he stopped in at Noé to talk about a drawing he had to make for the next exhibition catalog, he checked with the framer for the exhibition, and he saw a rehearsal of Thomas' show. That was a full day.

He was also investing in real estate: "Fred Gunnison has got me in $2500 or $5000 for a Long Island Land Scheme. Burdick says he expects to make that Key West 5000 into 25000—I shall never make big money—I only hope to keep what I have going modestly." Putting risk capital into friends' "schemes" was the bulk of his investment portfolio.

On January 16, he heard the good news from Philadelphia. The sketch model had been approved, although Miller told him that the contract with the Association would be delayed a month until the next trustees' meeting. Remington replied immediately, expressing his hope that he could get right to work: "I am very anxious to get ahead with the model," he said, "since I want plenty of time on it before Summer. Can I go ahead now? I don't care particularly about the money just now but would like $5000 down to begin with. I have concluded to build a new studio and I want to begin on that."

The new model that Remington mentioned was the intermediate stage, the "working model," where the sketch model was redone by the sculptor into a four-foot size. All of the final detailing was put into the working model, which was then regarded as the end of the sculptor's artistic responsibility. "Throwing up" the working model into the final heroic statue was usually done by assistants and students whose task was only to make a perfect copy.

As a precedent for the money that Remington wanted "down," Daniel Chester French had wangled a $3,000 advance from the Association when there was a delay not his fault. If Remington had asked for less money, the advance might have been granted after the contract was signed, but his request was unreasonable and he was refused. Miller told him that there was a policy against advances because sculptors had been eccentric in the past. Remington did not insist. "I shall undertake the work and the financial arrangements will be settled to the best advantage someway or somehow. I warn you that no matter what other sculptors have done—nothing but a physical breakdown— fire or not will keep me dawdling for five years. That is temperamental with me."

Remington was still alone at Endion. He had a "bad catarrahl cold coming on" but so far just the symptoms. He told his wife that his

painting was affected by his solitude: "I mean to stay here & work but it['s too] D_____ Lonesome," and the signs were ominous. An acquaintance "dropped dead in front of Club yesterday while we were lunching." The message from 301 Webster Avenue was, "Well—the 301 yawns for you."

Meanwhile, the drafting of the contract was going on, in ways that the anxious Remington would never have suspected. The Fairmount Park people had entered into tens of commissions to sculptors, but the more their purchases continued, the more their experiences with sculptors made them wary. Lawyer Beck read the first draft January 26 and was looking for a provision that would give the Association the right to reject the finished statue even after the working model had been accepted. Approval of the working model should have been approval of the job, so Beck was taking another advantage for the Association.

On February 3, Beck was back with a new draft to show to the Association. "I have tried to provide that Remington must cast and recast the statue," he stated, "until it meets with the approval of the Association. Remington is required to give a bond for his compliance with all the terms of the contract. If he does not deliver, his bond becomes due. So far as the Association is concerned, this seems to protect it. It would seem therefore to be a question for Remington to determine whether to protect himself."

Beck had drawn a one-sided contract and he added that "I fear that the agreement is so drastic that Remington may hesitate to execute it, as Saint Gaudens did. However, he [St. Gaudens] probably is more independent than other sculptors." St. Gaudens took four years before the contract was redrawn to suit him, and then he spent six years on the sculpture, without ever giving the Association the composition it had wanted. St. Gaudens was, as Beck observed, independent, but for Remington the Association was the only game going.

While Remington was waiting to see the contract, his fourth and last painting exhibition at Noé opened February 5. He had said about Noé that "this d_____ ex_____ ought to be good, I've had enough trouble over it," but the paintings included the beginnings of the ill-advised series on "The Great Explorers." Reviews were more restrained than in 1905. The issue for the art establishment was the same as in Remington's sculpture: Does a work have an apparent story? If so, it is illustration, not art. Fine art called for the denial of the stated subject, in favor of symbolism and beauty. Bitter as the criticism was to Remington, he could still see the joke in it. He kidded Weir about a coon hunting picture in the show of The Ten American Painters, saying that "the whole thing is rich and distinguished but you must be

careful—it is perilously near a story. Art must rise superior to human interest—not to speak of coons."

On February 16, Remington received Beck's draft of the contract and he replied at once. His concern was with the provision that related to his artistic integrity, which did not concern the folks from Philadelphia, and not to the money, which did. He said that "the agreement is all right in the main." What bothered him was that approval of the working model should have been the bottom line. If he died before then, his estate should return the $500. If he died after then, the contract should proceed to completion with his heirs through Bertelli picking the sculptor to replace him. With these comments as his only objections, he returned the contract for correction.

The agreement seemed to be close to resolution after the two and a half frustrating months that followed the completion of the sketch model, and luckily there had been in that period some enervating moments for Remington that proceeded from his friendship with Roosevelt. The most important social event in the nation was the marriage of Roosevelt's daughter Alice to Representative Nicholas Longworth of Ohio. Only 1,000 invitations to the wedding were issued, and the Remingtons had one. Eva Remington was wild to go but Remington begged off. Just being remembered was enough for him while the contract was pending. Because Roosevelt did not get to talk to Remington at the wedding, three days later he sent a personal message from the White House. He had read *The Way of an Indian* and he commented that "it may be true that no white man ever understood an Indian, but at any rate you convey the impression of understanding him! Is there ever any chance of your getting down to Washington? I should like to see you."

Remington might as well have gone to the wedding because the Philadelphia lawyers were not yet through with him. Beck made Remington's suggested change and went over the contract again. With the payments spread over five years, the Association was gaining the equivalent of two thousand dollars as the value of the use of the money for the term. While discussing Remington, Beck told Miller on March 22 that "the distribution of payments will give him little incentive to complete it in less time, but as he may delay the matter for many years—after the manner of sculptors, especially talented ones—the Association can protect itself by the time limit." Miller wrote Beck that the contract as amended again was "in excellent shape" and Cohen added that it was "excellent in all particulars." It was, for the Association.

While all this legal sharpening was going on, Remington was in the dark. He asked Miller, "What are the prospects for action? I want to

start a studio but I hesitate." Miller's reply was, "As soon as I can get the contract satisfactory" to the trustees, it will be sent. Remington might have guessed that the delay was not for his benefit. He wrote again in April after another month had passed, "How goes the cow-boy affair. I go north for the summer middle of next month." Miller answered that he hoped to have the contract before May 1. All of the contractual traps they could think of had been set, and the contract was mailed as Miller had said.

No limitation that the Association could conceive of bothered Remington. He wrote Miller on April 30: "Have the 'Cow Boy' agreement and it is satisfactory. I will have my lawyer attend to the Bond Business and will then sign and send you the paper. I am not doing this thing with much reference to the money and before this thing is over I intend to give you people a piece of horse-bronze which will sit up in any company. You can bet a few on that Prof."

The rub came when Remington's lawyer George M. Wright read the contract. Remington had instructed Wright to accept any provision that was not definitely ruinous to him, but Wright's reading turned up Beck's penalty bond that actually was ruinous. If Remington died before the working model was done, he would have failed to perform under the contract, and his estate would be obligated to the Association for a penalty of twenty thousand dollars, although he had received only five hundred.

Even the penalty bond did not excite Remington. He wrote Miller May 2, enclosing "a letter from my attorney in re Bond business. I had not understood this matter. It would ruin me to pay of [f] $20,000 for 4 years. My idea is to protect you by [Payment] Bond as I incur obligations. Let me know what you think." Wright's redraft of the bond provision deleted the penalty bond in favor of a payment bond as surety for money Remington received from the Association before the statue was in place. Remington refused to discuss the other provisions with Wright. He wanted the agreement at any cost that would not burden his estate, so that he could get on with the statue as quickly as possible.

Beck was surprised that Remington and Wright had picked up only the most prejudicial provision in his draft. He changed the bond article and Miller resubmitted the final agreement to Remington on May 14. Remington was obligated to make and deliver a twelve-foot bronze statue in accordance with the sketch model. The bronze was to be a lost-wax casting, erected by June 1, 1910. The price was $19,500, with $3,500 due when the working model was complete, $4,000 due one year later if the model of the statue was complete, and $4,000 yearly for three years thereafter. The Association could require the bronze to

be cast and recast until satisfactory. If Remington died before the working model was approved, payments made to him would have to be repaid to the Association. The last provision was George Wright's surety bond. The agreement was signed by Remington and witnessed by Eva A. Remington.

So, sixteen months after Miller's first inquiry, Remington was authorized to start in. Six months had gone to making the sketch model and ten months to the paperwork. Remington was happy, telling Bertelli to "get that man of yours to throw up my [working] model here [but] I dont want him to put any detail work on it because I mean to do that myself." He was off to Ingleneuk, although the folks from Philadelphia had him hog-tied on a one-way commission where if he died before the working model was approved, his estate owed five hundred dollars despite the modeling that had already been done. He was committed to the lost-wax process, and he had only Bertelli's word that the process would handle a statue of heroic size. If the Association elected to be sticky, it could just refuse to approve the final casting and bankrupt Remington by requiring successive recasts forever. If the statue was completed on schedule and approved, the Association would still be withholding twelve thousand dollars, pocketing the interest and leaving him without a source of funds to pay all his costs.

None of that bothered Remington once he had the job nailed down. He wrote Miller from Ingleneuk May 19, "Now we will proceed to do the Cow-Boy and let us hope he doesn't fall off his horse in the process." That was an inside joke because Miller could not have known about the riding accident, but Remington was so impatient to get started that he did not observe that the cowboy would now have farther to fall. The Philadelphians had provided for Remington to deliver a twelve-foot statue rather than the ten feet on which his price had been established.

33.

An Alleged Rigidity in the Left Foreleg

Remington at forty-four was able to see past the paperwork of the people from Philadelphia to one of the great goals of his artistic career, the sculpture of a heroic statue. As long as the Association did not compromise his professional reputation or endanger his estate, he let the trustees have their way with the contracts so that he could save time in getting to the bronze. The Association thought of him as equivalent to an inexperienced "greenhorn" because of his disregard for financial consequences, but he never spoke other than respectfully about the Association.

When he knew he had the Fairmount Park job in hand, he was again able to settle down to planning his work schedule, and he calmly fit that immense task into his concentrated regular program of statuettes and paintings. As his horizons were expanding in art, his physical powers were diminishing, but he was still able to turn out more quality work than his peers. His creative strength grew while his stamina ebbed, as if the vigor of his art had an existence of its own.

Before he went to Ingleneuk for the summer of 1906, his fourteenth

and fifteenth statuettes were completed. He had been modeling them while all the fuss about the big "Cow-boy" had entered his life, during the preparations for the Noé show and the paintings for *Collier's*, and while he complained about his inability to remain in the studio at his easel and table.

The fourteenth bronze was "The Outlaw: Cowboy on a pitching bronco horse, same jumping in air and balanced on 'off' forefoot only." Remington returned to storytelling when he went back to statuettes, and this was another tour de force in balance. Although the critics were not impressed, one hundred of "The Outlaw" were sold at $250.

The second of the 1906 statuettes, the "Paleolitic Man," was another matter. The composition was intended as serious, "a human figure bordering on an ape, squatting and holding a clam in right hand and a club in left hand." Unfortunately, the little figure was popularly regarded as funny, and only fifteen were sold at one hundred dollars. Remington was proud enough of the bronze to send one to President Roosevelt, citing the bivalved connection between the clam and the location of Roosevelt's summer home in Oyster Bay, Long Island. The gift occasioned a formal invitation to the Army and Navy reception in Washington and the private supper in the White House afterwards, but again Remington did not go. He had rejected both pomp and the military, to the displeasure of his wife.

During the summer at Ingleneuk, he was involved in preparing paintings for a winter show at the prestigious Knoedler's, his breakthrough into the quality galleries, and that task had to be finished before he could start on the working model for the big "Cow-boy" in September. The *Collier's* pictures were now only third in importance to him, despite the high earnings that *Collier's* provided. "The Great Explorers" series had run over into 1906 and was a continuing embarrassment. He knew what he should have done in choosing more compatible subjects. "The next play you write," he had told Shipman, "you want to write about some place you know—about a situation you feel the heat of, and have characters in it you love." He did not follow his own advice in the "Explorers" paintings for *Collier's*.

The explorers he drew were too pallid to permit his male audience to see themselves as the protagonists. In addition, he wrote his own short captions and they were duller than the pictures: "Pierre Raddison [Radisson], a Frenchman, together with Groseiller [Médard Chouart, sieur des Groseilliers], in 1659 voyaged west of Lake Superior to Lake Winnipeg, and also covered a great deal of new territory in the vicinity of Hudson's Bay." That was one of the better examples,

and it was a poor launching pad for fantasy. "Raddison" was the only picture in the series that was made into a print, and it was the only original that sold. Even there, Remington took the low payment of five hundred dollars, from a banker in Grand Rapids.

Collier's not only failed to promote "The Great Explorers," it printed a long letter to the editor presenting an attack almost as devastating as Colonel Schuyler Crosby's defense of Schreyvogel. The letter writer also praised Schreyvogel before going on to say about Remington that "for the money he is getting he ought to be willing to expend enough of his abundant vitality to think up something worth while, not merely mechanically filling his order by turning out inane and meaningless pictures. The point is that he is not doing for you, for a big price, what he did for a small price for other magazines before you monopolized him. He is not giving you what you, and we, have a right to demand—his best work." *Collier's* also carried "a gibe or so" from the old antagonist Emerson Hough, who referred to Remington in an article entitled "Wild West Faking."

Public attacks were the price of being a public man, but the signals from *Collier's* were confusing. On the one hand, Robert Collier personally complained to Remington and he printed complaints from readers. On the other hand, he bought twenty-five new pictures during 1906, thirteen of them to be stored away for future use. Remington had become a costly asset, sending in more pictures than *Collier's* could use, without weeding out the poorer examples. He could not turn off the spigot of his talent.

The best of his paintings had been reserved for Knoedler's exhibition in December. Because Knoedler's represented a giant step up from Noé which exhibited lesser artists, Remington was "losing that rose madder complexion and gettin' an English red," painters' talk to indicate the enrichment of his pride. Of the ten paintings hung that were for sale, five were purchased during the exhibition, a fine result. The highest price received was $2,500, a record for Remington at a gallery show in a period when 95 percent of American families had gross incomes of less than three thousand dollars a year.

The mood of his pictures had changed in the last few years, and the thrust of the titles changed with them. The 1901 nocturne "The Old Stage Coach of the Plains" had been a simple and direct painting with a title to match, but in 1906 the horses were shying away from an unseen threat and the title was "A Taint on the Wind." The New York *Times* said that "it is a softened and harmonized Remington we find this year, his pictures having atmosphere and looking for all the world as if he had been abroad studying the delicate aerial niceties we find in Corot and Mauve, Pissaro [Pissarro] and LeSidaner. He takes the

shades of night to help him to those tones of mystery which most of his previous pictures lacked."

As far as Remington was concerned, these ten 1906 paintings for Knoedler were his peak up to that moment. Current works like these were the only paintings that he now acknowledged. He had tens of old pictures in his stacks, most of them illustrations that remained unsold, but he did not expect ever to offer them for sale again. In his opinion, they depreciated his present things. He did not tell customers that they existed. The dealer Annesley & Co. had asked for paintings to hang a month before the Knoedler exhibition and was told that "I am going to show 10 pictures, all I have—at Knoedlers so I cant sell any now." He would not let the old pictures out of his hands. After two decades as a painter, he had finally realized that a current exhibition should be limited to current work.

Childe Hassam, who was one of The Ten, declared that the Knoedler paintings "are *all* the best things—Nobody else can do them." He had become a close friend. Remington went on a camping trip with Hassam, Burdick, and Wales, who was a lucky amateur painter to be with two masters. Hassam and his wife had Sunday dinner at Endion, too, after being told that "you can pick your train but mind you dinner is at 6 p m and any fellow what aint here gets his cold—no dinner coat—just plain clothes."

Remington still took his long walks with Gus Thomas in New Rochelle, walks that Thomas saw as curtailed because of "the waning of his great strength" due to "his increasing weight." He spent a lot of his spare time with Thomas, and Remington in turn considered that the playwright was becoming odd. Thomas had been a liberal Democrat, which was unusual enough in New Rochelle, but now he was becoming "one of the new kind of individualistic socialists." He was a leader of one of two schools of the arts that were in conflict. St. Gaudens, Parrish, Shipman, and his Cornish colony were Concordians, pursuers of the goddess of beauty and harmony, and concerned with the decorative above reality, while Thomas' New Rochelle circle "imbued the atmosphere with anti-Concordian philosophy."

Remington followed neither the Cornish nor the New Rochelle school. He wanted to paint and sculpt in his own way, and he was convinced that he had the most in common with The Ten. He went to Branchville, Connecticut, with his wife to visit Alden Weir. Weir told Hassam that the Remingtons were "looking for a place as New Rochelle is crowding them out. I showed them the place we call yours, he liked it but after[wards] I took him to Ridgefield which I thought at the time would suit him better." Weir said that Remington bought thirty acres in Ridgefield to build there. After all the false

starts in leaving New Rochelle, he had finally made the first move, although he could not proceed with construction until he sold Endion or Ingleneuk.

Another new Remington friend was the very savvy A. Barton Hepburn, a lawyer, politician, and president of Chase Bank. Hepburn was also from the North Country, having taught in Canton and then in Ogdensburg when Remington was a boy. He purchased an existing summer home in Ridgefield, to be near Remington. In a month, he had moved in. "Hepburns auto showed up at 4.30—very much belated," Remington mentioned. "We went to Ridgefield via Shore road [now U.S. 1]. broke down at New Canaan—tire busted. Had good dinner & then on to Ridgefield [in the dusk] without our lamps going. Road very dim but arrived without accident at the Inn. Walked up to Hepburns place in the dark & to bed."

The next morning, he "had to wait until 8 oclock for my breakfast" at banker's hours. "Then out to farm [his Ridgefield acreage] where we walked all over. Made arrangements to gather my hay—Home in Hepburn's auto. 51 miles, here at 5 pm.— beautiful ride. Very tired." Along with indigestion, fatigue had become his companion, although he never bought a car. Horses were part of his work and he had more empathy for a coachman than a mechanic.

To Remington, the Ridgefield connection with Weir and The Ten reflected his growing obsession to be recognized as one of the leading American artists. He still believed that if he had been European trained, he would have been a full Academician before 1907. He felt that what had held him back were the years as an illustrator, the more than twenty-seven hundred pictures he had made for reproduction. Those drawings thwarted his ambition as long as they existed. Almost all of those original illustrations had been sold. He could not touch the ones that were gone, but on February 8, 1907, he performed the next best act of defiance available to him on those that were left. He "burned every old canvas in house today out on the snow. About 75.— and there is nothing left but my landscape studies" and a couple of favorites like "The Last Lull in the Fight."

This was the first group of pictures that Remington burned, the illustrations he had done before 1904. To him, they were just drawings that had been offered for sale over the years, without a buyer. They were a realizable asset to a modest degree, but another auction would have been beneath him at this point. Besides, he was more concerned with cleaning his artistic slate than he was with money. Many other illustrators who turn out a large quantity of work have done the same thing. Illustrators make pictures that are interpretive of text. The illustrations are drawn to a deadline. After the drawings have been ac-

cepted for publication, the purpose is ended. The pictures are like yesterday's newspaper and they take up storage space. With luck and talent, new illustrations are commissioned in a steady stream. Only the unique illustrators like Remington could sell most of their originals.

The destruction of the old drawings was accompanied by a sense of accomplishment. The decks were clear for the new paintings that would be the real thing, especially the nocturnes of Western mood pieces that were now his forte as a painter, as well as for his modeling of the big "Cow-boy."

The rough "throwing up" of the working model for the "Cowboy" statue had been done by Bertelli over the previous summer, so that Remington could start right in on the clay when he came back from Ingleneuk in September 1906. Not until January 5, however, after four long months of modeling, had he been able to write to Miller at the Association to say that "I am out of the woods with the cowboy. I had a lot of hard going but have finally made the horse and rider do what I expected of them and am now finishing and if the horse don't buck I'll be ready for your committee in a month or so." This working model was the intermediate "quarter size," although Remington's cowboy was larger than one fourth of the contracted height. The composition was again clay, temporary like the sketch model.

By January 25, Remington had been half again longer in the modeling than he had anticipated. He advised Miller that "the working model of the Fairmount *cow-puncher* is done and ready for the inspection of your committee. When may I expect them. I am anxious to get it in plaster." Cohen established February 5 for the visit, and Remington acknowledged that "I shall be at the station to meet you with transportation for however many folks you say will arrive. I only hope we can have good weather—or at least a bright day."

Instead, Remington got a snowstorm. The inspection was postponed until February 11 when the committee of four came to New Rochelle and made its determination on the working model: "Resolved—that the Committee recommends that the model of the Mounted Cowboy as examined to-day be approved. A minority (Mr. [John T.] Morris) dissented from this action and opposed the acceptance of the model in its present state on account of an alleged rigidity in the left foreleg of the horse." Morris said that Remington may have been anatomically correct in the foreleg, but Morris knew what he liked artistically. He was the same "pedestrian patrician" who had objected to St. Gaudens' statue in 1893, saying then that the sculptor "is treating us miserably."

Remington was initially distressed at Morris' dissent. Miller knew it and promptly wrote, "I presume you were quite prepared for a cer-

tain amount of discussion over the action of the left foreleg. With this
exception the Committee was unanimous in its most cordial, even en-
thusiastic, approval of the model." Miller need not have worried about
how Remington would take Morris' dissent. He had already adjusted
the statue to make it possible for Morris to back down, without
changing the position of the leg. "I am of course delighted to have
your committee's approval," he replied, "and sorry for the dissenting
opinion. That foreleg is imperative however and cannot be compro-
mised. I have run the plinth out to it and think it improves the group.
My final bronze will be so much better than this working model that
you won't know it." The extended foreleg was drama, the continu-
ation of the forward motion of the horse that seemingly would have
fallen over the bluff except for the opposed action of the haunches
digging in.

Even after the committee approved the model, Remington was
again fussing with the piece. He engaged a helper, not the usual tech-
nician but his outdoor companion, the railroad official Burdick, whom
he called a "good modeler." Remington quit detailing the clay only
when it was taken away from him to cast the plaster that would serve
as the reference for modeling the statue. On March 2, he indulged
himself in a gesture of relief. He "sold that d_____ fool horse I am
using as a model for 90 dollars to a grocery man and d_____ glad to
get rid of him." The plaster casting was transported to Roman Bronze
Works for storage.

On March 13, Remington received notice from Miller that the sec-
ond payment was ready for him. Remington thought that meant he
had the money in his hands. "All right," he replied, "I will take steps to
get a bond for the $3500 to indemnify you for your expense-." In two
days of looking for the bond, however, Remington lost some of his in-
nocence about Philadelphia lawyers. He was wearied but still not
complaining when he wrote:

> I have chased around New York after a Surety bond for your folks. The
> people I talked to hem and haw and want me to deposit collateral securi-
> ties and do all sorts of absurd things before they will furnish a bond. They
> do not seem to understand the whole matter—it is an unusual sort of busi-
> ness, so I got disgusted and threw up my hands.
>
> Now I would suggest that you people get a Philadelphia Co to make me
> a bond which shall be satisfactory to you if possible or otherwise I will let
> you deposit the money in a Savings bank or Trust Co subject to joint
> order from us both and let the whole thing go as it lays.

Remington's suggestion of the bank deposit was acceptable to the As-
sociation, as Miller told Cohen, and the two of them proceeded to
explore the mechanics of the deposit.

Remington did not need the Association's payment that year. Money was plentiful. So was fame. The sculptor Daniel C. French, as chairman of the Committee on Sculpture, Metropolitan Museum, wrote Remington, "the Museum had approved the purchase of four bronzes, The Old Dragoons, Bronco Buster, Mountain Man, and Cheyenne." Remington was so elated at this second "brevet before death" that he would have donated the bronzes if it had been seemly. Instead, he sold them to the museum through Tiffany's after deducting his own share as a gift.

In the midst of the rising fortunes, Uncle Will Remington who had paid for Remington's start died in Canton, and Remington attended the funeral. While there, he made the arrangements to have his father's remains transferred to his "new cemetary plot just bought." The original interment of the Colonel had been on the western side of the Canton cemetery. Remington's plot was along the main drive toward the east, on a high sandy ridge covered with a forest growth of pine. Remington noted that "my fathers body & tomb-stone removed to my new plot in Canton cemetary which I am sure is my lasting place." That is, last resting place. He also said that "George Wright [the attorney] came up to Endion & we made our wills—Kemble & Elsie as witnesses."

Meanwhile, the folks in Philadelphia were still discussing Remington's money that had been due him since February 11. Remington wrote to them again, courteously as always, saying that "I am going to New Mexico for a few weeks. May I ask what you have decided to do about the payment?" On the letterhead of the Association, Cohen advised Miller at the Association that the treasurer had found a Philadelphia bank to hold Remington's money in a joint account but payment had not been made into the account because the Remington contract and the Remington correspondence had to be sent to the Philadelphia lawyers to draft another agreement on this to submit to Remington for his signature before presentation to the Board of Trustees at the next meeting, thereby permitting payment into the account. While this was going on, the Association continued to retain the funds. There was no word to Remington. There never was an attempt to help Remington find a Philadelphia bonding company.

Remington was not really concerned. On March 25, *Collier's* decided to continue with Remington color spreads for another year, but not without hesitation. "Colliers gave me a letter contract $1000 a month," he wrote, "& had big talk about the illustration criticism articles—lunched Players." The talk was not so "big" that it extended beyond lunchtime, but the series about the explorers was still a sore subject with *Collier's*. So was the series that had followed, "Tragedy

of the Trees," on lumbering. Remington was not impressed. The explorers and the trees were in the past and done with. He had already reverted to the historical Western subjects that *Collier's* required.

By March 27 Remington had gone stale, as he did whenever he worked steadily for more than a couple of months. "I try for painting ideas," he observed, "but tired & ideas wont come. I yearn to get to work in the open." He was less than a week away from leaving for New Mexico and the anticipation made him edgy. The next day he was again unable to work. "Mrs and I went in to town to Metropolitan Museum," he declared. "Lunched and then to [National] Academy. I bought a little painting of Hudson River 125.–" His refusal to exhibit at the Academy did not prevent him from enjoying the show and acting like a patron. On March 30, Remington was still not working. March 31 was Easter. He "walked with Gus," seeing himself as one with nature, unaware that Thomas looked at him as a man who had to pause frequently because "he lost his wind."

On April 2, with no word having come from the Association, Remington "left New York on Central with Henry Smith on Limited 3.30 for Southwestern trip." Smith was another New York lawyer. The following day, Remington told his wife, "Dear Kid—We got to Chicago all right and lunched, then drove all over Chicago in an auto until 6.30 when we were given a dinner at Chicago Club with Genl [W. H.] Carter and other notables and got a 9.30 train on Rock Island almost dead." He was "very tired. Hard work on water wagon." This was a debilitated man worn out on a journey that had just begun.

They were "on time Kansas City" April 4 but did not lay over to see the old friends. They transferred to the Southern Pacific in order to get "out at Tucumcari N M 6 a m, a dismal little plains town, country green and look uninteresting. Slept at hotel all afternoon." As a desert genre painter, Remington had different requirements than would an Eastern landscape painter who would consider a green countryside a plus and big clouds a wonder. Remington needed the one brown and the other removed. "I am almost discouraged," he said.

They abandoned Tucumcari and April 6 they were in "El Paso at 6," checking in at the St. Regis Hotel where they changed their railroad tickets to "come back Santa Fe Road in hopes Colorado wont be so green. We have slept every minute and both of us have recovered our nerves which is all we can say for the enterprise. Still this trip gives me a renewel of my impressions and I hope for the best."

On April 8, the outlook was improved. He wrote that "everything promises well. To-morrow morning we go 8000 feet up Superstition Mountains to Cloudcroft and we are promised a 40 mile trip to Mescalaro [Mescalero] Apache reservation. I expect to get some thing

(d_____ this old pen). I havent been discouraged until now but I guess itll make it worth while."

After going back north again on the Southern Pacific, Cloudcroft was not what Remington had expected. "Came up 9000 ft—all pines & not very paintable," he said. "Horrible dinner. Something must be done." The following day was April 10 and he "sketched all day—mountains & horses," but April 11 was the end of Cloudcroft. "We can no longer stand the altitude," he grumbled. "My heart nearly stopped when I took bath this morning. We are overcome by lassitude. Went down to Alamagordo. I sketched bluffs at sunset & had terrible ride home across irrigation ditches." April 12 he "came [back south] to El Paso and go to Grand Canon Arizona tonight. I made 7 sketches at Cloudcroft and 2 sunsets at Alamagordo. We are both feeling bully. I sent you some spoons and a jug. These spoons are Moki—I am not stuck on travelling & wish I was home again. Its to d_____ long between places out here."

Remington left El Paso on the Santa Fe after having "sketched Rio Grande river—wonderful red color." The 14 he "got Albuquerque 6 a m— Left for Grand Canyon at noon." This was his first visit to the Grand Canyon. He was developing a taste for sketching the Western panorama, but not as fine art. Western landscape—even the Grand Canyon—was merely the backdrop for possible figure paintings.

On April 15, Remington "got to Canyon—El Tovar hotel. Sketched at evening. Canyon bigger there than I was led to expect by description or pictures." The next day he "loafed. Smith went down Bright Angel trail with others. Sketched a little—Bought buckskin shirt & spoons—Navajo." April 17, he "left for home 8.30 a m. Delay at Williams 2½ hrs. Williams trying place," and that was the end of the Grand Canyon of Arizona, as far as Remington was concerned. He could not physically manage the trail into the canyon, as he could not handle the elevation at Cloudcroft.

On April 18 he was heading east "on Sante Fe limited—very rough." The nineteenth, "K C about 10 a m—tired enough to die." The twentieth, "We are very tired of traveling & both our stomachs have given out." Finally, on the twenty-first, "Grand Central 8.45. 9 o clock to New Rochelle & d_____ glad to get home—Stomach given out—must diet." Compared to his earlier Western visits, his New Mexico trip had been a businessman's excursion, all trains and hotels, and he could not handle even that. In twenty days, he had tried Texas, New Mexico, and Arizona and was now home again, having enjoyed none of it.

After a night's sleep, he was still restless. He "went in town—tried on clothes—lunched lightly & came out home ill with stomach trou-

ble. Went to bed at 5 o'clock—paid Henry Smith 54.17 settlement in full for our trip west." The Southern Pacific railroad had subsidized some of the expenses. The next day he was still "not feeling very well —diet seems better. Working on painting ideas and on [ideas for the] sculptor studio [the new "shanty" for the big cowboy]. We are beginning to [get ready to] leave for the Island. Real estate market very slow in New Rochelle." Endion was for sale, with only one looker.

April 25 he painted, but the twenty-sixth he had "no canvas—loafed all day—Medicine ball with Gus." Medicine ball was a turn of the century exercise that Remington practiced frequently. The ball was leather, a little larger than a pumpkin, and filled with sand. The activity was simply passing the ball to another person, at chest height, and having the ball handed back to you. Remington was still not settled down. The twenty-eighth he "went to town" again. The next evening there were the "Kembles at supper," but the result was "large row with girls in kitchen. Maggie the cook going to quit. Cooks scarce & hard to rope & throw. Bad outlook." That was taken care of in one day: "Glory Be—our old Annie has come back to us."

April 29 and 30 he was "working on my designs for painting this summer." He "went with Tim [Bergin] to study goats in Italian quarter" of New Rochelle. "Stomach weak—tired out & crazy to get to Island." He had taken the New Mexico trip because he needed a break and was too fidgety to work. When he returned, his stomach was upset and he still could not work. He expected that the enforced diet at Ingleneuk would cure him and he was looking forward to summer although it was only April.

He was still not on a regular painting schedule by May 3. He was "in town—lunch at Players—My picture 'Stage Coach' in Knoedlers window." The painting was given no more emphasis in the diary he had begun than his next thought, "I have three sets of young chickens off." On May 8, he "worked on pictures," but only in the early morning because "Mrs & I in town. Lunched with Irma & Buffalo Bill. Saw Wild West Show." The end of the week, he was "trying to catch a rat thats after my chickens. Leaves trying to come out. Magnolia blossoms going." On Saturday, he was "in town—watched Police Parade —fine body of men but officers look like bum politicians dressed up soldier fashion. Lunch at Players. Indigestion at night."

On Sunday, he "walked with Gus." There were guests "up to lunch —me dieting." What he meant by dieting was not so much the reduction of calories but rather the elimination of certain foods thought to be irritating. This proscribed the pork that he loved, so he would backslide when he ate at The Players, and indigestion would follow.

He was "in town" more than he painted. If he had stomach problems after he ate at home, he blamed it on the potatoes.

Seeing Buffalo Bill had put him in mind of the folks from Philadelphia. There had been no word on the February 11 installment, so he wrote to Miller, "Have you decided what you are to do with the money for the payment due?"

In reply, he received a four-page legal document with the preamble, "And Whereas, the said Remington has requested that, instead of giving bond as heretofore provided, the payments to be made by the Association to him for the working model and at the successive stages of completion of the statue shall be deposited in the Fidelity Trust Company of Philadelphia, to the joint account of the said Remington and the Fairmount Park Art Association, at interest of three per cent., until the said statue is completed and accepted." The agreement carried out the preamble, with provisos for reversion of the money to the Association if for any reason the Association refused to accept the statue. Remington "signed Fairmount Park addenda to my contract" May 8. The treasurer made the deposit May 16 and held on to the passbook. The Association had managed to delay its payment more than three months while retaining use of the money.

Remington was as acquiescent then as he had been in the beginning. He did not need money in May 1907. He thought that if he ever did need funds, the folks from Philadelphia would come through for him. As he told Miller, "the full-scale figure would be done in plasteline. It is my intention to have the work thrown up late in the summer and to try and finish it next winter. If nothing goes wrong I ought to have it ready for the plaster man by spring & then it wouldn't be long going through the wax and casting &c and ought to be ready by that autumn, and right then I would need some money. As you know a 'lost wax' casting bill is a good stiff institution and not to be passed over lightly."

It turned out that the folks from Philadelphia were not very flexible. They had Remington pinned to a table of legalisms. Remington noted May 18 that he had "received $3500 for Fairmount Park." He had not. He had nothing but the initial $500 until the Association elected to give it to him. He was lucky that the Association did not charge him for its legal fees.

34.

It's a Dandy, Professor

By the spring of 1907, in a restless and relatively unproductive period, Remington's career had divided into four parts. As a painter, he skirted the edge of the commercial world by doing easel paintings in color for *Collier's*. He also exhibited fine art paintings in Knoedler's, the most prestigious outlet he could have expected. He continued as a sculptor of statuettes, but his greatest satisfaction came from the modeling of the heroic Big Cowboy statue for Fairmount Park "Sculpture," he declared, "is the most perfect expression of action. You can say it all in clay."

He had been unable to make any progress on the Big Cowboy, however, since the February approval of the working model. The reason was that he had not yet figured how to mechanically handle throwing the four feet up to twelve feet. How would he set up the job? He could not start until he knew what he had to do and he was not content to do what others did, place the armature on the studio floor, build scaffolding, and have assistants go to it, copying the working model. He had to find his own way, and until he had a plan he could not begin the modeling of the clay for the final statue.

In the interim, he took pleasure in creating what now seemed to him to be intimately proportioned two-foot statuettes. The fun was to use a solid like bronze to tell a fast-moving story.

While he was delayed in working on the Big Cowboy, he had begun "The Horse Thief" statuette, a "nude Indian on horse holding buffalo skin with right arm as a protection." He did not show the composition to Bertelli until he finished on May 7. This bronze proved to be difficult to cast because of the heavy sections and the price was set at $550, even though "The Horse Thief" was just a single figure like the $250 "Bronco Buster." The higher price did not bother Remington as long as the esthetics were correct, but after the piece went on display, only five castings were sold.

When he went to Greenpoint to work on the waxes for "The Horse Thief," Remington broke the molds for "The Triumph" and "The Cheyenne." "That ends them," he said. "They had lost all semblance of my modeling." This was not a symbolic act, like burning old paintings, but simply recognition that in these two bronzes, the edges in the molds had been eroded to the extent that the waxes required too much work by Remington to produce perfect castings. Breaking a mold sounded as final as burning a painting. It was not. "The Cheyenne" was soon in demand again after being selected by the Metropolitan Museum for the permanent collection. Bertelli's people simply constructed a new model and Remington added the ultimate detailing.

The trips to Roman Bronze had become easier now that Bertelli gave him a ride home in his automobile. As summer approached, Remington was again pressing Bertelli for results so that the work in process on the statuettes would be done before he went away. Ingleneuk was his emotional refuge. He told Howard, "Oh I am itching to get up on that Island. I look forward to it like a school boy. I want to get out on those rocks by my studio in the early morning while the birds are singing and the sun a shining and hop in among the bass. When I die my Heaven is going to be something like that. Every fellow's imagination fixes up a Heaven to suit his tastes and I'de be mighty good and play this earthly game according to the rules if I could get a thousand Eons of something just like that."

Ingleneuk was where he wanted to be, but he had to get his statuette finished and he had to wait until the North Country cold relaxed enough to allow reasonable comfort in a summer cottage. He always wanted to believe the weather would be warm before it was. He asked Howard about the cold on May 14 and was told that "weather up north is awful." "Dont know when we can go to Island," Remington worried. He asked Pete Smith, the handyman, the same

question on May 17 and received the answer he wanted, "weather fine." Right or not, that was the word he was eagerly waiting for, so the next day he "went in town early & bought berth tickets." "The Horse Thief" was copyrighted May 22 and May 23 the Remingtons "left N Y on 11.20 p m train. 'Sandy' [the setter] by baggage."

On the island, it was cold, too cold to paint. For the first week, Remington observed that he was having "trouble keeping warm—cant do any thing," and then "weather clearing out" but "still cold.—Kid gardening." By the end of May, he could say "weather quiet but not warm. Worked in studio. Both feeling in splendid health so despite weather it does us good."

When he finally started painting, the long-established island routine quickly set in. The Cedar Island general store was a gathering point for gossip, but there was no selection of comestibles suitable for the Remingtons' tastes and their elaborate entertaining. Seeds and simples could be bought in Chippewa or in Canada after a trip in the launch. Big grocery shopping, though, had to be done in Ogdensburg. Eva Remington would take the early steamer to go east the fifteen miles, to buy her provisions in the various specialty stores that would deliver her boxes to the dock house in their wagons. The boxes would be assembled there until she was ready to return to the island. On rare evenings the Remingtons might go to Ogdensburg to attend a play or an affair, and occasionally he would go alone to the Century Club to break his diet or to drink. On Independence Day in Ogdensburg, the "boys [were] all on water wagon."

As the family confidant, Howard was the most frequent visitor to the island. City friends like Kemble and Bertelli were weekend guests, despite Bertelli's incompatibility in the country. "Bartelli is very uneasy fellow," Remington declared, "& hard to entertain. He has no repose & gets on ones nerves." Remington was not aware of the social gap that would make first-generation Italians, Jews, or Irish uncomfortable in his house.

He kept to his own regimen. Early to bed was a habit. One night he "sat up with John & smoked until 10 o'c—Late dissipation for me." On another night when the cottage was full of guests, he "went to bed as usual leaving them to play cards." He still painted until three in the afternoon while his wife went about her own activities in the cottage and in the garden. When he finished, he sometimes joined her in the garden, planting seeds or mowing the lawn. He had become an ardent fisherman and with minnows "caught a three pound bass on a five ounce rod and had a dandy ten minutes." "A bass has more quality than a bull dog," he told Shipman. "Well—spit on your hands and lets hear how it is."

His physical activities were minimized. There was no daily exercise in the canoe but rather a steadier use of the "put-put" motor launch that he had disdained in more active years. He was riding in the launch without fretting. Tennis tired him and he "passed medicine ball." One day he "passed medicine ball with Ebbie," who was a child, so that he "felt like a nursemaid. I wish I had some playmates of my own age or older." He considered himself to be "slightly rheumatic." The chronic stomach trouble was improved and his home diet had switched from pork to chicken although the supply of fowl at Chippewa Bay was poor. "Forresters chickens d_____ tough," he sighed. "They are grasshopper chasers & hot water bath no soften the rugged virtues."

June and July were the months that he thought of as belonging to *Collier's,* to do the twelve paintings that he had conceived and composed in sketches in the spring. In 1907, however, he was subjected to new controls by the magazine. Robert Collier was contemplating a more stylish format for his publication and turned persnickety with Remington, becoming a squeaky wheel that insisted on the artist at his best in the old and proved formula. Violent Western action in daylight or classic Indian symbolism was what *Collier's* wanted, not dreamy nocturnal mood images. Collier told Remington what Remington had told Wister a dozen years ago, let everything happen at noon.

The publisher's heavy hand on the creative process was contrary to the fine arts concept that had been the foundation of the relationship, but Remington made no fuss. He shipped three paintings to *Collier's* on June 18 and five more July 29, working at his usual pace of about a painting a week. With the new regime at *Collier's,* six of the first eight paintings were accepted by the publisher, one was refused "for keeps," although Remington had characterized it as a "very successful picture," and one was returned "for corrections." When a painting was rejected for what he considered a whim, he saved the picture for his coming Knoedler exhibition. When a change was requested, he made it and sent the painting back in. Sometimes the change helped and sometimes it hurt. "My Scalp Ceremony back," he observed sadly, "& impossible. My improvement has put it on the bum." Remington went along with the controls without protest, although he did not complete the ninth and tenth paintings until August 20.

Robert Collier was pleased. He was again buying the highest order of popular Western art. He told Remington that the "Story of Where Sun goes is great picture" and a standard of symbolic excellence even compared to the pastoral Taos school. "Shadows at the Water Hole" and "The Howl of the Weather" were virile expressions of men test-

ing themselves, while "Bringing Home the New Cook" and "Downing the Nigh Leader" were high action. The persuasiveness of his pictures continued to amuse Remington. "Jack English and some well bred boys called," he remarked. "They take my pictures for veritable happenings & speculate on what will happen next to the puppets so arduous are boys imaginations."

Collier's bought its twelve paintings during the course of the year but published only six. The growing backlog of pictures signified trouble in the association, although Remington still did not notice what was happening. If he had, and felt concerned, he could have limited the number of paintings he sold *Collier's* to the number that would be published. He was as casual with the numbers, however, as he was about agreeing to change his compositions to suit *Collier's* pop standards, against his own judgment.

At the end of July, Remington decided that he had "finished the work I had laid out for summer," although he had not. "Intend to sketch for study now & loaf," he said, "a sort of vacation." August he had saved for himself. He immediately "tried color study of lawn—failed." He "studied moon till 11," out in his "put." It was a "beautiful moon more than half full" and the next day he "worked on moonlight from my fresh observations." The "vacation" could not last. *Collier's* kept him on his toes until the end of the summer, so much so that he had no opportunity to do paintings for exhibition.

By September 10, he was back in New Rochelle, full of pep and ready to begin the Big Cowboy in what he thought of as that rare instance where the sculptor himself takes on the final statue and makes it better than the working model. While he was waiting for the contractors he needed and he was feeling good, he got a start on another statuette, "The Buffalo Horse," his ultimate expression of action in bronze. The composition was triple complexity, "a bull buffalo reared on hind legs with a pony on his nigh shoulder being tossed and above all the Indian rider being hurled upwards with hands and one toe in contact with pony." He had studied the European Bison at the Bronx Zoo for details but critics were offended by the realism of the piece and only one casting was made. Remington still believed in the concept, however, and two years later he made a painting of the identical composition, in the same way that other times he made a bronze from the theme of a painting, an interweaving of his arts.

For the modeling of the Big Cowboy, Remington had decided to build a new sculpting "studio" at Endion that would be 25 feet long, 17 feet wide, and high enough at 17 feet to accommodate the heroic size of the work. One end of the building could be opened wide to

permit a track to run in from the outside to transport a flatcar made the length and width of the statue. The deck of the 2½ foot high flatcar was a turntable to allow the model to be swung radially to catch the light when it was outside. "Staging" would be placed along the insides of the sidewalls of the building, to serve as movable platforms to stand on when modeling the cowboy's head, which would reach 14½ feet in the air. Ladders would be used to get at spots not accessible from the staging.

On September 12, Remington talked by phone with the contractor Paine from Hoboken, New Jersey, who would "superintend job" of "putting up Big Cowboy" and "get car built. Pat Bergin contracts to put it [the studio] up for $850 and put a man digging." It was a radical idea, that a statue to be seen outdoors should be sculpted in outdoor light. When the weather permitted, Remington and Burdick could run the car outside and either do the modeling there or get impressions of the play of the sunlight on the planes of the figures so that the feeling could be carried out on the clay when the model was back inside the sculpting studio that came to be known as "the shanty." Remington said that he did not "know of any other equestrian [statue] in this country that was done out of doors."

Constructing the facility meant another delay. It was an inappropriate time for Frederick MacMonnies, the elite international sculptor, to ask for the favor of borrowing pioneer clothing from Remington's stock of artifacts. MacMonnies wrote to Alden Weir from Giverny in France, enclosing "a letter to Remington asking him to loan me any old thing he may have for the Denver Monument. I thought you might explain to him how much I would appreciate it. I know him but slightly you know." MacMonnies did not understand how ambitious Remington was. Remington's reaction was, "It makes me sick. I ought to have had that. I refused him because I need the costume myself." It did not matter to Remington that he did not yet have the credentials to deserve a commission like the Denver Pioneer monument. The Big Cowboy, his only large statue, was not complete.

While waiting for Paine and Bergin to finish, he refrained from painting and frequently went to New York City, attended lectures, and bought more books than usual. One lecture on American art appealed to him because the message was that "paint for paint sake is out of date." Art was coming around to Remington's point of view, by accepting stories as subjects just as Remington was learning to emphasize beauty. The books were a mixture. He purchased Marshall's *History of Kentucky* for $20, the Catlin *Portfolio* for $80, Schoolcraft, Mayne Reid novels, *Travels in North America, Viking Age,* and

Human Bullets by a Japanese officer. He also thought about Owen Wister and asked for an inscription for the Big Cowboy that he never used. These were the last letters between them.

As the result of city meals, his digestion suffered. On September 24, "Dr. Dalrymple up in evening for a belly ache of which I am the proprietor." Three days later, he was worse. "D[alrymple] up," he noted, "& has put me on severe diet." Then, the next day "D here—I am well." After that, he said that "N Y tires me almost to death." He "played tennis with Gus & it nearly killed me."

The beginning of October 1907 was Remington's twenty-third wedding anniversary and his forty-sixth birthday. *Pearson's Magazine* also called 1907 his silver anniversary as an artist, stretching time a bit by dating his start from the crumpled Wyoming sketch that W. A. Rogers had redrawn twenty-five years earlier. *Pearson's* featured a long article on Remington, headed by a letter from President Roosevelt:

I regard Frederic Remington as one of the Americans who has done real work for this country, and we all owe him a debt of gratitude. He has been granted the very unusual gift of excelling in two entirely distinct types of artistic work for his bronzes are as noteworthy as his pictures. He is, of course, one of the most typical American artists we have ever had, and he has portrayed a most characteristic and yet vanishing type of American life. The soldier, the cowboy and rancher, the Indian, the horses and the cattle of the plains, will live in his pictures and bronzes, I verily believe, for all time. Nor must we forget the excellent literary work he has done in such pieces as "Masai's Crooked Trail," with its peculiar insight into the character of the wildest Indians.

It is no small thing for the nation that such an artist and man of letters should arise to make permanent record of certain of the most interesting features of our national life.

Remington had turned down the interview for the article until he was told that "the editor of Pearsons has a letter from President Roosevelt saying bully things about you. You'll blush when you read it if modesty hasn't forsaken you. It is the manly kind of praise one expects from TR—nothing sloppy or flamboyant just a straight-from-the-shoulder appreciation of big work well done." That was the kind of promotional approach no public man could resist. It got the interview.

The article itself was the familiar "unbiography," calling Remington the "patron saint of the red man rampageous." Mention was made of the artist's "boyish front" and unlined face. The article reported that Remington had quit writing, a fact not publicly known, but did not disclose the disappointing writing realities like his royalty check for $50 for the first year of *The Way of an Indian* as a book.

Personal details were the usual fiction, that he had "wanted to go to West Point but could never master the multiplication table." He was "once a ranger on the limitless prairies, a hard-riding, rough-living, free-fighting cow-puncher." Remington concluded with the theatrically stated truth that "my West passed utterly out of existence so long ago as to make it merely a dream. It put on its hat, took up its blankets and marched off the board; the curtain came down and a new act was in progress."

Remington's largest example of that Western dream was the Big Cowboy. Bertelli had been constructing the armature at Roman Bronze and by October 10 when the shanty, track, and car were completed, Bertelli's artisan mounted the armature to the car's flat top and proceeded to lay on the clay. He took three weeks, building up all of the solid areas of the statue, right to the detailing. By October 31, the facilities and the blocked-in statue were ready for Remington and Burdick.

On his first day, Remington was already "getting over my fear of the big surfaces on the Big Mud job—ordered a new step ladder. I expect to break my neck working man's head." Those were two fears combined, the dread of height and the worry about whether he was competent to handle the faceting of a more-than-life-size object. The modesty about his talent was fleeting, but eight feet in the air was a high perch for a man "of elephantine bulk."

On November 7, he still said "I cannot work on high staging," although "B[urdick] does well on upper figure. The horse held by Tim proves useful" in giving poses. The new ladder that was wider than usual soon made him more confident and the job began to go well. "I feel like a working man after the hard work of the week on the big model and its a healthy tired," he declared. "Had great time tackling big horse outside modeling—outline is ratty but am getting at whole figure & hope to establish final style as I finish." Soon he was up on top, modeling the head of the horseman. He "paid Burdick $72 for two weeks. He is slower than time but good."

He had to interrupt the modeling in December to be present at his second Knoedler painting exhibition. Between the demands by *Collier's* and hard going on the Big Cowboy, the painting show had been shortchanged from the start. There just had not been enough hours to spare. "With awful times financially," Remington declared, "I dont expect to sell much" anyway.

The 1907 depression had come upon an unaware country. Crops had been good and there was thought to be a fixed economic cycle that had not yet reached the down phase. In November, President Roosevelt had stated that "there has been trouble in the high financial

world." He was late. The panic had struck in October, after nine months of declining stock values. The Knickerbocker Trust Company had closed its doors and the Westinghouse Company went into bankruptcy. None of Remington's friends in the know had warned him and his investments were locked into the depressed market. He even "voted straight Democratic ticket [in local elections] as a protest."

In the midst of monetary disaster and retrenchment, the Knoedler exhibition opened December 2. The prices of the twelve paintings ranged from $1,000 to $2,400 for the sunlit "On the Southern Plains" and "Downing the Nigh-leader" (as it was titled in the catalog), both from *Collier's*. The old faithful "The Last Lull in the Fight" was in Knoedler's window, still unsold.

Royal Cortissoz's review in the New York *Tribune* was a blow after the previous year's praise. Cortissoz sensed the attention that had been given to the magazine's needs in those pictures, most of which had been done for *Collier's*, and noted "the rather crude effects exploited again and again," with "glaring tones not one whit more agreeable in quality than they ever were." Cortissoz's complaints were Robert Collier's requirements. The "night scenes," though, were "a great stride forward," and because of them "Mr. Remington deserves the warmest congratulations." The New York *Times* agreed that the scenes at high noon were "blatantly, glaringly crude," adding that "the paintings of night may presage great things for Mr. Remington."

Only two paintings were sold. The rest went back into Knoedler's stacks. Remington called the Knoedler show "my most unfortunate. I had fair press notices, some quite good ones. I dont care what such people [as Cortissoz] say but realize that they have their effect." The Corcoran Gallery told Knoedler that "we are not now in a position to consider" a purchase, but the Pennsylvania Academy of the Fine Arts borrowed two of the nocturnes for an exhibition arranged by Willard Metcalf of The Ten.

On the big statue, Remington had made an earlier progress report to Miller after he had returned to sculpting, and he wrote on December 12 that "the Cow-boy goes ahead all right and I find the track of greatest advantage. The hard lights of in-doors are so different from the diffused light of out-doors that it looks like two statues. I want your committee to see it out doors but how we are to regulate the wind when you come here I do not know. I am trying to give you a Remington broncho and am not following the well known receipt of sculptors for making a horse."

Two days later he added, "My job is modeled in Italian plastaline because it is soft but Italian plastaline also shrinks rapidly. I am afraid we will have to waive weather conditions." When Miller who was in-

trigued with the process asked more questions, Remington's reaction was to damn the wind and request speed. "I am anxious to get the thing through the plaster stage," he repeated, "and into the final wax where the real finish comes. It's a dandy Professor and I am not a bit afraid of your old committee."

The committee always cooperated in giving its time, if not its money. The visit was arranged for December 26, drawing Remington's admiring response that "my but this is *action*—much better than I had hoped. Well—I am mighty glad you are coming and shall make medicine for a fine day with no wind." He did not care that the censurer of the rigidity of the left foreleg, John T. Morris, had not altered his opinion. Morris chose not to go to New Rochelle because he had to attend a funeral, but he admonished the indifferent Miller that "I feel strongly that we should not have a statue with such an inartistic pose." Actually, Remington had deemphasized the foreleg by extending the base, as he had said, thus diminishing both the committee's internal conflict and the impact of the statue. The offending foreleg was no longer dangerously over the edge of the cliff. All of the action was now contained by the base.

After the committee had come to New Rochelle, had seen the clay model of the statue, and had been escorted back to the station on December 26, Remington entered in his diary that "the committee approved my Fairmont Cow Boy. I am tickled to death." The first sentence was in red ink, the only red entry. With Burdick's help, he had completed the clay modeling of the heroic statue in just seven weeks, a Herculean task for a man of limited physical capacity.

Eva Remington wrote to the relatives in Canton that "Frederic has finished the cowboy statue. The Committee praised his work very much. A plaster cast is now being taken of it. Frederic gave me a mahogany dresser which I am enjoying very much." In this most satisfying moment of Remington's career, his wife maintained her primary involvement with the home and did not jump with his joy. It helped keep Remington's hat size down to share his existence with a wife who had no feeling for his work, other than how the results related to her.

She was a woman of her time, as Remington was a man of his. The visit of the committee meant that she had to arrange the house and studio for visitors, a task she was used to, and to provide refreshments and small talk while Remington handled the viewing. He was the star of the marriage but she was the boss of the household. At the end of the summers in Ingleneuk each year, she closed the cottage according to a list she made up. The island studio was done first and Remington was locked out. All he could do was to watch from a spot on the

porch steps. "I always despise this breaking up here," he said to himself. "It's slow & upsets everything. One cannot amuse himself but just sit around & wait. Mrs R is precise & formal in these matters!" He was not permitted to move lest he get in the way.

She had brought a small-town prejudice to the marriage. Art was decoration done by a woman. She had married an iron broker and she would not have agreed to go away with an artist any more than she would have with a silent saloonkeeper. In the first months of the marriage she had chosen to separate herself from his art and to denigrate his talent because she did not trust art as a means of support. As art became his career, she noted the stages of his success and she appreciated the Steinway in her stocking, yet she remained at arm's length from the problems and decisions in his work, finding an outside activity for herself as an officer of the New Rochelle Nursery. She did not contribute in any tangible way other than as the housekeeper, just as he would never have dared to interfere in matters concerning the house. On the other hand, she did not distract him in his professional regimen, running her household to suit his schedules and adjusting to his occasional need to be with "the boys." She did not break in on his working hours. She was self-sufficient in her own role, as the kingpin in the kitchen.

She had become adept at telling fortunes by the stars. When Poultney Bigelow drove his daughter over to Endion from Malden on Hudson, he said that "she wants to talk horoscopathy & astrologitio with Madame, & I am only her daddy." Remington was sympathetic to his wife's psychic practices and sometimes read his own fortunes in terms of portents.

He was, however, utterly dependent on her presence. His life had become his work, painting and sculpting, but he could not work effectively when she was away from him.

35.

Ready for Glory

At the outset of the economically depressed year 1908, Remington was deeply preoccupied with the sculpting of the Big Cowboy for Fairmount Park. At exactly the same time, he was in the process of losing the most far-reaching forum he had attained as a painter, the monthly color spreads in *Collier's Weekly*. The joy of sculpting was so euphoric, he scarcely noticed that *Collier's* was slipping away from him.

The bronze was particularly dear to Remington, even though the casting of the Big Cowboy would not be a world-shaking artistic event, but rather just the coming into being of an exceptional Western sculpture in a remote corner of a Philadelphia park full of statues. In this first try at a heroic statue, he was successfully completing a technically unique product, a bronze that was both designed for its specific site and modeled in sunlight. Consequently, he was still surprisingly docile about the payments coming to him and about the formalities with the Association, but he was learning.

His January 3, 1908 letter to Miller was dated with the wrong year, as is common the first few days of every January. He wrote to Miller

because the thought had occurred to him that there had been no writ-
ten approval of the clay model, although Contini was ready to start
the plaster casting. Also, he had "Bartelli's estimate/425 for plaster/50
for carpenters gear/5850 for bronze/150 in place/$5475," and it was
just as well that he had never tried for West Point because the correct
total was $6,475. "Bronze people say they want payments as thing
progresses," he told Miller, "or about $3000 in all until [the statue is]
in place. I have financed this thing up to now but will need some
money. I do not own many stocks or negotiable securities now but let
me know how much I will have to deposit with Trust Co to insure
payment of [the first] $3500. How will 100 shares of Copper Range
(Boston Market) quoted at 52-3-4-5 nowadays do as a security?" All
of the cushion in Remington's huge earnings had been dissipated by
his style of living and by investments in the get-rich schemes of his
friends. His stock holdings were depleted and his land deals were dor-
mant. He had no ready money.

Miller conveyed Remington's request to the Trustees at their Janu-
ary 10 meeting. The decision was to affirm the committee's approval
of the statue in clay but to instruct Miller to tell Remington that "no
payment is due at this time" and "it is impossible to alter the terms of
his contract." If he needed money, he could go to the Philadelphia
bank holding the $3,500 in the joint account, to look into "the matter
of a loan on security" like any stranger to the Association. Even
though Remington's work on the statue was substantially finished and
he had received only $500 against the expenditures, he was treated in
as high-handed a manner as if he had been one of the sculptors who
were troublemakers. Miller did not hurry to pass along this bleak mes-
sage, so Remington sent him a follow-up, saying that the "work goes
on and I must take measures to raise money soon." When Remington
was told of the Trustees' negative decision, he made no further men-
tion of the money but only noted that the "FPAA had accepted my
'Cow-Boy'—Hurrah!"

On February 11, the anniversary of the 1907 approval of the work-
ing model, Remington notified Miller that "the vans took the cow-boy
away this morning. I hear by telephone it has been safely delivered at
the Roman Bronze work at Greenpoint—a good plaster job with out a
crack or a mar and I am truly thankful. If it doesn't blow up in the
casting I guess the worst is over." He noted that "my first big work is
successfully off my hands with no accident at any stage of its con-
struction." He still needed the consent of the Philadelphia Park Com-
mission to the support he had in mind for the base, but that was rou-
tine. There was nothing left to do on the Big Cowboy but to get the

model into wax and then bronze and then stick it up on that bluff in the park.

He was drawn to Roman Bronze to watch the end of the labors on the statue. His wife was in Syracuse again, visiting her sister Emma Caten, and he wrote to her February 13, "Saw plaster to day [at Bertelli's]—all right. Sally F[arnham] there—she has a dandy 2 figure group soldier monument. Dont know when I will go Phila. D_____ lonesome here." He had been scheduled to go to see the Park Commission and to "contract for a concrete & rock pedestal &c," but instead he hung around the foundry.

Sally James Farnham was fifteen years younger than Remington and the daughter of the leading trial lawyer in Ogdensburg. Her husband was Paulding Farnham, Tiffany's silver designer who was known as "the Cellini of America." There was an obvious friendship between Remington and Sally Farnham. His letters to her were full of professional encouragement. Her work was "as ugly as the devil," he told her, "but it's full of ginger. Keep it up, Sally." She called him her friend and tutor. His modeling of the "Paleolithic Man" had been an aberration from his usual line of composition, but Sally Farnham responded to his bronze as if it were her personal Cave Man, modeling her own mate to it that she called her Cave Woman. Gossip had them together frequently at Roman Bronze, and at the foundry there was a sunken room, originally a wine cellar and later used for parties.

The cowboy credo that Remington admired, however, called for avoidance of women of the same social class as oneself, the "good" women, in favor of illegitimate sexual encounters with women of lower classes. It was said that in the sunken room at Roman Bronze there were parties that Remington attended, with a female office employee and with women from the cigar factory across the street. It was about this time that Remington wrote Bertelli the undated note pleading, "For G_____ sake send me my bath robe—I am going away." There was no sandy beach in Greenpoint.

He was so full of his trials with the Big Cowboy and with his obligations at Roman Bronze that he had not paid much attention to the basic changes that had been going on at *Collier's*. In the fall of 1907, Robert Collier had made Will Bradley the new art editor, to join Charles Belmont Davis, the fiction editor, and Condé Nast, the advertising manager who later bought *Vogue*. Bradley was Collier's personal choice to design an individual style for the magazine. He was an exponent of nouveau typographic design and layout, building circulation by providing the individual look that subscribers wanted. To maintain a homogeneous overall appearance, Bradley eliminated the

blockbuster writers like Zane Grey and illustrators like Howard Chandler Christy, and presumably Remington. Nevertheless, in the Thanksgiving issue that was Bradley's first test, Remington's pastoral "Story of Where the Sun Goes" was included in full color.

The issue itself was so artistically advanced that critics even reviewed the design. Royal Cortissoz gave Bradley his multi-purpose compliment, "More power to your elbow," that was no more meaningful than Roosevelt's "bully." Bradley left *Collier's* after two years for much greener opportunities on his own, but his impact on Robert Collier was tremendous. He had brought with him the European fashion that was art nouveau and helped it to become absorbed into America.

Even if Remington, who stood for native American subjects and techniques, had participated in Collier's internal politics, he might have been confused. Great artists like him were to be excluded as a matter of policy, but his picture had been included in Bradley's key issue. Robert Collier had extended Remington's contract through 1908, so Remington started planning the magazine's pictures for the year 1908 on New Year's Day, without waiting for summer in Ingleneuk. By then, he anticipated the possibility of trouble. "The Long Horn Cattle Sign" he "thought out" January 1, "layed in" January 4, "painted" January 17, "finished" January 20, and sent to *Collier's* January 23. While the one painting was progressing from perception to publisher, other paintings were similarly being "thought out," "drawn in" or "redrawn from the first little picture," "painted on," and sometimes "finished."

He said that "it seems to take me a little hard [time in] getting back into the painting mood after modeling so long—4 months & ½," but two days later he felt "quite in the mood for pictures." Immediately after recovering "the mood for pictures," however, he began revising his favorite bronze, "The Rattlesnake," which he had copyrighted in 1905. He spent two weeks on an enlarged model, then said that it was "a great improvement. Now think it is good enough to throw up to 10 feet without developing any unmapped peninsulas." He believed that "The Rattlesnake" could be expanded into a statue ten feet high, in the event that he secured such a commission.

Resculpting a statuette was a way of working off his feelings at the mounting troubles with *Collier's*. "Paintings returned by 'Sad Eyed Bradley,'" he noted, "& '23 for me or words to that effect.' Begin to think of taking to the sage brush in Big Horn Basin." In slang, "23" meant "skiddoo," but he misunderstood the problem. He did not conform to Bradley's developing pattern for *Collier's* and he could not if he had wanted to. That was the basis for the underlying hostility.

Bradley caused Remington's March check to be stopped, although Robert Collier sent a new check two days later because the existing contract required the payment.

The conflict between the designy Bradley and the cowboy Remington might have made it seem that Bradley was au courant in the American art scene while Remington was a primitive bumpkin painting on a bucolic easel. That was the impression Remington sought to give. In reality, however, Remington was an opinionated elitist ahead of the academic mainstream in American art.

On a typical visit to New York City, he started the morning at the "Met Museum" to pump himself up for the day. "My bronzes beautifully shown under glass cases," he was glad to observe. "There is a Whistler as black as the inside of a jug." Then he went "down to Am Art Ass[ociation] and saw the Bierstadts—big canvases but they wont do as we understand painting. The old men did not paint 'air'—they saw things darkly." Disliking Bierstadt and Whistler was denying both the past and the future on the same day.

He had lunch with the critic and painter Arthur Hoeber at The Players, having "seen his article in Forum on Am Art and it is a step in right direction." In the afternoon, he "saw Bobbie Reid's new work —splendid—a good long stride. Then to the Macbeth [Gallery] where saw some 'punk' Whistlers and how people can see anything in them I do not know." Whistler was too understated for Remington in 1908, although ten years earlier Remington had been ridiculing the American Impressionism that he had since made into his own. Now he was verbally attacking Whistler's tonalism in exactly the same way, as a possible prelude to blending Whistler's concepts into his own when the right time came.

On another day, Remington was "in Towne—saw [National] Academy ex—The Massacre of the Ancients—a very good show—fresh and breezy." A few days later he returned to the Academy to see the Impressionists "Redfield, Carlson [Carlsen] Benson, Lawson, Tarbel[l]" once again. Then he went on to look at the show of The Ten and called it "a splendid ex. Chase and Metcalf and Hassam and Benson at their best." He did not carry his personal grievance against Chase into his feelings for the paintings. Metcalf he named "the boss" of the landscape painters, although Hoeber had told him that only one Metcalf painting sold. His thoughts frequently concerned The Ten, including Twachtman who had died before the acceptance of the Impressionists. "The American people let that great genius starve to death and yet the idiots were spending millions on chocolate colored junk. Jesus wept," he declared. He recalled the story about Twachtman sketching near the entrance gate to Seton Thompson's estate

when the outdoors painter and writer was known as "Wolf" Thompson. Twachtman drew $ lines through the S in Thompson's monogram. It did not occur to Remington that in 1900, the story would have been just as funny if Twachtman had made the F in Remington's monogram into a dollar sign. Remington had changed drastically since then, while Seton Thompson had only changed his name to Thompson Seton.

Being part of the art ferment in New York radicalized Remington's painting theories. He said that "I sometimes feel that I am trying to do the impossible in my pictures in not having a chance to work direct [from nature] but as there are no such people as I paint its 'studio' or nothing, yet these transcripts from nature fellows who are so clever cannot compare with the imaginative men in the long run." He worked from models in his paintings, but he recognized that for his compositions there was no reality. The "puppets" he put down on canvas were from his imagination. His Indian models had become sophisticated, too. "My Red-skin model did not come," he noted, "but telephoned and is due Monday. I loafed." On Sundays, he "did nothing but loaf. When I started in art I worked Sundays but I'm too old for that pace." No longer did he work as if he had forty kids hanging on his coat tails.

He was caught up in the competition among painters. He considered himself to be one with the Impressionists, in his diffusion of the edges of his subjects, in his palette, and in his techniques. "I am frankly of the opinion that painting is now in its infancy," he observed. "By gad a fellow has got to race to keep up now days—the pace is fast. Small canvases are best—all plein air color and outlines lost—*hard outlines* are the bane of old painters. Bierstadt knew nothing of harmony." It was still the nocturnes that intrigued him. "Wonderful moonlight nights—tried to distinguish color in some sketches I took out of doors but it is too subtle a light. Studying—it has not yet been painted but I think I am getting nearer all the time. The rough [coarse] canvas [is] a great help in moonlights."

He was chock full of these new concepts and "did 'Thunder Fighter' 3 times and dont know whether I shall be able to satisfy myself." He was so upset at failing to reach his elevated goals that he "burned up a lot of old canvases 'New Cook and Apache Water hole and Lengthening Shadows' among them—also 'Drifting Before Storm'. They will never confront me in the future—tho God knows I have let enough go that will." He was destroying paintings that had been published in *Collier's* as recently as 1907 in this extreme attempt to edit his catalogue raisonné.

He was feeling self-righteous, but his tries at keeping his art pure

were not understood by all of his contemporaries. On a day at The Players, he "met Emerson Hough and he has written an article for Collier's in which I judge he gives me a roasting. That made me uncomfortable and then Tommie Dewing [of The Ten] sat down by me at luncheon and for the melancholy Dane he is the Best. Jesus I nearly committed suicide. Two more disagreeable people I dont know." He added that "there is one thing a man who does anything in America can figure on—a d_____ good pounding. It seems to be one of the penalties for achievement."

Part of the achievement was the Big Cowboy. Remington was in Philadelphia March 6 to "look at the site—see the Park authorities and a stone & cement man" to make a support for the base. Miller had thought that October would be a suitable month for installation of the statue, but Remington objected. He and Bertelli had assumed "it would be unveiled in June. I must pay him for it when in place and neither of us like to assume the risk of it any longer [than that]. Today the big thing [mold] is steaming away in the [wax] melting furnaces."

The only unresolved question was the support. The folks from Philadelphia were used to high statues raised to elevations that let the viewers look up at the figures divorced from the surroundings. Remington would accept only a natural Big Cowboy set realistically on his bluff, "not putting it away up in the air" like "a baloon ascension." That resolved the support question, and Miller advised him that both the Art Committee and the Park Commission wanted to come to New York on April 25 for a last look at the model at Roman Bronze. Remington replied, "All right. I have ordered '*beef and*' for eleven starving people at 12.30 Players Club, so every minute after that—grub is spoiling—remember. We will hurl that in and then I have carriages ordered at Greenpoint—regular funeral outfit." The Philadelphians had lost their apprehensions about eating at Remington's expense. After all, they had advanced him that same $500 for the sketch model three years earlier.

Something that was said to Remington during the visit to Roman Bronze alerted him to the copyright situation and two days later he filed for "a bronze equestrian statue of cowboy on a Spanish horse. Reining sharply up, squatted behind—nigh front leg off ground." He told Miller that "I have copyrighted the 'Cow Boy' and shall scratch it on in an inconspicuous place. If you say nothing about this, it will not be generally known and I don't intend to avail myself of its privileges unless some one should reduce it and try to sell them on the open market—thus interfering with my business. It is not exactly a bronze for 'a statuette' but one never can tell." What he meant was that he

wanted to prevent the Association from making and selling copies of the statue because there would be no benefit to him from statuette sales. It was a lesson for lawyer Beck, from an old illustrator.

The Association and the Park Commission invited Remington to a celebratory dinner but he turned it down. He said that his wife was "not at all well at present," along with a string of other excuses. He might have gone if he had known what Trustee Cohen was up to. Cohen was again talking about the site, saying "it has one serious defect—it is too high from the ground." Miller scotched that. Remington was a greenhorn about money but he was a tiger about art.

It was Cohen who ended with the customary job of preparing the "relics to put under the Cowboy" in "a flat copper box." Miller told Cohen, "I am sure you will not get as stupid a letter from any official as Morris [the rigid forefoot man] got from [Governor] Pennypacker to put under the Medicine Man." Cohen did accumulate enough material so that the list of the box's contents took seven typed pages. Included were eight printed annual reports of the Association, "Philadelphia Past and Present," the Philadelphia telephone directory, newspapers, a set of United States silver coinage but not gold, a one-dollar silver certificate no. 47546901 but no higher denomination, a silk American flag with forty-six stars, thirty-seven views of Philadelphia, two Remington prints, an artotype of President Roosevelt, and so on. Cohen asked for a Presidential letter from Roosevelt for the box but was refused by a secretary. When Roosevelt saw photographs of the Cowboy, he remarked, "By George, that is a corking bronze! but do you know, I do not think that any bronze you will ever make will appeal to me more than the one of the broncho-buster, which you know my regiment gave me."

By May 11, Remington was chafing to get to Ingleneuk, saying that "I do not know what we would do without the Island at this time of year. We would go crazy if we had to stay here" in New Rochelle. He saw Ingleneuk as the annual cure for his continual bellyache. "Am dyspeptic," he declared, "and hope for relief at Island—its nerves [that bother me] but outdoors will cure."

On May 18, he was "at Island." The weather was cold and there had been a rise of twelve inches in the St. Lawrence River that put his docks under water. He had the tribulations of supervising "labor which has to be overlooked in the doing" and there were guests. Despite all the diversions, he was "working like the devil [at painting] & by the looks shall be well through with my work so as to loaf a little later." On May 30, he observed that "nothing happens at Ingleneuk which is 'Why' I am doing great work. A man to work should not have any thing else happening." He was so involved with painting that

he even "forgot to send flowers to my fathers grave" although it was Decoration Day. "Damn it," he said, "I dont know how I did it." The next day, however, he again offered Ingleneuk for sale.

This change of feelings concerning Ingleneuk seemed sudden but it had been brewing for three years. Problems with the local help were upsetting, and painting was more difficult in the cold, and there was a rich neighbor on the next island, and Remington was short of capital to proceed with building in Ridgefield, but none of those reasons was new. What had happened to him was that the outdoors at Ingleneuk was no longer a panacea for his stomach pains. Rest and diet could not repair the physical ravages of his obesity, the stomach muscles that had been torn by his bulk and the irritated gallbladder that produced the pains he called indigestion. The days when he had been light on his feet and could paddle a canoe comfortably or play tennis to win were over. He had sold the despised $700 naphtha launch for a bigger "put-put" and now he had Pete Smith operate the boat. He was as much a captive of his body on the island as he had been in New Rochelle.

Moreover, in the Thousand Islands he was divorced from the rousing art discussions that more and more appealed to him and kept him on his toes in the city. Productive as the island studio might be, he no longer wanted to paint in isolation. He missed the art gossip. There was no one to talk to, for example, about the "great stir over Clausen Art Case" where Remington's 1901 dealer was charged with forging paintings by the deceased Homer Martin and George Inness for resale to the proposed National Gallery of Art in Washington. Remington could tell only his diary that he hoped "it will teach the people who have money something about buying. Better pictures are being painted in America today than any before—but it will take another generation to discover it." His advice was, buy the live painters, not the dead ones who can be forged.

There was no immediate purchaser for Ingleneuk, as there had been none for Endion, and so Remington went on with his painting. By June 5, he had "5 pictures done & all of them will pass inspection I think. I am learning to use Prussian [Blue] & Ultramarine in proper way." Soon after, he said he "painted in studio & I have *now* discovered for the first time how to do the *silver sheen* of moonlight." This was the culmination of years of study, but he noted the accomplishment casually.

These achievements in painting equaled his attainments with the Big Cowboy that was approaching its completion, and he was equally casual there. Before he left for the Island, he had approved the finished bronze casting of the statue and had arranged for Bertelli to handle

the installation in Fairmount Park. He told Miller that the unveiling should be a simple ceremony, remarking that "I don't think a lot of high stepping would improve the bronze any and it would make everyone more or less uncomfortable." That was Remingtonizing the situation, avoiding the commotion. To the Association people, however, ceremonies were part of their perquisites, despite fraternization with the sculptors they hated. They distrusted Remington even after his bronze was cast. The Association's fiscal officer left for vacation, telling Miller that "if R. takes a notion to play any antics I most sincerely trust that I shall not be around to sign the check." To the Philadelphians, all sculptors were an outlaw breed, open to gratuitous insults.

Early in June, Miller advised Remington that the Association had decided on a ceremony after all, for June 20, and that immediately afterward he would arrange for the money that was due to be handed over. Remington's answer was that there was "no hurry about settlement—take your time. So you put it off until 20th—good—I suppose you will have a speech or so. I cannot be there in the flesh but will be in spirit. It won't matter; no one will know—the newspapers never mention the sculptor, you will notice, in such events."

Miller wrote Remington on June 22 enclosing "the best newspaper account of the exercises. I also enclose, what is more substantial, the payment of $4,000 due you this year and a checque for $3,614.19, the amount of last year's payment with interest. Now that the work is in position, I feel more strongly than ever that it is a magnificent thing." Hetherington, one of the trustees who had visited New Rochelle, received the statue on behalf of the city of Philadelphia. He later told Remington that "no statue was ever unveiled with more appropriate ceremonies. I wish you could have seen the pictures [of a band of cowboys and Indians]—it was much like one of your own—He Dog the Chief who pulled the rope [for the unveiling] has been ever since the proudest Indian possible—When I saw your modest letter I resolved that all the praise should be given you. Remington's Mounted Cowboy and thousands have been to see it."

The amount of the payment did not even reimburse Remington for his expenses on the Big Cowboy, but that did not lessen his pride. The statue "looks exactly as I had it pictured in my mind's eye when 'in place,'" he replied to Miller. "Some more solemn & reposeful thing might defend itself in a foundry but that cow boy had to be on the bluff he was intended for. I hope now some one will let me do an Indian and a Plains cavalryman and then I will be ready for Glory." Miller did not bite on the offer, but the two statuettes Remington

modeled in 1908 were suggestions for him; "The Savage" was the head of an Indian and "Trooper of the Plains 1868" was the cavalryman.

The Association asked Remington to provide autobiographical data for its catalog, and for the first time the artist provided an absolutely straight set of vital statistics. The data was followed by a " 'puff' as puffy as I can make it" in which Remington enumerated his claims to artistic fame. He was, he said, "the first man to do horse action as it really is," "one of the first men to do 'lost wax' bronze statuettes in America," and the sculptor of the Big Cowboy that was "the only sculpture which was made out-of-door[s]." He added the frivolity "if you want any more 'you can sing it yourself' " before striking that line to conclude with the claims that he had made the West into his personal turf and that his achievements were free from obligations to schools, academic convention, or patronage. The Association catalog incorporated the statistics but deleted the "puff."

Nevertheless, the claims were essentially correct. He was different from other artists of his day. Like the painter George Bellows, Remington began "when the trite and the sentimental seemed to be in ascendant in art, fearlessly painting things that were ugly and crude, with all of his qualities derived from America." Bellows, however, became a National Academician. Remington could brag about his homegrown gusto and his lack of debt to tradition but in truth he still yearned to be a full Academician. It was a blow when twenty-three members were chosen for the Academy in 1906 including MacMonnies, Hassam, Reid, and Tarbell, when eight were chosen in 1907 including Pyle, and when one made it in 1908. Yet he still would not exhibit at the Academy, despite a letter from Harrison Morris, chairman of the Academy's Committee on Ways and Means, saying "you are the laureate of the might of the real America. I wish we could find a way to have such work at the NAD. Why don't you." On the other hand, he did not resign as an Associate, the way Henry Mosler did, leading the Academy to strike Mosler's name from the list of Associates as if it had never been there.

The reasons why he was not named an Academician were the same as they had been. He acted as though he was a better painter than the Academicians, he earned more money than they did, and he lived on a high plane when many of his peers were strapped. "Poor Hoeber and Bobbie Reed [Reid]," he noted, "are pathetically hard up." He continued to antagonize artists like MacMonnies, saying "Macmonnies in the country and I expect he will want some more information for his Denver monument but I guess he'll have to go it alone. I haven't accumulated all my knowledge on this matter to glorify a Paris artist who

knows no more of our West than a Turk." When he saw Solon Borglum's monument of General Sheridan, he called it a "dead ringer for my Fairmount horse. I shall take pains that he has no knowledge of my next horse." He criticized Alden Weir silently, when Weir at The Players "put up his customary beef. If I was JAW I'de commit suicide. I wouldn't be as *bilias* as he is if I got run over by the cars." He considered himself to be a better painter than Hassam, observing that he "saw Muley Hassam's desert things—not so much—he does not reach the high light tone. He has the grey tones and skies on the sun light."

Another big reason for resentment against Remington on the part of the Academicians was the connection with *Collier's Weekly*, as it had earlier been with *Harper's*. Robert Collier took care of that objection. On June 29, he severed the relationship with Remington as of January 1909, at the request of Will Bradley. Remington said the causes were that "Collier pays Roosevelt $1 a word which is why they cant keep me," "they had 20,000 of my drawings [on hand]," "Collier's Weekly has run down & I guess they find it hard to get back circulation," and "my stuff has been held up for two years & not published so I have nothing to do with it." He never did comprehend that his style was incompatible with Bradley's format.

He went right on working, without rancor or change in his life-style, except that instead of *Collier's* pictures he "made a study of white birches. The trouble with my landscapes is that they are rarely pretty. I love the work, tho." Ten days later, he said that "my stuff that I brought up here [for *Collier's*] is done & I now think that I will only sketch from nature around here. It is the only vacation I have had in years & seems strange to really have nothing to do & no anxiety about it all. I dont know whether I shall like it or not with the harness off." He quickly found out how he would behave with the harness off. In two days, he was again revising three of the *Collier's* pictures he had called done, saying "it seems I can never satisfy myself." When he thought the pictures were complete, he had a "hanging day" in the little studio. According to his friends who were invited, he would "tiptoe around and watch your expression. If the picture doesn't strike the observer at once it's all wrong, to Remington's way of thinking, and he forthwith studies it out and works until he puts it there." He had grown to be like Owen Wister, a painstaking technician sensitive to any negative expression. It was August 13 before he finally packed and shipped the last pictures for *Collier's*.

The end of the summer was approaching. On August 19, there was "rain & storm—& to complete the desolation Kid put us all out doors —cleaning for her fuss tomorrow. All she needs to complete a tragedy

is a storm. Imagine being put out doors." This was the party for the end of the summer, and after that, a *Herald* article commented, "when the fall comes he sighs and dons a derby hat and store clothes and hies away to New Rochelle until the West lures him away for the scenes of his boyhood days."

On September 8, Remington did leave New Rochelle for Wyoming, to travel the same routes he had followed when he was a younger and more active man. He went alone, which was unusual, but he was to meet lawyer Beck from Philadelphia in Cody. On September 12, he wrote to his wife in Gloversville where she was visiting her sister Clara. It was Saturday night and he was stuck in Sheridan, Wyoming, waiting for his rail connection to Cody. He said that he "never had such a grilling as this trip. It was the hot spell of 1908 and I got it all. Even now my baggage has gone on and I am back in the dirty clothes I took off at Chicago but I am going to laundry them to night in the wash bowl. Such is the life of an artist in search of the beautiful. Keep your nose clean." The September heat was bothering him, and his new goal was the "search of the beautiful," not the search of the subject matter that had occupied him the last time through nine years ago.

Cody was difficult to reach. The next morning he "got Toluca" in Montana—"a god forsaken water tank with nothing not even prairie dogs in sight. Had sausage & fried potatoes for breakfast." He left Toluca for Frannie, the head of the Cody spur, and "had corn beef in a detracked car—nice diet for me. The Cody branch ran right up the River Gap of the Big Horns & I recognized it all the way having ridden over it years ago with Indians, Wolf Voice, Ramon & others all dead now. Got Cody. I nearly died of the heat."

He called Cody "a nice town" and The Irma hotel a "dandy—as good as one could want." Beck had met him with the gear accumulated for a hunting trip, "horses, tents, pots, saddles etc and they are hard to pay for out here." The destination was Jackson Lake, a back-breaking 70 miles over the 12,000-foot mountains of the Continental Divide. Beck's plan was for Remington "to paint slowly up the valley because before he boosts me over the main divide he wants me to get used to the thin air. It is quite an undertaking for a one legged man but I'm in for it. It will be a month without doubt."

September 16, Remington had "a hard pull up the mountain to Irma Lodge" with two wagons and drivers. It was the "same old place as 9 years ago. Grand view across the valley. In camp late—blowing—cold —teepee tents. D_____ near busted my hips lying on ground. I feel the light air of this 7000 ft altitude. I dont like it." He was chafing on the first day, although he was transported in a wagon with the gear.

Two days later, they were still in the camp because Remington was

adjusting poorly, although he said that "we had a good talk by big camp fire—real thing—smoke blowing in your face & sparks flying." This was an ailing middle-aged man trying to be one of the boys, sleeping on the ground, his right foot uneasy because of the chronic gout, dyspepsia on edge from the railroad and camp food, and his heart pounding due to his excess weight in the thin air. His artistic vision exceeded his physical powers. "The transparency of air here is confusing to paint. Sage brush under your nose has the same vividness as mountains 40 miles away. It is quite unbelievable to one who has not seen it. The blue sky is vivid." This was the old phenomenon, arousing the same comment he had made for twenty-five years, but it was all new to him once again.

On September 20, they reached Buffalo Bill's ranch and Remington "slept in Col Cody's bed." The next morning, they "made Beck's camp at one o'c over the g_____ d_____est road I ever jolted. Very primitive log camp right under towering Shoshoni 12000 ft. Beck getting ready to go on trail. I slept on a d_____ old bed which made pictures all over me." Beck had waited for Remington because he needed the gear in the wagons, but he could not delay any longer and Remington was not ready to go ahead. When Beck's party left for the hunting trail, Remington stayed behind in the camp. "Old trapper Miller" was detailed to take care of him.

That night, Remington "didnt sleep well—mountain vast & lonesome." He was stuck in the camp for the three weeks or more that Beck would be away, and he did not have the personal resources to tide himself over. He "made sketch of ranch & two ponies—photographed" and he told trapper Miller to pack up and they returned to the Cody ranch. He was two weeks out of New Rochelle, defeated by the routine of camping, and anxious to get home. "I went West," he said. "Got caught in a blizzard and fell off the water-wagon—got out of the blizzard and back on the wagon."

The next day, he was on the train. On September 27, he was "at St Paul—Had to take a state room $8.00 to save my self from upper berth. Some years ago I fell out of an upper berth & I am shy on uppers." That was flip talk to his diary, but he had been physically unable to cope with the wilderness trip and he could not maneuver his bulk into an upper berth. He could not ride a horse, eat camp food, sleep on a cot, walk a trail, or tolerate altitude, on a mountain or in an upper.

On September 29, he was "glad to get home—tired—dirty & nervous. Had a good bath & another before going to bed." October 1 he noted as his twenty-fourth wedding anniversary, and October 4 he said that "I am 47 years old today," but he was an old forty-seven. His Western junkets were ended.

36.

I Have Landed
Among the Painters

On his dispirited way home from the debilitating try at Rocky Mountain hunting, Remington rode down the railroad spur from Cody to Frannie through the valley where he had years ago camped with Wolf Voice and Ramon as a correspondent for the Harpers. Thinking back to those distant days, when he had been an illustrator of events rather than a painter of moods, the high spot for him had certainly been the Indian wars, and in particular the brush with the Sioux near Wounded Knee. He had been a prudent young man, but he had been in real danger from the Sioux until protected by Red Bear. After he returned to New Rochelle September 29, he "sent Maj Michaels $20 for grub for Red Bear. He saved my life—$20 not much but he is so poor it may save his—less heroic however." Remington had also shipped Red Bear a rifle in 1891. He was right about the gifts. They were few compared to the deed, and they were far between.

On that same interminable rail journey following the aborted Western expedition that was his last, he convinced himself that he could not wait forever to sell Endion and Ingleneuk to be able to build in Ridgefield. He had thought of building during the past summer and had gone so far as to put architectural drawings into the hands of con-

tractors for estimates, but he had not proceeded because of *Collier's* failure to extend his contract and the continuing hard times. If living in Ridgefield would tie him closer to The Ten and help his career as a painter, however, the sooner he made the move the better. With the Big Cowboy completed, painting was his "best hold" until another commission for a statue came along.

After he sent the little bit of money to Red Bear, he wrote to the banker Fred Gunnison about a lot of money. "I am getting estimates on house in Ridgefield," he declared, "and the day after election if Taft is It I am going to let contracts—provided I can depend on that money in Dec from mortgage—Can I?"

As a believer in fate, he was allowing politics to resolve his future residence. President Roosevelt was not running for reelection although he had told Remington that he was "still looking forward, and not back." Roosevelt had picked Taft as his successor, to run against the Democratic candidate William Jennings Bryan. To Remington, Taft was the cure for the country's economic ills. He advised Bertelli, whose foundry was short of work, that "Taft is going to be elected— the West is booming and times are going to come good with a bound, so don't worry. The people of this country are going to tell Mr. Bryan to go way back and sit down so hard that even he can under- stand it."

Bertelli had bronze as his only product, while Remington also sold paintings. Remington noted October 3 that he had "finished Cavalry picture ['Night Halt of Cavalry']. Quite vibrating & good tone." The concept of vibration was straight out of Monet, applied to Western action rather than the Frenchman's water lilies. Painting was "an ex- pression of light," Remington asserted, and the canvas should "glow and quiver until it seems to exude the palpitating quality which light holds."

In addition to Monet's light related to action, Remington thought again about painting sizes. He was so open to suggestion that he lis- tened to gallery owners. "W. Scott Thurber of Chicago wants 'Long Horn Cattle Sign' to try for a sale," he wrote, but "Thurber's man in Chicago didn't take my picture. Too big. Wants a smaller." Two days later, he was still thinking about Thurber. "I see the virtue of small pictures," he stated, "I shall only paint gallery pictures [of the 27 by 40 inch exhibition size] & small ones [for casual customers]." He went ahead and did "Hope in the Day" which was 12 by 18 inches and "The Last of His Race" at 18 by 12 inches, but not for exhibition at Knoedler's

On the weekend beginning October 9, he took a short trip to the Catskill Mountains with the cartoonist Homer Davenport. They went

by train to Summitville for the night, then on by automobile ten miles north to Napanoch in Ulster County. "A most gorgeous view of mountains," he said. "Moonlight beyond any thing I can remember." He was chauffeured wherever he went, over long-established highways, like any other moneyed Easterner. His flesh restricted him to springy vehicles on good roads.

Davenport had become a staunch friend. He was six years younger than Remington, brought up on an Oregon farm that he had left only because of the "one thing that would repay me for leaving Oregon and the pioneers and that would be the forming of acquaintances of great men. A discussion then took place [between Davenport and his father], as we leaned against an old stake and rider fence, what men. Remington and Frost, were the main men." Without any formal schooling, Davenport had worked his way as jockey, fireman on a railroad engine, and circus clown until he caught on as Hearst's political cartoonist. He had "formed the acquaintance" of Remington at the *Journal* in New York City and had been so influenced by Remington's stories about Africa that he traveled to the Sahara in 1906 and brought back the first twenty-seven Arabian horses to reach the United States. In return, Remington said that he had been influenced to buy his farm when Davenport made the suggestion across a dinner table at the Lotus Club. Remington remarked that "Davenport made a great hit with me" because of his storytelling abilities, the "verbal pictures" he "painted."

The verbal pictures were the only ones that were painted on the Napanoch trip. Davenport was not a painter and Remington was along just to relax with the boys. The Catskills and the Hudson River were burned out for Remington as painting subjects. That had been the turf of the nineteenth century Hudson River School painters Remington called "very uninteresting. The old fellows did nothing of interest to modern artists. They used a sort of salad dressing— chocolate & cheese—and each had a patent way of applying paint. No more old pictures for me." Remington's preferred scenery was the Adirondacks and the St. Lawrence. He was proud that Gus Thomas had told him that his "landscapes are as good as anyone paints & says I will be a great landscapist. One will always believe nice things of himself," although he had not yet had the confidence to exhibit the landscapes.

He was reading voraciously, as if he still took stock in what he had said as a younger man about literature being the companion of art. "Rereading 'Deluge,'" he noted. "God if America only had a novelist like Sincaiwitz." This was the Polish novelist Henryk Sienkiewicz who had won a Nobel prize in 1905. Remington also reread Froissart,

the chronicler of the fourteenth century, and looked "in vain for any virtues in the day of 'chivalry.'" Rex Beach was a contemporary who had written the heavily advertised *The Spoilers*, which Remington called "fine. Rex says that the physical aspects of the frontier changes, the people are always the same." Instead, Remington had found that the people in the West became civilized along with the land.

He told Gunnison that the Westerners "are all for Taft" and he was pretty sure of the outcome of the election. Thomas teased him. "Gus says Bryan by two million," Remington observed, "but I dont know whether he believes it or not." On November 3, Remington voted "straight Republican ticket." He went to bed not certain who had won and the next morning, the outside man Tim "woke us—telling [us that] Bryan elected—I jumped out of bed & found that it was a little joke" instigated by Thomas. Reassured that Taft had won, Remington let the contracts in the amount of $28,000 for the construction of the Ridgefield house.

Remington never worried about money. In his mind, he would be selling Endion and Ingleneuk the next week, or he would get another statue to do, with payment in advance, or he would sell a set of statuettes, or he would organize painting exhibitions around the country. In the meantime, however, Gunnison had given him the bad news that he would not be getting the money on the mortgage, so he wrote to the friendly folks from Philadelphia, saying, "I am about to build a house and have to borrow some money in the process and I was wondering if you know of any financial juggelry whereby I could get the money owing me by Fairmount Park Art Asstn." As usual, he waited for the answer.

With the three land holdings, he was short of capital but he was not so short that he accepted the offer of "500 apiece for two" large paintings from the investment banker Robert Dudley Winthrop when that amount was below what he was asking. He was not driven to painting when he did not feel like it, either. He toured the New York City art galleries with Charlie Taylor the illustrator and saw "Van [Dearing] Perrines work—very splendid" and "Pyles work—a great dramatic bit." He wanted to examine the paintings of all of his progressive contemporaries.

Everybody's magazine carried the anecdote that when he had returned from Wyoming, he saw "an exhibition of very impressionistic pictures" without enthusiasm. When asked for an opinion, he replied, "Say! I've got two maiden aunts in New Rochelle who can knit better pictures than those." In fact, he now painted "very impressionistic pictures" himself, and the pivotal show of those pictures was to open

December 1 at Knoedler's. This would be the test of whether he could survive as a fine art painter, without the financial backing of *Collier's*. Knoedler's did its part, mailing out 3,500 catalogs to customers on its list and holding another 1,000 for the door trade. The paintings were previewed by two of his peers, Hoeber and Hopkinson Smith, and their opinion was that the paintings were "the big note in American art." That sounded great, but they did not put it in print.

The day the exhibition opened, Remington finally heard from the Fairmount Park people. Because the Association had the money and Remington had the need, Miller was instructed to ask him to "make a definite proposition." The Philadelphians wanted to find out just how desperate Remington was. With the burden back on him, Remington stayed with the quest for the money despite the potential sale of oils at Knoedler's. He replied on December 2 that "as far as proposition goes —settlement of the *Cowboy statue* account—a proper discount would be an ordinary business discount at a bank—but if it is trouble I should be willing to consider [reconsider] that." The discount was figured at 6 percent per year, with Remington asking for $11,004 as the cash settlement for the $12,000 that was owing, and he left himself open for a bigger bite if the Association insisted. After making the proposition, he was required to wait again until the Association elected to let him know when a decision had been reached.

The same day, December 2, the newspaper reviews began appearing on the Knoedler exhibition. The first was the New York *Times:* "Nineteen paintings show the artist's constant study of dramatic movement and color, and the types of Western character are like what we see in imagination when we call to mind a Western scene. A number of pictures are Eastern scenes [landscapes] rendered with frankness and simplicity." In 1892, *Scribner's* had remarked that Easterners "have formed their conceptions of what Western life is like" from Remington's pictures of the West then. Sixteen years later, that West had "gone off the boards" and Remington's Western pictures now presented the dramas of history. The *Times'* review was a total acceptance of Remington's art, the color and the composition, including the Adirondack landscapes in their initial showing.

That was a strong evaluation. The next morning, the New York *Globe* carried a rave review: "Frederic Remington sounds a purely American note. His color is purer, more vibrant, more telling, and his figures are more in atmosphere. Go see the pictures." The bit of criticism that appealed most to Remington, he clipped from the paper and pasted in his old 1888 journal: "Though no Indian, no cowboy, no cayuses ever lived that were equal in fierce ugliness to these, his pic-

tures are nevertheless great." That was it, the accolade he had waited for. All of the other Western painters, the Schreyvogels and the Russells, were outdistanced.

Seven of Remington's thirteen Western paintings in the show sold in the first week, along with one of St. Lawrence scenery. Despite the depressed economy, Knoedler's took in $8,500, and there were other paintings that sold after the show closed December 12. Remington told the woman who bought "A Scare in the Pack-train" that the key to understanding the picture was not just what she saw but also the awareness that "something is due to happen *muy pronto.*" He gave the buyer of "The Stampede" a similar key, that "man was never called on to do a more desperate deed than running in the night with long horns." He had said that "I have always wanted to be able to paint running horses so you would feel the details and not *see* them. I am getting so I can stagger at it." Over the two decades since he had redrawn the gallop in art for the sake of realism, he had simplified the motion to where he sometimes coincided with the Muybridge views.

He was finally sure of both the critics and the customers. He told John Howard, "my show made a great hit. I am no longer an illustrator," and he held to himself the thought that "it was a triumph. I have landed among the painters and well up to[o]." That done, he went back to work and started another picture. He believed that capturing light a la Monet was the trick. "Fine day," he said. "Worked all morning on the cowboys in the early morning light. If a man could paint that very illusive thing it would not be interesting from lack of color. Burned it up with other failures." That was December 19, his third destruction of groups of paintings by fire.

His vehemence was so great, he could not scrape fresh paint off the canvas to re-use it like an ordinary artist. He had to destroy failures. When he could not, he complained: "A man wants to sell my early painting 'The Missionary.' Thus my early enemies come to haunt me. I am helpless. I would buy them all if I were able and burn them up." When "Harper's boy tried to get Knoedler to sell an old football drawing of mine," he replied that "Remingtons of that day have no commercial value." A more confident man would have been protective of the early pictures that showed his developing technique, but no museum had yet claimed his paintings and he was not certain of his place in art history.

On December 22, when Remington's financial situation promised to ease a little after the exhibition, he heard from Professor Miller. The Association had approved Remington's proposition on December 7 because its funds on deposit in the bank were earning only 3 percent and Remington had offered 6. The delay in responding to Remington had

been caused by having Beck's partner Robinson prepare a receipt for the money, and that was now finished. Remington was instructed to come in person to Philadelphia so he could surrender the original agreement with his own hand and sign the receipt in Miller's presence. They could have allowed him to have his signature guaranteed by a bank in New York City so he could mail the agreement, but the folks from Philadelphia were cavalier right to the end.

Remington did not mind. He noted in his diary that December 31 was "the last of 1908 which in [astrological] theory was to be good to me & it was. This year I

> Unveiled a monument of a cow-boy in Fairmount Park
> I painted a lot of pictures which made a great hit at Knoedlers
> I started building a house in Ridgefield Conn
> And my gross receipts in money were 36614.87
> and owing from Knoedlers 6800.
> and I kept on the water wagon."

The receipts were impressive, $36,614.87 against only $28,000 that he needed for his house, but the house was not his only expense and the income figure was the gross. Unpaid costs on the Big Cowboy were about $6,600, leaving $30,000. Of that, $18,618.29 was from Fairmount Park, a one-time transaction not to be repeated in 1909, and $12,000 was from *Collier's* under a now cancelled contract. He had had little recent income from the statuettes and relatively little from paintings. The proceeds from Knoedler's would not be paid until January.

He was deluding himself on the felicity of his 1908 receipts in the same manner that he was wishfully thinking that he "kept on the water wagon." His biggest fall from sobriety had been at the Rough Rider dinner honoring General Wood on the tenth anniversary of the Santiago Campaign. Two days after the dinner he could not paint because he was still "not fully recovered. I shall go to no dinners again that dont begin at 6 and end at 6.30."

In his final entry for the year on New Year's Eve, he remarked that "I worked all day at painting." His work ethic kept him going as he closed the one box of time and opened the next box. "Here we go again," into 1909, he told his diary. He "talked of the future joyously, as if on the threshold of a new world where he was coming into his own." He said he would be "fully embarked on the uncertain career of a painter, no longer on a salary." His health was generally good at the moment and on his own turf he did not express himself like a debilitated person. He usually held to his diet, kept more on the wagon than off, and maintained regular hours. For a forty-seven-year-old fat man, he was in good enough shape to handle his physical prob-

lems for the foreseeable future. He was too far into obesity to be able to take off any appreciable amount of weight, however, and if he had tried, he could not have functioned as a painter.

Ingleneuk and Endion remained unsold. Endion was the harder to dispose of because it had been on the market for so long and because now the Westchester & Boston Railroad's tracks that were approaching the property were expected to pass through. Remington glossed over the impending railroad line like a real estate agent, saying that he was moving to Ridgefield only to obtain the acreage that was needed to graze the horses that were his models.

There were not yet enough funds in hand to pay for completing the construction of "Stony Broke" in Ridgefield, despite the Knoedler sales and the cash settlement on the Big Cowboy. Progress in construction was slow over the winter, fortunately, and that minimized the required outlay. There was no easy way to get money from the stock or real estate investments, and Remington remarked that henceforth he "would rather put his money in manure." To help himself a little, he resold extra acreage at Ridgefield, retaining ten acres as ample for his needs.

Barton Hepburn watched the construction, reporting that "I have seen your mansion at 'Stony Broke'; it looms up beautifully." Hepburn was an important economist on the national scene, the author of legislation and books on transportation and currency, and yet as a friend he served as Remington's private banker for Ridgefield. When Gunnison at last produced a thousand dollars of mortgage money, the payment came through Hepburn.

Eva Remington and the architect had planned the Ridgefield house. She was happy while she had a real role in the new home, as she had enjoyed fixing up Ingleneuk. She had no comprehension of the problems that Remington faced in his expenditures, and she was not directly involved in his earnings. Remington left the planning of the mansion to her and busied himself with supervising the actual construction. That he could paint at all while Ridgefield was in process was a tribute to his concentration.

Yet, selling paintings was substantially his entire income, so he had to hustle. He had active dealers in Chicago, Albany, and Washington as well as in New York City, and he sought to establish a Boston market with a Doll & Richards exhibition opening January 8, 1909. The gallery was a respected source for art by European-trained Boston favorites. Remington had high hopes for a strong showing based on the New York results. Snide Boston reviews, however, prevented the sale of even one painting.

The chief critic was the Boston figure painter Philip Leslie Hale,

who had studied with the French academics. The husband of a successful painter, Hale taught and also moonlighted as an art critic, but he thought that the work for the Boston papers was beneath him and he did not take his duties seriously. When he did not like a painting or a painter, his comments were cruelly sarcastic, as Remington discovered. Some of Remington's denigrators had declared that his popularity was due not to ability but to luck in chancing on the West as his subject. Others like Hale were more basic, declaring that no painter who stooped to exploit such a vulgar subject as the West could possibly have talent as a professional artist. What Hale stated was that "one would not be disposed to take these things very seriously as paintings, although one or two of the landscape backgrounds suggest nature not a little. But if one puts the idea of painting from one's mind, as illustrations these scenes are distinctly amusing." After Remington read the review, he remarked that "one Philip Hale gives my paintings a turning over. He must have liked the frames since he didn't put acid in them. I never got such a roasting in my life." The show was a complete washout. "They call my moonlights 'Monochromes,'" he exclaimed. "I fear Boston will never enjoy Freddie again." At the end of the show he added, "Dear old Boston—I have got about all the Boston I will require in my life."

Remington had sent Boston the most macho of his unsold pictures, the sixteen Westerns left over from the 1907 and 1908 Knoedler exhibitions. If he had shipped his modest Adirondack landscapes instead, he might have had a more favorable review. The only good word Hale had was for the landscape backgrounds to the action. Boston made Remington so depressed that he took the thousand dollars from Winthrop for the two large paintings he had held on to when he was more confident.

During the Boston exhibition, there was a "letter from Bobbie Collier confirming understanding that I am no longer to reproduce pictures with him. He says when they catch up he hopes to resume," but *Collier's* still had twenty-one paintings that were purchased and not published, enough for four years of irregular appearances. "I hope I will not have to" resume, Remington observed.

On January 21, he read an article about the National Academy in the *Craftsman,* a magazine for American handicrafts. The article brought into the open for the first time that Remington was "not represented at all [in the current National Academy exhibition], although he is at present one of the most notable American painters and sculptors which the nation can boast. He is, in fact, one of the few men in this country who has created new conditions in our art; and must be reckoned with as one of the revolutionary figures in our art

history." The article bucked up Remington's aspirations and led him to believe that he might use the *Craftsman* to a greater extent in his continuing campaign to be elected an Academician on his own terms. He had refused to grant the magazine an interview in 1907 but now he solicited an article on himself.

Business conditions were still depressing the art market, although the popular painters were always prosperous. Sargent received $12,000 for a portrait. Thomas Moran earned $45,000 a year. Chase charged $3,000 for a fish picture. Hassam did well. Remington did, too, "although no bronzes sold this year—worse than last year. Things have slowed down commercially in the United States until you can't get a rabbit to run from a dog."

Some of the outstanding painters were hurting. Metcalf continued to have sales problems, despite Remington's recognition of him as "no. 1." Remington applauded Hoeber for an exhibition and was told that "your commendation came just at the moment when I needed a pat on the back for I was mighty low in mind." Remington's particular friend Robert Reid fared poorly, perhaps because "he asks too much money." By the end of the year, the New York *Times* reported "Artist Reid a bankrupt," with "liabilities of $18,244 and assets of $12,450." Reid could not count on earning even the additional $6,000 needed to balance his books, although he was a National Academician and one of The Ten.

Remington did a lot of his gallery hopping with Reid. They did not think much of the "Great Exhibition of German Art" at the Metropolitan Museum, and hoped for American art to go the "long way toward teaching the unholy rich that there is something beside their old masters (faked) and the early molasses boys and the late Dutch to whom out of doors looks like a full cream cheese." They liked Sorolla, the Spanish Impressionist who "makes everything else look like a collection of lead quarters." There was a dinner for Sorolla at The Players that Remington did not attend because of his diet. He remained fascinated by Whistler's paintings, though, and did go to hear Whistler, whose "talk was light as air and the bottom of a cook stove was like his paintings."

Remington intended to spend most of the year creating paintings for the coming Knoedler exhibition, and more than half of the subjects he planned were Indian. He did not look for another publisher to replace *Collier's*. It was bad enough for him that *Collier's* continued to reproduce his paintings from the overstock while it "advertises me exclusively although I am fired." No association with any periodical that could connect him with illustration would be tolerated. A great painter like Winslow Homer could call himself "just a reporter," but

he was regarded as kidding when he did so. Remington had no sense of humor on the subject. On February 15, he again "burned up a lot of old canvases." This fourth act of destruction demonstrated the pressure he put on himself to be born again as a serious painter when he moved into the new studio in Ridgefield.

With the start of warmer weather, the pace of the Ridgefield construction picked up. Hepburn who was Remington's stand-in superintendent abandoned the project when he went to the Caribbean for a month's vacation with the Bachellers. Remington was forced to cut down on his painting to commute to the site. He had never bought an auto so travel was by carriage, twenty-five miles each way. "This Ridgefield farm," he said, "is the first enthusiasm I have had since those Spanish boys were shooting at me down around Santiago."

His financial plight was eased on February 22 when he sold Ingleneuk to a boyhood friend from Ogdensburg, Thomas F. Strong. John Howard memorialized the sale in a bit of doggerel:

> There was mournin' on the river
> When Rem. he quit the Bay
> There was bile on Howard's liver
> When Rem. he quit the Bay;
> For it seemed like Death had took him,
> That never more we'd look him
> In the eye, that ne'er forsook him,
> When Rem. he quit the Bay.
>
> The laughter died in Faithful Pete
> When Rem he quit the Bay;
> There was silence in the "put-put" fleet
> When Rem he quit the Bay;
> Not a blessed sound of gladness,
> Just a great big sob o' sadness,
> For the world seemed gone to badness
> When Rem he quit the Bay.

Remington was less concerned with the real estate negotiations than he was with an invitation to a *Collier's* "breakfast" in honor of Theodore Roosevelt. Many of his old friends, like Leonard Wood, Caspar Whitney, and John Fox, Jr., would be there, and his increased weight had depleted his wardrobe. "Clothes for the breakfast are troubling me," he noted. "I do not own a cutaway coat" that fits. Though he had said he "wouldn't go again to town in the night for any body or anything," he attended the breakfast and "met all the boys—met Pres Roosevelt & we had a most enjoyable time. Took a few drinks" and the "whiskey tore my guts out." Being on the wagon made occasional indulgence harder to handle.

He had stayed in touch with Roosevelt by accepting an honorary membership in the New York chapter of the Roosevelt Rough Riders. He was able to share Roosevelt's biases, sending the President a *Collier's* clipping about a "White Frontier on Pac coast to keep the Asiatics out." Roosevelt replied, "I am keeping him out."

Remington was still under the weather when he went to the National Academy exhibition in March and slighted it as having "no very distinguished pictures." At the Academy, he happened to meet the Academician Gilbert Gaul, an illustrator and painter of military and Indian subjects. Gaul had no European training either. He told Remington that "if I would show they would try to get me in," but Remington could not conform. He had been the maverick too long, and his goal had been to force the Academy to elect him on his terms. The full biographical study he had solicited from the *Craftsman* was published in March, and he "sent them a mailing list to send to my friends," including the Academicians. He called the study the "only intelligent art article about myself ever written," as he should have. He had dictated the theme.

The article was the old "unbiography" brought up to date and expanded to provide the European origin for his art that he thought necessary as the clincher for the Academy. In the early years, the familiar story went, he had been a hotheaded patriot as a cadet, an imitator of the French military painters when he began in art, and an athlete at Yale. He went West in 1881, to herd cattle with the cowboys, subsist on game he shot, and camp with the Indians who were a clean people ruled by great chiefs, until he received the call to record the unique quality of the West for the nation.

In pursuit of his mission, he went to New York City in 1885 but there was no audience for his art. He was forced to accept the diminished role as illustrator and to permit *Harper's Weekly* to dilute and slick up his virile drawings. In 1892, he quit illustration. The public was not yet ready for his art so he travelled the world over, to ponder and to write.

In 1902, he was able to return to his original mission to present the West to America, on canvas and in bronze, choosing the absolute essence of the West in a manner that was vastly significant to the nation. Monet was his one influence, in the theory of light in relation to art, where paint was merely the means of bringing light to the picture. In Remington's paintings, Monet was present in the silver radiance, the harsh bronze effects, the gray-green early night, and the glow of the camp fire. This was vibration, the mysterious suggestion of sentient life. The complete acceptance of Remington's work in 1909 was both the American nation awakening to its own art possibilities and the

passage of time overcoming a "national stupidity" concerning Remington.

In toto, the article was the perfected biographical lie, the most complete Remingtonizing of the past couched in the most pretentious verbiage, and Remington relished it. It gave him the European connection he had lacked for his credentials, although his only real touch on Monet had been through The Ten. American Impressionism as expressed by The Ten, however, was more lyrical than the power of Monet, a more delicate treatment of idyllic nature. Remington did not realize it but his own power kept him from ever blending in with The Ten. He was unique, his own man, a oner, with strength beyond lyricism expressed by a firm hand rather than delicately, in moonlight rather than sun, and showing nature bleak and unforgiving purely as a background for figures in extreme action.

American Impressionism never lost its European origin, whereas Remington was American all the way and he reckoned without the elitist attitude of the art establishment. The Academicians could never be forced to elect him to their membership unless he compromised first by exhibiting at the Academy shows, and there was no assurance that they would elect him if he did exhibit. The result was an impasse.

The *Craftsman* article had diverted Remington's attention from Ridgefield for a moment, but soon he was back as the informal supervisor of construction. He told Shipman, "You ought to see my new shack in Ridgefield—all covered [the roof on] and plumbers running up time on the contractor. It is not the biggest building in America but it is altogether the finest. Your artistic soul would simply shiver with delight if you saw it." He added March 18, "My new shack is the finest what ever was. I have some dandy outbuildings up and an appalling proposition to make a poor old Stony Lonesome Rubbed out hill in Connecticut sit up and bleed like Kansas. I believe all I read in the fertilizer advertisements."

The estate was "about one mile west from the village street on West Mountain Road." Scoffers called it Remington Village, with a mansion, a studio big enough for a mounted trooper, quarters for Tim, a horse barn, a chicken house, and a grain storage room. The end of April, Remington told Davenport that he was "dismantling" his Endion "studio pre to moving. This place looks like the third day at Gettysburg. Never mind—peace will follow. The Ridgefield picture is only sketched in as yet but no man can make a landscape without the aid of time. I've made a stone road up there longer than the U[nion] P[acific] and they are putting dirt over it. No one will see it and it will take a ten minute lecture delivered 8000 times before I make people understand. What?"

He gave Davenport an Ingleneuk landscape painting that had been unsold at Knoedler's, and evoked a maudlin response: "This same old Father and the one that left Oregon for the companionship of big men found our eyes glistening with water. As I took from the wrapper 'The White Birches' we neither of us could speak and had the stake & rider fence been there we would have leaned harder than ever on it." Remington replied, "We split even. You have made pictures on my mind which have bitten in on it."

He told Cousin Ella about the new house in the old vernacular. "Come up if you are Down," he declared. "We begin 1st of May to pack up to move." On May 11 he caught cold in the midst of the packing but he opted for home remedies, resolving that "camphorated oil and a little whiskey will pull me through."

Despite the cold and the moving, he attended the May 12 dinner that the photographer Rodman Wanamaker gave for Colonel W. F. Cody. Wanamaker suggested the placing of "a colossal statue of the North American Indian at the mouth of the Hudson in New York Harbor." Generals Miles and Wood, Remington, and Davenport who were all at the dinner "warmly endorsed" the plan. Then Davenport made the concept more specific: "When the foreigner comes into this broad harbor his eyes will rest on a fine group, as big as or bigger than the Statue of Liberty, of Remington Indians welcoming him to America." What a coup that was to be, a Remington statue of an American Indian dwarfing the Frenchy Liberty.

37.

The Shadow of Death
Seems Not Far Away

In May 1909, Endion was sold for $30,000, as Remington had hoped. The fifty-year-old house had cost him $13,000 and he had added $7,000 in improvements. It was one of his better investments, providing a cushion of capital for the new home.

The big move to Ridgefield took place on May 17, after six months of building and landscaping. The Remingtons buckled down to the job of settling in, without taking an immediate vacation as they had when they moved into Endion. Everything was larger and grander in Ridgefield. The studio was bigger than the one at Endion, but it was decorated in the same way with Western hangings—"Indian relics, lassoes, western plains momentoes of Indians Cow-boys and wild life, skins, snakes, pots, pans and other [camp] cooking utensils, clothing—" In front of the easel was the same squatty rocking chair Remington had used for twenty years, which let him lean in for the brushwork and lean back to look. The modeling stand filled a corner.

The decoration of the interior of the mansion was far from complete. Remington told E. W. Deming, the Indian painter and muralist, "I have built this place up here and it has cost me a lot of money—so

much that I can't do anything more for some time to come but my plan is to panel my dining room if they [good times] come my way—and when I do I will get you to help out on a panel or so." He added a commendatory touch, hoping to obtain the panels gratis, and said as the quid for the quo, "I haven't a bit of that decorative feeling. When I am commissioned to do Indians alone" in murals, "I'll send them along to you." The sales pitch produced no free panels from Deming so Remington forgot about both them and the references.

He considered himself to be the unquestioned authoritative Indian sharp. Through his friends and customers in Albany, he began angling for a commission from the State of New York to paint a mural of Seneca Indians in the state capitol. He would be invading the turf of the decorators like Deming and Edward Simmons and he was looking forward to learning the new techniques. Paintings and statuettes he was used to but the prospect of working on walls was heady stuff. He expected that a mural would be to a painting as the Big Cowboy for Fairmount Park had been to a statuette.

In Ridgefield, Eva Remington had charge of the mansion, including the Irish cook who was renowned because she "made chocolate layer-cake with layers about two inches thick—and pies on the same order." As in any new house, details like doors and windows did not all function properly, and the builder had to be called in for corrections.

Remington handled the studio and the outside. He ran a functioning farm with Keeler, the local hand, taking care of the plantings. The life of the country squire suited him. He bought a cow. Soon the "pig pen" was "near complete," and two weeks after moving in he "bought 4 pigs $6 apiece." They had crated and brought along the Endion chickens that now had plenty of Connecticut ground to scratch around in without bothering a neighbor.

The horses were Tim Bergin's responsibility. There was a matched pair for the "station wagon" that "went like a bird" and for the "natural wood-color three seater [buckboard] with wood panels." There was a large brown and white Shetland pony for the brown wicker Irish dogcart that was entered from steps at the end, with "seats running lengthwise through the middle—guests seated facing the sides of the roadway—and attracting much attention." There was also a pinto for riding, although Remington used the horse only as a model.

Now that he was a "local," Remington had his hair cut by the Ridgefield barber, Conrad Rocklein, sometimes getting a shave at the same time. Rocklein talked about the "brownish hair" with "none to spare on top." Remington was a star in little Ridgefield, a step up from having been Thomas' satellite in bigger New Rochelle. He had grown away from Thomas since the practical joke on the election re-

sults. Thomas had failed to comprehend how emotional Remington had become about the election of Taft as the deciding factor on the risky move to Ridgefield that he wanted so much to make.

The Connecticut countryside proved to be a pleasant change. While Remington worked outside or in the studio, his wife was basking in attention from neighbors. "Lots of ladies called," he noted. "Very embarrassing for me in my John Hobb's garb [coveralls]—but I mostly duck." Hepburn was the Remingtons' social sponsor. "Dressed in our best bibs and tucker and drove over to Mr & Mrs Hepburn who gave a Tea to meet us," Remington said. "Many Ridgefielders came & I chinned myself hoarse. People very nice tho I find first meetings trying." On another day, "we drove pony over to Hepburns & spent two hours in afternoon pleasantly. Hepburn is a man who has mixed up in big events and talks intimately & interestingly." Remington even stayed up late. Hepburn visited and they "sat up & gabbed and drank Scotch until 12 when we turned in."

Some mornings he helped with the gardening. The heavy work was supposed to be the province of the local Italian men he hired by the day but on occasion he "mowed weeds for 2 hours" by hand with a scythe. Manual labor was unusual for the Ridgefield well-to-do. "I was out pecking at a stone with a sledge when a grand Dame in an auto came by. She thought I *was one of* the local Romans." The oversight rankled. He added that "lots of people" were still leaving "their first call cards—and I hope this part is done now. Of course its gratifying but I dont care to pose out in the fields in a jumper for a grand Dame in an auto." The outdoor work put him in good physical condition for a corpulent man. He was active enough so that those who saw him every day did not notice his obesity.

On June 15, Remington declared, "I am back in my stride painting," although six days later he was still only "slowly regaining the mental vision of an artist instead of a constructor of buildings." It was not until July 6 that he finally "worked to great advantage. Finished 'The Love Call' in one sitting—got a scheme on 'Outlier' and pulled 'The buffalo runners' into harmony and light."

He was mixing into the summer social scene, with a brand new audience for his lectures on the West. "As to *Ranching*," he said, "it is a good deal as though you suddenly asked the Dr 'now tell me all about medicine.' You would find that he couldn't reduce 30 years of observation to a few sentences." He referred the readers in the crowd to authors Roosevelt, Andy Adams, Mayne Reid, and Alfred Henry Lewis, and spoke about the effects of irrigation and the wire fence. "Now this is all I can think of off handed," he concluded, "but with a dead-rest I could talk this way for 20 years." He was grateful to

Hepburn for having eased the move and said, "I am going to give the Hepburns a painting—a small landscape—not the 'Grand Frontier' but a small intimate Eastern thing which will sit as a friend at their elbow."

He searched for a name for the estate, without his old chums Clarke and Ralph to guide him. "Stony Broke" was no longer apt. He tried "Springdale" on Davenport but met with apathy: "Think well about the name of the new farm. I don't know whether that name has in it all you need in your business or not." "Springdale" was a solid Englishy description of a gentleman's farm, better than Coseyo or Shingaloo, but he decided to wait for the perfect name. They were on Lorne Place, so he used that address temporarily, and he scribbed a substantial stationery order to his city printer, avoiding the high-priced shop in Danbury. In his handwriting, he customarily left the tops of the "n's" open in the middle of a word, and sometimes he elevated the "e's" at the end. The stationery was delivered with the heading "Lorul Place," but Remington used the sheets anyhow. The new name was a puzzle to his friends. Hoeber asked him "what the deuce is meant by 'Lorul' Place? Laurel I could understand but Lorul—oh that gets me. Prithee, kind sir, elucidate." Remington never did. The address was a joke to the post office, having a house called Lorul Place on a street called Lorne Place.

There was no Western trip in 1909. Summer vacation was at the Pontiac Club in northern Quebec, Canada. On July 31, Remington said that they "packed up & got off. I feel the need of a change—things have been pretty strenuous this last year and this will be the first time I have left the pilot house since I stood on Hepburn's steps last October & said, 'I will build a house on that hill if Taft is elected.'" He found the Club "a fine comfortable jumble of log cabins on a beautiful lake." An agile man again considering his bulk, he "tried a small birch bark canoe and managed all right but my knees are not calloused by prayer and I get a groan in them kneeling." He sketched at the Pontiac Club and "had too much scotch."

On August 19, he was back in Ridgefield, painting vigorously. After eight days, he "doctored" a group of pictures he had finished, giving them "the final bath of air. I wonder if this bunch will make artistic New York sit up?"

Social obligations in his new neighborhood were becoming a bother. He grumbled that he was "back at one o'c from Hepburn's dance. I simply hate going out this way but we could not refuse the Hepburns. It was a nice little dance for young people." Another time, "Kid and I passed out a jug of cider from the mill. A man gave us a basket of grapes—thus we are becoming chummy with our neighbors. I am glad to have them feel that I am not a d_____ snob." They were meeting

the Ridgefield residents without making close friends. The house was not fully decorated and they did not have all of the new furniture Eva Remington had ordered so they did not give parties. She was beginning to think about an apartment in the city for use on weekends.

The servants they had brought along were lonely. Tim Bergin left on September 17. "He has been with me 18 years," Remington remarked. "He discharged himself—I have felt a great responsibility for him and his long service but his high handed conduct has relieved my conscience & I shall speedily forget him." Bergin had presumed on the master-servant relationship when he acted for Thomas in the Bryan joke, and the parting was without a cash gift of any substance. Bergin returned to New Rochelle where he had a brother and a chance for other work. He had been the closest contact to Remington outside of Eva Remington, but he never again played a part in Remington's life. Remington undertook some of Bergin's chores, killing "a big chicken —fat & yellow," and Keeler came in to take care of the horses until a new coachman could be hired.

On September 26, Remington decided to model "a solid group of cow-boy and steers in sculpture—'The Stampede.'" The next day he built the armature and "laid in" the wax roughly. Thereafter, when he was painting, getting "mad" so that he "cut & slashed" at the canvases, he also "worked Stampede a little." For relaxation he remained a reader, choosing titles that could never be anticipated. This season, he "read 'Tom Cringle's Log'—a fine old 1814 sea novel. Some wonderful good old novels have been lost in the scrap." With money in the bank again, he reverted to investing in the stock market. Hepburn wrote him enclosing "statement of your gambling transaction, with check whereby you will be able to get your hat back and $408.43 to the good." The economic depression was lifting.

Remington was disadvantaged in Ridgefield in one way that was important to him. Most of his social relationships had been art connected, and he had been looking forward to the closest association with The Ten through Weir. He found Weir difficult to take by himself, and it was the greatest boon when Childe Hassam came to spend the fall near Ridgefield. Remington had given "Muley" Hassam his nickname, after Muley Hassan in Washington Irving's *Alhambra*. They became close friends, visiting back and forth every few days.

Hassam was Remington's age, a relaxed type who painted when he felt like it and still turned out a large volume of pictures. He had a history as a drinker, too. In an earlier year, Weir had noted that "Old Hassam has been off on a bat for three weeks but is all right again." Like Remington, Hassam needed to refresh himself away from his easel, and when he painted he worked rapidly. His paintings were

in the collections of fifteen museums, he had won sixteen medals and prizes, he was a National Academician, and he belonged to art associations in France and Germany as well as in America. His honors in art were substantially superior to Remington's. Trained in Boston and Paris, he had it made with the art establishment, while Remington did not.

On a day when Remington wanted to show Ridgefield off, Bigelow motored over from Malden. With Hassam, they put on blue jeans, tied pirate bandannas around their heads, and Bigelow wore carpet slippers with the toes cut out to ease his feet. The new coachmen hitched up the three-seater buckboard for them and they drove the three miles to Weir's house in Branchville. Dogs were running alongside and bicyclists challenged them while the three friends were roaring with laughter and shouting so that they could be heard at a great distance. Weir's daughter said that they "were all in high good spirits, like boys out of school, and how they all enjoyed just being alive."

Another morning, Eva Remington joined the two artists in driving "over to Weir's. His place looked fine. Saw his pictures." In the afternoon, Hassam returned to Ridgefield with his wife, and Bertelli arrived on the 5:16 train. They all stayed "to dinner—jolly evening. To bed early." What Bertelli wanted was to talk about sculpture, and particularly about making a bigger version of "The Bronco Buster" that would be three feet high instead of two feet, to provide a more expensive product that would be more limited in quantity. Remington liked the idea for a different reason. If he received an inquiry for a second cowboy statue, the big "Buster" might serve as the quarter-size working model, so he agreed to have Bertelli's man shape a fully detailed model of the new size for his approval.

For Remington, one wonderful event now followed quickly on another. The art editor of Scribner's Magazine told him that a feature article was planned for the January 1910 issue to consider the "totality of your work," emphasizing the paintings to be shown in Knoedler's annual exhibition the end of November. Remington's answer was, "Davis & Eckmayer are my photographers. Tell Davis you want the Front Face." Royal Cortissoz was assigned as the writer. He intended to omit the usual portrait of the artist, despite Remington's preference for the full face, but he told Remington that he would write the article from the approach that "the joy of living gets into Mr. Remington's work," suggesting "a talent that is always ripening, an artistic personality that is always pressing forward."

Remington was at the height of his artistic powers and he was feeling fit. "I never was so happy," he rejoiced, "& so well in many a year." He was in good enough physical shape to walk a brisk mile into

Ridgefield with Hassam and walk back. He "made a huge success of 'Outlier,'" and "Hassam thinks Outlier best of my pictures." Sure of himself, he criticized Hassam again for painting the desert the same way he painted the Eastern landscapes he was more accustomed to. When Bertelli delivered the three-foot Plasticene model of "The Bronco Buster," the exuberant Remington could not let it pass without adding his own touches.

On November 11, Remington was modeling both the enlarged "Bronco Buster" and the new statuette "The Stampede," confident of his standing as a sculptor because his bronzes were in two museums and in Fairmount Park, when he received news of his first equivalent recognition as a painter. Knoedler wrote that William T. Evans, who was collecting the best of American art as a gift to the government, "has purchased your painting, 'Fired On' for the National Museum at Washington for $1,000, and we will have to put on a new frame, which he selected. He asked if you were an Academician." The painting was a night scene Remington had called "cavalry fired on at the ford" when he sent it in for the 1907 exhibition. Offered at $1,500, it had not sold then. Knoedler's had retained "Fired On," fortunately, because some of the pictures returned from that show had been burned.

Remington was triumphant, never even mentioning the reduction in price. "Aside from St. Louis," he said, where "A Dash for the Timber" was in the City Art Museum on loan from Washington University, "this is my first painting in a Public gallery. If I can get my head in I'll get the rest of my body." "Fired On" was the period of his work that he wanted in museums, not the early realism of "A Dash for the Timber."

Just as the two public paintings differed in style, the enlarged "Bronco Buster" changed the emotional impact of the earlier "Bronco Buster" statuette. When the "big thing" was finished on November 17, the quirt was gone from the "Buster's" hand because the realism of appurtenances was no longer desired. This was a rider in a contest with the horse to stay on, not to break an agonized animal's spirit.

Surprisingly, Evans had not asked to preview the paintings for the 1909 Knoedler exhibition before making his choice from the 1907 leftovers. Remington had worked on the new canvases since the end of the 1908 show, finishing thirty pictures in the twelve months compared to the 200 or more he had done in a year when he was an illustrator. The opening of the exhibition of twenty-three of these paintings was to be November 29 and Remington subordinated everything to making sure that "New York" did "sit up" for his show. Nelson Miles had invited the Remingtons to Washington for his son Sher-

man's wedding November 24. The response was, "I am sorry I cannot get to the wedding but my annual show of paintings opens at Knoedlers on 29th and that is altogether the important event for me in the year as I have to be 'on the job' you see. Give my regards to Sherman and tell him we will let this marrying go this time but don't let it occur again." He was much too skittish to travel anywhere on a day so close to the start of the exhibition.

He was particularly concerned about the show because two early illustrations in black and white had been sold at public auction in March. One had brought only $80 and the other $63. The old favorite "The Mexican Major" that was in color had been sold at auction to William Randolph Hearst for $370. While the pictures had remained at the same prices they sold at originally, proving their stable values, it was natural for Remington to fear that these low amounts might disturb the buyers for his current and more costly paintings.

His usual nervousness increased after the catalogs were mailed and the date of the exhibition approached. When friends told him they had learned that the opening had been postponed five days to December 4, he became agitated. He said the delay was because of "Knoedler's breaking faith with me. I hear nothing from them and no longer have any confidence in R K [Roland Knoedler]." It was too late for customers and critics to be notified. "Poor Burdick came to N Y to see my pictures today," Remington complained on the 29th. His only consolation was that on the "lovely winter day—we packed up Stampede with Contini and shipped it $140 [including Contini's charge for the plaster model] by freight to Roman Bronze." The complex group of stampeding steers with a mounted cowboy in their midst had been finished in seven weeks.

On the day of the postponed Knoedler opening, December 4, the overwrought Remington had rheumatism in his right foot and was on crutches, confined to Ridgefield. The disablement did not diminish his enthusiasm when he was told by phone that the "show had great crowds." Six of the seventeen Western paintings were sold the first night for a total of $5,200. Hepburn was there, "expecting to see you but understand that your excuse is good as an excuse but most uncomfortable as a fact."

What impressed Hepburn about the show was not "the number of pictures sold" or "the rapidity with which they went" but "the character of the people who bought them." For that, "I congratulate you," he said. He "preferred the moonlight camp scene with men and horses about the fire," called "The Hunters' Supper," but it was a thousand dollars and quickly sold. Then he "regretted afterwards that I did not take the 'Blanket Signal,'" but it too was a thousand and sold while he

was making up his mind, so he bought "The War Bridle" at six hundred. He fudged about what he took and what he should have taken, but, like the banker he was, he bought the cheapest one. It looked like the best value for the money, and the subject was the "Grand Frontier," not the intimate Eastern landscape that Remington had thought right for him.

Despite two days of favorable reports from friends, Remington was apprehensive about the lack of press coverage. "No notices of my show in Herald or Times. C Hassam [exhibition was reviewed] in Times. The papers are certainly not good to me. I can get the 5th Ave crowd [of buyers] but not the insects of the art columns but cheer up —the pups will come." Excitement was mixing the metaphors, and he did not allow for the critics' need to reschedule their time because of the postponement.

Then, on December 8, he discovered a "good notice in Times—the young woman came off the grass." The review stated that the "canvases form a chronicle intimately connected with the origins of a great nation, with the picturesqueness cleverly subdued to a more aesthetically rewarding beauty of surface and color." The next day, Remington was gloating because "the art critics have all 'come down' —I have belated but splendid notes for all the papers. They ungrudgingly give me a high place as a 'mere painter.' I have been on their trail a long while and they never surrendered while they had a leg to stand on. The 'illustrator' phase has become back ground."

As he said, the reviews were uniformly laudatory: "Remington's work is splendid in its technique, epic in its imaginative qualities, and historically important. American history will be made more vivid than through printed pages." Another struck a more poetic note: "In all Remington's pictures, the shadow of death seems not far away. One sees the death's head through the skin of the lean faces of his Indians, cowboys and soldiers. The presence of a great central motive like this is an indication of power and a proof of genius."

In essence, the reviews were just catching up to the old claims that Wister had recorded a decade earlier. Physical beauty was taken for granted in the pictures while the critics concentrated on finding long words to repeat the concept that Remington was the pictorial historian of the West. The brags had all come true. The mention of the death's head was not new and not accurate. There had been morbidity in his work for a year after the Spanish-American War, but that was all changed. In 1909, vividity was the key.

On December 16, Contini was out to Ridgefield again, casting the big "Bronco Buster" in plaster. Remington told Bertelli that "this size lends itself to my hand much better than the smaller." He was excited

at having done a good modeling job in three weeks, despite the show and his crutches, and he enthused, "Say Bartelli, you ought to see the 1½ Bronco Buster—It will make your eyes hang out on your shirt. Get ready to retire the small one—mind you."

By the end of the two-week exhibition, ten of the seventeen Western paintings and one of the six Eastern landscapes had been sold at the Knoedler Galleries, but Remington said only that "my sales are disappointing why I dont know." The reason for the disappointment was that Knoedler's had decreased the selling prices so that the monetary return was less than expected. Most of the unsold paintings were retained by Knoedler for sale in 1910 but a couple were sent back because they had evoked no interest. One was "The Sun Dance," where Remington had anticipated that the subject would not be salable. The second was an equestrian portrait of "Major General Leonard Wood" that Remington had painted to replace a Custer he had planned. Wood had postponed going to Ridgefield until the other exhibition paintings were done and then he brought "a good horse" with him for a weekend. Remington had believed that the military would buy the picture at the show. When that did not happen, he gave the painting to Wood who sent "a thousand thanks" for the present.

Charles Dana Gibson mailed an invitation to a dinner for de Thulstrup to be held January 5, saying that Wood was coming and wanted to sit next to Remington. The excuse of the rheumatic foot was still valid for Remington. He was only able to walk a little and so could hold off responding. Plotting how to get a painting into the Metropolitan Museum occupied his thoughts. His friend Henry Smith "seems to stand well [with the Fifth Avenue art crowd]," he mused. "He will get picture in Met for me—Through Hearn or Morgan [the collectors who donated]. Hope."

With both of the statuettes in plaster and his foot improving, he switched back to painting, a job that could be done seated. "After modeling a time," he said, "one has to change his view point which does not happen in a minute but in a few days I shall *think* in color again." While he was painting, he could sculpt a little for relief. When he was sculpting steadily, however, he could not paint. The color sense could not be turned on quickly but now he was too eager to wait for it so he started right in on his compositions for the 1910 Knoedler exhibition.

On Saturday, December 18, he "wrenched" a stomach muscle operating the crank on the corn sheller that separated dried kernels from the cobs for chicken feed. It was only a minor distraction and he painted on Sunday morning, just as he had when he was younger. He was more isolated than he had been in New Rochelle. The summer

residents like Hepburn, Hassam, and Weir were gone and the year-round Ridgefield people kept to themselves.

While painting on Monday morning, December 20, he "was caught with intense pains in belly. I was afraid of a stoppage of the intestines so took a lot of Jeannels [a patent laxative] and yet I wrenched myself Saturday and dont know which was the trouble. I got a hole through my guts but it put me in a wounded man's fever and I went to bed so stiff & sore I could hardly move and staid there." He had lived with stomach cramps for years and he thought that the pains were from constipation.

"I am somewhat recovered from my belly ache," he said on Tuesday, December 21, "and worked. Keeler showed a nice red horse" that Remington went into the field to examine. "I do not know what I will do about a horse." At his desk, he wrote a good-humored note to the actor John Drew who was in the hospital with a broken collarbone from a riding accident. He told Drew that he had "observed that a man don't have so much glue in the seat of his pants at 40 as at 20." He also wrote to Jack Follansbee in Mexico to thank him for the loan of a "Jacamo or enihow you spell it, as fancy as the ruffles on a ladies pants," to be used as a painting prop. Emma Caten had arrived to spend the holidays.

On Wednesday morning, December 22, he started for New York City on the 8:26 train to pick up a painting at the safe deposit vault of the Lincoln National Bank. The picture was "The Show Down," bought by his old pal Brolley at the "utmost of a concession" price of $500. Eva Remington was worried enough about his condition to go along. The jolting of the station wagon made him ill again and she wanted to turn back. He had his mind fixed on the painting, though, and insisted on proceeding. In the city, he confessed to feeling worse. They secured the painting and caught the noon train for Ridgefield. At three in the afternoon, he was back in bed and she phoned the new family physician, Dr. R. W. Lowe of Ridgefield. Dr. Lowe came over and then sent for Dr. E. A. Stratton of Danbury, the nearest big town, as the consultant. Remington was too weak to make his own diary entry and asked his wife to do it for him. He spent a sleepless night in severe pain.

The first thing Thursday morning, December 23, the two doctors called in Dr. Robert Abbe from New York City. He had been the professor of surgery at New York Post-Graduate Medical School and was consulting surgeon at three city hospitals. Soon after he arrived in Ridgefield with his nurse, the decision was made to operate on an emergency basis. Remington was asked for his permission and replied, "Cut 'er loose, Doc."

The kitchen table was chosen for its size and hard surface. Pots of water were put on to boil and the table was scrubbed down. Hot towels were made ready and Eva Remington and the servants were sent from the area. Remington was helped into the kitchen and onto the table. The two doctors and the surgeon were present, along with Abbe's nurse and a local nurse called in by Dr. Lowe.

Abbe's nurse was the anesthetist. She gave Remington ether but his obesity was a problem. The fatty tissues absorbed the ether so a large quantity was required and the anesthesia was a long time taking effect. Dr. Abbe used tincture of iodine to prepare the area for the incision. The fatty tissue was a mechanical difficulty, too. As Dr. Abbe cut, manual retractors had to be applied to keep his field of vision clear. It was a heavy physical job just to hold the wound open when the patient was as fat as Remington. The two doctors did the pulling for the surgeon.

What Abbe found was that the appendix had burst and peritonitis had set in. He poured tincture of iodine into the wound cavity and inserted a tube into the abdomen to drain the infection by gravity. Then he stitched Remington up, leaving space for the tube. The fatty tissue retained the ether over a long period, keeping Remington comatose. After the ether wore off, morphine was administered. Remington's own bed was made ready and four men carried him there on a stretcher. Eva Remington was allowed in to see him, while Dr. Abbe and his nurse left to return to the city. Dr. Lowe found two local nurses to work on twelve-hour shifts around the clock. When the routine was established, he left with Dr. Stratton.

The day after the operation was December 24, Friday, the day before Christmas. The operation seemed to the Remingtons to have been successful. He was drowsy under the morphine but cheerful and more comfortable with the nurses to take care of him. Dr. Lowe returned to consult with Eva Remington, and Emma Caten was allowed into the bedroom for a short visit. Remington thought that his condition was improved, although he was restless during the night.

Christmas Day was stormy. Remington had rallied for a happy holiday morning. He was again optimistic and at ease while the family exchanged and opened gifts. Dr. Lowe was in attendance when a change came for the worse about one o'clock. Remington was kept free of pain but he sank into a coma and Dr. Lowe said that "it was the beginning of the end."

Early the next morning a furious snowstorm raged over Ridgefield. Eva Remington entered in Remington's diary for December 26, 1909, that "at 9.30 A M Frederic passed away."

38.

Bricked Up
from the Bottom

After Remington was dead, Dr. Lowe disclosed that the operation had uncovered an "acute inflammation spread from the appendix and that septic peritonitis had developed." From then on, the medical attention had been just to alleviate suffering. There had been no hope. Remington's good fight on Friday and on Saturday morning was a fiction as the abdominal infection became generalized, producing shock and coma.

The postmortem diagnosis was that Remington had chronic appendicitis, indicated by the history of his repetitive bellyaches. This was what was known as the "American disease" to the smart set in England, where they had an "operation mania," although the surgical "fad" had not yet reached the United States.

"A person suffering from appendicitis is much like a man walking around with a stick of dynamite in his coat pocket," according to the 1905 New York Times. An acute attack was evidenced by sudden pain in the abdomen and by fever. Obesity made diagnosis more difficult. The caveat was that "under no circumstances should a purgative be given." Remington had an acute attack Monday morning, De-

cember 20, when he recorded "intense pains in belly" and "a wounded man's fever." Instead of avoiding increased contraction of the appendix, he took an overdose of the harsh chemical laxative Jeannels, a sodium potassium tartrate, that put pressure on the appendix and burst its walls. Acute peritonitis set in, and there was no antibiotic to control the infection. Although he was a vigorous man, his death was quick, the result of doctoring himself.

There was a morbid connection between Remington and George Bellows, in addition to the artistic. Bellows too died at the height of his power following an operation for appendicitis. At Bellows' funeral, the pallbearers were a cross-section of the art establishment, a huge and impressive array. At the brief prayers that were said at the Ridgefield house on Monday morning, December 27, however, only Eva Remington, her sister Emma, and close Eastern friends attended. Some came from New York City in spite of the devastating storm and the lack of timely notice in the press. Kemble, Thomas, Hassam, Bertelli, Bacheller, and Hepburn were there. The Reverend John H. Chapman, rector of the Episcopal Church in Ridgefield, read the service.

That afternoon, Eva Remington and her friend Mrs. Henry Smith accompanied Remington's body on the train to Canton. They arrived at 10:10 the next morning. The women were escorted to the home of Remington's uncle Robert Sackrider while the body was carried to the Universalist Church to lie in state until the funeral at 2 P.M. The stores were closed out of respect for Canton's most famous son, as they had been for the Colonel, Remington's father. His mother, Mrs. O. S. Levis of Geneva, New York, had arrived at the Sackriders' the previous night. She called herself Clara Sackrider Levis, still bitter about the Remingtons. Her reunion with Eva Remington was sympathetic, however, and when Remington's mother died in 1912, Eva Remington arranged for her to be buried in the family plot with her first husband and her only son.

At 2 P.M., the church was crowded with residents of the North Country. The terrific storm that had been raging over New York City caused the artists to stay away, although they had been expected. They sent flowers, as did groups representing the arts and letters, Western admirers, and the New York Association of Rough Riders. The coffin was hidden under the mass of flowers.

The Reverend Dr. Almon Gunnison, president of St. Lawrence University, delivered the eulogy as he had for Remington's father. He agreed with Eva Remington to follow the text of the *Craftsman* article that Remington had thought the best biography. Remington "took his liberal patrimony," Gunnison declaimed, "and, investing it in a

western ranch, he ranged over the fields with his men, herded the cattle, and heated the branding irons in the exhilarant life of the cattle chasers and the round-ups. The broncho was his delight and the camp fire his passion. He was the friend of the Indians, and was at home in every tepee. The chiefs were his friends and the braves his chums. He learned their legends and studied their life with the passion of a lover." The bearers of the coffin were six of Remington's boyhood friends, four from Ogdensburg and two from Canton. In accordance with Remington's wish, the body was buried in a grave bricked up from the bottom like an underground vault.

The gravestone was plain with just the surname. The small headstone bore the name and dates. Many times Remington had expressed the wish that was important to him, that the stone read "He Knew the Horse," but his wife refused the expanded inscription when the gravestone was cut. She did not consider the legend proper for a cemetery and she would not have felt comfortable in her own eternal rest alongside such a common claim. In her first independent decision, she deflated his image to a size that suited her.

Mrs. Remington passed the next six weeks with cousin Ella and her husband in Massachusetts, then returned to Ridgefield. She had Knoedler's send Brolley his picture February 11. The Remington estate was probated at the surprisingly small amount of $54,666 and the remaining artwork was valued at $20,750. Paintings continued to be offered for sale through Knoedler's and privately from the widow. A modest number were purchased by buyers who realized that there would never be a new Remington painting and who considered Remington to have been the best recorder of the dying Indian culture. The paintings that were sold were the ones that Remington had completed and signed. The paintings he had not wanted sold he had burned, except for the few in process.

Eva Remington lent paintings for exhibition, to the Art Institute of Chicago and to Knoedler's for the annual summer shows, as Remington would have done. She also lent to the exhibitions of the American Water Color Society and to the Society of Illustrators, shows that would have been anathema to Remington as compromising his principles. She had not understood his pride or his ambition. Some of his distinctions were foolishness to her, as she had told Owen Wister before the Spanish-American War.

The old statuettes continued to be sold through Tiffany's. The bronzes that had been in inventory when Remington died were depleted as purchases were made, and new inventory was cast by Bertelli as a matter of course, although Remington was not there to rework the waxes. Remington had bragged about the number of finished

bronzes that he broke because they were not up to his standards, but that control was now gone. Bertelli was acting for the dead sculptor as well as for himself as the manufacturer, with no one to check the conflict of interest. He had a big investment in Remington so he did not bring up the sculptor's role in lost wax and no one else did, either.

"The Stampede" was unfinished when Remington died. He had not even seen the wax. After his wife came back to Ridgefield in the middle of February, she took two months to make up her mind about the statuette. On April 13, she decided to go ahead with production and she filed for the copyright, turning the matter over to Bertelli, who had correctly told her that the income from this one project might be as much as $15,000. The distinction that Remington would have seen, that he had never touched the wax and that the remodeling would be done by the same Bertelli hand whose work he had rejected on the clay for "The Bronco Buster," was a technical nicety that meant nothing to his wife. Indeed, some critics called "The Stampede" Remington's finest, but it was a flawed example to have chosen. No one knows what changes Remington would have made. As Remington had told Professor Miller, "there is a lot more character in the [bronze] than in the plaster which is what one can do with 'lost wax.'"

The nomenclature that has been suggested for Remington's lost wax bronzes establishes the highest order of statuette as an "original," a bronze from the original plaster where the artist had the opportunity to remodel the intermediate wax. Every "original" Remington bronze had to have been cast before 1910. Next there were classifications for "authentic," "replica," and "recast," with descending participation by the artist, but "The Stampede" was none of these. It was simply unfinished. The big "Bronco Buster" was the same, a posthumous work, a Remington-Bertelli production.

The gigantic Indian bronze that Wanamaker and Davenport had conceived for Staten Island died with Remington. The artist was no longer there to design the statue. Davenport immediately turned to Theodore Roosevelt and together they launched The Frederic Remington Monument Fund. A two-page promotional pamphlet sought to raise funds by donation from Westerners, pleading that "you knew him—all of you—and loved him; he knew you and loved you and immortalized you." When Roosevelt went to Cheyenne to make a major speech on August 28, 1910, declaring that "America must be Progressive or cease to exist," he also sought money for the statue that "should be raised to Remington by some really first-class artist." Eva Remington was present at Roosevelt's invitation and she "heard the colonel offer a fine tribute to her husband. She broke down during the speech," but no donation of consequence was made. The idea for the

monument was not catchy, a portrait of an obese Anglo in bronze on a marble block in Washington.

Mrs. Remington had one idea for a statuette that Remington had considered before he died, a twenty-four-inch replica of the Big Cowboy in Fairmount Park. She wrote to the folks from Philadelphia for approval and waited while they indulged in their usual ream of letters to each other before they discovered that Remington himself had owned the copyright. They had no control over the production of the replica. The attorney gave that as his opinion, after four months, assuming that Remington "like most artists left his family in destitute circumstances." When she turned to Bertelli with the approval, however, he saw no reason to finance a production that would have to start with remaking the sketch model that had been destroyed. The popularity of Remington's sculpture was not increasing and Bertelli had plenty of other bronzes to make and sell. The statuette of the Big Cowboy was never cast, although it would have been an artistically defensible extension of Remington's art.

She also suggested that the Fairmount Park Art Association consider commissioning an additional cowboy statue, telling Miller that "some time when you are in Tiffanys it might interest you to see the enlarged Broncho Buster, Mr. Remington's last work. He made it that way thinking that some time he might wish to make a statue of it— And it w*d* not have to be redone." She was adopting a new businesslike verbiage in her correspondence, including the "w*d*'s" and "c*d*'s," to affect the commercial experience she did not have. She did not go elsewhere to sell the concept of the statue because she had never done such things before. Expecting to be rejected, she was halfhearted and diffident in the presentation. When she had the personal stationery reprinted to add a black mourning border, she did not change "Lorul" Place to "Lorne." "Lorul" had been good enough for him, and she used it too.

She tried to sell Remington's vaunted Indian artifact collection to the Smithsonian Institution, specifying that the pieces be kept together as a memorial, but the expert who came up from Washington told her that most of the pieces were not select enough for the Smithsonian. Instead of donating the collection to a Western institution, she planned to keep a small private museum in the Ridgefield house, like a shrine. She also thought of having one each of his bronzes made for herself, but that proved to be too costly.

Finding a basis for a memorial was elusive until she spoke to her neighbor, C. C. Buel of the Century publishing house, suggesting an illustrated biography with text by Owen Wister. Buel accepted the proposal, provided Wister would write the text, and so she contacted

Wister who surprisingly agreed to complete the book in six weeks. "I shall try to do this," he replied, "and it will be the only piece of writing I shall attempt for many months as I am not able to work at present or even often to write letters." She then contacted other Remington correspondents like Miller, asking for letters they "wd" allow her to use so she could provide Wister with a large amount of research material.

Wister's name lent marketability to the project, and he would also have been acceptable to Remington as the author, although Wister had no more idea of Remington's goals or his achievements than Eva Remington did. Wister had no need for letters, journals, or diaries to write what he conceived as an introduction for a picture book, and she would in any event have made the personal material available only after deleting what she considered to be offensive words and opinions. She was so pleased with the idea that Wister would be doing the book that she did not press him after the expiration of his promised date. She knew that he was ill, but as the months went by, the time for the biography to be published was passing rapidly. Remington's art was vulnerable to the old nay-sayers and he was not there to defend himself.

One group of his detractors was the "know nothings," the pals from the North Country who unconsciously reduced what he had done to a level they could understand. He was like them, a good old country boy, a lush and a poacher who had this trick that was his art and let him paint a fish with whiskey in its mouth on a barroom wall. Then there were the "know littles," the leaders of the art establishment who said he had only the talent suitable to a clever illustrator, whether working in two or three dimensions, and expressed themselves as "not enthusiastic over Remington's paintings as painting." The "know the Wests" said he was a cowboy not an artist, and in view of his limited abilities, had been "lucky enough to stumble upon a new field that had not been touched." In addition, there were the "know no mores" who said that his "demise was not untimely. He had reached the apex of his career," "the likelihood of Remington adapting to the new direction [of 'Modernism'] was rather remote," and "his contribution to American art and history was already made." Along with all of these went the intelligentsia who wrote that "there are, if not thousands, then hundreds of people who would be willing to pay a dollar to avoid a Remington exhibition" because he was "virtually nonexistent" as an artist.

For the biography, Eva Remington had picked flash in choosing Wister, the man she admired for his society origins, rather than Thomas or Bacheller, who had loved Remington and would have done

a warmhearted job quickly if not with understanding. The man she should have selected was Royal Cortissoz, the friend who came closest to being able to eliminate the blarney in Remington's concocted biography and also to evaluate Remington's true achievement in American art.

There were hundreds of people who remembered Remington with respect and admiration. Of these, about a dozen documented their recollections with tangible mementos. Sally James Farnham had sculpted her "Cave Woman." Davenport had tried for the gargantuan Indian on Staten Island and joined Roosevelt in the Monument Fund. Eva Remington had launched a number of failed ventures.

Gus Thomas attempted one that succeeded, at least halfway. On January 1, 1912, Thomas finally managed to bring into power the Democratic administration in New Rochelle that he had once induced Remington to vote for. The first legislative act of Thomas' council on the day it was installed was to resolve that the New York, Westchester and Boston Railway name a new station for Remington, and that was done. Thomas also arranged for Robert Aitken, a fellow member of The Players who had done portrait sculpture of Thomas, Bellows, and Metcalf, to do a portrait bust of Remington with four bas-reliefs for the base of a monument to be erected in front of the station. The monument was also to carry the "commemorating phrase, 'He Knew the Horse,'" but the work was never finished. Eva Remington did not have the admiration for the neighbor Thomas that she had for the remote Wister. She failed to offer the relatively few dollars that would have been required to complete the Aitken sculpture.

There were a few posthumous poems, like "A monument to him who knew the West!/Whose brush so deftly told its every tale," but they were not widely circulated. Henry Smith made a contribution to remembering Remington that would have been close to Remington's own heart, but it too did not work out satisfactorily at the time. He solicited contributions of $100 from fifteen friends to buy "Cavalry Charge on the Southern Plains" from Eva Remington and he "presented it to the Metropolitan Museum of Art. The picture was hung in an obscure place for a short period and then was relegated to the cellar." Smith wrote a letter of complaint to the editor of The New York *Herald*, but the museum's curator was not persuaded to revise upward his basement rating of Remington's art.

For two years, Eva Remington waited for Wister to produce the text for the biography because "he cd do it better than anyone else." Late in 1912, she "rec'd a telegram from Mr. Wister saying he cd not possibly write the book." She told Century that she "wd very much like a book done about Frederic—one that wd be a credit," but the

publisher had lost interest. She had allowed the project to lapse until there was no public appeal. General Custer's widow was the role model for her endeavors, but Mrs. Remington was short the toughness and the capacity.

Thomas, who would have written the biography if asked, did do "Recollections of Frederic Remington" for *Century Magazine* in July 1913. The more sophisticated Richard Harding Davis told Thomas that "it was a most charming, virile, likeable man you reproduced. I am not telling you what sort of a man Fred was—you knew him much better than I—I am congratulating you on the way you made him appear."

John Howard attempted a substantial memorial to Remington and he succeeded more than most. His partner, George Hall, had bought the Parish Mansion in Ogdensburg. The structure was a local joke, owned by George Parish in the mid-1800s when he also owned much of the North Country itself. In 1841, Parish had played an all-night poker game with the son of President Van Buren. After winning the Van Buren money, Parish played a last hand for Van Buren's mistress, Madame Maria Amerigo Vespucci, and won her. Madame Vespucci claimed to be a descendant of the family after whom the continent was named but when she lived in the mansion from 1841 to 1859 she was known as "Parish's Fancy" and she was ostracized by Ogdensburgers.

In 1913, Eva Remington and her sister Emma were induced to become the rent-free tenants of the infamous mansion, bringing with them the Remington collection that needed storage space after the Ridgefield house was sold. Howard acted as Eva Remington's adviser and was able to keep the collection substantially intact for her.

On January 18, 1918, Barton Hepburn wrote to her in Ogdensburg, saying that he had been thinking of her "a great deal of late. The bank here presented me 'Coming through the Rye.' You can easily imagine how much I enjoyed the present." His affection led him to perhaps the truest tribute. When he was selecting his own burial plot in Canton's Evergreen Cemetery, he found that the space adjoining Remington's was vacant. Buyers feared a celebrity's aura. Hepburn, however, took the plot, saying that he would like to "snuggle up to Remington."

Eva Remington died November 3, 1918. In her will, she bequeathed "to Ogdensburg Public Library, all the unsold paintings by Frederic Remington, together with sketches, furniture, baskets, etc." and "one copy of each of Frederic Remington's bronzes. A further provision is made that after one replica of each bronze is cast for the Remington

collection, the models are to be destroyed, so that no more Remington bronzes will be reproduced. This will greatly enhance the value of the bronzes now in existence." John Howard was executor, along with the other unmarried sister Grace Caten who did not live in Ogdensburg. Emma was excluded from the management of the estate and remained in Ogdensburg to be the expert on the Remington collection, a way to structure her time but not to boost the artist's image.

This was Howard's triumph, holding near him forever the art and the trappings of his immortal friend, although the arrangement did not work out as well as it might have for Remington's reputation. The bronzes that came to the collection were late castings, not necessarily representative of the originals, and only fourteen of them were delivered. The paintings and the bronzes were temporarily stored in the library awaiting transfer to a more secure location when the library burned. The "paintings were buried in the ruins" but were said to have been "recovered intact," a lucky conclusion to a cavalier exposure by unprofessional custodians. Eva Remington had not considered the collection to be worth a great deal but said it was "historical and as time passes will be more valuable and much more appreciated." The Ogdensburgers treated the collection accordingly.

Madame Vespucci's Parish Mansion was remodeled and fire-proofed to receive the Remington things from the burned library. On July 19, 1923, the mansion opened, metamorphosed into the Remington Art Memorial. The Remington memorabilia shared space with other donors' furniture, glass, china, silver, cameos, nineteenth-century European paintings, and sculpture. More money was needed to initiate the museum than Howard could raise, so space had to be made available for the mixed bag of other exhibits.

Eva Remington's bequest to Ogdensburg did not foster her husband's fame. The museum was inaccessible. No one who wanted to see the art, artifacts, and papers could easily get to Ogdensburg to see them, and no one who was in Ogdensburg wanted to see them. In addition, the museum staff boosted the fake cowboy image at the expense of the artist, claiming that "before ranching in Kansas, Remington learned to throw a lariat and handle a six-gun. He roamed from Mexico to Canada, rode the wagon trains across the plains and deserts and through the mountain passes, rode the cattle trails from Texas to Montana, prospected for gold in the Apache country of Arizona Territory, and worked as a hired cowboy." The museum also sold off Remington's "studio collection," enough to decorate a 1,600-square-foot display, after not opening one case of eighty small paintings for forty years. Further, Eva Remington's command that "no more Rem-

ington bronzes will be reproduced" was not heeded. The museum sanctioned the casting of copies, the same size as the originals and distinguished only by a stamped mark.

Consequently, Remington's reputation was reduced to the level of those untrained Western artists who bragged that they gained their expertise from having "been thar" before the fences went up. He was touted as the macho cowboy, the barroom brawler who doubled as a New York City sycophant, the hardcase who knew Indians only from looking down a gun barrel at them but who had a friend in every tepee, the soldier artist who hated blood.

What the reading of the details of his life shows, however, is that his accidental death nipped his expanding talent at the height of his artistic power, while he was hip-deep in the contemporary art movement, absorbing Monet and approaching Whistler. He was an artist full of enthusiasm for the future, looking to do murals and monuments, progressing into his own Americanized version of European Impressionism that he applied to action scenarios of the West, while he was on the verge of something entirely new, something simplified, muted, symbolic, mysterious, the motif not death but vitality, an enigmatic application of Western values to his individual view of the American past.

Notes

CHAPTER 1 THE BONFIRE

The weather report is from New York *Times* (⸸685 in Selected Bibliography). Description of the activities of the day is from Remington's diary in the Taft collection, Kansas State Historical Society (⸸793). The opening episode is taken from its chronological positions later in the text. "Bad men to meet" is from the New York *Times* review Mar. 15, 1904 (⸸681).

Thomas' comments are from his autobiography (⸸992). Genealogical data not otherwise ascribed is from the Taft collection, ⸸803, and ⸸804. Universalism is explored in the various religious texts (⸸1010, 1011, 1012). Data on Canton is from Durant (⸸281). The data for the Remington-Sackrider marriage is per Harriett Armstrong, Town of Canton Historian (letter).

The Colonel's war appearance is in T. W. Smith (⸸953). Data on his rank is from the Adjutant General's Office. Skirmishes are from Phisterer (⸸736). Opinions on the outcome of Stuart's delay are in McClellan's history of Stuarts's Cavalry, Swinton's history of the Army of the Potomac, and Longstreet's work on Gettysburg, all as cited in T. W. Smith. Bloomington data is from *Newspapers and Periodicals of Illinois* (⸸650).

Boyhood in Canton is from Webster (⸸1041) and Manley (⸸546). Individual recollections are from letters in the Taft collection (⸸510). The

math drill is from Emma Caten (♯510). The Colonel as Collector is from the Watertown *Daily Times* (♯873). Remington and his Ogdensburg chums is from the 1961 Ogdensburg *Journal* (♯703). The "unusual boy" quote is from a Henry Sackrider letter (♯510).

CHAPTER 2 THE ACTING CORPORAL

Data on the Vermont Episcopal Institute is from its catalog (♯1015) and from the Taft collection, Kansas State Historical Society. Data on Ogdensburg schools is from Garand (♯700). Life at the Institute is from Webster, including the "spoil grub" letter (♯1041). The Howard letter is in St. Lawrence University (♯514). The Henry Sackrider memory is in the Taft collection.

The Hayes campaign is from the Watertown *Daily Times* (♯1033). Data on life at Highland Military is from Crooker (♯228). The letter to Horace Sackrider is in the Taft collection. Highland Military records are from the Worcester Public Library.

Remington's Yale is in Lee (♯503). Data on Weir and Niemeyer is in *American Art Annual* (♯13). Remington's classroom is described in Bigelow's autobiography (♯94). Data on Bigelow is from Remington's article in *Harper's Weekly* under Bigelow (♯86, 87). Dormitory decorations are from Bigelow's sketch in the Samuels collection. The "Notice to Freshmen" was Dec. 21 (♯1096).

Descriptions of Eva Caten are from McCracken (♯561), Manley (♯546), Card (♯163), and McKown (♯571). Data on the Catens is from Kathleen L. Kosuda, Librarian, Gloversville Free Library. Yale information is from the college catalog (♯1099). Football data is from Hurd (♯408). The bloody jacket is from *Harper's Weekly*, Nov. 18, 1893. Remington's letter to Camp is in Camp's book (♯151).

Data on life in Albany is in the Taft collection. A "free-thinking Englishman" is from a letter to Aunt Marcia in the Taft collection (♯515). The letter to Lawton Caten is from McKown (♯571). The letter from Brolley (♯517) is in the Remington collection, Archives of American Art.

CHAPTER 3 A TRIAL OF LIFE ON A RANCHE

Remington's rationale for a Western trip is in Marden (♯550). The newspaper account was the St. Lawrence *Plaindealer*, Aug. 10, 1881 (♯910). The route was suggested by the Montana Historical Society. Buffalo data is from Card (♯335). Local data is from *Montana, the magazine* (♯594), including Teschemacher and deBillier, the cattle investors. Sheridan in Montana is from the *National Cyclopedia* (♯622). The Colt .45 is from Manley (♯546). The "little sketch" is from Rogers (♯878). The Parsons reference is from his exhibition catalog (♯725) and from Exman (♯310).

The letter to Uncle Horace is Oct. 18, 1881, in the Taft collection (♯515). "Your discovery" is from the Parsons catalog (♯725). Scaring the Albany horses is in the Albany *Evening Journal,* Dec. 28, 1909 (♯3). The

cowboy sketch is in *Harper's Weekly*, Feb. 25, 1882. *The Gridiron* annual (✳358) is by Beta Theta Pi in the spring of 1882.

The Peabody melancholy is from Ms. Brown (✳127–131). The stock boom is in Freeman (✳330). The tallgrass is from the New York *Times*, Mar. 15, 1978 (✳689). The history of the Camp area is from Murdock in Wichita *Eagle* (✳1067), and Ms. Bullock's letters (✳510). Resigning in Albany is from the St. Lawrence *Plaindealer*, Feb. 28, 1883 (✳913). Remington episodes in Peabody are part of the recorded oral history of the area, Federal Writers Project in the Taft collection. The umbrella story is from Judge C. M. Clark and the Kansas City *Star*, Mar. 6, 1942 (✳446). Terra-Cotta is from "Coursing Rabbits on the Plains," *Outing*, May 1887 (✳711). Bowing to the women is from Judge R. A. Scott in the Ms. Brown interviews (✳129–131). Lucinda Clifford gave the advice on potatoes.

The letter to Uncle Horace is in the Taft collection (✳515). "Man just shot" was to Poste in Taft collection. Parties in Peabody are from J. H. Sandifer and Rolla Joseph under Brown interviews. The revolver shot behind the Englishman is from Murdock (✳1067). The town bully is from the Topeka *Journal* (✳1002). Losing Terra-Cotta is from "Coursing Rabbits."

Uncle Mart's visit is in the Peabody *Gazette*, Oct. 18, 1883 (✳727). The Halloween prank is from Dary (✳240). The Christmas affair is from the Wichita *Eagle* (✳1066). The trial is from Charles Lobdell in the Kansas City (Kan.) *Tribune*, Nov. 12, 1897 (✳457). The old "maw" in the window is from the Topeka *Capital-Journal* (✳1001).

The letter to the Ogdensburg chum is to Arthur Merkly (✳515). The information on selling the stock and equipment is from Judge Scott, and the anecdote about the sheriff is from General Hugh Scott's autobiography (✳937). The report from Canton is in the St. Lawrence *Plaindealer*, Feb. 27, 1884 (✳914). The returns to Peabody are from Rolla Joseph under Brown interviews.

CHAPTER 4 THE ORIGINAL KANSAS CITY HIT-MAKER
Background on Kansas City is from Garwood (✳344). The listing of the firm is in *Hoye's Kansas City Directory* (✳404). There are references in the Kansas City press, the *Times* in 1961, and the *Star* in 1910, 1911, and 1925.

The Nellie Hough article is in *International Studio* (✳400). The Al Hatch story is in the *Star*, 1910 (✳439), "roaping" in the *Star*, 1925, as is George Gaston (✳442). Tarsney's billiard hall and the cashier's story are *Star*, 1910. "Harum-scarum" is from the El Dorado *Republican*, 1890 (✳295). The Bishop & Christie investment is *Star*, 1911 (✳440) and 1920 (✳441). George Reick is *Journal*, 1885 (✳435). Remington's role in the saloon is *Star*, 1909 (✳437). His new address is from *Hoye*.

The wedding was reported in the Gloversville *Intelligencer*, Oct. 2, 1884 (✳350). Details on Eva Remington's Kansas City stay are in letters in the Taft collection, including Harriet Appelton's. The Findlay stories are from the *Star*, 1911 and 1920, and *Collier's*, Oct. 22, 1910 (✳210).

"Oklahoma Boomer" is Mar. 28, 1885. The meeting with Mother Remington is in Nellie Hough (✻400), and in *Carthage* (✻171). The demise of Reick is in the *Times* 1885 (✻450) and *Journal* 1885 (✻435). The new saloon is from *Hoye*. The exit from Kansas is from the *Star* 1910 (✻439).

"Start penniless" is from *Mentor* (✻574). The return to Kansas City is from Nellie Hough.

CHAPTER 5 **THE BROOKLYN COWBOY**
The Benj. Wilson data is from the Taft collection. The West as a drawback is from *Harper's Weekly*, July 20, 1895. Increasing Western interest is in Garraty (✻343) and S. E. Morison (✻598). The interview with Henry Harper is in the *House of Harper* (✻364). "Very bad drawing" is from Maxwell (✻555). The rate of pay is in a letter to Clarke in the Missouri Historical Society (✻511).

The painting for Grandfather Sackrider is in a Henry Sackrider letter in the Taft collection (✻510). The sale to the doctor is in *The Saturday Evening Post*, Nov. 10, 1900 (✻935). Senator Platt is in the New York *Sun* (✻669). Uncle Bill's steadfastness is from Ella Remington in the Taft collection. Data on Uncle Bill is from the Canton *Commercial Advertiser* (✻154).

Background on the League is from Dan Beard's autobiography (✻76). The forearm bending is from Beard. The atelier is from Beard. The new drawings are April 24 and May 29. Descriptions of technique are in Edgerton (✻291) and in Thomas in *Century* (✻993).

CHAPTER 6 **AN ARTIST IN SERCH OF GERONIMO**
Remington's "Journal" is in the Taft collection, Kansas State Historical Society. Data concerning the trip is in the "Journal" if not otherwise ascribed. The *Harper's* commission is discussed in the Denver *Republican* 1889 (✻261). Details of the Geronimo chase are from Lt. Bigelow's account (✻85). The unsigned letter is *Harper's Weekly*, June 19, 1886.

Data on General Miles is from his biography by Johnson (✻585). Forsyth's article is in 1895. Background on Forsyth is in Knight (✻476), and from letters in Remington collection (✻517). Miles' mention of Clarke is in *Personal Observations* (✻582).

The "infernal wood engravers" is from Maxwell (✻555). The *St. Nicholas* and other illustrations are listed in McCracken (✻561). The *Outing* interview is in Bigelow's autobiography (✻94).

CHAPTER 7 **MUYBRIDGE AND BEYOND**
Real wages are from *Standard of Living* (✻288). For use of photographs, see Ewers (✻308) and Taft, *Photography* (✻986). Remington's reaction is in *Book Buyer*, Hamerton (✻107). His claims are in the *National Cyclopedia* (✻622) and in Maxwell (✻555).

Muybridge data is from his book (✻611 and 612) and from MacDonnell (✻542). Meissonier is from Greard (✻355). The Aug. 21, 1886 drawing is

in *Harper's Weekly*. Quotes of Remington familiar with and identical to Muybridge is from Taft (⌗986). "The camera paints" is in a letter to Mrs. Sage (⌗512). The train wheels are from Leigh (⌗504). The hobbyhorse race is in *Outing*, March 1887 (⌗711).

The painting regimen is from McCracken (⌗561). The 60 Broadway address is from the exhibition catalogs (⌗620).

His Canadian route is traced from the published drawings, beginning with *Harper's Weekly*, May 7, 1887. Remington's memory of the trip is in *Century*, July 1889. The Gunnison newspaper is the Brooklyn *Daily Times* (⌗123).

The Canton experiences are from letters in the Taft collection. Rushton data is from Manley's Rushton book (⌗547) and the Ellsworths is from Bacheller in Taft collection (⌗510). The Western pony story is from the Canton *Commercial Advertiser* (⌗153), as is the Malterner episode.

The move to Marlborough House is from letters to Clarke, Clarke collection, Missouri Historical Society (⌗511), and Poste (⌗515). Haggling on the groceries is from letters from Eva Remington to Uncle Horace (⌗508). Riding data is from *Harper's Monthly*, Sept. 1887. The musical ride is a letter to Clarke (⌗511). Letters to Poste are from the St. Lawrence *Plaindealer* (⌗918). Roosevelt data is from Pringle (⌗744) and the *Dictionary of American Biography* (⌗265). Relations between Roosevelt and Bigelow are from Bigelow's autobiography (⌗94).

CHAPTER 8 SEVEN LITTLE INDIANS
Data on the National Academy of Design is from Clark (⌗189). The American Water-Color Society show is *Harper's Weekly*, Feb. 4, 1888 and Mar. 31, 1888. The NAD review is from *Harper's Weekly*, Apr. 7, 1888. The New York *Times* review (⌗672) is May 6, 1888, New York *Herald* review (⌗653). The mention of living conditions is from letters from Eva Remington to Uncle Horace (⌗508).

Data on Orrin Levis is from the Canton *Commercial Advertiser* (⌗154). Henry Sackrider was Mother Remington's financial agent and he said that Remington never saw his mother again, Taft collection.

Remington's letter on Kemble is to Clarke. Hard times for young painters is *Harper's Monthly*, Aug. 1888. Cowboys milking is from Cannon (⌗429). Remington at *Century* is from Vail (⌗1013). McDougal is from his autobiography (⌗569).

CHAPTER 9 A SCOUT WITH THE BUFFALO SOLDIERS
Details on the rail start are in Remington's letters to his wife (⌗515). Eva Remington's letters are to Uncle Horace (⌗508). Pennington data is in the *American Art Annual* (⌗13). The Remington imitation is in a letter to Clarke. The House Book is in the Taft collection. The articles are in Samuels' *Writings* (⌗927).

Clarke's biographical data is from his army personnel folder (⌗190). Material on photographing is in *Harper's Monthly*, Jan. 1889. In the same

Century issue that has the Remington article "On the Indian Reservation" (see Samuels' *Writings*), the Mabie response appears as an open letter. Cheyenne data is from Monaghan (※590) and from O. O. Howard (※402, 403). Whirlwind's art is in Snodgrass (※954).

CHAPTER 10 HAS THE ARTIST KILLED HIMSELF?

The description at 26 is from the Denver *Republican* 1889 (※261). The freebooting Westerner is from Thomas in *Century* (※993).

The letter to Robert Sackrider is in the Taft collection (※515). For the bronco article, see Samuels' *Writings* (※927). The encouraging summer letter is to Grant Fitch, New Milwaukee Art Center (※513).

CHAPTER 11 THE PLACE WHERE I AM AT

Remington's letter to Parsons is in the Amon Carter Museum (※511). Letters to Clarke are in the Clarke collection, Missouri Historical Society (※511). The letter from Poste to Walter Gunnison is in the Taft collection. The letter to Poste is in Taft collection (※515). "The Last Lull" in Paris is New York *Herald*, Mar. 10, 1889 (※654). Eva Remington to Uncle Horace is in Taft collection (※508).

The report on the Mexican trip is *Harper's Weekly*, Apr. 27, 1889. The letter to Gilder at *Century* is in the New-York Historical Society (※513).

July Fourth is from Fowler (※328). The critic of the Ojibwa is Ewers (※308). Announcement of second-class medal is in *Harper's Weekly*, Aug. 31, 1889. Information on Converse is from the *Dictionary of American Biography* (※265). Tel el Kabir is from the *Encyclopaedia Britannica*. The *Herald* review is Nov. 16, 1889 (※655), the *Times*, Nov. 26 (※674). Data on obesity is from Dr. Ben Daitz, University of New Mexico, School of Medicine. Hughes' portrait is from Lithgow (※510). The Dan Beard dinner is in Beard's autobiography (※76).

The Players was the subject of a *Harper's Weekly* article Feb. 15, 1890. Drinking with Julian Ralph is from Teri Card (※163). The estate letter is to Clarke. The Endion article is in the New York *Sun* c. Jan. 1893 (※669).

CHAPTER 12 A WAR DANCE IN ADVANCE

The "bits of his past" comes from *Harper's Weekly*, Aug. 9, 1890, "perfects history" from Jan. 25, 1890, "especial beauty" from Jan. 11, 1890, and "the strength" also from Aug. 9, 1890.

"Cast aside the conventional" comes from *Harper's Weekly*, Sept. 20, 1890, the uniforms and troops from Aug. 30, 1890, and the Ralph anecdotes from *Journalist* (※758). The spanking is from Thomas in *Century* (※993), Endion's opulence from Hamerton (※107).

Clarke letters are from the Clarke collection (※511). "Burst of speed" is from *Harper's Weekly*, Sept. 20, 1890. Abbey is from a Clarke letter. The Players is from *Harper's Weekly*, 1890 (※740). The Mansfield letter is from Remington collection (※517). The Kemble move is from *Book Buyer*, Hamerton (※107). His friendship is from Thomas in *Century*.

The Schell letters are mainly from the New-York Historical Society (⚹513). Henry Inman letter is from West Point (⚹515). The bull moose, the horse show, and the pencil marks are from Denver Public Library (⚹512). The toothache is from American Archives, as is "improving the original" (Remington collection). The Brooklyn Art Club is also from the New-York Historical Society. The Millet letter is from the Remington collection (⚹517).

Ralph data is from *Who's Who in America* 1900 (⚹1064) and the letter is from the Remington collection. The pony war dance is from *Journalist*. The "Ordeal" is *Harper's Weekly*, Dec. 13, 1890. The last letter from Remington to Ralph is from American Archives.

CHAPTER 13 "TALLY-HOEING" AFTER THE INDIAN FOX

Biographical data on Miles is from Johnson (⚹585). Letters to Clarke are from the Clarke collection (⚹511). The *Harper's Weekly* article is "Two Gallant Young Cavalrymen," Mar. 22, 1890. "Chasing" is in *Harper's Weekly*, Feb. 6, 1890. Cortissoz wrote *American Artists* (⚹218). Data on the Indian Commission is in *Montana*, winter 1977 (⚹594). The Sydenham excerpts are from his Daily Journal (⚹983). The reference to the English saddle is from "Chasing."

"Irregular Cavalry" is in the *Harper's Weekly*, Dec. 27, 1890. Positions on the subject are in the *Harper's Weekly*, Dec. 27, 1890, and Jan. 10, 1891. The Harper correspondent is in the Taft collection (⚹515). Christmas night details are from *Harper's Weekly* "Lieutenant Casey's Last Scout," Jan. 31, 1891, and "A Merry Christmas in a Sibley Tepee," Dec. 5, 1891.

The wagon party incident is in the Washington *Evening Star*, Jan. 17, 1891, as "The Remington Story" (⚹375). The reporters present were named in Knight (⚹476) and Hogarth (⚹395). The buck with the knife is in McKown (⚹571).

The Seventh Cavalry report is "The Sioux Outbreaks in South Dakota," called a "superb report" by Dobie (⚹269). "How Remington Was Discouraged" is in the Washington *Evening Star*, Jan. 24, 1891 (⚹376). Remington's side is also in the Kansas City *Star*, Jan. 23, 1891 (⚹436). The Plenty Horses episode is in *Montana* (⚹1046). The expression "Tally-Hoeing" comes from Charles Dana Gibson (⚹277).

CHAPTER 14 AN ASSOCIATE OF THE NATIONAL
 ACADEMY

Letters to Clarke are in the Clarke collection (⚹511). The Ralph puff is in *Harper's Weekly*, Jan. 17, 1891. "General Miles' Review" is *Harper's Weekly*, July 4, 1891. Eva Remington's comments are to Clarke (⚹508). "El Cinco de Mayo" is in *Harper's Weekly*, May 7, 1892. The Chinese coolies letter is in the Denver Public Library (⚹512).

The ultimate accolade is Coffin (⚹201). The Dixon letters are in Burnside (⚹141). Eva Remington on Chinese tea is to Clarke.

The Schell letters are in the Amon Carter Museum (⚹511). The notice

of ANA is in *Harper's Weekly*, June 6, 1891. The reference to Remington's friends is in the Card biography (⌗163). Irwin's letter is in the National Academy of Design (⌗510). The auction is Sotheby Parke Bernet, New York, Apr. 20, 1979.

Cranberry Lake data is from Fowler (⌗328). Salt pork is from Manley (⌗546) and the loon is a Manley letter (⌗510). "Good Hunting" is the *Harper's Weekly*, Jan. 16, 1892, along with Whitney (⌗1061).

Remington's opera outfit is from Sydenham (⌗983). The Carr article is in *Harper's Weekly*, Jan. 16, 1892, and in the *Journal* (⌗800). Data on Carr is in his biography by King (⌗165). The letter to Harper on Carr is in the Amon Carter Museum (⌗511). The "drawing from memory" quote is the Denver *Republican*, c. 1889 (⌗261).

Bodmer data is from Samuels' *Encyclopedia* (⌗933). Remington letters to Parkman are from the Parkman collection (⌗513). Parkman letters are in the Remington collection (⌗517).

The letter to Edwards is in the Amon Carter Museum. The Smedley party is the *Harper's Weekly*, Dec. 3, 1892. The David's Island dance is in Martha Summerhayes' *Vanished Arizona* (⌗982). The discussion of Canton mores is based on Canby (⌗152).

CHAPTER 15 THE EMPEROR'S SPIES

The Society of American Artists data is from Larkin (⌗497) and the exhibition data from the respective catalogs (⌗955). The Hanging Committee came from Emma Caten, Taft collection.

Eva Remington letters are to Clarke (⌗508). Bigelow on the Danube is *Seventy Summers* (⌗94) and *Harper's Weekly*, Aug. 8, 1890. Letters to Bigelow are in the Bigelow collection, St. Lawrence University (⌗511). The Bigelow-Harper material is in the Remington collection. Remington on Bigelow is *Harper's Weekly*, Aug. 20, 1895. The Mark Twain quote is from *Guide Through North and Central America* (⌗360). Remington and the Kaiser is from the Ella Remington recollections, Taft collection.

Remington in collapse is from *Seventy Summers*. Bigelow and the Kaiser is from Ella Remington. Russian champagne is from *Book Buyer* (⌗107). Remington's disclaimer of Bigelow is from the Watertown *Daily Times* (⌗1037). The letters to Ralph are in the Taft collection (⌗515). Bigelow's first article in *Harper's Monthly*, Jan. 1893, describes the clandestine rendezvous and the American cover. Bigelow's letters to Remington are in the Remington collection, as are the papers on the Kaiser's portrait. Bigelow's "The Russian and His Jew" (⌗93) contains the anti-Semitic material. *Harper's Weekly* on Jews is part of an 1891 series. Miles' letter to Remington is in the Remington collection.

Bigelow's confession of spying is in *Prussian Memories* (⌗92), as well as in *Seventy Summers*. The New York *World* reference is in *Harper's Weekly*, July 2, 1892. F. Hopkinson Smith in *American Illustrators* (⌗952) worries about Remington going abroad. "A Mimic War" is addressed to Bigelow.

On the auction, the avoidance of writing letters is to Clarke and the plea

of poverty is to Bigelow. The *Harper's Weekly* publicity is Jan. 7, 1893. Remington's copy of the catalog shows prices and buyers' names.

The Remington to Harper letter from Chihuahua is in the authors' collection. Remington describes Follansbee in "An Outpost of Civilization," *Harper's Monthly*, Dec. 1893. The true Follansbee is in Mrs. Fredmont Older's book (※707). The Putnam data is from his biography (※746).

Remington's solicitousness of his wife is from Ella Remington.

CHAPTER 16 MY FRIEND CLARK

Substantially all of the quotations are from the Clarke collection of letters from the Remingtons in the Missouri Historical Society (※511) and from Clarke's personal file in the military archives (※190). The Thomas circle is from "Recollections" (※993).

The Lamont correspondence is from the Library of Congress (※513). Miles' letter is from the Remington collection (※517), as are letters from Clarke to the Remingtons.

The Bigelow letter is in the Bigelow collection (※511). The *Herald* and the *Journal* articles are in the Clarke army file, while the Sunday *Sun* article is reported in *Harper's Weekly*, June 10, 1893.

The material leading up to and the details of Clarke's death are from the army file.

CHAPTER 17 MISTER WISTER

The Wister data comes from three primary sources, *Owen Wister Out West* (※1077), Wister's manuscript journal (※1078), and his book *Roosevelt* (※1086). Vorpahl's biography of Wister (※1021) was also used. Remington's letters to Wister are in the Library of Congress (※513). Information on Philadelphia society is in *Henry McCarter* by R. Sturgis Ingersoll, private printing, Cambridge, 1914.

The Bigelow letters are in the Bigelow collection (※511). The Harper letter is from the Denver Public Library (※512). The "little report" is "A Gallop Through the Midway," *Harper's Weekly*, Oct. 7, 1893. The listing of Remington's drawings at the Fair is in the *Catalogue* (※1093).

Remington's "had to hustle" letter was to Grandpa Sackrider and is in the Taft collection (※515). The makeup of the party and details of the hunt are from Stevens' book (※975). The story of the drawings of uniforms is from Scott's book (※937). The composition of the pack of dogs is from Miles' *Personal Observations* (※582).

The letter from Stevens is in the Library of Congress (※513). Miles' letter is in the Remington collection (※516).

Wister spelled Frederic as Frederick in his unedited journal (※1078).

CHAPTER 18 AMONGST THE SKOPTSI OF BESSARABIA

The details of the West Virginia trip are from Ralph's *Journalist* (※758). The Richmond visit is in *Harper's Weekly*, Feb. 24, 1894, with the Remington puff on Ralph. The "go to Harper's" letter is in the Taft col-

lection (#515), "a drawer" in Amon Carter Museum (#511). The *Herald* interview is Jan. 14, 1894 (#656). The Russo-German book review is in *Harper's Weekly*, Apr. 6, 1895.

The African trip is from Bigelow's *Seventy Summers* (#94), modified by his "An Arabian Day and Night," *Harper's Monthly*, Dec. 1894. The April 1 return is from the Bigelow collection.

The NAD exhibition is from the *Record* (#620), the Union League from the Wales letters (#515). Teaming Remington and Wister is from Exman on the Harpers (#310). Letters to Wister are in Library of Congress (#510).

The strike data is from Garraty (#343) and from the *Harper's Weekly*, July 7, July 14, and July 21, 1894. "The Mob" is *Harper's Weekly*, July 21. "The Law", July 28. Eva Remington's letter is in the Missouri Historical Society (#508).

Martin on illustrations is June 23, 1894, the one on Wister is Aug. 11, 1894, *Harper's Weekly*.

CHAPTER 19 THE ORIGIN OF THE EVOLUTION OF THE BRONCO BUSTER

Roosevelt hyperbole is from his *Autobiography* (#881). Letters to Wister are from the Library of Congress (#513). The Bigelow letters are in the Bigelow collection (#511). Remingtoniana is from Wister. The Mizell story is from Smiley (#951).

Thomas and the sculptor's eye is from Thomas' book (#992) and article (#993). Reversing the characters is from Teri Card (#163). Remington's revelation is from Arthur Hoeber's "From Ink to Clay," *Harper's Weekly*, Oct. 10, 1895. The Poles is from Childe in the Denver *Republican*, 1889 (#261). Ruckstuhl is from his book, before he changed his name to Ruckstull (#895). Remington to his wife is from Ella Remington's notes, Taft collection.

The Pyle letter is from Abbott (#748). Difficulties in sculpting are from Emma Caten quoted in McCracken (#561). Ruckstuhl as guide is from Henry L. Sackrider letter (#515). The Zogbaum incident is from the son's autobiography (#1104).

CHAPTER 20 ART THAT THE MOTH DONT STEAL

The Henri-Bonnard story is in *Harper's Weekly*, Feb. 2, 1895. Sand casting details are from the authors' experience. The copyright description is from the U. S. Patent Office.

The *Harper's Weekly* puff is Oct. 19, 1895. Tiffany details are from Tiffany catalogs under Remington/sculpture (#855). Preston Remington is from a clipping in the Taft collection, Kansas State Historical Society. Loredo Taft is from Gardner (#336). The Howells letter is in the Remington collection. The *Century* article is May 1896 and the *World* correspondence from the Taft collection. The New York *Times* clipping is Nov. 15, 1896, under Remington sculpture (#856).

Bigelow letters are in the Bigelow collection (※511), Brolley in the Remington collection (※517), and Wister in the Library of Congress (※513). Letters from Wister to Remington are in the Remington collection (※517). Estimates of "Buster" sales are from Broder (※122), Wear (※1039), Hassrick (※382), and Card (※161). "Steinway in my stocking" is confirmed by an Aug. 6, 1980, letter from John H. Steinway. Breaking versus gentling horses is from Elbert Hubbard (※405).

The Burdick agreement is in the Remington collection. The letter to Lamont is in the Library of Congress (※513). A "little dissipation" and "quit drinking" are letters to Bigelow. The Aldine Club episode is from the Ellsworth book (※298). The Roosevelt dinner is in Wister's book on Roosevelt (※1086). Remington wrote Bigelow that he did not go. The letter from Kipling is in the Remington collection (※517). Lighting the gas is from *Outlook* 1910 (※715).

Cortissoz is in *Harper's Weekly*, Apr. 16, 1895. Letters from Jefferson are in the Remington collection. The Jefferson anecdote is in Francis Wilson's book (※419). The "loco" trip was with Summerhayes; see the next chapter. Ralph's article on Remington is *Harper's Weekly*, July 20, 1895. Letters to Pyle are in Abbott (※748).

Reviews of *Pony Tracks* are in the 1895 Harper ads (※846). The "azure heights" quote is from Martin in *Harper's Weekly*, Sept. 21, 1895. The "verve" quote is from the Brooklyn *Times*, Aug. 11, 1895, under Remington *Pony Tracks* (※848). The Howells comment is in *Harper's Weekly*, Nov. 30, 1895. The letter from Remington to Howells is in the Taft collection (※515). The Southwest as Remington's turf as a writer is *The Bookman* (※108).

The auction catalog is in the Remington collection. The *Times* is Nov. 21, 1895, "The Remington Pictures Sold" (※676). The letter from Roosevelt is in the Remington collection.

The letter to Mrs. Clarke is in the Clarke collection (※511). The data on the bike fad is from Sullivan, volume I (※980). "Two Little Girls in Blue" is from Ewen (※307). The details of the lawsuit are in the New Rochelle *Paragraph* beginning Mar. 9, 1895 (※631).

CHAPTER 21 GOOD BYE LITTLE ONE

The reference to architect Degen is in the New Rochelle *Paragraph*, Apr. 18, 1896 (※634). The letter to Wister is in the Library of Congress (※513). The Eva Remington story is from Thomas (※993).

Letters to Wales are in the Winterthur (※515). Background landscapes are in a letter to Frost, Mannados Catalog (※548). Musk ox is to Wister. The Whitney letter is in the Remington collection (※517).

Summerhayes' military record is from (Army) Powell (※57). The pass from Miles is in the Remington collection. The characterization of the trip is from Mrs. Summerhayes (※982). The Ranger interviews are from Raymond (※767). A short biography of Frost is in Samuels' *Encyclopedia* (※933).

Placing Remington in Canton for the summer is in Manley (⅍546). Montana sweat is to Wister. "The Attack on the Camp" is from the Samuels collection, and the text is from "Vagabonding with the Tenth Horse" in *The Collected Writings* (⅍927).

The "nigh leg" is from the *Harper's Weekly* review. Sculpture prices are from the Tiffany catalogs (⅍855). The bronze listing is from the Remington collection.

The Russell contract is in the Remington collection. Reviews are *The Art Interchange* (⅍60) and *Book Buyer* (⅍107). The letter to Russell is in the Denver Public Library (⅍512). The letter from Roosevelt is in the Remington collection. The Roosevelt-Stevens meeting is from Stevens' book (⅍975).

The letter to Ralph is in the Samuels collection. The Cuban background is partly from C. H. Brown (⅍126). The Davis material is from Downey (⅍278) and Langford (⅍496). Davis the campaigner is in Older (⅍707), as is *Vamoose*. Thomas called *Vamoose* mackerel-shaped and describes the sea cook (⅍993). The *Raleigh* markmanship is a certificate in the Remington collection.

Letters from Remington to his wife are in Taft collection. The Goven murder is in Brown. Remington at the coal-window is in "Under Which King?" *Collier's*, Apr. 8, 1899, as is the Weyler interview. Remington getting his cocktails right is in Langford. The cable to Hearst is in Lundberg (⅍534), the reply is in Creelman (⅍227) and Winkler (⅍1074), as well as in the movie *Citizen Kane*. Hearst's clotted nonsense is in the *Literary Digest* (⅍524).

The Yellow Kid Journalist letter to Ralph is in the Samuels collection. The letter to Bigelow is in the Bigelow collection (⅍511).

Senorita Arango's story is in C. H. Brown. Teri Card (⅍163) covered the curves. The *Journal* edition is discussed in Langford, Congress in Rea (⅍768), and Davis' wit in Millis (⅍588).

CHAPTER 22 THE ANTICIPATION OF WAR

The Cuban drawings in the *Journal* start Jan. 24, 1897. The Barb is in "Horses of the Plains," Samuels' *Collected Writings* (⅍927). Spanish buying in Florida is in "Spanish Cavalrymen Being Bucked Off," the *Journal*. The *World* contract is in the Remington collection. Brisbane details are in his biography (⅍120). The letter from Brisbane is in the Taft collection.

The pneumonia and bike trip are letters to Wales in the Winterthur (⅍515). Letters to Wister are in the Library of Congress. The dictated letter is from Vorpahl (⅍1021), as is Wister background. Cranberry Lake incidents are in Fowler (⅍329). "Fat" is in *Harper's Weekly*, Mar. 28, 1896. Killing deer is in Fowler. The tiger hunting is in R. U. Johnson (⅍430).

For Cisneros story, see ⅍186. Royal Academy reference in letter to Wales (⅍515). The Boston exhibition is in the Remington collection, review in *Transcript* (⅍112). Pyle's article is in *Harper's Weekly*, July 17, 1897.

Data on the stamps is from Dykes (✻284). Bigelow letter is from Bigelow collection (✻511). Cody and Elwell are in *Montana*, Winter 1957. Rain-in-the-Face is from Vestal (✻1017). "Mohongui" and "Goodenough" are in Samuels' *Writings* (✻927). Roosevelt's letters are in the Remington collection. Massai background is from Downey (✻276). Remington letters to Roosevelt are in the Library of Congress (✻513). Theodore Roosevelt in a rowboat is from Kermit Roosevelt (✻879).

Thomas and Arizona are in Thomas' autobiography (✻992). "Help" listed in *Directory for New Rochelle* by Turner (✻1005). The day nursery benefit is in New Rochelle *Pioneer*, July 10, 1897 (✻641) and *Press*, July 10, 1897 (✻645) and in Teri Card (✻163). Article on Remington in *The Art Interchange* (✻60).

CHAPTER 23 THE GREATEST THING MEN DO

The "ring off" incident is from Thomas' autobiography (✻992). The coastal fort drawing is *Harper's Weekly*, Apr. 2, 1898. Coastal fear is in Alger (✻959). Beginnings with *Collier's* is in Samuels' *Writings* (✻927). Bonsal background in *Who's Who in America* (✻1064). The quote is from Bonsal's *Santiago* (✻106).

The Laurentians trip is in Samuels' *Writings*, "The White Forest." Background to the war is in Morison (✻598). Emma Caten's diary is in Allen (✻7). The correspondents' activities are in C. H. Brown (✻126). Davis' letters are in Langford (✻496). Yellow press circulation is *Harper's Weekly*, Mar. 12, 1898.

Remington on the *Iowa* is in Samuels' *Writings*, "Wigwags." The black cat is May 8, 1898. The letter from Evans is in the Remington collection (✻517). Alger's routine is in Alger.

Background on the Rough Riders is from Downey on Davis (✻278). Davis' photographs are in Langford. Wood's inside track is in Downey. "The War Dreams" is in Samuels' *Writings*.

Bigelow's article is *Harper's Weekly*, June 4, 1898 and July 16, 1898, with Whitney June 11, 1898. Roosevelt's diary is in Millis (✻588), as are the *Gussie* incident and Shafter vs. Miles. Davis and his commission are in Downey.

The letter to Wister is in the Library of Congress (✻513). The data on the generals is in *Who's Who* (✻1064). The Young and Roosevelt tie is in Chaffee's biography by Carter (✻170). The Roosevelt and Davis encounter is in Downey. Miles vs. Alger is in Brown and Millis. Reflipe W. is in Brown. Miles' train is in Millis. The metal pier is in Downey. Remington and the cavalry is in Samuels' *Writings*, "With the Fifth." Details on the invasion fleet are in Davis, *Cuban and Porto Rican* (✻245), Brown, and Millis.

Remington the parvenu is in Bonsal.

CHAPTER 24 ALL THE BROKEN SPIRITS

Details of the landing are from C. H. Brown (✻126) and Millis (✻588), as well as Remington's "With the Fifth" from Samuels' *Writings* (✻927).

Letters to Eva Remington are in the Taft collection (※515). The lunch with Young is from Bonsal (※106). Talk about Wheeler's plan is in McIntosh (※570).

The night landing is from R. H. Davis' *Notes* (※248). Las Guasimas is covered in all the Cuban references. The Cashin *Tenth Cavalry* (※173) is the best collateral view. Davis' letters are in Langford (※496). The "solar plexus blow" is from Bonsal. The discussion between Remington and Fox is from "With the Fifth."

Health and cleanliness are in the letters to his wife. The smoking mix is from a Davis letter. Remington as a rustler is from Bonsal. Ostracized is from "With the Fifth." The Norris reference is from Walker (※1022).

"With the Fifth" gives Remington's thoughts. Replacements for Wheeler are in Brown. Details of San Juan Hill are in all the Cuban references including Millis, Brown, and Davis' *Cuba* (※245). For the picture of "Grimes's Battery," see "With the Fifth." The Norris incident is from Walker. The casualty count is from Millis, the ratio from Davis (※245). Froissart is from the *Encyclopaedia Britannica*. Casualties for the "Black Buffaloes" are from Cashin.

The light haversack and dry canteen are from Bonsal, as are the meeting and the conclusion. The letter from Davis is in the Remington collection (※517).

CHAPTER 25 NOT HAPPY IN YOUR HEART

The letter from Pyle is in the Remington collection (※517). The list of heroes is Davis in *Harper's Monthly*, May 1899. Thomas is from *Century* article (※993). Rogers' feelings are from his autobiography (※878). The Garland data is in Pizer (※342) and in *Roadside* (※341). Roosevelt vs. Alger is in *Harper's Weekly*, Aug. 13 and Aug. 27, 1898. Miles vs. Alger is in Remington's article in *Harper's Weekly*, Oct. 15, 1898. The plagiarizer incident is in Goodrich (※327), and the Remington letter on his fake is in the Taft collection (※515).

The Rough Riders' mustering out is in *Collier's*, Oct. 1, 1898. Roosevelt's thanks are in *The Rough Riders* (※885). The letter to Roosevelt is in the Library of Congress (※513), the response is in the Remington collection (※517). NIAL is from the Remington collection. Letters to Wister are in the Library of Congress (※513).

"The Wicked Pony" copyright is Dec. 3, 1898. The outlaw pony is from Barnes (※72). The quantity cast is from Wear (※1039), Broder (※122), and Gardner (※336). "The Triumph" copyright is Dec. 10, 1898. The characterization is from the *Harper's Weekly* review. "Articulations" is from Coffin in the *Weekly*.

Crooked Trails is May 26, 1898, copyright. "One of us" is in the copy Remington inscribed for Thomas. The letter to Harper is in the Denver Public Library (※512). Remington in his studio is from Summerhayes (※982). The Ella data is from Taft collection, as is the letter to Uncle Rob.

"Grimes's Battery" is in "With the Fifth Corps" from Samuels' *Writings*

(✻927). Remington in Havana is from Scott (✻937). The biographical detail is in the Edgerton interview (✻291). Blumenschein is in Chase (✻178). Thomas on Peters is in *Century* (✻993). Wister's letter is in the Library of Congress (✻513).

CHAPTER 26 BITS THAT HAD NEVER MET

The letter to Ralph is in the Samuels collection. Ralph's reply is in the Remington collection (✻517), as are letters from Church. The letter from Beveridge is in the Remington collection. The quote from Beveridge is in Sullivan (✻980).

The *Journal* is Mar. 8, 1900. The New York *Times* is June 24, 1900. The Chicago *Times* is Sept. 2, 1900. Verification of the Yale degree is in the Taft collection. Letters from Professor Weir are in the Remington collection. "Remington's Secrets" is in *Harper's Weekly*, Feb. 3, 1900. The Bangs material is from his biography (✻71).

The letter from Remington to Wister is in the Library of Congress (✻513). Background on *Harper's* is from Erisman (✻303). The letter to Summerhayes is in *Vanished Arizona* (✻982). The Remington writings are in Samuels (✻927). Remington letters to Harper on *Men with the Bark On* are in the Taft collection (✻515), and the Amon Carter Museum (✻511). "Bark" is in R. F. Adams (✻2). The ad is in *Harper's Weekly*, Apr. 7, 1900.

"The Way of an Indian" is implied in Harold Johnson's article, Watertown *Daily Times*, Aug. 17, 1900 (✻424). Bertelli data is from an interview with the Continis. Letters to Bertelli are in the Stark Museum (✻514). Wear (✻1039) and Card (✻161) discuss "The Norther." Process description is in Barnes (✻72). Eggs and whiskey are from the Continis.

Schreyvogel background is from Horan (✻397) and from Samuels' *Encyclopedia* (✻933). *Harper's Weekly* is Jan. 13, 1900. The *Herald* is in Horan. "False and fake" is from Thomas in *Century* (✻993). Paris Exhibition is from the catalog (✻719). The letter to Ralph is in the Amon Carter Museum.

The H. B. Johnson *Watertown* article on Ingleneuk was updated Sept. 28, 1961 (✻425). Negotiations are in the Ogdensburg *Journal*, May 26, 1900. Remington's leaving date is in Bertelli letters in the Stark Museum (✻514), as is the route to Ingleneuk. "Island Belle" details are in Harold Johnson (✻425). "Boer" love is in the Samuels collection. Chapman details are in Samuels' *Encyclopedia* (✻933). Chapman story is in Manley (✻546) and in a letter in the Taft collection.

CHAPTER 27 DERBY HATS AND BLUE OVERHAULS

The Santa Fe Railroad collection is from its exhibition catalog (✻934). Letters to Eva Remington are in the Taft collection (✻515). Remington's movements are taken from his letters. Biographical data for Wade and Wolcott is from *Who's Who in America* 1902 (✻1064). The Denver *Republican* interview was Oct. 21, 1900 (✻262); it referred to Wolcott and

Overland Park. For data on Denver artists, see Samuels' *Encyclopedia* (❋933).

The Republican Convention is in Morison (❋598). The deceased Vice President was Hobart; see *Dictionary of American Biography* (❋265). For Thomas Moran's landscapes, see Samuels' *Encyclopedia*.

Data on Taos is from Remington's unpublished article (❋863). For Blumenschein and Phillips, see Samuels (❋933). The Tum tiddy TUM is from Bill Moyers (see Samuels' *Encyclopedia*). Remington's quote on Phillips is from an unidentified local paper. The letters to Phillips are in the Phillips collection (❋513). The letter to Alden is under Harper in the Amon Carter Museum (❋511).

"Natchez's Pass" is in Samuels' *Writings* (❋927). The Summerhayes letter is in the Remington collection (❋514). Letters to Wister are in the Library of Congress (❋513). Mrs. Crane's letter is in the Remington collection. Remington's refusal is in Columbia University Library (❋511). Crane background is in Chidsey, under Spanish-American War (❋962), and Stallman (❋968). The *New Magazine* is in a letter from Roosevelt to Wister in the Wister biography of Roosevelt (❋1086). The Civil War letter was to Sparhawk.

Edwards' poetry is in the Remington collection. Tahamont data is from the Denver Public Library. Selling by sketch is from the Fine Arts Museum of San Diego. Letters to Macbeth are in Archives of American Art (❋514).

"Injuries received by the horse" is in the New Rochelle *Press*, Apr. 20, 1901 (❋646). The unidentified New York City newspaper clipping is in Kansas State Historical Society.

The Ingleneuk details are from the two Watertown *Daily Times* articles (❋425). The drinking is from Charlie McLellan's 1943 recollections in the Taft collection.

CHAPTER 28 40 YEARS AND A DOWN HILL PULL

Collier's illustrations are in McCracken (❋561). Edwards' note is in the Remington collection (❋517). The text for "Smugglers" is in Hassrick (❋382). The wire to Wister is in the Library of Congress (❋510). The puncher is in *Collier's*, Sept. 14, 1901, with the quatrain. The revised line is in *Done in the Open* (❋794). Letters to Wister are in the Library of Congress (❋513). Norris' text was reprinted in *The Pit—A Deal in Wheat* (❋697). *Saturday Evening Post* illustrations are listed in McCracken. "A Bunch of Buckskins" is a portfolio of prints (❋787). Letters to Wister from Russell and Singleton are in the Library of Congress (❋510). The letter from Roosevelt is in the Remington collection (❋517).

"A Desert Romance" is in Samuels' *Writings* (❋927). Johnson's letter is in the New York Public Library (❋516). Letters to Bertelli are in the Stark Museum (❋514). The Bertelli story is in McCracken (❋561). The price is from Tiffany (❋855) and the heights from museum catalogs. The number of casts is in Wear (❋1039). The "Buffalo Signal" letters are from

Devereaux in the Remington collection (\times517), as is the letter from F. S. Church. The newspaper review is not identified, from the Taft collection.

Dewey is in *Harper's Weekly*, Apr. 12, 1902. Roosevelt vs. Miles is in Pringle (\times744). The Baker memo is in the Remington collection. Remington's letter on Sampson is in the Library of Congress as is Roosevelt to Remington on Daniels. Data on Daniels is in Pringle. Trivia for 1902 is from *Harper's Weekly* for the year. The letter from Boughton is in the Remington collection. The Schreyvogel article is Nov. 15, 1901, praise for Wister is Sept. 27, 1901, and Verestchagin is Jan. 25, 1902.

Edwards' letter is in the Remington collection. "Western Types" is *Scribner's*, Oct. 1902. Howard is in McCracken (\times561). The letter from Wister to Singleton is in the Library of Congress and to his mother is in Vorpahl (\times1020).

CHAPTER 29 LONG STORY IS MY PROBLEM

Letters to Bertelli are in the Stark Museum (\times514). Letters to Wister are in the Library of Congress (\times513). The crowbar is from McCracken (\times561). The letter to Gunnison is in the Taft collection (\times515). The inventory is from the 1905 Knoedler catalog (\times477). The sale of the second casting is in a letter to Wister.

The Louisiana Purchase Exposition is from Stevens (\times920) and from Gardner (\times336). Bitter is from a letter from Henry Sackrider in the Taft collection (\times510), as is a letter from Henry Reed with Portland details. Museum holdings are from Broder (\times122).

Wister to his mother is from Vorpahl (\times1020). Summerhayes is in *Vanished Arizona* (\times982). Garland's book was reviewed in *Harper's Weekly*, Apr. 5, 1902. Letters to Shipman are in the Amon Carter Museum (\times511). Details on Wister are from Vorpahl.

Remington's regimen is from Wildman (\times1070). The phonograph is from Emma Caten in McCracken (\times561). The "old gentleman" is a letter to Wister. Carrie Nation is from the *Dictionary of American Biography* (\times265). The chiding of Shipman is in Mannados (\times25), under Latendorf (\times499), and Shipman's background is in *Who's Who in America* (\times1064). The letter from Brett is in the Remington collection (\times517). The Gibson drawing is from R. N. Gregg (\times356). The positive review is the New York *Times* (\times678) and the negative one Herbert Craly (\times224). Wright, Shipman, and Kelley letters are in the Remington collection.

CHAPTER 30 A PERFECT JACK

The letter from Edwards is in the Remington collection (\times517). The letter to Shipman is in the Taft collection (\times518). Information on Hackett is in *Who's Who in America* 1902 (\times1064). "Good to see" is in *Harper's Weekly*, Sept. 14, 1901. Letters to Wister are in the Library of Congress (\times513). The letters to Shipman are in Mannados (\times499), concerning *Crisis*, and in Amon Carter Museum (\times511), concerning the pastel. *Harper's Weekly*, Oct. 18, 1902, has a photo of Charlotte Walker.

Data on the Cornish colony is in *Encyclopaedia Britannica* and Colby
(✳215). The Cornish letters to Shipman are in Mannados (✳499). The
Wade, Parrish, and Churchill data is from the Taft collection. The failure
to buy in Cornish is from the County Registry of Deeds. "Working like
hell" is a letter to Shipman in the Amon Carter Museum (✳511).

Cobb is from his *Saturday Evening Post* article (✳199). Weir data is
from his biography (✳1044). The Union League catalog is in the Detroit
Institute (✳1008), the Noé catalog is in the Taft collection (✳694), as is
the *Times* review (✳680). Cortissoz is in *Scribner's* (✳941).

Background for Schreyvogel is in Horan (✳397) and Samuels' *Encyclo-
pedia* (✳933). Borglum praise is in *Harper's Weekly*, May 9 and May 16,
1903. The letter to Crosby and the Schnuck letter are in Horan.

The *Collier's* agreement is in McCracken (✳561). The letter to Bigelow
is in the Watertown *Daily Times*, Oct. 23, 1961 (✳1037). The letters to
Shipman are in Mannados (✳499). The war was *Harper's Weekly*, Feb.
20, 1904. Robert Collier in Ogdensburg is in McCracken.

The second "working like hell" is in the Amon Carter Museum. The let-
ter from Howard on tennis is in the Remington collection. The pier and
toad stories are from McCracken. Letters to Shipman on *Ermine* are in
Mannados and the Amon Carter Museum. "Mountain Man" data is from
Gardner (✳336). "Iroquois trapper" is from a letter to the Corcoran Mu-
seum (✳511). Wood as the model is in Taft collection (✳515). Comment
on painting at Ingleneuk is in Wildman (✳1070). The Chief of Police is a
letter in the Remington collection.

The Boston "Programme" is in the New York Public Library (✳815).
The Summerhayes' experience is in *Vanished Arizona* (✳982). Reming-
ton's lack of sleep is in a letter to Martha Summerhayes. "Lobster Louis" is
in the Amon Carter Museum.

The Chicago opening was Oct. 5, 1903. The *Post* review is in the Taft
collection (✳179). *Harper's Weekly* New York review was Nov. 21, 1903,
the closing notice, Dec. 10, 1903. The letter to Bertelli is in the Amon
Carter Museum. Hough is in *Collier's* (✳399), Remington in Sum-
merhayes, *Vanished Arizona*.

CHAPTER 31 WHY WHY WHY CAN'T I GET IT

The letter to Shipman is in Latendorf ✳25 (✳499). The letter from Cox is
in the Remington collection (✳517). The osteopath is from Thomas in
Century (✳993). The Howard background is from his obituary (✳401).

Details on the trip are in letters to Eva Remington in the Taft collection
(✳515). The *Collier's* contract data is from McCracken (✳561). The leader
and his followers is from de Kay (✳256) and the New York *Times*,
Mar. 15, 1904 (✳681). Charles Russell data is from Garst (✳900), Russell
(✳899), and Bollinger (✳103). The Noé review is in the New York
Times, Mar. 15, 1904.

The macho letters to Eva Remington are in the Remington collection, to

Shipman in Mannados (※499), and to Dan Beard in the Library of Congress (※513). The "5 models" letter is to Shipman. The high school boy is D. F. McEllen whose recollections are in the Taft papers. Letters to Bertelli are in the Stark Museum (※514). The negative on Newfoundland was to Summerhayes (※515). The information on the cruise to Newfoundland is from a watercolor by W. M. Mitchell in the authors' collection.

The Cuba letters to Eva Remington are in the Taft collection. The letter to Cox is in the Taft collection. Knoedler catalogs are from Knoedler (※477), Bertelli on "The Rattlesnake" is from McCracken (※561).

The Noé catalog (※696) and the Cortissoz letter are in the Remington collection.

Letters to Eva Remington on the Bad Lands are in the Taft collection. The illustrations in the *Cosmopolitan* office are from "Magazine Shop-Talk," in *Cosmopolitan* for Dec. 1905. The applause for *The Way* is Merle Johnson (※426).

For casual research, the letter from Thwaites in the Remington collection (※517) was part of the homework on the "Explorers." The letter to Bertelli on "no bronzes to sell" is in the Norton Gallery (※513). There are a letter from Chapman and an interview with him in the Taft collection.

CHAPTER 32 THE FOLKS FROM PHILADELPHIA

Basic information on the Fairmount Park Art Association (FPAA) is from its book (※314). Letters from Remington to Miller and Cohen are in the FPAA collection (※512), as are the documents mentioned. Data on Miller, Cohen, and Beck is in *Who's Who in America* (※1064). Trego is from the Honey Brook *Herald* under Fairmount Park (※313).

The April 12 letter to Miller is on Waldorf stationery. Borglum's price is from Walker (※1022), Dallin's from FPAA. Data on Katherine Cohen is from FPAA. Letters to Bertelli are from the Stark Museum (※514). The French data is from FPAA.

Letters to Eva Remington are in the Taft collection (※515). *Man and Superman* is discussed in *Harper's Weekly*, Nov. 25, 1905. Reference to the bronzes at Knoedler's in 1906 is in a letter from R. W. Gilder in the Remington collection (※517), which also has the invitation and letter from Roosevelt. The letter to Weir is in his biography (※1044).

CHAPTER 33 AN ALLEGED RIGIDITY IN THE LEFT
FORELEG

The greenhorn reference is in the Fairmount Park book (※314). Statuette descriptions are from the copyrights. The letters to and from Roosevelt are in the Library of Congress (※513, 516). The reception invitation is in the Remington collection, and the refusal is per Emma Caten, Taft collection.

The letter to Shipman is from Mannados (⚒499). Raddison was Jan. 13, 1906, in *Collier's*. The letter to the editor is Mar. 23, 1907. Hough is in his "Wild West Faking" (⚒399). Ewers is in his book (⚒308).

The "English red" is a letter to Shipman. Knoedler's data is from Knoedler's (⚒478). The income data is from *Harper's Weekly*. The letter to Annesley is in the Denver Public Library (⚒512). Letters from Hassam are in the Taft collection (⚒518), to Hassam are in Remington collection (⚒514). Data on Thomas is in *Harper's Weekly*, May 18, 1907, and Sept. 29, 1907. Weir's letter to Hassam is in American Institute of Arts and Letters (⚒510).

Data on Hepburn is from his biography (⚒386). Data on the interments is in the diary (⚒793).

In 1907, the Remington statements not otherwise ascribed are in his diary in the Taft collection. Material on the Big Cowboy is in the Fairmount Park Art Association. Remington's adverse reaction to Morris is in the Philadelphia *Inquirer*, Apr. 19, 1974 (⚒735). The letter from French is in the Remington collection, as are letters to Eva Remington.

CHAPTER 34 IT'S A DANDY, PROFESSOR

The sculpture quote is from *Pearson's* by Maxwell (⚒555). Data (like Bertelli's price) not otherwise ascribed is from the diary. Sales information is from Tiffany catalogs (⚒855).

The letter to Howard is in the St. Lawrence University collection (⚒514). The letter to Shipman is in Mannados (⚒499).

"The Buffalo Horse" and the painting are both in the Gilcrease Institute (⚒348, 349). Data on the shanty is in letters to Miller in the Fairmount Park Art Association (⚒512). The MacMonnies letter is in the Remington collection (⚒517). The letter to Wister is in the Library of Congress (⚒513). The letter from Maxwell of *Pearson's* is in the Remington collection (⚒517). "Elephantine bulk" was from the article (⚒555). Modeling the head is from a letter from Henry Sackrider in the Taft collection (⚒510).

The economic data is from *Collier's Weekly*, Apr. 20, 1907, and *Harper's Weekly*, Nov. 9, 1907. Knoedler data is from the catalog (⚒479). The two reviews are in the Taft collection (⚒684).

CHAPTER 35 READY FOR GLORY

Letters to Miller are in the Fairmount Park Art Association (⚒512). Bertelli's estimate and other unattributed Remington data are in Remington's diary (⚒793). The letter to Eva Remington is in the Taft collection (⚒515). The letter to Sally Farnham is in Jackman (⚒415). Data on her work is in the Savoy auction catalog of her estate (⚒936). Data on her is in *Who's Who in America* (⚒1064). The reference to parties with Brooklyn women is from Roman Bronze employees. The bath robe letter is in the Stark Museum (⚒514).

Data on Will Bradley is from the Hornung book (✳115). Data on Ernest-Seton Thompson and vice versa is in *Who's Who in America.*

The letter from Roosevelt is in the Remington collection.

Data on the St. Lawrence is from a letter to Miller. The bigger launch is from the New York *Herald* article, "Joy of Wielding the Paddle" (✳662). The Miller and Hetherington letters are in the Remington collection. Bellows data is from his *Memorial Exhibition* catalog (✳79). Mosler data is from the New York *Times*, Nov. 18, 1906. Hanging Day is from the New York *Herald*, Aug. 23, 1908 (✳662).

The fall from the water wagon is a letter to Shipman in Mannados (✳499).

CHAPTER 36 I HAVE LANDED AMONG THE PAINTERS

Unattributed quotations are from Remington's 1908 and 1909 diaries. The reference to contractors' estimates is from a Hepburn letter in the Remington collection (✳517). The letter to Gunnison is from Jeff Dykes. The letter to Bertelli is in the Stark Museum (✳514).

The Monet material is from Edgerton, *The Craftsman*, Mar. 1909 (✳291). Davenport data is from *Who's Who in America* (✳1064), as are Hassam, Hale, and Gaul details. Also see Samuels' *Encyclopedia* (✳933). The letter from Davenport is in the Remington collection (✳517). The letter to Davenport is in the Taft collection (✳515).

Letters to the Fairmount Park Art Association are in the Association files (✳512). The maiden aunt anecdote is in the New Rochelle *Evening Standard* (✳647). Knoedler data is from Knoedler (✳481). The *Times* review is Dec. 2, 1908 (✳686), the *Globe* (✳482).

The letter on "Pack-train" is in Wildenstein (✳1069). The letter on "Stampede" is in *The American Scene*, vol. V (✳31). Obesity data is from Dr. Ben Daitz, University of New Mexico, Medical School.

The approaching railroad is from the New Rochelle *Standard-Star* Feb. 27, 1934 (✳648). Money in manure is from McCracken (✳561), as is reselling surplus acreage. Hepburn letters are in the Remington collection (✳517). Eva Remington as architect is in a letter to Shipman in Mannados (✳499).

The Hale review is in the Boston *Herald*, Jan. 9, 1909. Hale as critic is in the *Dictionary of American Biography* (✳265). Painters' earnings are from *The Bookman* (✳108). The letter from Hoeber is in the Remington collection. Reid's bankruptcy is Dec. 3, 1909. Homer data is from Wheelwright (✳1054).

Howard's doggerel is in the Remington collection. The Stony Lonesome letter to Shipman is in Yale University Library (✳515). The estate location is in the *Commercial Advertiser*, 1943, under Rockwell (✳876). Remington Village is from Emma Caten.

The Davenport letter is from the Remington Collection (✳514). Cousin Ella is in the Taft collection (✳515). The Wanamaker dinner is from the Amon Carter Museum (✳1028).

CHAPTER 37 THE SHADOW OF DEATH SEEMS NOT FAR
AWAY

Endion data is from the New Rochelle Public Library, Paula M. Zieselman (❋629). Ridgefield data is from *The History of Ridgefield* (❋875). The letter to Deming is from the Deming biography (❋257); also see Samuels' *Encyclopedia* (❋933). Events and opinions not otherwise attributed are from the 1909 Remington diary. Data on the cook, the wagons, and the barber are from Ridgefield letters in the Taft collection.

The lecture on ranching is in a letter to Mrs. Glentworth Butler in the Addison gallery (❋511). Letters to Remington are in the Remington collection unless otherwise ascribed. The letters from Davenport and Hoeber are so located, as are those from Hepburn.

Hassam data is in *Who's Who in America* (❋1064) and Samuels' *Encyclopedia*. His drinking, the buckboard ride, and the nickname are in Weir's biography (❋1044). Remington's reason for the big "Bronco Buster" is per Eva Remington in McCracken (❋561).

The *Scribner's* story is a letter from J. H. Chapin, the Cortissoz quote is from the *Scribner's* article (❋941). Washington University data is from Hassrick (❋382). The letter to Miles is in the New-York Historical Society (❋513). Auction data on the illustrations is from *American Art Annual* (❋13). The letters to Bertelli are in Hassrick. The reference to the mural is in McCracken (❋561).

The letter to Drew is in his autobiography (❋280). The letter to Follansbee is in the Remington collection (❋514). Details on the operation are in the Taft collection and were supplemented by Dr. Ben Daitz. Data on Dr. Abbe is from *Who's Who in America*. The weather report is from the New Rochelle *Paragraph* (❋832).

CHAPTER 38 BRICKED UP FROM THE BOTTOM

The review of the operation is from the New York *World* (❋837), New York *Times* (❋836), and Black (❋100). Data on the laxative is from Dr. William Troutman, University of New Mexico, School of Medicine. Bellows' funeral was Jan. 10, 1925, as reported in the New York *Times*. The Ogdensburg services are from the Watertown *Daily Times* (❋838) and the New Rochelle *Paragraph* (❋832).

Eva Remington's visit to Massachusetts is in a letter from Ella Remington in the Taft collection (❋510). "The Stampede" as the finest is from a curator of the Amon Carter Museum (❋25). The nomenclature of originality in statuettes is suggested by Wear (❋1039). The Frederic Remington Monument Fund is from the Taft collection, as is the Roosevelt speech. Data on the Big Cowboy statuette is in the Fairmount Park Art Association. The proposed sale of artifacts to the Smithsonian is in a letter to Miller (❋508). The letter from Buel is in the New York Public Library, along with the letters to him (❋508). The letter from Wister is in the Library of Congress (❋509). The quotation from the intelligentsia is in the *Times*.

Thomas' accomplishment on Remington Place is from his autobiography (⚹992). The poem is in Brininstool (⚹119). Henry Smith's 1911 presentation to the Metropolitan is in the Museum's catalog (⚹580).

Data on the Parish mansion is in *Historic Ogdensburg* (⚹699). Eva Remington's bequests are in the Taft collection. The letter from Hepburn is from the Remington Collection (⚹509). His snuggling is from the Hepburn biography (⚹386). Data on the Remington Art Museum is from its publications (⚹772–778). Data on the studio collection is from the Denver *Post* (⚹135). The reissuance of Remington bronzes is "The Remington Art Memorial Edition."

Selected Bibliography

This bibliography is the listing of the Remington materials that were used in the preparation of the biography. Tens of associations, societies, libraries, museums, galleries, and individuals photocopied their files for this project. The result was a mountain of paper, much of it undated or unplaced, which in time fit together like a mosaic. We do not have full bibliographic references for all of these bits of data and we have elected to place some of them below in the way we used them in writing the book, in order to make them easier to recall.

The items that were by Remington remain a la Remington, full of his misspellings and sometimes twisted grammar. As Remington said, Webster was a monopolist like Rockefeller. This biography retains Remington's free enterprise in English and Spanish, without employing the disruptive "sic" that would be overwhelming if it appeared three times a line.

1. Adams, Adeline. *The Spirit of American Sculpture*. New York: The National Sculpture Society, 1923, 1929. Text.
2. Adams, Ramon F. *Western Words/A Dictionary of the American West*. Norman: University of Oklahoma Press, 1968. Text.
3. Albany *Evening Journal*, Dec. 28, 1909. "Remington's Albany Days."

4. Albany *Times Union*, Apr. 30, 1943. E. S. Van Olinda, "Recalling Old Albany."
5. (Alden) "Henry Mills Alden's 70th Birthday." *Harper's Weekly*, Dec. 15, 1906, p. 1810.
6. "Aldine Club Dinner to Mark Twain." *Harper's Weekly*, Dec. 15, 1900, p. 1203.
7. Allen, Douglas. *Frederic Remington and the Spanish-American War.* New York: Crown Publishers, 1971. Text, illustration.
8. ——, compiled by. "Frederic Remington—Author and Illustrator/A List of His Contributions to American Periodicals," *Bulletin of the New York Public Library*, vol. 49, no. 12 (Dec. 1945), p. 895.
9. ——, ed. *Frederic Remington's Own Outdoors.* New York: The Dial Press, 1964. Text, illustration.
10. ——, and Douglas Allen, Jr. *N. C. Wyeth/The Collected Paintings, Illustrations and Murals.* New York: Crown Publishers, 1972. Text.
11. Alter, Judith. "Frederic Remington's Major Novel *John Ermine*," *Southwestern American Literature*, 2 (Spring 1972), pp. 42–46.
12. Altman, Violet and Seymour. *The Book of Buffalo Pottery.* New York: Bonanza Books, 1969. Text.
13. *American Art Annual*, vols. 1–8. New York: The Macmillan Co., vol. 1, 1898. Boston: Noyes, Platt & Co., vol. 3, 1904. New York: American Art Annual, vol. 4–8, 1903–10.
14. American Art Association/Anderson Galleries, Inc. (Auction) *Sale no. 4153*, Feb. 8, 1935; *sale no. 4243*, Mar. 19, 1936; *sale no. 4368*, Jan. 27, 1938. Text, illustration.
15. *American Art by American Artists/One Hundred Masterpieces.* New York: P. F. Collier & Son, 1914. Illustration.
16. American Art Galleries. *American Paintings and Sculpture, Fifth Prize Fund Exhibition.* New York, 1889. Text.
17. —— (American Art Association, Managers). *Catalogue of Paintings. . . .* Apr. 7, 1890. Text.
18. (——) "Frederic Remington's Exhibition of Paintings," *Harper's Weekly*, Jan. 7, 1893.
19. ——. *A Collection of Paintings, Drawings and Water-Colors by Frederic Remington ANA* to Be Sold by Auction on Friday evening Jan. 13, 1893.
20. (——) "Mr. Remington's Pictures/Something Less Than 100 Works Fetch Something More than $7,000." Newspaper clipping c. Jan. 14, 1893.
21. ——. *Catalogue of a Collection of Original Works* in Black and White/Water Color and Oil . . . To Be Sold at Public Sale without reserve on Tuesday evening Nov. 19, 1895.
22. American Art League. *Discussions on American Art and Artists.* Boston, c. 1895. Illustration.
23. (——). *American Art & Artists.* American Art Company, 1897.
24. *American Art Review.* Peter Hassrick, "Frederic Remington at the Amon Carter Museum," vol. I, no. 1 (Sept–Oct 1973), p. 41. Text, illustration.

25. ———. Peter Hassrick, "The American West Goes East," vol. II, no. 2 (Mar–Apr 1975). Illustration.

26. ———. Francis Martin, Jr., "Edward Windsor Kemble, A Master of Pen and Ink," vol. III, no. 1. (Jan–Feb 1976). Text.

27. American Guide Series. *Kansas/A Guide to the Sunflower State*. New York: The Viking Press, 1939. Text.

28. ———. *New Mexico/A Guide to the Colorful State*. New York: Hastings House, 1940, 1947. Text.

29. ———. Kent Ruth. *Oklahoma/A Guide to the Sooner State*. Norman: University of Oklahoma Press, 1941, 1957. Text.

30. American Museum of Natural History. *Frederic Remington/The American West*. Selected and edited by Philip R. St. Clair. Kent, Ohio: Volair Limited, 1978.

31. *The American Scene*. "Special Edition, Frederic Remington Exhibition," The Thomas Gilcrease Institute, vol. V, no. 2 (1961).

32. ———. "Titans of Western Art," vol. V, no. 4 (1964).

33. American Social Science Association (National Institute of Arts, Science and Letters). Appointment letter to Remington, July 1, 1898.

34. American Watercolor Society, exhibition catalog 1887, p. 26. Text, illustration.

35. ———, 1888, pp. 30, 44. Text, illustration.

36. (———) "Arrest of an Indian Murderer," *Harper's Weekly*, Feb. 4, 1888, p. 79. Text, illustration.

37. ———. *Illustrations of Pictures and Catalogue of the Twenty-Fourth Annual Exhibition*, New York. 1891. Text, illustration.

38. ———. *Illustrations of Pictures and Catalogue of the Twenty-Seventh Annual Exhibition/New York/1894*. Text.

39. ———. *Forty-Third Annual Exhibition of the American Water Color Society*. 1910. Text.

40. (———) Ralph Fabri. *The First Hundred Years*. 1969.

41. Amon Carter Museum of Western Art. *Catalogue of the Collection, 1972*. Fort Worth, 1973. Text, illustration.

42. ———. Peter Hassrick. *Frederic Remington*. Forth Worth, 1972. Text, illustration.

43. ———. *Inaugural Exhibition*. Forth Worth, 1961. Text, illustration.

44. ———. *Two Giants of the American West/Frederic Remington and Charles Marion Russell*. La Jolla Museum of Art Oct. 23–Nov. 20, 1966.

45. Anderson Auction Company, The. No. 685, May 20, 1908. *Original Drawings*.

46. Anderson Galleries, The. Sale No. 1739, Apr. 25, 1923, and *Scoville Sale*, Feb. 1925. Text, illustration.

47. Andrews, Robert Hardy. "Frederic Remington: The Man Who Invented John Wayne," *Mankind*, vol. II, no. 10 (Nov. 1970). Text, illustration.

48. ———. "The Pickfair Remingtons." *Ibid*.

49. (Anthropometrics) Bowles, Gordon Townsend. *New Types of Old Americans at Harvard*. Cambridge: Harvard University Press, 1932.

50. (——) Stewart, T. D. *The People of America*. New York: Charles Scribner's Sons, 1973.

51. Archives of American Art, Smithsonian Institution. *A Checklist of the Collection*. Spring 1975. Text.

52. Argonaut Book Shop. Catalogue 14. *An Extremely Important Collection of the Work of Frederic Remington*. . . . San Francisco, c. 1950.

53. (Army, U. S.). *Official Register*, Jan. 1890. Table of pay to officers.

54. (——) Cullom, George W. *Biographical Register of the Officers and Graduates of the U. S. Military Academy at West Point, N.Y.: 1802–1890*. Cambridge: Riverside Press, 1891.

55. (——) Heitman, Francis B. *Historical Register and Dictionary of the United States Army*. Washington: Government Printing Office, 1903.

56. (——) *Medal of Honor Recipients, 1863–1973*. Washington: Government Printing Office, 1973.

57. (——) Powell, William H. *List of Officers of the Army of the United States from 1779–1900*. New York: Hamersly and Co., 1900.

58. *The Art Index*. New York: The H. W. Wilson Co. Published yearly. List of illustrations.

59. The Art Institute of Chicago. *A Collection of Paintings in Water Color by American Artists*. 1910. Text.

60. *The Art Interchange*, Christmas 1897. Text, illustration.

61. The Art League Publishing Association. *The Artists Year Book 1905–1906*. Chicago, 1906. Text.

62. (Art Students League of New York) *The Story of the Art Students League of New York*. Marchal E. Landgren. New York: Robert M. McBride & Co., 1940. Background.

63. (——) Dr. John C. Van Dyke. *Harper's New Monthly Magazine*, Oct. 1891, p. 688.

64. (——) *Centennial 1875–1976*. New York, 1975. Text.

65. (atlas) *New Ideal State and County Survey and Atlas*. Chicago: Rand McNally & Co., 1909.

66. (——) *Lippincott's Gazetteer of the World*. Atlas Edition. Boston: George V. Jones, 1888.

67. *The Authors Club/An Historical Sketch*. Duffield Osborne. New York: The Knickerbocker Press, 1913. Background.

68. *The Autograph/A Bi-Monthly Magazine for Literary and Historical Collectors*. Vol. I, nos. 1–8 (1911).

69. Bacheller, Irving. *Best Things from American Literature*. New York: Christian Herald, 1899. Illustration.

70. Baigell, Matthew. *The Western Art of Frederic Remington*. New York: Ballantine Books, 1976. Text, illustration.

71. Bangs, Francis Hyde. *John Kendrick Bangs/Humorist of the Nineties*. New York: Alfred A. Knopf, 1941. Text.

72. Barnes, James. "Frederic Remington—Sculptor," *Collier's Weekly*, Mar. 18, 1905, p. 21. Text, illustration.

73. Baxter, Elizabeth. *Historic Ogdensburg.* Ogdensburg: Ryan Press, 1968. Text.

74. Baylor, Frances Courtenay. *Juan and Juanita.* Boston: Tichnor & Co., 1888. Illustration.

75. Beach, F. C. "Modern Amateur Photography," *Harper's New Monthly Magazine,* Jan. 1889, p. 288. Background.

76. Beard, Daniel. *Hardly a Man is Now Alive/The Autobiography of Dan Beard.* New York: Doubleday, Doran & Co., 1939. Text.

77. Bedini, Silvio A. *Ridgefield in Review.* Ridgefield: The Ridgefield 250th Anniversary Committee, 1958. Text.

78. Beer, Thomas. *The Mauve Decade/American Life at the End of the Nineteenth Century.* New York: Alfred A. Knopf, 1926. Text.

79. Bellows, George. *Memorial Exhibition. 1882–1925.* New York: The Metropolitan Museum of Art, 1925. Background.

80. (——) The New York *Times,* Jan. 6, 1925, p. 17. "G. W. Bellows Dies."

81. (——) The New York *Times,* Jan. 11, 1925, p. 5. "Artists at Bellows Bier."

82. Below, Ida Comstock. *Eugene Field in His Home.* New York: E. P. Dutton & Co., 1898. Background.

83. The Benedict (Kan.) *Courier,* Nov. 9, 1900. "News of Al Reid, Artist, from The Neodesha Register." Text.

84. *Bicentennial Inventory of American Paintings.* Paintings by Frederic Remington as of July 6, 1976. Washington: National Collection of Fine Arts. Listing.

85. Bigelow, John, Jr. *On the Bloody Trail of Geronimo.* Los Angeles: Westernlore Press, 1958, 1968. Text, illustration.

86. (Bigelow, Poultney) "Personal." *Harper's Weekly,* Oct. 3, 1891, p. 743. Text.

87. (——) "Personal." *Harper's Weekly,* July 2, 1892, p. 634. Text.

88. (——) E. S. Martin. "This Busy World," *Harper's Weekly,* Dec. 9, 1893, p. 1132. Text.

89. (——) St. Lawrence *Plaindealer,* July 19, 1893. Text.

90. ——. *The Borderland of Czar and Kaiser.* New York: Harper & Brothers, 1894. Text, illustration.

91. ——. "Frederic Remington: With Extracts from Unpublished Letters," *Quarterly Journal,* N. Y. State Historical Society, vol. 10, no. 1 (1929).

92. ——. *Prussian Memories 1864–1914.* New York: G. P. Putnam's Sons, 1915.

93. ——. "The Russian and His Jew." *Harper's Monthly,* Mar. 1894, p. 603.

94. ——. *Seventy Summers.* 2 vols. New York: Longmans, Green & Co., 1925. Autobiography.

95. ——. "Some Personal Notes from the German Grand Manoeuvres," *Harper's Weekly,* Oct. 19, 1895, p. 996.

96. ——. *White Man's Africa.* New York: Harper & Brothers, 1898. Illustration.

97. Bigelow, Mrs. Poultney. *While Charlie Was Away.* New York: D. Appleton & Co., 1901. Background.

98. Bishop, Joseph Bucklin. *Theodore Roosevelt and His Times/Shown in His Own Letters.* 2 vols. New York: Charles Scribner's Sons 1920. Text.

99. Blackburn, Henry. *The Art of Illustration.* London: W. H. Allen & Co., 1894. Text.

100. *Black's Medical Dictionary*, 31st ed. William A. R. Thomson, M.D. London: A & C Black, 1976.

101. *Blatter and Bluten.* Louis Lange. St. Louis: 1907, in German. Illustration.

102. (Body Language) Fast, Julius. *Body Language.* New York: Pocket Books, 1971.

103. Bollinger, James W. *Old Montana and Her Cowboy Artist.* n/p 1963, pp. 20–22, "Two Remingtons Ruined." Text.

104. Bolton, Theodore. *American Book Illustrators.* New York: R. R. Bowker, 1938. Text.

105. Boniface, Capt. Jno. J., 4th Cavalry. *The Cavalry Horse and His Pack.* Kansas City: Franklin Hudson Publishing Co., 1903. Illustration.

106. Bonsal, Stephen. *The Fight for Santiago.* New York: Doubleday & McClure Co., 1899. Text.

107. *Book Buyer.* New Series XI 1894–95 pp. 437–440. PGH (Hamerton) Jr. Biog. New York: Charles Scribner's Sons, 1894.

108. *The Bookman/*An Illustrated Magazine of Literature and Life. Vol. XXX (Sept. 1909–Feb. 1910). Text, photo.

109. (Borglum, Solon) "Mr. Borglum's Broncos and Bronco-Busters," *Harper's Weekly,* May 16, 1903, p. 790. Text.

110. Boston Art Club. *Forty-First Exhibition, Oil Paintings/1890.* Text.

111. ——. *Forty-Third Exhibition, Oil Paintings/1891.* Text.

112. Boston *Evening Transcript,* Dec. 8, 1897. "The Fine Arts/Paintings and Drawings by Frederic Remington." Hart & Watson exhibition.

113. ——, Jan. 8, 1909. "The Fine Arts. Doll & Richards—Mr. Remington's Paintings." Text.

114. Boston *Herald,* Jan. 9, 1909. Philip L. Hale, "Art. Mr. Frederic Remington exhibits. . . ." Text.

115. (Bradley) *Will Bradley/His Graphic Art.* Clarence P. Hornung, ed. New York: Dover Publications, 1974. Text on *Collier's.*

116. Brady, Buckskin. *Stories and Sermons.* Toronto: Briggs, 1905. Illustration.

117. Brady, Cyrus Townsend. *Indian Fights and Fighters.* Garden City: Doubleday, Page & Co., 1904, 1913. Illustration.

118. Brandywine River Museum. *The Art of American Illustration.* Chadd's Ford, Pa, 1976. Biography.

119. Brininstool, E. A. *Trail Dust of a Maverick.* New York: Dodd, Mead and Co., 1914, p. 95. Poem.

120. (Brisbane) Carlson, Oliver. *Brisbane/A Candid Biography*. New York: Stackpole Sons, 1937. Text.

121. ———. Agreement Feb. 19, 1897, with Remington for *The World*.

122. Broder, Patricia Janis. *Bronzes of the American West*. New York: Harry N. Abrams, 1974. Text and illustration.

123. Brooklyn *Daily Times*, clipping marked June 1887. Remington in Canada.

124. Brooklyn Museum, The. *A Century of American Illustration*. 1972. Illustration.

125. Brooks, Elbridge S. *The Century Book for Young Americans*. New York: The Century Co., 1894. Illustration.

126. Brown, Charles H. *The Correspondents' War*. New York: Charles Scribner's Sons, 1967. Text, illustration.

127. Brown, Myra L. "Kansas and the Art of Frederic Remington." Unpub. Kansas State Historical Society (KSHS).

128. Brown, Myra Lockwood, and Robert Taft. "Painter of the Rip-Roaring West," *Country Gentleman*, vol. 117, no. 9 (Sept. 1947), p. 16. Biography and illustration.

129. ———. "Frederic Remington, Kansas Rancher." Unpub. KSHS.

130. ———. "Remington Found Kansas." c. Feb. 11, 1945. Unpub. KSHS.

131. ———. "Genius Wasn't Enough." c. 1952. Unpub. KSHS.

132. (Brush) Bowditch, Nancy Douglas. *Recollections of a Joyous Painter*. Peterborough, N.H.: Noone House, 1970. Background.

133. Buffalo Bill Historical Center, Whitney Gallery of Western Art. *The Frederic Remington Studio Collection*. Cody, Wyo., 1959. Text.

134. ———. Col. William F. "Buffalo Bill" Cody. c. 1976. Museum pamphlet. Illustration.

135. (———) Denver *Post*, Nov. 14, 1957. "Buffalo Bill Museum at Cody to Get Famed Remington Art."

136. (———) *Ibid.*, April 25, 1959. "Western Art in New Home at Cody."

137. Burbank, E. A., as told by Ernest Royce. *Burbank among the Indians*. Caldwell, Ida.: The Caxton Printers, Ltd., 1944, 1946. Text.

138. Burdick, Joel W. Agreement July 27, 1895 with Remington on patent.

139. Burke, John M. *Buffalo Bill's Wild West*. New York: Cody and Salsbury, 1895, 1900, 1901. Text.

140. Burgess, Gelett, and Oliver Herford. *Enfant Terrible*, no. 1 (April 1, 1898). Advertisement.

141. Burnside, Wesley M. *Maynard Dixon/Artist of the West*. Provo, Utah: Brigham Young University Press, 1974. Text.

142. Butler County *News*, Sept. 5, 1963. Corah Mooney Bullock, "This Story of Frederic Remington." Text.

143. Caffin, Charles H. "Frederic Remington's Statuettes: 'The Wicked Pony' and 'The Triumph,' " *Harper's Weekly*, Dec. 17, 1898, p. 1222.

144. ———. "Annual Exhibition of the National Academy," *Harper's Weekly*, Jan. 13, 1900, p. 31. Schreyvogel's prize.

145. (calendar) Winchester Arms Co., 1892, 1893, 1894. Illustration.

146. (———) R. H. Russell, 1899. Three styles. Illustration.

147. Calkins, Frank W. *Hunting Stories.* Chicago: Donohue, Henneberry & Co., 1893. Illustration.

148. ———. *Indian Tales.* Chicago: Donohue, Henneberry & Co., 1893. Illustration.

149. ———. *Boy's Life on the Frontier.* Chicago: Donohue, Henneberry & Co., 1893. Illustration.

150. ———. *Old Stumpy or, Indian Tales of the West.* Chicago: Donohue & Co., n/d. Illustration.

151. Camp, Walter. *Football Facts and Figures.* New York: Harper & Brothers, 1894. Remington letter.

152. Canby, Henry Seidel. *The Age of Confidence.* New York: Farrar & Rinehart, 1934. Background.

153. Canton *Commercial Advertiser*, c. 1886–87. Remington fell in mud.

154. ———, c. Feb. 9, 1937. "Looking Through a Main Street Window." Remington stories, 1886–87.

155. ———, May 18, 1943. "Looking Through a Main Street Window." Remington in school.

156. Caproni, P. P., and Brothers. *Catalogue of Plaster Reproductions from Antique. . . .* Boston 1911, 1913. Background.

157. Card, Helen L. *Catalog No. Three.* New York: Helen Card, spring 1960. Printing plates from *Harper's.* Illustration.

158. ———. *Catalog No. Four. To the True American Spirit.* New York: Helen Card, n/d. Text.

159. ———. *Catalog No. Five. Hang On, Fellers! We're Out on a Limb.* New York: Helen Card, n/d. Text, illustration.

160. ———. *A Collector's Remington.* Woonsocket, R.I.: Helen Card, 1946. Bibliography.

161. ———. *The Collector's Remington/A Series. The Story of His Bronzes.* Woonsocket, R.I., 1946. Text.

162. ———. "Frederic Remington's Bronzes," *American Scene*, vol. V, no. 4 (1964), p. 48. 22 bronze copyrights.

163. Card, Teri, compiled by. *Frederic Remington's Life Story.* c. Nov. 1968. Unpub. The Amon Carter Museum of Western Art.

164. Carmer, Carl, ed. *Cavalcade of America.* New York: Crown Publishers, 1956. Biography and illustration.

165. (Carr) King, James T. *War Eagle/A Life of General Eugene A. Carr.* Lincoln: University of Nebraska Press, 1963. Text.

166. Carroll, John M., ed. *The Black Military Experience in the American West.* New York: Liveright, 1971. Text.

167. Carter, M. H., ed. *Panther Stories Retold from St. Nicholas.* New York: The Century Co., 1904. Illustration.

168. Carter, W. H. *From Yorktown to Santiago with the Sixth U. S. Cavalry.* Baltimore: Lord Baltimore Press, 1900. Text, illustration.

169. ———. *Old Army Sketches.* Baltimore: Lord Baltimore Press, 1906. Illustration.

170. ———. *The Life of Lieutenant General Chaffee.* Chicago: The University of Chicago Press, 1917. Background.

171. Carthage *Evening Press*, c. 1904. Clipping, Mrs. Nellie Hough's Remington sketches.

172. Casey, E. W. Contents of War Department personnel file.

173. Cashin, Herschel V. *Under Fire with the 10th Cavalry*. New York: Bellwether Publishing Co., 1970. Text.

174. Caten, W. L. Quote on Remington from Nov. 19, 1933, Chicago *Tribune*.

175. *The Cavalry Journal*. Vol. XLVI, no. 1 (Jan.–Feb. 1937). Illustration.

176. *The Century Gallery—Selected Proofs*. New York: The Century Co., 1893. Illustration.

177. *The Century Illustrated Monthly Magazine*. Vol. 35 (Nov. 1887–Apr. 1888). Illustration. Also vols. 36–39, 41–44, 46, 52, 53, 56, 59, 61, 63, 67.

178. Chase, Joseph Cummings. *The Romance of an Art Career*. New York: J. H. Sears & Co., 1928. Text.

179. Chicago *Evening Post*, Oct. 6, 1903. "Music and the Drama." Review of *John Ermine*.

180. Chicago or New York *Times*, June 24, 1900. Clipping, the Remington typewriter.

181. Chicago *Times*, Sept. 2, 1900. "The 'Arizona' Cowboy/Frederic Remington Objects to His Dress and It Is Changed."

182. Chicago *Sunday Tribune*, Nov. 12, 1933, part 8, p. 4. James O'Donnell Bennett, "Paintings by Remington in Color Today." Text, illustration.

183. Chicago *Tribune*, June 13, 1897. Part 7, p. 1. Illustration.

184. Child, Theodore. *The Spanish-American Republics*. New York: Harper & Brothers, 1891. Illustration.

185. Cincinnati Museum. *American Illustrators Exhibition*, 1910.

186. Cisneros, Evangelina. *The Story of Evangelina Cisneros Told by Herself*. New York: Continental Publishing Co., 1898. Illustration.

187. (——) Martin, E. S. "This Busy World," *Harper's Weekly*, Sept. 18, 1897, p. 923. A Cuban story.

188. (——) *Ibid.*, Oct. 23, 1897, p. 1051. Cisneros' escape.

189. Clark, Eliot. *History of the National Academy of Design 1825–1953*. New York: Columbia University Press, 1954.

190. Clarke, Lt. Powhatan H. Contents of War Department personnel file.

191. (Clarke) Clark, Lt. Pohattan H. "The Military Riding-School of Germany," *Harper's Weekly*, Nov. 14, 1891. Illustration.

192. Clarke, Powhatan H. "Characteristic Sketches of the German Army," *Harper's Weekly*, May 30, 1893, p. 479. Illustration.

193. Clarke, Powhatan H. "Professional Notes. Remarks on the German Cavalry," *Journal of the United States Cavalry Association*, vol. V (1892).

194. (Clarke) "Waifs and Strays," *Harper's Weekly*, June 19, 1886, p. 395. The rescue of Corporal Scott.

195. Clarke, Powhatan H. Letter May 7, 1893, to the New York *Herald*: "Reforms Needed in the U. S. Army."

196. Clarke, Mrs. P. H. Clipping from (?) *Journal* Aug. 27, 1927. Obituary.

197. Clausen's Gallery. *Paintings/Pastels and Drawings by Frederic Remington*. New York, 1901.

198. (——) Review in New York *Commercial Advertiser*, Dec. 10, 1901.

199. Cobb, Irvin S. "Art," *The Saturday Evening Post*, Aug. 10, 1912, pp. 14–15.

200. Cody, W. F. *Story of the Wild West and Camp-Fire Chats by Buffalo Bill*. Philadelphia: Historical Publishing Co., 1888. Illustration.

201. Coffin, William A. "American Illustration of To-Day," *Scribner's Magazine*, vol. XI, no. 3 (March 1892), p. 333. Text.

202. Coke, Van Deren. *The Painter and the Photograph*. Albuquerque: University of New Mexico Press, 1972. Muybridge data.

203. (Collier) *A Dinner on the Occasion of the Tenth Anniversary of Collier's under the Guidance of Mr. Robert J. Collier*. New York: P. F. Collier & Sons, 1908.

204. Collier, P. F., & Son. *Thirty Favorite Paintings by Leading American Artists*. New York: 1908. Color illustration.

205. (Collier's Artist Proofs) *A Catalogue of Collier's Artist Proofs*. New York: P. F. Collier & Son, 1905.

206. *Collier's Catalog of Prints 1907*. New York: P. F. Collier & Son. Text, photo, illustration.

207. *Collier's Weekly*, vol. 20, 1897–98. Text, illustration. Also vols. 22–29, 31–48, 50, 52.

208. ——, "Remington Number," vol. 34, no. 25 (Mar. 18, 1905).

209. ——, "A Letter to the Editor," vol. 38, no. 17 (Mar. 23, 1907).

210. ——, "Remington's Beginning," Oct. 22, 1910, p. 10.

211. Connelley, William Elsey. *Doniphan's Expedition and the Conquest of New Mexico and California*. Kansas City: Bryant & Douglas, 1907. Illustration.

212. The Corcoran Gallery of Art. *Catalogue of Casts, Marbles/Bronzes. . . .* Washington, 1910. Text.

213. ——. *American Processional/1492–1900*. Washington: The National Capital Sesquicentennial Commission, 1950. Illustration.

214. "Cornell's 25th Birthday." *Harper's Weekly*, Sept. 30, 1893, p. 952.

215. (Cornish) Colby, Virginia Reed. "Stephen and Maxfield Parrish in New Hampshire," *The Magazine Antiques*, June 1979, p. 1290. Background.

216. Cortissoz, Royal. "At the Academy of Design," *Harper's Weekly*, April 6, 1895, p. 318. Text.

217. ——. *Annual of the Society of Illustrators*. New York: Charles Scribner's Sons, 1911.

218. ——. *American Artists*. New York: Charles Scribner's Sons, 1923.

219. *The Cosmopolitan/A Monthly Illustrated Magazine*, vol. 11 (May–Oct. 1891). Illustration. Also vols. 12, 13, 16–19, 21, 22, 24, 30, 33.

220. ——, vol. 40 (Nov. 1905–April 1906). "The Way of an Indian."

221. "Coursing Jack-Rabbits at Great Bend, Kansas," *Harper's Weekly*, Dec. 18, 1886, p. 825.

222. (Coursing) "A Jack-Rabbit Drive in Southern California," *Harper's Weekly*, Oct. 27, 1888, p. 812.

223. (——) "Jack-Rabbit Coursing—A Growing Western Sport," *Harper's Weekly*, Feb. 23, 1895, p. 189.

224. Craly, Herbert. "Frederic Remington as an Author," *The Reader*, vol. 1 (Jan. 1903), p. 230. *John Ermine* review.

225. Crawford, Albert Beecher, ed. *Football Y Men/1872–1919*. New Haven: Yale University Press, 1962. Biography.

226. Crawford, Alta M., and Gordon R. Schultz. "Frederic Remington: Artist of the People," *Kansas Quarterly*, vol. IX (Fall 1977), p. 88.

227. Creelman, James. *On the Great Highway*. Boston: Lathrop Publishing Co., 1901. Text.

228. Crooker, Orin Edson. "A Page from the Boyhood of Frederic Remington," *Collier's Weekly*, Sept. 17, 1910, p. 28.

229. *Current Literature*, vol. 43, no. 5 (Nov. 1907), p. 521. "Frederic Remington—A Painter of the Vanishing West."

230. Curry, Larry. *The American West*. New York: The Viking Press, 1972. Text, illustration.

231. Custer, Elizabeth B. *Following the Guidon*. New York: Harper & Brothers, 1890. Illustration.

232. ——. *Tenting on the Plains*. New York: Charles L. Webster & Co., 1887, 1893. Illustration.

233. (Custer) *Cyclorama of Custer's Last Battle*. Compiled and edited by A. J. Donnelle. Reprinted New York: Promontory Press, 1966. Custer's garb.

234. (——) *Wild Life on the Plains and Horrors of Indian Warfare*. St. Louis: Royal Publishing Co., 1891. Illustration.

235. *The Daily Advertiser*, Trinidad, Colo., July 13, 1888, p. 3. "His Last Sketch."

236. ——, July 14, 1888, p. 3. "The Frederic Remington."

237. ——, July 18, 1888. "Fred Remington/Conclusive Evidence."

238. ——, July 20, 1888, p. 3. "The True Sketch."

239. Dallas Museum of Fine Arts. *The Centennial Exposition*. 1936.

240. Dary, David. "Frederic Remington in Kansas," *Westerners, Kansas Corral*, vol. 1 (1973), p. 79–84. Biography.

241. (David's Island, N.Y.) "The Recruit and His Training at David's Island, N.Y.," E. W. Kemble, *Harper's Weekly*, June 28, 1890, p. 511. Background.

242. Davis, Charles Belmont. "Remington—the Man and His Work," *Collier's Weekly*, Mar. 18, 1905, p. 15.

243. ——. *Adventures and Letters of Richard Harding Davis*. New York: Charles Scribner's Sons, 1917. Text.

244. Davis, Richard Harding. *Cuba in War Time*. New York: R. H. Russell, 1899. Text, illustration.

245. ——. *The Cuban and Porto Rican Campaigns*. New York: Charles Scribner's Sons, 1898. Text, photo.

246. ——. "A Day with the Yale Team," *Harper's Weekly*, Nov. 18, 1893, p. 1110. Text, illustration.

247. ——. *In the Fog*. New York: Grosset & Dunlap, 1903. Illustration.

248. ——. *Notes of a War Correspondent*. New York: Charles Scribner's Sons, 1910. Text.

249. ——. *Ranson's Folly*. New York: Charles Scribner's Sons, 1902. Illustration.

250. ——. *Soldiers of Fortune*. New York: Charles Scribner's Sons, 1897. Background.

251. ——. *The West from a Car-Window*. New York: Harper & Brothers, 1892. Text, illustration.

252. ——. *A Year from a Reporter's Note-Book*. New York: Harper & Brothers, 1897. Illustration.

253. (——) Quinby, Henry Cole. *Richard Harding Davis/A Bibliography*. New York: E. P. Dutton & Co., 1924. Text.

254. Dawes, Anna Laurens. "An Unknown Nation," *Harper's Magazine*, vol. LXXVI (March 1888), p. 598. Indian Territory.

255. de Kay, Charles. "A Painter of the West/Frederic Remington and His Work," *Harper's Weekly*, Jan. 1910, p. 14. Text and photo.

256. de Kay, Charles, ed. Mary Innes, *School of Painting*. New York: G. P. Putnam's Sons, 1911. Text.

257. Deming, Therese O. *Edwin Willard Deming*. New York: private printing, 1925. Text.

258. (Deming) Lamb, Thomas G. *Eight Bears*. Oklahoma City: Griffin Books, 1978. Text.

259. (Denver) "The city of Denver." Roberta Edwards, *Harper's Magazine*, vol. LXXVI (May 1888), p. 344. Background.

260. Denver Art Museum. Patricia Trenton. *Colorado Collects Historic Western Art*. 1973. Illustration.

261. (Denver?) *Republican*, c. 1889. Clipping, "A Study of the Horse/A Talk with Frederic Remington." Text, illustration.

262. Denver *Republican*, Oct. 21, 1900, p. 13. "Frederic Remington Here To Study the Blanket Indians of Colorado."

263. ——, Jan. 3, 1901. "A Famous Indian Model Who Poses for Remington."

264. ——, Jan. 11, 1905. "Latest Picture of Frederic Remington."

265. *Dictionary of American Biography*. New York: Charles Scribner's Sons, 1937. Text.

266. Dimitry, John. *Indian Stories Retold from St. Nicholas*. New York: The Century Co., 1905. Illustration.

267. Dippie, Brian W. "Frederic Remington's Wild West," *American Heritage*, April 1975, p. 7. Biography.

268. ——, introduction. *Frederic Remington (1861–1909) . . . in the Collection of The R. W. Norton Art Gallery*. Shreveport, 1979.

269. Dobie, J. Frank. "A Summary Introduction to Frederic Remington," in *Pony Tracks*. Norman: University of Oklahoma Press, 1961. Text.

270. ——. "Titans of Western Art," *American Scene*, vol. V, no. 4 (1964), p. 4. Biography.

271. ——. "Frederic Remington," *True West*, Oct. 1975, p. 12.

272. Dodd, Loring H. *Golden Age of American Sculpture*. Boston: Chapman, 1936. Text.

273. Dodge, Theodore Ayrault. *Riders of Many Lands*. New York: Harper & Brothers, 1893. Illustration.

274. Doll & Richards. *Exhibition of Paintings by Frederic Remington*. Boston, 1909. Text, illustration.

275. (Dow) Moffat, Frederic C. *Arthur Wesley Dow (1857–1922)*. Washington: Smithsonian Institution Press, 1977. Background.

276. Downey, Fairfax. *Indian-Fighting Army*. New York: Charles Scribner's Sons, 1941. Text, illustration.

277. ——. *Portrait of an Era/as drawn by C. D. Gibson*. New York: Charles Scribner's Sons, 1936. Text.

278. ——. *Richard Harding Davis/His Day*. New York: Charles Scribner's Sons, 1933. Text.

279. ——, and Jacques Noel Jacobsen, Jr. *The Red Bluecoats*. Fort Collins, Colo.: The Old Army Press, 1973. Text.

280. Drew, John. *My Years on the Stage*. New York: E. P. Dutton & Co., 1922. Text.

281. Durant, Samuel W., and Henry B. Peirce. *History of St. Lawrence County, New York*. Philadelphia: L. H. Everts & Co., 1878. Text.

282. Dwight, Timothy. *Memories of Yale Life and Men 1845–1899*. New York: Dodd, Mead and Co., 1903. Art school.

283. Dykes, Jeff C. "Frederic Remington—Western Historian," *The American Scene*, vol. IV, no. 2 (Summer 1961), p. 4. Biography.

284. ——. *Fifty Great Western Illustrators*. Flagstaff: Northland Press, 1975. Bibliography.

285. ——. *Western High Spots*. Flagstaff: Northland Press, 1977. Books.

286. Eastman Kodak advertisement. *The Four-Track News*, June 1904. Illustration.

287. "The East Side Art Exhibition," *Harper's Weekly*, July 16, 1902, p. 675. Text.

288. (Economics) Bureau of Applied Economics, Inc. *Standard of Living*, Bulletin no. 7. Washington, 1920.

289. (——) Bureau of Railway Economics. *A Comparative Study of Railway Wages and the Cost of Living*, Bulletin no. 34. Washington, 1912.

290. (——) Douglas, Paul H. *Real Wages in the United States 1890–1926*. Boston: Houghton Mifflin Co., 1930, p. 41 (table 9 in index).

291. Edgerton, Giles. "Frederic Remington, Painter and Sculptor: A Pioneer," *The Craftsman*, vol. 15, no. 6 (Mar. 1909), p. 658. Biography.

292. Edwards, William H. *Football Days*. New York: Moffat, Yard and Co., 1916. Text.

293. Eggleston, Edward. *A History of the United States and Its People*. New York: American Book Co., 1888. Illustration.

294. ——. *The Household History of the United States and Its People*. New York: D. Appleton & Co., 1901. Illustration.

295. El Dorado *Republican*, May 16, 1890. "Remington in Plum Grove."

296. El Dorado *Times*, Nov. 24, 1943. "Coppins Knew Remington."

297. Ellis, Edward S. *The Indian Wars of the United States*. Grand Rapids: P. D. Farrell & Co., 1892. Text.

298. Ellsworth, William Webster. *A Golden Age of Authors*. Boston: Houghton Mifflin Co., 1919. Text.

299. El Paso newspaper, April 13, 1907. Clipping unidentified, "Noted Artist Here." Cloudcroft.

300. Emerson, Edwin, Jr. *A History of the Nineteenth Century Year by Year*. 3 vols. New York: P. F. Collier & Son, 1900. Illustration.

301. Emporia *Gazette*, April 22, 1960. "Remington in Kansas."

302. Emporia *Weekly Gazette*, Nov. 4, 1897. William Allen White on Remington.

303. Erisman, Fred. *Frederic Remington*. Boise: Boise State University, 1975. Text.

304. Erlanson, Charles B. *General Miles*. Privately printed, 1969. Background.

305. Evans, Robley D. *A Sailor's Log*. New York: D. Appleton and Co., 1901. The *Iowa*.

306. *Everybody's*. List of illustrations 1901–1905.

307. Ewen, David. *The Life and Death of Tin Pan Alley*. New York: Funk & Wagnalls Co., 1964. Spaulding.

308. Ewers, John C. *Artists of the Old West*. Garden City: Doubleday & Co., 1965, enlarged edition, 1973. Text, illustration.

309. Exman, Eugene. *The Brothers Harper*. New York: Harper & Row, 1965. Background.

310. ——. *The House of Harper*. New York: Harper & Row, 1967. Text, illustration.

311. Fairbanks, Charles Mason. "The Wounded Bunkie," *Harper's Weekly*, Nov. 28, 1896, p. 1177. Illlstration.

312. Fairmount Park Art Association (FPAA). *50th Anniversary 1871–1921*. Philadelphia, 1922. Text, illustration.

313. (——) Honey Brook (Pa.) *Herald*, Feb. 27, 1958.

314. ——. *Sculpture of a City*. New York: Walker Publishing Co., 1974. Text, illustration.

315. (——) Resolution May 5, 1905 by Charles J. Cohen that Miller secure a sketch model from Remington for $500, and other letters, resolutions, agreements, and memoranda to December 29, 1909. FPAA files.

316. (——) FPAA 37th Annual Report on history of the statue.

317. Farmer, G. Robert. "A Remington Portfolio," Watertown *Daily Times*, Dec. 14, 1970. See also Dec. 15–19, 26, 1970.

318. (Field, Eugene) *Field Flowers*. Chicago: A. L. Swift & Co., 1896. Illustration.

319. Fifth Avenue Book Company, New York. *Exhibition and Sale of Paintings and Drawings by Frederick Remington*. No date. Illustration.

320. First United States Cavalry, Officer's Club. Minutes of meeting Sept. 11, 1894, in Fort Grant, Arizona. Gift of painting.

321. Fiske, Horace Spencer. *Provincial Types in American Fiction.* New York: The Chautauqua Press, 1903. Text.

322. Fitzgerald, James. *Proceedings at the 121st Anniversary Dinner of the Society of the Friendly Sons of St. Patrick.* New York: Dempsey & Carroll, 1905. Illustration.

323. Flexner, James Thomas. *Nineteenth Century American Painting.* New York: G. P. Putnam's Sons, 1970. Text, illustration.

324. ———. *That Wilder Image.* Boston: Little, Brown and Co., 1962. Text.

325. (Foord, John) "Personal." *Harper's Weekly,* April 18, 1885, p. 243. Reference as editor, Brooklyn *Union.*

326. (Forest, Fish and Game Commission) *Eighth Report of the Forest, Fish and Game Commission.* Year ending Sept. 30, 1902. Albany, N.Y., Jan. 30, 1903. Background.

327. (Forgeries) Goodrich, David L. *Art Fakes in America.* New York: The Viking Press, 1973. Text.

328. Fowler, Albert, ed. *Cranberry Lake from Wilderness to Adirondack Park.* Syracuse: The Adirondack Museum, 1968. Text.

329. ———. *Cranberry Lake 1845–1959.* Blue Mountain Lake, N.Y.: Adirondack Museum, 1959. Text.

330. Freeman, James W. *Prose and Poetry of the Livestock Industry.* Denver: National Livestock Historical Association 1959, reprint of 1905.

331. French, Dr. L. H. *Desertion of Sgt. Cobb.* New York: Knickerbocker, 1901. Illustration.

332. Froissart, Sir John. *Chronicles of England, France, Spain and the Adjoining Countries.* 2 vols. New York: P. F. Collier & Sons, 1901.

333. Frothingham, Washington. *History of Fulton County.* D. Mason & Co., 1892. Caten family.

334. Fry, Jason B. *Indian Fights, 1887.* New York: D. Van Nostrand, 1887. Illustration.

335. Gard, Wayne. *The Great Buffalo Hunt.* New York: Alfred A. Knopf, 1960. Background, illustration.

336. Gardner, Albert TenEyck. *American Sculpture/A Catalogue of the Collection.* New York: The Metropolitan Museum of Art, 1965. Text, illustration.

337. Garland, Hamlin. *The Book of the American Indian.* New York: Harper & Brothers, 1923. Illustration.

338. ———. *The Captain of the Gray-Horse Troop.* New York: Grosset & Dunlap, 1902. Background.

339. ———. *Crumbling Idols.* Cambridge: The Belknap Press, 1960 reprint. Text.

340. ———. *My Friendly Contemporaries.* New York: The Macmillan Co., 1932. Text.

341. ———. *Roadside Meetings.* New York: The Macmillan Co., 1930. Text.

342. (———) Pizer, Donald, ed. *Hamlin Garland's Diaries.* San Marino, Cal.: The Huntington Library, 1968. Text.

343. Garraty, John A. *The American Nation*. New York: Harper & Row, 1966. Text.

344. Garwood, Darrell. *Crossroads of America*. New York: W. W. Norton & Co., 1948. Kansas City.

345. Genthe, Arnold. *As I Remember*. New York: Reynal & Hitchcock, 1936. Text.

346. (Geronimo) Clum, John P. "Geronimo," *New Mexico Historical Review*, vol. III. no. 3 (July 1928), p. 217. Background.

347. Gilcrease Foundation, Thomas. *An Exhibition of Paintings and Bronzes by Frederic Remington/Charles M. Russell/May to October 1950*. Edward Everett Dale, "Frederic Remington."

348. Gilcrease Institute. "Data on the Bronzes," *The American Scene*, vol. IV, no. 2 (Summer 1961), p. 35.

349. ——. "The Paintings of the Collection," *The American Scene*, vol. IV, no. 2 (Summer 1961), p. 6. Illustration.

350. Gloversville *Intelligencer*, Oct. 2, 1884. "The marriage of Mr. Frederic Remington of Kansas City."

351. Godfrey, Edward S. *General George A. Custer and the Battle of Little Big Horn*. New York: The Century Co., 1908. Background.

352. (Gollings) *Annals of Wyoming*, vol. 9, no. 2 (Oct. 1932). Reference.

353. *Gorham Proudly Announces Collector's Plates of Frederic Remington*. No date. Advertising pamphlet. Text, illustration.

354. Gould, A. C., ed. *Sport, or Shooting and Fishing*. Boston: Bradless, Whidden Publishing Co., 1889. Two color plates.

355. Greard, Vallery C. O. *Meissonier/His Life and His Art*. New York: A. C. Armstrong and Son, 1897. Background.

356. Gregg, Richard N. "The Art of Frederic Remington," *The American Connoisseur*, vol. 165, no. 666 (Aug. 1967), p. 269. Biography.

357. Gregory, John G. *History of Milwaukee*. Vol. IV. Chicago: The S. J. Clarke Publishing Co., 1931. Robert Camp.

358. *The Gridiron*, published by Beta Zeta chapter of Beta Theta Pi Fraternity, St. Lawrence University, 1882. Illustration.

359. Griffin, Solomon Bulkley. *Mexico of Today*. New York: Harper & Brothers, 1886. Illustration.

360. *Guide through North and Central America/*with the Compliments of the North-German Lloyd Bremen. Berlin: J. Reichmann & Cantor, 1898. Background.

361. (Guide) *Campbell's New Revised Complete Guide and Descriptive Book of Mexico*. Mexico City: Sonora News Co., 1899.

362. Gunnison, Almon. *Wayside and Fireside Rambles*. Boston: Universalist Publishing House, 1894. Illustration.

363. Hans, Fred M. *The Great Sioux Nation*. Chicago: M. A. Donohue and Co., 1907. Illustration.

364. Harper, J. Henry. *The House of Harper*. New York: Harper & Brothers, 1912. Text.

365. (Harper) *The Armies of To-Day*. New York: Harper & Brothers, 1893. Illustration.

366. *Harper's Bazar.* 1887, 1893, 1899. Illustration.

367. *Harper's Encyclopedia of United States History.* 10 vols. New York, 1901. Illustration.

368. *Harper's Magazine.* Centennial Issue 1850–1950. Cover illustration.

369. *Harper's New Monthly Magazine,* vol. 79 (June–Nov. 1889). Illustration. Also vols. 81–84, 86–100, 102, 103, 106.

370. *Harper's Round Table.* 1896–99. Illustration.

371. *Harper's Weekly,* vol. 26 (1882). Illustration. Also vols. 29–42, 44, 45, 48.

372. *Harper's Young People,* 1887 and 1894. Illustration.

373. Harper & Brothers. Agreement Jan. 14, 1895, with Remington on *Pony Tracks.*

374. ——. Agreement March 28, 1898, with Remington on *Sundown Leflare.*

375. Harries, George H., in *Washington Evening Star* Jan. 17, 1891, on Remington's scare.

376. ——. *Washington Evening Star,* Jan. 24, 1891. "How Remington Was Discouraged."

377. Hart & Watson. *Paintings and Drawings by Mr. Frederic Remington,* on exhibition, Boston, 1897.

378. (Harte) *The Writings of Bret Harte.* 21 vols. Boston: Houghton Mifflin Co., 1896. Illustration.

379. (Hassam) Hirschl & Adler Galleries, Inc. *Childe Hassam/1859–1935.* Exhibition, 1964. Background.

380. (——) Pousetee-Dart, Nathaniel. *Childe Hassam.* New York: Frederick A. Stokes Co., 1922. Background.

381. Hassrick, Peter H. *Frederic Remington/An essay and catalogue.* Fort Worth: Amon Carter Museum, 1973. Biography.

382. ——. *Frederic Remington/Paintings, Drawings, and Sculpture in The Amon Carter Museum and the Sid W. Richardson Foundation Collection.* New York: Harry N. Abrams, 1973. Biography and illustration.

383. ——. "Remington in the West," *Arts in Virginia,* vol. 17, no. 2 (Winter 1977), p. 19. Biography.

384. ——. *The Way West.* New York: Harry N. Abrams, 1977. Text, illustration.

385. Hawthorne, Julian. *The History of the United States from 1492 to 1910.* 3 vols. New York: P. F. Collier & Son, 1910. Illustration.

386. (Hepburn) Bishop, Joseph Bucklin. *A. Barton Hepburn/His Life.* New York: Charles Scribner's Sons, 1923. Text.

387. Herron Art Institute, John. *Catalogue of the Collier Collection.* Indianapolis, 1907. Includes "Frederick" Remington.

388. Highland Military Academy *Catalogue* for 1882–83.

389. Hill, Dean. *Football Thru the Years.* New York: Gridiron Publishing Co., 1940. Text, illustration.

390. Hill, J. L. *The End of the Cattle Trail.* Long Beach, Cal.: George W. Moyle Publishing Co., c. 1922. Text.

391. Hitchcock, Ripley, ed. *Decisive Battles of America.* New York: Harper & Brothers, 1909. Illustration.

392. Hoeber, Arthur. *The Barbizon Painters.* New York: Frederick A. Stokes Co., 1915. Background.

393. ———. "From Ink to Clay," *Harper's Weekly,* Oct. 19, 1895, p. 993. Text, illustration.

394. ———. "Painters of Western Life," *The Mentor,* serial no. 85, 1915. Biography.

395. Hogarth, Paul. *Artists on Horseback.* New York: Watson-Guptill Publications, 1972. Text.

396. (Hogg Collection) Houston *Post,* April 25, 1943. "Remington Paintings Given Museum by Miss Hogg, Brother."

397. Horan, James D. *The Life and Art of Charles Schreyvogel.* New York: Crown Publishers, 1969. Text.

398. Hough, Emerson. *The Way to the West.* New York: Grosset & Dunlap, 1903. Illustration.

399. ———. "Wild West Faking," *Collier's Weekly,* Dec. 19, 1908, p. 18. Text.

400. Hough, Nellie. "Remington at Twenty-three," *International Studio,* Feb. 1923. Text, illustration.

401. (Howard) Ogdensburg *Journal,* Feb. 8, 1940, p. 5. "John C. Howard, 79, Killed by Train."

402. Howard, O. O. *Famous Indian Chiefs I Have Known.* New York: The Century Co., 1908. Illustration.

403. ———. *My Life and Experiences among Our Hostile Indians.* Hartford: A. D. Worthington & Co., 1907. Illustration.

404. *Hoye's Kansas City Directory,* 1884 and 1885. Text.

405. (Hubbard) *Selected Writings of Elbert Hubbard.* New York: William H. Wise & Co., 1916. Text.

406. Humfreville, J. Lee. *Twenty Years among Our Savage Indians.* Hartford: The Hartford Publishing Co., 1897. Illustration.

407. Huntington, F. C. *Programme of 10th Annual Mounted Games of Squadron "A."* New York: Knickerbocker Press, 1900. Illustration.

408. Hurd, Richard M. *A History of Yale Athletics.* New Haven: Yale University, 1888. Text.

409. Ingersoll, R. Sturgis. *Henry McCarter.* Cambridge: The Riverside Press, 1944. Background.

410. Inman, Henry. *The Old Santa Fe Trail.* New York: The Macmillan Co., 1898. Illustration.

411. *The Inter Ocean,* Oct. 6, 1903. Burns Mantle, *"John Ermine of the Yellowstone."*

412. (Irving) *The Works of Washington Irving.* New York: The Century Co., 1911. Illustration.

413. Isaacson, Robert. *Frederic Remington.* New York: private printing, 1943. Biography and illustration.

414. Isham, Samuel. *The History of American Painting.* New York: The Macmillan Co., 1927. Text.

415. Jackman, Rilla Evelyn. *American Arts.* Chicago: Rand McNally & Co., 1928. Biography.

416. Jackson, Marta, ed. *The Illustrations of Frederic Remington.* New York: Bounty Books, 1970. Illustration.

417. Janvier, Thomas A. *The Aztec Treasure-House.* New York: Harper & Brothers, 1890. Illustration.

418. (Jefferson) *The Autobiography of Joseph Jefferson.* New York: The Century Co., 1897.

419. (——) Wilson, Francis. *Joseph Jefferson.* New York: Charles Scribner's Sons, 1906. Text.

420. (——) Winter, William. *Life and Art of Joseph Jefferson.* New York: The Macmillan Co., 1894.

421. Jenks, Tudor. *The Century World's Fair Book for Boys and Girls.* New York: The Century Co., 1893. Illustration.

422. Johnson, Carter Page. Contents of War Department personnel file.

423. (——) Alliance (Neb.) *Daily Times-Herald,* Dec. 13, 1916. "Noted Scout and Indian Fighter Died of Heart Failure."

424. Johnson, Harold B. Watertown *Daily Times,* Aug. 17, 1900. Remington's island.

425. (——) Watertown *Daily Times,* Sept. 28, 1961. "Harold B. Johnson Wrote in 1900 About Remington's Island." Also, "Few Changes in Remington's Island."

426. Johnson, Merle. *High Spots of American Literature.* New York: Bennett Book Studios, 1929.

427. ——, his Remington bibliography. Texas University, New York Public Library, and Denver Public Library.

428. (——) Burrows, Carlyle. "A Pioneer Illustrator," New York *Herald Tribune,* June 30, 1929, p. 8.

429. (——) Cannon, Carl I. "Remington's West Kept for Posterity," *The New York Times Magazine,* June 30, 1929.

430. Johnson, Robert Underwood. *Remembered Yesterdays.* Boston: Little, Brown and Co., 1923. Text.

431. Johnson, Rossiter, ed. *The Biographical Dictionary of America.* 10 vols. Boston: American Biographical Society, 1906. Text.

432. Jones, S. Walter. "Remington on Tiger-hunting," *Century Magazine,* vol. 85, p. 959 (April 1913).

433. Judd, Mary C. *Story of Fremont & Carson.* Dansville, N.Y.: F. A. Owen Pub. Co., 1906. Illustration.

434. Kansas City Art Institute and School of Design. *A History of Community Achievement 1885–1964.* Background.

435. Kansas City *Journal,* July 28, 1885, p. 3. "The Body of George Reick Found."

436. Kansas City *Star,* Jan. 23, 1891, p. 5. "He is a big-fellow."

437. ——, Dec. 27, 1909. "Frederic Remington Dead."

438. ——, *Ibid.* "When Remington Lived Here."

439. ——, Jan. 23, 1910, editorial section. "Frederic Remington's Hale Days in Young Kansas City."

440. ——, Feb. 5, 1911. "Dim Beginnings of Remington." Illustration.

441. ——, March 25, 1920. "When Fred Remington Was 'Trimmed Out' of His Cash." Illustration.

442. ——, May 3, 1925, p. 16, magazine. "Kansas City, Cradle of Remington's Art."

443. ——, Jan. 28, 1938. "Frederic Remington, Painter of the Old West."

444. ——, Nov. 2, 1941. "Indian Pageantry."

445. ——, Feb. 1, 1942. "'Scholars' on the Range."

446. ——, March 6, 1942, p. D. Cecil Howes, "Kansas Notes."

447. ——, Nov. 29, 1947. "Frederic Remington Gets His First Real Biography."

448. ——, Dec. 6, 1970, magazine. David Dary, "The Sketches of a One-Time Sheep Rancher Led to Art Now Valued at $100,000."

449. Kansas City *Times*, July 20, 1885, p. 8. "The Blue Boulevard." Background.

450. ——, July 27, 1885, p. 8. "Drowned in Brush Creek."

451. ——, July 30, 1885, p. 8. "George Reick's Funeral."

452. ——, Apr. 21, 1936. "Pictures by Remington Comprise a Vivid Record of Pioneer West."

453. ——, Sept. 24, 1942. "Frederic Remington Gains Stature."

454. ——, May 14, 1948. "Frederic Remington Learned About West."

455. ——, Sept. 30, 1961. John Edward Hicks, "Frederic Remington Groped Here." Illustration.

456. Kansas City (Kan.) *Tribune*, Oct. 29, 1897. Charles Lobdell.

457. ——, Nov. 12, 1897. Lobdell.

458. *Kansas Teacher*. Kirke Mechem, "Frederic Remington in Kansas," vol. 60, n. 5 (Jan. 1952), p. 38. Biography.

459. Katz, William Loren. *The Black West*. Garden City, N.Y.: Doubleday & Co., 1973. Text, illustration.

460. Kelsey, D. M. *History of Our Wild West and Stories of Pioneer Life*. Chicago: The Charles C. Thompson Co., 1901. Illustration.

461. Kelty, Mary G. *The Story of the American People*. Boston: Ginn and Co., 1946. Illustration.

462. Kemble, Edward. *Lambs All Star Gambol*. New York: Tribune Printing Co., 1909. Program, illustration.

463. (——) G. A. Baker & Co., Inc. *Catalogue No. 16*/Books, etc. of Edward W. Kemble. October 25, 1938. Painting and drawing.

464. (——) Ridgefield Public Library. Letter March 11, 1943.

465. Kende Galleries of Gimbel Brothers. New York, Jan. 7, 1943, Jan. 28, 1943, Feb. 16, 1946, Jan. 31, 1952.

466. Kennedy Galleries. Exhibitions 1956, 1968 (2), 1970, 1977, 1979.

467. *Kennedy Quarterly*. Vol. I, no. 4; vol. IV, no. 2; vol. V, no. 3; vol. VI, no. 2; vol. VII, no. 2; vol. VIII, no. 2; vol. IX, no. 1; vol. XI, nos. 1 and 4; vol. XII, nos. 3 and 4; vol. XIII, no. 2; vol. XIV, no. 2; vol. XV, nos. 1 and 3; and vol. XVI, no. 4.

468. King, Charles. *An Apache Princess*. New York: The Hobart Co., 1903. Illustration.

469. ——. *A Daughter of the Sioux.* New York: The Hobart Co., 1903. Illustration.

470. ——. *A Soldier's Trial: an Episode.* New York: Grosset & Dunlap, 1905. Illustration.

471. ——. *To the Front.* New York: Harper & Brothers, 1908. Illustration.

472. King, Moses, ed. *King's Handbook of the United States.* Buffalo, N.Y.: The Matthews-Northrup Co., 1896. Background.

473. ——. *Notable New Yorkers of 1896–1899.* New York: Bartlett & Co., 1899.

474. King, W. Nephew. *The Story of the Spanish-American War.* New York: P. F. Collier & Son, 1900. Illustration.

475. Kletzing, H. F., and W. H. Crogman. *Progress of a Race.* Atlanta: J. L. Nochols & Co., 1900. Illustration.

476. Knight, Oliver. *Following the Indian Wars.* Norman: University of Oklahoma Press, 1960. Text.

477. Knoedler & Co., New York. Exhibition, 1905. *Lost Wax bronzes by Frederic Remington.*

478. ——. *Paintings by Frederic Remington,* 1906.

479. ——. *Paintings by Frederic Remington,* 1907.

480. (——) Royal Cortissoz review of above, New York *Tribune,* Dec. 4, 1907.

481. ——. *Paintings by Frederic Remington,* 1908.

482. (——) Review of above, New York *Globe,* Dec. 3, 1908.

483. (——) Review of above, unidentified clipping in Remington journal.

484. ——. *Paintings by Frederic Remington,* 1909.

485. (——) Two reviews of above, unidentified clippings.

486. ——. Typed list for *1913 Summer Exhibition.*

487. ——. *Seventh Annual Summer Exhibition,* May 28, 1914.

488. ——. *Eleventh Annual Summer Exhibition,* 1918.

489. Knox, Thomas W. *The Boy Travellers in Mexico.* New York: Harper & Brothers, 1890. Illustration.

490. Kobbe, Gustav. "Painters of Indian Life," New York *Herald,* Dec. 26, 1909. Biography.

491. Krakel, Dean. *Adventures in Western Art.* Kansas City: The Lowell Press, 1977. Text, illustration.

492. ——. "Visions of Today," *American Scene,* vol. V, no. 4 (1964), p. 56.

493. Kramer, Hilton. "Art. Radical, Traditional Degas," New York *Times,* Feb. 25, 1977. Muybridge.

494. Kunitz, Stanley J., and Howard Hawcraft, ed. *American Authors 1600–1900.* New York: The H. W. Wilson Co., 1938. Text.

495. *The Lamp,* Feb. 1903. *John Ermine of the Yellowstone.*

496. Langford, Gerald. *The Richard Harding Davis Years.* New York: Holt, Rinehart and Winston, 1961. Text.

497. Larkin, Oliver W. *Art and Life in America*. New York: Rinehart & Co., 1949. Text.

498. Latendorf, E. W. *Frederic Remington* (Bibliographical Check List). Mannados Bookshop Catalogue No. 17, New York, c. 1947. Illustration.

499. ———. *The West*. Mannados Bookshop Catalogue No. 25, New York, c. 1955. Illustration.

500. Lathrop, George Parsons. "The Progress of Art in New York," *Harper's Magazine*, vol. LXXXVI, no. DXV (Apr. 1893), p. 740. Text.

501. Laut, A. C. *Lords of the North*. Toronto: The Ryerson Press, 1920. Illustration.

502. ———. *Pathfinders of the West*. New York: Grosset & Dunlap, 1904, 1906. Illustration.

503. Lee, Lloyd. *A Story of Yale*. 1878. Text.

504. Leigh, William R. *The Western Pony*. New York: Huntington Press, 1933. Muybridge.

505. (Lenz) *The Alfred David Lenz System of Lost Wax Casting*. New York: National Sculpture Society, 1933. Background.

506. Leposky, George. "Bone Mizell/Remington's Cracker Cowpoke," *True West*, Sept.–Oct. 1975, p. 18.

507. *Leslie's Weekly*. "Notable Statuary at the St. Louis Exposition," vol. XCIX (Nov. 7, 1904), p. 470.

508. Letters from Eva Remington: In Fairmount Park Art Association, to Leslie Miller; in the Library of Congress, to Owen Wister; in Mannados, to Lisle Thomas; in the Missouri Historical Society, to Powhatan Clarke; in the New York Public Library, to C. C. Buel; and in the Taft Collection, Kansas State Historical Society, to Emma Caten, Franklin Hough, H. D. Sackrider, and Mrs. Robert Sackrider.

509. Letters to Eva Remington: In the Library of Congress, from Owen Wister; and in the Remington Collection, Archives of American Art, from William Alexander, Daniel Appleton, Powhatan Clarke, and A. B. Hepburn.

510. Letters concerning Remington: In the American Institute of Arts and Letters, from J. Alden Weir to Childe Hassam; in the Chicago Historical Society, from R. H. Davis to Gus Thomas; in Horan, from Charles Schreyvogel to "Schnuck"; in the Library of Congress, from *Collier's Weekly* to Owen Wister, F. Lungren to Owen Wister, R. H. Russell to Owen Wister, and Owen Wister to R. H. Russell; in the National Academy of Design, from Benoni Irwin; in the Remington Collection, Archives of American Art, from Poultney Bigelow to *Harper's*, Powhatan Clarke to his mother, John Parish, Elihu Root to Mr. Cortelyou and F. Hopkinson Smith; in the Samuels Collection, from Harriett Armstrong, Cesare Augustus Contini (interview), Frank Cross, E. W. Deming, Free Library of Philadelphia (Nameless Club), Edwin Hough, New Rochelle Library (Paula M. Zieselman), New York Public Library (*New Magazine*), Phil Scalvo (interview), Francis B. Wilson; in Sotheby's, from Mrs. Benoni Irwin; in the Taft Collection, Kansas State His-

torical Society, from Raymond Abel, Harriett Appleton, Irving Bach-
eller, W. I. Barth, Myra Brown, Corah Bullock, Henry L. Carey,
Emma Caten, Charles Chapman, Winston Churchill, Powhatan Clarke,
Charles Everitt, J. A. Finnigan, Forbes Lithograph Manufacturing Co.,
Alice Poste Gunnison, William J. Heckles, Historical Society of Mon-
tana, John Henry Hopkins, Edwin Hough, William F. Kip, Library As-
sociation of Portland, D. C. Lithgow, Atwood Manley, D. F. McEllen,
G. V. Millett, Ella Remington Mills, Ogdensburg Public Library, Kate
Oglebay, W. A. Poste, Henry E. Reed, Harvey F. Remington, Pierre
Remington, Henry M. Sackrider, Norman Sackrider, Sullivan County
Register of Deeds, R.W.G. Vail, John Van Kennen, Elmo Scott Wat-
son, Mary DeForest Weeks, Worcester Free Public Library, and Yale
University Library; in Vorpahl, from Owen Wister, to his mother;
and in Wister, from Theodore Roosevelt to Wister.

511. Letters from Remington: In Abbott, to Howard Pyle; in Addison
Gallery, to Annesley & Co. and Mrs. Glentworth Butler; in the Amon
Carter Museum, to Riccardo Bertelli, G. W. Edwards, E. Leslie Gilliam,
Mr. Harper, *Harper's Weekly*, Colonel Harvey, Mr. Hornaday, Charles
Parsons, Barnet Phillips, Julian Ralph, Theodore Roosevelt, Fred B.
Schell, *Scribner's*, Louis Shipman, and Arthur B. Turner; in *The Auto-
graph*, to Julian Ralph; in Batchelder (Ambler, Pa.), to Julian Ralph; in
Benjamin (Hunter, N.Y.), to Mr. Goodfellow; in the Bigelow Collec-
tion, St. Lawrence University Library, to Poultney Bigelow; in Burnside,
to Maynard Dixon; in Camp, to Walter Camp; in Cannon, to E. W.
Deming; in the Clarke Collection, Missouri Historical Society, to Pow-
hatan Clarke, Mrs. Clarke, and Dr. Clarke; in Columbia University Li-
brary, to Mrs. Stephen Crane and Prof. Matthews; in the Corcoran Gal-
lery, to the Corcoran; in Crooker, to Scott Turner; in the Current
Company (Providence, R.I.), to Julian Ralph; in the Deming Collection,
University of Oregon Library, to E. W. Deming.

512. ——: in the Denver Public Library, to Annesley & Co., Major G.
W. Baird, Riccardo Bertelli, *Century*, John Foord, J. Henry Harper,
Julian Ralph, R. H. Russell, Fred B. Schell, Arthur B. Turner, and
Wadsworth; in the Drew autobiography, to John Drew; in the Dykes
Collection, to Fred Gunnison; in the Fairmount Park Art Association, to
Charles J. Cohen and Leslie Miller; in the Fine Arts Gallery of San
Diego, to Mr. Arnold; in the Gilcrease Institute, to Mr. Schofield; in the
Michael Harrison Collection (Fair Oaks, Cal.), to Alvin Sydenham; in
Hassrick, to Mrs. Sage; in Horan, to Colonel Schuyler Crosby; in the
Huntington Galleries, to John B. Colton; in Jackman, to Sally James
Farnham.

513. ——: in the Library of Congress, to Dan Beard, Frank G. Carpen-
ter, John Hay, Daniel S. Lamont, Theodore Roosevelt, and Owen
Wister; in Mannados, to (anonymous), Riccardo Bertelli, H. C. Du Val,
A. B. Frost, Mrs. Heminway, Fred B. Schell, Louis Shipman, and Gus
and Lisle Thomas; in McKown, to Lawton Caten; in the Metropolitan

Museum of Art, to F. Edwin Elwell; in the National Academy of Design, to the Academy; in the New Milwaukee Art Center, to Grant Fitch; in the New-York Historical Society, to *Century*, E. Leslie Gilliam, Mr. McMaster, General Miles, Fred B. Schell, Frank Squier, Arthur B. Turner, and Stanford White; in the New York Public Library, to R. U. Johnson; in the Norton Gallery (Shreveport, La.), to Riccardo Bertelli, Mr. Harper, and Julian Ralph; in the Ogdensburg Public Library, to Poultney Bigelow; in the Parkman Collection, to Francis Parkman; in the R. J. Phillips Collection (San Diego, Cal.), to Bert Phillips; in the Rainone Collection (Arlington, Tex.), to W. W. Findlay; in Randall & Windle (San Francisco, Cal.), to Julian Ralph.

514. ——: in the Remington Collection, Archives of American Art, to Jennings Cox, Homer Davenport, Jack Follansbee, Harper Brothers, Childe Hassam, William Macbeth, Julian Ralph, Eva Remington, Nate Salsbury, Fred B. Schell, and Mr. Sparhawk; in St. Lawrence University Library, to John Howard; in the Samuels Collection, to Joseph Asay, Mr. Harper, Julian Ralph, and Otis Skinner; in *Scribner's*, to Colonel W. H. Carter and R. H. Russell; in the Stark Museum, to Riccardo Bertelli.

515. ——: in the Taft Collection, Kansas State Historical Society, to "Say Bill," C. T. Brady, *Century*, Corbin, Herbert Gunnison, Mr. Harper, Mr. Howells, Charles F. Knoblauch, Daniel S. Lamont, Arthur Merkly, W. A. Poste, Julian Ralph, Ella Remington (Mills), Eva Remington, Henry L. Sackrider, Horace D. Sackrider, Marcia Sackrider, Robert Sackrider, Fred B. Schell, Mrs. Henry Smith, Charles Bern Todd, and Arthur B. Turner; in the UCLA Library, to *Illustrated Graphic News*; in the University of Oregon Library, to Major Cetus Newell; in Summerhayes, to Jack Summerhayes and Martha Summerhayes; in Young (※1044), to J. Alden Weir; in the West Point library, to Gunnison and Colonel Henry Inman; in Wildenstein, to Mrs. Greenway; in the Winterthur Museum, to Edward H. Wales; and in the Yale Library, to Louis Shipman.

516. Letters to Remington: In the Amon Carter Museum, from *Harper's Weekly*; in Horan, from Schuyler Crosby and Elizabeth B. Custer; in the Huntington Galleries, from John B. Colton; in the Library of Congress, from Montague Stevens and Theodore Roosevelt; in the New York Public Library, from R. U. Johnson.

517. ——: in the Remington Collection, Archives of American Art, from John W. Alexander, Irving Bacheller, S.H.P. Bell, Albert J. Beveridge, Poultney Bigelow, G. H. Boughton, Cyrus Townsend Brady, George Brett, Arthur Brisbane, A. S. Brolley, C. C. Buel, Robert J. Callie, J. H. Chapin, F. S. Church, Powhatan Clarke, Walter Appleton Clarke, S. L. Clemens, John J. Clinton, W. F. Cody, the Corcoran Gallery of Art, Jennings Cox, R. Rice Crandell, Homer Davenport, R. H. Davis, French Devereux, Mildred F. Devereux, J. S. Donovan, J. H. Dorst, A. W. Drake, H. C. DuVal, G. W. Edwards, J. E. Edwards, William E. Ellish, Robley D. Evans, Fairmount Park Art Association,

George A. Forsyth, John Fox, Jr., Daniel C. French, C. D. Gibson, R. W. Gilder, Jules Guerin, B. F. Gussant, John Hay, A. B. Hepburn, A. R. Herriman, A. G. Hetherington, Arthur Hoeber, John Howard, W. D. Howells, Imperial German Consulate General, Joseph Jefferson, Carter Johnson, James M. Johnston, Jerrold Kelley, Edward Kemeys, W. Lacy Kenly, J. C. Kennedy, Charles King, Rudyard Kipling, Knoedler's, The Lambs, Daniel Lamont, Frederick Latimer, Arthur H. Lee, Alfred Henry Lewis, Charles F. Lummis, F. W. MacMonnies, Richard Mansfield, Perriton Maxwell, Arthur McCorwin, W. L. Metcalf, Nelson Miles, Frank D. Millet, George E. Morris, Harrison Morris, Casey B. Myer, Walter L. Palmer, Francis Parkman, Howard Pyle, Julian Ralph, Alfred Remington, Charles F. Roe, Theodore Roosevelt, Roosevelt Rough Riders Association, Elihu Root, Carl Rungius, Augustus St. Gaudens, T. C. Scott, Stephen Y. Seyburn, Henry Shrady, Edward Simmons, R. G. Thwaites, Gladys Unger, W. A. Wadsworth, Edward H. Wales, John F. Weir, West Point (U. S. Military Academy), Caspar Whitney, Francis Wilson, Owen Wister, Leonard Wood, and George M. Wright.

518. ———: in the Taft Collection, Kansas State Historical Society, from Riccardo Bertelli, Royal Cortissoz, R. H. Davis, Fairmount Park Art Association, Childe Hassam, John Howard, Harold B. Johnson, Rudyard Kipling, W. A. Poste, Post Office Department, Red Bear, Seth Remington, William R. Remington, S. C. Robertson, Theodore Roosevelt, Louis Shipman, Mason Wade, Owen Wister, and Leonard Wood.

519. Lewis, Alfred Henry. *The Black Lion Inn*. New York: R. H. Russell, 1903. Illustration.

520. ———. *Wolfville*. New York: Frederick A. Stokes, 1897. Illustration.

521. ———. *Wolfville Days*. New York: Frederick A. Stokes, 1902. Illustration.

522. Library of Congress, 59 photographs of Remington paintings and drawings.

523. *LIFE*, "The most exciting stories," Sept. 14, 1942, p. 72. Text, illustration.

524. *The Literary Digest*, Dec. 1907, pp. 903–4. "Mr. Hearst's Tiff with the London 'Times.'"

525. ———, Jan. 7, 1912, p. 160. "How Art Misrepresents the Indian."

526. ———, July 13, 1929, p. 18. "The Spell of the Indian for Artists."

527. *London Graphic*, 1887 and 1889. Illustration.

528. Longfellow, Henry Wadsworth. *The Song of Hiawatha*. Boston: Houghton Mifflin Co., 1891. Illustration.

529. Lovett, Richard. *United States Pictures drawn with pen and pencil*. London: The Religious Tract Society, 1891. Illustration.

530. Lowe Art Museum, University of Miami. *The Passing of the Great West*, 1975. Intro, good biography.

531. Lucas, E. V. *Edwin Austin Abbey*. New York: Charles Scribner's Sons, 1921. Text.

532. *The Lucky Bag*, vol. 11 (1904). Illustration.

533. Luhan, Mabel Dodge. *Taos and Its Artists.* New York: Duell, Sloan and Pearce, 1947. Text.

534. Lundberg, Ferdinand. *Imperial Hearst.* New York: Equinox Cooperative Press, 1936. Text.

535. (Lungren) Berger, John A. *Fernand Lungren.* Santa Barbara: The Schauer Press, 1936. Text.

536. Lutz, Paul V. "Transmississippi Americana," *Manuscripts* (the Manuscript Society). Fall 1972, p. 286. Text.

537. Mabie, Hamilton Wright. *Essays on Work and Culture.* 2 vols. New York: Dodd, Mead and Co., 1898, 1899. Background.

538. ——. *Footprints of Four Centuries.* Philadelphia: International Publishing Co., 1896. Illustration.

539. ——. *Giants of the Republic.* Philadelphia, Winston, 1895. Illustration.

540. ——. "Indians, and Indians," *The Century Magazine,* vol. XXXVIII, no. 3 (July 1889), p. 472. Text.

541. ——. *Our Country in Peace and in War.* Philadelphia: J. H. Moore Co., 1895, 1898. Illustration.

542. MacDonnell, Kevin. *Eadweard Muybridge.* Boston: Little, Brown and Co., 1972. Background.

543. Mahan, A. T. *The War in South Africa.* New York: R. H. Russell, 1901. Illustration.

544. Mails, Thomas E. *The Mystic Warriors of the Plains.* Garden City, N.Y.: Doubleday & Co., 1972. Text.

545. Manley, Atwood. "Frederic Remington and the University," *The St. Lawrence University Bulletin,* vol. XXIV, no. 2 (Jan. 1966), p. 4. Biography.

546. ——. *Some of Frederic Remington's North Country Associations.* Canton, 1961. Biography.

547. ——, with the assistance of Paul F. Jamieson. *Rushton and His Times.* Syracuse: The Adirondack Museum, 1968. Text.

548. Mannados Book Shop, New York. *Catalogue No. 18,* 1951. Illustration.

549. (Mansfield) Wilstach, Paul. *Richard Mansfield.* New York: Charles Scribner's Sons, 1908. Background.

550. Marden, Orison Swett. *Little Visits with Great Americans.* New York: The Success Co., 1905. Text.

551. Marshall, S.L.A. *Crimsoned Prairie.* New York: Charles Scribner's Sons, 1972. Background.

552. Martin, E. S. "This Busy World," *Harper's Weekly,* June 10, 1893; Aug. 12, 1893; June 23, 1894; Aug. 11, 1894; Apr. 6, 1895; Sept. 21, 1895; Jan. 1, 1898; Oct. 22, 1898; Nov. 5, 1898; June 9, 1900; Oct. 9, 1901.

553. Mather, Frank Jewett. *The American Spirit in Art.* Vol. 12, *The Pageant of America.* New Haven: Yale University Press, 1927. Text.

554. Maus, Marion P. "The New Indian Messiah," *Harper's Weekly,* Dec. 6, 1890, p. 947. Text.

555. Maxwell, Perriton. "Frederic Remington—Most Typical of American Artists," *Pearson's Magazine*, Oct. 1907, p. 403. Biography.

556. (McCarrell) *The Joseph E. McCarrell Collection of Frederic Remington. . . .* Amon Carter Museum.

557. *McClure's Magazine*, vols. 13 and 16.

558. McCracken, Harold. *The American Cowboy*. Garden City, N.Y.: Doubleday & Co., 1973. Text, illustration.

559. ——. "Chronicler of the Old West," *Arizona Highways*, Sept. 1950. Biography.

560. ——. *Frederic Remington/a Collection of Ink Drawings and Gouaches*. Graham (Gallery), 1971.

561. ——. *Frederic Remington/Artist of the Old West*. Philadelphia: J. B. Lippincott Co., 1947. Biography. List of illustrations.

562. ——. *The Frederic Remington Book/A Pictorial History of the West*. Garden City, N.Y.: Doubleday & Co., 1966. Biography, illustration.

563. ——. *Frederic Remington's Own West*. New York: The Dial Press, 1960. Text, illustration.

564. ——. "Frederic Remington's Studio," *Southwestern Art*, vol. I, no. 1 (Spring 1966). Biography, illustration.

565. ——. "Frederic Remington—Writer," *The Westerners/N.Y. Posse Brand Book*, vol. 3, no. 2 (1956).

566. ——. "A Portfolio of Paintings by Frederic Remington," *TRUE/The Man's Magazine*, May 1954, p. 54. The Gila gang.

567. ——. *Portrait of the Old West*. New York: McGraw-Hill Book Co., 1952. Biography and illustration.

568. ——. "Remington's Home and Studio," *The American Scene*, vol. V, no. 4 (1964), p. 13. Biography and illustration.

569. McDougall, Walt. *This Is the Life*. New York: Alfred A. Knopf, 1926. Text.

570. McIntosh, Burr. *The Little I Saw of Cuba*. London: Tennyson Neely, 1899. Text.

571. McKown, Robin. *Painter of the Wild West*. New York: Julian Messner, 1959. Biography.

572. McLennan, William. *In Old France and New*. New York: Harper & Brothers, 1900. Illustration.

573. Meadon, Joseph, ed. *The Graphic Arts and Crafts Year Book 1908*. Hamilton, Ohio: The Republican Publishing Co., 1908. Illustration.

574. *The Mentor*. Albert Bushnell Hart. "The Explorers," vol. 1, no. 22 (July 14, 1913). Biography and illustration.

575. Meriwether, Lee. "How Working-Men Live," *Harper's Magazine*, vol. LXXIV (Apr. 1887), p. 785. Background.

576. (Metcalf) *Willard Leroy Metcalf, A Retrospective*, selection and catalogue by Francis Murphy. Springfield, Mass.: The Museum of Fine Arts, 1976. Background.

577. *Metropolitan* magazine, 1896, 1906, 1908.

578. (Metropolitan Club) "A Night at the Metropolitan Club," *Harper's Weekly*, Feb. 21, 1903, pp. 300–1. Background.

579. The Metropolitan Museum of Art. Compiled by Albert TenEyck Gardner. *A Concise Catalogue of the American Paintings*. New York, 1957.

580. ———. Compiled by Bryson Burroughs. *Catalogue of Paintings*. New York, 1931.

581. ———. *19th-Century America*. New York, 1970. Biography and illustration.

582. (Miles) *Personal Recollections and Observations of General Nelson A. Miles*. Chicago: The Werner Co., 1897. Text, illustration.

583. ———. *Serving the Republic*. New York: Harper & Brothers, 1911.

584. ———, introduction. *Harper's Pictorial History of the War with Spain*. New York: Harper & Brothers, 1899. Illustration.

585. (———) Virginia W. Johnson. *The Unregimented General*. Boston: Houghton Mifflin Co., 1962. Text, illustration.

586. ———, Contents of War Department personnel file.

587. Miller, Joaquin, et al. *Western Frontier Stories Retold from St. Nicholas*. New York: The Century Co., 1907. Illustration.

588. Millis, Walter. *The Martial Spirit*. Cambridge: Literary Guild, 1931. Text, illustration.

589. *Modern Maturity*, Feb.–Mar. 1964, p. 34. "Frederic Remington . . . the New Yorker."

590. Monaghan, Jay. *The Book of the American West*. New York: Bonanza Books, 1963. Text, illustration.

591. ———. *The Book of the American West*. New York: Bonanza Books, 1963. Portfolio of Remington prints as supplement to above.

592. Monro, Isabel Stevenson, and Kate M. Monro. *Index to Reproductions of American Paintings*. New York: The H. W. Wilson Co., 1948.

593. ———. *Ibid.*, first supplement. 1964.

594. *Montana, the magazine*. Vol. VI, no. 1; vol. VII, no. 1; vol. VIII, no. 4; vol. X, no. 2; vol. XI, no. 4; and vol. XXVI, no. 3.

595. Moore, Charles. *The Northwest under Three Flags*. New York: Harper & Brothers, 1900. Illustration.

596. (Morgan) Satterlee, Herbert L. *J. Pierpont Morgan*. New York: The Macmillan Co., 1939. Background.

597. Morison, Elting E., selected and edited by. *The Letters of Theodore Roosevelt*. Vol. II. Cambridge: Harvard University Press, 1951.

598. Morison, Samuel Eliot. *The Oxford History of the American People*. New York: Oxford University Press, 1965. Text.

599. Morris, Charles. *Child's History of United States*. W. E. Scull, 1900. Illustration.

600. ———. *The Greater Republic*. Philadelphia: Winston, 1899. Illustration.

601. Morris, Edmund. *The Rise of Theodore Roosevelt*. New York: Coward, McCann & Geoghegan, 1979. "The Bronco Buster."

602. (Mosler) New York *Times*, Nov. 18, 1906, p. 7. "Henry Mosler Resigns as Academy Associate."

603. (——) *Ibid.*, Dec. 9, 1906, part 4, p. 4. "Henry Mosler Resigned."

604. Mowry, William A. *First Steps in the History of Our Country*. New York: Silver, Burdett & Co., 1899. Illustration.

605. ——, and Arthur M. Mowry. *A History of the United States for Schools*. New York: Silver, Burdett & Co., 1896. Illustration.

606. ——, and Blanche S. Mowry. *American Pioneers*. New York: Silver, Burdett & Co., 1905. Illustration.

607. Muir, John, ed. *Picturesque California and the Region West*. San Francisco: The J. Dewing Co., 1887, 1888. Illustration.

608. Mundell, Frank. *Stories of the Far West*. London: Sunday School Union, 1896. Illustration.

609. The Museum of Fine Arts, Houston. Dennis Harrington, *Days on the Range*. 1972. Text, and illustration.

610. ——. Marjorie S. Thompson, *Selections from the Hogg Brothers Collection*. 1973. Text, illustration.

611. Muybridge, Eadweard. *Animals in Motion*. London: Chapman & Hall, 1899.

612. ——. *The Human Figure in Motion*. New York: Dover Publications, 1955. Introduction.

613. (——) "Personal," *Harper's Weekly*, May 7, 1887, p. 323.

614. (——) *Harper's Weekly*, May 28, 1887, p. 379. On Eakins' photographs.

615. (——) Talcott Williams. "Animal Locomotion in the Muybridge Photographs," *The Century Magazine*, July 1887.

616. Myers, Richard G. *A Guide to Old Remington Prints*. Ogdensburg: Ryan Press, 1975. Listing.

617. (National Academy) "Personal," *Harper's Weekly*, June 6, 1891, p. 419.

618. National Academy Exhibition. "As Seen by Bert Wilder," *Harper's Weekly*, Dec. 12, 1891, p. 1000. Spoof.

619. (——) *Commemorative Exhibition 1825–1925*. National Academy of Arts and Design. 1925. Text.

620. ——, *Exhibition Record 1861–1900*. 2 vols. Maria Naylor. New York: Kennedy Galleries, 1973. Listing.

621. National Cowboy Hall of Fame. *Guide Book*. N/d. Illustration.

622. *National Cyclopedia of American Biography*. Biography of Remington by Emma Caten.

623. National Museum of Racing, The. *Equine Portraits, Sculptures and Histories*. Saratoga Springs, N.Y., 1962. 2 illustrations.

624. National Sculpture Society. *Catalogue of the Exhibition*. Municipal Art Society of Baltimore, 1908. Background.

625. Neuhaus, Eugen. *The History & Ideals of American Art*. Stanford University Press, 1931. Biography.

626. ——. *The Galleries of the Exposition*. San Francisco: Paul Elder and Co., n/d. Text.

627. (New Mexico) *First Report of Game and Fish Warden for 1909–1910–1911*. Santa Fe: New Mexican Printing Co., 1912. Illustration.

628. (New Rochelle) *Life in New Rochelle*. "A Glimpse at 1891." New Rochelle Trust Co., 1953, p. 30. Text.

629. New Rochelle Library. "Letter to a patron" on Remington house. Paula M. Zieselman letter on Remington Place and Terrace.

630. New Rochelle *Paragraph*, Mar. 2, 1895, p. 1. Carriages collided.

631. ——, Mar. 9, 1895, p. 8. "Wants Spaulding to Pay."

632. ——, Mar. 16, 1895, p. 1. The case for damages.

633. ——, Mar. 23, 1895, p. 5. "A Wee Judgment."

634. ——, Apr. 18, 1896. Remington studio.

635. ——, Mar. 19, 1898. New Rochelle Day Nursery.

636. ——, June 18, 1898. The Day Nursery.

637. ——, Aug. 6, 1898. "At the Orchard."

638. ——, Aug. 20, 1898. "A Red Cross Rally."

639. New Rochelle *Pioneer*, Apr. 25, 1896. "A Beautiful Studio."

640. ——, June 26, 1897, p. 5. "A lawn party."

641. ——, July 10, 1897, p. 4. "Mrs. Remington's Lawn Party."

642. ——, June 25, 1898, p. 1. "Red Cross Society Fete."

643. ——, July 2, 1898. Party at Lather's Hill.

644. New Rochelle *Press*, Mar. 19, 1897, p. 5. Meeting of directors.

645. ——, July 10, 1897, p. 1. "Day Nursery Lawn Party."

646. ——, Apr. 20, 1901. "Horse Fell with Rider."

647. New Rochelle *Evening Standard*, May 23, 1909. "Remington's Frank Criticism."

648. New Rochelle *The Standard-Star*, Feb. 27, 1934. "Remington Place and Terrace."

649. ——, June 26, 1964. "Artist Lived, Worked Here." Biography.

650. *Newspapers and Periodicals of Illinois 1814–1879*. Illinois Historical Collections, vol. 6.

651. *New York City Directory*, for 1886–87, 1887–88, 1888–89, 1889–90.

652. New York *Herald*, Mar. 31, 1888, p. 4. "Catholicity in Art."

653. ——, Apr. 18, 1888. Remington description.

654. ——, Mar. 10, 1889, p. 16. "Home Artists' Paris Exposition Contributions."

655. ——, Nov. 16, 1889. "Frederic Remington's Large and Excellent Work."

656. ——, Jan. 14, 1894, p. 13. "Remington's Fame Was Won Quickly."

657. ——, Apr. 19, 1903, *Literary Section*, p. 9. "Custer's Demand."

658. ——, Apr. 28, 1903. "Finds Flaw in 'Custer's Demand.'"

659. ——, Apr. 30, 1903. "Schreyvogel Right, Mrs. Custer Says."

660. ——, *Ibid*. Letter to the editor from Remington.

661. ——, May 1, 1903. Letter from Colonel Schuyler Crosby.

662. ——, Aug. 23, 1908, *Magazine Section*, p. 7. "Joy of Wielding the Paddle."

663. ——, Mar. 14, 1909. Robert Collier's lunch for Roosevelt.

664. New York *Herald Tribune*, June 30, 1929. Carlyle Burrows. "A Pioneer Illustrator." Merle Johnson exhibition.
665. ——, Dec. 28, 1947, *Weekly Book Review*. Thomas Craven, "A Man's Artist."
666. The New-York Historical Society. *Annual Report 1947*, p. 16. Text.
667. New York *Journal*, March 8, 1900. "The Be-ludless Tr-ragedy."
668. ——(?), April 15, 1901. "Frederic Remington Hurt."
669. New York *Sun*, clipping n/d but c. Jan. 1893. "A Great Painter."
670. ——, n/d. Clipping found in Remington diary, Apr. 24, 1908. Reference to Kettle Hill.
671. New York *Times*, Nov. 28, 1879, p. 5. "Kicking the Leather Egg."
672. ——, May 6, 1888, p. 5 National Academy Spring Exhibition.
673. ——, July 14, 1888, p. 5. Remington suicide.
674. ——, Nov. 26, 1889. "Paintings at the Academy."
675. ——, Aug. 11, 1894, p. 7. "With Remington in the West."
676. ——, Nov. 21, 1895. "The Remington Pictures Sold."
677. ——, Apr. 15, 1900, p. 26. "Buffalo Bill's Wild West Show."
678. ——, Apr. 15, 1901, p. 3. "Wants Rough Riders School at Cody."
679. ——, Dec. 13, 1902. Review of *John Ermine*.
680. ——, Apr. 7, 1903, p. 9. "Remington's West."
681. ——, Mar. 15, 1904, p. 8. "Paintings by Remington."
682. ——, Feb. 4, 1906, part 4, p. 8. "Recent Paintings."
683. ——, Dec. 23, 1906, part 4, p. 4. "A Closed Chapter of Life."
684. ——, Dec. 5, 1907, p. 8. "New Remington Paintings."
685. ——, Jan. 25, 1908, p. 1. "All New York Snowbound."
686. ——, Dec. 2, 1908, p. 8. "Remington Paintings on View."
687. ——, Dec. 9, 1909, p. 10. "Twenty Impressive Paintings."
688. ——, June 3, 1921, p. 15. "George L. Spaulding, Song Writer."
689. ——, Mar. 15, 1978. "Preserving a Piece of the Prairie."
690. New York *Tribune*, July 14, 1888. "Has the Artist Killed Himself."
691. ——, Jan. 14, 1893, p. 7. Sale of Remington paintings.
692. ——, Jan. 5, 1902, supplement, p. 12. "An Arizona Cow-boy."
693. New York *World*, Apr. 11, 1897, p. 1. "A Regular Contributor." Also Apr. 18, 1897; Apr. 25, 1897; May 2, 1897; May 9, 1897; May 16, 1897; May 23, 1897; May 30, 1897; June 6, 1897; June 13, 1897.
694. Noé Art Galleries, New York. *Special Exhibition*. 1903.
695. ——. *Ibid.*, 1904.
696. ——. *Ibid.*, 1905.
697. Norris, Frank. *The Pit—A Deal in Wheat*. New York: P. F. Collier & Son, 1903. Text.
698. *Northwestern Miller*, n/d. Illustration.
699. (Ogdensburg) Elizabeth Baxter. *Historic Ogdensburg*. Ogdensburg: Ryan Press, c. 1968. Text.
700. (——) P. S. Garand. *The History of the City of Ogdensburg*. Ogdensburg: Rev. Manuel J. Belleville, 1927.
701. Ogdensburg *Journal*, July 22, 1879, p. 3. Camp on Prison Island.

702. ——, summer 1879. Personal columns.

703. ——, Oct. 4, 1961. "Remington 'Always the Leader.' "

704. ——, *Ibid*. "New Kansas School To Honor Rancher Remington."

705. Ogdensburg Public Library. *Catalogue of the Remington Collection*.

706. Ogdensburg *The Republican*, Feb. 25, 1880. "Death of Col. S. P. Remington."

707. Older, Mrs. Fremont. *William Randolph Hearst/American*. New York: D. Appleton-Century Co., 1936. Text.

708. (The Omaha Exposition) *Harper's Weekly*, Aug. 20, 1898, p. 822. Text.

709. (——) *Ibid*., Oct. 8, 1898.

710. Omaha *World-Herald*, Sept. 17, 1905, p. 32. Photograph of Remington.

711. *Outing/The Gentlemen's Magazine*. Vol. 9 (Oct. 1886–Mar. 1887). Also vols. 10–12, 14, 19, 21, 26, 27, 33, 34, 36, 39, 41, 42, 55.

712. (Outing) *Short Stories from Outing/The Gentlemen's Magazine*. New York: The Outing Publishing Co., 1895. Illustration.

713. *The Outlook*, Dec. 4, 1897. George W. Edwards, "The Illustration of Books."

714. ——. *Ibid*. Book Review of *Drawings*.

715. ——, Jan. 8, 1910. "The death of Frederic Remington."

716. *Pacific Monthly*, July 1905, p. 87. Anabel Parker McCann, "Decorative Sculpture at the Lewis & Clark Exposition."

717. The Paine Art Center and Arboretum, Oshkosh. *A Retrospective Exhibition*. 1967. Text, illustration.

718. (Paris Exposition) "Personal," *Harper's Weekly*, Aug. 31, 1889, p. 699. Harper's artists win awards.

719. (——) *Exposition Universalle 1900*. W. Walton. The Chefs D'Oeuvre. Vol. III. Philadelphia: George Barrie & Son, 1900. Text.

720. Parke Bernet, Sotheby. Sales Feb. 1, 1940; Jan. 20, 1949; Feb. 2, 1950; June 8, 1950; Feb. 28, 1955; Apr. 13, 1956; Oct. 21, 1959; Jan. 31, 1961; Oct. 9, 1963; Jan. 29, 1964; Apr. 23, 1964; Nov. 15, 1967; Mar. 14, 1968; Mar. 19–20, 1969; Oct. 22, 1969; Jan. 28–29, 1970; Apr. 15, 1970; Oct. 20, 1975; May 25, 1977; Oct. 25, 1977.

721. Parkman, Francis. *The Oregon Trail*. Boston: Little, Brown and Co., 1892. Preface and illustration.

722. (——) Sedgwick, Henry Dwight. *Francis Parkman*. Boston: Houghton Mifflin Co., 1904. Background.

723. Parrish, Randall. *The Great Plains*. Chicago: A. C. McClurg & Co., 1907. Illustration.

724. (Parsons) Alden, Henry Mills. "Charles Parsons," *Harper's Weekly Advertiser*, vol. VIV, no. 2813 (Nov. 19, 1910), p. 21. Text.

725. (——) Montclair Art Museum, New Jersey. *Charles Parsons and His Domain*, 1958. Text.

726. Peabody (Kansas) Centennial Committee. *Peabody the first 100 years*. 1971, p. 55. Text.

727. Peabody *Gazette*, June 21, 1883, p. 4. "Plum's Grove notes." Oct. 18, 1883, Uncle Mart's visit.
728. Pennell, Joseph. *Modern Illustration*. London: George Bell & Sons, 1895. Text, illustration.
729. ———. *Pen Drawing and Pen Draughtsmen*. London: Macmillan and Co., 1889, 1894. Text.
730. Pennsylvania Academy of the Fine Arts. *Catalogue of the One Hundred and Fifth Annual Exhibition*. 1910. Sculpture.
731. (Perrine) Lolita L. W. Flockhart. *A Full Life/The Story of Van Dearing Perrine*. Boston: The Christopher Publishing House, 1939. Background.
732. Philadelphia *Daily News*, June 18, 1908. The "Big Cowboy" stopped.
733. *Philadelphia Guide*, July 1961. "What's That Statue?"
734. Philadelphia *Inquirer*, June 21, 1908. "Unveiling of Fairmount Cowboy."
735. ———, Apr. 19, 1974. "They Know the Artist 'Knew the Horse.'"
736. Phisterer, Frederick, compiled by. *New York in the War of the Rebellion*. 5 vols. and index. Albany: F. B. Lyon Co., 1912.
737. Pink, Louis H., and Rutherford E. Delmage, ed. *Candle in the Wilderness*. New York: Appleton-Century-Crofts, 1957. Background.
738. Pitz, Henry C. *Pen, Brush and Ink*. New York: Watson-Guptill Publications, 1949. Text, illustration.
739. ———, introduction by. *Frederic Remington*. New York: Dover Publications, 1972. Text and 173 illustrations.
740. (Players, The) "A Saturday Night at The Players," *Harper's Weekly*, Feb. 15, 1890, p. 124. George H. Hessop.
741. Prentice, Ezra P., *et al. Programme Eleventh Annual Mounted Games, Squadron "A."* New York: Robertson & Wallace, 1901. Illustration.
742. ———. *Programme Twelfth Annual Mounted Games, Squadron "A."* New York: Roy Press, 1902. Illustration.
743. Prentis, Noble L. *A History of Kansas*. Topeka: Caroline Prentis, 1909. Illustration.
744. Pringle, Henry F. *Theodore Roosevelt*. New York: Harcourt, Brace & Co., 1931. Text.
745. Prown, Jules David. *American Painting*. Cleveland: Skira, 1970. Text.
746. (Putnam) Heyneman, Julie Helen. *Desert Cactus*. London: Geoffrey Bles, 1934. Text.
747. Pyle, Howard. "A Small School of Art," *Harper's Weekly*, July 17, 1897, p. 710. Text.
748. (———) Abbott, Charles D. *Howard Pyle*. New York: Harper & Brothers, 1925. 2 letters.
749. (———) Pitz, Henry C. *Howard Pyle*. New York: Clarkson N. Potter, 1975. Text.
750. *The Quarterly Illustrator*. Vols. 1 and 2 (1893–94).
751. Rains Galleries, New York. *The Famous Frederic Remington Collec-*

tion Formed by the Late Merle Johnson, Books, Written and Illustrated by Frederic Remington. Sale Catalog 553. 1937.

752. Ralph, Julian. "Behind the 'Wild West' Scenes," *Harper's Weekly*, Aug. 18, 1894, p. 775. Illustration.

753. ———. "Canadian Backwoods Architecture," *Harper's Weekly*, Jan. 25, 1890, p. 74. Text, illustration.

754. ———. *Dixie or Southern Scenes and Sketches*. New York: Harper & Brothers, 1896. Illustration.

755. ———. "Frederic Remington," *Harper's Weekly*, Jan. 17, 1891, p. 43. Biography.

756. ———. "Frederic Remington," *Harper's Weekly*, July 20, 1895, p. 688. Photo and biography.

757. ———. "How a Tourist Sees Richmond," *Harper's Weekly*, Feb. 24, 1894, p. 179. Text, illustration.

758. ———. *The Making of a Journalist*. New York: Harper & Brothers, 1903. Text.

759. ———. *On Canada's Frontier*. New York: Harper & Brothers, 1892. Text, illustration.

760. ———. *Our Great West*. New York: Harper & Brothers, 1893. Illustration.

761. ———. "Shoot! Shoot!" *Harper's Weekly*, Jan. 11, 1890, p. 26. Text, illustration.

762. ———. "Trout-Fishing Through the Ice," *Harper's Weekly*, Mar. 15, 1890. Text, illustration.

763. (———) Obituary, *Harper's Weekly*, Jan. 31, 1903, p. 186.

764. Rand, Jerry. "The Reviews: Remington, Painter of the Old West." No publisher or date.

765. (Ranger) Bell, Ralcy Husted. *Art-Talks with Ranger*. New York: G. P. Putnam's Sons, 1914. Background.

766. Rathbone, Perry T., ed. *Westward the Way*. City Art Museum of St. Louis, 1954. Text, illustration.

767. Raymond, Dora Neill. *Captain Lee Hall of Texas*. Norman: University of Oklahoma Press, 1940. Text, illustration.

768. Rea, George B. *Facts and Fakes about Cuba*. New York, 1897. Text.

769. Reid, Mayne. *The White Chief*. New York: Carleton, 1879. Background.

770. (Reid, Robert) New York *Times*, Dec. 3, 1909. "Artist Reid a Bankrupt."

771. Reinhardt's Annex Gallery, Chicago. *Special Exhibition of Paintings by Frederic Remington and Portraits by A. de Ferraris of Vienna*. 1908.

772. (Remington Art Memorial) The Frederic Remington Memorial, *Catalog*. Ogdensburg, n/d. Entrance Hall, east galleries.

773. ———, pamphlet. Cover is Parish residence.

774. ———. *The Artist*, pamphlet, n/d.

775. ———. *A Catalogue of the Memorial Collection*. New York: The Knoedler Galleries, 1954.

776. Remington Art Museum. 6-page pamphlet, "Antoine's Cabin" on cover.

777. ———. *50th Anniversary*. Ogdensburg, 1973.

778. ———, 6-page pamphlet, "The Outlier" on cover.

779. "Remington Memorial," Emma L. Caten. *American Magazine of Art*, vol. 14, no. 10 (Oct. 1923), p. 550.

780. (Remington, Clara Bascomb Sackrider) Obituary, St. Lawrence *Plain-dealer*, Mar. 19, 1912. "Mrs. Clara Sackrider Levis."

781. (Remington, Eva) Ogdensburg *Journal*, Nov. 8, 1918. "Remington Will Made Public."

782. (Remington, Frederic) (Appendicitis) New York *Times*, Mar. 12, 1905, sec. III, p. 5. "Don't Think New York Will Catch the Operation Mania."

783. ———. "The Attack on the Camp/Johnson charging the infantry up hill." Page from 1896 sketch book with description on reverse.

784. ———. Book, Thackeray's *Vanity Fair*, 1868 edition, signed S. P. Remington.

785. ———. Bookplate. Buffalo skull between Ex Libris and signature, in *Zoological Report to Routes in California*, by R. S. Williamson.

786. ———. Bookplate in *Message to Congress*, by James K. Polk.

787. ———. *A Bunch of Buckskins*. New York: R. H. Russell, 1901. Also published in sets, with *Indians* and *Rough Riders*.

788. ———. *Collier's Large Folio with Hard Boards*, 1904–8. Six color prints c. 11 × 17 inches print area.

789. (———) "Coming Through the Rye." New York *Times*, June 23, 1976.

790. ———. *Crooked Trails*. New York: Harper & Brothers, 1898. Also Boy Scout Edition, Grosset & Dunlap, c. 1913.

791. ———. *Harper's Weekly*, Oct. 8, 1898, p. 996. Book review of *Crooked Trails*.

792. ———. *Harper's Weekly*, Nov. 12, 1898, p. 1119. Advertisement, *Crooked Trails*.

793. ———. Diaries 1907, 1908, 1909.

794. ———. *Done in the Open*. New York: P. F. Collier & Son, 1902.

795. ———. *Drawings*. New York: R. H. Russell, 1897. Wister foreword.

796. ———. *Eight New Remington Paintings*. New York: P. F. Collier & Son, 1909.

797. ———. *Frederic Remington Four Pictures: 1906–07*. New York: P. F. Collier & Son, 1907.

798. ———. *Frederic Remington's Paintings*. New York: P. F. Collier & Son, 1908.

799. ———. *Frontier Sketches*. Akron: The Werner Co., 1898. Introduction by George S. Rowe.

800. ———. "The Galloping Sixth," *Army and Navy Journal*, Jan. 16, 1892, p. 355. Also editorial.

801. ———. *Ibid*. Letter Feb. 6, 1892, from Alonzo Gray to *Army and Navy Journal*, p. 412.

802. ———. *Ibid*. Letter Feb. 20, 1892, from W. C. Brown to *Army and Navy Journal*. Also letter from R. H. Davis as managing ed., *Harper's Weekly*.

803. ———. Genealogy. St. Lawrence *Plaindealer*, Sept. 24, 1940. "Frederic Remington Came of Old English Family."

804. ———. Genealogy of Sackriders. Kansas State Historical Society.

805. ———. Genealogy of Catens. *Fulton County Census Records*, 1875, 1880. Remington/Caten wedding certificate. (Kathleen L. Kosuda, Gloversville Free Library.)

806. ———. Gothum. "Riding in New York/By a Rider," *Harper's Magazine*, Sept. 1887, p. 489.

807. ———. *"Horses of the Plains"* and *"A Scout with the Buffalo-Soldiers."* Excerpts from *The Century Magazine*. Santa Barbara: W. T. Genns.

808. ———. *House Book*. Record of 1888 trip to Arizona and Indian Territory. 36 pages. KSHS.

809. ———. "Indians as Irregular Cavalry" and "Sitting Bull and the Indians," *Harper's Weekly*, Dec. 27, 1890, p. 1002. President favors Remington position.

810. ———. "In the Bad Lands," *Harper's Weekly*, Jan. 10, 1891, p. 18. General Miles and Red Cloud.

811. ———. "Indian Recruits for the Army," *Harper's Weekly*, Mar. 26, 1892, p. 290. Legislation.

812. ———. "Army Officers as Indian Agents," *Harper's Weekly*, Apr. 23, 1892, p. 386.

813. ———. *John Ermine of the Yellowstone*. New York: The Macmillan Co., 1902.

814. ———. "At the Play," *Harper's Weekly*, Sept. 14, 1901, p. 932. Background.

815. ———. Programme, Globe Theatre, Boston. Week of Sept. 14 to 20, 1903.

816. ———. "James K. Hackett as *John Ermine*," *Harper's Weekly*, Nov. 21, 1903, p. 1868.

817. ———. "Failed to draw in New York," *Harper's Weekly*, Dec. 19, 1903, p. 2061.

818. ———. *Journal of a Trip across the Continent through Arizona and Sonora Old Mexico*. On cover is "Frederic Remington/Canton, St. Law. Co., N.Y." 1886.

819. ———. "The Last Lull in the Fight," *Harper's Weekly*, Mar. 30, 1889, p. 244. Article referring to "the artist."

820. ———. "The Last of the Apaches." Unpublished manuscript printed later as "How an Apache War Was Won."

821. ———. "The Last Stand," *Harper's Weekly*, Jan. 10, 1891, p. 23.

822. ———. "Lt. Johnson and the 10th U. S. Cavalry in Arizona," *Harper's Weekly*, Dec. 22, 1888, p. 989.

823. ———. *Men with the Bark On*. New York: Harper & Brothers, 1900.

824. ———. Advertisement for *Men with the Bark On*. "The Best Books

for Summer Reading," Harper & Brothers. *Harper's Weekly*, June 9, 1900, p. 522.

825. ——. "Personal," *Harper's Weekly*, Apr. 27, 1889, p. 327. Mexican trip. The regular army of Mexico under Remington's orders.

826. ——. "Mexican Troops in Sonora," *Harper's Weekly*, Aug. 7, 1886, p. 509.

827. (——) Obituary, Albany *Evening Journal*, Dec. 27, 1909.

828. (——) Obituary, Brooklyn *Daily Eagle*, n/d.

829. (——) The Carthage (Mo.) *Evening Press*, c. Dec. 28, 1909, "Artist Remington Is Dead."

830. (——) (Chicago ?) *Times*, Dec. 27, 1909. "Frederic Remington, Painter of Western Themes, Is Dead."

831. (——) Obituary, *LIFE*, c. Jan. 1910.

832. (——) New Rochelle *Paragraph*, Dec. 31, 1909. "Frederic Remington Dies."

833. (——) New Rochelle *Pioneer*, Jan. 10, 1910, p. 8. "Artist Remington Dead."

834. (——) New Rochelle *Evening Standard*, Dec. 27, 1909, p. 1. " 'Fred' Remington Died Yesterday."

835. (——) New York *Daily Tribune*, Dec. 27, 1909. "Remington Dead."

836. (——) New York *Times*, Dec. 27, 1909. "Remington, Painter and Author, Dead."

837. (——) New York *World*, Dec. 27, 1909. "Remington, the Artist Is Dead of Appendicitis."

838. (——) Watertown *Daily Times*, Dec. 27, 1909. "Remington Dies After Brief Illness."

839. (——) Watertown *Daily Times*, Dec. 28, 1909. "Many at Funeral of Remington," "Dr. Gunnison's Tribute to Frederic Remington." "Had Many Friends in Ogdensburg."

840. (——) Obituary. Unidentified clipping, West Mount Vernon. "At this time there is no artist's works better known."

841. ——. Paintings. List by Remington, his catalogue raisonné of 162 paintings he acknowledged at end of 1908. Some purchasers and prices specified.

842. ——. Photographs. Ella Remington Mills, photos of Grandpa Remington, Mart, Aunt Maria, and Josie; daguerreotype of Grandpa Remington. 3 photos of Col. S. P. Remington and 2 autographed pictures of Frederic Remington. All at Remington Art Museum.

843. ——. Photographs at Remington Art Museum; shots Remington made of horses with legs flexed or light reflected, album of instantaneous photographs taken with Scovill Detective Camera as brown prints, 2½" × 3½", of Arizona.

844. ——. *Pony Tracks*. New York: Harper & Brothers, 1895. Edited reprint of 15 articles, with sequences, punctuation, titles revised.

845. ——. *Ibid*. The Harold McCracken Edition. Columbus: Long's College Book Co., 1951.

846. ——. Advertisement for *Pony Tracks;* "Books Just Published." *Harper's Weekly,* July 27, 1895, p. 718.

847. ——. Advertisement for *Pony Tracks;* "Books for the Season." Reprinted reviews from Chicago *Inter-Ocean* and Boston *Transcript.*

848. ——. Advertisement. "Two Books by Frederic Remington." *Harper's Weekly,* Nov. 12, 1898, p. 1119. Reviews from Boston *Journal* and Brooklyn *Times.*

849. (——) "Pony Tracks in the Buffalo Trails." Melville Millar to A. W. Tillinghast quoted in catalog, American Art Association, Anderson Galleries, New York, Feb. 20, 1930.

850. ——. Postcards. Forrest Lyons, Jr. *Collectors Guide to Postcards.* Gas City, Ind.: L-W Promotions, 1974.

851. ——. Prints. *Remington's Four Best Paintings.* New York: P. F. Collier & Son, 1908. Some cropped with replaced signature.

852. ——. "A Questionable Companionship," *Harper's Weekly,* Aug. 9, 1890, p. 627. Textual reference.

853. ——. *A Rogers Ranger in the French and Indian War.* New York: Harper & Brothers, 1897.

854. ——. Sculpture. Remington's own list of 19 bronze statuettes cast in his lifetime. KSHS.

855. ——. Sculpture. The Tiffany & Co. *Blue Book,* 1896–1909, New York.

856. ——. Sculpture. New York *Times,* Nov. 15, 1896, p. 5. "American Art Association, Notable Pictures."

857. ——. Sketches. New-York Historical Society: Portfolio of 32 sketches and 10 letters, 1945. Includes kicking burro bookplate.

858. ——. Sketches. Notebooks at Remington Art Museum: about 25 bound books c. 4″ × 8″ and loose sheets 10″ × 14″. Pages removed.

859. ——. Stamps. Suzanne J. Hansberry, "He Knew the Horse," *Minkus Stamp Journal,* vol. XIII, no. 1 (1978). Biography and review.

860. ——. *Stories of Peace and War.* New York: Harper & Brothers, 1899.

861. ——. "The Story of a Man." Unpublished manuscript.

862. ——. *Sundown Leflare.* New York: Harper & Brothers, 1899. 5 stories from *Harper's Monthly,* Sept. 1897 to Nov. 1898.

863. ——. "Taos," unpublished article.

864. ——. *The Way of an Indian.* New York: Fox Duffield & Co., 1906.

865. ——. *De Witte Otter (The Way of an Indian).* Amsterdam: H. Meulenhoff, 1920. Illustrated by Jan Wiegman.

866. ——. *Western Types.* Prints. New York: Charles Scribner's Sons, 1902. Also separate issue of smaller prints.

867. (Remington, Lamartine Z.) Albany *Morning Express,* Dec. 11, 1884. Obituary.

868. (——) *Ibid.,* Dec. 13, 1884. "His was a condensed life." Obituary of Lamartine Remington.

869. (Remington, Seth Pierre) *War of the Rebellion.* Washington, 1889. Series I, vol. 27, part 1, p. 1037. Report of James B. Swain, Colonel, on Fairfax Court-House action of Major Remington, June 27, 1863.

870. (——) Surrender demand from J. R. Scott, Col. Comdg/Hd. Qurs. Cav. Brigade/Aug. 5, 1864.

871. ——. Report of Maj. S. Pierre Remington, c. Aug. 8, 1864.

872. (——) Statement of the Military Service of S. Pierre Remington, furnished April 15, 1943, by authority of the Secretary of War.

873. (——) Appointment Dec. 24, 1873, by Ulysses S. Grant, President, of Col. Remington as Collector of Customs for Oswegatchie.

874. (——) St. Lawrence *Plaindealer*, Feb. 28, 1880. Obituary.

875. Rockwell, George L. *The History of Ridgefield.* 1927, p. 438.

876. (——) *Commercial Advertiser*, c. May 1943. "Geo. L. Rockwell Knew Frederic Remington, Artist."

877. *Rocky Mountain News* (Denver), July 14, 1888. "Remington's Suicide."

878. Rogers, W. A. *A World Worth While.* New York: Harper & Brothers, 1922. Text.

879. Roosevelt, Kermit. *The Long Trail.* New York: Metropolitan Publications, 1921. Text.

880. Roosevelt, Theodore. "An Appreciation of the Art of Frederic Remington," *Pearson's Magazine*, Oct. 1907, p. 403.

881. ——. *An Autobiography.* New York: Charles Scribner's Sons, 1913. Text.

882. ——. *Big Game Hunting in the Rockies and on the Great Plains/* Comprising "Hunting Trips of a Ranchman" and "The Wilderness Hunter." New York: G. P. Putnam's Sons, 1899. Illustration.

883. ——. *Good Hunting.* New York: Harper & Brothers, 1907. Illustration.

884. ——. *Ranch Life and the Hunting Trail.* New York: The Century Co., 1888. Illustration. Also 1901 edition with additional illustrations.

885. ——. *The Rough Riders.* New York: Charles Scribner's Sons, 1899.

886. ——. *Stories of the Great West.* New York: The Century Co., 1909. Illustration.

887. ——. *The Winning of the West.* New York: P. F. Collier & Son, 1903. Illustration.

888. ——. "Who Should Go West?" *Harper's Weekly*, Jan. 2, 1886, p. 7.

889. ——. *The Wilderness Hunter.* New York: G. P. Putnam's Sons, 1893. Illustration.

890. ——. *The Frederic Remington Monument Fund.* Theodore Roosevelt, Custodian and Treasurer. Homer Davenport, Secretary. Pamphlet 2pp., 1910.

891. (——) Rochester (N.Y.) *Herald*, Aug. 28, 1910. "Cowboys Whoop It for Roosevelt." On Remington Monument Fund.

892. (——) *Rocky Mountain News*, Aug. 28, 1910, p. 2. "Statue to Remington, TR's Plea."

893. Rossi, Paul A., and David C. Hunt. *The Art of the Old West.* New York: Alfred A. Knopf, 1973. Text, illustration.

894. Rubinfine, Joseph. *Autographs.* List 48. Pleasantville, N.J., n/d. Item 163.

895. Ruckstull, F. W. *Great Works of Art and What Makes Them Great.* Garden City, N.Y.: Garden City Publishing Co., 1925. Text.

896. Rugoff, Milton. *Prudery and Passion/Sexuality in Victorian America.* New York: G. P. Putnam's Sons, 1971. Background.

897. Rush, N. Orwin. *Frederic Remington and Owen Wister.* Tallahassee: Florida State University, 1961.

898. ———. "Remington the Letter Writer," *American Scene,* vol. 4, no. 4 (1964), p. 28.

899. (Russell, C. M.) Austin Russell. *Charles M. Russell/Cowboy Artist.* New York: Twayne Publishers, 1957. Text.

900. (———) Garst, Shannon. *Cowboy-Artist.* New York: Julian Messner, 1960. Text.

901. (———) "How a Woman Made a Cowpuncher into another Remington," *The Main Trail,* "Nancy Russell Issue," vol. 2, no. 1 (Autumn 1973).

902. Russell, Robert Howard. *Star Gambol of the Lambs, May 1898.* New York: R. H. Russell, 1898. Illustration.

903. ———. Agreement Dec. 7, 1896, with Remington for publication of *Drawings,* Eva A. Remington as witness.

904. ———. Agreement Apr. 4, 1899, with Remington for publication of a set of prints, Eva A. Remington as witness.

905. (Russia) Remington visa Mar. 29, 1892.

906. Saint-Gaudens, Homer. *The American Artist and His Times.* New York: Dodd, Mead and Co., 1941. Text.

907. ———, edited and amplified by. *The Reminiscences of Augustus Saint-Gaudens.* 2 vols. New York: The Century Co., 1913. Text.

908. (St. Lawrence Co.) *Gazetteer and Business Directory of St. Lawrence County, N.Y., for 1873–4.* Hamilton Child. Syracuse: The Journal, 1873.

909. St. Lawrence *Plaindealer,* summer 1877. "A trip into the woods."

910. ———, Aug. 10, 1881. "A trial of life on a ranche."

911. ———, Aug. 2, 1882. "Struck for the woods."

912. ———, Nov. 15, 1882. William Remington elected.

913. ———, Feb. 28, 1883. "To start for Dakota."

914. ———, Feb. 27, 1884. "On a visit from Kansas."

915. ———, Apr. 18, 1888. "When Artist Frederic Remington was in Blossom." Reprint of contemporary quote from New York *Herald.*

916. ———, July 2, 1889. "Art Honors to Frederic Remington at Paris."

917. ———, Aug. 23, 1932. Description of Remington at 20.

918. ———, July 20, 1943. "Some of Fred Remington's Letters Come to Light."

919. ———, July 27, 1943. "Tells How Osteopath Works on the Artist."

920. (St. Louis Exposition) Walter B. Stevens, introduction by. *The World's Fair.* St. Louis: N.D. Thompson Publishing Co., 1903. Background.

921. St. Louis *Globe Democrat,* Feb. 17, 1923. Remington and Russell.

922. St. Louis *Star,* Mar. 10, 1910. Remington and Russell.

923. *St. Nicholas,* vol. XIV, (Nov. 1886–Apr. 1887) part 1. Illustration. Also vol. XVII, part 1; vol. XV, part 1; vol. XVIII, part 1.

924. (——) *Panther Stories Retold* (from *St. Nicholas*). M. H. Carter. New York: The Century Co., 1904. Illustration.

925. (——) *Indian Stories Retold* (from *St. Nicholas*). New York: The Century Co., 1906. Illustration.

926. (Salmagundi Club) William Henry Shelton. *The History of the Salmagundi Club.* New York: privately printed, 1927. Background.

927. Samuels, Peggy and Harold. *The Collected Writings of Frederic Remington.* Garden City, N.Y.: Doubleday & Co., 1979. Text, illustration.

928. ——. "Frederic Remington and the Cow-skin Quarter-horse," *Speedhorse,* vol. 13, no. 5 (Jan. 1981) p. 86.

929. ——. "Frederic Remington as Soldier Artist," in *Frederic Remington the Soldier Artist.* West Point: United States Military Academy, 1979.

930. ——. "Frederic Remington's Stirrings in Kansas City," *Missouri Historical Society Bulletin,* Oct. 1978.

931. ——. "Frederic Remington, the Holiday Sheepman," *The Kansas Historical Quarterly,* Spring 1979.

932. ——. "Frederic Remington, Well Documented Artist, Left Dim Young Tracks in Montana," *Montana Post,* vol. 16, no. 3 (Aug.–Sept. 1978).

933. ——. *The Illustrated Biographical Encyclopedia of Artists of American West.* Garden City, N.Y.: Doubleday & Co., 1976.

934. (*Santa Fe Railway Collection*) *An Exhibition of Paintings of the Southwest from the Santa Fe Railway Collection.* c. 1960. 600 paintings in collection. Background.

935. *Saturday Evening Post,* Nov. 10, 1900, p. 15. "Frederic Remington's First Painting." Also 1901, 1903.

936. Savoy Art & Auction Galleries. Sale No. 71, Oct. 8, 1943. New York. The estate of Sally James Farnham. Remington reference.

937. Scott, Hugh Lenox. *Some Memories of a Soldier.* New York 1909. Text.

938. *Scribner's Magazine,* vol. 11 (Jan.–June 1892). William A. Coffin, "American Illustrators of To-day." Also 1893.

939. ——, vol. 25 (Jan.–June 1899). "The Rough Riders." Text, illustration. Also 1901.

940. ——, vol. 32 (July–Dec. 1902). "Western Types." Text, illustration.

941. ——, vol. 47 (Jan.–June 1910). Royal Cortissoz, "Frederic Remington: A Painter of American Life." Text, illustration.

942. ——, vol. 101, no. 1 (Jan. 1937). *Fiftieth Anniversary.* Illustration.

943. (Scribner, Stories from) *Stories of the South.* New York: Charles Scribner's Sons, 1893. Illustration.

944. Seely, Howard. *The Jonah of Lucky Valley.* New York: Harper & Brothers, 1892. Illustration.

945. Seitz, Don C. *Joseph Pulitzer*. New York: Simon & Schuster, 1924. Background.

946. Seoane, C. A. "Remington's Cavalryman," *Cavalry Journal*, vol. 52, no. 6 (Nov.–Dec. 1943), pp. 86–87. Text, illustration.

947. Sheldon, George William. *Recent Ideals of American Art*. New York: D. Appleton and Co., 1888. Text, illustration.

948. Shipman, Louis Evan. *The True Adventures of a Play*. New York: Mitchell Kennerley, 1914. Background.

949. Simmons, Edward. *From Seven to Seventy*. New York: Harper & Brothers, 1922. Text.

950. (Smedley, W. T.) "Personal," *Harper's Weekly*, Dec. 3, 1892, p. 1167. Remington at dinner.

951. Smiley, Nixon. *Yesterday's Florida*. Miami: E. A. Seeman Publishing, n/d. Bone Mizell.

952. Smith, F. Hopkinson. *American Illustrators*. New York: Charles Scribner's Sons, 1892. Text, illustration.

953. Smith, Thomas West. *The Story of a Cavalry Regiment*. Chicago: W. B. Conkey Co., 1897. Text on the Colonel.

954. Snodgrass, Jeanne O., compiled by. *American Indian Painters*. New York: Museum of the American Indian, 1968. Kicking Bear and Whirlwind.

955. Society of American Artists. *Fourteenth Exhibition*. New York, 1892. Listing.

956. Society of Friendly Sons of St. Patrick in N.Y.C. *121st Anniversary Dinner*. New York, 1905. Illustration.

957. Society of Illustrators. *Catalogue of the Second Annual Exhibition*. New York, 1903. Listing.

958. ———. *Annual*, with an introduction by Royal Cortissoz. New York: Charles Scribner's Sons, 1911. Text, illustration.

959. *The Spanish-American War*. Alger, R. A. New York: Harper & Brothers, 1901. Background.

960. (———) Azoy, A.C.M. *Charge!* New York: Longmans, Green and Co., 1961. Text.

961. (———) (Poultney Bigelow) *Harper's Weekly*, July 16, 1898, p. 682.

962. (———) Chidsey, Donald Barr. *The Spanish-American War*. New York: Crown Publishers, 1971.

963. (———) "The Horrors of Our War," *Harper's Weekly*, Sept. 10, 1898, p. 882.

964. (———) "Mr. Roosevelt's Testimony," *Harper's Weekly*, Dec. 3, 1898, p. 1170.

965. (———) Wheeler, Joseph. *The Santiago Campaign 1898*. Philadelphia: Drexel Biddle, 1899. Background.

966. Spofford, A. R., ed. *The Library of Historical Events and Famous Events*. Philadelphia: William Finley & Co., 1896. Illustration.

967. Squires, Henry C. *Catalog of Sportsmen's Supplies*. New York: Knickerbocker Press, 1891. Text.

968. Stallman, R. W. *Stephen Crane.* New York: George Braziller, 1968. Text.

969. Stanley, Henry M. *Slavery and the Slave Trade in Africa.* New York: Harper & Brothers, 1893. Illustration.

970. Stark Museum of Art. *The Western Collection 1978.* Julie Schimmel. Orange, Texas. 4 drawings and 14 bronzes. 21 letters, 3 notes, and 2 postcards to Bertelli.

971. State Department. Special Passport No. 1082 to Remington. Signed James G. Blaine, Secretary of State, April 15, 1892.

972. ———. Introduction April 16, 1892, of Remington for travel abroad under commission from *Harper's Magazine.* Signed James G. Blaine.

973. Steele, Matthew Forney. *American Campaigns.* Washington: U. S. Infantry Association, 1935. Background.

974. Steinfels, Margaret O'Brien. *Who's Minding the Children?* New York: Simon and Schuster, 1973. History of day care.

975. Stevens, Montague. *Meet Mr. Grizzly.* London: Robert Hale Ltd., 1950. Text, illustration.

976. Stillman, J.D.B. *The Horse in Motion.* Boston: Osgood, 1882. Text.

977. Stokes, Anson Phelps. *Memorials of Eminent Yale Men.* New Haven: Yale University Press, 1914. Text.

978. Storke, Thomas M. *California Editor.* Los Angeles: Westernlore Press, 1958. Text.

979. *Success,* May 13, 1899. Charles H. Garrett, "Remington and His Work." Illustration.

980. Sullivan, Mark. *Our Times.* 4 vols. New York: Charles Scribner's Sons, 1932. Background.

981. Summerhayes, John Wyer. Contents of War Department personnel file.

982. Summerhayes, Martha. *Vanished Arizona.* Salem, Mass.: The Salem Press Co., 1911. Text, illustration.

983. Sydenham, Alvin H. *Frederic Remington.* New York Public Library, 1940, p. 609. Text.

984. ———. "Tommy Atkins in the American Army," *Harper's Weekly,* Aug. 13, 1892. Illustration.

985. Taft, Robert. *Artists and Illustrators of the Old West.* New York: Charles Scribner's Sons, 1953. Text.

986. ———. *Photography and the American Scene.* New York: The Macmillan Co., 1938. Reprinted Dover Publications, 1964. Text, illustration.

987. ———. "The Pictorial Record of the Old West. V. Remington in Kansas," *The Kansas Historical Quarterly,* vol. XVI, no. 2 (May 1948).

988. ———. "Chapter VII/Sheep-Ranching in Kansas." Manuscript.

989. Taos newspaper clipping, unidentified, c. Dec. 1900. Remington visit with Bert Phillips.

990. Tappan, Eva March, selected and arranged by. *Adventures & Achievements,* vol. 8, *The Children's Hour.* Boston: Houghton Mifflin & Co., 1907. Illustration.

991. Thomas, Augustus. *Arizona/A Drama in Four Acts*. New York: R. H. Russell, 1899. Illustration.

992. ———. *The Print of My Remembrance*. New York: Charles Scribner's Sons, 1922. Text.

993. ———. "Recollections of Frederic Remington," *The Century Magazine*, vol. 86, no. 3 (July 1913), p. 354. Text.

994. ———. *Souvenir of the 100th Performance of "Arizona."* Chicago, 1899. Illustration.

995. (———) "Personal and Pertinent," *Harper's Weekly*, May 18, 1907, p. 724.

996. Thompson, Slason. *Eugene Field*. 2 vols. New York: Charles Scribner's Sons, 1901. Background.

997. Throop, George E. *Squadron "A" Games, Souvenir Program*. New York: Fox Press, 1897. Illustration.

998. *Time*, July 15, 1946. "He Knew the Horse." Text, illustration.

999. *Today's Art*, vol. VIII, no. 11 (Dec. 1960), p. 6. "Reputations Re-examined." Biography and illustration.

1,000. Tooker, L. Frank. "As I Saw It from an Editor's Desk," *The Century Magazine*, vol. 107, no. 2 (Dec. 1923), p. 257. Background.

1,001. Topeka *Capital-Journal*, Mar. 31, 1974. David Arnold. "Remington in Kansas."

1,002. Topeka *Journal*, Dec. 28, 1909. "Remington in Kansas."

1,003. ———, Mar. 17, 1920 (1930?). Clipping, W. Findlay rebuys painting.

1,004. Turner, Frederick Jackson. *Frontier and Section: Selected Essays*. Englewood Cliffs, N.J.: Prentice Hall, 1961. Background.

1,005. *Turner's Directory for New Rochelle*. Yonkers: E. F. Turner & Co., 1897.

1,006. ('21' Club) Maria Naylor, "Frederic Remington at the '21' Club, New York," *The Connoisseur*, Dec. 1973, p. 260. Text, illustration.

1,007. Twitchell, Ralph Emerson. *The History of the Military Occupation of the Territory of New Mexico*. Denver: The Smith-Brooks Co., 1909. Illustration.

1,008. The Union League Club, New York. *Painting by Contemporary Americans*. 1903.

1,009. ———. *American Figure Paintings*. 1904.

1,010. Universalism. A Believer. *The Universalist's Assistant*. Boston: Abel Tompkins, 1846. Background.

1,011. (Universalism) Rogers, George. *The Pro and Con of Universalism*. Cincinnati: published by the author, 1843.

1,012. (———) Smith, Matthew Hale. *Universalism Not of God*. New York: American Tract Society, 1825.

1,013. Vail, R.W.G., "The Frederic Remington Collection," *Bulletin of The New York Public Library*, vol. 33, no. 2 (Feb. 1929). Text, illustration.

1,014. Verestchagin, Vassili. *Painter, Soldier, Traveler. Autobiographical*

sketches by F. H. Peters. New York: The American Art Association, 1888. Background.

1,015. Vermont Episcopal Institute. *34th annual report,* June 17, 1890. Appendix E of *Journal of the Centennial.* Montpelier, 1890. Background.

1,016. Vesey-Fitzgerald, Brian. *The Book of the Horse.* London: Nicholson, 1946. Text.

1,017. Vestal, Stanley. *The Missouri.* The Rivers of America. New York: Farrar & Rinehart, 1945. Text.

1,018. ———. *Sitting Bull.* Boston: Houghton Mifflin Co., 1932. Text.

1,019. Vincent, George E., ed. *Theodore W. Miller/Rough Rider.* Akron: privately printed, 1899. Text.

1,020. Vorpahl, Ben Merchant. *Frederic Remington and the West.* Austin: University of Texas Press, 1978. Biography and illustration.

1,021. ———. *My dear Wister.* Palo Alto, Cal.: American West Publishing Co., 1972. Biography and illustration.

1,022. Walker, Dale L. *Death Was the Black Horse.* Austin: Madrona Press, 1975.

1,023. Wallach, Amel. "Abundant Degas," *Newsday* (Long Island, N.Y.), Feb. 25, 1977, p. 10A. The Muybridge connection.

1,024. Walnut Valley *Times,* Jan. 11, 1884. "Plum Grove on Christmas Eve."

1,025. ———, Feb.(?) 1884. Miss Ada Smith, who had Remington scrapbook.

1,026. Walsh, Richard J., in collaboration with Milton S. Salsbury. *The Making of Buffalo Bill.* Indianapolis: Bobbs-Merrill, 1928. Text.

1,027. Walworth, Jeannette H. *History of New York in Words of One Syllable.* Chicago: Belford, Clarke & Co., 1888. Illustration.

1,028. Wanamaker, Rodman. *A Tribute to the North American Indian.* Philadelphia: privately printed, 1909. Text.

1,029. Wardman, Ervin. *Squadron "A" Games, Souvenir Program, 1898.* New York: Gilliss Brothers, 1898. Illustration.

1,030. Ware, Eugene F. *The Indian War of 1864.* Lincoln: University of Nebraska Press, 1960. Background.

1,031. Warner, Charles Dudley. *Our Italy.* New York: Harper & Brothers, 1891. Illustration.

1,032. Watertown *Daily Times,* Nov. 26, 1920. Remington bucked off bronc.

1,033. ———, Sept. 16, 1961. "Frederic Remington's Father Was Staunchest Republican."

1,034. ———, Sept. 27, 1961. "Boyhood Life of Artist Told."

1,035. ———, n/d. "The Remingtons/Main Street Window Column."

1,036. ———, Oct. 21, 1961. "Remington Letters Reveal."

1,037. ———, Oct. 23, 1961. "Remington as Individualist Revealed."

1,038. Wear, Bruce. *The Bronze World of Frederic Remington.* Tulsa: Gaylord, Ltd., 1966. Text, illustration.

1,039. ———. *The 2nd Bronze World of Frederic Remington.* Upper Montclair, N.J.: Ranch Publishing Co., 1976. Text, illustration.

1,040. ———, "The Art of Frederic Remington. The Making of a Bronze," *The American Scene*, vol. IV, no. 2 (Summer 1961) pp. 18–19. Text, illustration.

1,041. Webster, Clarence J. "Frederic Remington Was A Carefree Canton Youth," Watertown *Daily Times*, Aug. 9, 1932, p. A10.

1,042. ———. "Remington Painted The Western Horse As He Was," Watertown *Daily Times*, Aug. 11, 1932, p. A12.

1,043. ———. "Some of Remington's Works Are Found in North Country," Watertown *Daily Times*, Aug. 12, 1932, p. A13.

1,044. (Weir, J. Alden) Young, Dorothy Weir. *The Life & Letters of J. Alden Weir*. New Haven: Yale University Press, 1960. Text.

1,045. (Weir, John Ferguson) *The Recollections of John Ferguson Weir*. Sizer, Theodore, ed. The New-York Historical Society, 1957. Background.

1,046. Weist, Katherine M. "Ned Casey and His Cheyenne Scouts," *Montana the magazine of Western History*, vol. XXVII, no. 1 (Winter 1977).

1,047. Weitenkamph, Frank. *The Illustrated Book*. Cambridge: Harvard University Press, 1938. Text.

1,048. Wells, John D. *Old Good-by's and Howdy-do's*. Buffalo: Otto Ulbrich Co., 1911. Poem.

1,049. West, Herbert Faulkner. *The Mind on the Wing*. New York: Coward-McCann, Inc., 1947. Text, illustration.

1,050. (Western Literature) Branch, Douglas. *The Cowboy and His Interpreters*. New York: Cooper Square Publishers, 1961. Background.

1,051. (———) Fiedler, Leslie A. *The Return of the Vanishing American*. New York: Stein and Day, 1968. Background.

1,052. (———) Keiser, Albert. *The Indian in American Literature*. New York: Oxford University Press, 1933. Background.

1,053. Wetmore, Helen Cody. *Last of the Great Scouts*. Chicago: The Duluth Press Publishing Co., 1899. Illustration.

1,054. Wheelwright, John. "Remington and Winslow Homer," *Hound & Horn*, vol. 6, no. 4 (July–Sept. 1933), p. 611. Text.

1,055. White, G. Edward. *The Eastern Establishment and the Western Experience*. New Haven: Yale University Press, 1968. Text.

1,056. White House, The. Invitation Feb. 16, 1905, to Mrs. Remington for reception.

1,057. ———. Announcement Feb. 17, 1906, of marriage of Roosevelt's daughter.

1,058. ———. Invitation Feb. 7, 1907, to Remingtons for reception.

1,059. ———. Invitation Feb. 20, 1908, to Remingtons for reception.

1,060. ———. Invitation Feb. 18, 1909, to Remingtons for reception.

1,061. Whitney, Caspar W. "The Butchery of Adirondack Deer," *Harper's Weekly*, Jan. 16, 1892, p. 58.

1,062. ———. *On Snow-Shoes to the Barren Grounds*. New York: Harper & Brothers, 1896. Text, illustration.

1,063. Whittier, John Greenleaf. *The Complete Writings*. Amesbury Edition in 7 vols. Cambridge: Houghton Mifflin Co., 1904. Illustration.

1,064. *Who's Who in America*. Chicago: A. N. Marquis & Co., 1899–1910.

1,065. *Who's Who on the Stage 1908*, ed. Walter Browne and E. De Roy Koch. New York: Dodge & Co., 1908. Background.

1,066. Wichita *Eagle* (evening), Feb. 16, 1939. "Of Frederic Remington and of the Halt He Made on Prairies of Kansas."

1,067. ——, March 9, 1945. Victor Murdock, "Kansas Horse in Action."

1,068. Wilcox, Harrison, ed. *Harper's History of the War in the Philippines*. New York: Harper & Brothers, 1900.

1,069. Wildenstein. *How the West Was Won*. New York, 1968. Biography and illustration.

1,070. Wildman, Edwin. "Frederic Remington, the Man," *Outing, the Magazine*, vol. XLI, no. 6 (March 1903), p. 712. Text, illustration.

1,071. Willets, Gilson. *Workers of the Nation*. 2 vols. New York: P. F. Collier & Son, 1903. Illustration.

1,072. (Wilson, Francis) *Francis Wilson's Life of Himself*. Boston: Houghton Mifflin Co., 1924. Mulligan Guards.

1,073. Wilson, Woodrow. *A History of the American People*. Documentary edition in 10 vols. New York: Harper & Brothers, 1901, 1917. Illustration.

1,074. Winkler, John K. *W. R. Hearst*. New York: Simon & Schuster, 1928. Text.

1,075. (Wisconsin) *Historical Sketch of Troop "A."* First Cavalry, Wisconsin National Guard. 20th Anniversary. Milwaukee, 1899. Illustration.

1,076. Wissler, Clark. *The Pageant of America*. New Haven: Yale University Press, 1925. Text.

1,077. Wister, Fanny Kemble. *Owen Wister Out West*. Chicago: University of Chicago Press, 1958. Text, illustration.

1,078. Wister, Owen. *Diary/Journal of Journies*. June 14–Dec. 31, 1893. Western History Research Center. Text.

1,079. ——. *The Jimmyjohn Boss and Other Stories*. New York: Harper & Brothers, 1900. Illustration.

1,080. ——. *A Journey in Search of Christmas*. New York: Harper & Brothers, 1904. Illustration.

1,081. ——. *Lin McLean*. New York: Harper & Brothers, 1897, 1907. Illustration.

1,082. ——. *Members of the Family*. New York: The Macmillan Co., 1911. Text.

1,083. ——. *Red Men and White*. New York: Harper & Brothers, 1896. Illustration.

1,084. (——) "Life and Letters." W. D. Howells, *Harper's Weekly*, Nov. 30, 1895, p. 1133. *Red Men and White*. Text.

1,085. ——. "Remington—An Appreciation." *Collier's Weekly*, Mar. 18, 1905, p. 15. Text, reprinted.

1,086. ——. *Roosevelt*. New York: The Macmillan Co., 1930. Text.

1,087. ——. *The Virginian.* New York: The Macmillan Co., 1902. Background.

1,088. ——. *Ibid.*, new edition with illustrations by Charles M. Russell and drawings by Frederic Remington. 1911.

1,089. (——) Etulain, Richard W. *Owen Wister.* Boise State College, 1973. Biography.

1,090. *Woman's Home Companion*, June 1903. Illustration.

1,091. (Wood, Leonard) Holme, John G. *The Life of Leonard Wood.* Garden City, N.Y.: Doubleday, Page & Co., 1920. Background.

1,092. (——) Sears, Joseph Hamblen. *The Career of Leonard Wood.* 2 vols. New York: D. Appleton and Co., 1919. Background.

1,093. World's Columbian Exposition. *Official Catalogue.* Chicago: W. B. Conkey Co., 1893. Listing.

1,094. *World's Work*, Aug. 1905. Robertus Love, "The Lewis and Clark Fair." Illustration.

1,095. *Yale Banner*, 1880, p. 88. Football Team for 1879–80, personnel and record.

1,096. *Yale Courant*, vol. 15 (Nov. 2, 1878) p. 47. "College Riff-Raff." Also vol. 16.

1,097. (Yale News) *Fifty Years of Yale News.* Poultney Bigelow. "The Golden Age of Dear Old Yale." Text.

1,098. (Yale) "Personal," *Harper's Weekly*, June 12, 1886, p. 371. The Yale School of Fine Arts.

1,099. Yale School of Fine Arts. *Catalogue*, 1878–79, pp. 71–74.

1,100. *The Year's Art as Recorded in The Quarterly Illustrator.* New York: Harry C. Jones, 1893. Text, illustration.

1,101. *The Year's Art/The Quarterly Illustrator for 1894.* New York: Harry C. Jones, 1894. Text, illustration.

1,102. Young, Art. *On My Way.* New York: Horace Liveright, 1928. Text.

1,103. *The Youth's Companion*, vol. 61, (Jan.–Dec. 1888). Illustration. Also vol. 62.

1,104. Zogbaum, R. F. *From Sail to Saratoga.* Rome: privately published, c. 1945. Text.

Index

ABOUT THE AUTHORS

Peggy and Harold Samuels are private dealers in the art of the American West, specializing in Frederic Remington paintings. They own the largest private Remington library and are listed in *Who's Who in American Art* as Remington authorities.

Harold Samuels studied art at Ohio University and corporate law at Harvard University. Peggy Samuels is a former editor of *Woman's Day*. Their previous books include THE ILLUSTRATED BIOGRAPHICAL ENCYCLOPEDIA OF ARTISTS OF THE AMERICAN WEST and THE COLLECTED WRITINGS OF FREDERIC REMINGTON. Also to be published in 1982 is CONTEMPORARY WESTERN ARTISTS. The Samuels live in Corrales, New Mexico, where they have reconstructed the lost statuette that was Remington's sketch model for the "Big Cowboy" in Fairmount Park.